Africa
Leni Riefenstahl

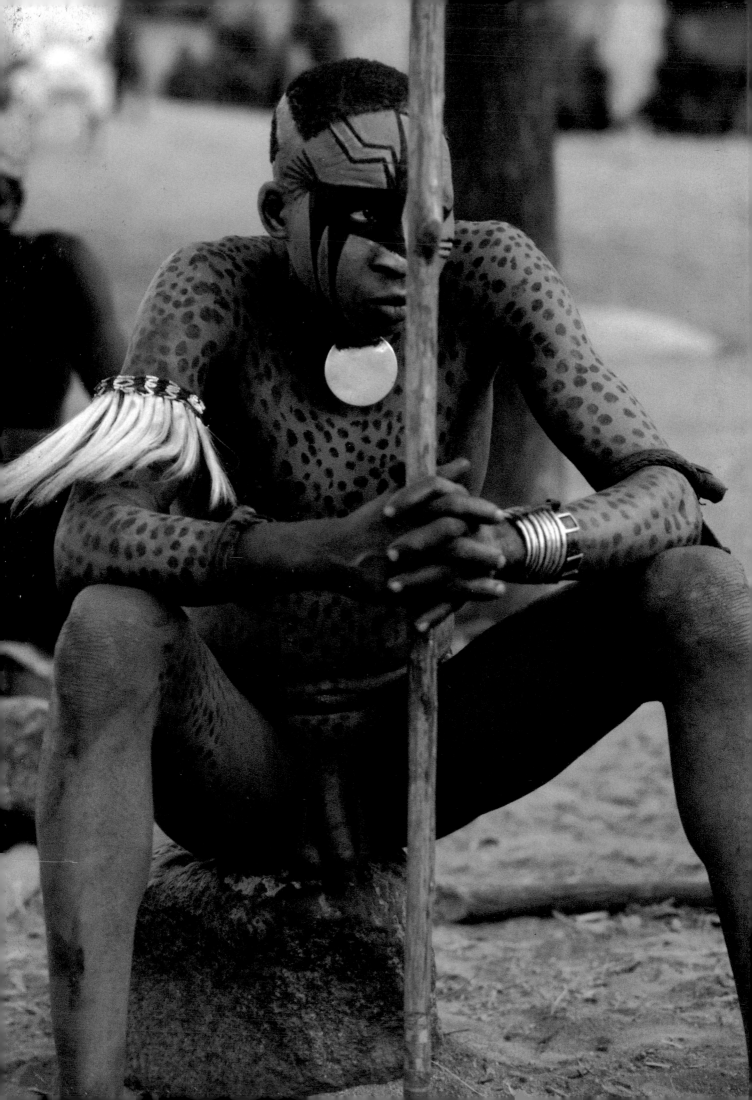

Africa
Leni Riefenstahl

TASCHEN

KÖLN LONDON LOS ANGELES MADRID PARIS TOKYO

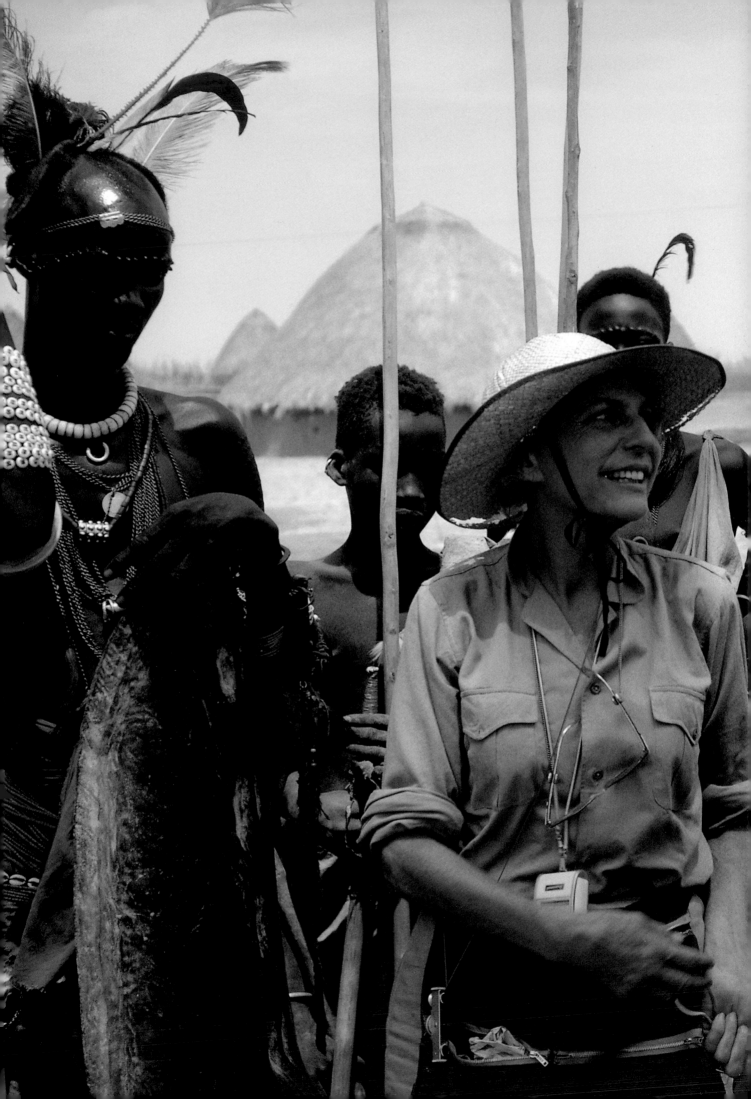

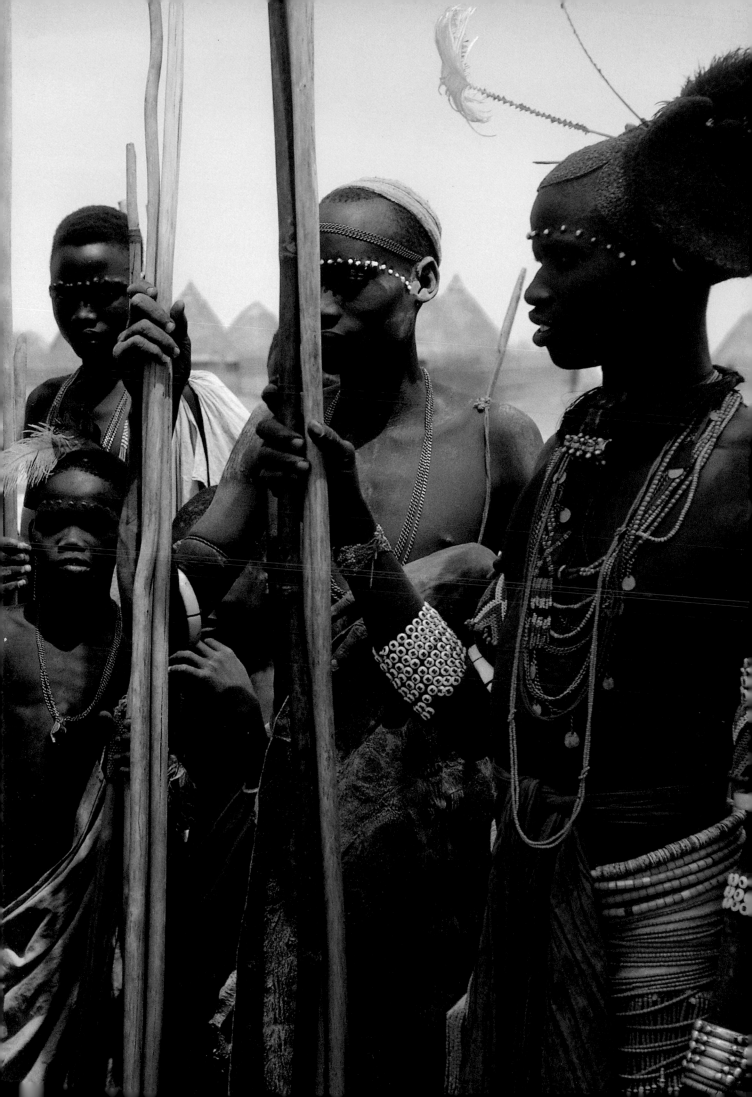

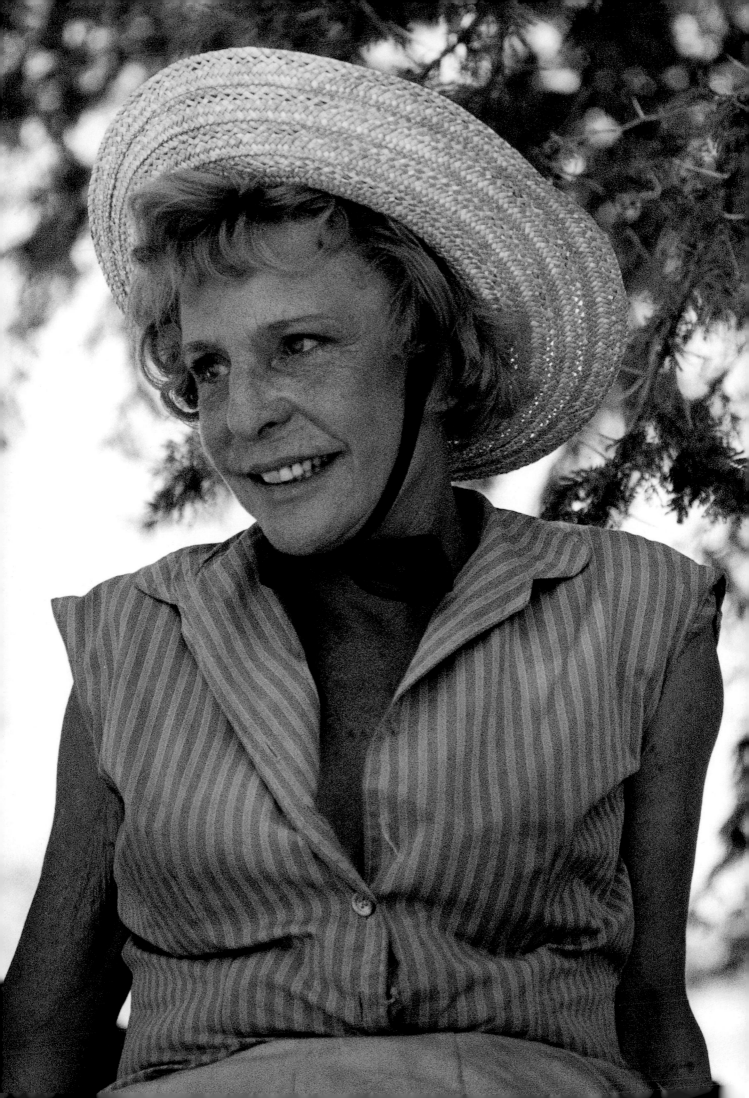

An indelible Love for Africa

If Leni Riefenstahl had done nothing but visit Africa and bring back her photographs, her place in history would be secure. For these pictures are an extraordinary record. Equally extraordinary is her stamina; while she made her first visit in her mid-50s, she undertook her most recent at 98. Her love for Africa resulted in three photographic books before this one.

Her first expedition should have acted as aversion therapy and put her off for life, for it could hardly have been more disastrous. In 1956 she set out to make a film about the illegal slave trade in Africa. While travelling north of Nairobi, the driver of her jeep tried to avoid a tiny dik-dik (dwarf antelope); the vehicle hit a rock and was hurled into the air, crashing down into a dry river bed. Leni went through the windscreen and she was severely injured—her head wound was sewn up with a darning needle—and she was not expected to live. With her incredible resilience she recovered. A fleeting glimpse of Masai warriors carrying spears and wearing tribal costume inspired a fascination which led eventually to her photographic work. Ernest Hemingway described the Masai as 'the tallest, best-grown, most splendid people that I had ever seen in Africa.'

When I spoke to her at her home in Pöcking, Leni Riefenstahl, still in pain from yet another crash in Africa, told me that Ernest Hemingway had been responsible for her fascination for the continent.

'I read Hemingway's book, **The Green Hills of Africa**. And that influenced me. And when I got there, this shimmer, this light that I found in Africa, the warmth and the colours that look so completely different in the heat from those of Europe, all that fascinated me greatly. It reminded me of the Impressionist painters—Manet, Monet, Cézanne.'

But it was a picture of Nuba wrestlers—one man carried on the shoulders of another (ill. p. 541)—taken by the English photographer George Rodger, that led to her becoming a great stills photographer herself. It looked, she said, like a sculpture by Rodin and with its brief caption 'The Nuba of Kordofan' it drew her magically to a forgotten, little-explored part of Africa. But how to get there? Her finances were low, she had no pension and she had a mother to support. She pursued an opportunity to make a film set around the Nile. She succeeded in obtaining a visa to travel in the Sudan from Ahmed Abu Bakr, the Director of Tourism, who became a friend and who would play an important role in her life. But then the Berlin Wall went up and her backers lost their money. The film was cancelled.

She was given a second chance by the head of the German Nansen Society. Herr Oskar Luz warned her how tough it would be, for Leni was over sixty. But with her training in ballet, mountain-climbing and skiing, she was exceptionally confident. After the meeting, she said, she felt 'reborn'.

'I had read that the Nuba lived in Kordofan. At first, nobody knew where Kordofan was. It took me a long time to find out that Kordofan was a province of the Sudan. And when I was in Khartoum, the capital of the Sudan, and asked about Kordofan, most people hardly knew, and no one knew where the Nuba might be. I was in Khartoum twice before I found someone who even knew the Nuba existed.

'When I found out about them, from the photo by Rodger which I had with me, and which I showed to people, and when I was on my way there, the police chief of Kordofan told me that these Nuba on the picture—"The unclothed Nuba"—no longer existed. They said they'd existed ten years earlier. But I didn't give up asking and trying to find out.'

The Nansen people drove on through the Nuba hills. After searching for a week, the only Nuba they had encountered looked like any other black African, wearing shirts and shorts. The morale of the expedition plummeted. One day, after they had been driving for hours through a deserted valley, the distinctive round houses of the Nuba appeared high above. Leni spotted a young, naked girl, who scampered away in fright. With great caution, and immense excitement, they moved forward on foot.

'The blacks,' as she wrote in her memoirs, 'were led by a number of men covered in snow-white ashes, who were naked and wore strange headdresses. They were followed by others whose bodies were painted and adorned with white ornamentation. At the end of the procession were women and girls, likewise painted and decorated with white pearls. They walked straight as candles and carried calabashes and large baskets on their heads. There was no doubt about it; these could only be the Nuba we were searching for.' (Memoirs, p. 635)

That same evening, the expedition saw the phenomenon of wrestling—a vast crowd of shrieking and strangely painted Nuba surrounded pairs of wrestlers who, accompanied by the constant sound of drumming, fought through a ritual which ended with the victors carried on shoulders, as in the Rodger photograph.

I asked Leni if she, a lone woman of advanced years in the middle of the African bush, felt the fear that I know I would have experienced.

'Not at all. I felt far safer than I would walking around the streets here on my own. One could see they were very good people. I felt it, I saw it in their faces, they radiated it. I was never afraid. Never, never—even when I was alone—did a Nuba touch me. They always treated me as one of their own.'

The Nansens pitched camp near a Nuba settlement in December,

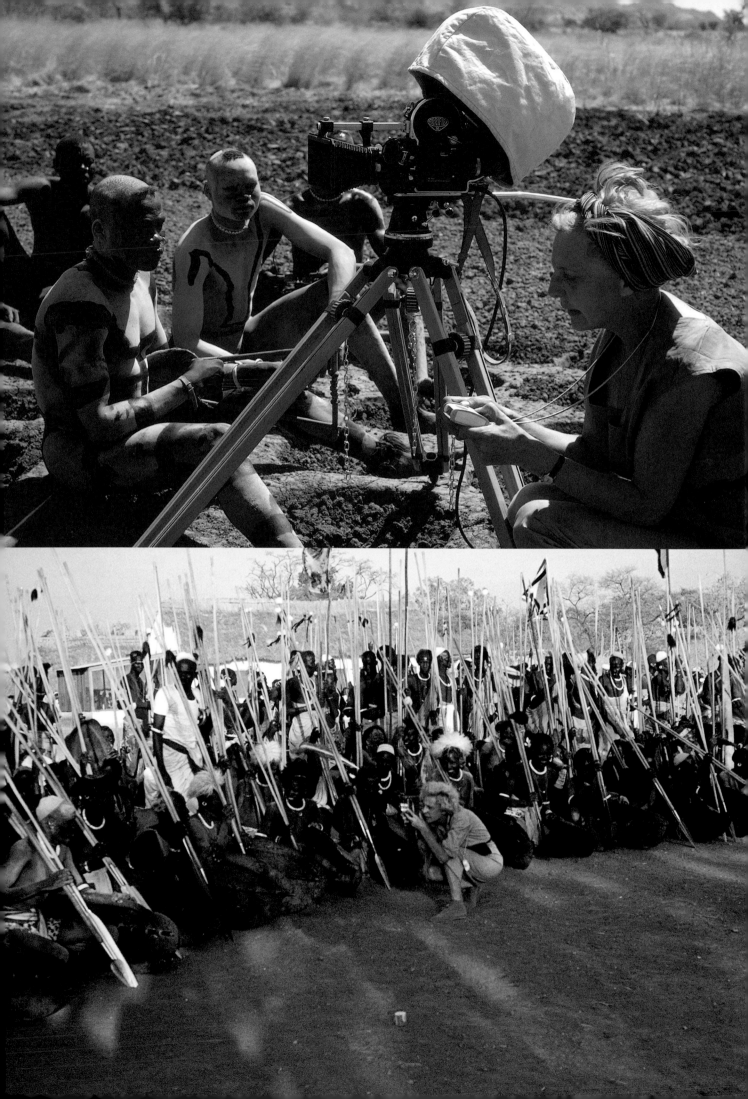

1962, under a tree which would become Leni's favourite spot in the world. She set out to learn the language and the customs. 'The blacks we are living among here are such fun that I never feel bored for a moment' (Memoirs, p. 638), she wrote to her mother, telling her how the Nuba, carrying spears, gathered round the radio and listened to their first broadcast—Christmas carols from Germany.

Since stopping at Kadugli, a young Sudanese policemen had joined the expedition with the specific purpose of acting as censor, and to prevent Leni photographing naked people. For nakedness was forbidden by the Muslims.

'As long as I was with the Nansen expedition, there was always a government policeman with us. But that was only up to 1963. Aftewards, when I was on my own, I never had a policeman with me. The Minister of Tourism in the Sudan, Ahmed Abu Bakr, gave me special permission so I could be there without a policeman accompanying me.'

'Did the policemen ever stop you taking pictures?'

'Yes, they tried. Despite the permission I had. At the last settlement where there were still Sudanese living, the officials there tried to stop me, and I screamed and raged and threw myself on the ground. I refused to go on and forced them to give in. I had worked out a plan. At a stop in a town a few hundred kilometres back, I had recorded an officer saying that I had got permission from the government in Khartoum to go and stay with the Nuba, and he was a high-ranking officer. And that tape I played at the last station. The distances are enormous—from Khartoum to the capital of the province, El-Obeid, is 500 kilometres. And that's where I showed the documents from the Ministry of Tourism in Khartoum to the officer in charge and I asked him to read the official permission on to tape for me. And I played that tape at the last station. They couldn't read there. But they could hear!'

As her relationship with the Nuba became warmer, with the Nansens, alas, it became cooler.

'The people who had organised this first expedition and who took me along, had promised that I could make a film about their work. They were supposed to make a scientific film for some German Ministry. The head of the expedition was Herr Luz and he had a son who was a professional cameraman. Not a real professional, an amateur. And he wouldn't do what I wanted him to do. I was meant to make a film, and he refused to take the shots he was supposed to take. The father wanted me to do it, but the son, no. And we had a severe problem then because the father couldn't do it without his son, and so he couldn't keep his promise to me that I was to make the film. And I had no money, no resources, I was completely dependent upon the Nansens. The son wanted me to be sent away, which wasn't possible, and I was in the middle between these two. I went through a dreadful time among these people, because I was dependent upon them. They gave me very little to eat. I was hungry and often very thirsty and they didn't give me enough water. And I was right out in the bush, thousands of kilometres from civilization, and I couldn't escape. I could have perished. Meanwhile, the Nansens had put up a base in a Nuba village and I came into contact with the Nuba. It was not really a village, just a few scattered huts. The Nuba were still going about unclothed. It was a place where no one ever came.'

The Nansens left after seven weeks, and having no transport, Leni had to go with them. But she managed to return surprisingly soon.

'Let's say that the time I spent with the Nuba was among the happiest of my life, among the most beautiful of my life. It was just wonderful. Because they were always cheerful, laughing all day long, good people who never stole a thing. They were happy about everything, pleased with everything. The punishments there were really harmless and the greatest crime was stealing a goat. A heavy punishment would mean that the offender would have to go for a few days to the nearest place that had a police station and do some punitive work there like road sweeping and other menial chores.'

But the Nuba's state of innocence offended the authorities. 'The Sudanese government had forbidden them to go around naked, they had to wear clothing.' This order, however, took some years to change the way they lived.

Leni had come to Africa primarily to make a film, not to take still pictures. But now the film had collapsed, she fell back on her trusty Leica camera.

I asked her why she did not use black and white, as in the Rodger photograph.

'I only took one or two films in black and white, because the colours were so interesting and beautiful. That's why I found the colour photos stronger than the black and white, but not all of them. Every photograph I have in colour I can copy in black and white and it is almost as interesting as in colour. It is a matter of taste.

'I started out with two Leicas and on the way one of them was broken and I ended up with one and three lenses—35mm, 50mm and 90mm. I did all the photos of the Mesakin Nuba with these three lenses. Those are the pictures in my first book.'

'Did the Leicas have an exposure meter?'

'No, the first Leicas had no exposure meter; one had a special separate exposure meter.'

'Were they reflex cameras?'

'No, I only started using the Leica reflex camera a few years later when I went to the Kau Nuba. It's interesting, for my first book I didn't use the reflex Leica, only the normal Leica. For my second book, when I went to the Kau Nuba, I worked only with the reflex Leica. That was 1974. From then on I used only the reflex Leica.'

'How did you keep the camera mechanism clear of sand?'

'I had a hood over the camera—one hood of cotton and one made of plastic material, like a dress.'

'Did you take flash?'

'Yes. On the first expedition my flash broke down and I couldn't use it. I took two flash-guns on later expeditions, but was seldom able to use either of them because they alarmed the natives. I used flash for fill-in purposes whenever possible.'

'When you were taking photos, did you bracket the exposure? One darker, one lighter?'

'That was hardly possible because of course they never stood still, there was always movement. I couldn't repeat the same photos. They'd either be walking about or walking off.'

'How did you and the film cope with the heat?'

'On several of the expeditions, I could take it. But during the last two expeditions, it became unbearable. When the rainy season started later and I could stay on longer, it got so hot that I could only stay there by constantly wrapping cloths soaked in water around myself and that made it bearable. Such heat was very dangerous for the film. We dug three-metre deep trenches and lined them with double layers of tarpaulin and earth. I stored the film then in an aluminium box. Astonishingly, it worked. We didn't lose a single film through heat.'

'Did you use a motor?'

'I worked with a motor on the Leicaflex camera.'

'What stock?'

'Most of the pictures were on Kodachrome and some on Ektachrome 64. Various sensitivities.'

'Over the years, have any faded?'

'Yes. I can show you. The normal Kodachrome rarely lost its colour—but the sensitive Ektachrome, these are now somewhat pale or violet.'

'How much stock did you take?'

'Less on the first expedition, maybe 30–40 rolls. Later 100–120. I even brought back unused film.'

'A difficult question: how did you know the right moment?'

'I simply try as quickly as possible—it has to be quick—to find the right framing. I work very, very fast.'

'Does a red light go on in your head—what is it?'

'No. Of course I see what will make an interesting photo. That is the reason I work a lot with a very good zoom lens.'

'When did you start using a zoom?'

'On my second expedition, 1964–1965. I didn't use a zoom with the Mesakin Nuba—only later with the Kau.'

'This remarkable talent could not have appeared overnight. When did you realise you had this talent?'

'I actually got that from my director, when I was appearing as an actress in my first films with Dr Arnold Fanck. He was an outstanding photographer. He showed me how to do it, and how to frame photographs. I absorbed it all unconsciously, watching him work. And then I began unconsciously photographing, just as he did. So unconsciously he was my teacher.'

'Did you ever consider Polaroids?'

'I had Polaroids for several reasons. One was to use them with the customs authorities. The various provinces had customs borders and it was always a great problem to get across. I would photograph the customs officers and give them the photo and I'd then get permission to cross the border. In fact, whenever I had problems with people, the Polaroid was my best helpmate. I also used them so that the Nuba could see for the first time what they looked like. It was very funny. When I showed the Polaroid, one Nuba would say to the other "That's you!" They'd never seen themselves and they just kept looking at the picture and then the other one would say "But that's you!" They had no mirrors, and when the first Nuba got a Polaroid picture, they all wanted one. I was completely overwhelmed. They were screaming for the pictures. I didn't have that much film on me. They were just crazy about them.'

'But the Muslims felt that photographing naked people was wrong?'

'Yes. In the Sudan that's a very grave offence. It's almost a crime. And that was my greatest difficulty. No one in the Sudan was supposed to know that I was photographing these naked people. During the first expedition, I still had to send my photographs to Khartoum to be censored. I have an album here with photos where you can see those marked that I wasn't allowed to publish. They didn't destroy the photos, I just wasn't allowed to publish them. One was always on a knife edge. It was dangerous with the government there. I kept getting on the blakklist in Khartoum. The really extraordinary thing was when there was one of those changes of government and President Nimeiri gained power—my books had already been published then—a miracle took place. Because Nimeiri said "These pictures are Art" and I ought to be given an award for them. Even when the people are naked. And I received the highest Sudanese order, and a Sudanese passport.'

Meeting the governor of the Upper Nile Province, Colonel Osman Nasr Osman, Leni told him over a dinner of her experiences with the Nuba and was surprised by his tolerant attitude, for he was from the north, and there were strong tensions between the northern and the southern Sudan. The meal was a wonderful experience after what she had experienced with the Nansens. Col. Osman suggested she accompany him on a trip to the king of the Shilluk, where there would be a great festival of warriors.

'The Shilluk are a very interesting tribe, very intelligent. The very best of them go off to the University of London. They still had a king, King Kur. I treated him with pills. He gave me a big shield—I have it here—of crocodile skin because I treated him. Once, I lived with the Shilluk on my own for four weeks. And some of their tribal leaders went around with me and performed their cult practices for me and I even learned a little of their language.

'The Nuba were much more primitive in comparison but basically the same. The Nuba as well as the Shilluk loved their cattle—the cattle were held to be sacred, as with the Masai. The Nuba were very, very poor and the Shilluk were not nearly so poor. If the Nuba family had one cow, the Shilluk would have ten.'

In her memoirs, Leni wrote how the plump king danced so wildly and yet so nimbly that she was enchanted, and then the warriors joined him in the dance. 'He was accompanied by his warriors as he danced. Even if it was all just a magnificent bit of show, it still had much that was original and unspoilt. The rhythm of the stamping men and their expressions of wild enthusiasm mounting to the point of ecstasy showed that, unlike the peaceful Nuba, the Shilluk were a warrior nation. Their faces glistened from the exertions of the dance, which apparently symbolized a battle between one army belonging to the king, and another belonging to their demigod Nyakang. There followed a succession of attacks and retreats; spears flashing silver through thick clouds of dust, fluttering leopard skins and outlandish wigs turned the scene into a spectacle scarcely matched by Hollywood. The wild screams of the spectators spurred the warriors on to ever greater heights of passion, while I took one shot after another until my camera was empty.' (Memoirs, p. 647)

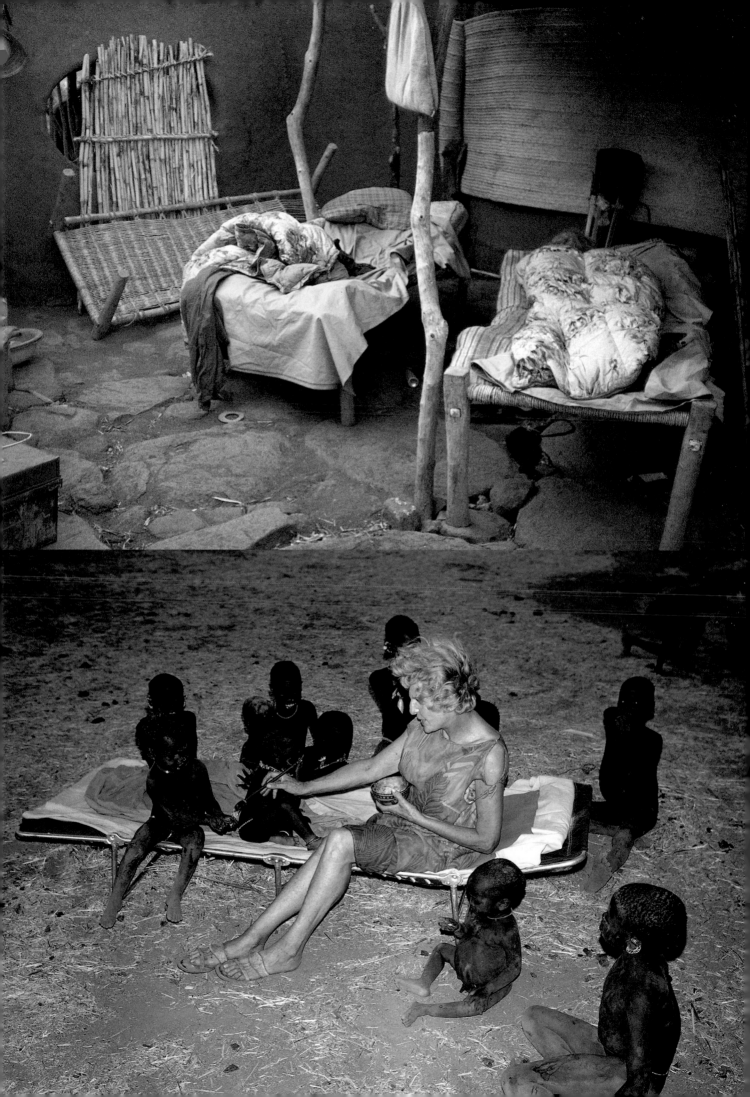

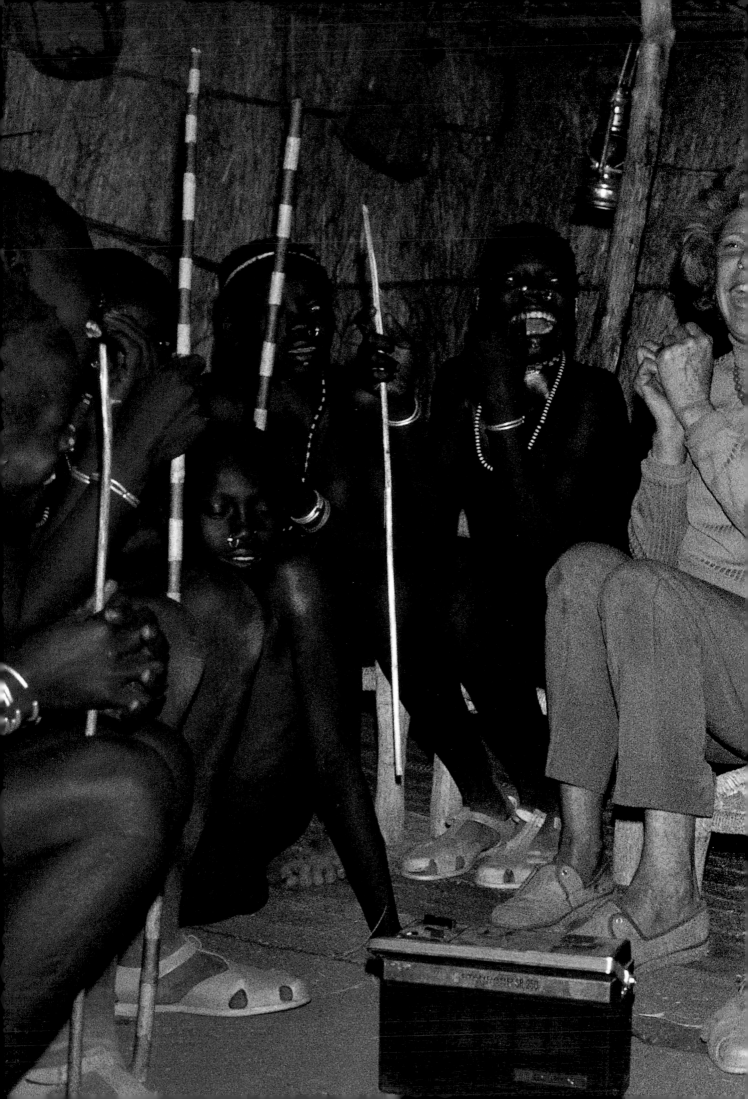

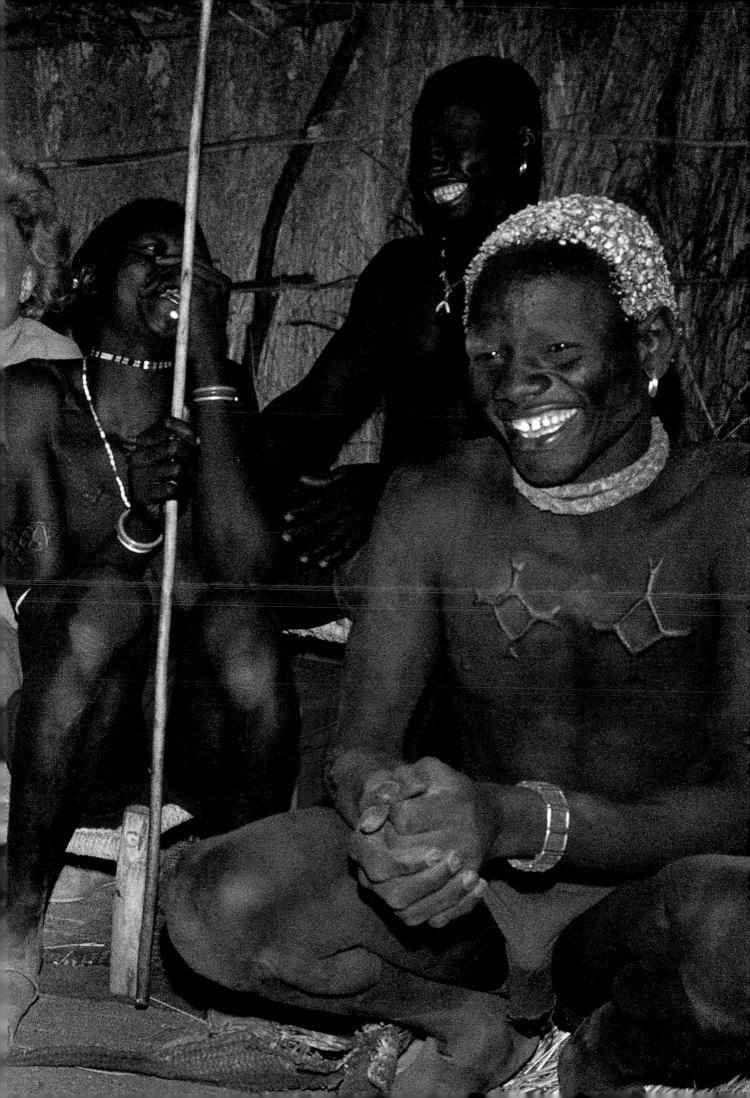

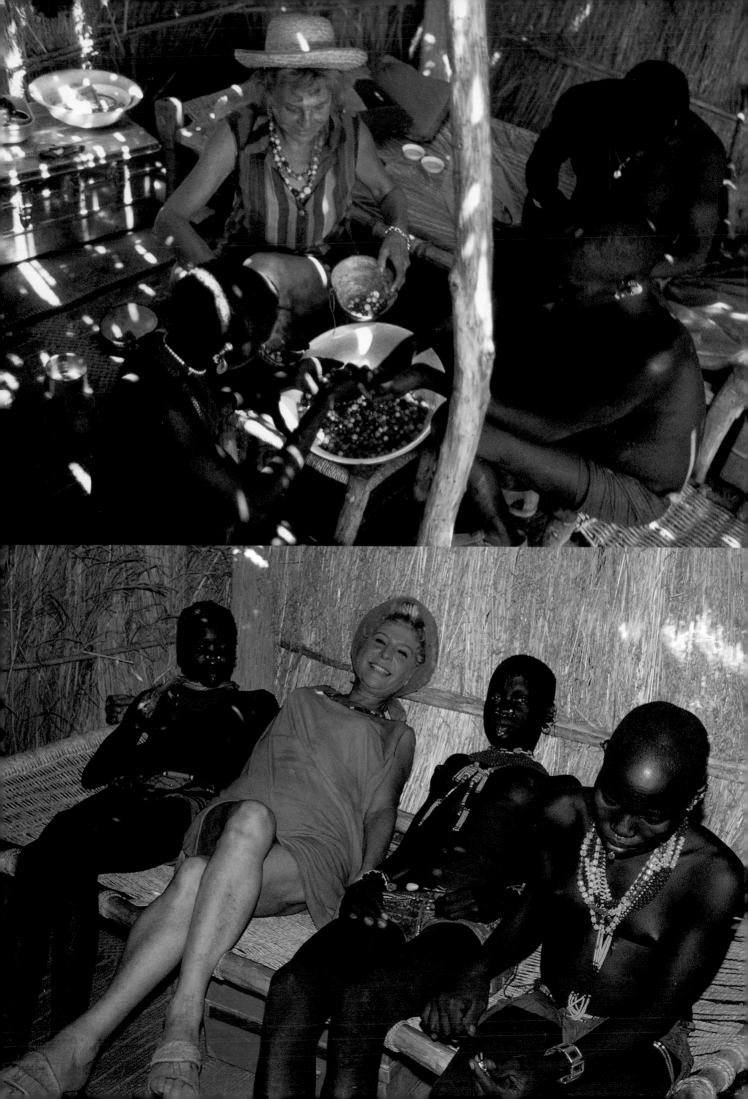

The European idea of 'savages' proved unfounded; in fact, she found the so-called 'savages' a lot more congenial than many of the 'civilized' people she encountered.

'During one of the expeditions I had engaged a German and an Englishman. This was in southern Sudan. They had an ancient car, an old VW van in bad condition. I talked them into taking me to the Nuba about 500 kilometres out of their way. I offered them the last bit of money that I had.'

For the four weeks she wanted to stay with the Nuba, the German demanded 1500 marks—payment in advance. When the VW got jammed in a morass, she was the one who had to set off into the night to find help. She always seemed to have better luck with the indigenous population than with Europeans and she encountered a Shilluk who spoke good English. The vehicle was rescued by military trucks, and set out again on the journey to the Nuba. When the van finally arrived at 'her' tree, the Nuba gathered round shouting 'Leni—Leni giratzo' (Leni's come back).

'The men and women hugged me, the children tugged at my clothes,' Leni wrote. 'It is impossible to describe their rejoicing. I was happy as never before. This was just the reunion I was hoping for, but it surpassed all my dreams.' (Memoirs, p. 653)

Next morning, the German announced they would be moving in two days. Leni protested she had paid for four weeks. But the German's mind was made up. The Nuba, recognising the situation, simply transferred her camp and lent her one of their huts. She was told that a grand wrestling festival was to take place.

'Wrestling was their life. For them, the most important thing after death was wrestling. They started as babies. As soon as they could toddle they'd start wrestling.'

Leni decided to go to the festival without informing the German. To her alarm, the distance proved to be enormous and in the fierce heat she passed out. A Nuba woman carried her the rest of the way in a basket on her head.

The festival surpassed anything she had ever witnessed. While she struggled through the crowd to photograph it, wrestlers nearly fell on top of her. Her Nuba friends escorted her to the spot where the best wrestler of the Mesakin Nuba was to fight the strongest from the Togadindi region, who was almost seven feet tall. The remarkable event had just reached its climax when Leni caught sight of her erstwhile friends, the German and the Englishman.

'They said they were leaving and I had to go with them, but I couldn't leave because my things were in another place, not where the wrestling was going on.'

But leave she had to, even though the Nuba begged her to stay. Weeping with frustration, she had to climb in to the van—and when she returned to her camp, the German admitted they couldn't leave until the next day. Leni could have stayed at the festival. That night, her Nuba came back. They had left the festival to say goodbye to her. And all too soon, it was time to depart.

'The German and the Englishman were dragging me off. The Nuba came running up and grabbed my hands. They wanted me to stay. But the others took me off by force. The Nuba didn't want to let me go. They'd already picked out a spot where they were going to build me a house. I really wanted to stay there, I was going to stay there for good.'

The Nuba ran beside the VW calling out 'Leni basso'. Of course, Leni knew she would come back. Meanwhile, she had another adventure. Discovering that she was at Wau, the capital of Bahr el Ghazahl, her friend Col. Osman invited her on a tour of inspection through the Upper Nile Province.

'The Governor took me on a trip to the border of Ethiopia—he went down there with a large number of troops, 40 soldiers and officers, and asked if I would accompany him.

'I took some extremely rare shots among tribes I was never able to visit again, on the other side of the Nile. We reached a region which no one gets to normally because there are no roads—and there were still people living there who wore those discs in their lips and in their ears. Very strange, rare people.'

Eventually, the governor had to return. Leni had secured a lift in a truck when she saw three Dinka warriors by the side of the road.

'The Dinka are very similar to the Shilluk. More royal, I should say. Of all the tribes, the Dinka is the most royal. They're very good warriors and have the most cattle, they're very wealthy. If you could imagine the southern Sudan ruled by anyone at all, it could only be the Dinka. But it was dangerous, photographing a Dinka without getting their permission.'

She asked the driver to stop. She took her Leica and approached the warriors and the tallest held out his hand for money. She nodded, but discovered to her alarm that she had no coins, only a cheque. The Dinka became angry and snatched her bag.

'I tried to gather up everything that had fallen to the ground. In that moment of danger my eye fell on a brass powder compact I had bought in Malakai, with a mirror set in the lid. I held the compact up to the sun so that it shone like gold.' Then Leni threw it high over the heads of the Dinka, into the grass. As they ran to pick it up her driver started the car, knowing that they had to make a very fast exit because the Dinka were after them brandishing their spears.

'That was the only time during my expedition when I was threatened by the natives. But I alone was to blame.' (Memoirs, p. 668)

'Did you keep a diary of these events?'

'If you could call it that. I wrote in tiny script in a tiny notebook. I need a magnifying glass to read it.'

In May, 1963, Leni accompanied the elderly Prince Ernst von Isenburg, who had lived in East Africa for 30 years, on a trip to the Masai. Celebrated for their fearlessness, the Masai were undefeated until they met the British and the Gatling gun. But they would not sign a peace treaty until they had been brought into the presence of the highest authority, Queen Victoria herself.

'The Masai are very interesting photo subjects—their appearance, their dress. The pictures I took in the Sudan are rare because people hardly ever get there, but those of the Masai photos are not worth a lot because there are so many of them.'

Leni was fascinated to see the difference between the Nuba, who had respect for women, and the Masai, for whom they had less value than a cow.

'But then they could be disarmingly nice, [...] and they even performed mock fights for us.' (Memoirs, p. 673)

When Leni returned to her home in Munich, her mother was horrified by her appearance. She had not been ill and felt immensely fit; only her hair had been damaged by the sun, and she had lost a great deal of weight. What concerned her were the rolls of film she had sent back.

'I gave them to a young man, a student I knew called Ulli, who was to take them to my mother. The student exposed all the films. Destroyed them all. Every one. I could never repeat them.'

Leni was shattered and could barely sleep or eat. She showed the destroyed rolls to detectives. It turned out that for some unaccountable reason, Ulli had taken the films out of their capsules in broad daylight and they were light-struck. The police found four undeveloped rolls in his apartment, and when developed these turned out to be flawless—they contained the shots of the Dinka. And fortunately, the first consignment of ninety rolls with all the Nuba shots were safe. Leni offered them to the German magazines *stern*, *Bunte Illustrierte* and *Quick* and presumably due to her record as a film-maker during the Third Reich, they were turned down by all of them. Only Axel Springer's *Kristall*, whose editors were amazed by the pictures, were willing to publish them—which they did in three editions. Leni took the pictures on the lecture circuit and received excellent reactions from every audience to whom she showed them.

Ill fortune has ruthlessly dogged Leni, but she has always had the resilience and courage to overcome it. And sometimes the ill-fortune was followed by strokes of astounding good luck.

Revolution had broken out in the Sudan. But her old friend Ahmed Abu Bakr obtained permits for filming in the Nuba Hills. 'The welcome I received from the Nuba was—if at all possible—even more effusive than it had been last time,' she wrote. 'Everything seemed the same. The Nuba struck me as the happiest people that the Lord had made.' (Memoirs, p. 692)

But such an ideal situation could not last. In January 1965, Leni's mother died and Leni felt she had to leave at once for Munich—it took her four days to make the journey. She arrived two days too late—her mother had already been buried. 'My only possibility of escaping from the pain was to return as quickly as possible to the Nuba hills.' (Memoirs, p. 693) This time she planned to make a film, and took with her a German cameraman, Gerhard Fromm. But again, that dreadful misfortune cast its shadow.

'At one of the wrestling matches, I was standing too close, and two wrestlers landed on me and my Leica and I broke a couple of ribs.' Leni laughed at the memory. She had to be taken to a small hospital at Kadugli and she returned in bandages. She and Fromm managed to film an adolescent initiation and a tattooing ritual. But then came news that war was coming.

'I experienced the precursors of the big revolution while I was down there with my Nuba. We heard rumours about fighting that was taking place, and on the basis of these rumours we drove in our car to the next—I can't call them villages, hill settlements—because houses were already said to be on fire there. When we got there, we saw houses on fire and signs of shooting, but we didn't catch the villains. One already had the feeling that something was brewing. In the evening, the Nuba came and asked me to drive with them to the south, there was said to be war down there. I was on my own at the time and I took my Land Rover southwards. It was very difficult because during the trip everyone jumped on my vehicle, they all wanted to come along, they were standing on the running boards, until finally I couldn't continue because the car gave up. I had to leave it and walk back for several hours to my base camp.'

On top of this, some wrestlers committed a crime regarded as heinous by the Nuba—they stole two goats and held a banquet. Nuba law held that not only the goat thief, but those who feasted upon it were guilty and the whole wrestling elite were sent to a police station. No more filming. 'It was sad parting from them, it was the most painful farewell I had ever had till then with the Nuba.' (Memoirs, p. 701)

On top of which one of the assistants on the trip stole sixteen rolls of Leni's film and sent the slides to his father. The first test of the motion picture film—shot on Kodachrome (25 ASA) and Ektachrome ER (64 ASA) —was excellent. But then Leni was faced with total catastrophe; the Geyer labs had incorrectly developed the fast Ektachrome and it had all been ruined. 'I can no longer find the words to describe [...] the way I felt [...]. My last chance to make a new life for myself had been lost, once and for all'. (Memoirs, p. 706 f.) She had to enlist the help of friends to refund the investment and cancel the contract with her American backers.

It was during a visit to the BBC in London a short time after this, in 1966, that I first met Leni; she came to the flat of Philip Jenkinson in Blackheath and to a group of us showed the surviving rolls of the Nuba film on 16mm. I remember feeling that Fromm's cinematography was careful and efficient, but when we saw the Nuba slides, without exception, her stills in colour of the same events were more effective. Many were incredibly good. The stills were arranged in sequence, and she edited them like one of her films.

'You can see I am a film-maker, yes?' she said.

We were amazed by mass scenes of tribesmen, the spears composed like paintings by Uccello, powerful close-ups, full figure shots showing her fascination with the beauty of physique, swirling action pictures of wrestling. Her depictions of innocence, the paradise before civilization, were most effective in close-ups of Nuba tribesmen and girls; the serene expressions she captured were most touching.

'Stills can also be artistic,' she said, suspecting prejudice from us film-makers. 'I like stills because there is more time to look.'

We all felt deeply privileged.

At the end of 1966, Leni returned to the Sudan for a brief visit. After the usual enthusiastic reception from the Nuba, she realised it was Christmas.

'I showed them what an angel looked like with a white sheet. I made some kind of wings. I tried to explain what Christmas was like with candles. I gave a small Christmas party—a surprise to the Nuba who didn't know what Christmas was. When I lit the candles in my hut, it turned out that they had never seen a candle.'

On the way back in the train, Leni missed her two Leicas and informed the police they had been stolen. She had to go back and confess that she had found them wrapped in towels in a crate. She took two Nuba on the journey because they so wanted to see an aeroplane in flight.

Leni kept in touch with them via tapes, which she sent to a Nuba schoolteacher in a nearby town. She had tried to solve their water problem by sending money for equipment for well construction.

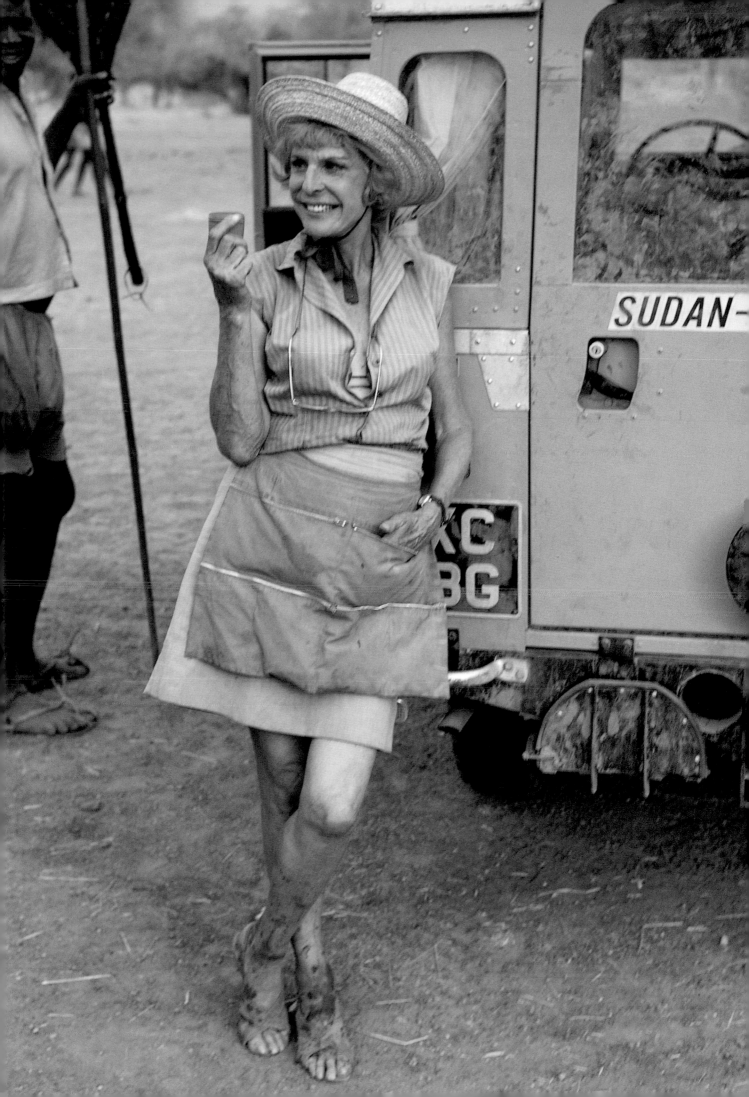

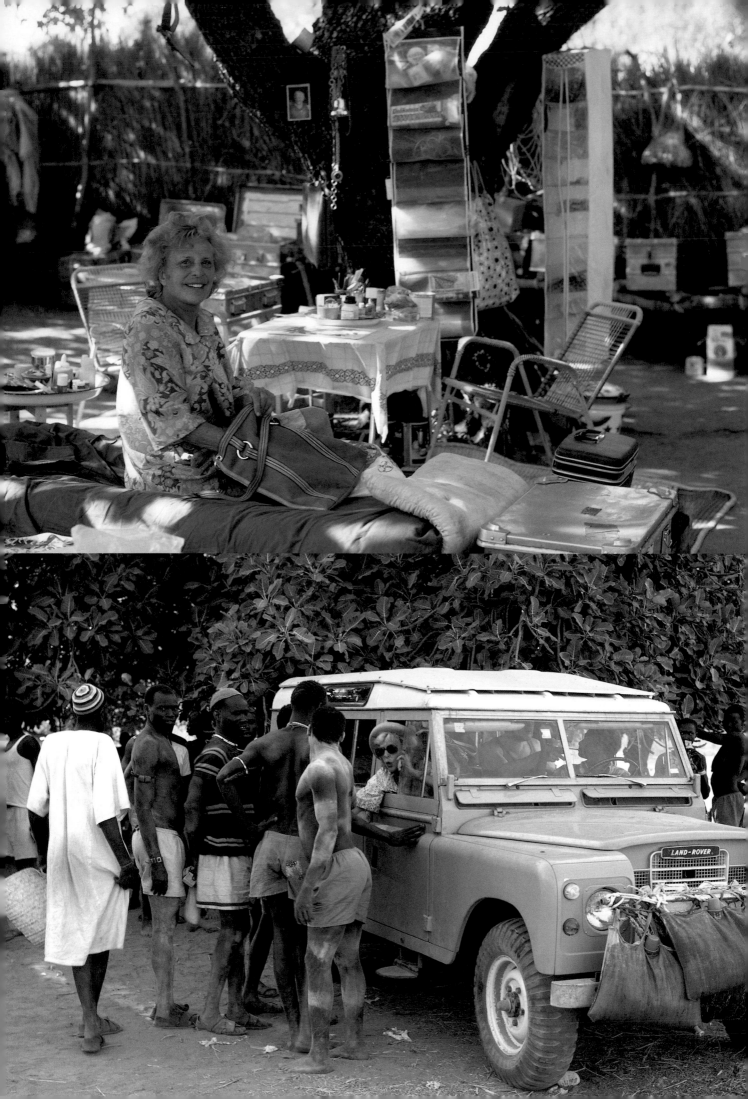

She realised that she could no longer manage alone; ideally she needed someone familiar with motion picture cameras who was also an engineer. And, incredibly, she found him in the form of Horst Kettner. 'His face filled me with confidence right from the very start.' (Memoirs, p. 742) And he proved his ability by going to England, despite not speaking a word of English, picking up a Land Rover, despite a strike at the factory, and driving it non-stop from London to Munich.

'I didn't film myself. I only photographed. Horst filmed with a 16mm Arriflex. Oh, he was a great help. Especially when the car broke down. Changing a wheel was very exhausting for me. And besides it was a very good feeling to have someone else to share all those beautiful things, a friend who could see and experience all that with me. For instance, if anyone were to doubt what I am telling you now, there would be a witness who could confirm what I said. He thinks the same way about the Nuba as I do.'

After overcoming a series of almost insuperable difficulties, vividly told in her memoirs, Leni reached her Nuba once more and again received an ecstatic welcome. They had built her a house.

'A Nuba house consists of six houses connected by a wall.'

But she was dismayed by the changes she saw.

'After five years' absence, when I came back they were suddenly all dressed in rags. They were forced to—the Sudanese government brought them clothing. They weren't allowed to go about naked any more. And that had changed them as well.'

The most urgent plight of the Nuba was the lack of water. Leni wanted to help them.

'I'd engaged a water diviner to look for water on a large-scale map. I'd already tried everything to get sponsorship for water, for wells to be dug, but no one came forward. But there was this American, a friend from Harvard who was travelling through Africa, and I persuaded him to buy tools for me in Khartoum, large axes and shovels. His name was Gardner; he made films himself later on. He bought these tools for me and left them with my friend, the Minister of Tourism, and the Minister was to organise getting these tools gradually down to the Nuba. Arab traders would sometimes drive down to sell salt to the Nuba. And it worked. I had certain Nuba with whom I had especially good contact, who were real friends, and I gave them the job of digging for water. What happened was that when they found no water, they covered the hole up with branches and soil. And one day a boy ran over it and fell in, and because the walls were smooth, he couldn't get out again, and the Nuba were standing about, unable to help. They shouted down into the hole but there was no answer. So I told them to get me a towing rope from the car and I gave one end of the rope to Horst and tied the other one round me like a mountaineer and climbed down into that hole and got the boy out. His father, who was absolutely livid, whacked the boy a couple of times, and I was so furious that I whacked the father a couple of times as well. The boy's back was injured but Horst treated him and he recovered.'

When Horst and Leni attempted to film a wrestling festival, they discovered that even the athletes were wearing trousers and carrying plastic bottles. Horst could not persuade the men to discard their clothing; now they were embarrassed. The ritual had changed so much that it was no longer worth shooting. More disturbingly, Leni heard that the Nuba had begun to steal. 'What could have brought this about?' she wrote. 'It couldn't be due to tourists, because with the exception of a British air

hostess who had once managed to make her way to me with her father, no one had ever come this far.' (Memoirs, p. 755) A number of bad harvests had forced the young men to go to work in the towns; they returned with clothes, venereal diseases and money.

'The first coin, the first piece of money of whatever currency they got hold of changed the character of the Nuba. From that moment, they could buy something in the market. They grew cotton and sold it in the market, and when they got the money for that and could buy things, the others wanted money as well. Before there had been no difference between them. Without money, they were all equal. But with the arrival of money, one would have more, the other one less and so all of a sudden something arose they hadn't known before, a certain competitiveness, a certain envy. And that changed their character.'

Leni feared that the catastrophe which had overwhelmed the Native American and the Australian aborigine would soon destroy the Nuba. As she wrote: 'Human happiness simply dissolves the moment it comes in contact with the darker sides of civilisation.' (Memoirs, p. 756)

Back in Germany, her photographs of the Nuba were printed in magazine in December, 1969, and soon they appeared in an impressive book, published in Germany (1973) and America (1974) as well as France (1976). She took the book to show the Nuba but when she arrived, she found her paradise destroyed. The Nuba were as affectionate as ever, and their old friends much the same, but the others came asking for medicine, tobacco, beads, batteries, sunglasses. And they all wore filthy, tattered clothes.

'When I showed them the pictures of what they'd looked like when they were still wearing no clothing, they were suddenly ashamed. They had been persuaded that this was bad.'

On this expedition, Horst thought Leni mad; she was determined to find a more distant Nuba tribe called the Kau, and despite lack of fuel and the fact that no maps existed for the area, they pressed ahead. The heat was furious, the journey uncomfortable, but they were rewarded by 'an extraordinary and captivating sight'. (Memoirs, p. 804)

'Lit by the last rays of the setting sun,' wrote Leni, 'these extremely slender creatures moved with the grace of dancers to the beat of the drums. The girls were likewise totally naked, their bodies oiled all over and painted in a variety of colours, extending from dark red to ochre to yellow. [...] Their provocative movements became increasingly wild. [...] I was hidden behind a tree trunk, so the dancers didn't notice me, and could photograph them using long telephoto lenses. [...] This was the greatest visual experience that I was ever to have on all of my African expeditions.' (Memoirs, p. 804 f.)

They were also able to photograph a *zuar* (knife-fight); it was the hope of seeing one that led Leni to embark on this expedition in the first place.

'The Kau don't wrestle; it was more of a fight with blades on their arms. No one had ever photographed them before. No other tribe in the entire world fights with these brass rings. There is nothing like it anywhere else in the world. For me, as a photographer, it was sensational. And no other people in the world are as gifted at painting masks. What the indigenous peoples do in New Guinea by comparison is primitive, but the Kau Nuba were artists. Their masks are art.'

She discovered these masks in another village, Nyaro. 'The body of a young boy had been fantastically painted to look like a leopard, and his face made me think of a Picasso. To my surprise, he allowed himself to

be photographed without any objection. Soon I discovered that he was not the only one to be painted in this extraordinary way; young men approached me from all sides, their faces resembling stylised masks.' (Memoirs, p. 807)

'Did they ever object to being photographed?'

'The Mesakin Nuba never. They were far better friends, anyway. There was a big difference between the Mesakin Nuba and the Kau. Some of the Kau Nuba did refuse. The work with the Kau Nuba was very, very difficult. No, what I saw I photographed.'

Her return in 1974 dismayed her. The warriors now wore shorts or Arab costumes. The Kau village was all but deserted. At her camp, she and Horst had to cope with the explosion of a gas-canister—Leni's clothes caught fire—and an hour later she cracked her skull on a branch. Horst was just tending her injury when two large vehicles arrived packed with tourists. Nothing could be more guaranteed to dismay them. The tourists were a pleasant enough group of Germans who had heard that Leni was there from an indiscreet official. But since they saw no sign of painted Nuba, they departed the following day.

Later, the Nuba produced banknotes, given to them by the tourists, and they began to expect payment for photos. Once unspoiled tribesmen had been plied with cash, said Leni, a photographer may as well pack up and leave.

'Did you not pay them for photographs?'

'If I had done that in the beginning I could never have worked there. All the Nuba, hundreds would have wanted money. It was a huge problem already with the glass beads we'd taken along. We had to stop that because they went mad, they all wanted beads. That was the trouble, you couldn't give them anything because then all would have wanted it. The most we did was that I, and later Horst as well, would spend two or three hours every evening treating people who were sick. At night, when it got too dark for our work, they'd come queuing up, with wounds on their legs—open wounds, mainly—and pneumonia. We had a proper medicine chest, prepared for us by a doctor here.'

Leni and Horst also set up a slide projector and showed the pictures she had taken the previous year. This caused enormous excitement. 'The Nubas' reaction to the pictures was indescribable [...] they seemed to recognise everyone, even when they were no more than a silhouette on the screen.' (Memoirs, p. 836)

'The first slide I showed—a young mother from Kau with her baby in her arms—was greeted with a bellow of laughter which redoubled when I followed it with close-ups of the baby. The Nuba found it past comprehension that a human head could be as large as it appeared on the screen.'

This presentation made the Nuba far less inhibited and in the following days they arrived at the camp to show themselves to Leni, the young men elaborately painted.

Back in Munich, Leni, who was, after all, 72 years old—an age at which many are vegetating in old peoples' homes—underwent a physical collapse. However, she all but forgot her illness when she saw the high standard of the still pictures and Horst's motion picture film. Stern and The Sunday Times published the Kau pictures and they were seen around the world. The Art Directors Club of Germany awarded Leni a gold medal for the best photographic achievement of 1975. There were antipathetic art-

icles, as there had always been, but the general reaction to her pictures—from every country that saw them—was amazingly enthusiastic. She was asked by a magazine to return, and in Khartoum received an award from President Nimeiri, who praised her two pictures books, the form and content of which allowed even Muslims to see the unclad Nuba without being offended. The Sudanese government gave several hundred copies of her books to foreign embassies at Christmas.

The changes to the Nuba were due not so much to tourism—the changes to the Mesakin Nuba occurred before any tourists had reached them—as to Arabization, and eventually war. By the time Leni and Horst returned in 2000 for a reunion, virtually none of her old friends were left. The idea behind this trip was to raise money for the Nuba, and to see how they had fared after so many years of war in the Sudan.

'When we'd been there for just a few hours, the police came with vehicles and we had to go back. The Bavaria Film Studios made a film about my last visit there two years ago, a full-length documentary, which is due out one of these days, and that shows everything that happened to us there. The cameraman was hurt in the helicopter crash. Yes, our helicopter crashed.'

'Normally, you don't walk away from helicopter crashes. What happened to you?'

'I broke some ribs. My lung was damaged and I was very ill. As soon as it happened, I was brought back to Germany in a rescue plane, and I was in hospital for three weeks.'

'What were you trying to film?'

'I wanted to film the reunion with our Nuba. The reunion after so many years.'

'Did you meet many of them?'

'No, I didn't meet many. There had been a war meanwhile and most of them were no longer alive. We were only there 24 hours altogether. We didn't have much time to talk to them and only three or four of our old friends were there.'

Leni Riefenstahl had travelled from the 20th century to the Stone Age. She had seen people living in perfect harmony with nature. And she had seen what 'the plague of civilization' could do to them. One great benefit of civilization, however, is the photograph, that frozen moment of time.

Kevin Brownlow, London, May 2002

Kevin Brownlow, London, interviewed Leni Riefenstahl on 2 May 2002 at Pöcking, with the help of interpreter Claus Offermann, Munich. Thanks also to Carla Wartenberg, London. Quoted passages have been newly translated from the original German edition of Leni Riefenstahl's Memoirs (Taschen, Cologne 2000). Page references are to the German edition.

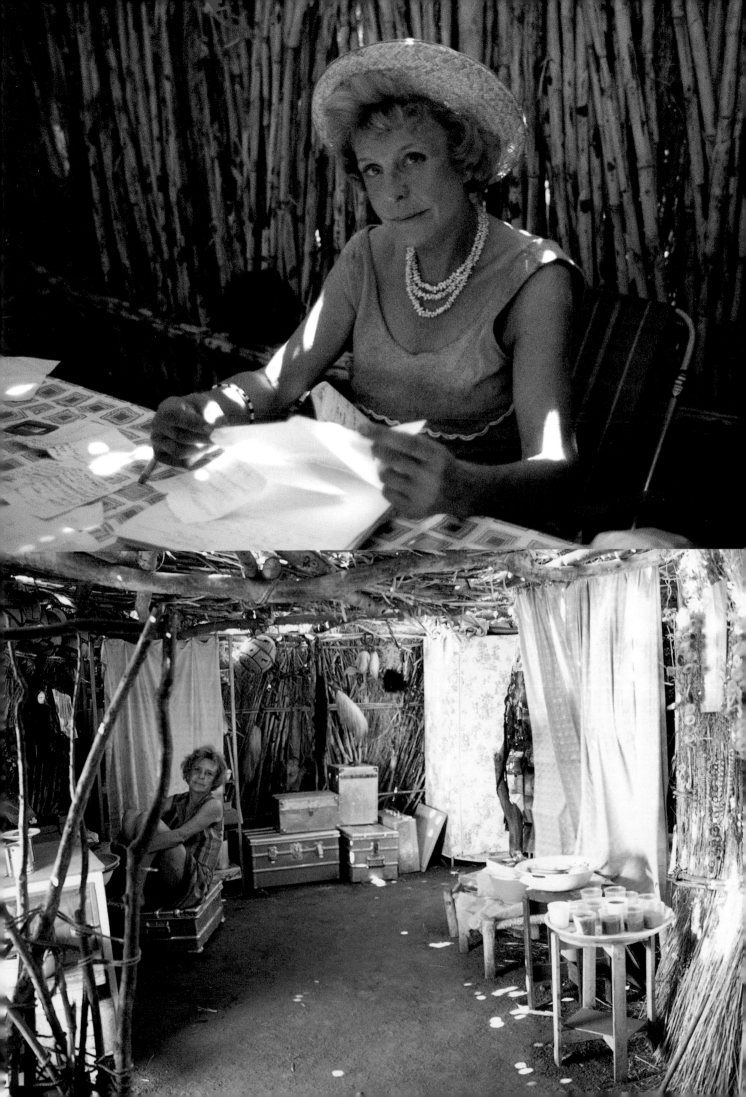

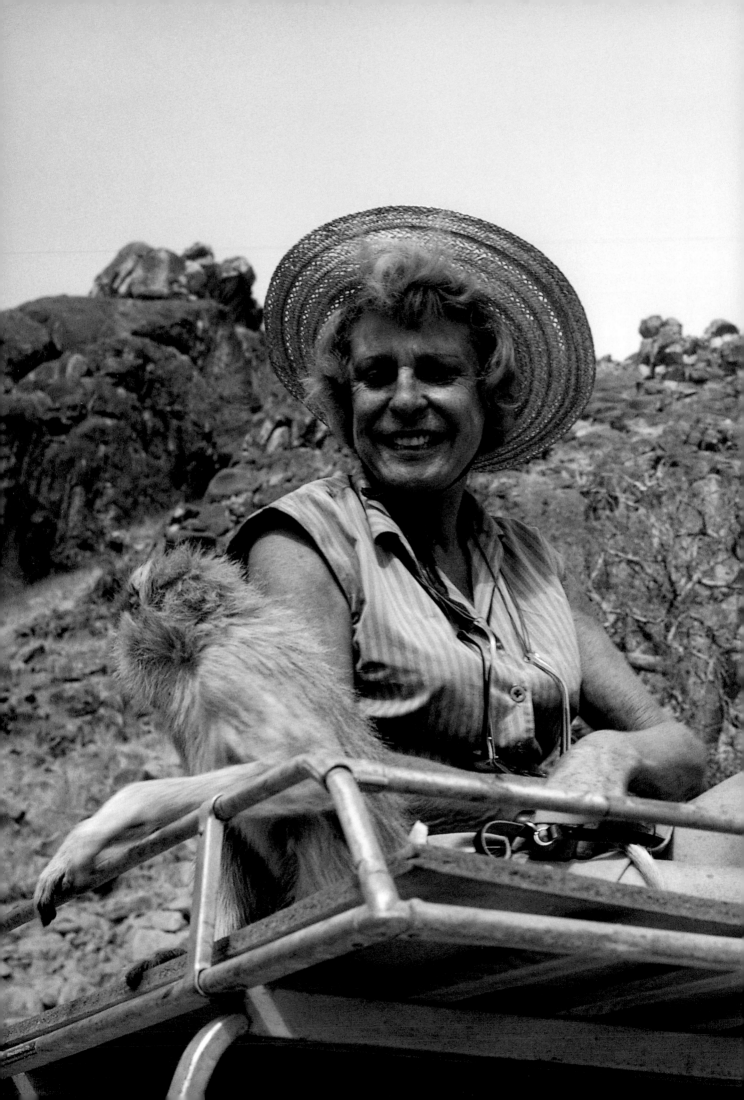

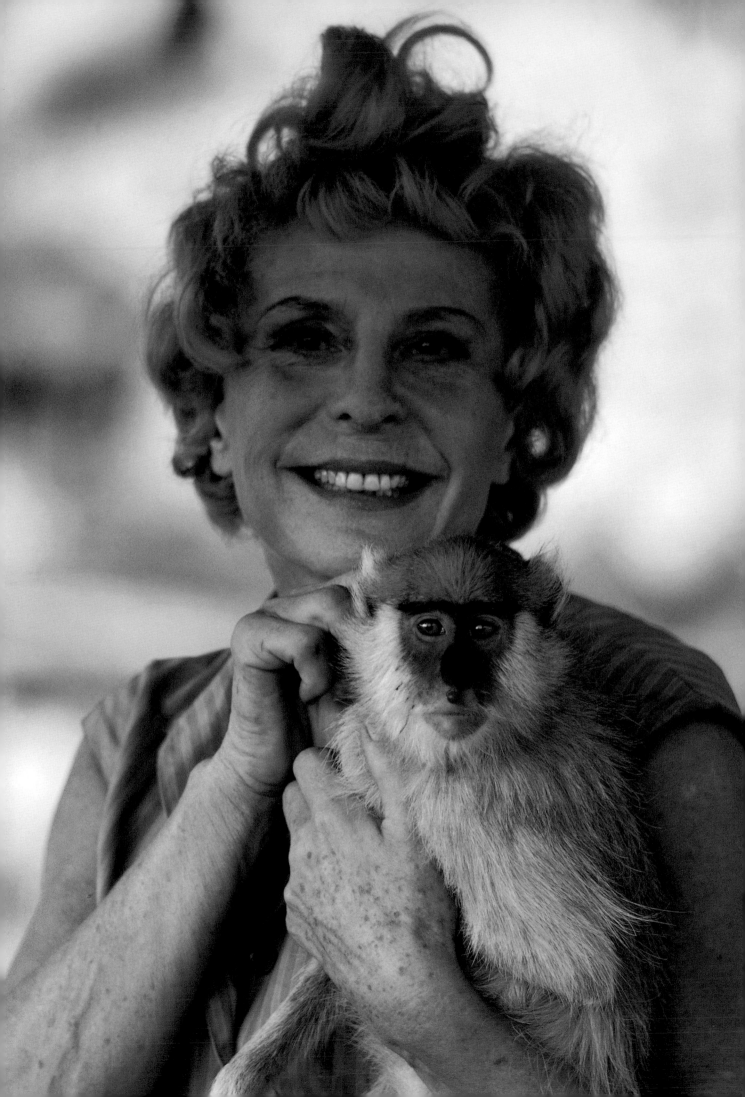

Eine
ganz große Liebe
zu Afrika

Und wenn Leni Riefenstahls Arbeit sich nur darauf beschränkt hätte, nach Afrika zu reisen und mit ihren Fotografien zurückzukommen, allein dafür wäre ihr ein Platz in der Geschichte gewiss. Denn diese Bilder stellen ein außerordentliches Zeugnis dar. Nicht minder ungewöhnlich ist ihre Ausdauer und Zähigkeit: Das erste Mal besuchte sie Afrika, als sie Mitte 50 war, zuletzt mit 98 Jahren. Ihre große Liebe zu Afrika ist vor diesem außergewöhnlichen Buch bereits in drei Bildbänden dokumentiert.

Leni Riefenstahls erste Expedition nach Afrika hätte geradezu eine Aversionstherapie sein können, die sie für den Rest ihres Lebens hätte davon abhalten können, jemals wieder hinzufahren, sie hätte kaum desaströser sein können. 1956 brach sie auf, um einen Film über den illegalen Sklavenhandel in Afrika zu drehen. Auf einer Fahrt in die Gegend nördlich von Nairobi versuchte der Fahrer ihres Jeeps einer kleinen Zwergantilope auszuweichen, dabei rammte das Fahrzeug einen Stein, wurde durch die Luft geschleudert und stürzte in ein ausgetrocknetes Flussbett. Leni flog durch die Windschutzscheibe und trug schwerste Verletzungen davon. Ihre Wunde am Kopf wurde mit einer Stopfnadel genäht – und man glaubte nicht daran, dass sie überhaupt überleben würde. Doch ihre unglaubliche Widerstandskraft und ihr starker Wille ließen sie wieder genesen. Auf dem Rückweg aus dem Krankenhaus inspirierte sie der flüchtige Eindruck, den zwei Masai-Krieger mit ihren Speeren und ihrer traditionellen Stammeskleidung hinterließen – eine Faszination, die später höchstwahrscheinlich zu ihrem fotografischen Werk geführt hat. Ernest Hemingway beschrieb die Masai als die „größten, bestgewachsenen, prächtigsten Menschen", die er je in Afrika gesehen hat.

Als ich mit Leni Riefenstahl in ihrem Haus in Pöcking sprach – sie litt immer noch an den Schmerzen eines neuerlichen Unfalls in Afrika – erzählte sie mir, dass es Ernest Hemingway war, der ihre Begeisterung für diesen Kontinent geweckt hatte.

„Ich habe von Ernest Hemingway das Buch *Die grünen Hügel Afrikas* gelesen, das mich sehr beeinflusst hat. Als ich daraufhin hinflog, haben mich dieses Flirren, dieses Licht, was mich in Afrika empfangen hat, die Wärme und die Farben, die dort in der Hitze ganz anders aussahen als alles in Europa, sehr gefesselt. Es hat mich an die impressionistischen Maler Manet, Monet, Cézanne erinnert."

Doch es war ein Bild des englischen Fotografen George Rodger von zwei Nuba-Ringern – einer trägt den anderen auf seinen Schultern (Abb. S. 541) –, das sie selbst zu einer großen Fotografin werden ließ. Sie sagt, sie sahen aus wie eine Skulptur von Rodin, und mit der kurzen Bildlegende „Die Nuba von Kordofan" zog es sie magisch zu einem vergessenen, so gut wie nicht erkundeten Teil von Afrika. Doch wie dorthin kommen? Sie hatte nur sehr wenig Geld, keine Rente und musste für den Unterhalt ihrer Mutter sorgen. Sie suchte nach einer Möglichkeit, einen Film, der am Nil spielt, zu drehen. Und schließlich gelang es ihr, von Ahmed Abu Bakr, dem Direktor des Tourismusministeriums, ein Visum für den Sudan zu bekommen. Er wurde zu einem Freund und sollte in ihrem Leben noch eine bedeutende Rolle spielen. Doch dann wurde die Berliner Mauer errichtet, ihre Förderer verloren Geld und ihr Filmprojekt wurde abgesagt.

Eine zweite Chance erhielt sie vom Leiter der Deutschen Nansen-Gesellschaft. Doch Oskar Luz warnte sie vor den Strapazen der Reise, da Leni bereits über 60 Jahre alt war. Aber gut trainiert durch Ballett, Bergsteigen und Skilaufen, war sie äußerst zuversichtlich. Nach diesem Treffen mit Oskar Luz, sagte sie, fühlte sie sich wie neugeboren.

„Ich habe gelesen, dass die Nuba in Kordofan leben. Zunächst wusste niemand, wo Kordofan lag. Es hat lange gedauert, bis ich herausgefunden habe, dass Kordofan eine Provinz des Sudan ist. Als ich dann in Khartum war, der Hauptstadt des Sudan, und nach Kordofan fragte, hat selbst dort niemand gewusst, wo Kordofan lag, und kaum jemand, wo die Nuba leben könnten. Ich war zweimal in Khartum, bis ich jemanden fand, der überhaupt wusste, dass es Nuba gibt."

„Zu dem Foto, das ich von Rodger hatte und das ich den Leuten gezeigt habe, erklärte mir auf dem Weg dahin der Polizeichef von Kordofan, dass es diese Nuba auf dem Bild – die nackten, unbekleideten Nuba – nicht mehr gäbe. Er sagte, vor zehn Jahren hätte es sie noch gegeben, aber ich habe nicht aufgegeben weiter zu fragen und zu forschen."

Die Nansen-Leute setzten die Fahrt durch die Nuba-Berge fort. Nach einer Woche Suche waren sie nur auf Nuba getroffen, die aussahen wie jeder beliebige Schwarzafrikaner auch, gekleidet in T-Shirts und Shorts. Die Stimmung der Expeditionsteilnehmer erreichte einen Tiefpunkt. Aber eines Tages, nachdem sie stundenlang durch ein ödes Wüstental gefahren waren, erschienen die charakteristischen Rundhäuser der Nuba hoch über ihnen. Leni entdeckte ein junges, unbekleidetes Mädchen, das ängstlich davonlief. Mit großer Vorsicht und sehr aufgeregt gingen sie zu Fuß weiter.

„Die Schwarzen wurden", schreibt sie in ihren Memoiren, „von mehreren schneeweiß eingeaschten Männern angeführt, die, unbekleidet, einen merkwürdigen Kopfputz trugen. Ihnen folgten andere, deren Körper mit weißen Ornamenten bemalt waren. Am Ende des Zuges gingen Mädchen und Frauen, ebenfalls bemalt und mit Perlen geschmückt. Kerzengerade, auf dem Kopf Kalebassen und große Körbe tragend, folgten sie leichtfüßig der Männergruppe. Kein Zweifel, das konnten nur die von uns gesuchten Nuba sein." (Memoiren, S. 635)

An eben diesem Abend bekam die Expedition das Ritual des Ringkampfes zu sehen – eine große Menge kreischender und kultisch bemalter Nuba umgaben Ringerpaare, die, begleitet von einem gleich bleibenden

Trommelrhythmus, nach einem Ritual kämpften, welches damit endete, dass die Sieger auf den Schultern getragen wurden, ganz so wie auf dem Foto von Rodger.

Ich fragte Leni, ob sie allein als Frau im fortgeschrittenen Alter mitten im Busch von Afrika Angst gehabt hätte, wie ich selbst sie sicher empfunden hätte.

„Überhaupt nicht. Ich habe mich viel sicherer gefühlt, als wenn ich hier alleine über die Straße gehe. Man hat gesehen, dass es sehr gute Menschen waren. Ich habe es gefühlt, ich habe es ihnen angesehen, sie haben es ausgestrahlt. Ich habe dort nie Angst gehabt. Und niemals, niemals – auch wenn ich allein war – hat mich ein Nuba berührt. Sie haben mich immer wie ihresgleichen behandelt."

Die Nansen-Leute schlugen im Dezember 1962 in der Nähe einer Nuba-Siedlung ihr Lager unter einem Baum auf, der zu Lenis Lieblingsplatz auf der ganzen Welt werden sollte. Sie begann sofort die Sprache und Gebräuche der Nuba zu studieren. „Die Schwarzen hier, unter denen wir leben, sind so lustig, dass ich keinen Augenblick Langeweile verspüre" (Memoiren, S. 638), schrieb sie ihrer Mutter und teilte ihr mit, wie die Nuba sich mit ihren Speeren um das Radio versammelten und zum ersten Mal Rundfunk hörten – Weihnachtslieder aus Deutschland.

Bei einem Stopp in Kadugli stieß ein junger sudanesischer Polizist zur Expedition, der den konkreten Auftrag hatte, als Zensor zu fungieren und Leni davon abzuhalten, unbekleidete Menschen zu fotografieren. Denn Nacktheit war bei den Moslems verboten.

„Solange ich mit der Nansen-Expedition zusammen reiste, begleitete uns immer ein Polizist von der Regierung, aber das war nur bis zum Jahr 1963 so. Später, als ich dann allein unterwegs war, war nie ein Polizist dabei, denn der Minister für Tourismus im Sudan, Ahmed Abu Bakr, gab mir eine Spezialerlaubnis, so dass ich ohne einen Beamten reisen konnte."

„Haben die Polizisten Sie je daran gehindert, Fotos zu machen?"

„Ja, sie haben es versucht. Obwohl ich die Sondergenehmigung hatte, haben die Beamten an der letzten Station, wo noch Sudanesen wohnten, versucht mich aufzuhalten, aber ich habe geschrien und getobt und mich auf die Erde geworfen. Ich bin einfach nicht weitergegangen und habe so die Weiterfahrt erzwungen. Außerdem hatte ich mir für alle Fälle etwas ausgedacht: An einer Station in einer Stadt, die ein paar Hundert Kilometer entfernt lag, habe ich die Stimme eines hohen Offiziers auf Tonband aufgenommen, der sagt, dass ich die Genehmigung von Khartum habe, mich bei den Nuba aufzuhalten, und dass mich niemand aufhalten darf. Die Entfernungen sind gewaltig, um von Khartum zur Hauptstadt der Provinz El-Obeid zu kommen, musste ich 500 Kilometer zurücklegen. Dem Offizier dort habe ich die Papiere vom Tourismusministerium in Khartum gezeigt und ihn gebeten, diese Genehmigung auf Band zu sprechen. Das Band habe ich dann an der letzten Station abgespielt. Denn dort konnten sie nicht lesen, aber sie konnten hören!"

Während ihre Beziehung zu den Nuba immer wärmer wurde, verschlechterte sich das Verhältnis zu den Nansen-Leuten.

„Die Leute, die die erste Expedition machten und mich mitnehmen wollten, versprachen, dass ich einen Film über ihre Arbeit drehen kann, denn sie sollten einen wissenschaftlichen Film für ein Ministerium hier in Deutschland machen. Der Leiter der Expedition war ein Herr Luz, dessen Sohn Kameramann war, kein richtig professioneller, eher ein Amateurkameramann. Ich sollte den Film drehen, aber er weigerte sich

die Aufnahmen zu machen, die ich machen wollte. Das Problem war, dass der Vater auf seinen Sohn nicht verzichten konnte, und so konnte er sein Versprechen mir gegenüber nicht halten, dass ich bestimmte, was gefilmt werden sollte. Da ich kein eigenes Geld, keine Mittel hatte, war ich auf diese Leute angewiesen. Der Sohn wollte mich wegschicken, was aber nicht möglich war. Sie gaben mir ganz wenig zu Essen, ich hatte Hunger und sehr oft starken Durst, denn ich bekam auch nicht genug Wasser. Da ich mitten im Busch war, Tausende von Kilometern von jeder Zivilisation entfernt, konnte ich nicht einfach wegfahren, denn dann wäre ich umgekommen. Inzwischen hatten die Nansen-Leute ein Lager in einem Nuba-Dorf errichtet und ich bekam persönlichen Kontakt zu den Nuba. Es war kein richtiges Dorf, nur einige Hütten, die zusammenstanden. Die Nuba waren hier noch unbekleidet, denn es war ein Ort, wo sonst niemand hinkam."

Die Nansen-Leute reisten nach sieben Wochen ab und da Leni keine andere Transportmöglichkeit hatte, musste sie mitfahren. Aber sie hat es erstaunlich schnell geschafft zurückzukehren.

„Sagen wir es mal so: Ich war in meinem Leben mit am glücklichsten in der Zeit, als ich bei den Nuba lebte, das gehört mit zum Schönsten, was ich erlebt habe. Es war einfach wunderbar. Weil sie immer fröhlich waren, den ganzen Tag gelacht, nie etwas gestohlen haben. Sie haben sich über alles freuen können. Das größte Verbrechen, das dort begangen wurde, war eine Ziege zu stehlen. Wenn der Dieb schwer bestraft wurde, musste er ein paar Tage in den nächsten Ort wandern, wo es schon eine Polizeistation gab, und dort einen so genannten Dienst erledigen, Straßen fegen oder so etwas."

Aber die Unschuld der Nuba beleidigte die Obrigkeit. „Die sudanesische Regierung hatte ihnen verboten nackt herumzulaufen, sie mussten Kleider tragen." Aber es dauerte einige Jahre, bis diese Anordnung ihre Lebensgewohnheiten wirklich veränderte.

Leni war in erster Linie nach Afrika gekommen, um einen Film zu drehen und nicht um zu fotografieren. Aber als das Filmprojekt starb, kam sie auf ihre treue Leica-Kamera zurück.

Ich fragte Leni, warum sie nicht in Schwarzweiß fotografiert hat, so wie George Rodger.

„Ich habe nur ein oder zwei Filme in Schwarzweiß fotografiert. Weil die Farben so interessant und schön waren, fand ich die Aufnahmen in Farbe stärker als die Schwarzweißen, aber nicht alle. Jede Aufnahme in Farbe, die ich gemacht habe, kann ich schwarzweiß kopieren und sie ist fast ebenso interessant in Schwarzweiß wie in Farbe. Es ist Geschmackssache."

„Ich besaß zwei Leicas und eine davon ist mir unterwegs kaputtgegangen, so dass ich nur eine Leica hatte und drei Objektive – 35 mm, 50 mm und 90 mm. Mit diesen drei Objektiven habe ich die ganzen Fotos bei den Masakin-Nuba gemacht. Das sind die Bilder in meinem ersten Buch von 1973."

„Hatte die Leica einen Lichtmesser?"

„Nein, die ersten Leicas hatten keinen eingebauten, man hatte einen separaten Lichtmesser."

„Waren es keine Spiegelreflexkameras?"

„Nein, die Leicaflex habe ich erst einige Jahre später eingesetzt, als ich zu den Kau-Nuba fuhr. Es ist interessant, für mein erstes Buch habe

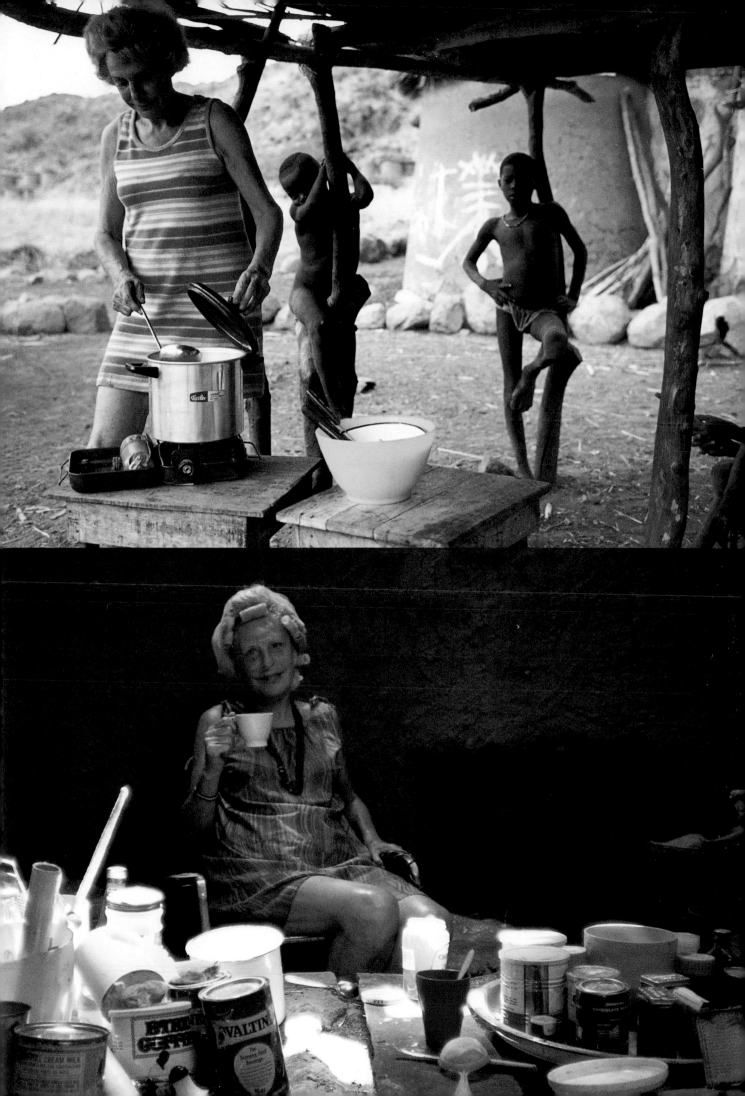

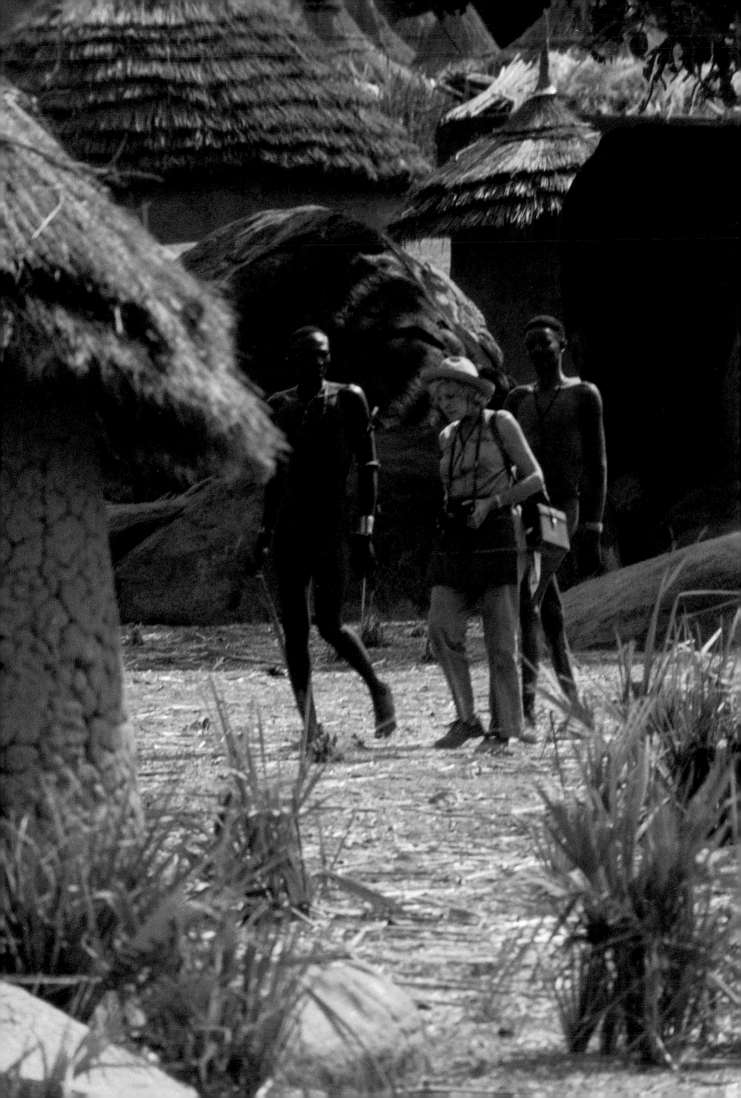

ich nur mit der normalen Leica gearbeitet. Die Aufnahmen für mein zweites Buch über die Kau-Nuba habe ich dann nur noch mit der Leicaflex gemacht. Das war 1974. Von da an habe ich nur noch die Leicaflex verwendet."

„Wie haben Sie den Kameramechanismus vor Sand und Staub geschützt?"

„Ich habe um die Kamera eine Art Haube gelegt – eine war aus Baumwolle und eine zweite war aus einer Plastikfolie, wie ein Kleid."

„Haben Sie mit Blitz gearbeitet?"

„Ja, auf der ersten Expedition ist mir allerdings der Blitz kaputt-gegangen und ich konnte ihn nur wenige Male benutzen. Bei späteren Expeditionen hatte ich zwei Blitzgeräte dabei, aber ich konnte beide nachts nur selten einsetzen, weil die Einheimischen das Blitzen er-schreckte. Tagsüber habe ich so oft wie möglich versucht, den Blitz als Aufhellung einzusetzen."

„Haben Sie mit mehreren Belichtungen gearbeitet? Einer dunkleren, einer helleren?"

„Das war kaum möglich, weil die Nuba für die Aufnahmen nicht still gestanden haben, sie waren meistens in Bewegung. Dasselbe Bild konnte ich gar nicht wiederholen, da sie entweder umhergingen oder weggingen."

„Wie sind Sie und der Film mit der Hitze klargekommen?"

„Auf einigen Expeditionen habe ich es gut ausgehalten, aber auf den beiden letzten war es unerträglich. Als die Regenzeit später einsetz-te als gewöhnlich und ich länger bleiben konnte, da wurde es so heiß, dass ich nur bleiben konnte, weil ich mich ständig mit nassen Tüchern einwickelte, dadurch wurde es erträglich. Für das Filmmaterial war diese Hitze sehr gefährlich. Wir haben drei Meter tiefe Löcher gegraben und diese dann doppelt mit Erde und Planen abgedeckt. Ich habe die Filme dann unten in der Erde in einer Aluminiumkiste aufbewahrt. Erstaun-licherweise hat das funktioniert. Es ist uns nicht ein einziger Film durch die Hitze kaputtgegangen."

„Haben Sie einen Motor benutzt?"

„Ich habe bei der Leicaflex mit Motor gearbeitet."

„Mit welchem Material haben Sie gearbeitet?"

„Die meisten Bilder sind auf Kodachrome- und einige auf Ekta-chrome-64-Filmen aufgenommen. Mit unterschiedlicher Lichtempfind-lichkeit."

„Sind einige nach all den Jahren verblichen oder farbstichig geworden?"

„Ja, das kann ich Ihnen zeigen. Der normale Kodachrome-Film verliert nur selten seine Farbechtheit – aber die empfindlichen Ekta-chrome-Filme sind jetzt irgendwie blass oder violettstichig."

„Wieviel Material haben Sie mitgenommen?"

„Weniger bei der ersten Expedition, vielleicht 30 bis 40 Rollen. Später dann 100 bis 120. Ich habe sogar unbenutztes Filmmaterial wieder mitgebracht."

„Hier kommt eine schwierige Frage: Wie erkannten Sie den richti-gen Augenblick, um auf den Auslöser zu drücken?"

„Ich versuche schnellstmöglich – es muss ja schnell gehen – den richtigen Ausschnitt zu finden. Ich arbeite sehr, sehr schnell."

„Leuchtete dann in Ihrem Kopf ein rotes Licht auf – wie ist das genau?"

„Nein. Ich sehe natürlich, was und wo es ein interessantes Foto geben wird. Aus diesem Grunde arbeite ich sehr viel mit einer sehr guten Zoom-Linse."

„Wann haben Sie zum ersten Mal ein Zoom benutzt?"

„Auf meiner zweiten Expedition 1964–1965. Bei den Masakin-Nuba habe ich noch keinen Zoom benutzt – erst später bei den Kau."

„Dieses außergewöhnliche Talent kann nicht über Nacht gekommen sein. Wann haben Sie selbst bemerkt, dass Sie dieses Talent besitzen?"

„Ich habe mir das eigentlich abgeguckt, von meinem Regisseur, mit dem ich als Schauspielerin in den Zwanziger Jahren die ersten Filme gedreht habe, von Dr. Arnold Fanck. Er war auch ein hervorragender Fotograf und hat mir das Fotografieren beigebracht und gezigt, wie man gute Bildausschnitte macht. Ich habe alles irgendwie unbewusst aufge-nommen, während ich ihm bei der Arbeit zuschaute. Dann habe ich angefangen, ohne es selbst zu bemerken, so zu fotografieren, wie er foto-grafiert hat. So war Arnold Fanck eigentlich mein Lehrer."

„Haben Sie jemals Polaroids gemacht?"

„Ich habe Polaroids aus mehreren Gründen gemacht. Einmal für die Zollbehörden im Sudan. Die verschiedenen Provinzen hatten Zollgrenzen und es war immer ein großes Problem, sie zu passieren. Da fotografierte ich die Zollbeamten und schenkte ihnen ein Foto, sie gaben mir daraufhin die Erlaubnis, die Grenze zu überschreiten. Das heißt bei vielen Problemen, die ich hatte, waren die Polaroidfotos mein bestes Hilfsmittel. Ich habe sie außerdem verwendet, damit die Nuba zum ersten Mal sehen konnten, wie sie aussahen. Es war sehr lustig, als ich ihnen die Polaroids zeigte und dann ein Nuba zu dem anderen sagte: ,Das bist du!' Sie hatten sich ja noch nie gesehen, sie haben immer nur auf das Bild geschaut und dann hat der andere gesagt: ,Das bist du!' Sie kannten keine Spiegel und als sie dann ihr Polaroidbild bekamen, woll-ten alle eins haben, ich konnte mich kaum noch retten. Sie schrien, um ein Foto von sich zu bekommen, aber ich hatte gar nicht so viele Filme dabei. Sie waren jedenfalls verrückt nach ihren Bildern."

„Die Moslems waren also der Ansicht, dass es falsch sei, unbeklei-dete Menschen zu fotografieren?"

„Ja. Im Sudan ist das ein ganz großes Vergehen, es ist fast ein Ver-brechen. Und das war auch eine große Schwierigkeit für mich. Niemand im Sudan durfte wissen, dass ich nackte Menschen fotografiere. Bei der ersten Expedition musste ich noch alle meine Aufnahmen zur Zensur nach Khartum schicken. Ich habe ein Album hier mit Fotos, in denen die markiert sind, die ich nicht veröffentlichen durfte, aber sie haben die Fotos nicht vernichtet, sie haben mir nur verboten, sie zu veröffent-lichen. Es war immer wie ein Seiltanz und gefährlich mit der Regierung und ich kam immer wieder auf die schwarze Liste in Khartum. Etwas wirklich Ungewöhnliches, fast ein Wunder geschah, als es einen dieser Regierungswechsel gab und Präsident Nimeiri an die Macht kam – meine Bücher waren inzwischen schon erschienen, und Nimeiri sagte: ,Diese

Bilder sind Kunst', ich müsse für sie ausgezeichnet werden, auch wenn die Menschen darauf nackt sind. Und ich bekam den höchsten sudanesischen Orden und als erste Ausländerin überhaupt einen sudanesischen Pass."

Bei einer Begegnung mit dem Gouverneur der Upper Nile Province, Colonel Osman Nasr Osman, erzählte Leni ihm während des Essens über ihre Erlebnisse bei den Nuba im Süden des Sudan. Sie war erstaunt über seine tolerante Haltung gegenüber den Nuba, denn er kam aus dem Norden und schon damals herrschten zwischen Nord- und Südsudanesen starke Spannungen. Nach den Erlebnissen mit den Nansen-Leuten, war dieses Essen eine wunderbare Erfahrung für sie. Colonel Osman schlug ihr vor, ihn auf eine Fahrt zum König der Schilluk zu begleiten, wo ein großes Fest der Schilluk-Krieger stattfinden sollte.

„Die Schilluk sind ein sehr interessanter Stamm, sehr intelligent. Die Besten unter ihnen werden nach London auf die Universität geschickt. Sie hatten damals noch einen König, König Kur. Ich behandelte ihn mit Tabletten und er hat mir dafür ein großes Schild – ich habe es immer noch hier – aus Krokodilleder geschenkt. Einmal lebte ich bei den Schilluk vier Wochen allein. Und einige ihrer Häuptlinge sind mit mir herumgezogen und haben mir ihre Kulthandlungen vorgeführt. Dabei habe ich auch ihre Sprache etwas gelernt."

„Die Nuba waren im Gegensatz zu den Schilluk viel primitiver, aber im Grunde ähnlich. Die Nuba, so wie die Schilluk, lieben ihre Herde – Kühe sind für sie etwas Göttliches, so wie für die Masai. Die Nuba sind sehr, sehr arm, die Schilluk sind lange nicht so arm wie die Nuba. Wenn eine Nuba-Familie, sagen wir mal, ein Rind besitzt, gehören den Schilluk vergleichbar vielleicht zehn Rinder."

In ihren Memoiren beschreibt Leni, wie der etwas plumpe König so wild und doch so geschmeidig tanzte, dass sie ganz begeistert war. „Ihm folgten seine Krieger im Tanz. War das ganze auch nur eine großartige Inszenierung, so steckte doch noch viel Ursprünglichkeit darin. Der Rhythmus der stampfenden Männer, der sich bis zur Ekstase steigernde Ausdruck wilder Begeisterung machten sichtbar, dass die Schilluk – anders als die friedlichen Nuba – ein Kriegervolk waren. Ihre Gesichter glänzten von den Anstrengungen des Tanzes, der eine Schlacht symbolisieren sollte, in der eine Armee die des Königs darstellte, die andere die ihres Halbgottes Nyakang. Angriff und Verteidigung lösten einander ab; aus dichten Staubwolken glänzten silbern blitzende Speerspitzen; wehende Leopardenfelle und phantastische Perücken machten die Szene zu einem Schauspiel, wie es selbst Hollywood kaum gelungen wäre. Die wilden Schreie der Zuschauer feuerten die Krieger zu sich ständig steigernder Leidenschaft an. Ich fotografierte, bis ich keinen Film mehr in der Kamera hatte." (Memoiren, S. 647)

Die europäische Vorstellung von „wild" erwies sich als unbegründet; tatsächlich empfand sie die so genannten „Wilden" als sehr viel umgänglicher als viele der „zivilisierten" Menschen, die ihr begegneten.

„Während einer der Expeditionen im Südsudan engagierte ich einen Deutschen und einen Engländer, die einen alten Wagen hatten, einen VW-Bus in schlechtem Zustand. Ich überredete sie, mich zu den Nuba zu fahren, was etwa 500 Kilometer jenseits ihrer Route lag und bot ihnen dafür mein letztes Geld an, das ich hatte."

Für die vier Wochen, die sie mit ihr bei den Nuba bleiben sollten, verlangte der Deutsche 1500 Mark – im Voraus. Als der VW-Bus dann im Morast stecken blieb, war Leni diejenige, die in die Nacht hinausging, um Hilfe zu holen. Sie schien mit den Einheimischen immer mehr Glück zu haben als mit Europäern und so traf sie auf einen Schilluk, der gut Englisch

sprach. Militär-Lastwagen befreiten schließlich das Fahrzeug, so dass die Reise zu den Nuba fortgesetzt werden konnte. Als der VW-Bus an „ihrem" Baum ankam, liefen die Nuba herbei und riefen: „Leni – Leni giratzo!" (Leni ist zurückgekommen).

„Die Männer und Frauen umarmten mich, die Kinder zupften an meiner Kleidung", schrieb Leni, „der Jubel war unbeschreiblich. Ich war glücklich, überglücklich. So hatte ich mir das Wiedersehen gewünscht, aber es übertraf meine Vorstellung." (Memoiren, S. 653)

Am nächsten Morgen verkündete der Deutsche, dass sie in zwei Tagen wieder abreisen würden, worauf Leni protestierte, denn sie hatte für vier Wochen bezahlt. Aber der Deutsche wich nicht von seinem Entschluss ab. Die Nuba, die die Situation erkannten, verlegten einfach ihr Lager und stellten ihr eine ihrer Hütten zur Verfügung. Man sagte ihr, das ein großes Ringkampffest stattfinden würde.

„Der Kampf war ihr Leben. Das Wichtigste außer dem Tod war für sie der Ringkampf. Sie begannen fast schon als Babys damit: Sobald sie laufen lernten, fingen sie an zu kämpfen und zu balgen."

Leni entschied sich, zum Ringkampffest zu gehen, ohne den Deutschen darüber zu informieren. Doch die Entfernung erwies sich zu ihrer Bestürzung als enorm und in der glühenden Hitze wurde sie ohnmächtig. Eine Nuba-Frau trug sie den Rest des Weges in einem Korb auf dem Kopf.

Dieses Ringkampffest übertraf alles, dem sie jemals beigewohnt hatte. Während sie sich durch die Menge kämpfte, um zu fotografieren, fielen die Kämpfer fast auf sie. Ihre Nuba-Freunde begleiteten sie an den Platz, wo der beste Masakin gegen den stärksten Mann der Togadindi-Region, der über 2,10 Meter groß war, kämpfen sollte. Dieses bedeutende Ereignis erreichte gerade seinen Höhepunkt als Leni ihre beiden ehemaligen Freunde entdeckte, den Deutschen und den Engländer.

„Sie kamen und sagten, dass sie jetzt wegfahren und ich mitkommen müsse. Da aber meine Sachen woanders waren und nicht da, wo die Kämpfe stattfanden, konnte ich nicht sofort mitkommen."

Vor Enttäuschung weinend stieg sie in den VW-Bus – und als sie zum Camp zurückfuhren, gestand der Deutsche, dass sie eh nicht vor dem nächsten Tag abreisen könnten. Leni hätte also beim Ringkampffest bleiben können. In der Nacht kamen ihre Nuba zurück, sie hatten das Fest verlassen, um sich von ihr zu verabschieden. Dann wurde es Zeit abzufahren.

„Der Deutsche und der Engländer zogen mich weg. Da kamen die Nuba und riefen: ‚Auf Wiedersehen, auf Wiedersehen!' Sie sind mitgelaufen und haben meine Hände gehalten und gedrückt. Sie wollten mich nicht gehen lassen, sie hatten schon einen Platz ausgesucht, wo sie mir ein Haus bauen wollten. Ich wollte wirklich dort bleiben, ich wollte dort überhaupt für immer bleiben. Aber die anderen haben mich einfach mitgenommen."

Die Nuba rannten neben dem VW-Bus her und riefen: „Leni basso." Natürlich wusste Leni, dass sie zurückkommen würde. In der Zwischenzeit hatte sie wieder ein neues Abenteuer. Als ihr Freund Colonel Osman von ihrem Aufenthalt in Wau, der Hauptstadt von Bakr el Ghazal, erfuhr, lud er sie spontan auf eine Inspektionsreise durch die Upper Nile Province ein.

„Ein Gouverneur nahm mich auf eine Reise an die Grenze nach Äthiopien mit – er fuhr mit einer großen Truppe, 40 Soldaten und Offiziere, und er fragte mich, ob ich ihn begleiten wolle."

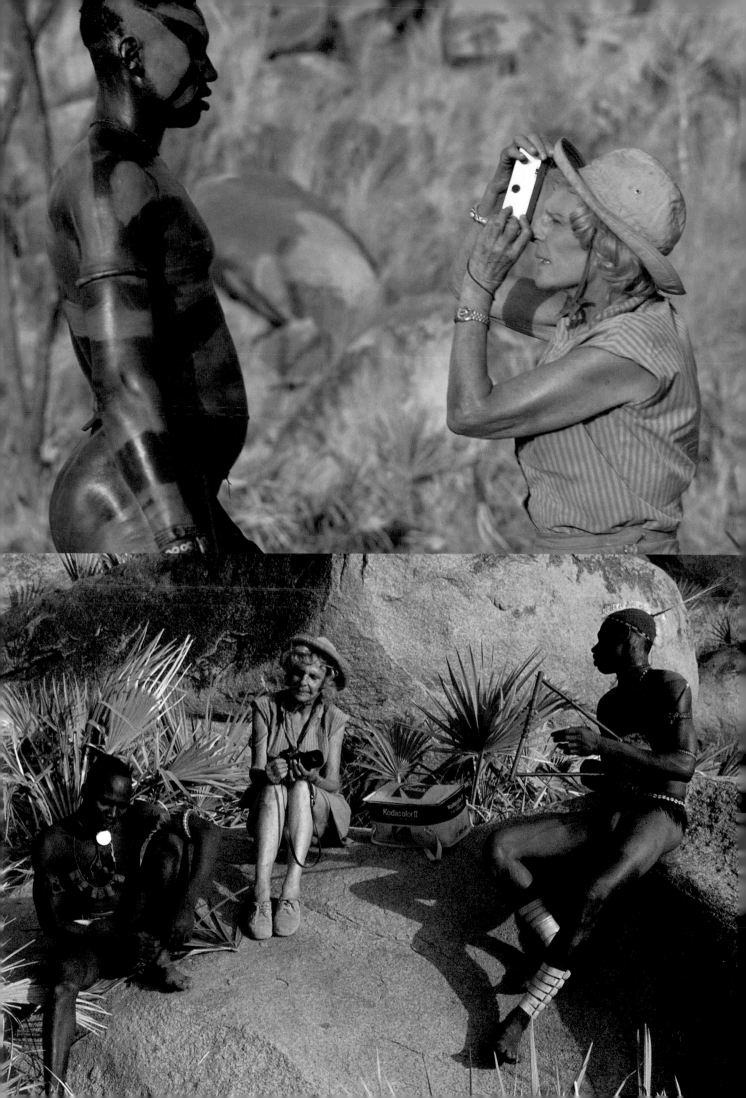

„Ich machte ein paar ganz seltene Aufnahmen von Stämmen auf der anderen Seite des Nils, wo ich danach nie wieder hingekommen bin. Wir waren in einem Gebiet, in das man sonst nie kommt, weil es dort ja keine Straßen gibt. Da lebten noch Menschen, die Metallscheiben in den Lippen und in den Ohren trugen, ganz ganz außergewöhnliche Menschen."

Schließlich musste der Gouverneur umkehren. Aber Leni hatte sich eine Mitfahrgelegenheit in einem Lastwagen gesichert, als sie Dinka-Krieger am Straßenrand sah.

„Die Dinka sind den Schilluk sehr ähnlich. Ich möchte sagen, noch königlicher. Von allen Stämmen sind die Dinka die königlichsten. Sie sind sehr gute Krieger und haben die meisten Rinder, sie sind sehr reich. Und wenn der ganze Südsudan von nur einem Stamm beherrscht werden würde, dann würden dafür immer nur die Dinka in Frage kommen. Aber es war gefährlich, einen Dinka ohne dessen Einverständnis zu fotografieren."

Sie bat den Fahrer anzuhalten, nahm ihre Leica und näherte sich den Kriegern. Der größte von ihnen hielt die Hand auf, er wollte Geld. Sie nikkte, entdeckte dann aber, dass sie keine Münzen hatte, nur einen Scheck. Die Dinka wurden wütend und rissen ihr die Tasche aus der Hand. „Ich versuchte alles einzusammeln, was herausgefallen war. [...] In diesem gefährlichen Augenblick fiel mein Blick auf eine Kompaktpuderdose aus Messing, die ich in Malakal gekauft hatte. Auf ihrem Deckel war ein Spiegel. Ich hielt die Dose hoch zur Sonne, dass sie wie Gold glänzte." Dann warf Leni die Dose in hohem Bogen über die Köpfe der Dinka ins Gras. Während sie nach der Dose rannten, startete ihr Fahrer, der ganz schnell fahren musste, weil die Dinka mit ihren Speeren auf sie losgegangen sind. „Nur dieses einzige Mal auf meiner Expedition bin ich von Eingeborenen bedroht worden. Es war mein eigenes Verschulden." (Memoiren, S. 668)

„Haben Sie ein Tagebuch geführt?"

„Wenn man das so nennen kann. Es ist sehr klein und ganz eng beschrieben, um es zu lesen, muss ich die Lupe benutzen."

Im Mai 1963 begleitete Leni den Prinzen Ernst von Isenburg, einen älteren Herren, der seit 30 Jahren in Ostafrika lebte, auf einer Reise zu den Masai. Gepriesen für ihre Furchtlosigkeit blieben die Masai unbesiegt, bis sie auf die Briten und das Gatling-Gewehr trafen. Sie wollten einen Friedensvertrag nur in Anwesenheit der höchsten Autorität, also damals Queen Victorias persönlich, unterzeichnen.

„Die Masai geben sehr interessante Motive ab – ihr Aussehen, ihre Kleidung. Aber die Aufnahmen, die ich im Sudan gemacht habe, sind selten, weil dort kaum Menschen hinkommen, dagegen sind meine Fotos von den Masai nicht so etwas Besonderes, weil sie viel fotografiert werden."

Leni war fasziniert vom Unterschied zwischen den Nuba, die ihre Frauen respektierten, und den Masai, für die Frauen weniger wert waren als Rinder.

„Dann aber konnten sie wieder entwaffnend nett sein, [...] und führten uns sogar Scheinkämpfe vor." (Memoiren, S. 673)

Als Leni wieder Zuhause in München ankam, war ihre Mutter über ihren Anblick entsetzt. Dabei war sie nicht krank und fühlte sich völlig fit; nur ihre Haare waren von der Sonne in Mitleidenschaft gezogen und vor allem hatte sie sehr viel Gewicht verloren. Was sie aber bei ihrer Rückkehr

am meisten beunruhigte waren die Filmrollen, die sie aus Afrika zurückgeschickt hatte.

„Ich gab diese Aufnahmen einem jungen Mann mit, einem Studenten namens Ulli, der sie meiner Mutter übergeben sollte. Er hat alle mitgegebenen Filme belichtet und zerstörte damit die Aufnahmen, die ich nie wieder machen konnte."

Leni war am Boden zerstört, sie konnte deshalb kaum noch schlafen oder essen. Sie zeigte die zerstörten Filmrollen der Polizei. Dabei kam heraus, dass Ulli aus unerfindlichen Gründen bei vollem Tageslicht die Filme aus ihren Hülsen gezogen hatte. Die Polizei fand in seiner Wohnung vier noch nicht entwickelte Filme. Nach deren Entwicklung waren diese einwandfrei – es waren Bilder von den Dinka. Glücklicherweise war die erste Sendung von 90 Filmen mit den Aufnahmen der Nuba in Sicherheit. Leni bot sie *stern*, *Bunte Illustrierte* und *Quick* an, aber auf Grund ihrer Arbeit als Filmemacherin im Dritten Reich lehnten alle ab, diese zu veröffentlichen. Nur Axel Springers *Kristall*, dessen Redakteure von den Bildern begeistert waren, erklärte sich bereit, sie zu drucken – was sie in drei verschiedenen Ausgaben auch taten. Leni nahm die Bilder mit auf Dia-Vortragsreisen und erhielt immer positive Resonanz vom Publikum.

Das Pech verfolgte Leni, aber sie hatte immer die Kraft und den Mut, damit fertig zu werden. Und manchmal folgten auf das Unglück jede Menge erstaunliche Glücksfälle.

Im Sudan brach die Revolution aus. Aber ihr alter Freund Ahmed Abu Bakr verschaffte ihr die Erlaubnis, in den Nuba-Bergen filmen zu dürfen. „Die Begrüßung der Nuba war, wenn überhaupt möglich, noch überschwenglicher als beim letzten Mal", schrieb Leni. „Es schien alles zu sein wie damals. [...] Die Nuba erschienen mir als die glücklichsten Menschen, die der Herrgott geschaffen hat." (Memoiren, S. 692)

Aber dieser wunderbare Zustand konnte nicht lange andauern. Im Januar 1965 starb Lenis Mutter und sie musste sofort nach München abreisen – die Reise nahm damals ganze vier Tage in Anspruch. Sie kam zwei Tage zu spät – ihre Mutter war bereits beerdigt. „Die einzige Möglichkeit, dem Schmerz zu entrinnen, sah ich darin, so schnell als möglich nach den Nuba-Bergen zurückzukehren." (Memoiren, S. 693) Dieses Mal hatte sie vor, dort einen Film zu drehen, und nahm den deutschen Kameramann Gerhard Fromm mit. Aber auch dieses Mal warf großes Pech seine Schatten voraus.

„Ich wollte zwei Ringkämpfer fotografieren und bin zu nahe an sie herangegangen. Während ich durch den Sucher schaute, stürzten beide über mich, und ich lag mit meiner Leica unter ihnen, einen stechenden Schmerz im Brustkorb."

Leni musste bei dieser Erinnerung lachen. Sie wurde mit ein paar gebrochenen Rippen in ein kleines Krankenhaus in Kadugli gebracht und kehrte mit Verbänden wieder zurück. Es gelang ihr und Fromm, die Initiation eines Jünglings und ein Tätowierungsritual zu filmen. Doch dann gab es Nachrichten über einen bevorstehenden Krieg.

„Ich habe die Vorläufer der großen Revolution selber erlebt, während ich bei den Nuba war. Wir hörten Gerüchte über Kämpfe, die stattgefunden haben sollen, und auf Grund dieser Gerüchte fuhren wir mit meinem Wagen in die nächsten – man kann nicht sagen Dörfer – eher Hügelgemeinschaften, um nachzusehen, ob da schon Häuser brannten, wie wir gehört hatten. Als wir dort ankamen, wurde geschossen und einige Häuser brannten, aber wir haben die Täter nicht erwischt. Man spürte, dass sich etwas zusammenbraute. Am Abend kamen die Nuba zu mir und baten mich, mit ihnen Richtung Süden zu fahren. Dort solle es

Krieg geben, hieß es. Ich war alleine damals und nahm meinen Landrover, um in den Süden zu kommen. Es war sehr schwierig, weil während der Fahrt alle auf meinen Wagen aufgesprungen sind, denn alle wollten mitkommen. Sie standen auf den Trittbrettern, bis ich schließlich nicht mehr weiterfahren konnte, weil der Wagen aufgab. Ich musste ihn stehen lassen und in mehreren Stunden Fußmarsch zu meinem Lager zurückkehren."

Hinzu kam, dass einige der Kämpfer ein in den Augen der Nuba sehr schweres Vergehen begangen hatten. Sie stahlen zwei Ziegen und veranstalteten ein Festmahl. Nach dem Gesetz der Nuba macht sich aber nicht nur der Ziegendieb strafbar, sondern jeder, der an dem Festmahl teilnimmt. So wurde die gesamte Ringkampfelite von Tadoro aufs Polizeirevier geschickt. Mit dem Filmen war es nun vorbei. „Der Abschied war traurig, der schmerzlichste, den ich bisher bei den Nuba erlebt hatte." (Memoiren, S. 701)

Zu diesem Unglück kam, dass einer der Mitarbeiter der Expedition 16 Diafilme gestohlen und sie seinem Vater geschickt hatte. Aber die ersten Muster des Materials für den Film – gedreht auf Kodachrome (25 ASA) und Ektachrome ER (64 ASA) – sahen hervorragend aus. Doch dann wurde Leni mit einer Riesenkatastrophe konfrontiert: Das Geyer Kopierwerk entwickelte das hoch empfindliche ER-Material unsachgemäß und ruinierte es dabei. „Ich kann heute nicht mehr die Worte finden, um zu beschreiben, wie mir [...] zumute war. [...] Ich hatte nun endgültig die letzte Chance, mir wieder eine Existenz aufzubauen, verloren." (Memoiren, S. 706 f.) Sie musste die Hilfe von Freunden in Anspruch nehmen, um die Vorfinanzierung zurückzahlen und den Vertrag mit den amerikanischen Geldgebern annulieren zu können.

Kurze Zeit später, 1966 während eines Besuchs der BBC in London, traf ich Leni zum ersten Mal. Sie kam in die Wohnung von Philip Jenkinson in Blackheath und zeigte einigen von uns die intakt gebliebenen Filmrollen von den Nuba auf 16 mm. Ich erinnere mich, dass ich Fromms Filmaufnahmen als bedacht und gut durchgeführt empfand. Doch die Dias von den Nuba, Lenis Farbaufnahmen derselben Ereignisse waren allerdings ausnahmslos wirkungsvoller. Viele davon waren unglaublich gut. Die Dias waren in Abfolgen so arrangiert, wie sie auch ihre Filme geschnitten hat.

„Jetzt sehen Sie, dass ich eine Filmemacherin bin, oder?", sagte sie.

Wir waren hingerissen von den Massenszenen der Stammesmitglieder, die Speere komponiert wie in einem Gemälde von Uccello, von den starken Nahaufnahmen und den Ganzkörperaufnahmen, die ihre Faszination für die physische Schönheit und wirbelnde Ringkampfszenen spiegelten. Ihre Darstellungen von Unschuld, des Paradieses vor jeglicher Zivilisation, zeigten sich am beeindruckendsten in den Nahaufnahmen der Nuba-Männer und -Frauen; deren gelassen-heiterer Ausdruck, den Leni in ihren Bildern einfing, berührte uns am meisten.

„Auch Fotografie kann Kunst sein", sagte sie, Vorurteile von uns Filmleuten erwartend. „Ich liebe Fotos, weil man mehr Zeit hat, hinzuschauen."

Wir alle fühlten uns zutiefst privilegiert, diesen Moment erleben zu dürfen.

Ende 1966 kehrte Leni für kurze Zeit in den Sudan zurück. Nach dem wie immer begeisterten Empfang durch die Nuba, wurde ihr bewusst, dass Weihnachten war.

„Ich habe ihnen vorgeführt, wie ein Engel aussieht, indem ich aus einem weißen Laken Flügel machte. Und ich habe versucht, ihnen

Weihnachten mit einer Kerze zu erklären. Ich veranstaltete eine kleine Weihnachtsfeier – eine Überraschung für die Nuba, die ja nicht wussten, was Weihnachten ist. Als ich in meiner Hütte die Kerzen anzündete, stellte sich heraus, dass sie noch nie eine Kerze gesehen hatten."

Nach ihrer Rückkehr blieb Leni mit den Nuba in Verbindung, indem sie ihnen über einen Lehrer einer nahe gelegenen Stadt Tonbandaufnahmen zukommen ließ. Außerdem versuchte sie das Wasserproblem der Nuba zu lösen, indem sie ihnen Geld für Arbeitsgeräte schickte, damit sie einen Brunnen bauen konnten.

Leni wurde klar, dass sie ihre Unternehmungen nicht mehr allein durchführen konnte. Idealerweise brauchte sie jemanden, der mit Filmkameras umgehen konnte und außerdem Mechaniker war. Und erstaunlicherweise fand sie ihn, Horst Kettner war ein hochgewachsener junger Mann. „Sein Gesicht flößte mir vom ersten Augenblick an Vertrauen ein." (Memoiren, S. 742) Und er bewährte sich, indem er ungeachtet der Tatsache, dass er kein Wort Englisch sprach, nach England fuhr, dort trotz eines Streiks der Fabrik einen Landrover abholte und diesen nonstop von London nach München fuhr.

„Ich selber habe nicht gefilmt, ich habe ja nur fotografiert. Horst filmte mit einer 16-mm-Arriflex. Er war so eine große Hilfe, zum Beispiel, wenn der Wagen kaputt war, denn Reifen zu wechseln war für mich sehr anstrengend. Und außerdem war es ein wunderbares Gefühl, alle diese schönen Dinge mit jemandem zu teilen, einen Freund zu haben, der das auch miterleben konnte. Wenn zum Beispiel jemand das bezweifeln würde, was ich jetzt sage, dann gibt es einen Zeugen. Er denkt und fühlt genauso über die Nuba wie ich."

Nachdem wieder eine ganze Reihe von scheinbar unüberwindbaren Schwierigkeiten, die Leni aufs Lebendigste in ihren Memoiren beschrieb, bewältigt waren, erreichte sie ein weiteres Mal ihre Nuba und auch dieses Mal bereitete man ihr einen begeisterten Empfang. Sie hatten ihr sogar ein eigenes Haus gebaut.

„Ein Nuba-Haus besteht aus sechs Häusern, die durch eine Mauer miteinander verbunden sind."

Aber sie war entsetzt über die Veränderungen, die sie sah.

„Als ich fünf Jahre nach meinem letzten Besuch dorthin kam, hatten sie plötzlich Lumpen an. Sie wurden dazu gezwungen – die sudanesische Regierung hatte ihnen Kleider gebracht, da sie nicht mehr nackt herumlaufen durften. Und dadurch hatten sie sich auch verändert."

Die größte Not der Nuba bestand jedoch darin, dass sie nicht genug Wasser hatten, und Leni wollte ihnen helfen, das Problem zu lösen.

„Ich hatte einen Wünschelrutengänger engagiert, der auf der Landkarte nach Wasser suchen sollte. Ich hatte schon alles versucht, um Sponsoren für die Wasserbeschaffung zu finden, zum Ausheben von Gruben, aber es fand sich niemand. Und dann traf ich einen Amerikaner, einen Freund von mir von der Harvard Universität, der durch Afrika reiste, den habe ich dazu überredet in Khartum Werkzeug zu kaufen, eine Axt und große Schaufeln. Er hieß Gardner und drehte später auch Filme. Er kaufte diese Werkzeuge für mich und gab sie bei meinem Freund, dem Tourismusminister, ab. Und dann sollte das Ganze mithilfe des Ministers langsam peu à peu zu den Nuba gebracht werden, über arabische Händler, die manchmal dorthin fuhren, um Salz an die Nuba zu verkaufen, was auch gut geklappt hat. Zu bestimmten Nuba hatte ich einen besonders guten Kontakt, wir waren richtige Freunde. Ihnen gab ich den Auftrag, nach Wasser zu graben. Sie gruben ein tiefes Loch, aber es war

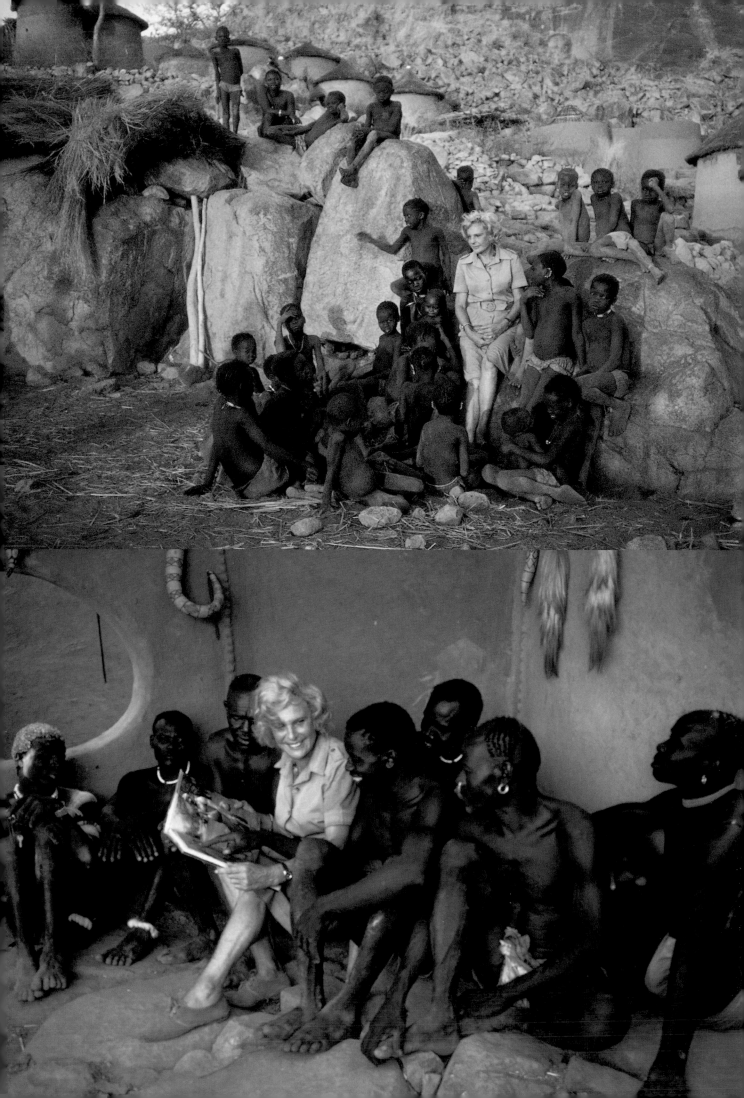

kein Wasser da. Dann deckten sie das Loch mit Zweigen und Erde ab. Eines Tages lief ein Junge aus Versehen darüber und stürzte hinein. Da das Loch glatte Wände hatte, kam er nicht mehr heraus. Die Nuba standen alle drumherum und konnten nicht helfen. Sie riefen in das Loch hinunter, aber es kam keine Antwort. Ich bat sie, mir das Seil vom Auto zu bringen, dann habe ich Horst das eine Ende gegeben und mir das andere umgebunden wie eine Bergsteigerin. Ich kletterte in das Loch hinein und habe den Jungen rausgeholt. Sein Vater war so wütend, dass er ihm rechts und links eine Ohrfeige verpasst hat, da war ich wiederum so wütend, dass ich ihm auch rechts und links eine Ohrfeige verpasst habe. Der Junge hatte eine schwere Rückenverletzung, aber Horst behandelte ihn und er wurde wieder gesund."

Als Horst und Leni versuchten, ein Ringkampffest zu filmen, fiel ihnen auf, dass selbst die Kämpfer Hosen trugen und Plastikflaschen anstelle der Kalebassen umgebunden hatten. Horst konnte sie nicht überzeugen, ihre Kleider abzulegen, sie schämten sich. Das Ritual hatte sich derart verändert, dass sie es nicht mehr filmen wollten. Noch beunruhigender war, dass Leni gehört hatte, die Nuba hätten angefangen zu stehlen. „Wie konnte das geschehen?", schrieb sie. „Auf Touristen konnte das nicht zurückgehen. Mit Ausnahme einer englischen Stewardess, der es einmal gelungen war, mit ihrem Vater bis zu mir vorzudringen, waren noch keine hierher gekommen." (Memoiren, S. 755) Aber eine Reihe schlechter Ernten hatte die jungen Männer gezwungen, in den Städten zu arbeiten; sie kamen mit Kleidern, Geschlechtskrankheiten und Geld zurück.

„Als die erste Münze, das erste Geldstück, ganz egal welcher Währung es war, in die Hände der Nuba kam, veränderte es ihren Charakter. Von diesem Augenblick an konnten sie sich auf dem Markt für das Geld etwas kaufen. Sie pflanzten Baumwolle an und verkauften sie auf dem Markt, und als sie Geld dafür bekamen und davon etwas kaufen konnten, wollten die anderen auch Geld haben. Vorher kannten die Nuba keinen Unterschied, es gab kein Geld und alle waren gleich. Als es dann später Geld gab, hatte der eine plötzlich mehr, der andere weniger und es entstand etwas, was sie vorher nicht kannten, eine gewisse Konkurrenz, ein gewisser Neid. Und das veränderte den Charakter."

Leni befürchtete, dass das Unheil, das den amerikanischen Indianern und den australischen Aborigines widerfahren ist, nun auch das Volk der Nuba zerstören würde. Sie schrieb: „Wo die Schattenseiten der Zivilisation sich ausbreiten, verschwindet menschliches Glück." (Memoiren, S. 756)

Zurück in Deutschland wurden ihre Fotos von den Nuba 1969 in der Dezemberausgabe von der Illustrierten *stern* abgedruckt. Und schon bald darauf erschienen sie in einem beeindruckenden Bildband, der in Deutschland (1973), Amerika (1974) und Frankreich (1976) veröffentlicht wurde. Sie nahm das Buch mit, um es den Nuba zu zeigen, aber als sie ankam, fand sie ihr Paradies zerstört. Die Nuba waren so warmherzig wie immer und ihre alten Freunde natürlich ebenso, aber die anderen fragten nach Medizin, Tabak, Glasperlen, Batterien, Sonnenbrillen. Und sie alle trugen schmutzige, zerrissene Kleidungsstücke.

„Als ich ihnen die Bilder zeigte, wie sie ausgesehen hatten als sie noch unbekleidet gewesen waren, haben sie sich geschämt. Weil ihnen eingeredet wurde, dass das schlecht sei."

Auf dieser Expedition hielt Horst Lenis Idee für völlig verrückt, einen weiter entfernten Nuba-Stamm finden zu wollen, die Kau. Aber ungeachtet des Benzinmangels und der Tatsache, dass keine Karten von dieser Region existierten, fuhren sie los. Die Hitze war unerträglich, die Reise sehr unbequem, aber sie wurden belohnt durch einen „ungewöhnlichen und hinreißenden Anblick". (Memoiren, S. 804)

„In den letzten Strahlen der untergehenden Sonne", schrieb Leni, „bewegten sich nach dem Rhythmus der Trommelschläge diese überschlanken Geschöpfe in tänzerischer Anmut. Auch die Mädchen waren völlig nackt, eingeölt und in verschiedenen Farbtönen geschminkt. Die Farbscala ging vom tiefen Rot über Ocker bis zu Gelb. [...] Ihre Bewegungen waren aufreizend und wurden immer wilder, [...]. Die Tanzenden hatten mich nicht bemerkt, da ich mich hinter einem Baumstamm versteckt hatte und mit langen Telelinsen fotografierte. [...] Für mich war dies das größte optische Erlebnis, das ich auf allen meinen Afrika-Expeditionen hatte." (Memoiren, S. 804 f.)

Sie konnten auch einen *zuar* (Messerkampf) fotografieren – Leni war in erster Linie zu dieser Expedition aufgebrochen, da sie hoffte einen solchen zu sehen.

„Bei den Kau-Nuba ist es kein Ringkampf; es ist ein Kampf mit Klingen aus Messing, die die Kämpfer am Arm tragen. Niemand hat sie je vorher dabei fotografiert. Es gibt auf der ganzen Welt keinen Stamm, der so kämpft, das ist etwas Einmaliges. Für mich als Fotografin war es eine Sensation. Außerdem gibt es auf der ganzen Welt keinen zweiten Stamm, der so wunderbare Masken malen kann wie die Kau, im Vergleich ist das, was die Indianer in Neuguinea machen eher einfach, die Kau sind Künstler. Ihre Masken sind Kunst."

Sie entdeckte diese Masken in einem anderen Dorf, in Nyaro. „Der Körper eines jungen Mannes war phantastisch bemalt, wie ein Leopard, und sein Gesicht erinnerte mich an Picasso. Zu meiner Überraschung ließ er sich widerspruchslos fotografieren. Bald entdeckte ich, dass er nicht als einziger so ungewöhnlich bemalt war, von überall kamen junge Männer auf mich zu, mit Gesichtern wie stilisierte Masken." (Memoiren, S. 807)

„Haben sie jemals etwas dagegen gehabt, fotografiert zu werden?"

„Also, die Masakin überhaupt nie. Sie waren auch meine engeren Freunde. Da war ein großer Unterschied zwischen den Masakin- und den Kau-Nuba. Bei den Kau-Nuba gab es einige, die sich verweigerten, und es war sehr schwierig, dort zu arbeiten. Aber, was ich gesehen habe, habe ich fotografiert."

Als sie 1974 zurückkehrte war die Enttäuschung noch größer. Die Kämpfer trugen Shorts oder arabische Kleidung. Das Dorf Kau war völlig zerstört. In ihrem Lager mussten Leni und Horst mit der Explosion eines Gaskanisters fertig werden, bei der Lenis Kleidung Feuer fing. Eine Stunde später stieß sie mit dem Kopf gegen einen Ast und zog sich eine Gehirnerschütterung zu. Als Horst sich gerade um ihre Verletzung kümmerte, trafen zwei große Fahrzeuge voll gepackt mit Touristen ein. Das war das Entsetzlichste, was sie sich vorstellen konnten. Die Touristen waren eine Gruppe netter Deutscher, die durch einen indiskreten Beamten von Lenis Aufenthaltsort gehört hatten. Als sie dann aber keinen einzigen bemalten Nuba zu Gesicht bekamen, fuhren sie am nächsten Tag wieder ab.

Später erhielten die Nuba Geldscheine von Touristen und von da ab erwarteten sie eine Bezahlung für das Fotografiertwerden. Einst unbeugsame Stammesmitglieder wurden mit Bargeld gefügig gemacht, und als Fotograf konnte man nur noch einpacken und abfahren, sagte Leni.

„Haben Sie die Nuba für die Fotos bezahlt?"

„Wenn ich das am Anfang gemacht hätte, hätte ich überhaupt nicht arbeiten können. Alle Nuba, Hunderte, wären gekommen und hätten Geld haben wollen. Es war schon ein großes Problem mit den Glasperlen, die wir mitgenommen hatten. Wir mussten bald schon wieder aufhören, sie zu verteilen, weil sie verrückt nach ihnen waren

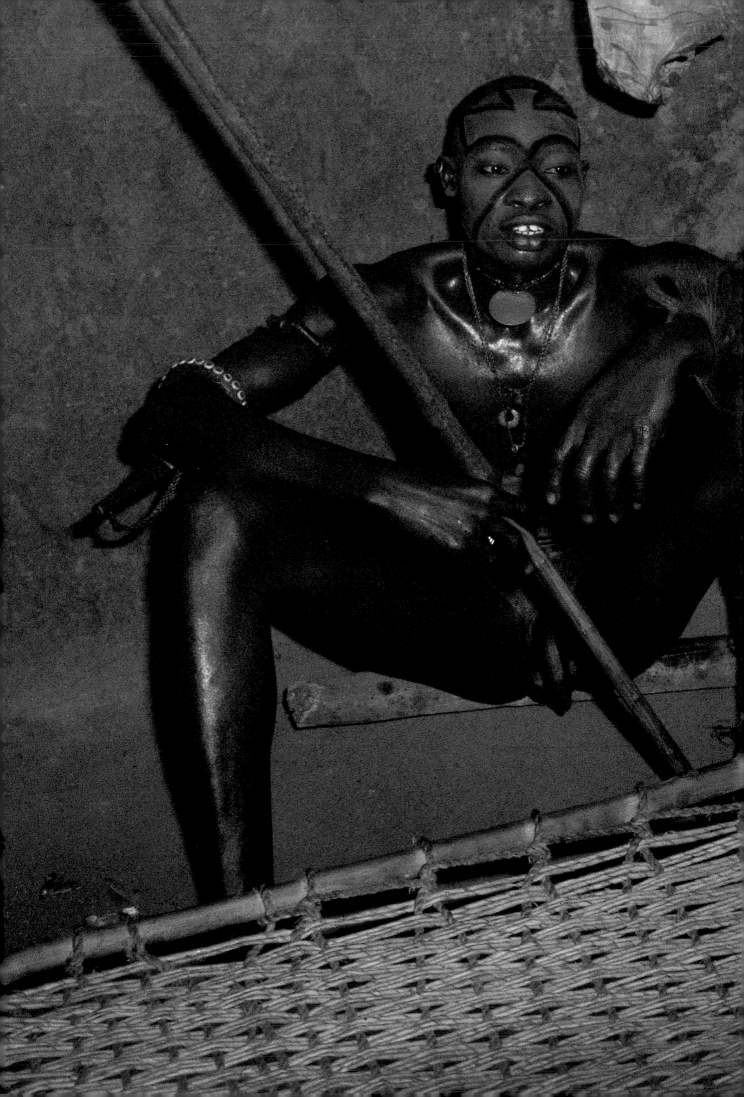

und jeder Perlen haben wollte. Meistens habe ich, später auch mit Horst, zwei bis drei Stunden jeden Abend die Kranken behandelt, wenn es zu dunkel wurde, um weiter zu arbeiten. Sie standen dann an mit offenen Wunden an den Beinen. Sie hatten hauptsächlich offene Wunden oder eine Lungenentzündung. Wir hatten eine richtige Reiseapotheke dabei, die ein Arzt für uns zusammengestellt hatte."

Leni und Horst stellten auch einen Diaprojektor auf und zeigten die Bilder vom letzten Jahr, was für große Aufregung sorgte. „Die Reaktion der Nuba auf die Bilder war unbeschreiblich [...] die Nuba schienen jeden, auch wenn er nur als Silhouette sichtbar war, zu erkennen." (Memoiren, S. 836)

„Als ich das erste Bild zeigte – es war eine junge Mutter aus Kau, die ihr Baby im Arm hielt –, erscholl tosendes Gelächter, das sich noch steigerte, als ich dann die Nahaufnahme des Babys folgen ließ. Es war für sie unfassbar, dass ein Kopf so groß werden konnte, wie er auf der Leinwand erschien."

Diese Vorführung nahm den Nuba ihre Hemmungen und in den darauf folgenden Tagen kamen die jungen, kunstvoll bemalten Männer zum Lager und zeigten sich Leni.

Zurück in München, hatte Leni, die mit ihren 72 Jahren schließlich in einem Alter war, in dem viele in einem Altersheim leben, einen physischen Zusammenbruch. Dennoch vergaß sie ihre Krankheit in dem Moment, in dem sie die hohe Qualität ihrer Fotos und der Filmaufnahmen von Horst sah. Der *stern* und die *Sunday Times* veröffentlichten die Kau-Bilder, sie gingen um die Welt. Der Art Directors Club in Deutschland zeichnete Leni 1975 für ihr fotografisches Werk mit einer Goldmedaille aus. Es gab wie immer ablehnende Artikel, aber die allgemeine Reaktion auf ihre Bilder – in allen Ländern, in denen sie veröffentlicht wurden – war erstaunlich enthusiastisch. Eine Zeitschrift bat sie, in den Sudan zurückzukehren und in Khartum erhielt sie eine Auszeichnung von Präsident Nimeiri, der Form und Inhalt ihrer beiden Bildbände lobte, da sie selbst Moslems erlaubten, unbekleidete Nuba anzuschauen, ohne dass ihre Gefühle verletzt wurden. Zu Weihnachten verschenkte die sudanesische Regierung mehrere Hundert Exemplare ihrer Bücher an Botschaften im Ausland.

Die Veränderungen bei den Nuba sind nicht so sehr dem Tourismus zuzuschreiben, denn die Veränderungen bei den Masakin-Qisar vollzogen sich, bevor irgendein Tourist in ihre Nähe kam, sie resultieren vielmehr aus den Folgen der Arabisierung und schließlich dem Krieg. Zu der Zeit, als Leni und Horst im Jahr 2000 zu einem Wiedersehen zurückkehrten, lebte kaum einer ihrer alten Freunde mehr. Der Hintergedanke der Reise war, Geld für die Nuba zu sammeln und zu erfahren, wie es ihnen nach den vielen Jahren des Krieges im Sudan ergangen war.

„Wir konnten nur wenige Stunden dort bleiben, dann haben sie uns mit Polizeiwagen abgeholt und wir mussten wieder zurückfahren. Über meinen letzten Besuch vor zwei Jahren hat die Bavaria einen Film gedreht, einen längeren Dokumentarfilm, der demnächst rauskommen wird. Er zeigt alles, was wir dort erlebt haben. Der Kameramann wurde verletzt bei dem Hubschrauberabsturz, ja unser Hubschrauber ist abgestürzt."

„Normalerweise überlebt man einen Hubschrauberabsturz nicht einfach so. Was ist mit Ihnen passiert?"

„Ich hatte einige Rippen gebrochen und die Lunge war verletzt. Ich wurde umgehend vom Unfallort mit einer Rettungsmaschine nach Deutschland zurückgebracht, wo ich drei Wochen im Krankenhaus lag."

„Was wollten Sie filmen?"

„Ich wollte das Wiedersehen mit unseren Nuba filmen. Das Wiedersehen nach vielen Jahren."

„Haben Sie viele getroffen?"

„Nein, nicht viele. Es war ja Krieg in der Zwischenzeit und viele von ihnen lebten nicht mehr. Wir waren insgesamt nur 24 Stunden im Sudan und hatten nicht viel Zeit mit ihnen zu reden, und von unseren Freunden waren nur noch drei oder vier da."

Leni Riefenstahl ist vom 20. Jahrhundert in die Steinzeit gereist. Sie hat Menschen in völliger Harmonie mit der Natur leben sehen. Und sie hat erfahren, wie sich die „Plage der Zivilisation" auf sie auswirken kann. Eine große Errungenschaft der Zivilisation ist jedoch die Fotografie, die den Augenblick einfriert.

Kevin Brownlow, London, Mai 2002

Das Interview von Kevin Brownlow, London, mit Leni Riefenstahl wurde am 2. Mai 2002 in Pöcking in Anwesenheit des Dolmetschers Claus Offermann, München, geführt. Dank gilt ebenfalls Carla Wartenberg, London. Zitiert wurde aus: Riefenstahl, Leni: Memoiren, Taschen, Köln 2000.

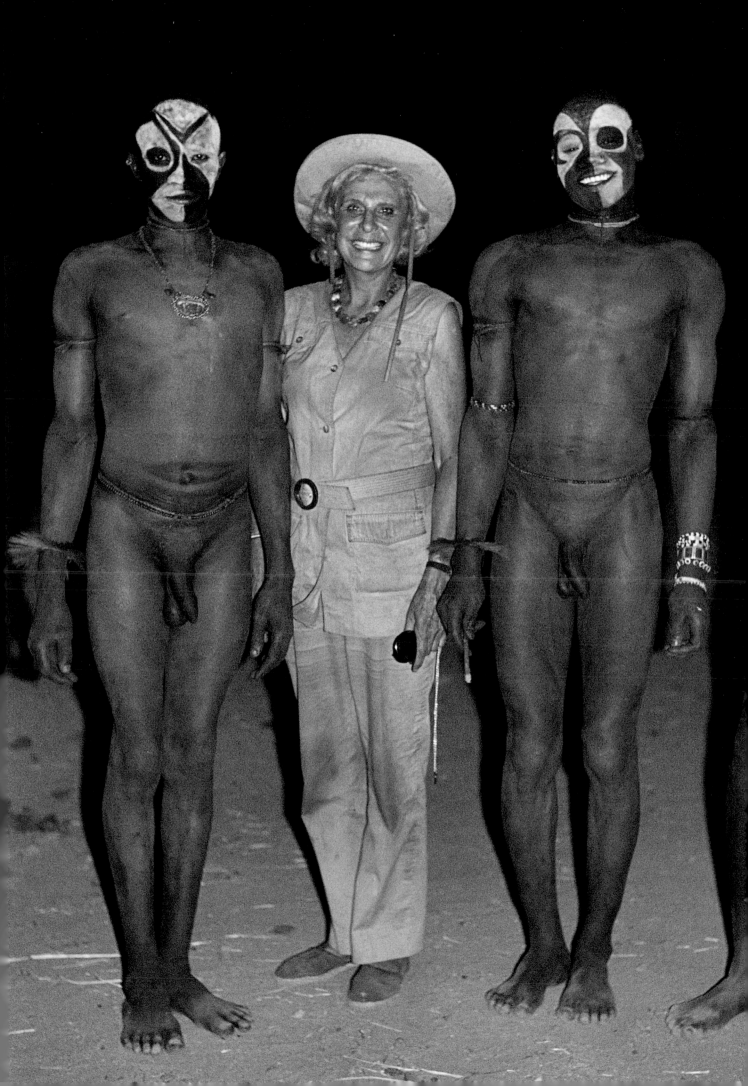

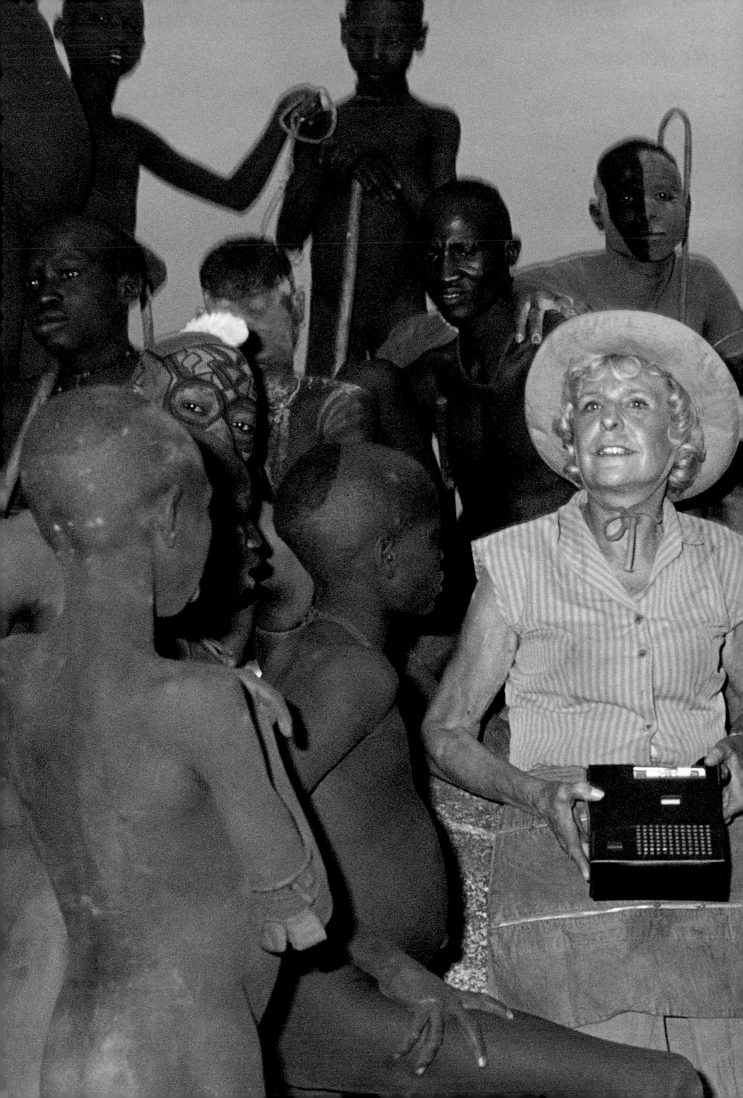

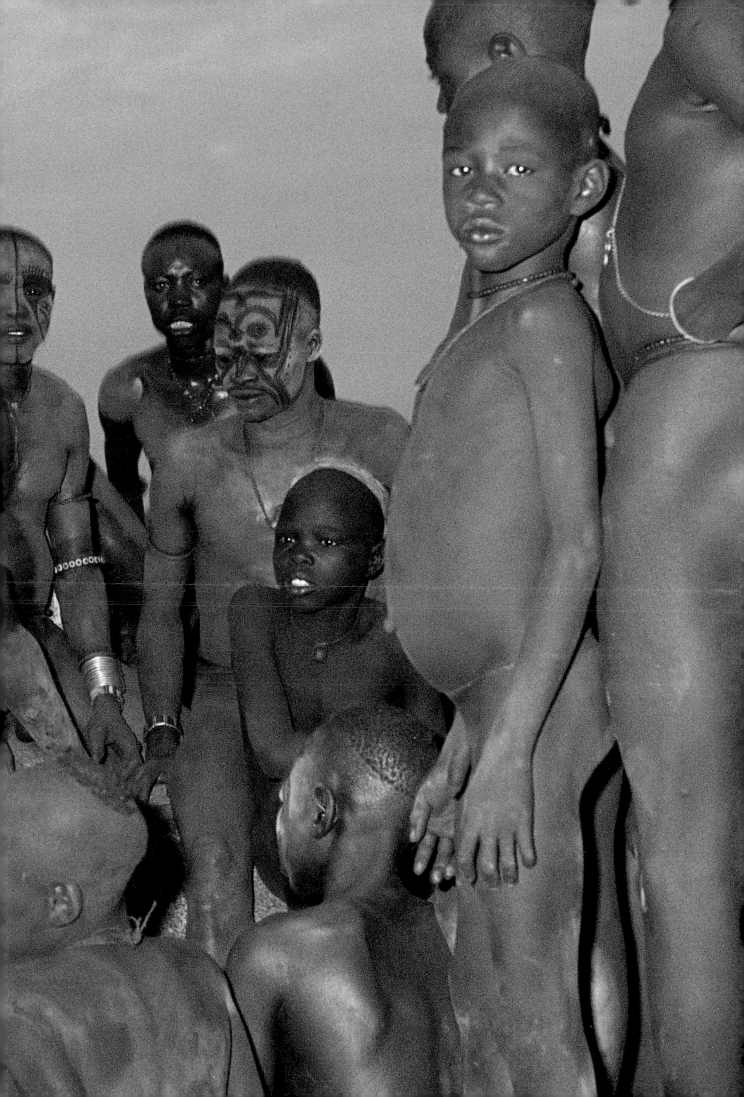

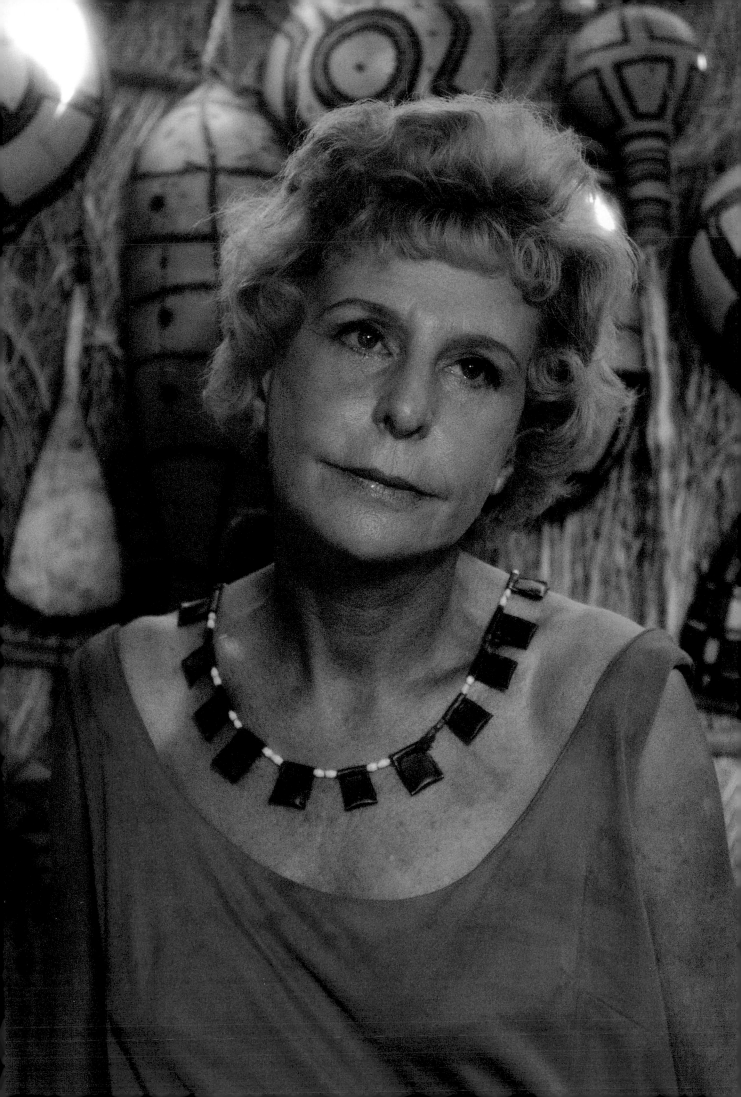

Leni Riefenstahl
ou l'amour de l'Afrique

Si Leni Riefenstahl n'avait rien fait d'autre que de se rendre en Afrique et d'en rapporter ses photographies, elle se serait assurée une place dans les annales, car elle a réalisé un exploit extraordinaire. Elle fait également montre d'une endurance hors du commun; en effet, si elle comptait une cinquantaine d'années lorsqu'elle a fait sa première visite en Afrique, elle avait 98 ans lors de la plus récente. Son amour de l'Afrique a généré trois albums photos avant celui-ci.

Sa première expédition aurait vraiment dû la dissuader à jamais d'autres entreprises de ce genre, car on peut à peine l'imaginer plus désastreuse. Elle partit tourner un film sur la traite des esclaves en Afrique. Alors qu'ils se trouvaient au nord de Nairobi, le conducteur de sa jeep tenta d'éviter un minuscule dik-dik (une antilope naine), heurta un rocher et le véhicule fut projeté en l'air avant de retomber dans le lit d'une rivière asséchée. La tête de Leni traversa le pare-brise et fut gravement blessée – la plaie fut recousue avec une aiguille à repriser. Personne ne pensa qu'elle allait s'en tirer, mais elle se rétablit grâce à son incroyable résistance. La vision fugitive de guerriers Massaï armés de lances et portant le costume de leur tribu la captiva à tel point que c'est peut-être la raison pour laquelle elle finit par les photographier. Ernest Hemingway a écrit que les Massaï étaient «les plus beaux hommes que j'aie jamais vus en Afrique. Les plus grands, les mieux bâtis. Magnifiques.»

Quand j'ai parlé avec elle dans sa maison de Pöcking, Leni Riefenstahl qui souffre encore des suites d'un autre accident en Afrique, me dit qu'Ernest Hemingway était responsable de la fascination qu'elle éprouvait pour le continent africain.

«J'ai lu *Les Vertes collines d'Afrique* d'Hemingway et ce livre m'a influencée. Et quand je suis arrivée en Afrique, que j'ai trouvé ce miroitement, cette lumière, la chaleur et les couleurs qui ont l'air si complètement différentes sous ce climat de celles que nous connaissons en Europe, tout cela m'a profondément fascinée. Cela me rappelait les peintres impressionnistes – Manet, Monet, Cézanne.»

Mais c'est une photographie de lutteurs Nouba – elle représente un homme qu'un autre homme porte sur ses épaules (ill. p. 541) – prise par le photographe anglais George Rodger, qui l'a amenée à devenir elle-même une grande photographe. Selon elle, on aurait dit une sculpture de Rodin et, avec sa brève indication «Les Nouba à Kordofan», cette photographie l'a attirée comme par magie vers un endroit oublié, peu exploré de l'Afrique. Mais comment faire pour y aller? Ses moyens étaient restreints, elle n'avait pas de retraite et sa mère non plus. Elle chercha une possibilité de tourner un film près du Nil et réussit finalement à obtenir un visa pour le Soudan grâce à Ahmed Abou Bakr, le directeur du Tourisme, qui devint un ami et qui jouerait bientôt un rôle majeur dans sa vie. Et puis le Mur de Berlin fut édifié, ses bailleurs de fonds perdirent leur argent, et le film fut annulé.

Le directeur de la société allemande Nansen, Oskar Lutz, lui donna une seconde chance. Il l'avertit que ce serait dur, parce que Leni était sexagénaire. Mais entraînée comme elle l'était par des années de danse, d'alpinisme et de ski, elle était exceptionnellement confiante en l'avenir. Après la rencontre, elle dit s'être senti «renaître».

«J'avais lu que les Nouba vivaient à Kordofan. Au départ, personne ne savait où se trouvait cet endroit. Il me fallut longtemps pour découvrir qu'il s'agit d'une province du Soudan. Et quand je me trouvais à Khartoum, la capitale du Soudan, et demandais des renseignements sur Kordofan, la plupart des gens ne savaient pas où cela se trouvait et personne ne savait où les Nouba pourraient être. Je suis allée à Khartoum deux fois avant de trouver quelqu'un qui sache seulement que les Nouba existent.»

«Quand j'ai enfin trouvé des informations, grâce à la photo de Rodger que j'avais emportée et que je montrais aux gens, et quand je fus en route vers cet endroit, le chef de la police de Kordofan me dit que les Nouba de la photographie «Les Nouba dévêtus» – n'existaient plus. Il disait qu'ils avaient existé dix ans plus tôt. Mais je continuais à poser des questions et à essayer de les trouver.»

L'équipe de Nansen traversa les monts Nouba. Au bout d'une semaine de recherches, les seuls Nouba qu'ils avaient rencontrés ressemblaient aux autres Africains noirs, portant des chemisettes et des shorts. Le moral des membres de l'expédition était au plus bas. Un jour, après avoir roulé des heures dans une vallée déserte, ils aperçurent tout en haut les cases circulaires caractéristiques des Nouba. Leni aperçut une fillette nue, qui s'enfuit terrorisée. Avec beaucoup de précautions et ressentant une immense excitation, ils continuèrent à avancer à pied.

«Les Noirs étaient conduits par plusieurs hommes nus blanchis à la cendre et dont les cheveux étaient bizarrement parés. D'autres les suivaient, le corps peint d'ornements blancs. À la fin du cortège marchaient les jeunes filles et les femmes, le corps peint elles aussi et parées de perles. Droites comme des cierges, portant des calebasses sur la tête et de vastes corbeilles, elles suivaient les hommes d'un pied léger. Cela ne faisait aucun doute, il s'agissait des Nouba que nous cherchions.» (Mémoires, p. 635)

Le même soir, les membres de l'expédition assistèrent au phénomène de la lutte – une multitude de Nouba au corps peint de manière étrange et poussant des cris perçants entouraient des paires de lutteurs. Accompagnés du rythme immuable des tambours, ils s'affrontaient selon un rituel précis, et le vainqueur était ensuite porté en triomphe sur les épaules d'un autre homme, exactement comme le montrait la photographie de Rodger.

Je demandai à Leni, si elle avait eu peur, seule à son âge au milieu de la brousse – je savais, moi, que j'aurais eu peur.

«Pas du tout. Je me sentais beaucoup plus en sécurité que si je marchais toute seule dans les rues ici. Il s'agissait de très braves gens, cela se voyait. Je le sentais, je le voyais sur leurs visages, ils rayonnaient la bonté. Je n'ai jamais eu peur. Jamais, jamais – même quand j'étais seule –, un Nouba ne m'a touchée. Ils m'ont toujours traitée comme l'une des leurs.»

Les Nansen établirent leur camp à côté d'un village Nouba en décembre 1962, sous un arbre qui deviendrait l'endroit préféré de Leni dans le monde. Elle partit étudier la langue et les coutumes. «Les Noirs au milieu desquels nous vivons ici sont si gais que je ne m'ennuie pas un instant» (Mémoires, p. 638), écrit-elle à sa mère, lui racontant comment les Nouba tenant leurs lances sont pressés en cercle autour de la radio et écoutent leur première émission – des chants de Noël d'Allemagne.

Depuis qu'ils avaient fait halte à Kadougli, un jeune policier soudanais avait rejoint l'expédition avec l'objectif bien précis d'opérer comme censeur et d'empêcher Leni de photographier des gens nus, vu que se montrer nu est interdit par l'Islam.

«Tout le temps que j'ai été avec l'expédition Nansen, il y a toujours eu un policier du gouvernement avec nous. Mais cela n'a duré que jusqu'en 1963. Ensuite, quand j'étais toute seule, jamais un policier ne m'a escortée. Le ministre du Tourisme du Soudan, Ahmed Abou Bakr, m'a donné une autorisation spéciale afin que je puisse être là sans être accompagnée d'un policier.»

«Est-ce que la police ne vous a jamais empêchée de prendre des photographies?»

«Oui, ils ont essayé, malgré l'autorisation dont j'étais munie. À la dernière station où habitaient encore des Soudanais, les fonctionnaires locaux ont essayé de m'arrêter, et j'ai crié, j'étais furieuse et je me suis jetée sur le sol. Je refusais de partir et je les ai obligés à céder. J'avais élaboré un plan. Au cours d'une halte dans une ville, à quelques centaines de kilomètres en arrière, j'avais enregistré la voix d'un fonctionnaire disant que j'avais l'autorisation du gouvernement de Khartoum d'aller chez les Nouba et de séjourner dans leur village, et il s'agissait d'un fonctionnaire de haut rang. Les distances sont gigantesques – 500 kilomètres séparent Khartoum d'El-Obeid, la capitale de la province. C'est à l'officier en charge à cet endroit que j'ai montré les documents du ministère du Tourisme à Khartoum et je lui ai demandé de lire l'autorisation officielle que j'ai enregistrée. Et j'ai fait écouter cet enregistrement aux fonctionnaires de la dernière station. Là, ils ne savaient pas lire, mais ils savaient entendre!»

Malheureusement, au fur et à mesure que ses rapports avec les Nouba devenaient chaleureux, ils se détérioraient avec les membres de l'expédition Nansen.

«Les gens qui avaient organisé la première expédition et m'avaient emmenée, avaient promis que je pourrais tourner un film sur leur travail. Ils étaient censés réaliser un film scientifique pour un ministère allemand. Le chef de l'expédition était monsieur Luz et son fils était cameraman, pas un vrai professionnel, un amateur. Et il ne voulait pas faire ce que je lui demandais. J'étais censée tourner un film et il refusait de prendre les plans qu'il était supposé prendre. Le père voulait que je tourne le film, mais pas le fils. Nous avons alors eu un grave problème car il m'avait promis que je déciderai de ce qui devait être filmé, mais lui de son côté ne pouvait pas travailler sans son fils. Quant à moi, n'ayant ni

argent, ni ressources, je dépendais complètement des Nansen. Le fils voulait que l'on me renvoie, ce qui n'était pas possible, et j'étais entre ces deux-là. J'ai connu un moment épouvantable avec ces gens parce que je dépendais d'eux. Ils me donnaient très peu à manger. J'avais faim et souvent très soif et ils ne me donnaient pas assez d'eau. Et j'étais à l'écart dans la brousse, à des milliers de kilomètres de la civilisation et ne pouvait pas m'échapper. J'aurais pu mourir. En attendant, les Nansen avaient établi une base dans un village Nouba et j'entrai en contact avec les Nouba. Ce n'était pas vraiment un village, juste quelques huttes éparpillées. Les Nouba continuaient à déambuler dévêtus. C'était un endroit où nul n'était jamais venu.»

Au bout de sept semaines, les Nansen quittèrent les lieux et ne disposant pas de moyen de transport, Leni dut les accompagner. Mais elle s'arrangea pour revenir étonnamment vite.

«Disons que le temps que j'ai passé avec les Nouba est l'un des plus heureux, un des plus beaux de ma vie. C'était absolument merveilleux. Parce qu'ils étaient toujours gais, riant toute la journée, des gens bien ne volant jamais rien. Ils étaient heureux de tout, contents de tout. Les châtiments qui existaient étaient vraiment innocents et le plus grand crime était de voler une chèvre. Quand le châtiment était plus lourd, le coupable devait se rendre pour quelques jours à l'endroit le plus proche ayant un poste de police et y faire des travaux punitifs comme balayer la rue ou autres corvées.»

Mais l'innocence des Nouba froissait les autorités. «Le gouvernement soudanais a interdit qu'ils déambulent nus, ils doivent porter des vêtements.» Cet ordre mit toutefois plusieurs années à changer leur mode de vie.

Initialement, Leni était venue en Afrique pour tourner un film et non pour prendre des photos. Mais maintenant que le projet de film était tombé à l'eau, elle se rabattit sur son fidèle Leica.

Je lui demandai pourquoi elle n'a pas photographié en noir et blanc, comme George Rodger.

«Les couleurs étaient si intéressantes et si belles que je n'ai pris qu'une ou deux pellicules en noir et blanc. Je trouvais les photos en couleurs plus fortes que celles en noir et blanc, mais pas toutes. Je peux copier en noir et blanc chaque photo que j'ai en couleur et elle est presque aussi intéressante qu'en couleur. C'est une question de goût.»

«J'ai commencé avec deux Leicas et puis l'une d'elle a été cassée et je n'avais plus qu'un appareil et trois lentilles – 35 mm, 50 mm et 90 mm. J'ai pris toutes les photos des Nouba Masakin avec ces trois lentilles-là. Ce sont les photos de mon premier album.»

«Est-ce que la Leica avaient un photomètre?»

«Non, les premières Leicas n'avaient pas de photomètre; l'un des appareils avait un photomètre spécial séparé.»

«C'étaient des appareils reflex?»

«Non, je n'ai commencé à utiliser l'appareil reflex de Leica que quelques années plus tard quand je suis allée chez les Nouba Kau. C'est intéressant, pour mon premier album, je n'ai pas utilisé le Leica reflex, mais uniquement le normal. Pour mon second album sur les Nouba Kau, j'ai seulement travaillé avec le Leica reflex. C'était en 1974. À partir de ce moment-là, je n'ai plus utilisé que le Leica reflex.»

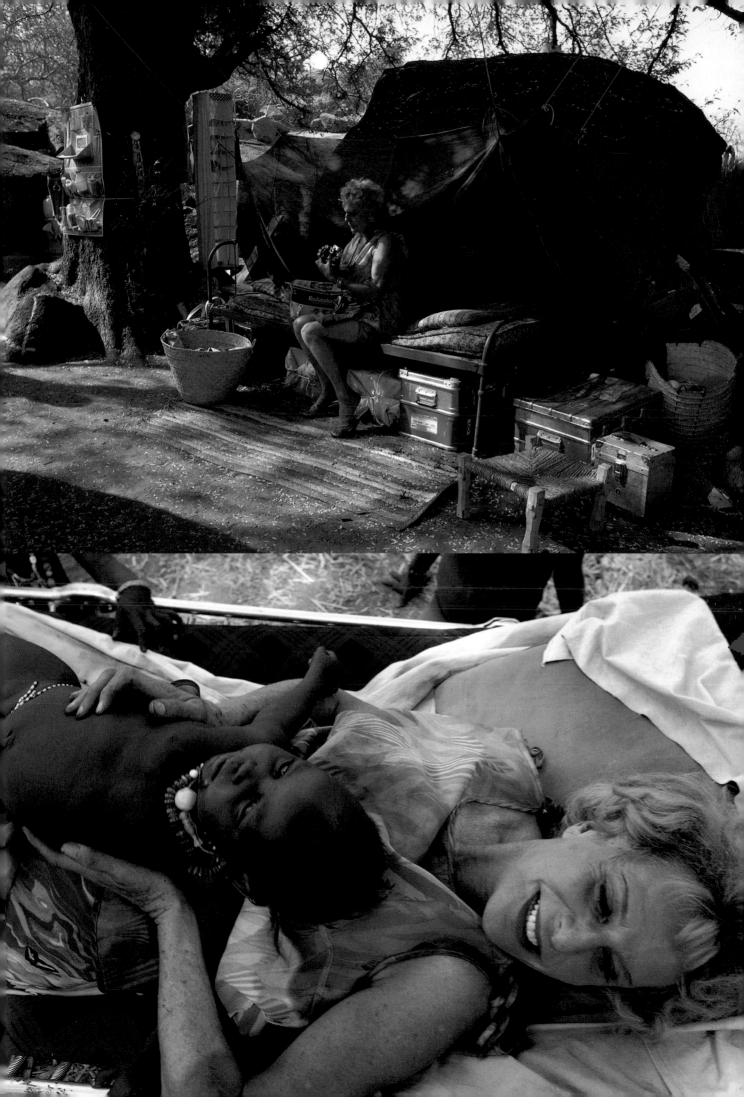

«Comment faisiez-vous pour protéger le mécanisme de l'appareil du sable et de la poussière?»

«J'avais posé un capuchon sur l'appareil – un capuchon en coton et un en plastique, comme une robe.»

«Vous avez travaillé avec un flash?»

«Oui. Mais, lors de ma première expédition, mon flash est tombé en panne et je n'ai pas pu l'utiliser. J'en ai emporté deux lors des expéditions suivantes, mais j'ai rarement pu me servir de l'un ou de l'autre la nuit parce qu'ils inquiétaient les autochtones. J'utilisai le flash de jour pour éclaircir chaque fois que c'était possible.»

«Quand vous preniez des photos, vous faisiez deux expositions? Une plus sombre, une plus claire?»

«Ce n'était guère possible, car ils ne se tenaient jamais tranquilles, ils étaient la plupart du temps en mouvement. Je ne pouvais pas refaire la même photographie. Soient ils allaient et venaient, soit ils partaient.»

«Comment vous et la pellicule vous accommodiez-vous de la chaleur?»

«Pendant plusieurs expéditions, je l'ai supportée. Mais, au cours des deux dernières, la chaleur est devenue insoutenable. Plus tard, quand la saison des pluies commençait et que je pouvais rester plus longtemps, il faisait si chaud que je ne pouvais la supporter qu'en m'enveloppant sans arrêt de vêtements mouillés. Une telle chaleur était très dangereuse pour les pellicules. Nous avons creusé des tranchées de trois mètres de profondeur et les avons recouvertes de doubles couches de toile goudronnée et de terre. Ensuite je conservais les pellicules au fond des tranchées, dans une boîte en aluminium. Étonnamment, ça a marché, nous n'avons pas perdu une seule pellicule à cause de la chaleur.»

«Vous utilisiez un moteur?»

«Je travaillais avec un moteur sur le Leicaflex.»

«Sur quel genre de pellicule?»

«La plupart des photos ont été prises sur Kodachrome et quelques-unes sur Ektachrome 64. Des sensibilités différentes.»

«Elles ont pâli au cours des années?»

«Oui, je peux vous le montrer. Le Kodachrome normal perd rarement ses couleurs, mais les photos sur Ektachrome sensible sont maintenant quelque peu pâles ou violettes.»

«Quelle quantité de pellicules aviez-vous emportée?»

«Moins pour la première expédition, peut-être 30 à 40 rouleaux. Plus tard 100 à 120. J'ai rapporté les pellicules inutilisées.»

«Une question difficile: comment saviez-vous quand il fallait appuyer sur le déclencheur?»

«J'essaie simplement de trouver le plus vite possible – il faut être rapide – le cadrage adéquat. Je travaille très, très vite.»

«Il y a une lampe rouge qui s'allume dans votre tête – comment ça se passe?»

«Non. Évidemment, je vois ce qui ferait une photo intéressante. C'est la raison pour laquelle je travaille beaucoup avec un très bon zoom.»

«Quand avez-vous commencé à utiliser un zoom?»

«Au cours de ma deuxième expédition, en 1964–1965. Je n'ai pas utilisé de zoom avec les Nouba Masakin – seulement plus tard avec les Kau.»

«Ce talent remarquable n'est pas apparu du jour au lendemain. Quand avez-vous compris que vous étiez douée?»

«En fait, je regardais faire le réalisateur avec qui j'ai tourné mes premiers films comme actrice, le Dr Arnold Fanck. C'était un photographe exceptionnel. Il m'a montré comment faire et comment cadrer des photographies. J'ai absorbé tout cela inconsciemment en le regardant travailler. Et puis sans m'en rendre compte, j'ai commencé à photographier exactement comme lui. Ainsi, sans le vouloir, il a été mon professeur.»

«Vous avez déjà fait des Polaroïds?»

«J'ai fait des Polaroïds pour plusieurs raisons. D'abord pour les douaniers. Les différentes provinces avaient des frontières douanières et les traverser a toujours été un grand problème. Je photographiais les douaniers et leur donnais la photo – j'avais alors la permission de passer la frontière. En fait, chaque fois que j'ai eu des problèmes avec les gens, les Polaroïds ont été mon aide la plus précieuse. Je les ai aussi utilisées afin que les Nouba puissent voir pour la première fois à quoi ils ressemblent. C'était très drôle quand je leur ai montré les Polaroïds et qu'un Nouba a dit à l'autre: ‹C'est toi!› Ils ne s'étaient jamais vus eux-mêmes et continuaient à regarder la photo et alors l'autre disait ‹C'est toi!›. Ils n'avaient pas de miroirs, et quand les Nouba ont eu leur photo Polaroïd, ils voulaient tous en avoir une. J'étais complètement submergée. Ils criaient tous pour avoir des photos. Je n'avais pas suffisamment de pellicule sur moi. Ils en étaient tous vraiment fous.»

«Les Musulmans pensent donc que photographier des gens nus n'est pas bien?»

«Oui. Au Soudan, c'est un délit très grave, presque un crime. Et c'était la plus grande difficulté que j'ai rencontrée. Personne au Soudan ne devait savoir que je photographiais ces gens nus. Durant la première expédition, j'ai dû envoyer mes photos à Khartoum où elles étaient examinées par la censure. J'ai ici un album avec des photos où vous pouvez voir marquées celles que je n'avais pas l'autorisation de publier. Ils ne détruisaient pas les photos, simplement on m'interdisait de les publier. On était toujours sur le fil du rasoir. C'était dangereux avec le gouvernement là-bas. J'étais sans cesse sur la liste noire à Khartoum. Et puis, chose vraiment extraordinaire, il y a eu un de ces changements de gouvernement et le président Nimairy a pris le pouvoir – à cette époque, mes livres avaient déjà été publiés. Un miracle s'est produit parce que Nimairy a dit ‹Ces photos sont de l'art.› Et que je devais être décorée pour elles, même si les gens sont nus. Et j'ai reçu la plus haute distinction soudanaise et un passeport soudanais.»

Rencontrant au cours d'un déjeuner le gouverneur de la province du Haut-Nil, le colonel Osman Nasr Osman, Leni lui parla de ses expériences avec les Nouba et fut surprise par son attitude tolérante à l'égard des autochtones car il était du Nord, et à l'époque, les tensions entre les Soudanais du Nord et du Sud étaient déjà fortes. Le repas fut une expérience merveilleuse après tout ce qu'elle avait connu avec les Nansen.

Le colonel Osman lui proposa de l'accompagner chez le roi des Shilluk où aurait lieu une grande fête des guerriers.

«Les Shilluk sont une tribu très intéressante; ils sont très intelligents. Les meilleurs d'entre eux sont envoyés à l'Université de Londres. Ils avaient encore un roi, le roi Kur. Je l'ai soigné avec des pilules. Il m'a donné un grand bouclier – je l'ai ici – en peau de crocodile pour me remercier. Une fois, j'ai vécu toute seule avec les Shilluk pendant quatre semaines. Et quelques-uns des chefs de tribus sont allés aux alentours avec moi et m'ont montré leurs rituels. J'ai même un peu appris leur langue.»

«Les Nouba étaient beaucoup plus primitifs en comparaison mais fondamentalement, ils se ressemblent. Les Nouba aussi bien que les Shilluk aiment leur bétail – pour eux le bétail est quelque chose de divin, comme chez les Massaï. Les Nouba sont extrêmement pauvres, ce qui est loin d'être le cas des Shilluk. Disons que si une famille Nouba possède une vache, une famille Shilluk en aura dix.»

Dans ses mémoires, Leni décrit comment le roi bien en chair danse avec une telle frénésie et pourtant une telle agilité qu'elle en est charmée, et comment ses guerriers le suivent. «Même si tout cela n'était qu'une formidable mise en scène, il y subsistait encore beaucoup du caractère originel. Le piétinement rythmé des hommes et leur enthousiasme sauvage croissant jusqu'à l'extase montraient que les Shilluk, contrairement aux pacifiques Nouba, étaient un peuple de guerriers. Leurs visages brillaient dans les efforts de la danse censée symboliser un combat symbolique dans lequel une armée représentait celle du roi et l'autre celle du demi-dieu Nyakang. Les mouvements d'attaque et de défense se succédaient; les pointes des lances jetaient des lueurs argentées dans les épais nuages de poussière; les peaux de léopard flottant et les perruques fantastiques transformaient la scène en un spectacle que même Hollywood aurait eu de la peine à réaliser. Les cris sauvages des spectateurs enflammaient les guerriers dont l'ardeur ne cessait de croître. Je photographiais jusqu'à ce que la pellicule vînt à manquer dans mon appareil.» (Mémoires, p. 647)

Les préjugés européens sur les «sauvages» s'avéraient non fondés; en fait, elle a trouvé ce que l'on appelle les «sauvages» beaucoup plus sympathiques que bien des personnes dites «civilisées» qu'elle a rencontrées.

«Pendant l'une des expéditions, j'avais engagé un Allemand et un Anglais. C'était dans le sud du Soudan. Ils avaient un vieux minibus Volkswagen en très mauvais état. Je les ai persuadés de m'emmener chez les Nouba à 500 kilomètres. Je leur ai offert tout l'argent qui me restait.»

Pour les quatre semaines de séjour prévus chez les Nouba, l'Allemand lui demanda 1500 marks – payables à l'avance. Quand le VW se retrouva enlisé dans un marécage, ce fut elle qui dut aller chercher de l'aide en pleine nuit. Il semble qu'elle ait toujours eu plus de chance avec les autochtones qu'avec les Européens, et elle rencontra un Shilluk qui parlait bien l'anglais. Le véhicule fut extrait de la boue par des soldats arrivés en camions militaires, et reprit son voyage vers les Nouba. Quand il s'arrêta finalement sous «son» arbre, les Nouba entourèrent Leni en criant «Leni – Leni guiratzo» (Leni est revenue).

«Les hommes et les femmes me prenaient dans leurs bras, les enfants tiraillaient mes vêtements», écrit Leni, «le brouhaha était indescriptible. J'étais heureuse et plus qu'heureuse. C'est ainsi que j'avais souhaité les retrouvailles, mais cela dépassait ce que j'avais imaginé.» (Mémoires, p. 653)

Le lendemain matin, l'Allemand lui annonça qu'ils repartaient dans deux jours. Leni protesta qu'elle avait payé pour quatre semaines mais l'Allemand ne changea pas d'avis. Les Nouba, comprenant la situation, déplacèrent simplement son camp et lui prêtèrent l'une de leurs cases. On lui dit qu'un grand tournoi de lutte allait avoir lieu.

«La lutte était toute leur vie. C'était pour les Nouba ce qu'il y a de plus important après la mort. Ils commençaient quand ils étaient bébés. Aussitôt qu'ils pouvaient marcher, les bébés commençaient à lutter.»

Leni décida de se rendre au festival sans en informer l'Allemand. Elle s'aperçut bientôt avec inquiétude que la distance était immense, et la chaleur était si intense qu'elle s'évanouit. Une femme Nouba la transporta dans une corbeille sur sa tête le reste du chemin.

Le tournoi de lutte surpassa tout ce à quoi elle avait déjà assisté. Alors qu'elle s'efforçait de photographier de tout près, des lutteurs faillirent tomber sur elle. Ses amis Nouba l'escortèrent à l'endroit où le meilleur lutteur des Nouba Masakin affrontait le champion de la région Togadindi qui mesurait plus de deux mètres dix de haut. Le combat remarquable atteignait son apogée quand Leni aperçut ses compagnons de route, l'Allemand et l'Anglais.

«Ils sont venus me dire qu'ils partaient et que je devais aller avec eux. Mais je ne pouvais pas parce que mes affaires étaient ailleurs, pas à l'endroit où avait lieu le concours de lutte.»

N'empêche qu'elle devait partir, même si les Nouba la suppliaient de rester. Pleurant de frustration, elle grimpa dans le minibus – et quand elle fut de retour au camp, l'Allemand déclara qu'ils ne partiraient que le lendemain. Leni aurait pu rester à la fête. Cette nuit-là, ses Nouba revinrent. Ils avaient quitté les festivités pour lui dire au revoir.

«L'Allemand et l'Anglais me pressaient. Les Nouba arrivaient en courant et disaient «Au revoir, au revoir» et agrippaient mes mains. Ils voulaient que je reste. Mais les autres m'emmenèrent de force. Les Nouba ne voulaient pas me laisser partir. Ils avaient déjà repéré un endroit où ils étaient en train de me construire une maison. Je voulais vraiment rester là, d'ailleurs je voulais y rester pour toujours.»

Les Nouba coururent derrière le véhicule en criant «Leni basso». Bien sûr, Leni savait qu'elle reviendrait. En attendant, elle eut une autre aventure. Découvrant qu'elle était à Wau, son ami le colonel Osman l'invita à l'accompagner dans la province du Haut-Nil.

«Le gouverneur m'a emmenée dans un voyage à la frontière de l'Éthiopie – il descendait là avec une troupe, 40 soldats et des officiers, et m'a demandé si je désirais l'accompagner.»

«J'ai pris des photos extrêmement rares de tribus que je n'ai jamais pu revoir depuis, sur l'autre rive du Nil. Nous étions dans une région inaccessible par des voies normales, vu qu'il n'y a pas de routes. Ici il y avait encore des gens qui portaient des disques de métal dans leurs oreilles, des gens particuliers, très étranges.»

Finalement, le gouverneur dut rentrer. Leni s'était assurée une place dans un camion quand elle aperçut soudain trois guerriers Dinka sur la piste.

«Les Dinka sont très semblables aux Shilluk, en plus royal je dirais. De toutes les tribus, les Dinka sont les plus majestueux. Ils sont d'excellents guerriers et ils possèdent le plus de bétail, ils sont très riches. Si on s'imagine le Soudan du Sud gouverné par quelqu'un, ce ne pour-

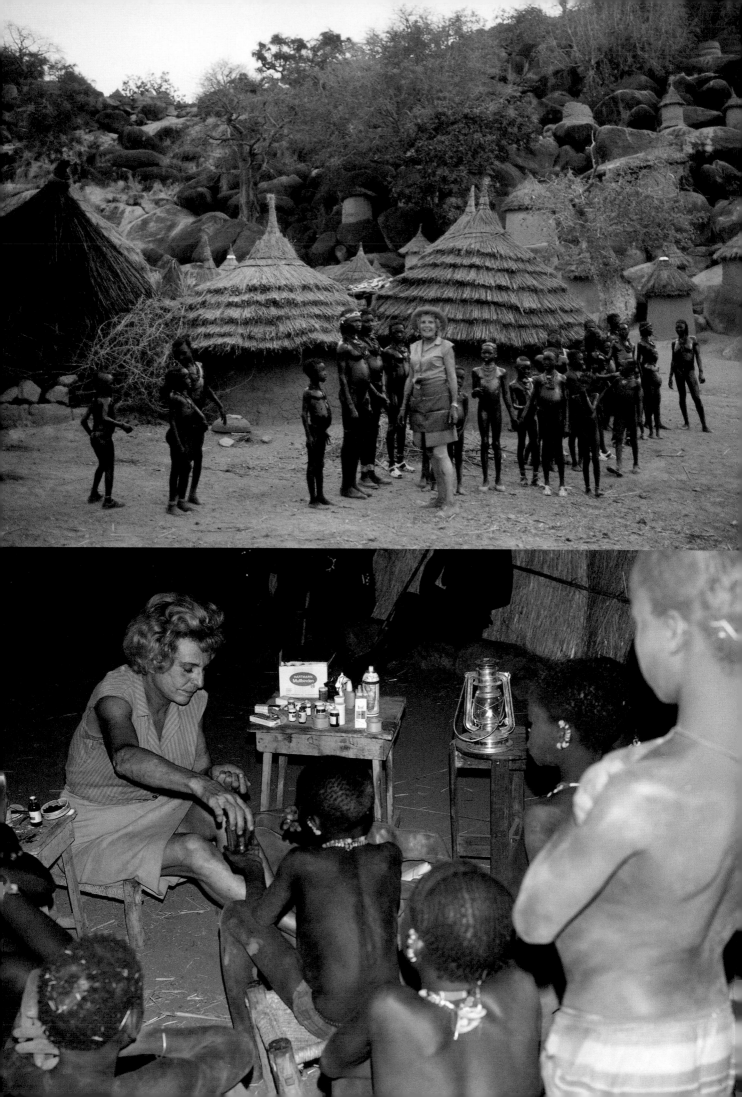

rait être que les Dinka. Mais il était dangereux de photographier des Dinka sans autorisation.»

Elle demanda au chauffeur de s'arrêter, prit son Leica et s'approcha des guerriers et le plus grand tendit la main afin qu'elle lui donne de l'argent. Elle acquiesça avant de découvrir, terrorisée, qu'elle n'avait pas de pièces de monnaie, seulement un chèque. Les Dinka se mirent en colère et l'un d'eux lui arracha son sac. «J'essayai de ramasser tout ce qui en était tombé. J'avais un poudrier vide avec un miroir sur son couvercle. Je l'agitai au soleil afin de le faire briller comme de l'or et le jetai au-dessus de leurs têtes dans l'herbe. Ils coururent le ramasser et je me souviens seulement que mon chauffeur a dû démarrer à toute allure parce que les Dinka s'étaient lancé à ma poursuite en brandissant leurs lances. Ce fut la seule fois où je me suis vraiment trouvée en danger et c'était entièrement de ma faute.» (Mémoires, p. 668)

«Teniez-vous un journal?»

«Si on peut l'appeler comme ça. J'ai un petit carnet où j'ai tout noté d'une écriture minuscule. J'ai besoin d'une loupe pour le lire.»

En mai 1963, Leni accompagna le prince Ernst von Isenburg, alors âgé, et qui vivait en Afrique orientale depuis plus de 30 ans, chez les Massaï. Réputés pour leur intrépidité, les Massaï ne connaissaient pas la défaite jusqu'à ce qu'ils se retrouvent face aux Anglais et au fusil Gatling. Mais ils ne signèrent aucun traité de paix avant d'avoir été mis en présence de l'autorité la plus haute, la reine Victoria elle-même.

«Les Massaï sont des sujets très intéressants à photographier – leur apparence, la manière dont ils sont vêtus. Les photos que j'ai prises au Soudan sont rares parce que les gens y vont rarement, mais celles des Massaï ne valent pas grand-chose parce qu'ils sont souvent photographiés.»

Leni était fascinée de voir la différence entre les Nouba qui respectent les femmes et les Massaï pour lesquels elles ont moins d'importance qu'une vache.

«Mais ils pouvaient être aussi désarmants de gentillesse [...]. Ils organisèrent même des simulacres de combats.» (Mémoires, p. 673)

Quand Leni revint chez elle à Munich, sa mère fut horrifiée par son aspect. Elle n'avait pas été malade et se sentait dans une forme éblouissante, mais le soleil avait abîmé ses cheveux et elle avait beaucoup maigri. Ce qui la préoccupait le plus, c'est ce qu'il était advenu des rouleaux de pellicules qu'elle avait renvoyés.

«Je les ai envoyés à un jeune homme, un étudiant que je connaissais, nommé Ulli, qui devait les remettre à ma mère. Il a exposé toutes les pellicules, les a détruites. Toutes. Je ne pourrai jamais refaire ces photos.»

Leni, bouleversée, en avait perdu le sommeil et l'appétit. Elle montra les rouleaux détruits à la police. Il s'avéra que pour une raison inexplicable, Ulli avait sorti les pellicules de leurs capsules et les avait laissées en plein jour et qu'elles étaient détériorées. La police perquisitionna chez lui et trouva quatre rouleaux qui, une fois développés, s'avérèrent parfaits. Ils contenaient les photos des Dinka. Et heureusement, la première expédition des 90 rouleaux de pellicule contenant les photos de Nouba était sauve. Leni les offrit aux magazines allemands *stern*, *Bunte Illustrierte* et *Quick*, mais tous refusèrent, probablement à cause de son passé de cinéaste durant le IIIe Reich. Seul *Kristall*, un magazine du groupe Axel Springer, dont les éditeurs étaient stupéfiés par les photos, décida de les

publier – et ils le firent dans trois numéros. Leni présenta les diapositives dans un cycle de conférences et les réactions du public furent toujours excellentes.

Leni a été impitoyablement poursuivie par l'adversité mais elle a toujours eu le ressort et le courage de vaincre celle-ci. Et parfois, le mauvais sort était suivi de coups de chance étonnants.

La révolution avait éclaté au Soudan, mais son vieil ami Ahmed Abou Bakr lui procura un permis de filmer et de photographier dans les monts Nouba. «L'accueil des Nouba fut, si c'est possible, encore plus exubérant que la dernière fois», écrit-elle. «Rien ne semblait avoir changé. Les Nouba m'apparaissaient comme les êtres humains les plus heureux de la Création.» (Mémoires, p. 692)

Mais une telle idylle ne pouvait durer. En janvier 1965, la mère de Leni mourut et Leni se rendit immédiatement à Munich – le voyage dura quatre jours. Elle arriva trop tard, l'enterrement avait eu lieu deux jours auparavant. «La seule possibilité d'échapper à la douleur me parut être de retourner le plus vite possible dans les monts Nouba.» (Mémoires, p. 693) Cette fois-ci, elle projetait de tourner un film et emmena avec elle un jeune cameraman allemand Gerhard Fromm. Mais, une fois de plus, la malchance guettait.

«J'ai voulu photographier deux lutteurs et me suis approchée trop près. Pendant que je cherchais le cadrage, ils sont tombés sur moi et mon Leica, et je me suis retrouvée sous eux, une douleur aiguë au thorax», Leni rit à ce souvenir. Il fallut l'emmener dans un petit hôpital à Kadougli et elle revint enveloppée de pansements. Elle et Fromm arrivèrent à filmer l'initiation d'un adolescent et un rituel de tatouage. Mais alors la nouvelle tomba: la guerre arrivait.

«J'ai fait moi-même l'expérience de ce qui a précédé la grande révolution pendant que j'étais ici avec mes Nouba. Nous entendions des rumeurs sur des combats qui auraient eu lieu et sur la base de ces rumeurs nous partîmes en voiture vers les prochains – je ne peux pas les appeler villages –, hameaux de collines, parce qu'on disait que là les cases étaient déjà en train de brûler. Quand nous sommes arrivés, il y avait des cases en flammes et on entendait de coups de feu, mais nous n'avons pas attrapé les criminels. On sentait déjà que quelque chose était en train de couver. Le soir venu, les Nouba sont venus me demander de les emmener en voiture vers le Sud, on disait qu'il y avait la guerre là-bas. J'étais toute seule à ce moment-là et je partis en Land Rover vers le Sud. C'était très difficile car tout le monde grimpait en cours de route sur mon véhicule, tous désiraient s'en aller, ils se tenaient debout sur les marchepieds, jusqu'à ce que finalement je ne puisse plus continuer parce que la voiture est tombée en panne. J'ai dû la laisser là et retourner à pied au camp, ce qui a pris des heures.»

En plus, quelques lutteurs commirent un crime odieux aux yeux des Nouba – ils volèrent deux chèvres et firent banquet. Selon la loi Nouba, ce ne sont pas seulement les voleurs de chèvres qui sont coupables mais aussi ceux qui ont participé au festin et toute l'élite des lutteurs de Tadoro fut envoyée au poste de police. Terminé, le film. «Les adieux furent tristes, les plus pénibles que j'aie vécus jusque-là.» (Mémoires, p. 701)

Pour couronner le tout, un des assistants vola 16 pellicules de diapositives et envoya les diapositives à son père. Le premier test de la pellicule de cinéma – Kodachrome (25 ASA) et Ektachrome ER (64 ASA) – était excellent. Mais alors Leni dut faire face à la catastrophe; les laboratoires Geyer n'avaient pas développé correctement l'ER ultrasensible et tout était perdu. «Aujourd'hui, je ne peux plus trouver les mots pour décrire ce que je ressentis en écoutant cette réponse nette et claire. [...]

Je venais de perdre définitivement la dernière chance de me reconstruire une existence.» (Mémoires, p. 706 s.) Des amis durent l'aider à rembourser le capital investi par le producteur américain et elle se vit obligée d'annuler le contrat avec lui.

J'ai rencontré Leni pour la première fois peu de temps après, en 1966, pendant une visite à la BBC de Londres; elle vint à l'appartement de Philip Jenkinson à Blackheath et montra à quelques-uns d'entre nous les rouleaux qui subsistaient de la pellicule Nouba en 16 mm. Je me rappelle avoir senti que les films de Fromm étaient corrects et bien réalisés mais quand je vis les diapositives montrant les Nouba, sans exception, ses photos en couleur des mêmes événements avaient plus d'impact. Beaucoup étaient incroyablement bonnes. Les photographies étaient disposées en séquence et elle les montait comme un de ses films.

«Maintenant vous voyez que je suis une cinéaste, n'est-ce-pas?», dit-elle.

Nous étions stupéfaits par les scènes montrant les foules d'hommes des tribus, les lances composées comme dans un tableau d'Uccello, des gros plans puissants, des photos de personnages en pied montrant combien la beauté physique la fascinait, des photos où l'on voyait des lutteurs tourbillonner. Ses représentations de l'innocence, de ce paradis avant l'arrivée de la civilisation étaient les plus impressionnantes quand elles apparaissaient dans des gros plans d'hommes et de jeunes filles Nouba; la puissance d'expression des images, la sérénité et la gaieté qui s'en dégageaient nous touchaient le plus.

«La photographie aussi peut être de l'art», dit-elle, en attendant d'être confrontée à nos préjugés de cinéastes. «J'aime les photographies parce qu'on a plus le temps de regarder.»

Nous nous sentîmes tous profondément privilégiés.

Fin 1966, Leni retourna au Soudan pour une courte visite. Après avoir été reçue comme d'habitude avec enthousiasme par les Nouba, elle réalisa que c'était Noël.

«Je leur montrai à quoi ressemble un ange en me drapant d'un drap blanc. Je fis une sorte d'ailes. J'essayai de leur faire comprendre ce qu'était Noël avec des bougies. Je donnai une petite fête – une surprise pour les Nouba qui ne savaient pas ce qu'était Noël. Quand j'allumais les bougies dans ma case, il s'avéra qu'ils n'avaient jamais vu de bougies.»

Leni resta en contact avec eux à l'aide de bandes magnétiques qu'elle envoyait à un maître d'école Nouba dans une ville proche. Elle essaya de résoudre leur problème d'eau en leur envoyant de l'argent destiné à acheter de l'équipement pour construire un puits.

Leni réalisa alors qu'elle ne pourrait plus continuer ainsi toute seule; l'idéal aurait été de trouver quelqu'un qui soit familiarisé avec la caméra et qui soit aussi mécanicien. Et, incroyable mais vrai, elle le trouva. Horst Kettner était un jeune homme de grande taille. «Son visage m'a inspiré confiance dès l'instant où je l'ai vu». (Mémoires, p. 742) Et il montra de quoi il était capable en se rendant en Angleterre sans parler un mot d'anglais, allant chercher une Land Rover, malgré une grève à l'usine et la conduisant d'une traite de Londres à Munich.

«Je n'ai pas filmé moi-même, je photographiais seulement. Horst filmait (avec une Arriflex 16 mm). Oh, son aide était précieuse, surtout quand la voiture tombait en panne. Changer une roue m'épuise complètement. Et en plus, je trouvais très agréable d'avoir quelqu'un avec

qui partager toute cette beauté, un ami qui pourrait voir et vivre tout cela avec moi. Par exemple, si quelqu'un doutait de ce que je vous raconte maintenant, on pourrait lui demander. Il partage mes idées sur les Nouba.»

Après avoir rencontré une série de difficultés apparemment insurmontables, racontées de manière vivante dans ses mémoires, Leni retrouva une fois de plus ses chers Nouba et reçut de nouveau un accueil extatique. Ils lui avaient construit une maison.

«Une habitation Nouba comprend six cases réunies par un mur.»

Mais les changements qu'elle observait la consternèrent.

«Quand je revins après cinq années d'absence, ils portaient tous tout à coup des guenilles. Ils y étaient obligés – le gouvernement soudanais leur distribuait des vêtements. Ils n'avaient plus le droit d'aller nus. Et cela les a transformés aussi.»

Le problème le plus urgent des Nouba était le manque d'eau. Leni voulait les aider.

«J'avais engagé un sourcier pour qu'il trouve de l'eau sur une carte à grande échelle. J'avais déjà tout essayé pour obtenir un sponsoring, pour les puits à construire, mais personne ne venait. Mais il y avait cet Américain, un ami de Harvard qui était en voyage en Afrique et je l'ai persuadé d'acheter des outils pour moi à Khartoum, une hache et de grandes pelles. Il s'appelait Garnder, et plus tard il a tourné lui-même des films. Il acheta ces outils pour moi et les laissa chez mon ami, le ministre du Tourisme, et le ministre s'arrangeait pour que ces outils parviennent petit à petit aux Noubas. Des marchands arabes descendaient quelquefois pour vendre du sel aux Nouba. Et ça a marché. Je connaissais certains Nouba avec qui j'avais un contact particulièrement bon, vraiment des amis, et je leur avais demandé de creuser pour trouver de l'eau. Ils creusèrent un trou profond et, ne trouvant pas d'eau, ils le recouvrirent de branches et de terre. Et un jour, un gamin qui passait dessus en courant est tombé dedans. Comme les parois étaient lisses, il ne pouvait plus en sortir, et les Nouba se tenaient tout autour, incapables de l'aider. Ils appelaient dans le trou sans le voir et ne recevaient pas de réponse. Je leur ait dit d'aller me chercher une corde de remorquage pour la voiture; je donnai une extrémité de la corde à Horst et arrimai l'autre autour de moi comme une alpiniste et descendis dans ce trou et fis sortir le gamin. Son père était si en colère qu'il le roua de coups, et cela me rendit si furieuse que je lui donnai aussi une paire de gifles. Le garçon s'était fait une blessure assez grave au dos, mais Horst l'a soigné et il guérit.»

Quand Horst et Leni tentèrent de filmer un combat au bracelet, ils découvrirent que même les lutteurs portaient des pantalons et des bouteilles en plastique à la ceinture au lieu de calebasses. Horst ne réussit pas à les convaincre de se débarrasser de leurs vêtements; maintenant leur nudité les gênait. Le rituel avait tellement changé qu'il ne valait plus la peine d'être filmé. Plus inquiétant encore, Leni entendit dire que les Nouba s'étaient mis à voler. «Comment cela a-t-il pu arriver?» écrit-elle. «Ce n'était pas à cause des touristes; à part une hôtesse de l'air anglaise qui avait réussi un jour à parvenir jusqu'à moi avec son père, aucun n'était encore venu ici.» (Mémoires, p. 755) Quelques mauvaises récoltes successives avaient forcé les jeunes gens à aller travailler en ville; ils en revinrent avec des vêtements, des maladies vénériennes et de l'argent.

«Le premier sou, la première pièce de monnaie quelle qu'elle soit qu'ils eurent dans les mains, changea le caractère des Nouba. À partir de ce moment, ils pouvaient acheter quelque chose au marché. Ils firent

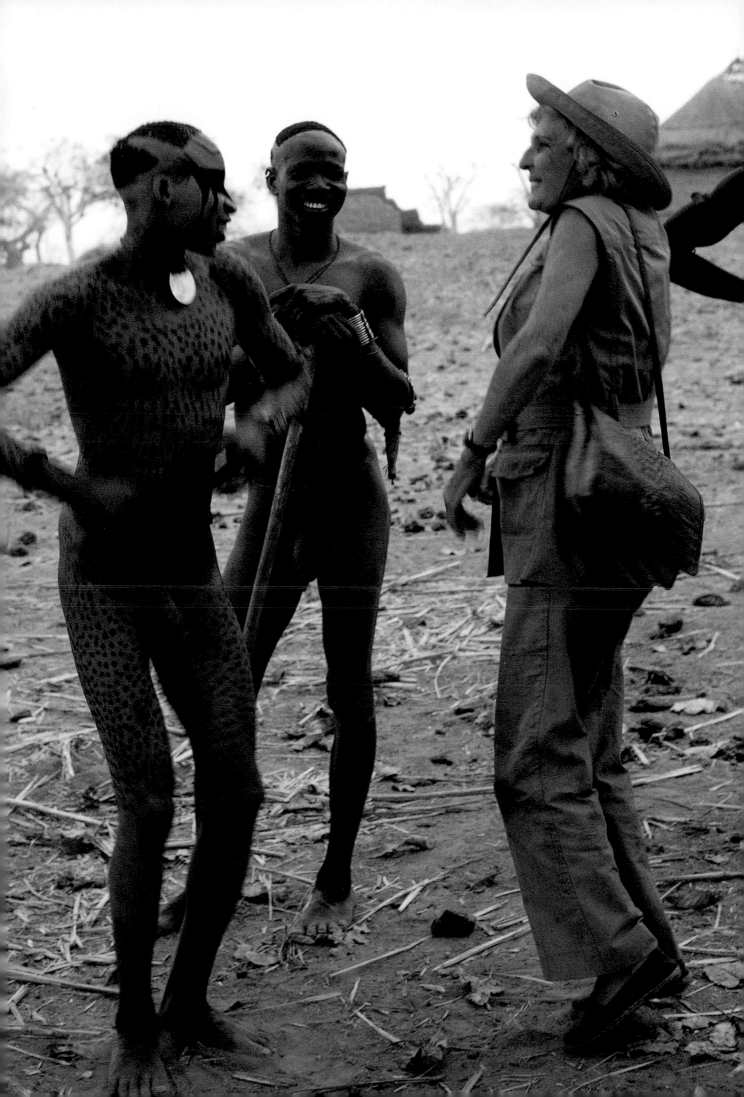

pousser du coton et le vendirent au marché, et quand ils obtenaient de l'argent pour cela et pouvaient acheter des choses, les autres voulaient de l'argent comme eux. Auparavant, il n'y avait pas de différence entre eux, sans argent, les Nouba étaient tous égaux. Mais avec l'arrivée de l'argent, l'un en avait plus, l'autre en avait moins et ainsi, tout à coup, quelque chose émergea qu'ils n'avaient jamais connu, une sorte d'esprit de compétition, une certaine envie. Et cela transforma leur caractère.»

Leni craignait que les Nouba ne connaissent le même sort catastrophique que les Indiens d'Amérique et les aborigènes d'Australie. Elle écrit ainsi: «Là où la civilisation étend ses zones d'ombre, le bonheur humain disparaît.» (Mémoires, p. 756)

De retour en Allemagne, ses photographies des Nouba sont imprimées dans le *stern* de décembre 1969 et elles paraissent bientôt dans un album impressionnant publié en Allemagne (1973), en Amérique (1974) et en France (1976). Elle emporta les albums pour les montrer aux Nouba mais quand elle arriva, elle trouva leur paradis détruit. Les Nouba étaient aussi affectueux que d'habitude, et leurs vieux amis n'avaient pas changé, mais les autres vinrent lui demander des médicaments, du tabac, des perles, des piles électriques, des lunettes de soleil et tous portaient des guenilles répugnantes.

«Quand je leur montrai les photos que j'avais faites d'eux quand ils ne portaient pas de vêtements, ils en avaient honte. On les avait persuadés que c'était mal.»

Au cours de cette expédition, Horst pensa que Leni était devenue folle; elle était décidée à trouver une tribu Nouba établie plus loin, les Kau. Ils partirent, malgré le manque de carburant et bien que la région ne figure sur aucune carte. Le voyage fut inconfortable mais ils furent récompensés par «un spectacle insolite et exaltant». (Mémoires, p. 804)

«Éclairées par les derniers rayons du soleil couchant», écrit Leni, «ces créatures extrêmement minces se mouvaient avec grâce au rythme du tambour. Les jeunes filles étaient elles aussi complètement nues, huilées et maquillées de différentes couleurs. La gamme allait du rouge profond au jaune en passant par l'ocre. [...] Leurs mouvements étaient provocants et devenaient de plus en plus sauvages [...]. Les danseuses ne m'avaient pas aperçue, vu que je m'étais cachée derrière un tronc d'arbre et que je photographiai au téléobjectif. [...] Pour moi, ce fut l'expérience visuelle la plus captivante que j'ai vécue au cours de toutes mes expéditions africaines.» (Mémoires, p. 804 s.)

Ils purent même photographier un combat au couteau; c'était dans l'espoir d'en voir un que Leni s'était embarquée dans cette expédition.

«Les Nouba Kau ne luttent pas à mains nues, la technique consiste à éviter d'être atteint par le bracelet de laiton aux arêtes tranchantes que porte l'adversaire. Personne ne les avait jamais photographiés. Aucune autre tribu ne se bat ainsi. Il n'existe rien de tel au monde. Pour moi, en tant que photographe, c'était sensationnel. Et aucun autre peuple n'est aussi doué pour peindre des masques car ce que font les Indiens de Nouvelle-Guinée est plutôt primitif, mais les Nouba Kau sont des artistes. Leurs masques sont de l'art.»

Elle découvrit ces masques à Nyaro, un autre village. «Le corps d'un jeune homme était peint de manière fantastique, imitant la peau d'un léopard, et son visage me rappelait Picasso. À mon grand étonnement, il accepta de se laisser photographier sans protester. Je découvris bientôt qu'il n'était pas le seul à être peint de façon si extraordinaire; de partout je vis venir vers moi des jeunes hommes dont les visages évoquaient des masques stylisés.» (Mémoires, p. 807)

«Se sont-ils parfois opposés à ce que vous les photographiez?»

«Les Nouba Masakin, jamais. Ils étaient de bien meilleurs amis, de toute façon. Il y avait une grande différence entre les Nouba Masakin et les Kau. Certains Nouba Kau ont refusé. Il était très difficile de travailler avec les Nouba Kau. Mais ce que j'ai vu, je l'ai photographié.»

L'expédition suivante, en 1974, fut plus décevante. Les guerriers portaient maintenant des shorts et s'habillaient à l'arabe. Le village Kau était complètement détruit. Au campement, elle et Horst durent faire face à l'explosion d'un réchaud à gaz – les vêtements que Leni avait accrochés à une corde prirent feu – et une heure plus tard elle se cognait le crâne contre une grosse branche. Horst s'occupait de ses blessures quand deux grands véhicules arrivèrent, bourrés de touristes. Rien n'aurait pu les affliger davantage. Les touristes étaient un groupe assez sympathique d'Allemands ayant entendu dire par un fonctionnaire indiscret que Leni était ici. Mais ne voyant aucun signe des Nouba peints, ils partirent le lendemain.

Plus tard, les Nouba leur montrèrent des billets de banque que leur avaient donné les touristes et ils espérèrent qu'ils seraient payés pour leurs photos. Une fois que le membre d'une tribu a fait la connaissance de l'argent, dit Leni, un photographe peut aussi bien remballer ses affaires et s'en aller.

«Vous ne les avez jamais payés pour les photographier?»

«Si j'avais fait cela au début, je n'aurais pas pu travailler du tout. Tous les Nouba, des centaines, seraient venus et auraient réclamé de l'argent. C'était déjà un énorme problème avec les perles de verre que nous avions emportées. Nous avons dû arrêter parce qu'ils devenaient fous, ils voulaient tous des perles. C'était bien le problème, on ne pouvait rien donner à personne parce qu'après tous le voulaient aussi. Ce que je faisais, c'est que, la plupart du temps, je passais – et plus tard avec Horst – deux ou trois heures chaque soir à soigner les malades. Le soir, quand il faisait trop sombre pour travailler, ils faisaient la queue, avec des blessures aux jambes – des blessures ouvertes principalement –, et souffrant de pneumonie. Nous avions une armoire à pharmacie convenable que nous avait préparée un médecin.»

Leni et Horst installèrent aussi un projecteur à diapositives et montrèrent les photos qu'ils avaient prises l'année précédente. Cela causa une excitation énorme. «La réaction des Nouba fut indescriptible [...]. Ils semblaient reconnaître la moindre silhouette.» (Mémoires, p. 836)

«La première diapositive que j'ai montrée – une jeune mère Kau avec son bébé dans les bras – fut saluée d'un beuglement de rires qui redoublèrent quand je poursuivis avec des gros plans du bébé. Les Nouba pensaient que cela dépassait la compréhension qu'une tête humaine puisse être aussi grande que celle qui apparaissait sur l'écran.»

La présentation enhardit beaucoup les Nouba et, dans les jours qui suivirent, ils arrivèrent au campement pour se montrer à Leni, les jeunes gens s'étant peint le corps avec beaucoup de soin.

De retour à Munich, Leni qui avait après tout 72 ans – un âge où beaucoup de gens végètent dans des maisons de retraite – s'effondra. Toutefois, elle oublia ses douleurs physiques quand elle vit à quel point ses photos et le film de Horst étaient réussis. Le *stern* et le *Sunday Times* publièrent les photos de Kau et le monde entier put les admirer. Le Club des directeurs artistiques d'Allemagne attribua une médaille d'or à Leni pour la meilleure réalisation photographique de 1975. Il y eut, comme toujours, des articles négatifs, mais la réaction générale envers les photos

– dans tous les pays où elles étaient publiées – fut incroyablement en-
thousiaste. Un magazine lui demanda de retourner chez les Nouba et elle
reçut à Khartoum une décoration de la main du président Nimairy qui fit
l'éloge de ses deux albums photos, dont la forme et le contenu permet-
taient même aux musulmans de voir les Nouba dévêtus sans que leurs sen-
timents religieux en soient offensés. Le gouvernement soudanais offrit plu-
sieurs centaines d'exemplaires de ses livres aux délégations étrangères en
ambassade au Soudan comme cadeau de Noël.

Les changements chez les Nouba étaient moins dus aux touristes –
ils affectèrent les Nouba Masakin bien avant l'arrivée de ceux-ci – qu'à l'a-
rabisation et en fin de compte, la guerre. En 2000, à l'époque où Leni et
Horst retournèrent là-bas pour une réunion, il ne restait pratiquement
aucun des vieux amis de Leni. Ils avaient en tête de collecter des fonds
pour les Nouba et de voir comment ils s'étaient débrouillés après tant d'an-
nées de guerre au Soudan.

«Nous étions là depuis quelques heures quand la police est venue
nous chercher avec des véhicules, et nous avons dû retourner chez nous.
Les studios Bavaria Films ont tourné un film sur ma dernière visite, il y
a deux ans, un long métrage documentaire qui sortira un de ces jours et
qui montre tout ce qui nous est arrivé là-bas. Le cameraman a été
blessé dans l'accident d'hélicoptère. Oui, notre hélicoptère s'est écrasé.»

«Normalement, on ne sort pas indemne d'un accident d'hélicoptère.
Que vous est-il arrivé?»

«J'ai eu quelques côtes cassées. Mon poumon était endommagé et
j'étais très malade. J'ai aussitôt été rapatriée en Allemagne dans un avion
de sauvetage et j'ai passé trois semaines à l'hôpital.»

«Qu'avez-vous essayé de filmer?»

«Je voulais filmer la réunion avec nos Nouba. La réunion après
tant d'années.»

«En avez-vous rencontré beaucoup?»

«Non, je n'en ai pas rencontré beaucoup. Il y avait eu une guerre
entre-temps et ils étaient nombreux à ne plus être en vie. Nous n'avons
passé que 24 heures ensemble. Nous avons eu peu de temps pour leur
parler et seulement trois ou quatre de nos vieux amis étaient là.»

Leni Riefenstahl a quitté le 20e siècle pour explorer l'âge de pierre.
Elle a vu des êtres humains vivant en harmonie parfaite avec la nature et
constaté ce que «le fléau de la civilisation» pouvait leur faire. Néanmoins,
la civilisation nous a apporté aussi la photographie qui fige un moment du
temps.

Kevin Brownlow, Londres, mai 2002

L'interview entre Leni Riefenstahl et Kevin Brownlow, Londres, s'est dé-
roulée le 2 mai 2002 à Pöcking en présence de l'interprète Claus Offer-
mann, Munich. Nous remercions également Carla Wartenberg, Londres.
Les citations sont extraites de l'édition originale allemande: Riefenstahl,
Leni, Memoiren, Taschen, Cologne 2000. Il s'agit d'une nouvelle traduc-
tion. Les pages mentionnées se réfèrent à l'ouvrage allemand.

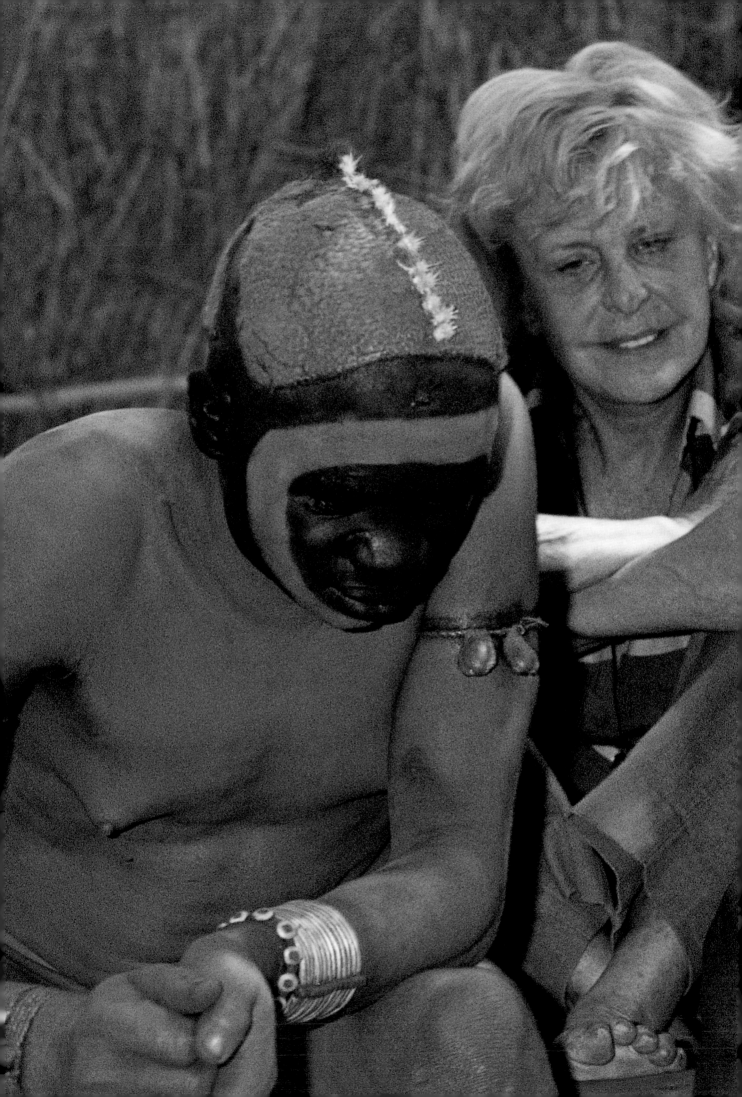

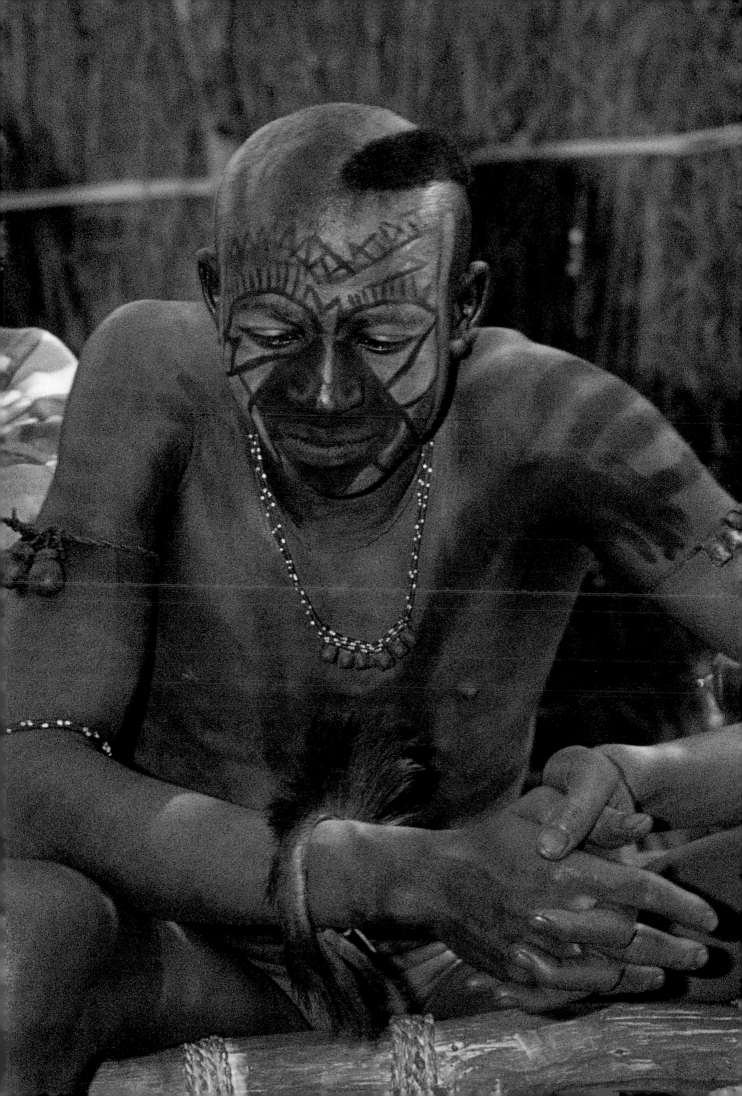

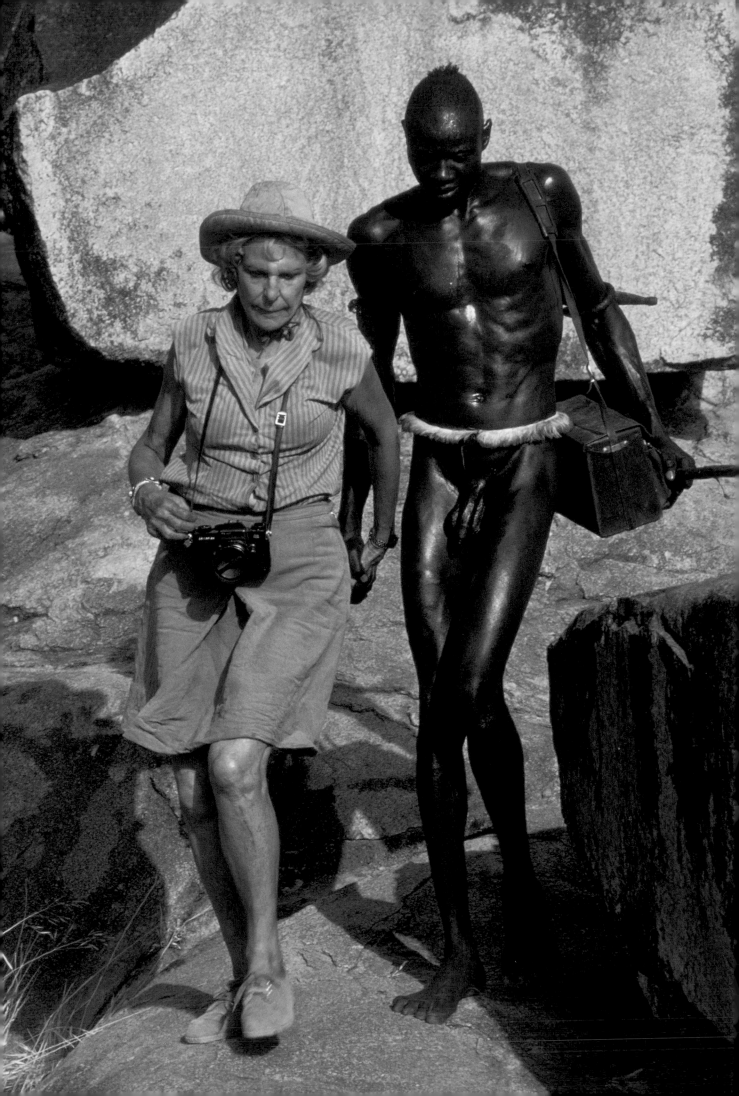

アフリカへの
消し去れぬ愛情

　もし、レニ・リーフェンシュタールがアフリカを訪問するたびに写真を撮っていただけの人物だとしても、彼女の歴史上の地位は揺るぎないものになっていただろう。それほど、これらの写真は非凡な記録なのだ。同じぐらい非凡なのが彼女のスタミナだ。最初のアフリカ行きは60歳代前半のことだったし、いちばん最近の旅行は98歳の時に決行された。彼女のアフリカへの愛情は、本作品以前にも3冊の写真集として結実している。

　最初の冒険旅行は、彼女を永遠にアフリカから遠ざけるべき嫌忌療法となってもおかしくないほど悲惨なものだった。アフリカで横行する違法な奴隷貿易に関する映画を撮るのが目的だった。ナイロビ北部をジープで走行中、ディクディクと呼ばれる小型レイヨウを避けようとしたドライバーが運転を誤り、岩に衝突した車体は宙に舞い上がってから、干上がった河床に激突した。フロントガラスに突っこんだレニは大けがを負い——頭の傷は編み針で縫合された——助からないだろうとさえ言われた。しかし、驚異的な生命力をもって彼女は快復した。そして、つかの間かいま見た、民族衣装を身につけ槍を手にしたマサイ族の戦士の姿に魅了されたことが、一連の写真作品を生み出すきっかけとなった。アーネスト・ヘミングウェイはマサイについてこう記している。「とても背が高く、均整のとれた身体をもった、私がアフリカで見たうちで最も輝かしい人々だった」

　私がペキングにある彼女の自宅で話を聞いたとき、またしてもアフリカ旅行で遭遇した事故の後遺症からくる痛みに苦しんでいたレニ・リーフェンシュタールは、自分をアフリカ大陸に結びつけた責任はアーネスト・ヘミングウェイにあるのだと語った。

　「ヘミングウェイの『アフリカの緑の丘』を読んで影響を受けたの。そして、実際にあの場所に行ったとき、そのきらめき、アフリカとしか表現できないその光、暑さの中で、なにもかもがヨーロッパとは違って見える色や熱気に完全に魅了されてしまった。同時にそれは印象派の画家たち——マネ、モネやセザンヌを思い起こさせもしたわ」

　しかし、イギリス人写真家ジョージ・ロジャー（1908–1995）がヌバ族のレスラーを撮った1枚の写真——ひとりの男が別の男を肩車している（p.443参照）——こそ、彼女を偉大なる写真家の道へと導いたのだった。彼女の言葉によると、写真の男はまるでロダンの彫像を思わせ、そこに短く添えられた『コルドファンのヌバ』というタイトルが、魔術のように彼女をアフリカの忘れ去られた、未開拓の土地へと引き寄せたのだ。しかし、どうやって彼の地に到達するのか？　彼女には資金も年金もなく、母親の面倒も見なければならなかった。彼女はナイル河に関する映画を撮るという企画を実現させようとしていた。そして、スーダンの観光局長、アーメド・アブ・バクールという男から国内を旅するために必要なビザを取得することに成功した。彼はレニの友人として、その後の彼女の人生において重要な役割を果たすことになる。しかし、その頃、ベルリンの壁が築かれたことで、彼女の映画スポンサーが出資金を失ってしまった。映画の撮影はキャンセルされた。

　二度目のチャンスはドイツ・ナンゼン協会の会長によってもたらされた。オスカー・ルッツは、60歳を過ぎたレニにとってアフリカ行きがどれほど困難であるかについて忠告を与えた。しかし、バレエや登山、それにスキーで鍛えあげていた彼女は自信に満ちていた。彼との打ち合わせの後、彼女は生まれ変わった気がしたと語っている。

　「ヌバはコルドファンに住んでいると本で読んではいたけれど、当初、コルドファンがどこにあるかを知る者は誰もいなかった。それがスーダンの州のひとつだと知るまでには長い時間を要したわ。スーダンの首都ハルトゥームに到着してからも、コルドファンを、ましてやヌバのことを知る人は皆無に等しかった。ヌバの存在を知っている人に出会ったのは、ハルトゥームを二度目に訪れたときだったわ」

　「ロジャーの写真を持ち歩いて、人々にそれを見せながら情報を得ようとしていたけれど、その途中、コルドファンの警察署長が言ったわ。この写真のような裸のヌバはもはやいない。10年前には存在したかもしれないけれどってね。だけど、私は彼らを探すことを諦めなかった」

　ナンゼン探検隊はヌバ山地を走りつづけた。1週間の探索の間に彼らが遭遇したヌバは、シャツとショートパンツを身につけて、他のアフリカ人と何ら変わるところがなかった。探検隊の士気は急速に落ち込んでいった。ある日、うち捨てられたような谷あいを何時間も走っていた彼らの目に、山腹に建てられた、ヌバ特有の丸屋根をもつ家の姿が飛び込んできた。彼らに驚き、慌てて逃げ出す全裸の少女の姿をレニは見逃さなかった。慎重に、しかし言いようのない興奮とともに彼らは徒歩で前進していった。

　彼女の回想録にはこう記されている。「雪のように白い灰を肌に塗りつけ、派手なかぶりものを頭につけた数人の裸の男たちに先導されて、肌を白く塗り、白い飾りをつけた男たちが歩いていく。やはり白い肌をして白いパールで飾り立てた少女と女たちが、軽やかに男たちのあとに続いている。彼女たちはろうそくのようにまっすぐな姿勢を保ち、頭の上にかごやひょうたんを乗せていた。間違いない。彼らこそヌバだ」（The Sieve of Time, p.468）

　その晩、ナンゼン隊はレスリング大会という出来事に遭遇する——絶え間ない太鼓の音の中、奇妙な化粧をほどこし、叫び声を上げるヌバの集団が囲んでいたのは2人のレスラーだった。闘いは、敗者が勝者を肩に乗せるという儀式で終わりを告げた。まさしくあのロジャーの写真のように。

　私はレニに、彼女のような高齢の女性が単身、アフリカの辺鄙な土地にいることに恐怖を、きっと私だったら経験したであろう恐怖を感じたことはないかと尋ねた。

　「まったくないわ。この街をひとりで歩くよりもずっと安心感があるぐらい。彼らは本当にすてきな人々なのよ。顔を見ればわかるわ。体から善良さを発散していて、そばにいるとそれを感じられる。怖いと思ったことは一度もないわ。絶対に、そう決して——私がひとりでいるときも——ヌバが私に危害を加えようとしたことはなかったわ。つねに、私を彼らの一員として扱ってくれた」

　1962年12月、ナンゼン隊はヌバの集落のそばにある、レニにとって、世界で最もお気に入りの場所となった大きな木の下にキャンプを張った。彼女は彼らの言葉や習慣を学ぼうと努力した。「我々を囲んでいる黒人たちはとても楽しい人々で、私は退屈する暇がありません」と、母親への手紙にそう書いている。そして、槍を手にしたヌバたちがラジオを囲み、彼らにとって初めての放送——ドイツから届いたクリスマスキャロル——を楽しむ姿を書き送った。

　カドゥグリに立ち寄って以来、若いスーダン人の警察官が、レニが裸の人々を写真に撮らないよう監視するお目付役として探検隊に加わった。イスラム教では、人前での裸は禁じられているからだ。

　「ナンゼン隊といる限り、つねに役人なり警察官が同行していた。だけどそれも1963年までのこと。その後、私が単独で行動するようになってからは、警官がついてきたことはないわ。スーダンの観光局長、アーメド・アブ・バクールが彼らの同行なしでも動けるように特別な許可をくれたから」

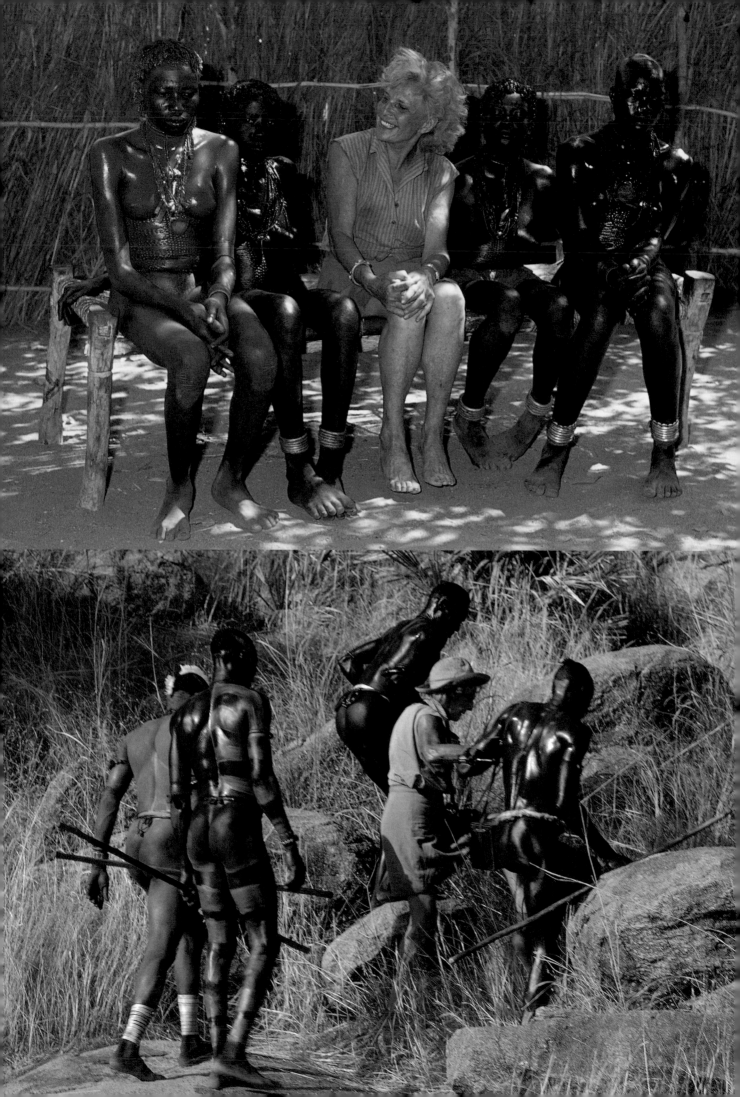

「警官が実際にあなたの撮影を阻止したことはありましたか?」

「あったわ。許可があったにもかかわらずね。私が最後にいた集落にはスーダン人も住んでいたけれど、そこの警官が私を止めようとしたとき、私は激怒し、大声で叫び、この身を地面に投げ出して逆らった。私は断固として彼らに従うことを拒否して、彼らに譲歩するよう迫った。実は、すでに計画を立てていたから。その集落から数百キロ離れた町に立ち寄ったとき、そこの高官に、私はハルトゥームの役所からヌバに滞在する許可をもらっていることを彼の声でテープに録音してもらっていた。そのテープを集落の警察署で聞かせたわけ。私が観光局からの書類を見せて許可証の内容を役人に録音してもらったエロベという州都とハルトゥームの間の距離たるや、500キロもあるのよ。で、最後の集落でそのテープを再生した。彼らは読むことはできないけど、聞くことはできるのだから!」

彼女とヌバとの関係が深まるに従って、悲しいかな、ナンゼン隊との関係は冷めたものになっていった。

「この探検旅行を企画し、私をこの地に連れてきた人々は同時に、彼らの活動に関する映画を私に撮らせることを約束していた。ドイツのお役所向けに科学ドキュメンタリーを撮る予定だったの。探検隊のチーフがルッツ氏で、彼にはカメラマンの息子がいた。本物のプロじゃないわ。アマチュア写真家ね。で、その息子が私の言うことを聞いてくれなかった。私は映画を作らなければいけないのに、カメラマンが撮るべき映像を撮らなかったことになるわね。父親は私にそれを望んでいたけど、息子は違った。それはとても大変な問題だったわ。父親は息子なしではやれなかったから、結果的に、彼は映画を撮らせるという私への約束を守れなかった。私にはお金も物資もなく、完璧にナンゼン隊に従属していたようなものだったから、ほとんど奴隷のような状況に陥ってしまった。息子は私を送り返したいと思っていたけれど、それもまた不可能で、私は親子の間の板挟みになっていた。彼らに依存せざるを得ない状況のなか、私は本当にひどい目に遭ってしまったわ。彼らは私に充分な食べ物もくれなかった。私はいつも空腹で、水さえ与えられないこともあった。文明から遠く離れた茂みの真ん中で、どこにも逃げ場がなかったの。死んでもおかしくないような状況だった。それでも、ナンゼン隊はヌバの集落に拠点を立てていたから、ヌバたちと接触することができた。小屋がいくつかあるだけの小さな集落だったけど。その頃、まだヌバは裸で生活をしていたわ。私たちの他には誰も訪れることのない場所だった」

ナンゼン隊は7週間後にその場所を後にする。移動の手段を持たないレニは彼らに同行せざるを得なかった。しかし、彼女は驚くほどすぐに舞い戻ってくることになる。

「ヌバと過ごした日々は、私の生涯のなかで最も幸福で、最も美しかった。ただ、すばらしいの一言よ。彼らはとても陽気で、1日中笑って過ごしていたし、善良な人々は決して人のものを盗むようなことはしなかった。彼らはいつも幸せで、すべてに満足していた。彼らの生活には極刑は存在しないし、最大の犯罪が羊泥棒だったから、与えられる刑罰も無邪気なもの。一番重い刑罰にしても、犯罪者が最寄りの警察署に出頭して、付近の道路清掃や、そのたぐいの雑用に数日間従事するというものだったわ」

しかし、ヌバのそんな純真さを当局は好ましく思っていなかった。スーダン政府は彼らが裸で動き回ることを禁止し、衣服の着用を命じた。それでも、この命令が彼らの生活を実際に変えるまでには数年の時を要した。

レニは、そもそも写真ではなく映画を撮るためにアフリカにやってきた。しかし、その企画がとん挫した今、彼女が頼るべきは慣れ親しんだライカのカメラだった。

私は、彼女がなぜロジャーの写真のようなモノクロ写真を撮らなかったのかと尋ねた。

「モノクロのフィルムは1、2本しか持っていかなかったの。なぜなら、何よりも色彩こそが美しく、興味深いものだったから。それで、カラー写真の方がモノクロより力強いと思ったけど、それも場合によるわ。カラーはすべてモノクロに焼くこともできるし、それもまた美しいけど、要は趣味の問題ね」

「ライカのカメラを2台持って出かけたけど、途中で1台が壊れたので、最終的にはライカと35mm、50mm、90mmの3種類のレンズが残ったの。マサキン・ヌバの写真はすべてこの3つのレンズで撮ったもので、それが最初の写真集になったわ」

「ライカに露出計はついていましたか?」

「いいえ。最初の頃のライカには露出計はなかった。でも、1台には特注した露出計を付属させていたわ」

「それはレフレックスカメラ?」

「いいえ。レフレックスカメラを使いだしたのはそれから数年後、カウ・ヌバを撮りだした頃からよ。最初の写真集の時は通常のライカ、2冊目になったカウ・ヌバの写真集のときはレフレックス・ライカだけ使ったわ。それが1974年のこと。それからはレフレックス・ライカをずっと使っているの」

「カメラを砂の被害からどうやって守っていましたか?」

「カメラ用のフードを作ったのよ——ひとつはコットンで、もうひとつはプラスチック。カメラのドレスみたいなものね」

「フラッシュは使いますか?」

「そうね。最初の探検旅行のときには持参したフラッシュが壊れてしまったので使えなくなってしまったわ。その後は2つ持っていくようにしたけど、現地の人々に警戒心を与えてしまうから基本的にはあまり使えないわ。あくまでも、チャンスがあったときのためという補足的な使い方ね」

「撮影のときに、ブラケット(訳者註:正しいと推定される露出の上下の露出レベルで追加の写真を撮ること)しましたか? 暗めのものと、明るめと?」

「それはほとんど不可能な話よ。被写体はつねに動いていて、じっとしていることがないから。同じ構図を二度と撮ることはできないの。彼らはだいたい歩き回っているか、立ち去ろうとしているから」

「あなた自身、そしてフィルムの暑さ対策は?」

「最初の何回かの遠征のときは何とかなったの。だけど、ここ最近の2回は耐えられなかった。雨期に入って少し楽になったから滞在をつづけることができたけれど、その後、またひどく暑くなって、水に浸した布をつねに体に巻きつけながら耐えたわ」

「フィルムにとって熱気は大敵。私たちは3メートルの深さの塹壕を掘って、防水シートと土を二重に敷いたところにアルミのケースに入れたフィルムを保管したの。それが驚いたことに効果があったのね。ただの1本もフィルムは駄目にならなかったから」

「発動機は使いましたか?」

「ライカフレックスの時に使ったわ」

「フィルムは何を?」

「ほとんどがコダクロームで、エクタクローム64も少し。様々な感光度を準備したわ」

「時間とともに色あせたものはありましたか?」

「ええ。見せてあげる。通常のコダクロームの場合、色は鮮やかなままだけど、感光度の高いエクタクロームの場合、あせたり紫がかったりしているわね」

「フィルムはどのぐらい持っていきましたか?」

「最初の頃はたいして持っていかなかったから、30、40本ぐらいね。その後は100本とか120本とか。それでも、未使用のまま持ち帰ったものもあるけれど」

「難しい質問ですが、どのようにして決定的瞬間を知るのですか?」

「できるだけ速く行動して——とにかく速く——いい構図をとらえること。私、本当に仕事が早いのよ」

「頭の中で赤信号が灯ることはありますか? それはどんなとき?」

「いいえ。ただ、もちろん何がいい写真になるかということはわかるわ。だからこそ優秀なズームレンズを多用するのよ」

「ズームレンズを使いだしたのはいつ頃ですか?」

「1964年から65年にかけて、二度目の遠征のとき。マサキン・ヌバの写真では使わなかった——その後のカウ・ヌバが初めてね」

「これほどすばらしい才能が一夜にして現れることはありません。自分の写真の才能に気づいたのはいつですか?」

「私が女優として初めて出演した映画監督、アルノルト・ファンクの影響が大きいと思うわ。彼自身、とてもすばらしい写真家だったから。彼が私に撮影の仕方、構図の取り方を教えてくれたの。彼の仕事ぶりを見ながら無意識のうちに吸収していたのね。それで、無意識のうちに写真を始めた。彼と同じように。だから、知らず知らずのうちに彼は私の教師になっていたというわけ」

「ポラロイドを使おうと思ったことは?」

「いくつかの理由からポラロイドを使ったの。第一に、税関の係官に対して有効だったから。各州ごとに税関があって、そこをいかに通過するかが大きな問題だった。そんな時、税関の係官の写真をポラロイドで撮ってあげると、境界線を越える許可がもらえたわ。実際、何か問題が起こりそうなとき、ポラロイドがつねに私の最高の協力者になってくれた。それと、ヌバの人たちが初めて自分たちの姿を見ることができたのもポラロイドのおかげ。とても面白かったのよ。ポラロイド写真を見せたとき、そこに写っていたヌバが別の人に向かって『これはお前だろ!』って言ったの。彼らは自分たちの姿を見たことがなかったから、みなでじっと写真を見つめて、今度はその言われた方のヌバが言った人に向かって、『いや、これはお前だ!』って言うわけ。彼らの生活の中には鏡もなかったから、みながポラロイドを欲しがって、私はその勢いに圧倒されてしまったわ。自分の写真を求めてわめき立てていたもの。それほどポラロイドのストックがなかったから困ってしまって。彼らは本当に興奮していたわね」

「しかし、イスラム教徒にとって裸の人間を撮影することは間違った行為なわけですね?」

「ええ。スーダンではとても重大な過ちだと思われている。ほとんど犯罪に等しいわね。それが、私にとって最大の難関だったわ。私が裸の人々を撮影していることは、スーダン人が知ってはいけないことだったの。最初の遠征のときには、ハルトゥームに写真を送って検閲を受けなければならなかった。このアルバムの中にある、しるしがついた写真が公表を差し止められたものよ。彼らは写真を破壊はしなかったけれど、出版を禁止したの。つねに危ない橋を渡っていたのよ。私は当局にとって危険人物であり、いつだってハルトゥームのブラックリストに載っていた。だけど、ニメイリ大統領が就任して当局に変化が生じたとき——私の写真集はすでに出版されていたけれど——奇跡が起きたのよ。ニメイリが私の写真集を見て『これは芸術だ』と言って、なおかつ私は表彰されるべきだと。たとえ被写体が裸だとしてもね。それで、私はスーダンで最高位の勲章とパスポートをいただいたの」

上ナイル州の総督、オスマン・ナスル・オスマン大佐と出会い、夕食をともにすることになったレニは、これまでの体験を話しながら、彼がヌバたちに対してとても寛容であることに驚いた。オスマン大佐はスーダン北部の出身で、「当時、南北スーダンの間には強い緊張状態にあったからだ」(The Sieve of Time, p.477)。ナンゼン隊との一件があったあとでは、この夕食会はとりわけすばらしいものに思われた。オスマン大佐は、シルク族の王を訪れる旅に同行しないかとレニを誘った。戦士たちの祭りがあるというのだ。

「シルクも非常に興味深い部族で、またとても知的な人々だわ。彼らのなかでも特に優秀な人間はロンドン大学に留学するのよ。彼らを治めていたのがクル王だった。私は王を薬で治療してあげたことがある。そのお礼にとこのワニ皮の盾をもらったのよ。一度、シルクのところに私ひとりで4週間滞在したことがあるわ。部族の長たちが私に付き添って様々な祭礼を見せてくれて、私は彼らの言葉を少し覚えたのよ」

「彼らに比べるとヌバの方がずっと原始的だけど、基本的な部分は同じ。ヌバもシルクも家畜の牛を愛している——マサイ同様、牛は神聖なものとされているの。ヌバはとても貧しいけれど、シルクは彼らほどではない。もしヌバの家族が牛を1頭所有していたとし

て、シルクなら10頭所有している、それぐらいの違いね」

レニはその回想録のなかで、丸々と太った王が激しく、そして敏捷な身のこなしで踊りだし、やがて戦士たちが次々とその踊りの輪に加わっていく様に見とれていたことを記している。「たとえそれが素晴らしく完成された演劇作品でしかなかったとしても、それはきわめて独創的なものだった。足を踏み鳴らす男たちのリズム、そして荒々しい熱狂が恍惚の極みへと高められていく表現様式を見ていると、シルク族は——平和を好むヌバと違って——戦闘的な民族だということがわかる。激しい踊りが男たちの顔を汗で光らせていた。この踊りは王の率いる軍隊と、半神ナヤカングの軍隊との間の戦闘を表すものだ。双方が代わるがわる攻撃や後退を繰り返し、舞い上がる砂塵の中、銀色に輝く槍が光る。振り回される豹の毛皮や華やかなかつらが、ハリウッド映画もかくやと思われる一大スペクタクルを演出していた。観客の叫び声が戦士たちの熱気をさらに高めていくなか、私は最後のフィルムを使いきるまで、無我夢中でカメラのシャッターを押しつづけた」(The Sieve of Time, p.478)。

ヨーロッパ人が考えるところの"野蛮人"は根拠のないものだということがわかった。実際のところ、彼女にとってはいわゆる"野蛮人"の方が、彼女が遭遇した多くの"文明人"よりずっと感じのいい存在だった。

「ある時、南スーダンでドイツ人とイギリス人の2人組に出会って一種の契約を交わしたの。彼らは旧式のおんぼろフォルクスワーゲンに乗っていた。私は彼らを説得して、500キロほど離れたヌバのところまで乗せていってもらうことにしたわ。そのために、なけなしのお金を払うことにしたの」

彼女がヌバに4週間滞在したいと言ったところ、ドイツ人は前金で1500マルクを要求した。

しかし、そのワーゲンが湿地帯で立ち往生したとき、暗闇のなか助けを求めに行かなければならなかったのは彼女だった。原住民との関係において、普通のヨーロッパ人よりもつねに幸運に恵まれる彼女は、そのときも流暢な英語を話すシルク人と遭遇した。車は軍のトラックによって救出され、再びヌバを目指して出発した。ワーゲンがようやく"彼女の"木にたどり着いたとき、すぐさまヌバが彼女を囲んでこう叫んだ。「レニ、レニギラッツォ(レニが戻ってきた!)」

「男たちも女たちも私に抱きつき、子供たちは私の洋服を引っ張った」レニはそう書いている。「彼らの喜びようたるやとても言葉にはできないほどで、私も我を失ってしまいそうに幸せだった。こんな再会を夢見ていたけれど、実際は期待をはるかに上まわっていた」(The Sieve of Time, p.482)

その翌朝、ドイツ人は2日以内に移動すると宣言した。レニは4週間分のお金を払ったのだからと抗議をしたが、ドイツ人の気持ちを動かすことはできなかった。その状況を察したヌバは、彼女の荷物を運び、彼らの小屋のひとつを貸し与えた。そして、彼女は大規模なレスリング大会が開催されることを知らされたのだ。

「レスリングは彼らの人生そのもの。彼らにとって、死の次に重要なことがレスリングなのよ。それは、彼らがまだ赤ん坊の頃から始まる。よちよち歩きができるようになるやいなや、レスリングを始めるのよ」

レニは、ドイツ人には何も言わずにレスリング大会に行くことにした。開催地までの道のりは予想以上に遠く、厳しい暑さのなかで彼女は気を失ってしまう。残りの道中、ヌバの女性が頭の上のカゴにレニを乗せて運ぶはめになった。

そこに繰り広げられていたのは、彼女がこれまでに目撃したものすべてを凌駕する光景だった。撮影しようと人波をかきわけていく彼女の上に、あやうくレスラーが落ちてきそうになったりもした。ヌバが連れていってくれたのは、マサキン・ヌバが誇るレスラーが、身長2メートルを超える大男のトガディンディ地区最強のレスラーと闘おうとしている場所だった。壮大なイベントがクライマックスに達しようとしたそのとき、レニの目にかつての友人、ドイツ人とイギリス人の姿が映った。

「彼らはすぐさま出発すると言ったけれど、私の荷物はレスリング会場ではなく別の場所にあるのだからすぐには行けないと言ったの」

ヌバが、彼女をとどまらせようと懇願したにもかかわらず、彼女はその場を離れな

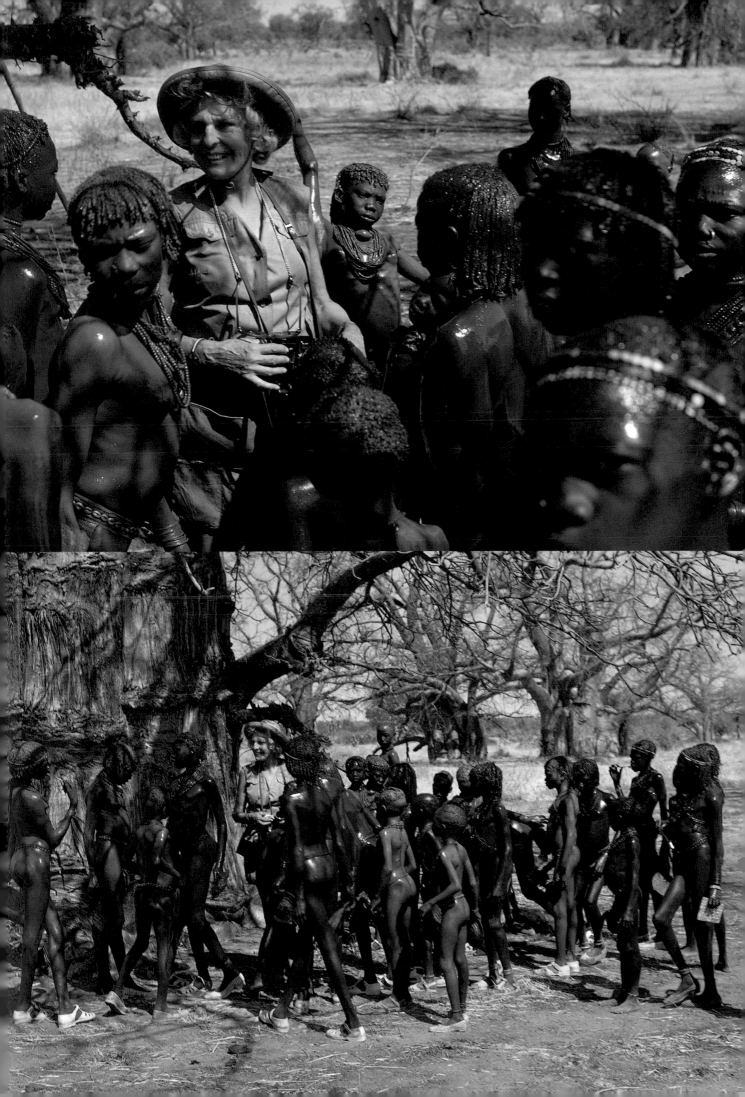

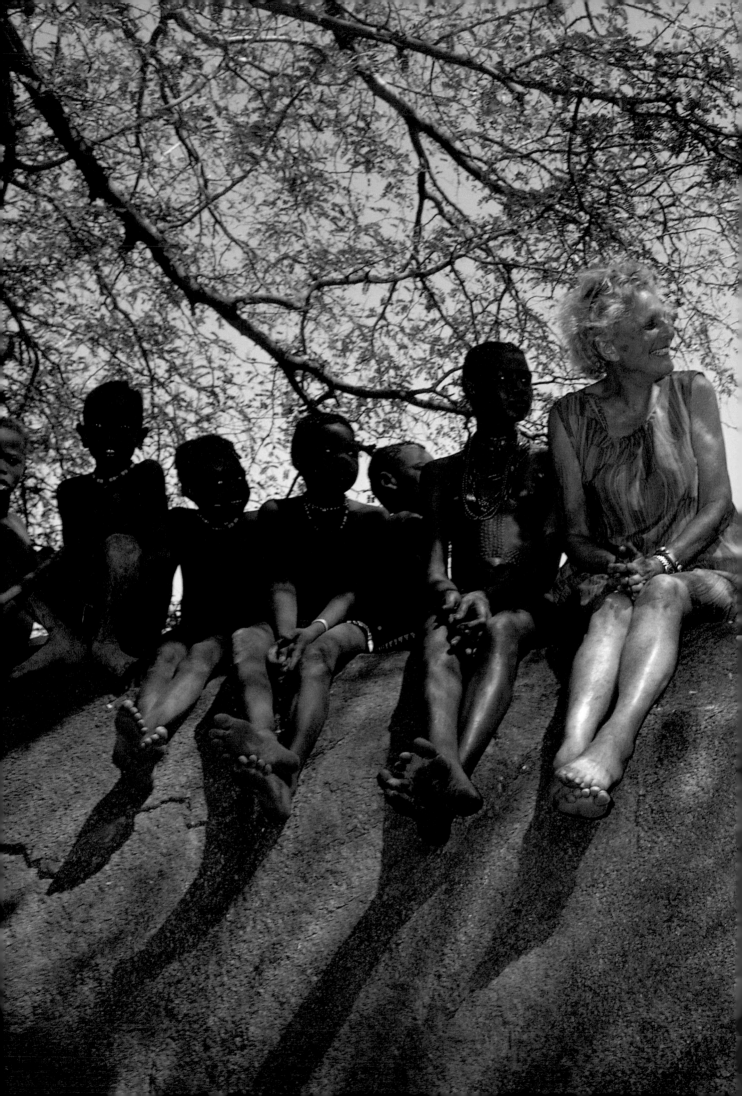

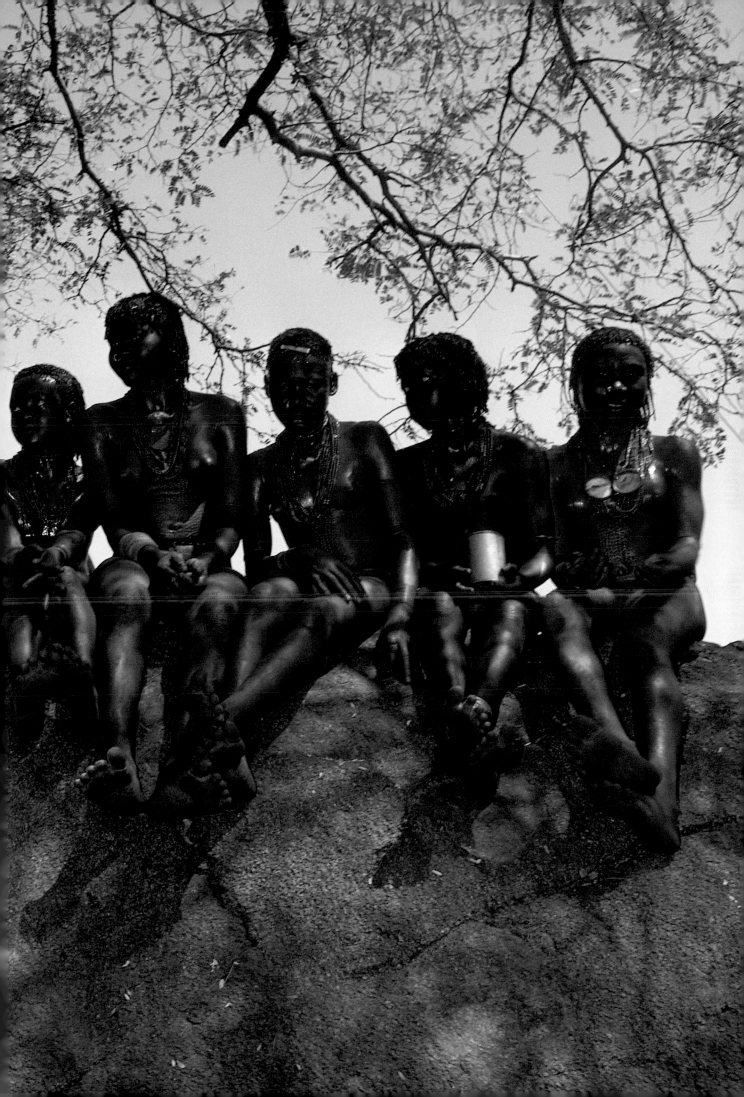

けれBならなかった。悔しさに泣きながら、彼女は車に乗り込んだ。しかし、キャンプ地に戻って初めてドイツ人は明日にならないと出発できないことを伝えてきた。レスリングを見ていても問題はなかったのだ。その晩、ヌバたちが帰ってきた。彼女にお別れを言うために、大会を途中でやめて戻ってきたのだった。しかし、あっけなく出発のときはやってきた。

「ドイツ人とイギリス人が私を無理やり連れていこうとしたの。ヌバが走り寄ってきて、私の手をつかむと何度もさようならを言ったわ。彼らは私にこの場所に残ってほしいと思っていた。行かせまいとしていたの。私の家を建てる場所も決めたというのよ。私だってどれほど残りたかったか。このまま永遠にあの場所にいたいと思っていた」

ヌバたちが、フォルクスワーゲンに並んで走りながら叫んでいた。「レニ・バッソ」。もちろん、彼女は自分がまたこの地に戻ることを知っていた。一方で、彼女には新たな冒険が待っていた。彼女がバハル・アル・ガザール州の州都ワウにいることを知ったオスマン大佐が、上ナイル州をめぐる視察旅行に誘ったのだ。

「総督は私をエチオピアとの国境への旅に連れていってくれた。彼のお供はかなりの大所帯で、40人の兵士や将校たちが一緒だったわ。彼はそこに私を同行したの」

「ナイルの向こう側で、私は二度と訪ねることがないであろう部族の、とても貴重な写真を撮ることができたわ。ブマ高原という、そこに至る道がないため、まず普通の人間が行くことはないという場所にも行って——そこには唇や耳に大きな輪をつけた、とても珍しい部族が住んでいたのよ」

やがて、総督は先に戻ることになった。ひとり残ったレニが別のトラックに乗ったそのとき、道路の脇を歩いていく3人のディンカ族の戦士に気づいた。

「ディンカはとてもシルク族に似ている。さらに高貴な存在と言ってもいいわね。すべての部族のなかで最も高貴な人々。優れた戦士であり、とても裕福でたくさんの牛を所有している。もし、スーダン南部を誰かが統治するとしたら、ディンカ以外には考えられない。でも、許可なしに彼らを撮影することはとても危険な行為だったわ」

彼女は運転手に車を止めるように言った。ライカを手にしてディンカたちに近づくと、一番背の高い男が金をくれと言うように手を差し出した。彼女はうなずいたが、嫌な予感がしていた通り、バッグの中には現金の代わりに小切手しか入ってないことに撮影が終わってから気づいた。ディンカは怒り、彼女のバッグをひったくった。

「私はバッグからこぼれ落ちたものをかき集めようとした。そこに、鏡のついたコンパクトがあった。これならいいかもしれない。鏡に太陽の光が反射して、きらりと光った——私が投げたコンパクトはディンカの頭上を越えて草むらの中に落ちた。彼らがそれを取りに走り——私が覚えているのは、とにかく運転手が慌てて車を発進させたこと——その後、槍を振りかざしながら私たちを追いかけてきた。唯一、私が身の危険を感じた瞬間だった。しかし、悪いのは私なのだ」（The Sieve of Time, p.492）

「日記はつけていましたか？」

「日記と言えるかどうか。小さなノートに、さらに小さな字で書きつけていたけど。読むには虫眼鏡がいるわ」

1963年5月、レニは30年以上東アフリカに滞在する老紳士、エルンスト・フォン・イーゼンブルグ公に同行してマサイ族を訪ねる旅にでた。その大胆不敵さで名高いマサイは、イギリス軍と彼らのガトリング銃に出会うまでは無敵を誇っていた。降伏した後も、イギリスの最高権力者であるヴィクトリア女王に直接会うまでは、平和条約に調印しなかったという人々だ。

「マサイは本当に興味深い被写体——外見や衣装——だわ。でも、私がスーダンで撮った写真のほとんどは、人が決して行かない場所のものだからこそ貴重だと言えるけど、マサイに関してはすでに多くの作品が出回っているからあまり価値はないわね」

レニは、ヌバとマサイの違いにも興味をひかれていた。ヌバは女性に対して敬意をもって接していたが、マサイにとって、女は牛よりも価値のないものだった。

「それでも、時に警戒心を解くような優しさを見せたり、彼らの戦闘の儀式を演じてくれたりもした」（The Sieve of Time, p.496）

レニがミュンヘンの自宅に戻ったとき、彼女の姿を見た母親は恐怖のあまり叫び声を上げた。彼女は別に病気をしたわけでもなく、むしろとても体調が良かったぐらいだが、髪は太陽に灼かれてひどく傷んでいたし、がりがりに痩せてしまっていた。しかし、彼女の気がかりはアフリカから送ったフィルムの行方だった。

「私はそれをウリという名の若い学生に託し、母に渡してくれるよう言ってあったの。ところが彼はそれをすべて露光させて駄目にしてしまった。ひとつ残らずね。二度と同じものを撮ることはできないのに」

打ちのめされたレニは一睡もできず、何も喉を通らなくなってしまった。彼女はだいなしになったフィルムを刑事に見せた。結局、なぜだかわからないが、ウリが真っ昼間に現像前のフィルムをケースから出したために、光が入ってだめになったのだ。警察は彼の自宅から4本の未現像フィルムを押収したが、現像したところ、それらについては何の問題もないことがわかった——そこにはディンカの姿が写っていた。さらに幸いなことに、最初に発送した、ヌバを撮影した90本のフィルムは無事だったことがわかった。彼女はその写真をドイツの『シュテルン』誌、『ブンテ』誌、そして『クイック』誌に持ち込んだが、おそらくは彼女の第三帝国時代の映画監督としての経歴が災いしたのだろう、すべて掲載を断られた。唯一、彼女の写真に驚嘆したアクセル・シュプリンガー社の『クリスタル』誌の編集者のみが出版を決め、3号に分けて掲載した。レニはまた、ヌバの写真をスライドにして講演会ツアーを行ったが、それは行く先々で絶賛された。

不運はどこまでも容赦なくレニにつきまとっていたが、彼女はエネルギーと勇気をもってそれを乗り越えてきた。そして、不運のあとに思いがけない幸運が訪れることもしばしばだった。

スーダンで革命が勃発した。しかし、旧友アーメド・アブ・バクールが、彼女のためにヌバ山地での映画撮影の許可を取ってくれた。「ヌバの歓迎ぶりは——もしそんなことが可能なら——前回よりもさらに喜びにあふれたものだった」。彼女はそう回想録に書いている（The Sieve of Time, p.512）。何もかも変わっていなかった。ヌバは世界で最も幸福な人々に思えた。

しかし、そんな理想的な状況は長くつづかなかった。1965年1月、レニの母親が亡くなったのだ。彼女はすぐさまミュンヘンに帰ろうとしたが、その旅は4日間かかった。彼女の到着は2日遅かった——母親はすでに埋葬されていた。「この悲しみから逃れる術は、なるべく早くヌバ山地に戻ることしかなかった」（The Sieve of Time, p.513）映画の撮影が目的だった彼女は、今回の旅にドイツ人カメラマン、ゲルハルト・フロムを同行した。しかしまたしても、忌まわしい不運がその影をおとそうとしていた。

「レスリング大会で、試合に近づきすぎた私とライカの上に2人のレスラーが落ちてきて、肋骨を2本折ってしまったのよ」レニが笑いながら思い出を語る。カドゥグリの小さな病院に運ばれた彼女は包帯を巻かれて戻ってきた。その後、彼女とフロムは成年式と刺青の儀式を撮ることができたが、やがて戦闘拡大のニュースが入ってきた。

「ヌバにいたとき、大きな革命の前兆を経験したわ。各地の戦闘の噂が入ってきて、それで私たちは隣村に車を走らせたの——いえ、村とは言えない、集落ね——家々が燃えていると聞いたから。実際その場に着いたとき、確かに家は燃えていたし、銃撃戦の跡も見られたけど、敵の姿はなかった。何かいやなことが起ころうとしていた。夜になると、ヌバがやってきて内戦が起こっているらしい南部の方まで連れていってほしいと言ってきたの。当時、私は単独行動をしていたので、ランドローバーに乗って出かけることにした。道中、人々がみな私の車に飛び乗ろうとするので、ドライブは楽なものではなかったけど。彼らがずっとステップの上に乗っているものだから、最後には車が動かなくなって、先に進むのをあきらめるしかなかった。私は車を置いて、ベースキャンプまで数時間かけて歩いて帰ったわ」

その頃、ヌバにとっては凶悪といわれる犯罪が起きていた。レスラーたちが2匹の羊を盗み、その肉を食べる宴会を催したのだ。ヌバの法律では、羊泥棒のみならず、その羊肉を口にした者も同様の罪に問われるため、精鋭レスラーたちが全員刑務所に拘留されるという事態となった。撮影は中止だった。「その悲しい別れは、私がヌバとともに経験したなかで最もつらい出来事だった」（The Sieve of Time, p.519）

さらに追い打ちをかけるように、レニのアシスタントのひとりが撮影済みのフィルム16本を盗んで父親に送っていたことが判明した。映画フィルムの最初のテストプリント——コダクローム（25ASA）とエクタクロームER（64ASA）——は完璧な出来だった。しかし、そ

の後、レニは大惨事に直面することになる。現像所のガイヤーが高感度のエクタクローム を誤って現像し、すべてをだいなしにしてしまったのだ。「今でも、そのときの気持ちを表現 する言葉を見つけることができない。私は自分のキャリアをとり戻す最後のチャンスを 失ったのだ」(The Sieve of Time, p.523)。彼女は、アメリカの出資者との契約をキャ ンセルし、友人たちの支援を受けて映画製作費を返済しなければならなかった。

　この事件直後の1966年に、ロンドンのBBCを訪ねていたレニと私は初めて出 会った。彼女はブラックヒースにあるフィリップ・ジェンキンソンのアパートにやってきて、生き 残ったヌバの16mmフィルムを上映してくれたのだ。フロムが撮影した映像は丁寧でよく できたものだったが、その後にヌバのスチール写真のスライドショーが始まったとき、同じ被 写体を撮っていても、例外なくレニの写真の方がずっと印象的だったことを覚えている。 多くの写真は信じられないほどすばらしいものだった。スライドは連続したシークエンスに 編集されていて、彼女の映画作品を彷彿とさせた。

　「私が映像作家だってことがわかるでしょ?」彼女が言った。

　部族民たちの集合シーン、ユトリロの絵のような構図をもった槍の形、力強いク ローズアップ、肉体の美しさに魅せられたレニの視線が表現された全身ショット、躍動感 あふれるレスリングの試合……。我々はそれらすべてに驚嘆させられた。彼女が描こうと した純真さ、そして文明以前の楽園は、ヌバ族の男性や女性のクローズアップがとらえ られた時に最もその効果を発揮していた。彼女のカメラがとらえた静謐な瞬間が私たちの 心を打った。

　「写真だって芸術たりえるのよ」。我々のような映像作家たちの中に存在する密か な偏見に気づいた彼女が言った。「スチール写真の方が、長い間見ていられるから好き なの」

　我々はみなそれをとても名誉なことに思ったものだ。

　1966年の末、ごく短い間だったが、レニはスーダンに戻っていた。ヌバから恒例と なった熱狂的な歓迎を受けたあと、彼女はその日がクリスマスであることに気づいた。

　「私は白い紙で羽を作り、天使がどんなものかを説明したわ。キャンドルを灯して クリスマスの雰囲気を再現してみた。そして、ヌバへのプレゼントとして、ささやかなクリス マスパーティを開いたの。彼らはクリスマスなんて知らなかったから。小屋の中に灯した キャンドルが、ヌバにとっては生まれて初めて見るものだったのね」

　レニは声を録音したカセットテープを近郊の学校教師のところに送ることで、ヌバ と連絡をとりつづけていた。同時に、彼女は彼らの水源問題を解決しようと、水脈掘りの 資金を送付していた。

　すでに、すべてをひとりで行うのは限界だということが彼女にもわかっていた。理想 は映画の撮影ができて、なおかつエンジニアの能力もある人。そして、信じられないこと に彼女はうってつけの人間を見つけたのだ。ホルスト・ケットナーは背の高い青年で、「最 初に彼の顔を見たときから、彼なら信頼できると思わせてくれた」(The Sieve of Time, p.548)そして、彼は実際にその能力を証明した。一言も英語が話せないにもかかわら ずイギリスに出かけていき、工場がストライキ中にもかかわらずランドローバーを調達し、 休むことなくロンドンからミュンヘンまで運転したのだ。

　「私自身は映像を撮らなかった。写真だけ。ホルストがアリフレックスの16mmカメ ラで撮影してくれたの。本当に、彼には何かと助けられたわ。特に車が壊れたときね。タイ ヤ交換は私にはつらい仕事だから。それに何よりも、美しいものを共有できる人がそば にいること、一緒に見て体験できる友人がいてくれるのが、とてもすてきなことだった。たと え誰かが私の話を信じなかったとしても、今度は証人がいるのよ。彼のヌバに対する想 いは私と同じだった」

　彼女の回想録に鮮明に記録された、ほとんど克服できないのではと思われた 数々の困難を乗り越えたレニは、再びその地を踏むことが叶った"彼女の"ヌバで、信じ られないような歓迎を受けた。彼らは彼女の家を建てていたのだ。

　「ヌバの家というのは壁つづきの6軒の家から構成されているの」

　しかし、彼女はそこで目にした変化に愕然とした。

　「5年の不在の後に出会ったヌバたちはボロ布を身にまとっていました。強制され たのよ。スーダン政府が彼らに衣服を持ってきたの。もはや裸で歩き回ることは出来な くなっていたの。そして、それがすべてを変えてしまった」

　ヌバの置かれた窮状のなかでも早急に何とかしなければならないのが水不足 だった。レニは彼らを助けようとした。

　「占い杖を持って水脈を探る人にまで相談してみたわ。水脈を見つけて井戸を掘 る資金を得るためにありとあらゆることを試みたけど駄目だった。そこに、アフリカを旅行 していたハーバード出身のアメリカ人の友人が現れて、私は彼を説得してハルトゥームで 大きな斧とショベルを調達してもらったの。彼の名はガードナーといって、その後、彼自身、 映画を作ることになるんだけど。彼が買った道具はまた別の友人の観光局長に預けて もらうことにして、局長がそれを何とかしてヌバに届ける算段をしてくれることになったの。 時折、アラブの商人たちが塩を売るためにヌバに来ていたから。それ自体はうまくいった の。ヌバのなかでも特に親しくしていた数人に水脈掘りの仕事をしてもらったけれど、結果 的に見つからなかったときに彼らがどうしたかというと、掘った穴を木の枝と土で埋めた の。そしてある日、ひとりの少年がそこに落ちてしまったのよ。土の壁が平らすぎて這い上 がれないし、ヌバたちもなす術なく周囲に立ち尽くしているだけだった。穴の中に呼び かけても、返事も返ってこなくなってしまった。そこで、私は車からザイルを持ってこさせて 一方の端をホルストに預け、残りをクライマーのように自分の体に巻きつけて穴に降りて、 少年を連れだしたわ。顔面蒼白になっていた少年の父親が息子を何度か叩いたものだ から、それに激怒した私も父親を叩き返してやったわ。少年は背中を痛めていたけれど、 ホルストが処置をして元気になってくれた」

　レスリングを撮影しようとしたホルストとレニは、レスラーたちでさえズボンを履き、プ ラスチックのボトルを携帯していることに気づいた。ホルストの説得にもかかわらず、彼らは 服を脱ごうとはしなかった。今や、男たちは恥ずかしがっていたのだ。儀式はあまりにもそ の様相を変えていて、もはや撮影する価値はなかった。さらに驚いたことに、レニは、ヌバ が盗みを始めたということを聞かされたのだ。「何がこのような変化をもたらしたのか?」 彼女は書いている。「観光客のせいではないだろう。あるイギリス人スチュワーデスと その父親が一度ここまでたどり着いたことを除けば、私以外に部外者が入ってきたことはない のだ」(The Sieve of Time, p.557)。幾たびかか訪れた凶作が、若者たちを仕事のために 町へと向かわせた。彼らは、洋服と性病と金を持って戻ってきたのだった。

　「最初の硬貨、通貨は何であれ、金というものの最初の一片が手に入った瞬間 にヌバの性格は変わってしまったわ。その瞬間から、彼らは市場でものを買うことができる ようになった。ヌバは綿を栽培していたから、それを市場で売った人はその金で別のもの を買うことができる。そうすると、他の人もお金を欲しがるようになる。それまで、彼らの間 に差異はなかった。貨幣が導入されるまで、彼らはみな平等だった。でも、金が入り込ん できてからは、ある人間が別の人間よりも多くを所有するようになり、突然、それまで存在 しなかった何かが頭をもたげてくる。ある種の競争意識や妬みといったものが。それが、 彼らを変えてしまったわ」

　レニは、ネイティブ・アメリカンやオーストラリアのアボリジニを打ちのめした大変動 がヌバさえも破壊してしまうことを恐れていた。彼女は書いている。「文明の闇が蔓延す るときはいつも、人間らしい幸福が消滅してしまうのだ」(The Sieve of Time, p.558)

　1969年12月、ドイツでは、彼女のヌバの写真が『シュテルン』誌に掲載され、その 後、ドイツ(1973年)、アメリカ(1974年)、そしてフランス(1976年)で立派な写真集となって 出版された。彼女がその本を持って再びヌバを訪ねたとき、彼女の楽園は完全に破壊さ れてしまっていた。もちろん、ヌバの歓待はいつにも増して愛情にあふれ、古い友人たちは 変わることがなかったが、それ以外の者は彼女につきまとい、薬やタバコ、ビーズに電池、サ ングラスをねだってきたのだ。そして、彼らはみな汚らしい、ボロボロの服を身にまとい、「ヨー ロッパのスラムにいる物乞いよりもひどい格好をしていた」(The Sieve of Time, p.588)

　「私が彼らに写真集を、服を着ていなかった頃はどんな様子だったかを見せたと き、彼らが自分たちの裸の姿を恥じていることがわかったの。それは悪いことだと教え込 まれてしまったのね」

　この探検旅行の際、ホルストはレニの気が違ってしまったのかと思った。彼女はよ り奥地に住んでいるカウと呼ばれるヌバを探す決意をしたのだ。ガソリンは底をつきかけ ていて、目指す場所の地図も存在しないにもかかわらず、彼らは探索を強行した。猛暑 の中の苦しい旅は、しかし、「これまで目にしたこともないような、刺激的で印象的な光景」

71

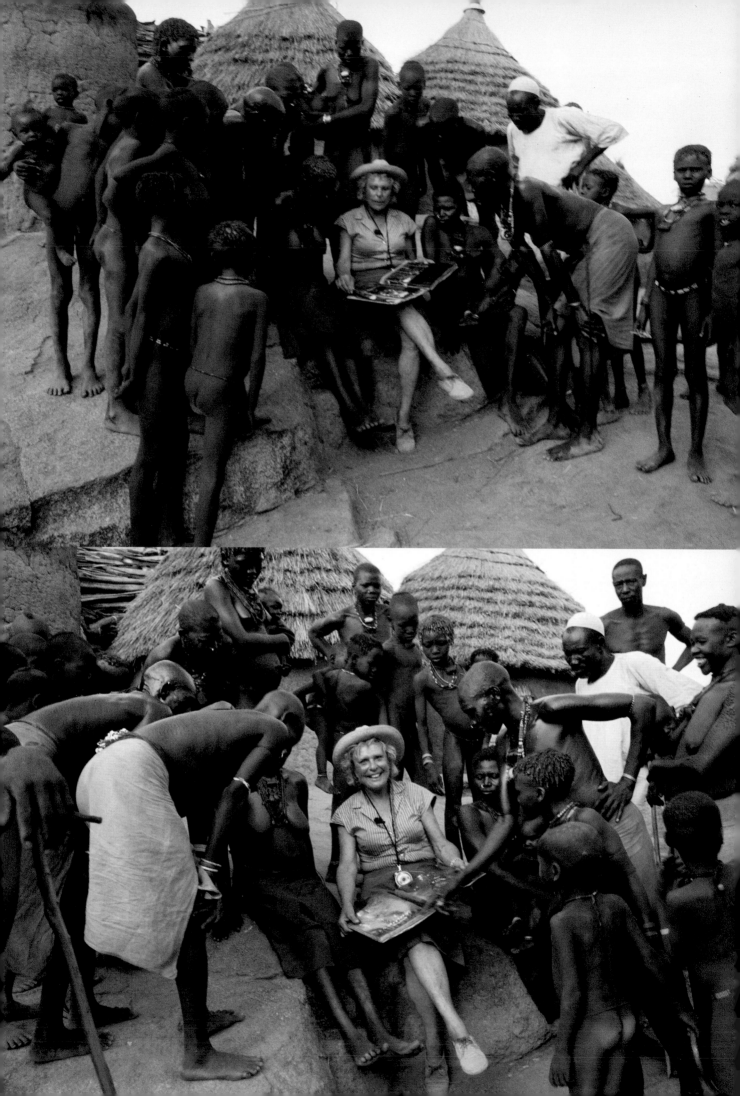

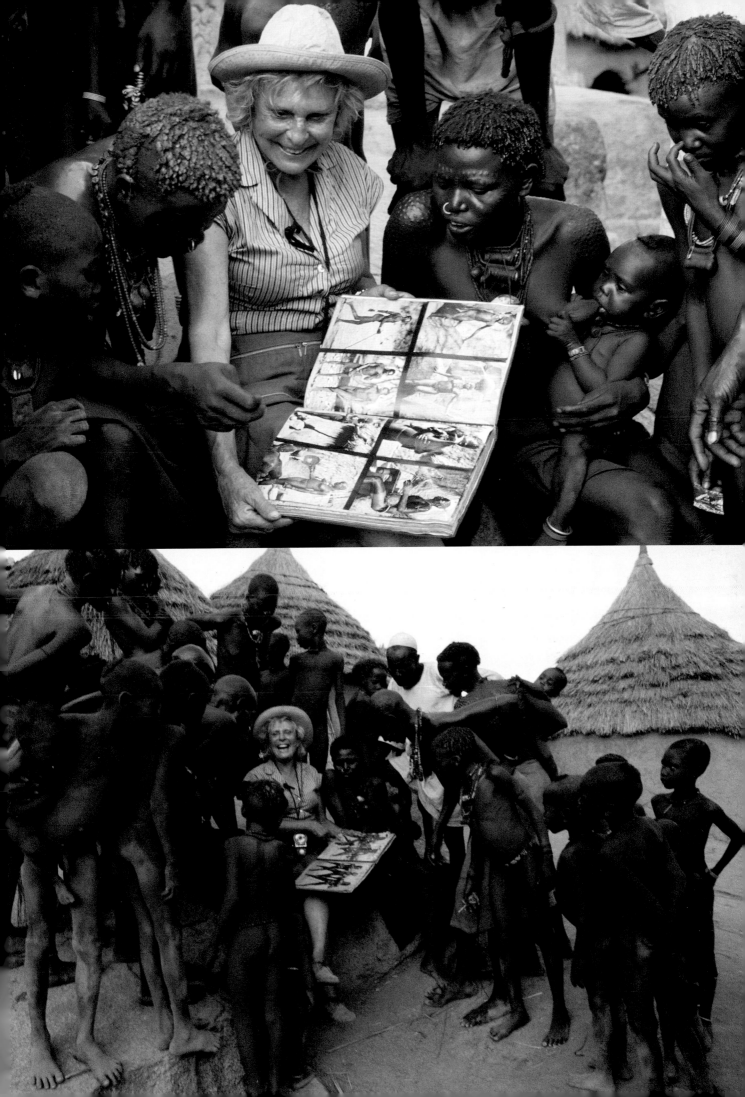

（The Sieve of Time, p.591）に出会うことで報われることになる。

「沈みゆく太陽の光の中で」と、レニが記している。「太鼓の音に合わせて、ほっそりとした体がバレリーナのような優雅さで踊っていた。少女たちは一糸まとわぬ姿で、全身に様々な色の——赤や黄土色や黄色——油を塗っていた。その動きは挑発的で、激しさを増すばかりだった。踊り手たちは、木の陰に隠れて望遠レンズを使って撮影していた私の存在には気づいていなかった。それは、私にとって、これまでのアフリカ冒険旅行の中でも最もすばらしい視覚体験だった」（The Sieve of Time, p.591）

彼らはまた"ズアル"と呼ばれるナイフを使った試合の撮影にも成功した。そもそもこの儀式を見たいという願いが、レニがカウを探そうと思い立った理由だったのだ。

「カウは、レスリングの代わりに腕にナイフをつけた闘いを行っていたわ。それを撮影した人間はそれまでいなかった。それに、世界中で彼ら以外に真鍮製の刃物をつけて闘う部族はいないのよ。世界でも類をみない儀式だわ。写真家の私にとって、それはまさしくセンセーショナルなものだった。そして、彼らは世界中の誰よりも仮面を描く才能を持った人々なの。ニューギニアの原住民の仮面は彼らに比べたらずっと素朴なものだけど、カウ・ヌバは本物のアーティストよ。彼らの仮面はアートなの」

彼女は隣村のニャロでも仮面を発見する。「若者の体には豹を彷彿とさせるすばらしい模様が描かれ、顔はまるでピカソのようだった。驚いたことに、彼は、私が彼の姿を写真に撮ることを許してくれた。やがて、並はずれた模様を持っているのは彼だけではないことに気づいた。様式美にあふれた仮面のような顔をした青年たちがあちらこちらから現れて、こちらに向かって歩いてきた」（The Sieve of Time, p.593）

「写真を撮らせてくれないということはありませんでしたか？」

「マサキン・ヌバの場合は絶対になかった。第一、彼らは私の友人だったし。マサキンとカウの間には大きな違いがあるの。カウ・ヌバには撮影を断られることもあった。彼らとの作業はとても困難なものだったわ。私は基本的に自分が見たものは撮影したけれど、すべてが禁じられていると考えた方がいい。カウでは何もかもが闘いだった」

1974年に決行されたスーダンへの再訪は、さらにひどい失望をもたらした。レスラーたちはショートパンツやアラブ服を身につけていた。カウの集落にはほとんど人気がなくさびれていた。キャンプ地では、レニとホルストはガスボンベの爆発——レニの服に火がついた——に対処しなければならなかったし、その1時間後には、レニが木の枝に頭をぶつけてけがをした。ホルストが彼女の傷の手当をしていたときだった。大勢の観光客を乗せた2台のバスが到着したのは、2人を落胆させるのにこれ以上のお膳立てはなかっただろう。観光客そのものは、感じのいいドイツ人のツアー客で、レニの居場所を軽率な役人から聞いたとのことだった。しかし、彼らも、体に模様を施したヌバの姿が見えないことに気づくと、翌日には出発してしまった。

その後、ヌバが観光客からもらった紙幣を差し出し、やがて写真撮影に対する支払いを期待するようになった。かつてはまったく毒されていなかった部族の人々が現金を積むようになったら、写真家にできるのは荷物をまとめてその場を去ることだけだ、とレニは言った。

「撮影料を払ったことはないわけですね？」

「最初にそれをやっていたら、私はあの場所で仕事をつづけることはできないでしょう。ひとりにあげたら、何百人というヌバすべてがお金を欲しがるようになっただろうから。すでに、お土産に持っていったガラスのビーズでも大きな問題が生じていたのよ。みながビーズを欲しがって狂ったようになってしまったから、持っていくのをやめたぐらい。何かものをあげたら、みながそれを欲するようになる。それが悩ましい問題なの。私やホルストが彼らのためにできた最高のことは、毎晩2、3時間を費やして病気の治療をしたことぐらい。夜になって、撮影ができない時間帯になると、私たちのテントの前に、足にけがをしていたり、肺炎を患っていたりした人たちが行列を作ったわ。私たちは、現地の医者が用意してくれた、ちゃんとした薬箱を持っていたのよ」

レニとホルストはまた、スライドプロジェクターを準備して、前の年に撮った写真のスライドショーを行った。これはすさまじい興奮をもたらした。「写真を見たときのヌバの反応たるや、とても言葉にはできない。ヌバには、ほんのシルエット程度でも誰が誰だか完璧にわかるようだった」（The Sieve of Time, p.614）

「最初に見せた、赤ん坊を抱いた若いカウの母親のスライドは、大きな笑い声とともに迎えられたわ。笑い声は、赤ん坊の顔がクローズアップになったとき、さらに高まったの。人間の顔がスクリーンに映っているような大きさになるということは、ヌバの理解を超えていたのよ」

この一件で、ヌバは彼らに対する警戒心を解いたようだった。それ以後、特に華やかな模様を体に施した青年たちがこぞってレニのキャンプ地に現れては自らを誇示するようになった。

ミュンヘンに戻ったレニはすでに72歳を超えていたが——同年代のほとんどは老人ホームでおとなしくしている年齢だ——さすがに肉体の衰えを感じずにはいられなかった。しかし、ヌバで撮った写真とホルストのフィルムのすばらしい仕上がりのおかげで、病気のことは忘れてしまった。『シュテルン』と『サンデー・タイムズ』がカウの写真を掲載し、それは世界中に発信された。1975年、ドイツ・アート・ディレクターズ・クラブは写真におけるレニの業績を評価し、金メダルを授与した。相変わらず彼女を誹謗中傷する記事も少なくなかったが、彼女の写真に対する一般的な反応は——それを見る機会のあったすべての国で——とても熱狂的なものだった。彼女はとある雑誌の依頼で再び彼の地に戻ることになり、ハルトゥームでは、ニメイリ大統領から勲章を授与された。大統領は彼女の2冊の写真集を、その形式も内容も、イスラム教徒でさえ裸のヌバを見て不快になることのないすばらしいものだと絶賛した。スーダン政府は写真集を数百部買い取って、各国大使館にクリスマス・プレゼントとして贈った。

ヌバに起こった変化は観光事業がもたらしたというよりは——マサキン・ヌバの場合、変化は最初の観光客が到達する以前に生じている——アラブ化と、やがて勃発した戦争のせいだろう。2000年、レニとホルストが再会のためにヌバを訪れた頃には、事実上、彼らの古い友人たちは誰も残っていなかった。その旅行の本来の目的はヌバのために資金を調達することと、長く続いたスーダンの内戦の後に彼らがどのように暮らしているかを確認するためだった。

「到着してたったの5時間で警察がやってきて、私たちはその場を立ち去らなければなりませんでした。バヴァリア・フィルム・スタジオがその5年前の旅行を撮影して、長編ドキュメンタリー映画として公開する予定になっているけれど、そのとき起こったことはすべて映画の中にあるわ。カメラマンはヘリコプターの墜落で大けがをした。そう、私たちが乗ったヘリコプターが墜落したのよ」

「通常、ヘリコプターが墜落して、けがひとつしないなんてことはないはずだ。あなたはどうしました？」

「肋骨を何本か折ったわ。肺も傷めて、とてもつらい状態だった。事故が起きてすぐ、私は救援機でドイツまで運ばれて、3週間入院していたの」

「どんな映画を撮ろうとしていたのですか？」

「ヌバとの再会を。とても長い時を経ての再会をね」

「たくさんの人と再会できましたか？」

「いいえ。あまり多くの人には会えなかったわ。ずっと内戦下にあって、ほとんどの人が死んでしまっていた。私たちがあの場にいたのはたったの24時間なの。あまり話す時間はなかったし、そもそも3、4人の友人しか残っていなかったわ」

レニ・リーフェンシュタールは21世紀から石器時代へと旅をした。彼女は、人々が自然と完璧な調和のもとに暮らしている姿を見た。そして、彼女は、文明の"悪疫"が彼らに何をしたのかも目撃した。しかしながら、文明の偉大なる恩恵のひとつに写真の存在があり、永遠に焼きつけられた瞬間がある。

（ケヴィン・ブラウンロウ、2002年5月）
レニ・リーフェンシュタールのインタビューは、2002年5月2日、ドイツ、ペキングにてロンドン在住のケヴィン・ブラウンロウによって行われた。通訳はクラウス・オッフェルマン（ミュンヘン）。引用文は『Leni Riefenstahl's Memoirs（TASCHEN、ケルン、2000年）』のドイツ語原版から再翻訳したものである。参照ページ数はドイツ語版を参看。

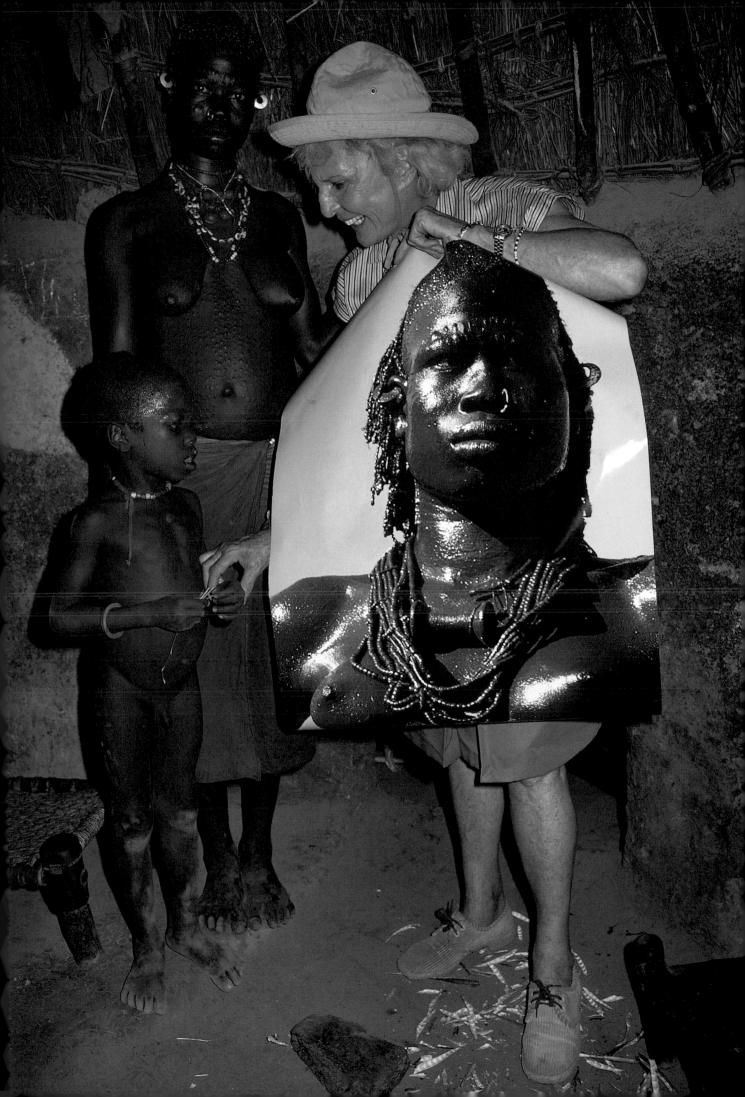

The Mesakin Quissayr

Die Masakin-Qisar
Les Masakin-Qisar
マサキン・キサイール

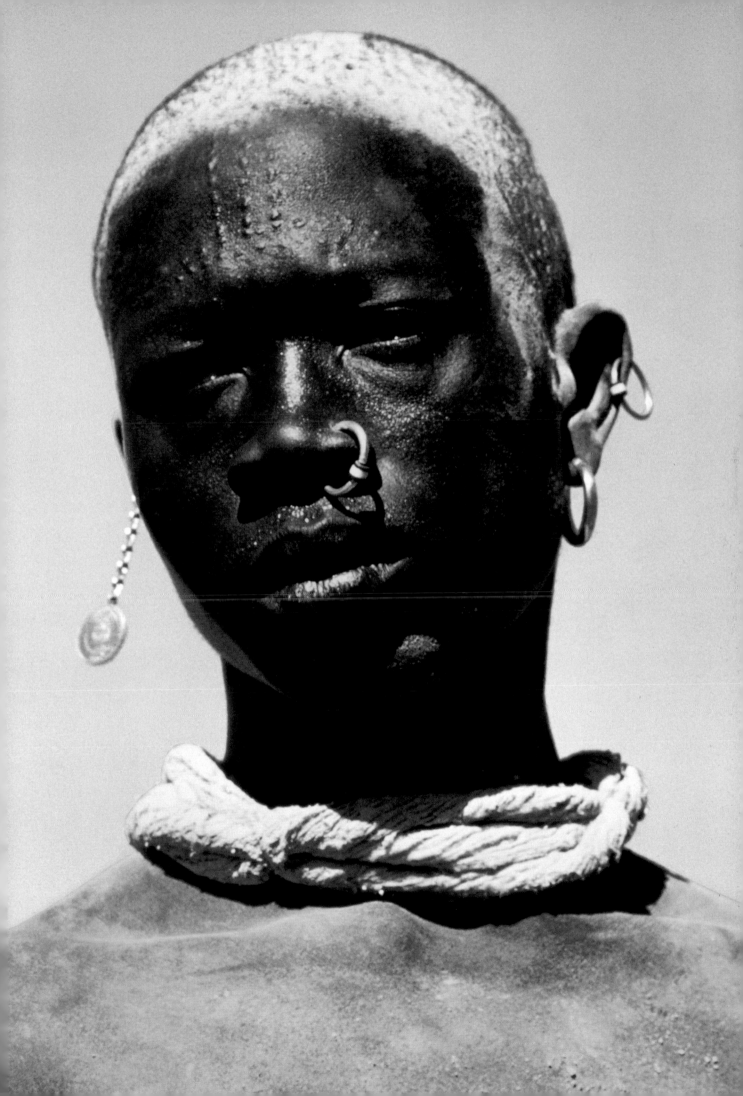

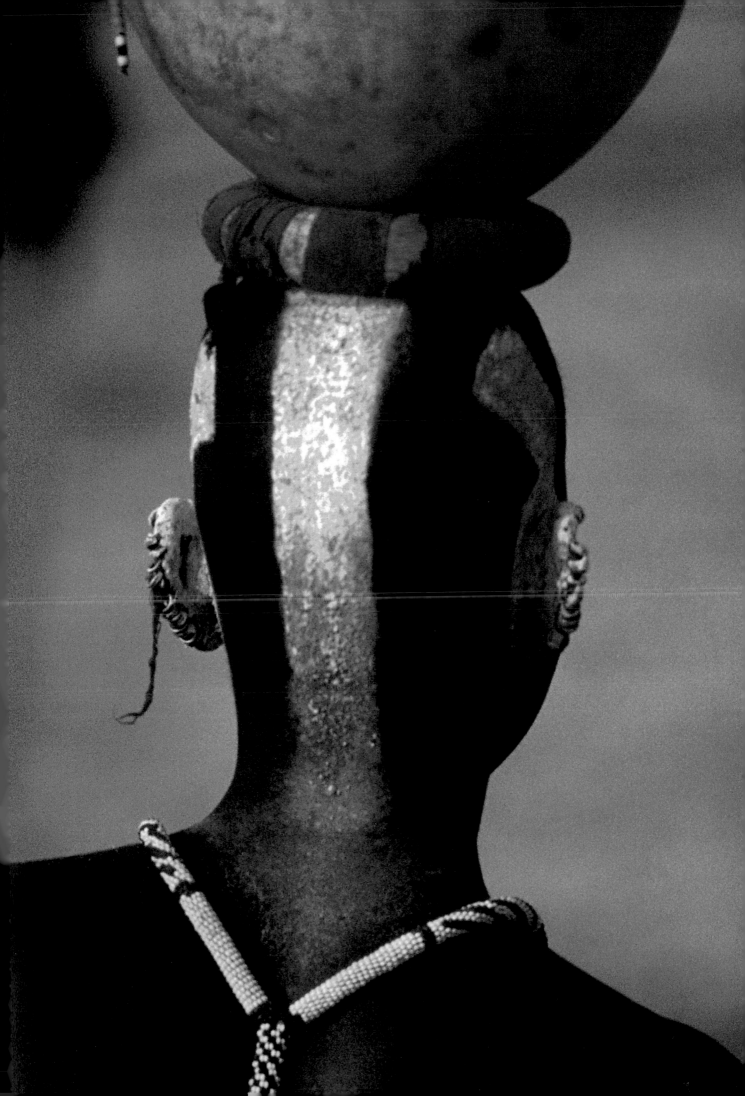

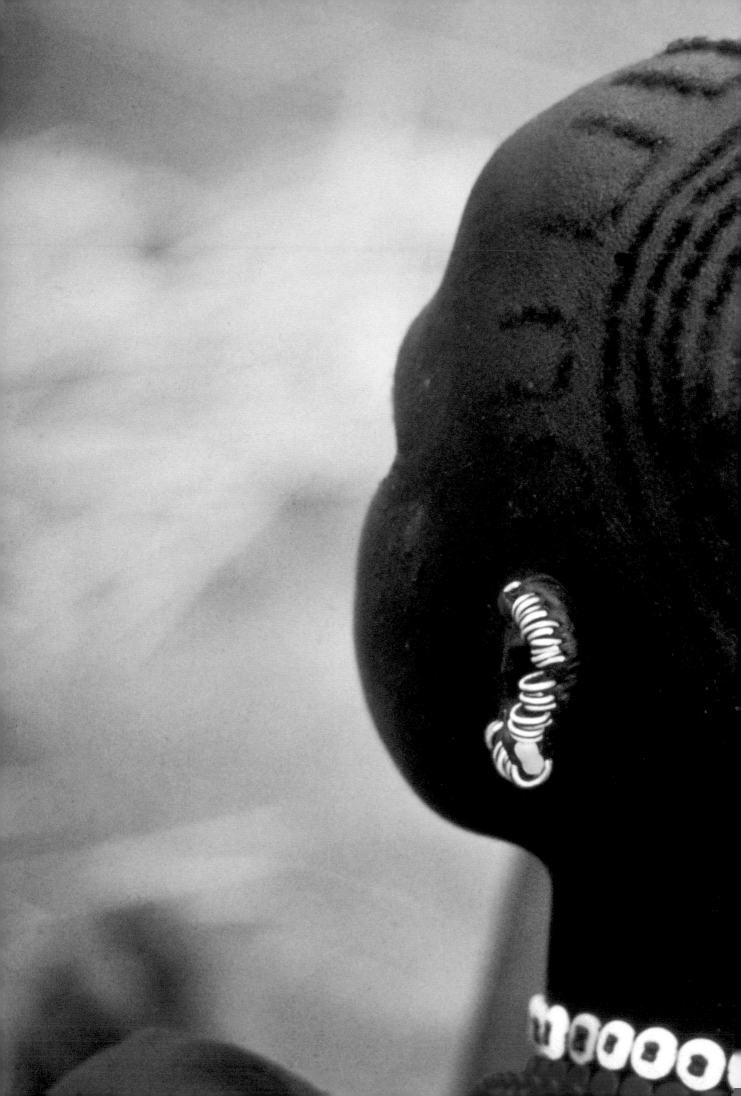

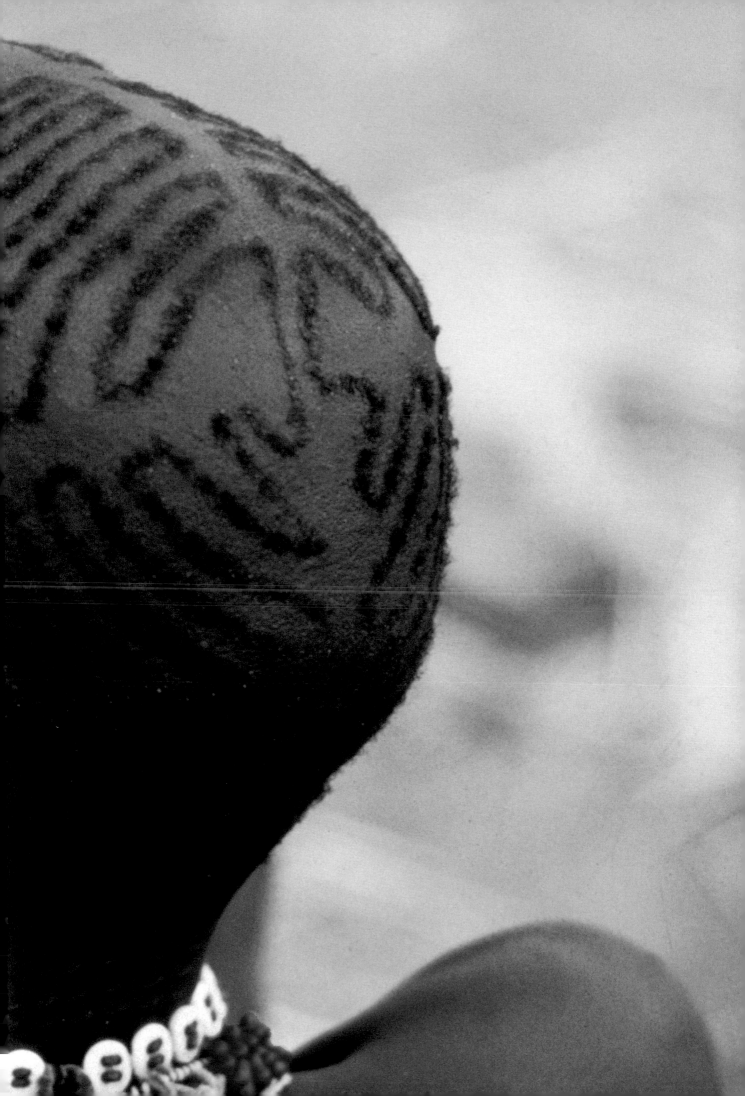

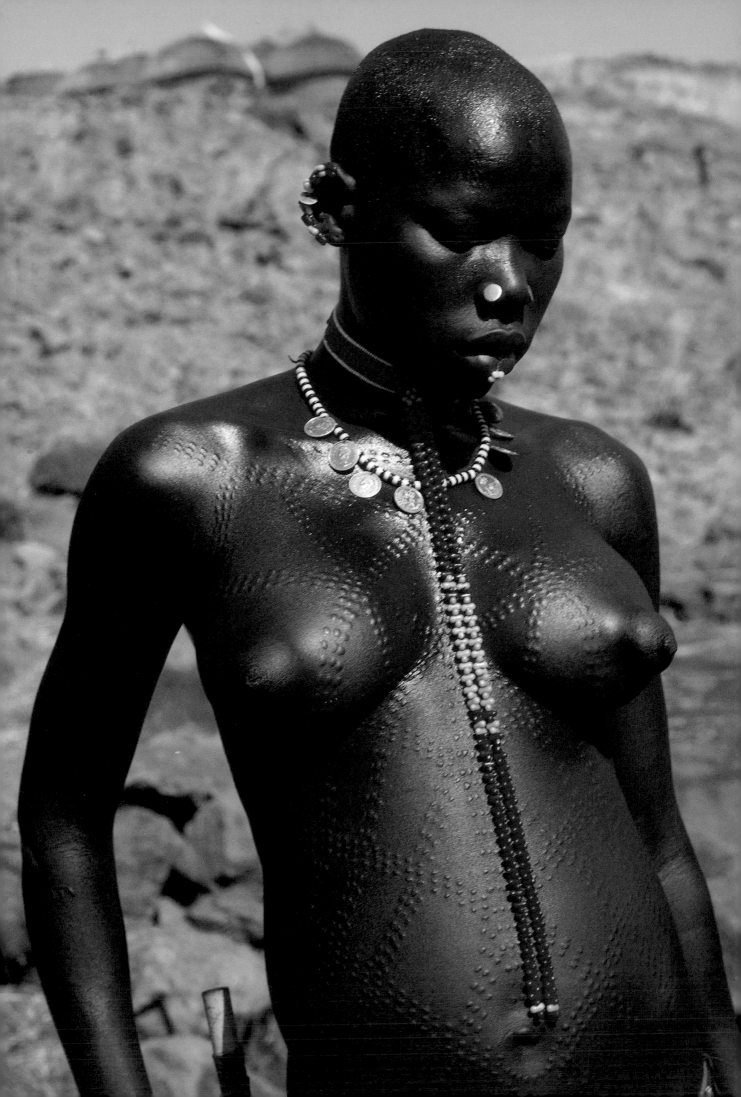

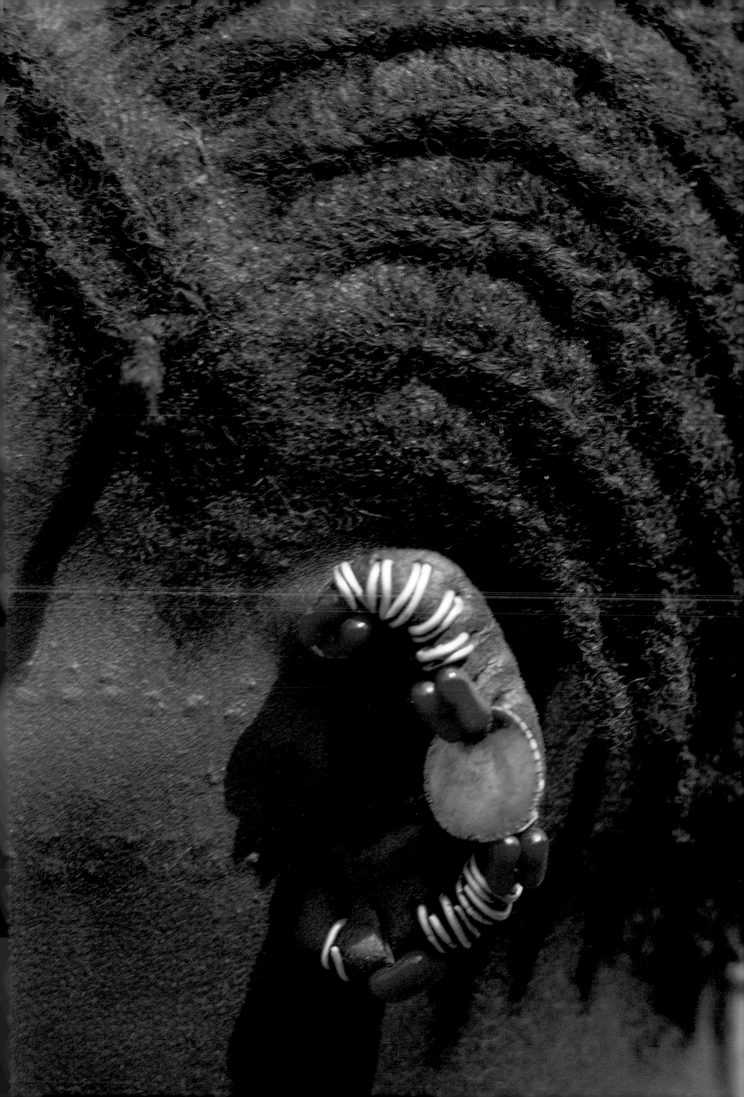

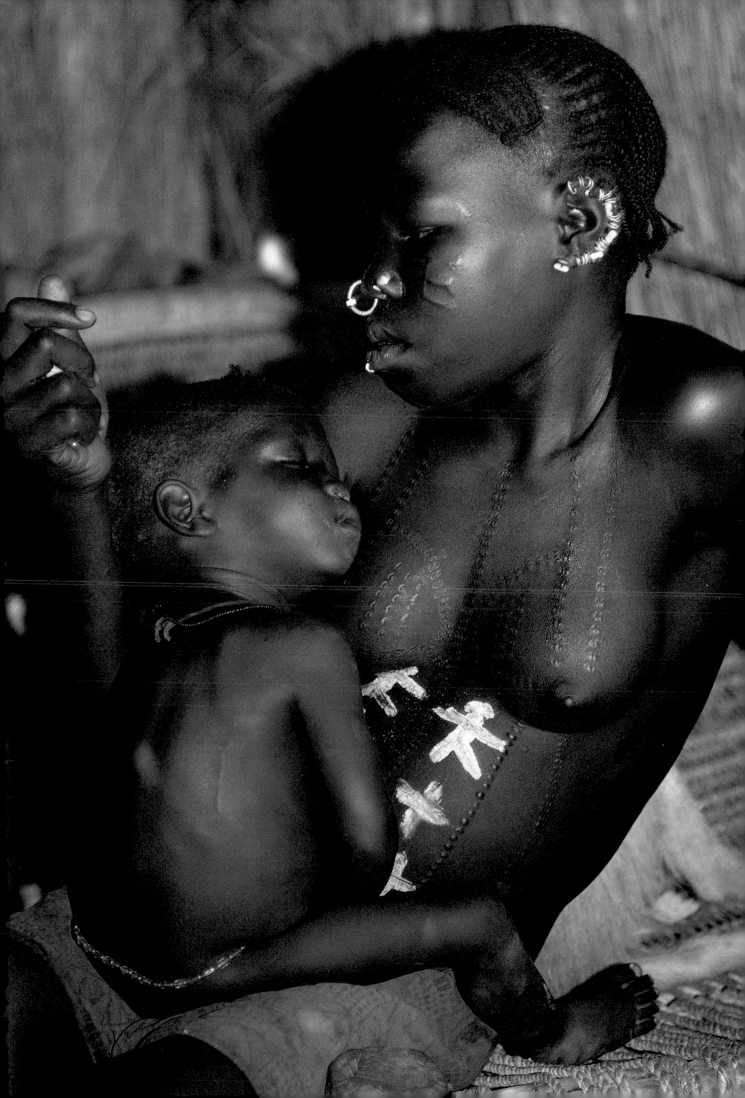

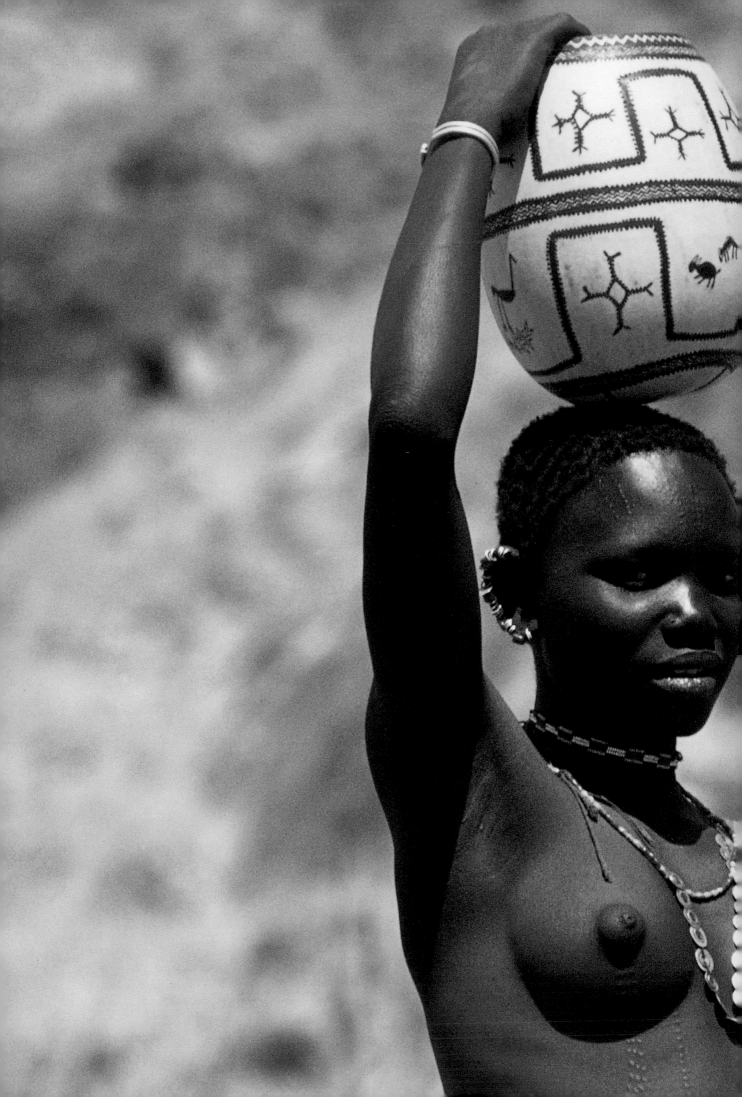

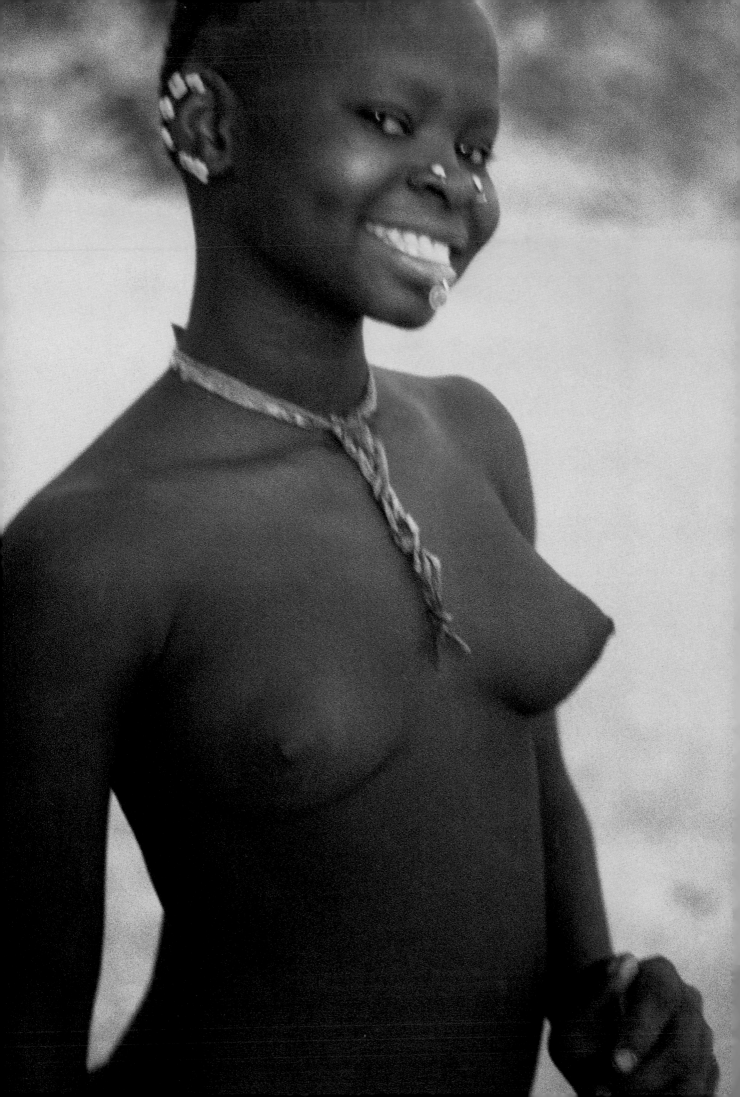

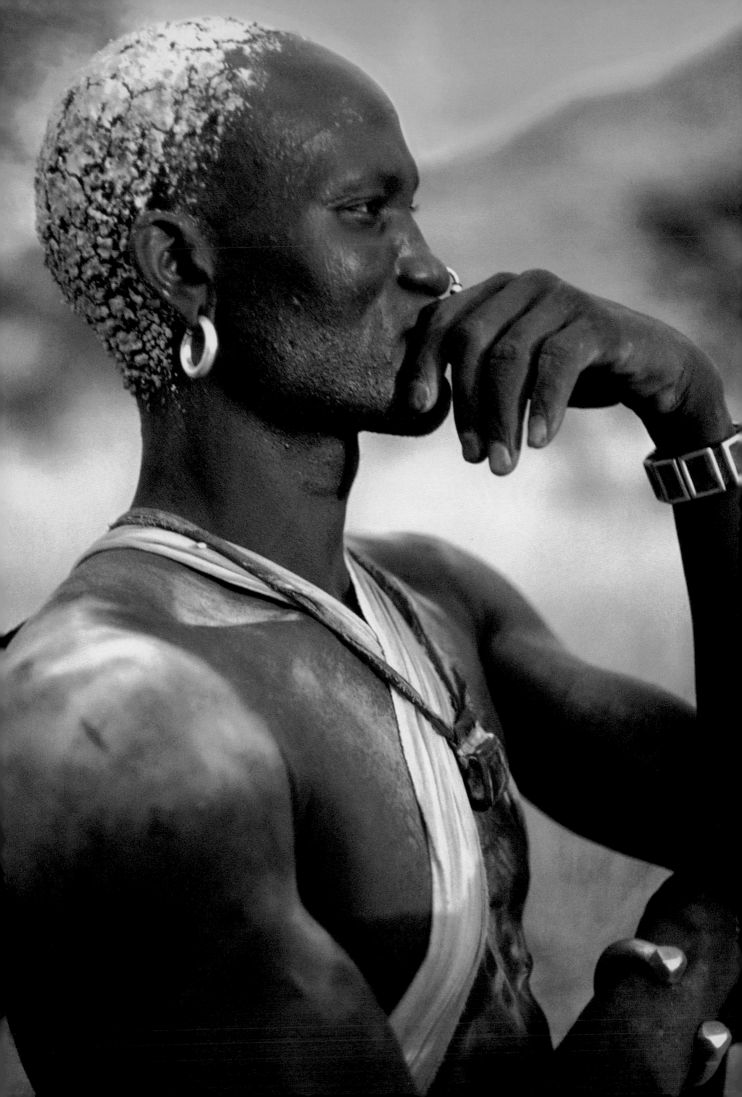

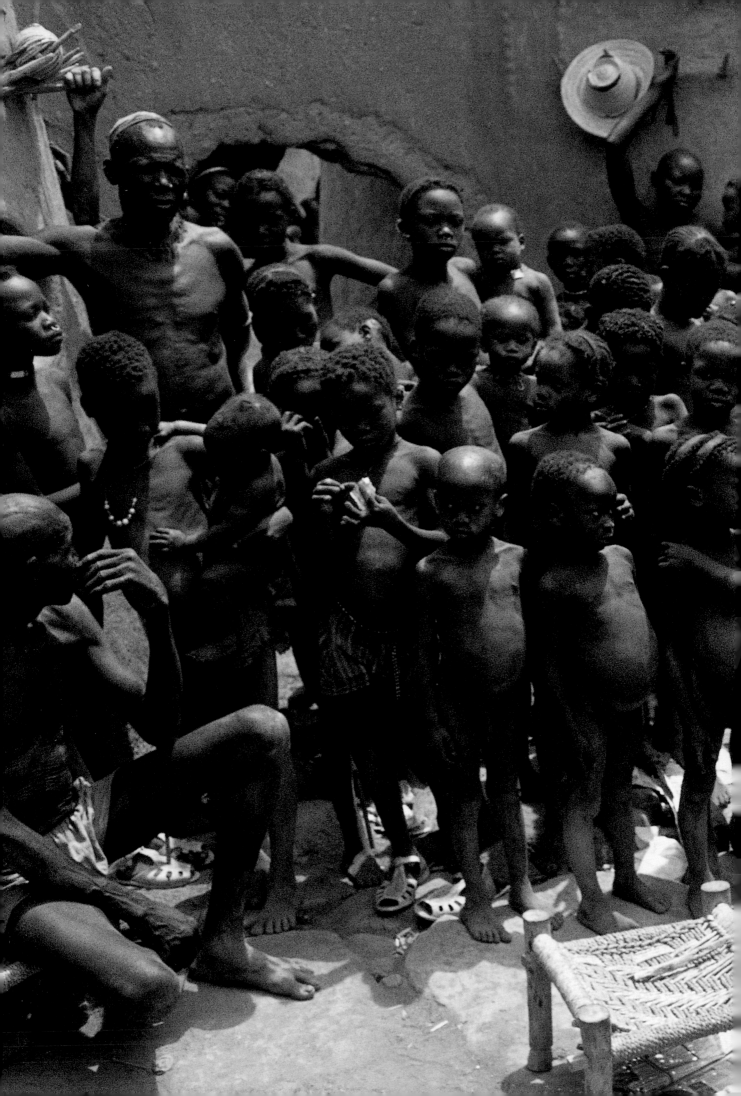

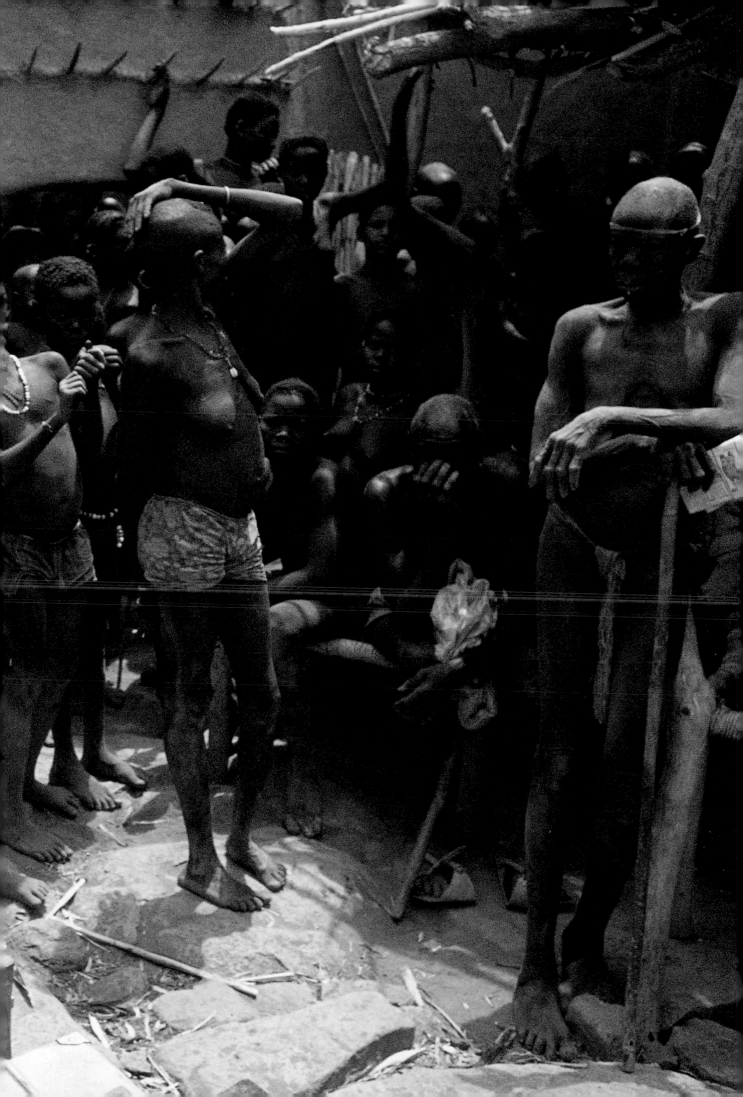

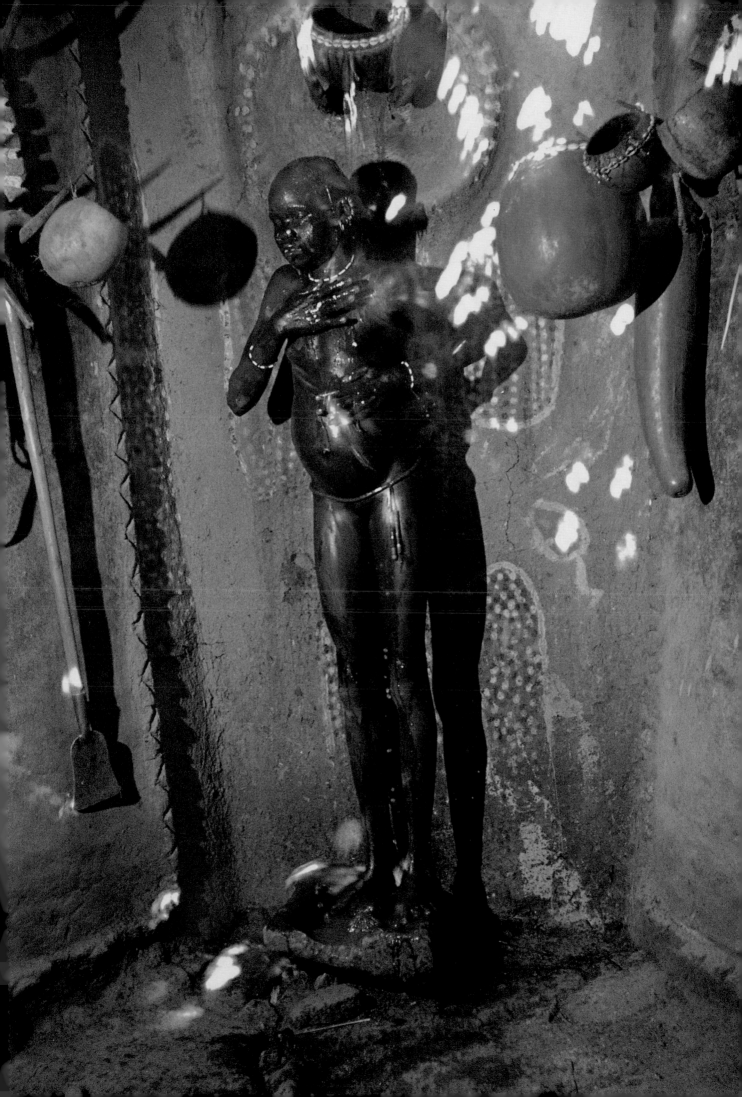

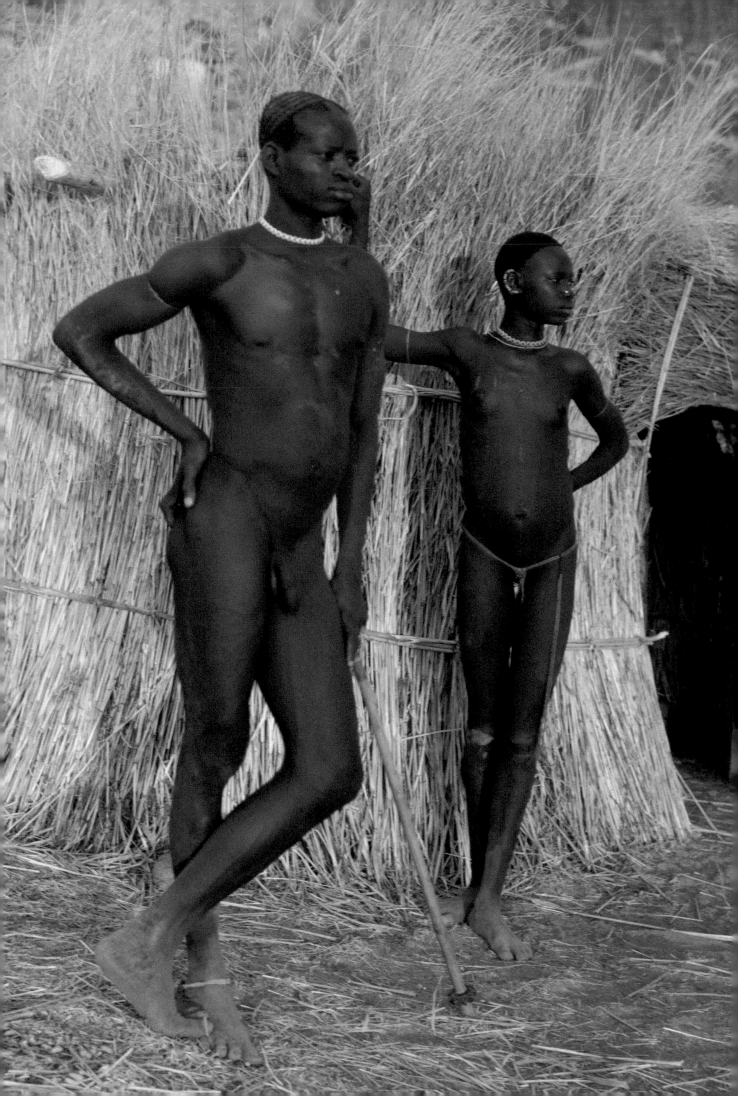

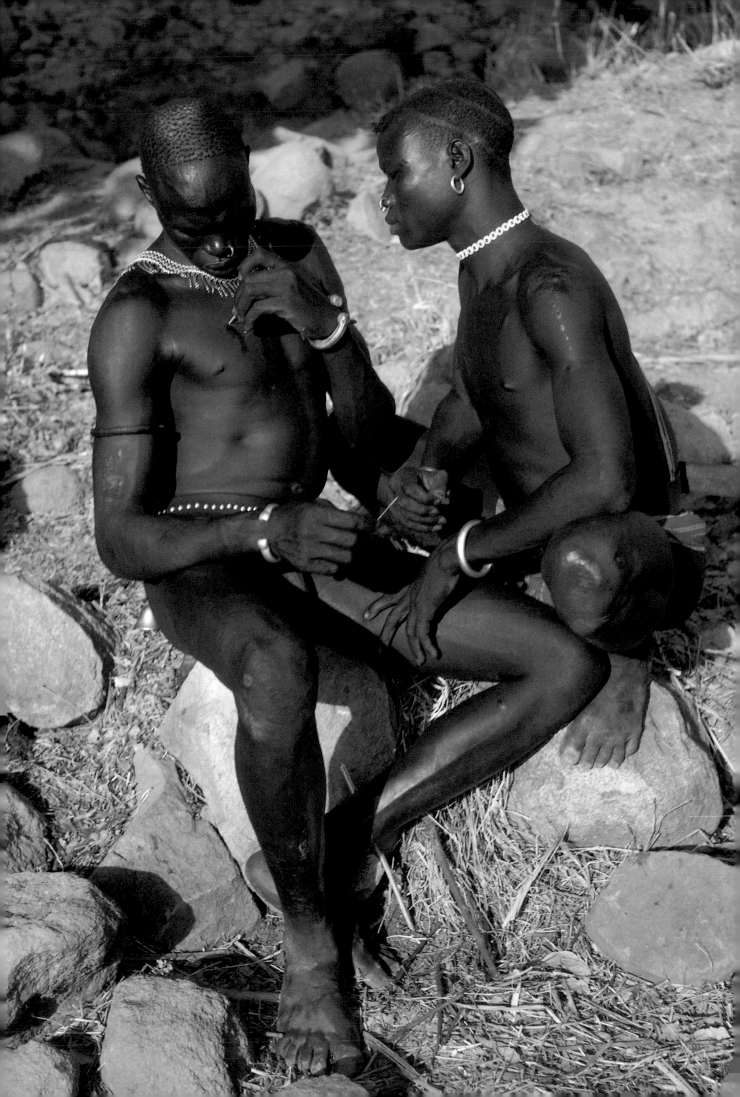

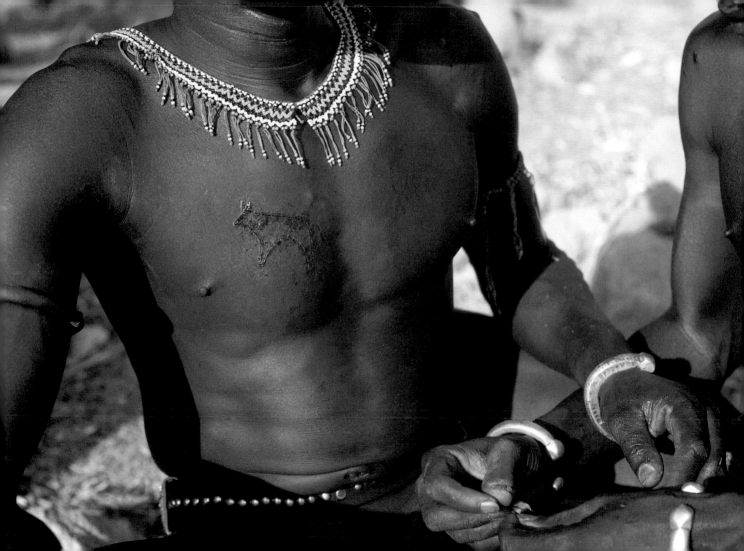

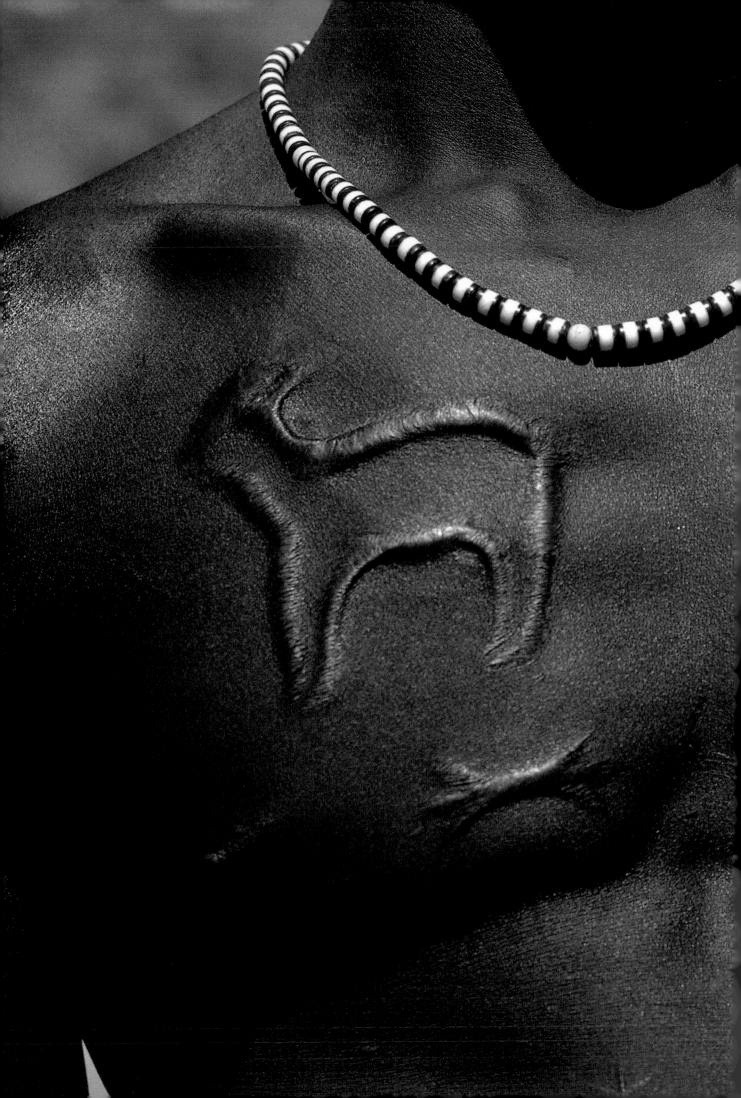

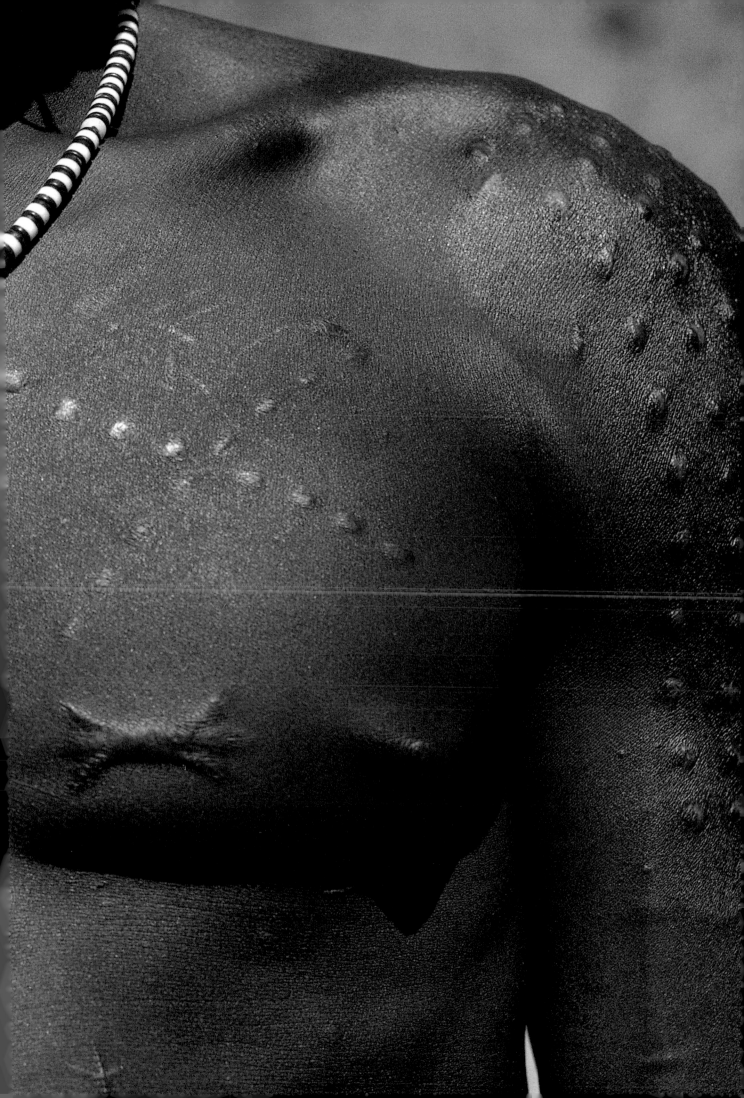

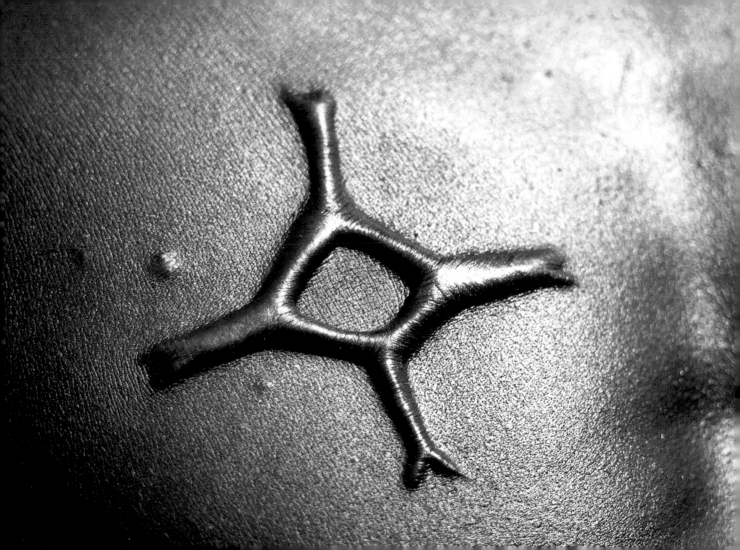

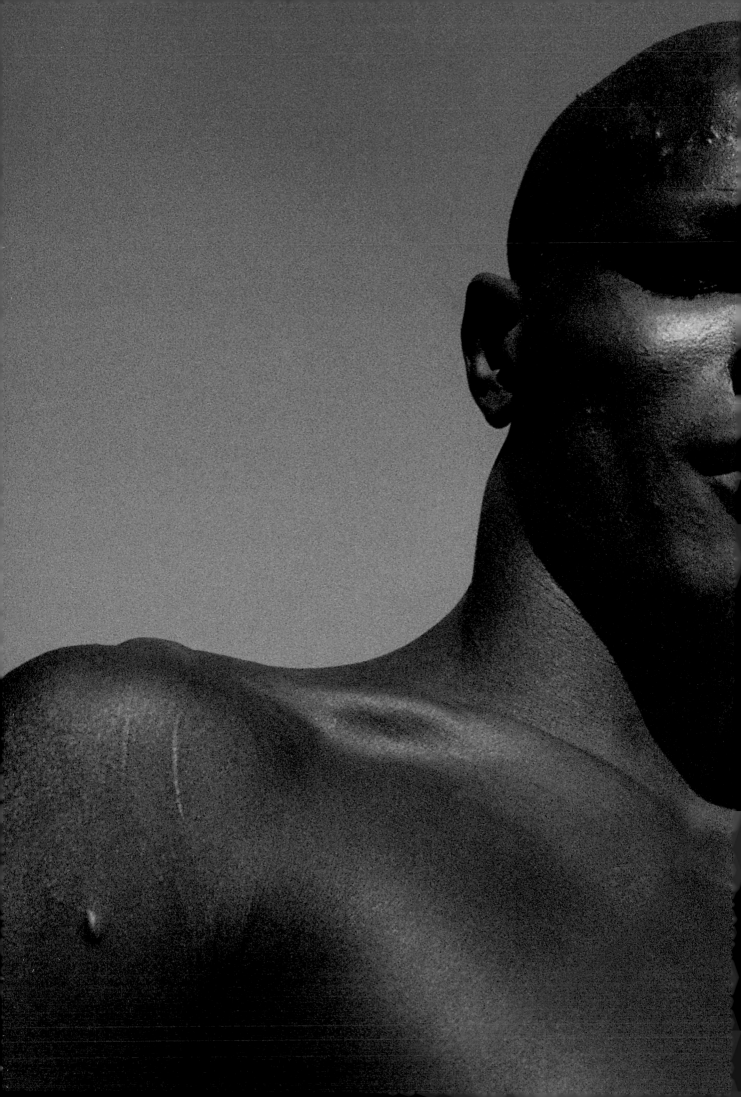

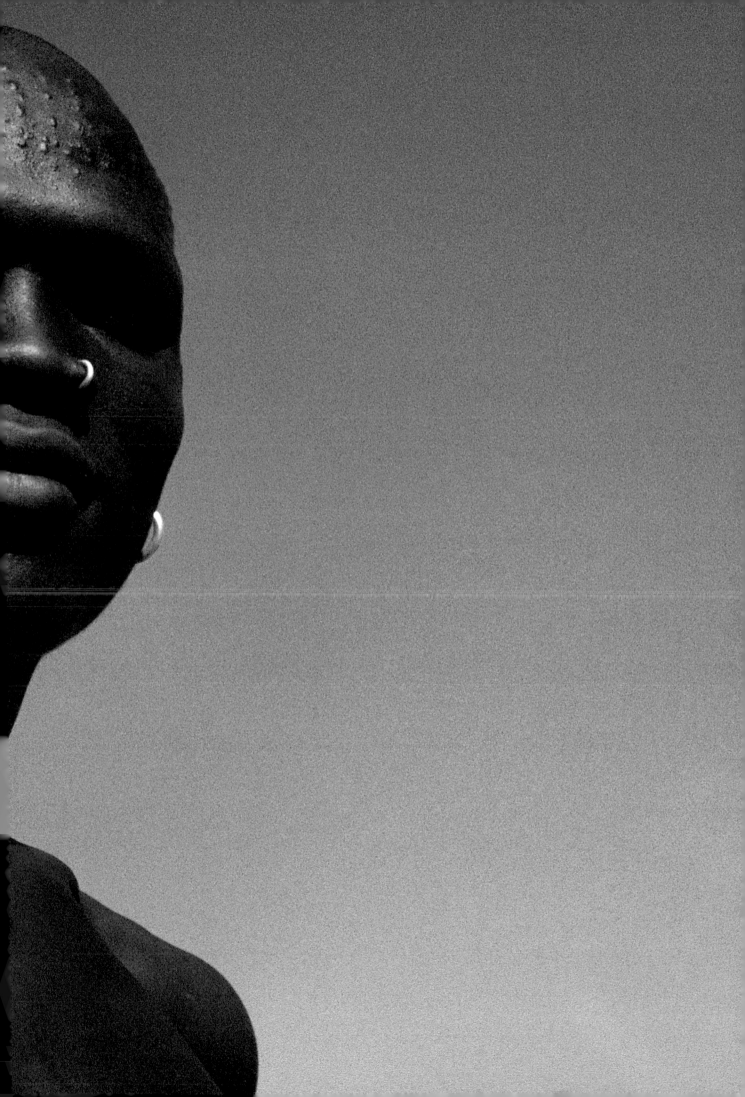

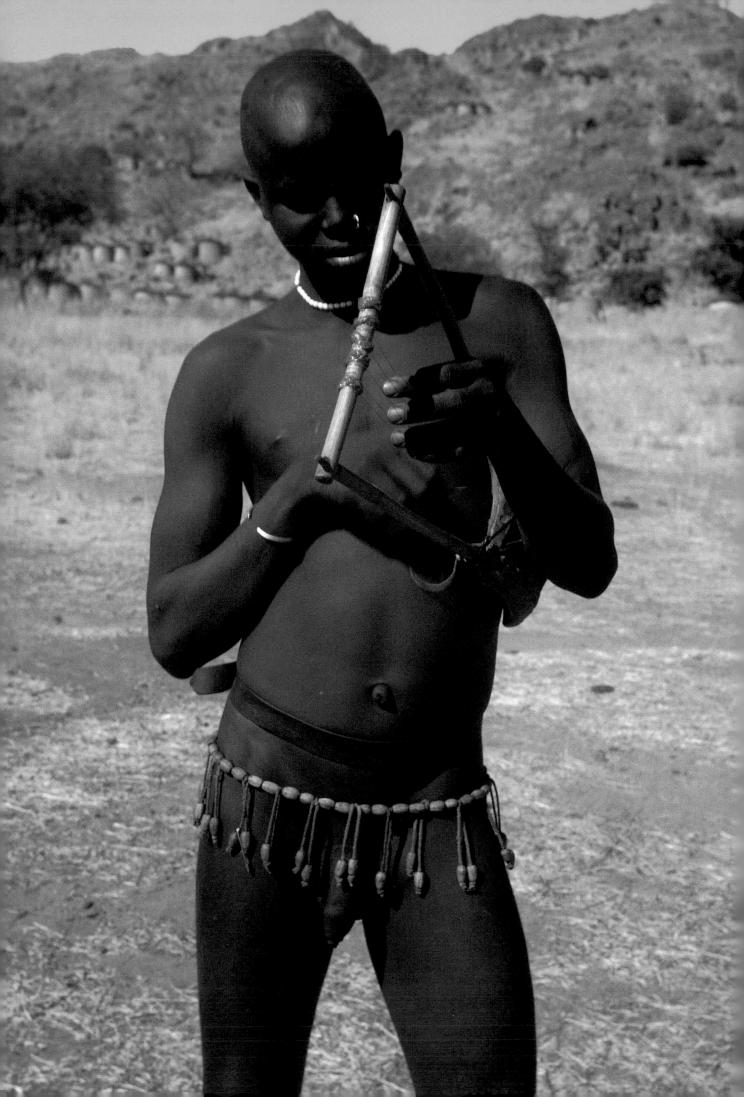

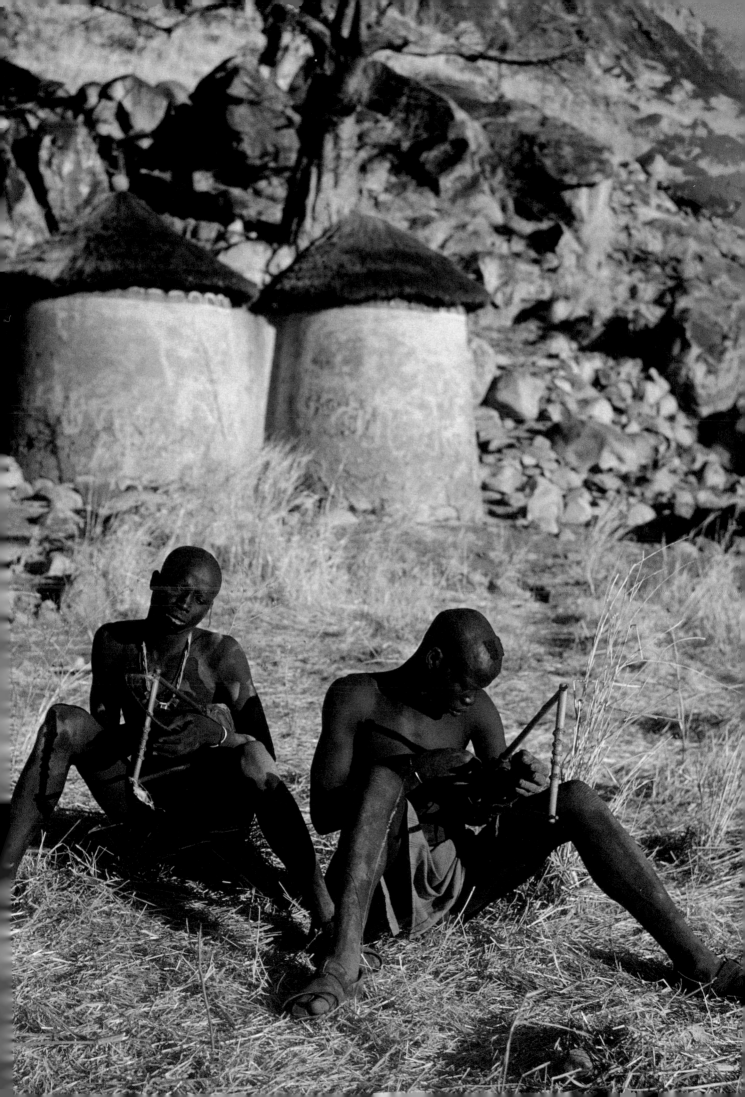

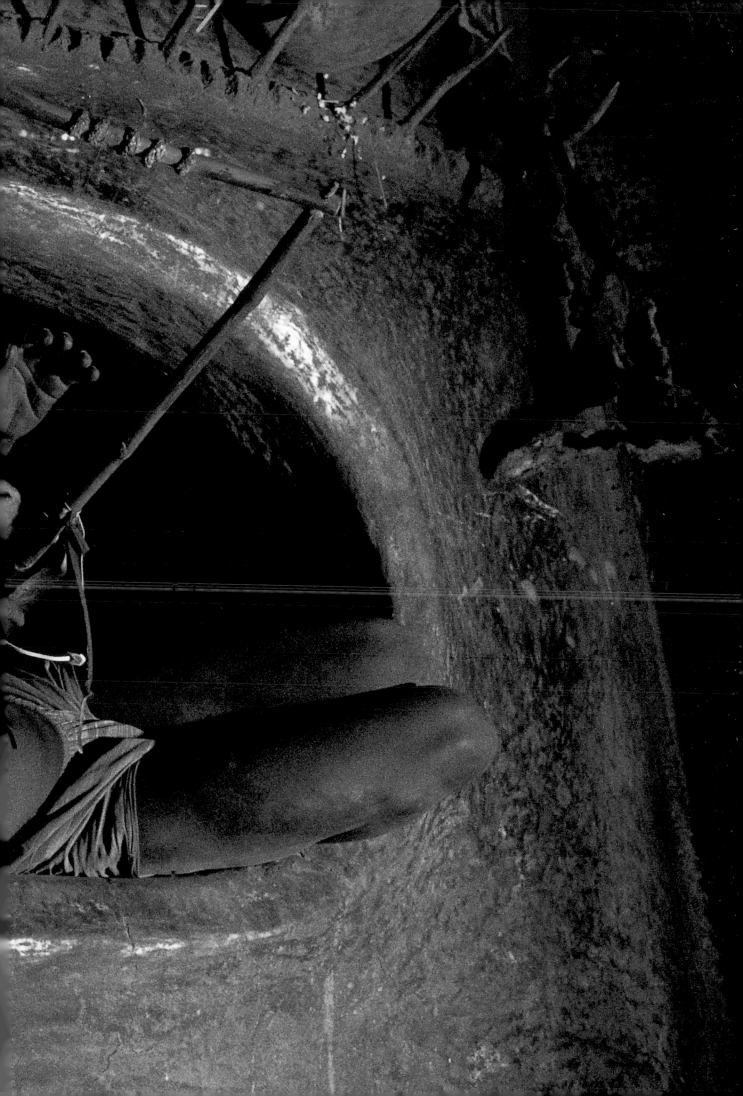

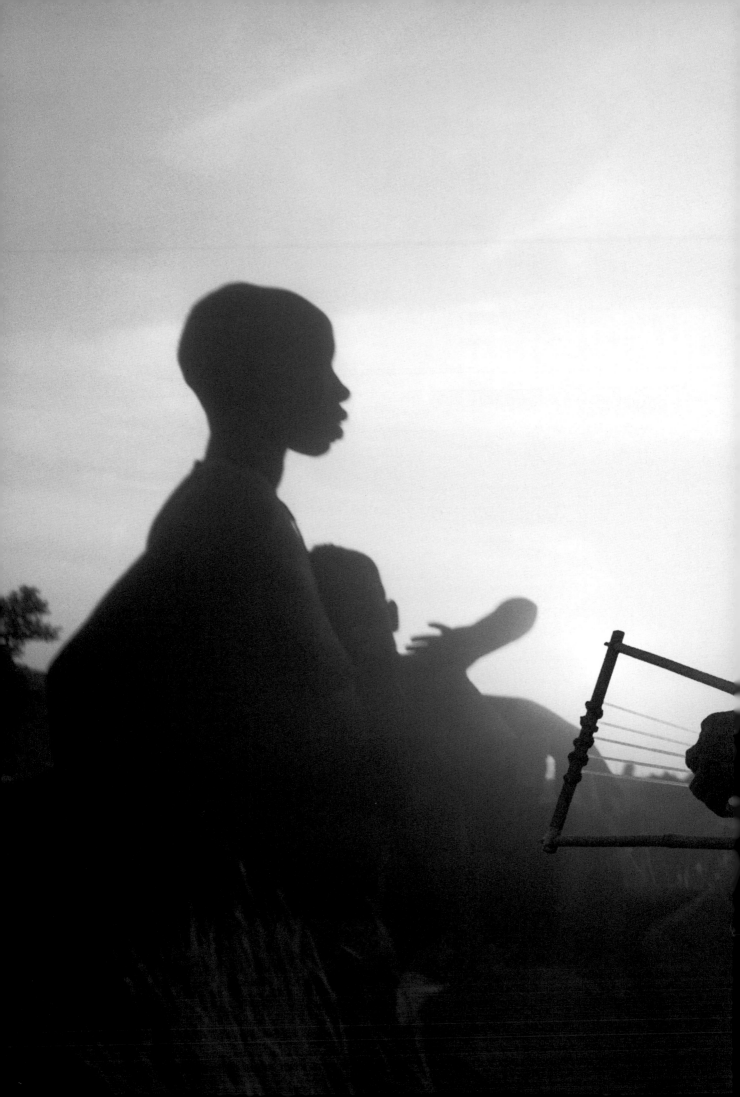

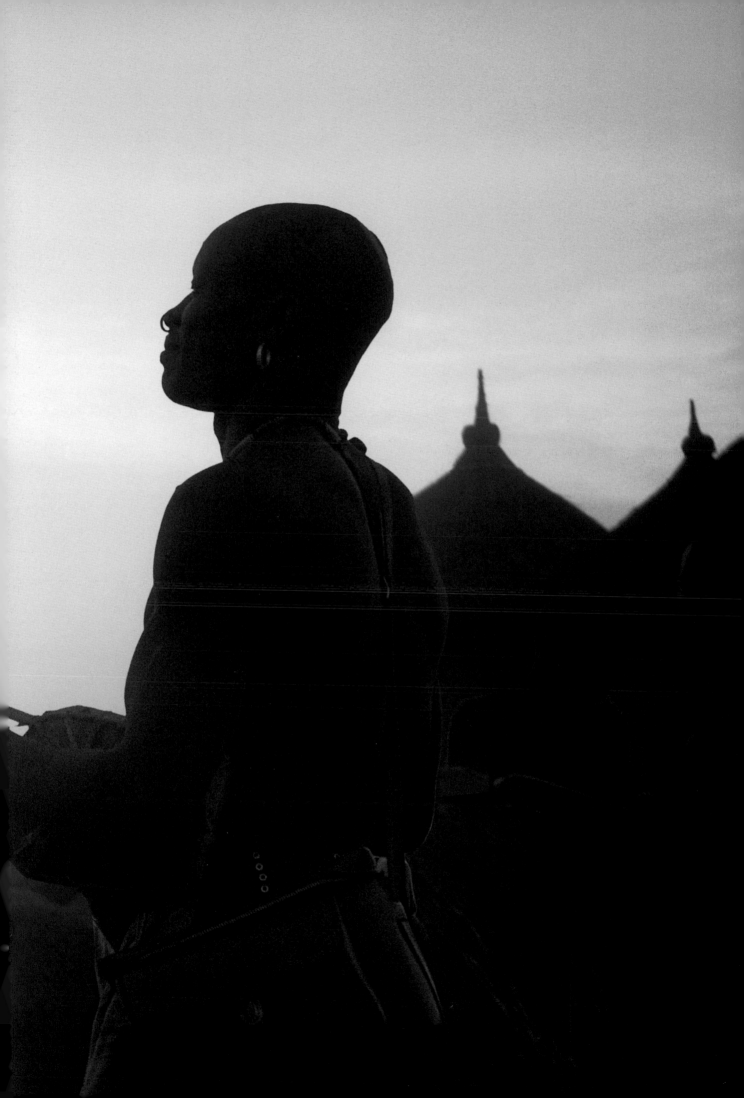

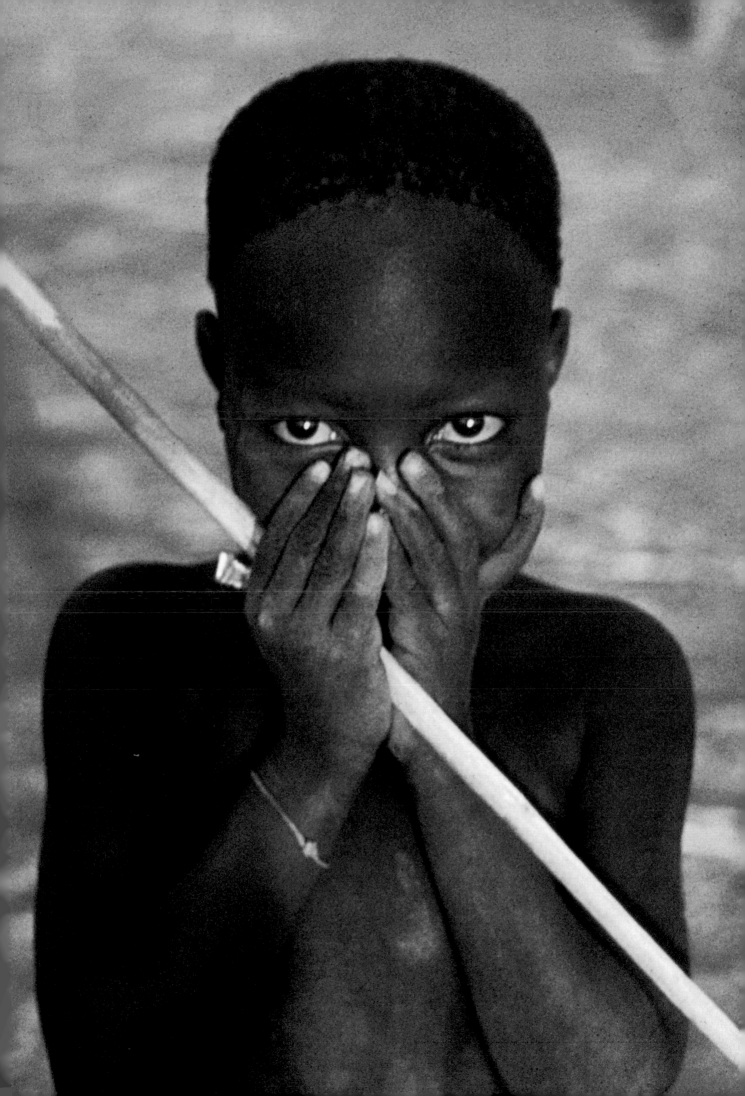

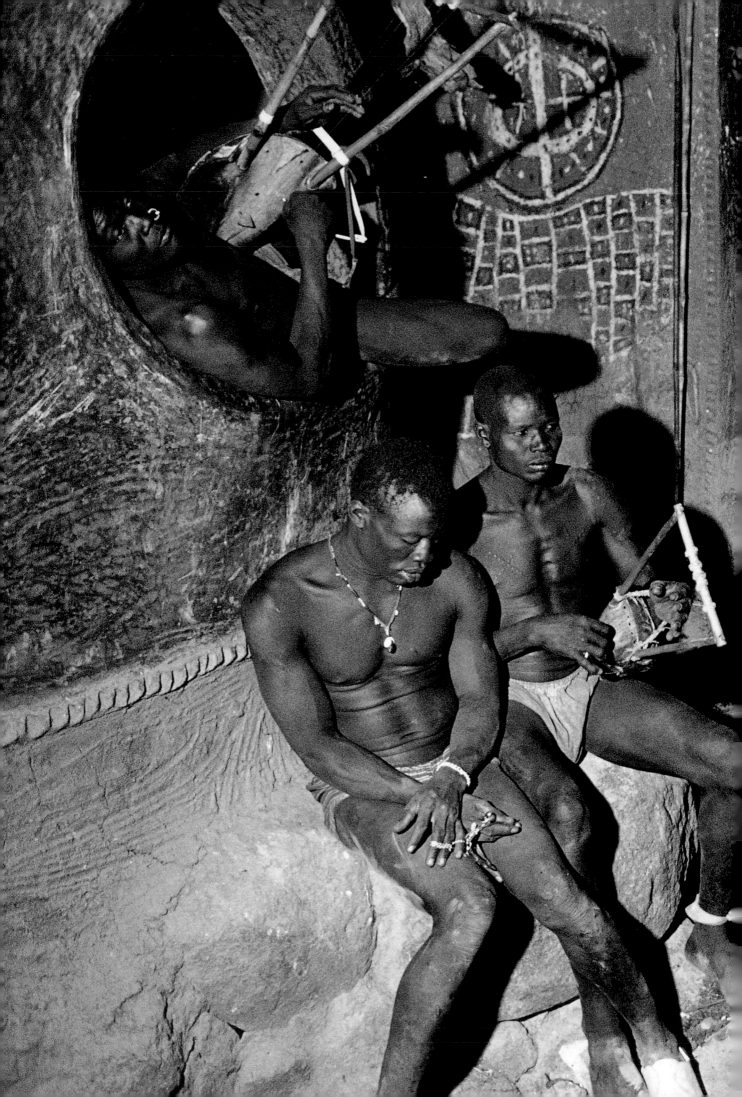

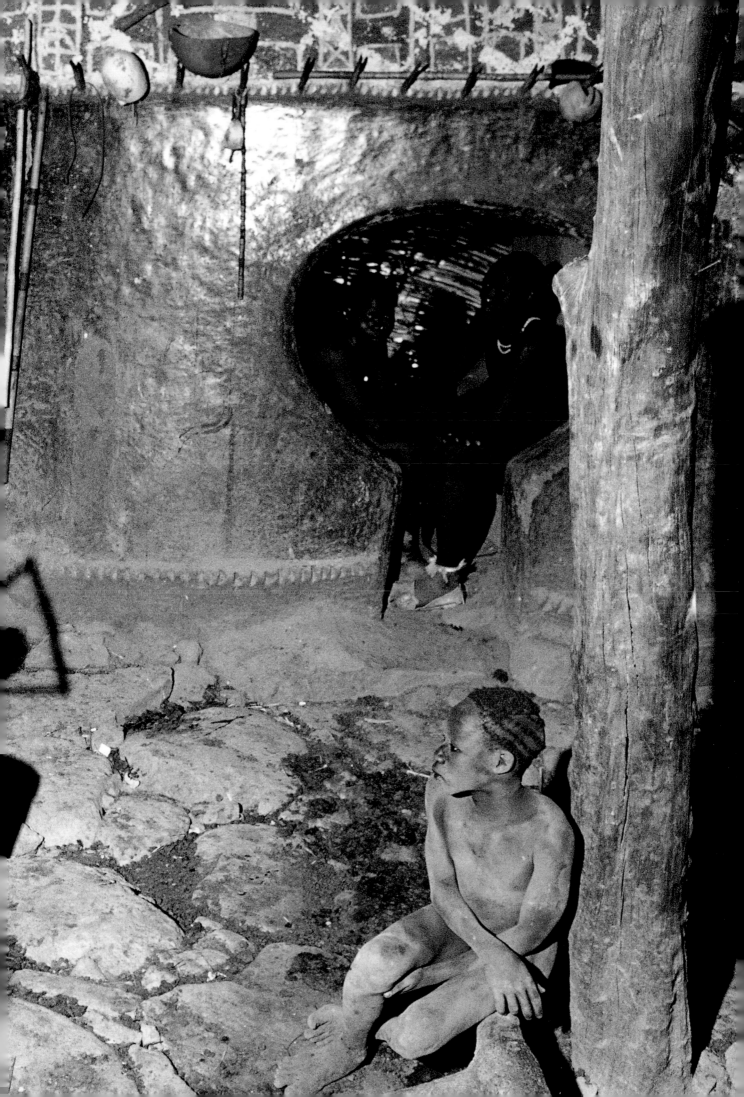

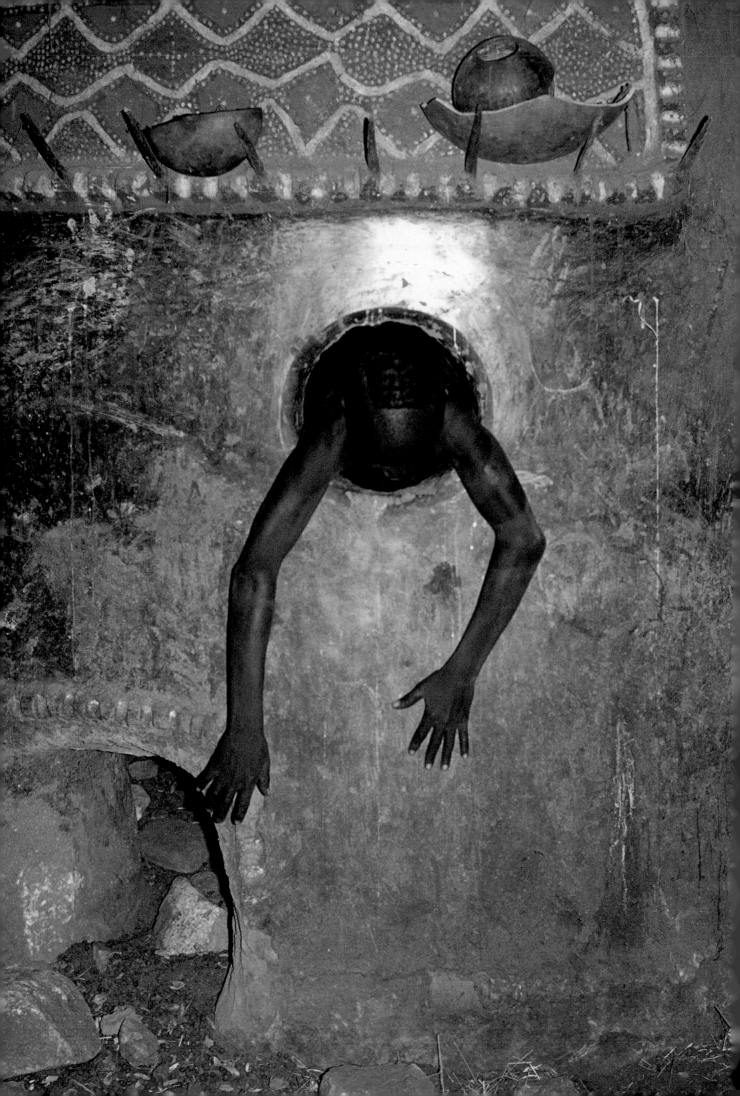

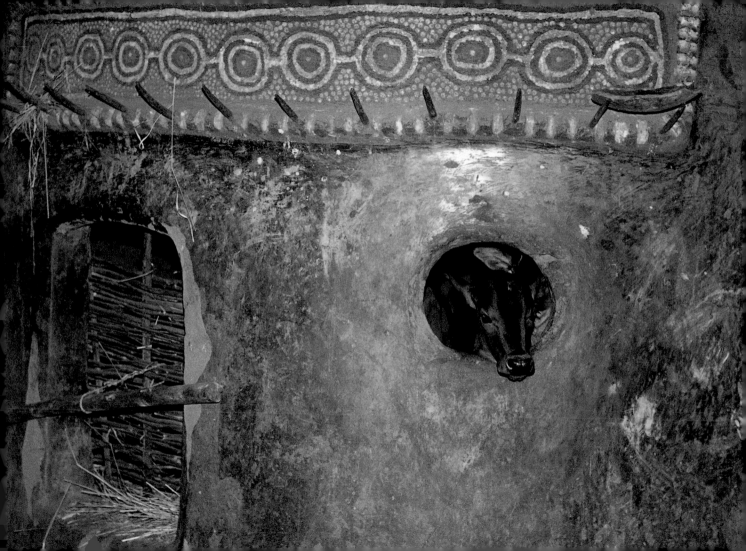

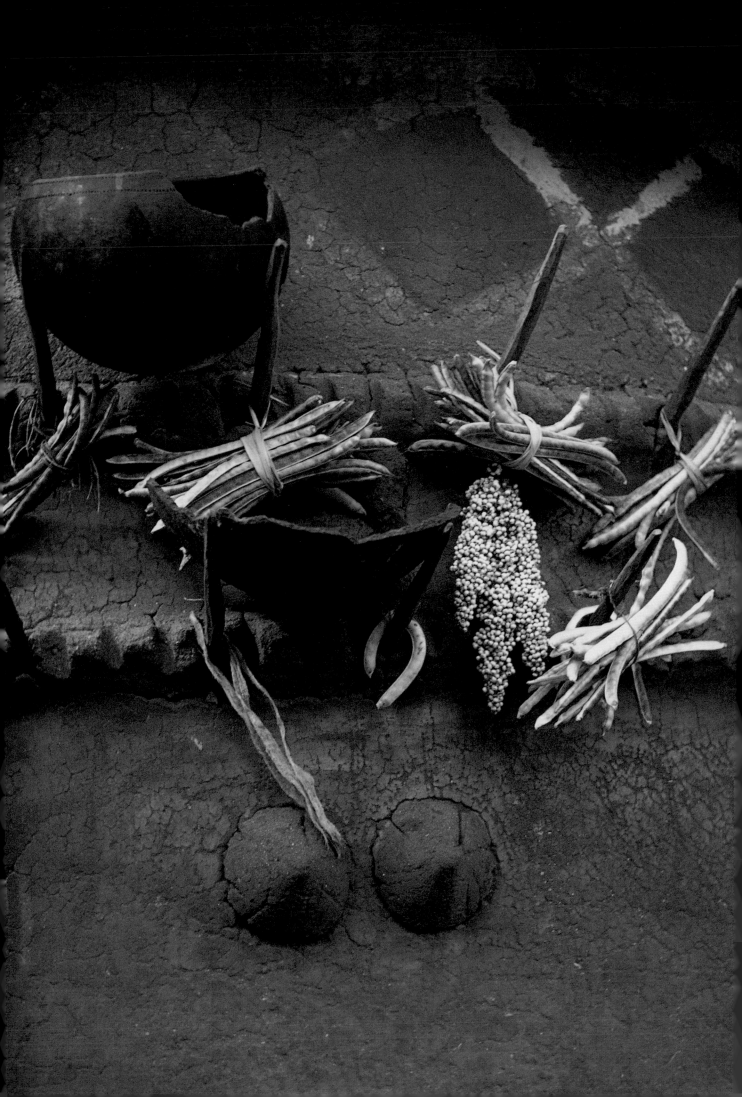

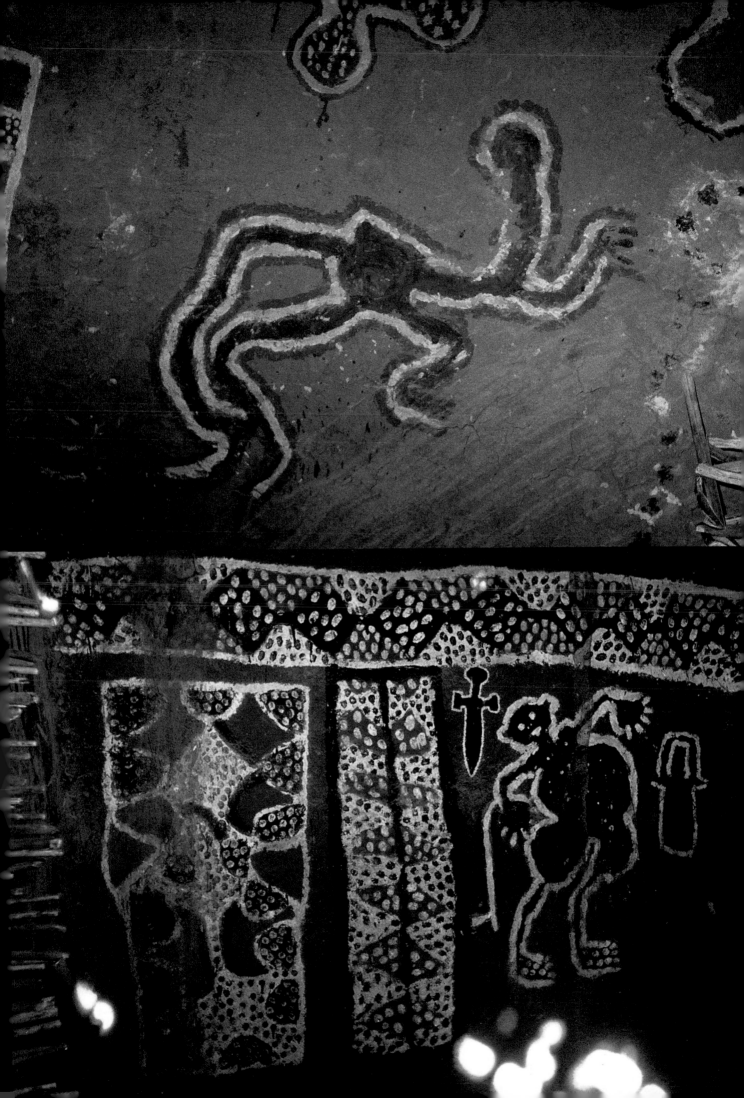

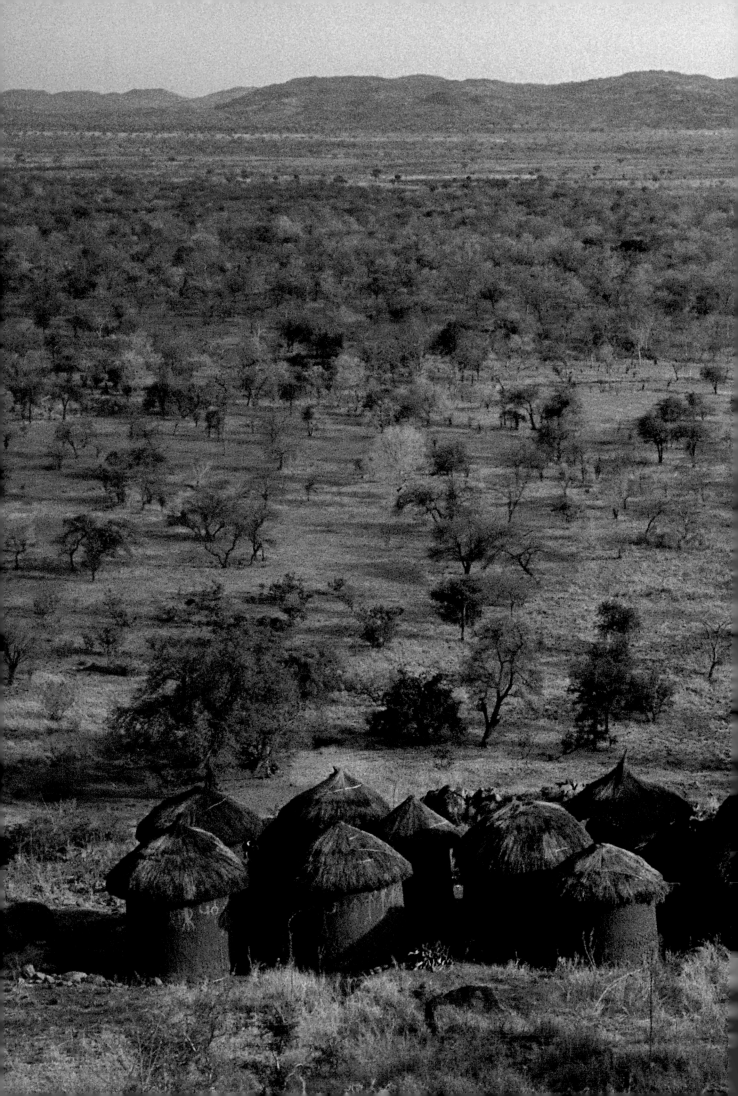

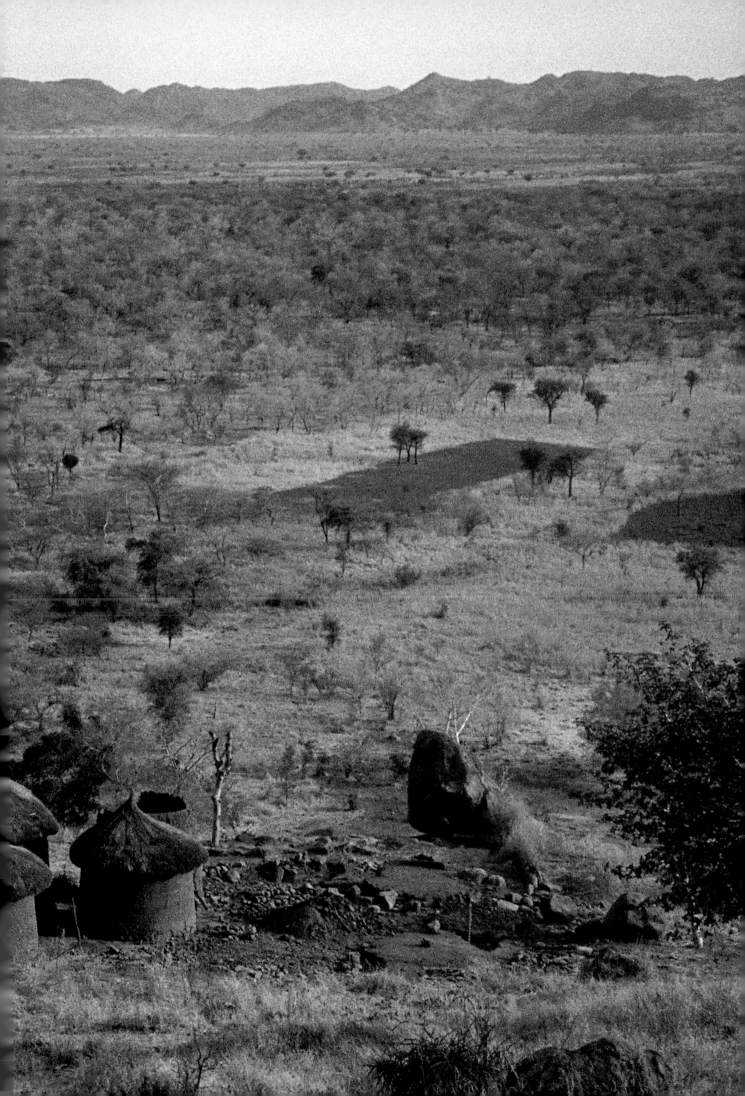

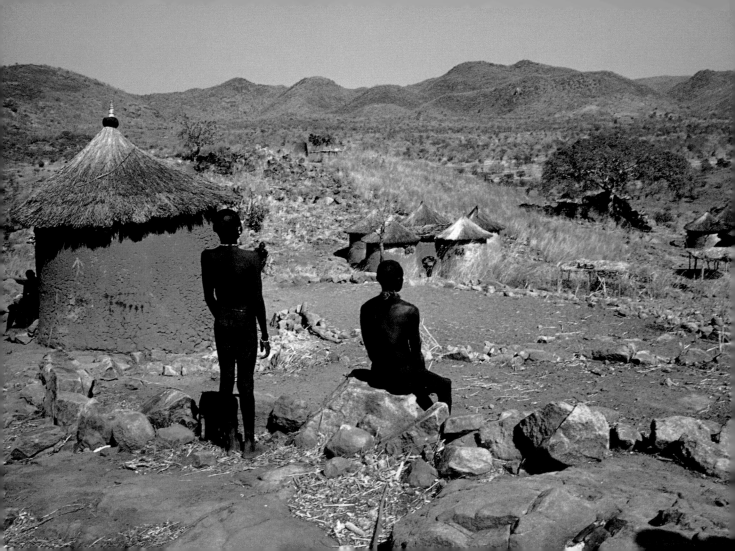

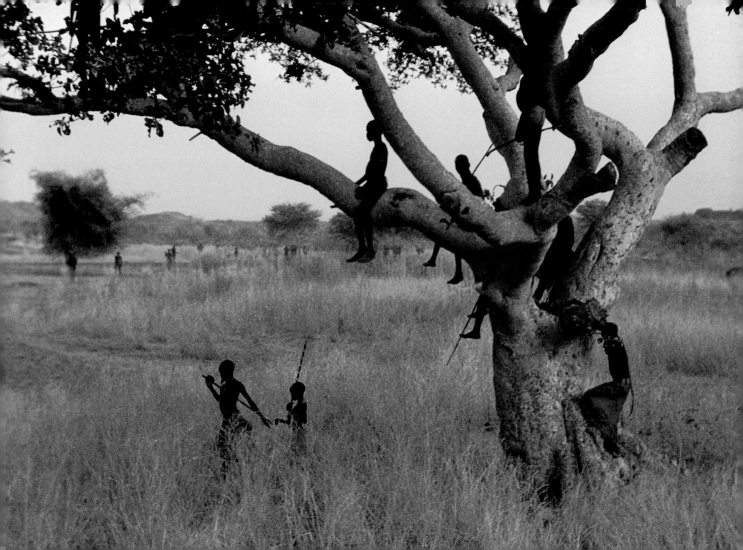

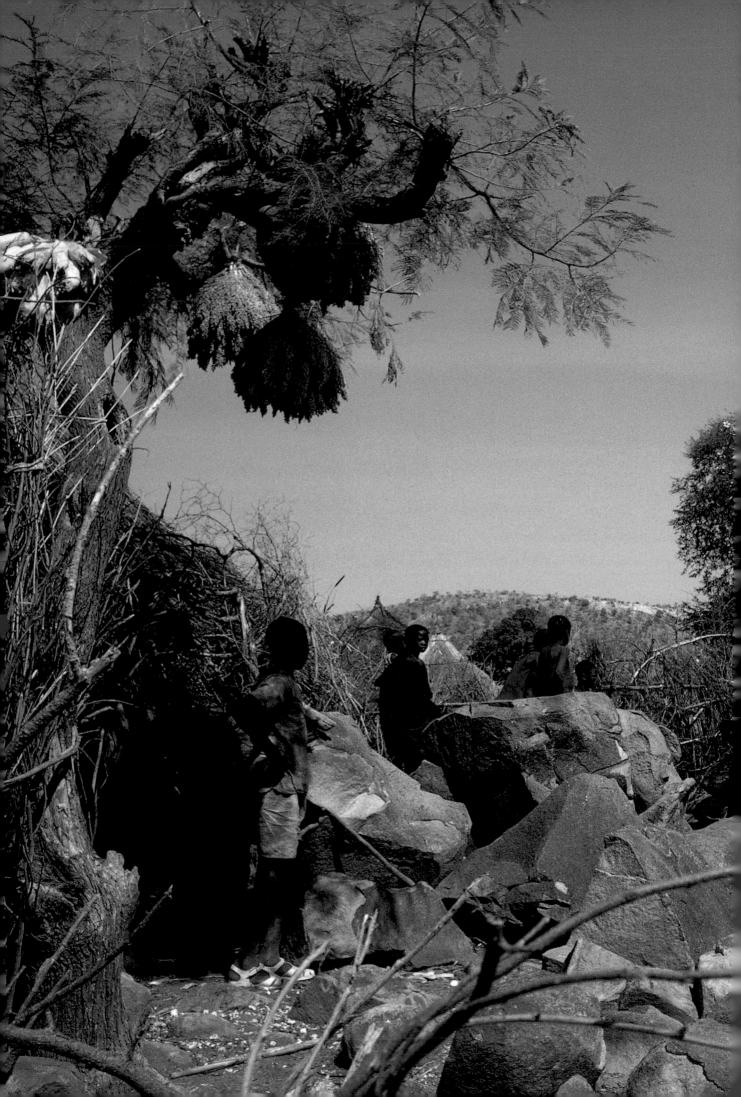

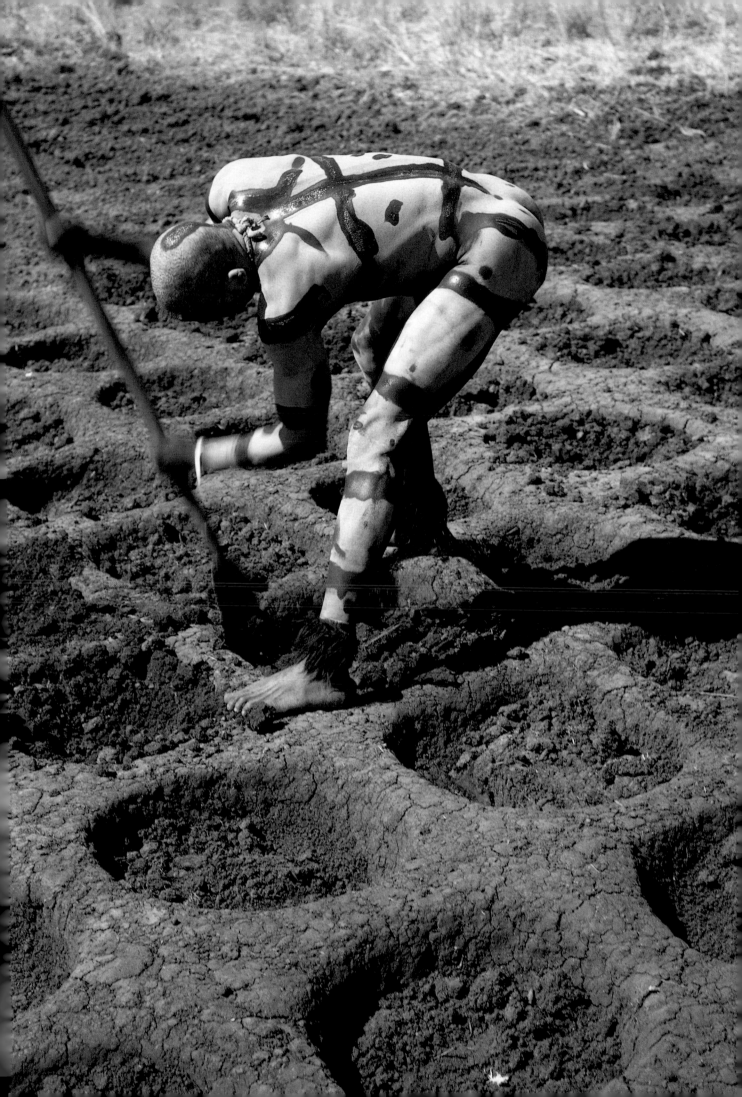

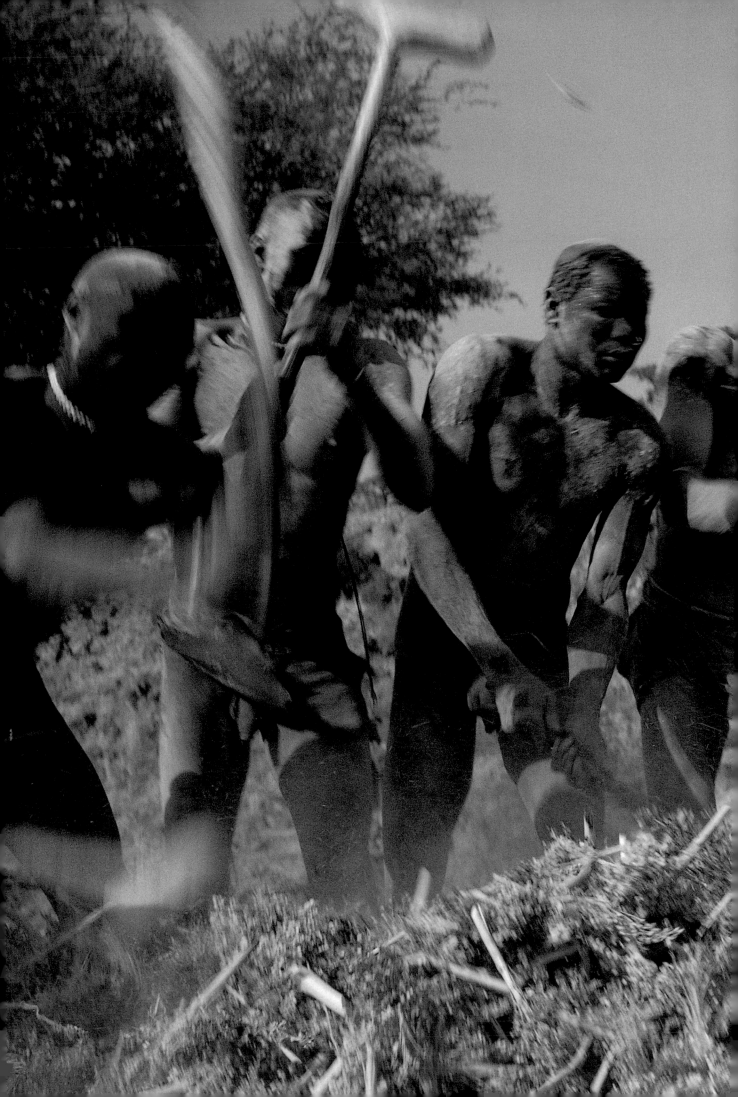

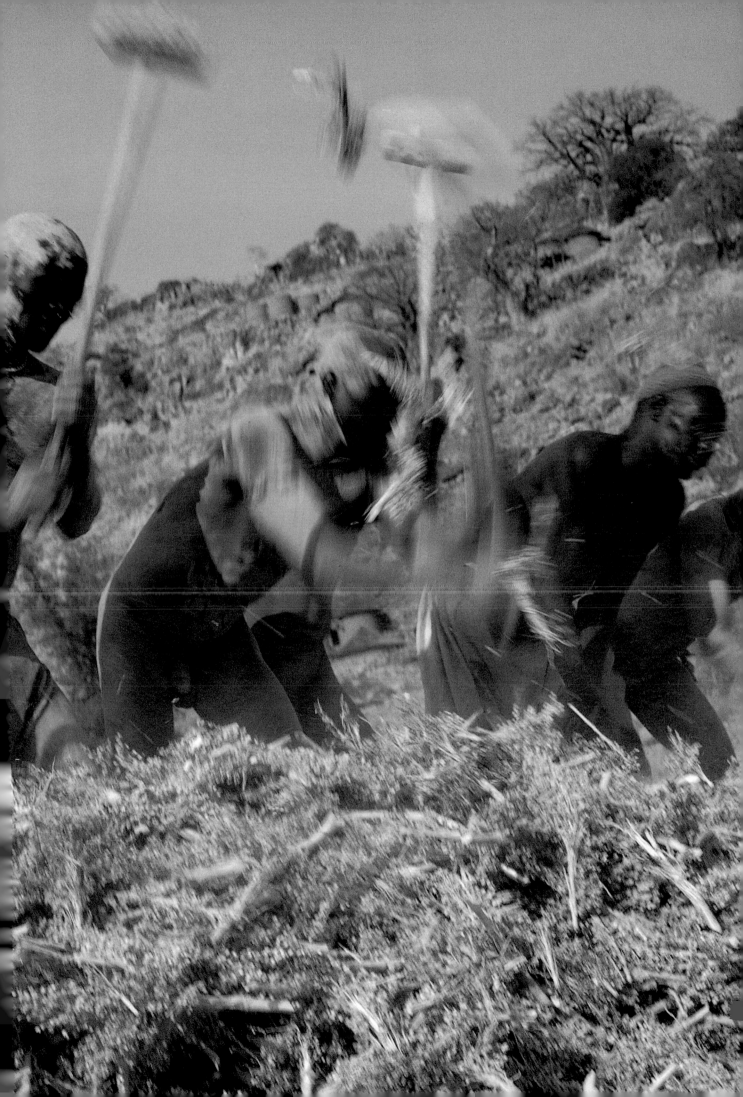

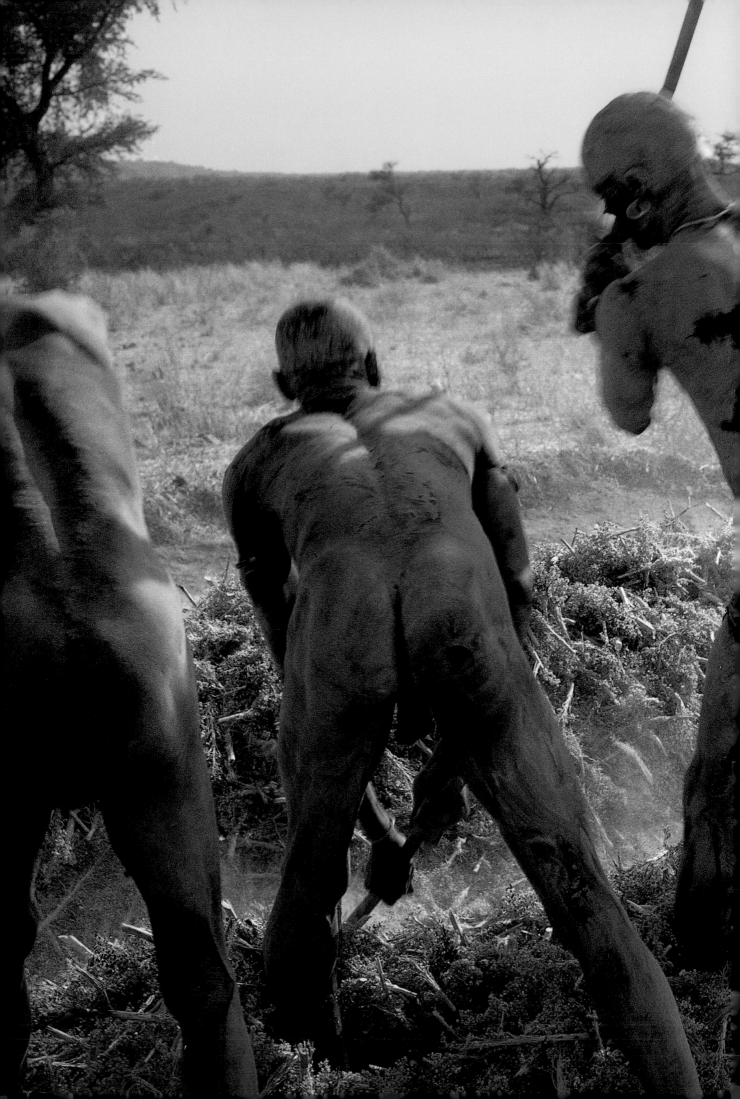

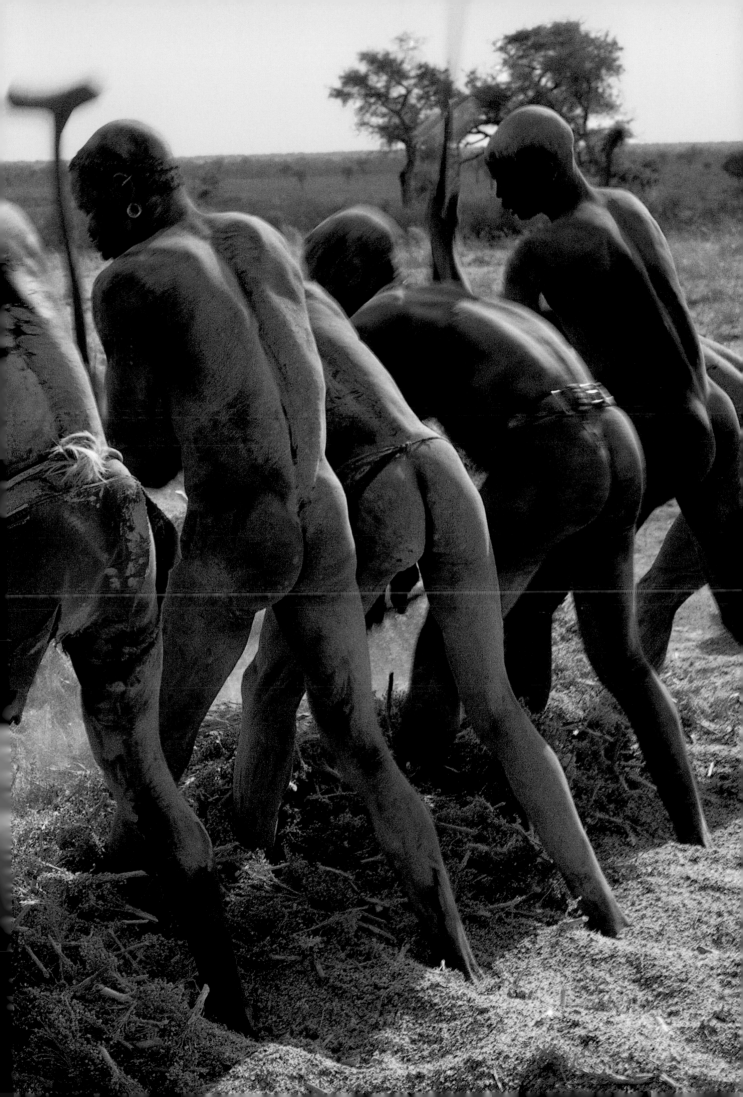

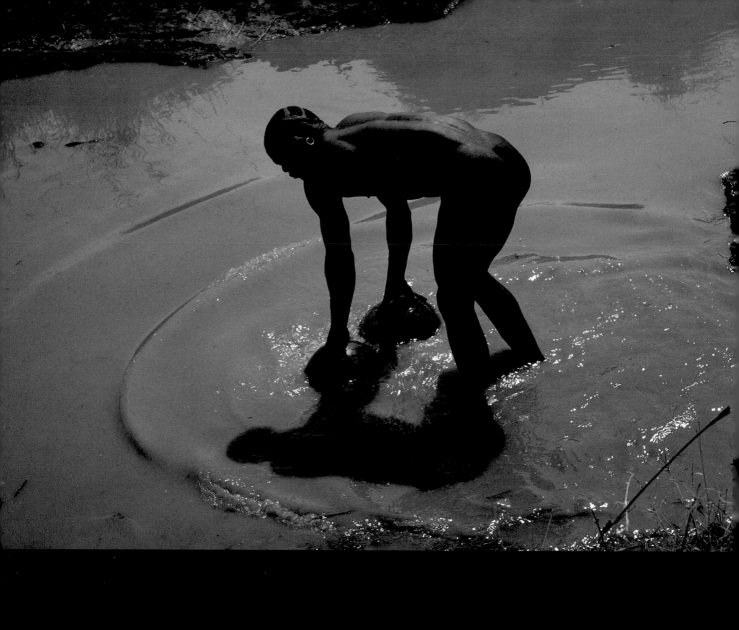

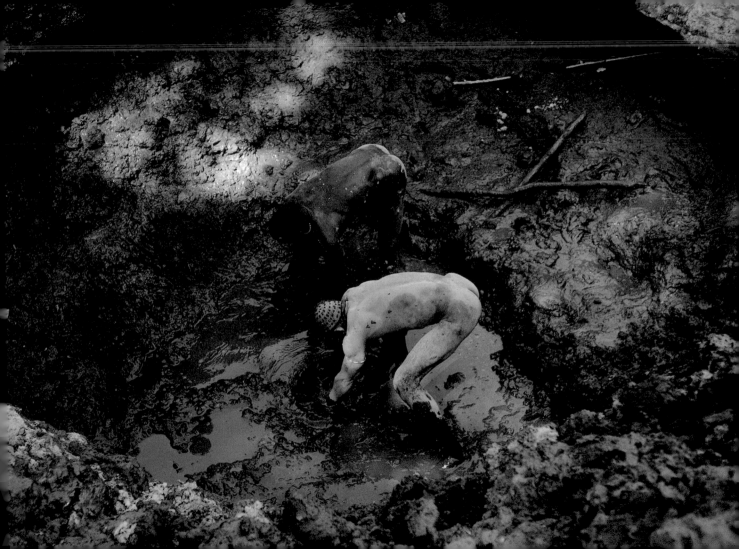

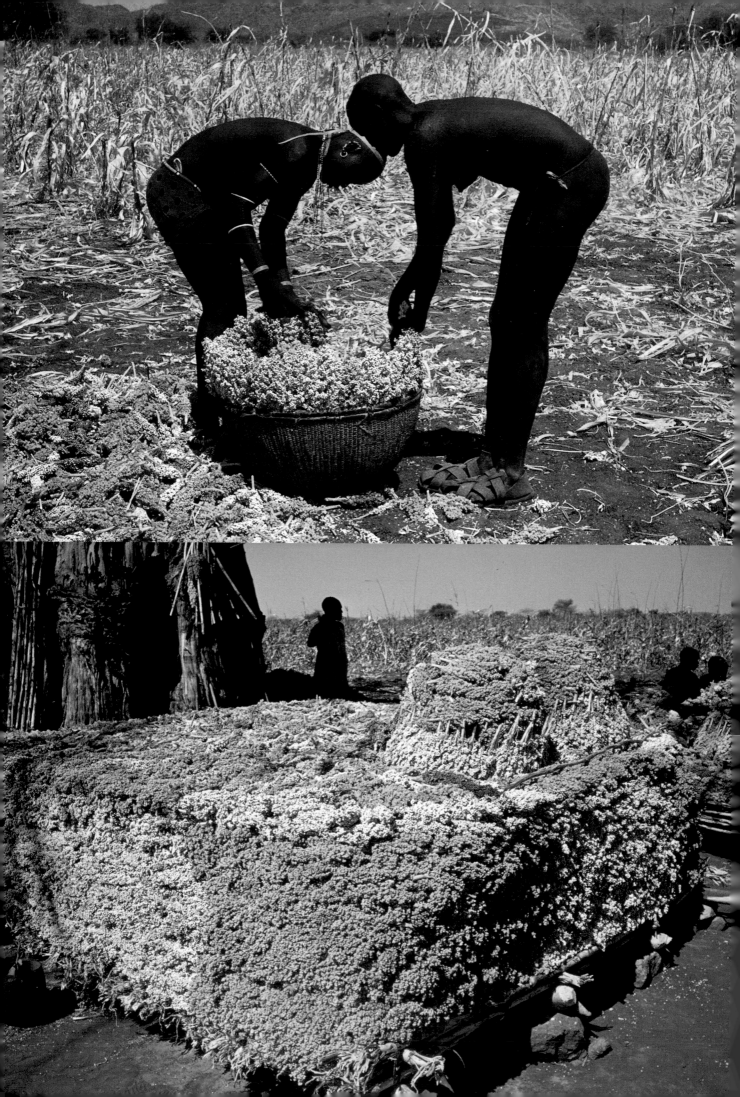

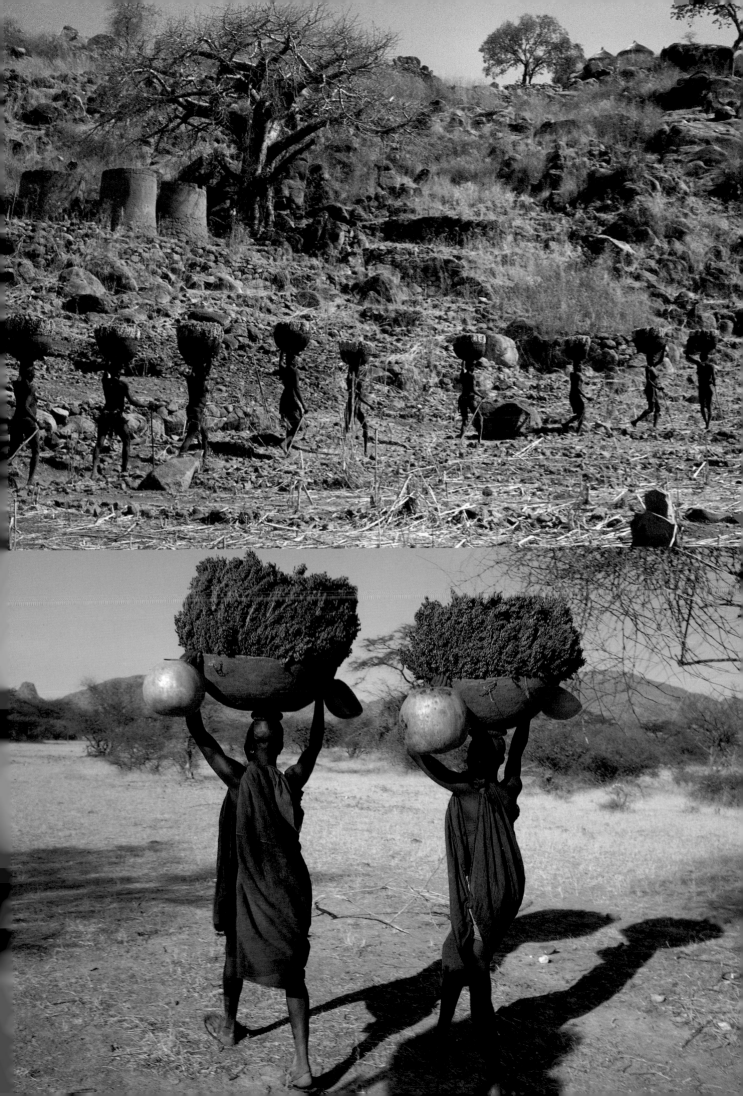

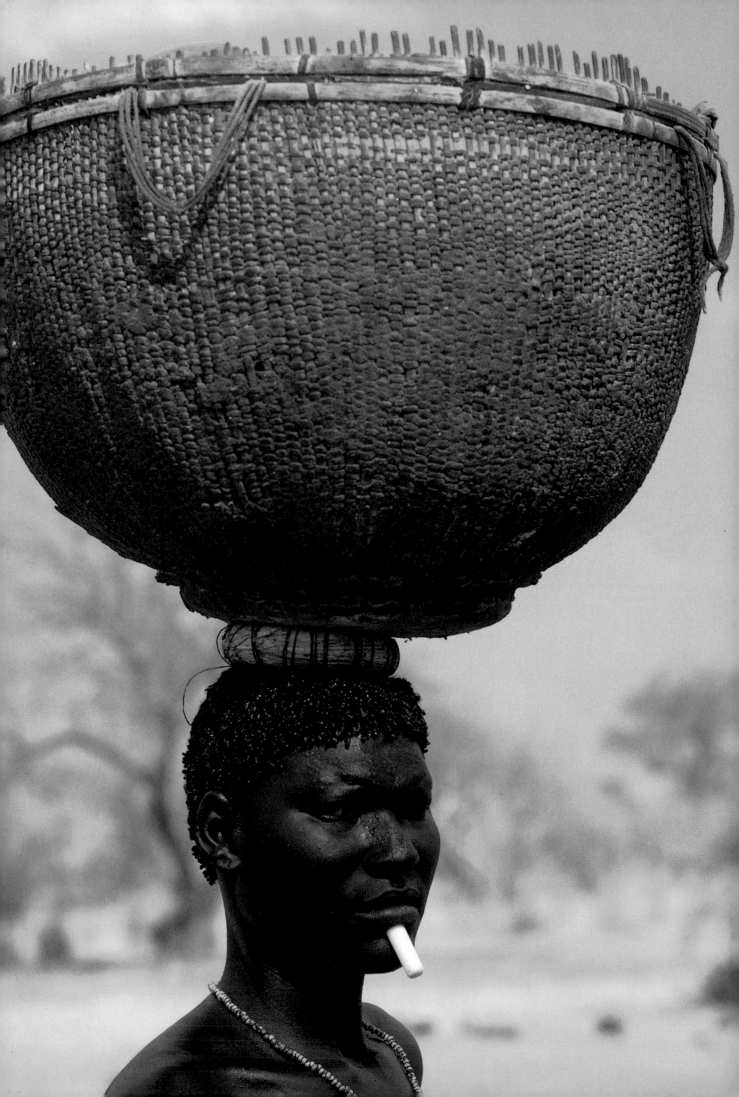

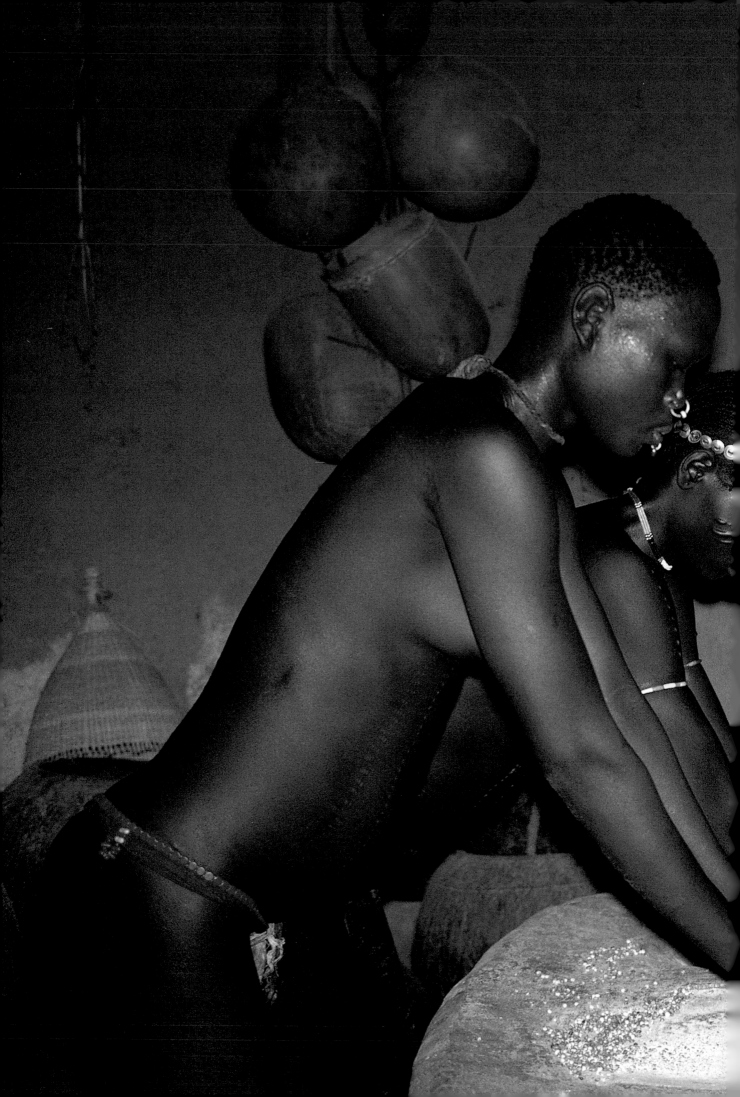

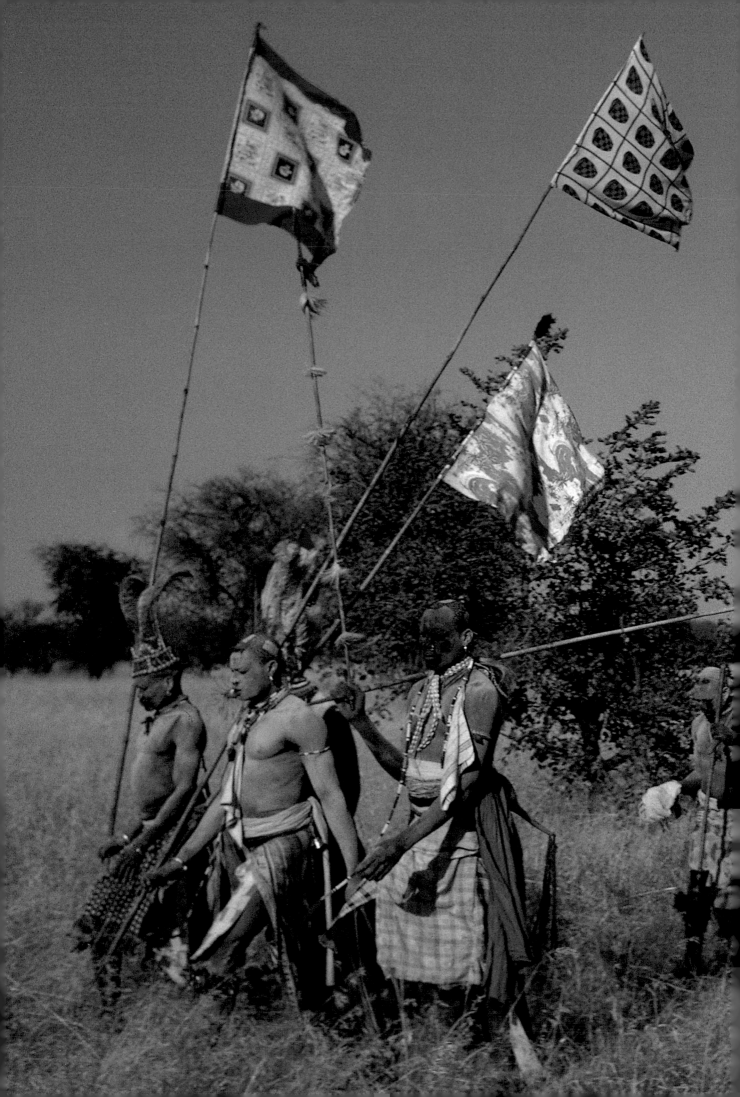

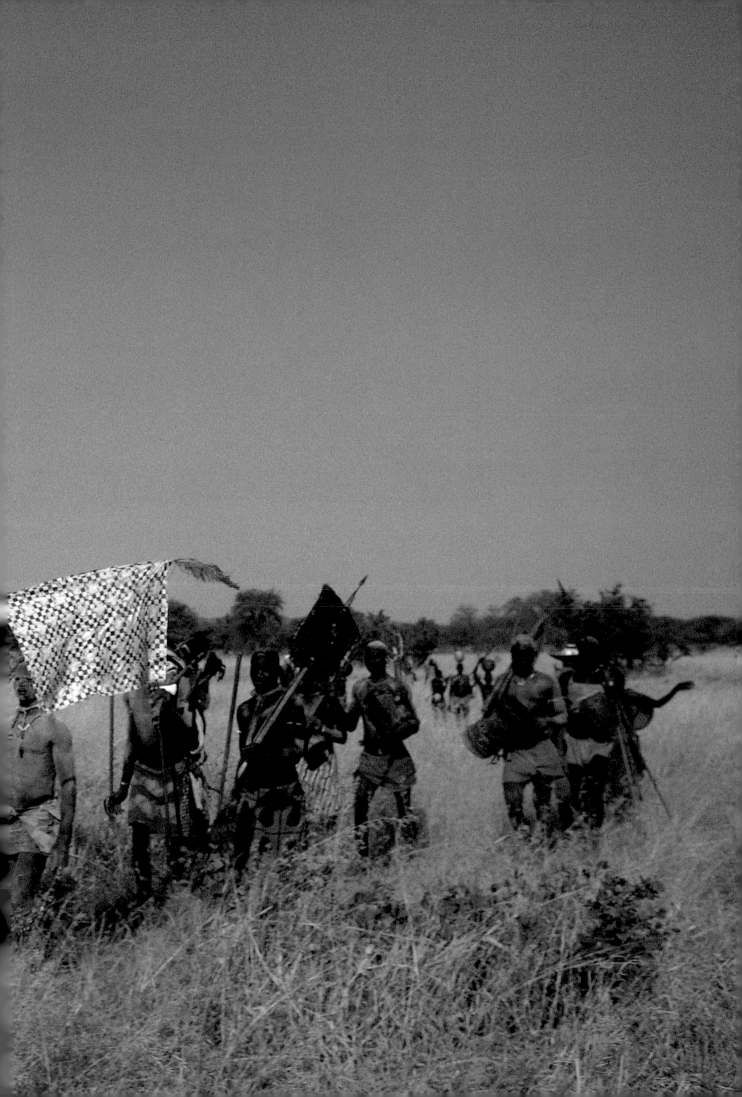

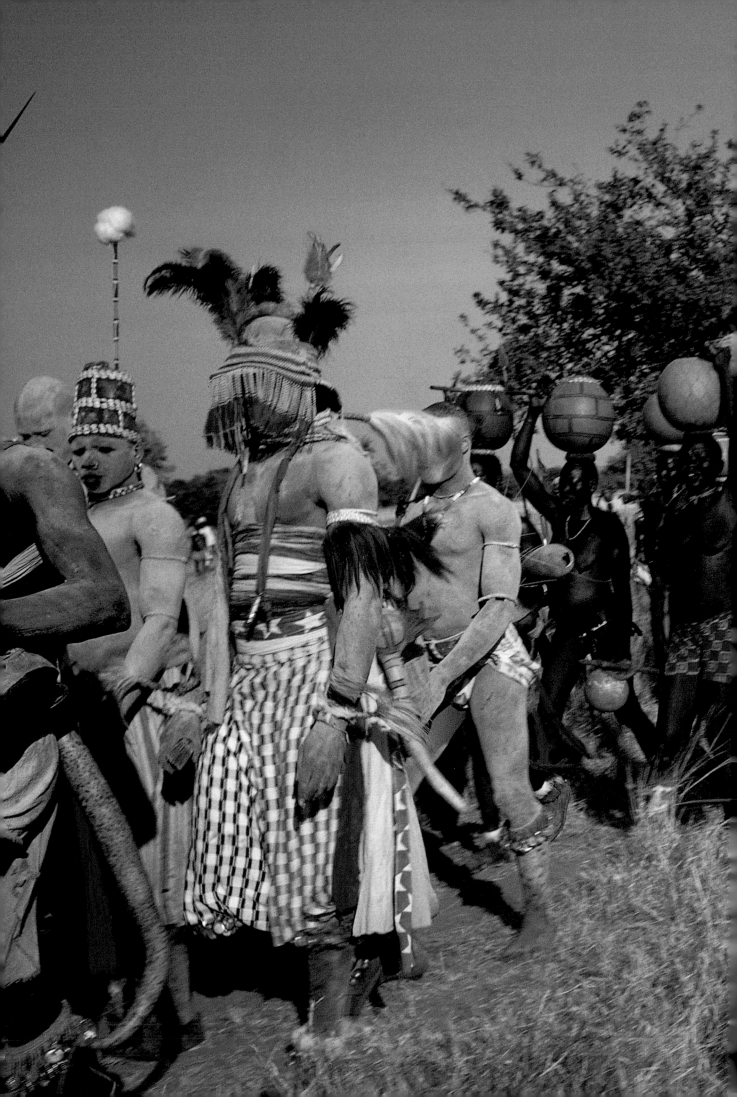

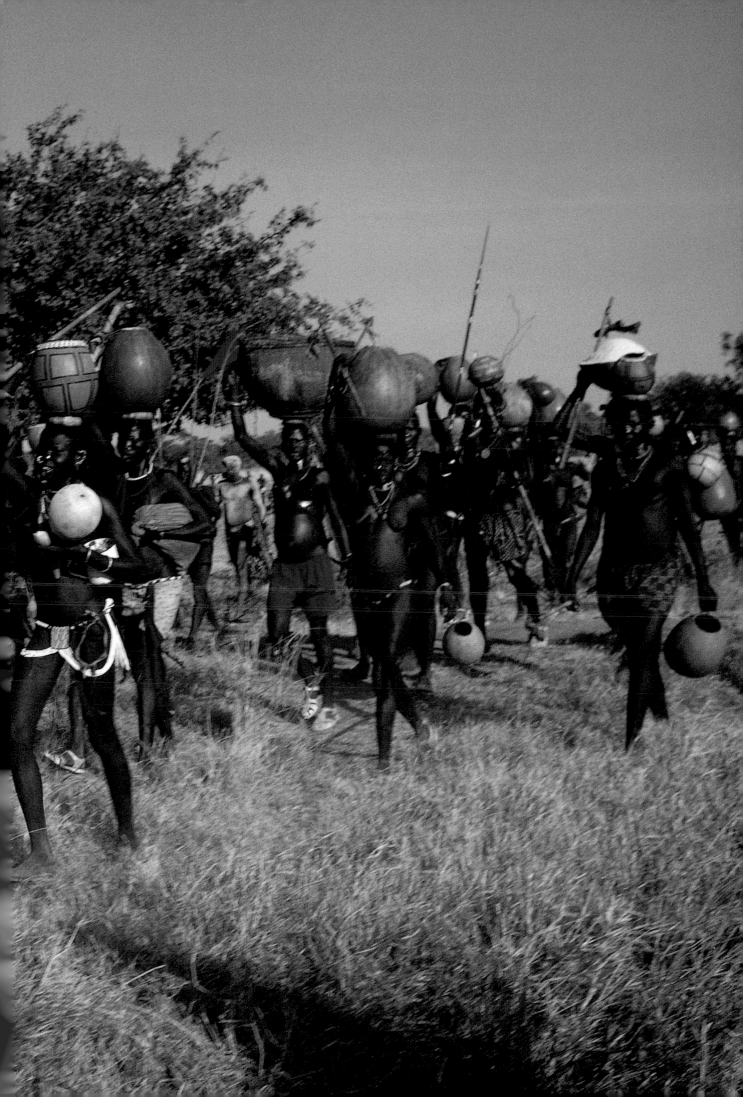

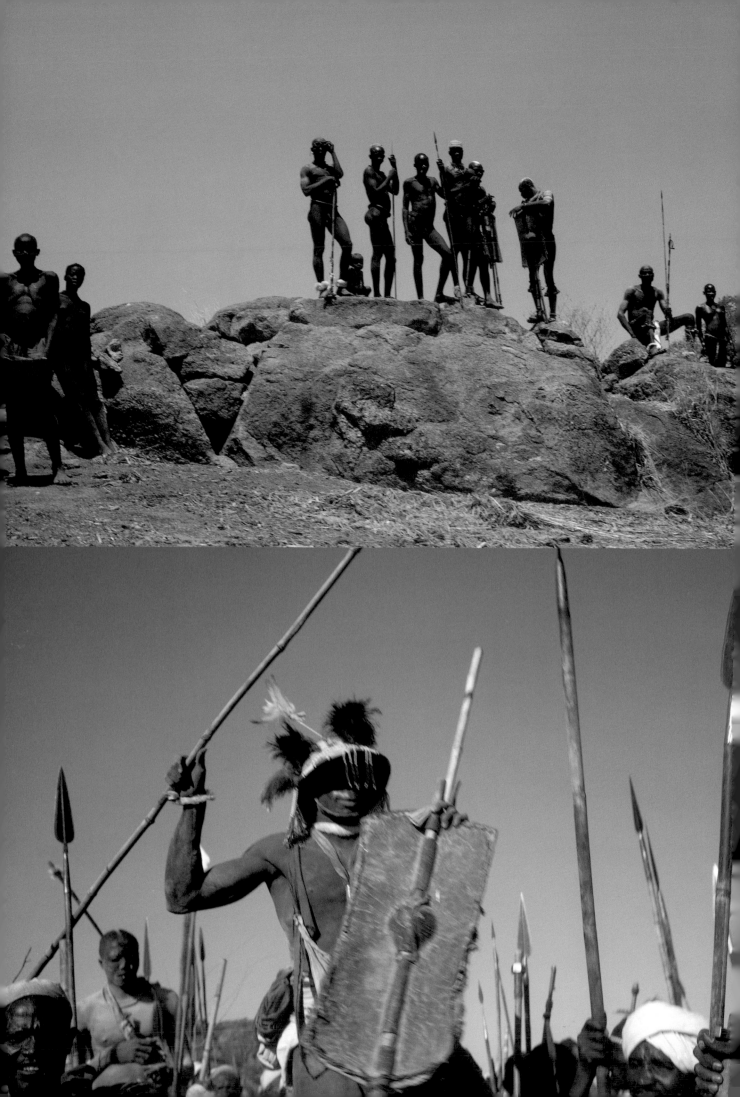

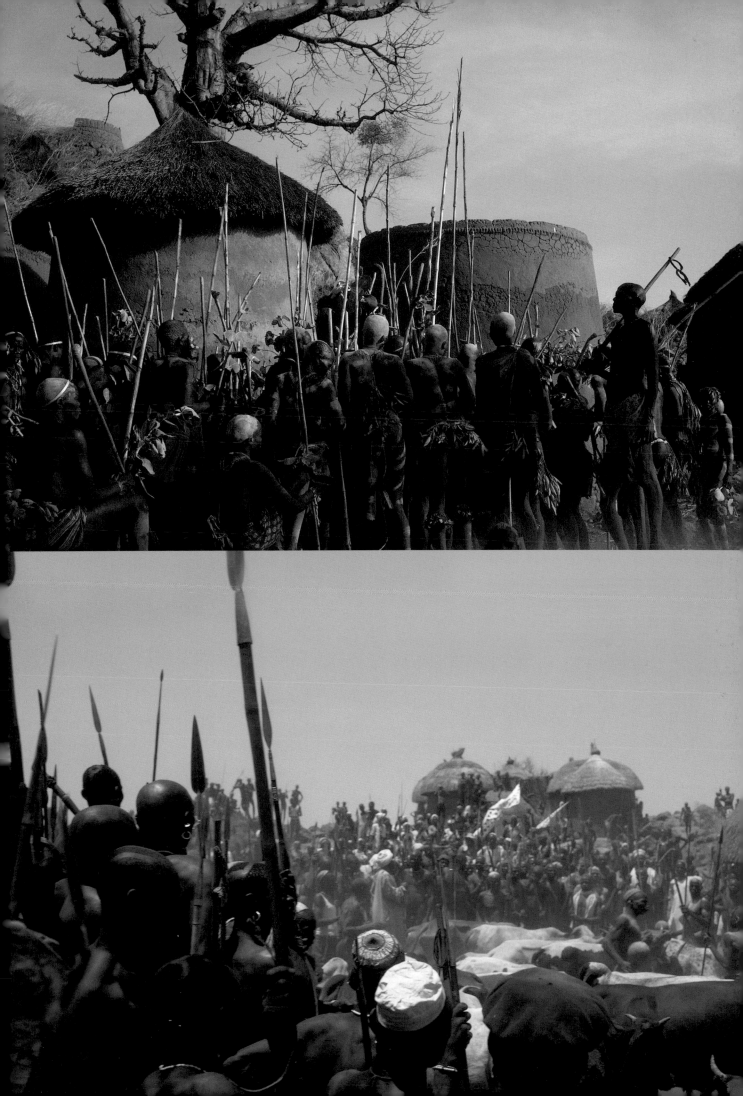

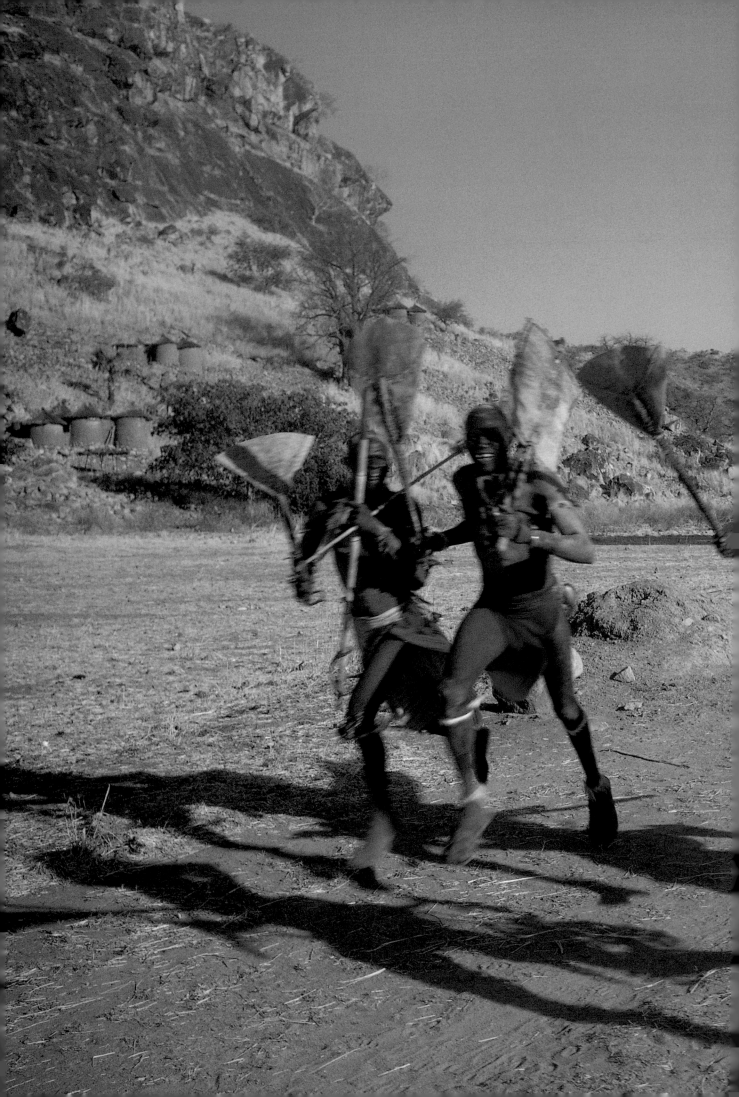

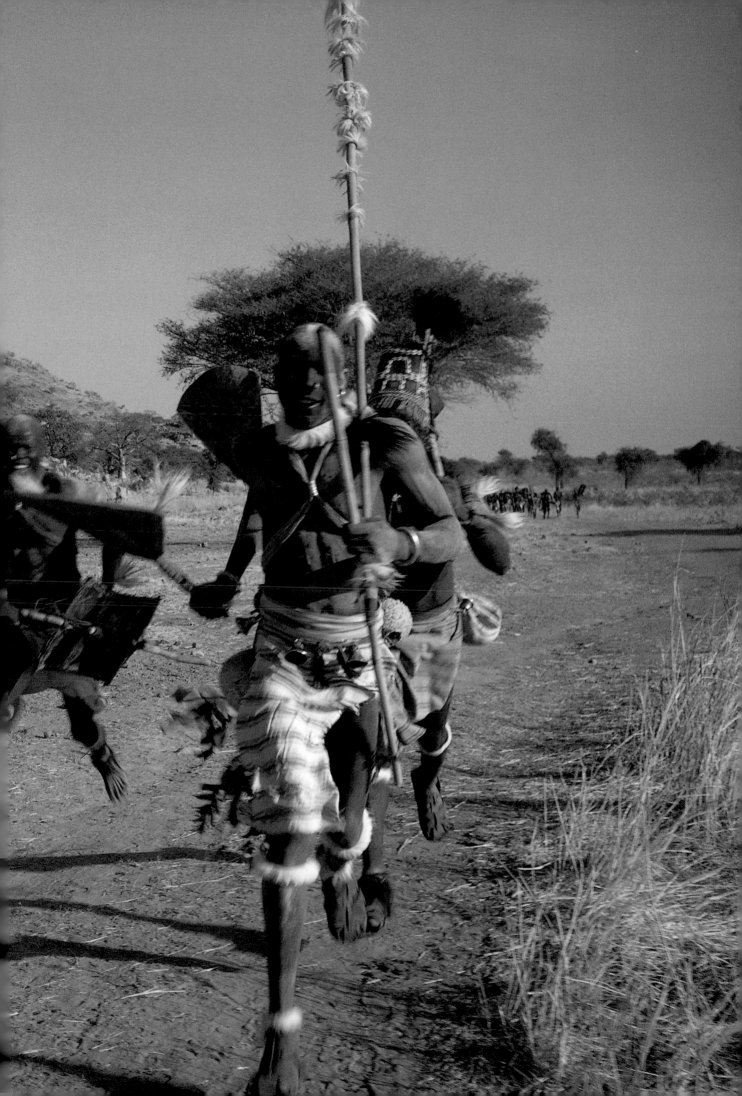

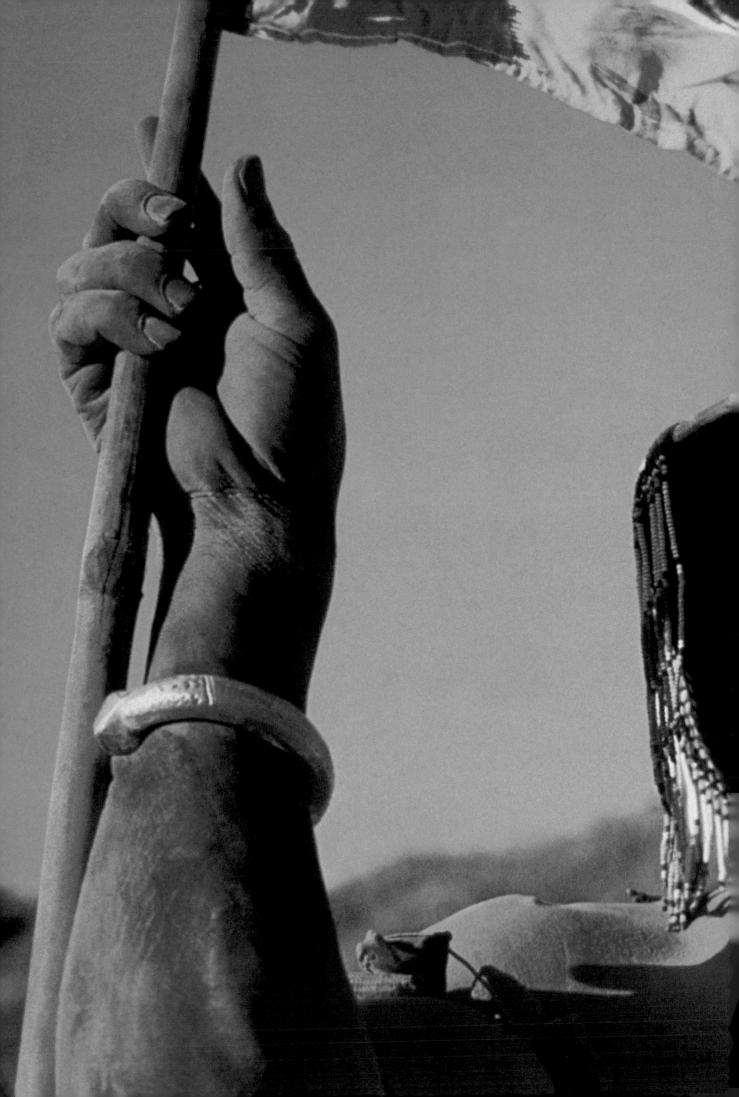

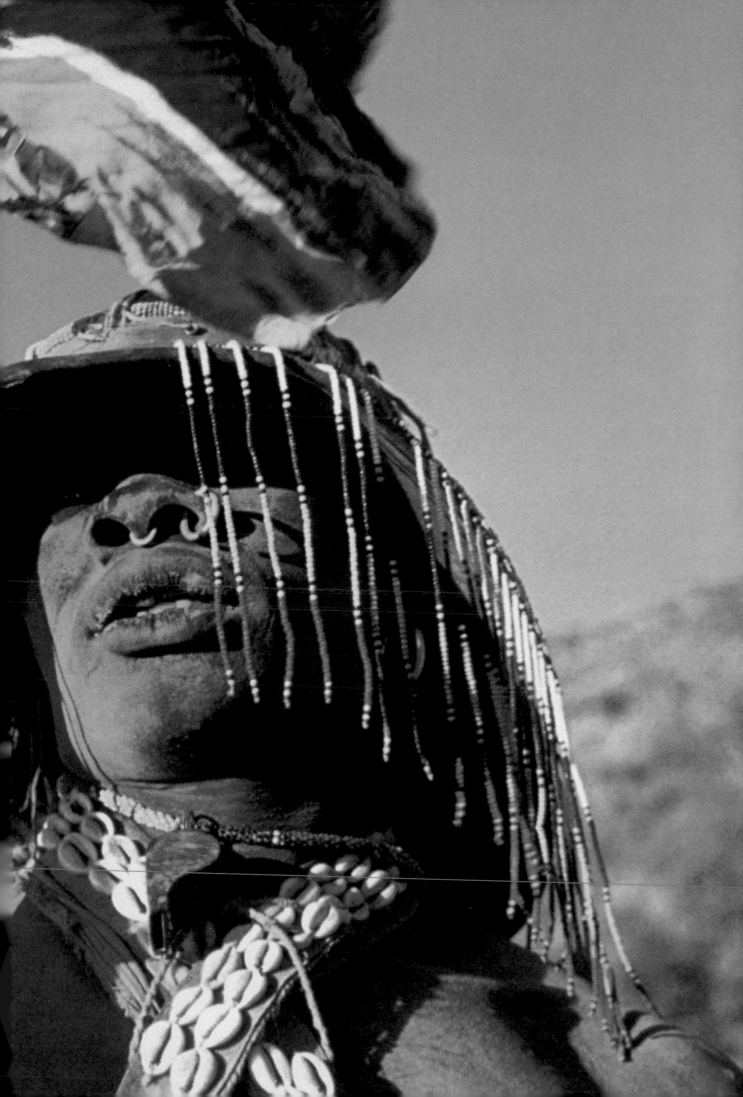

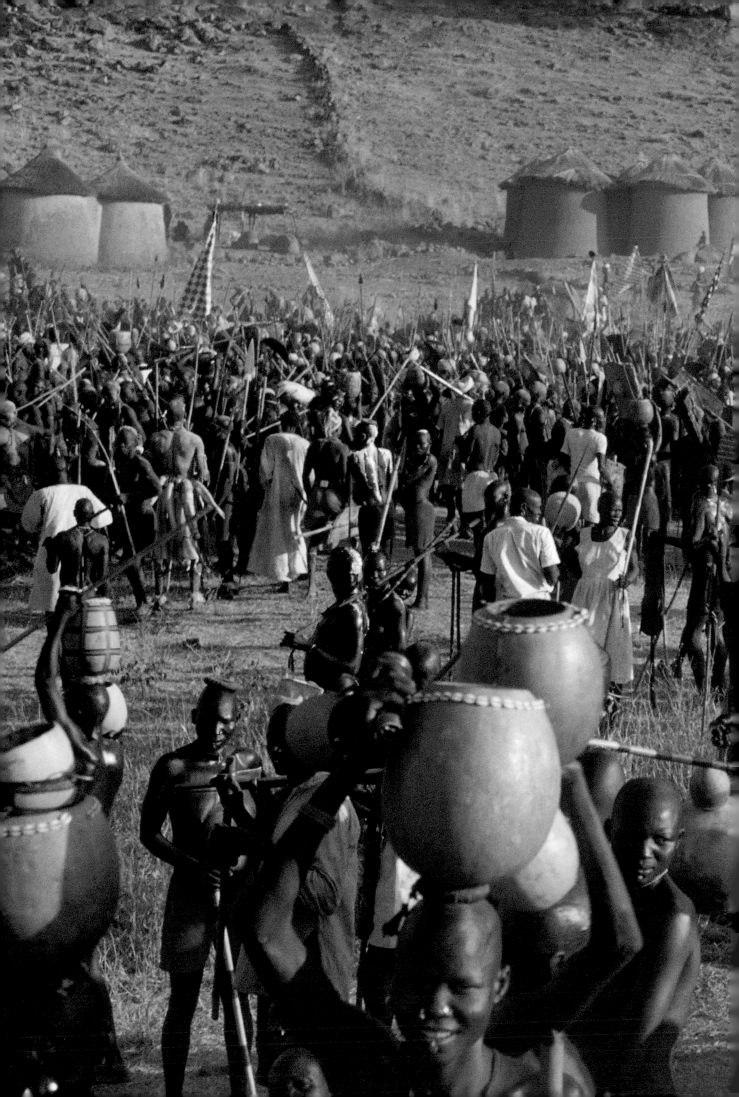

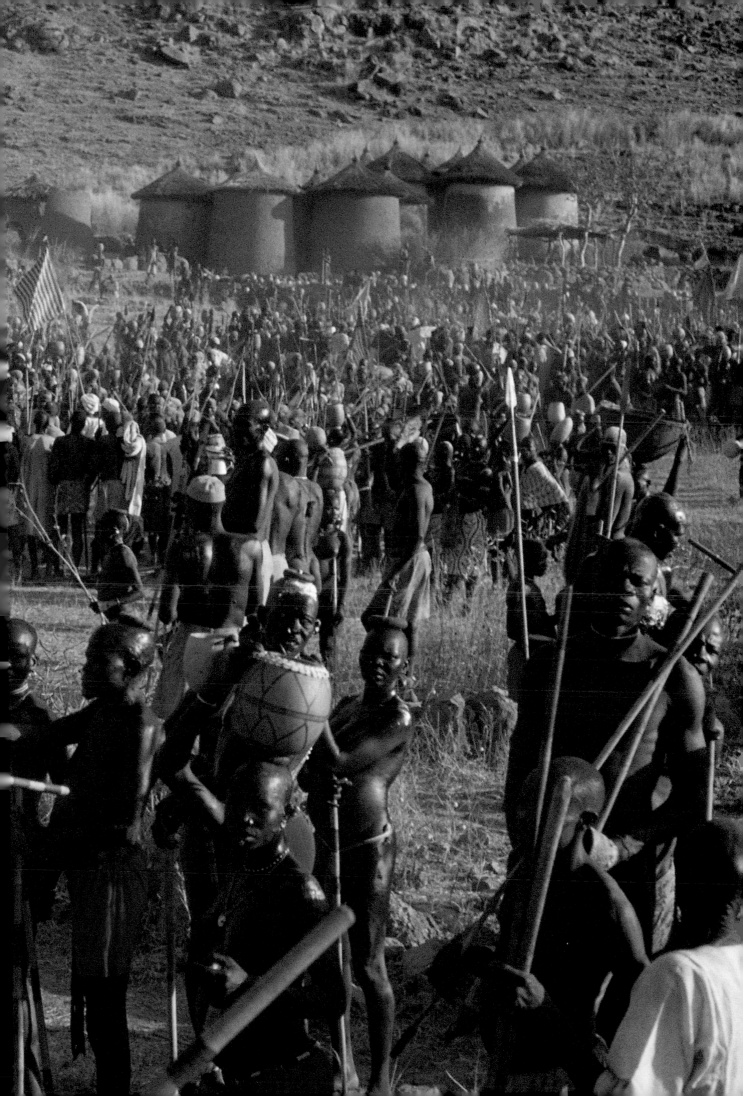

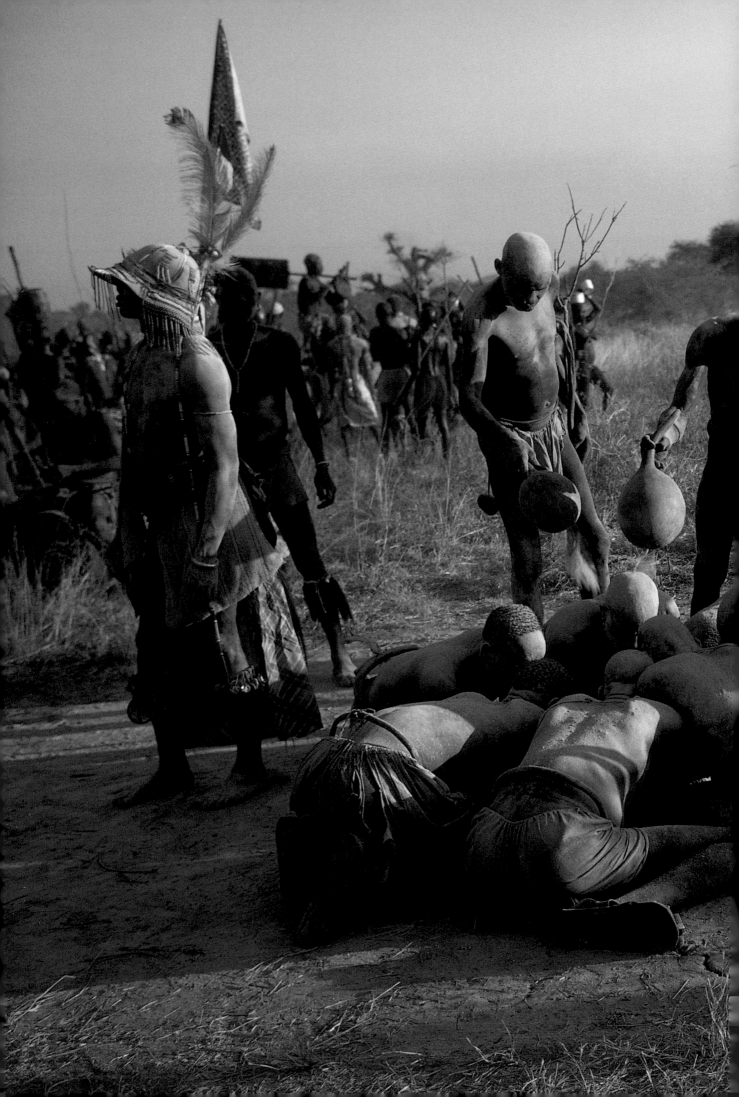

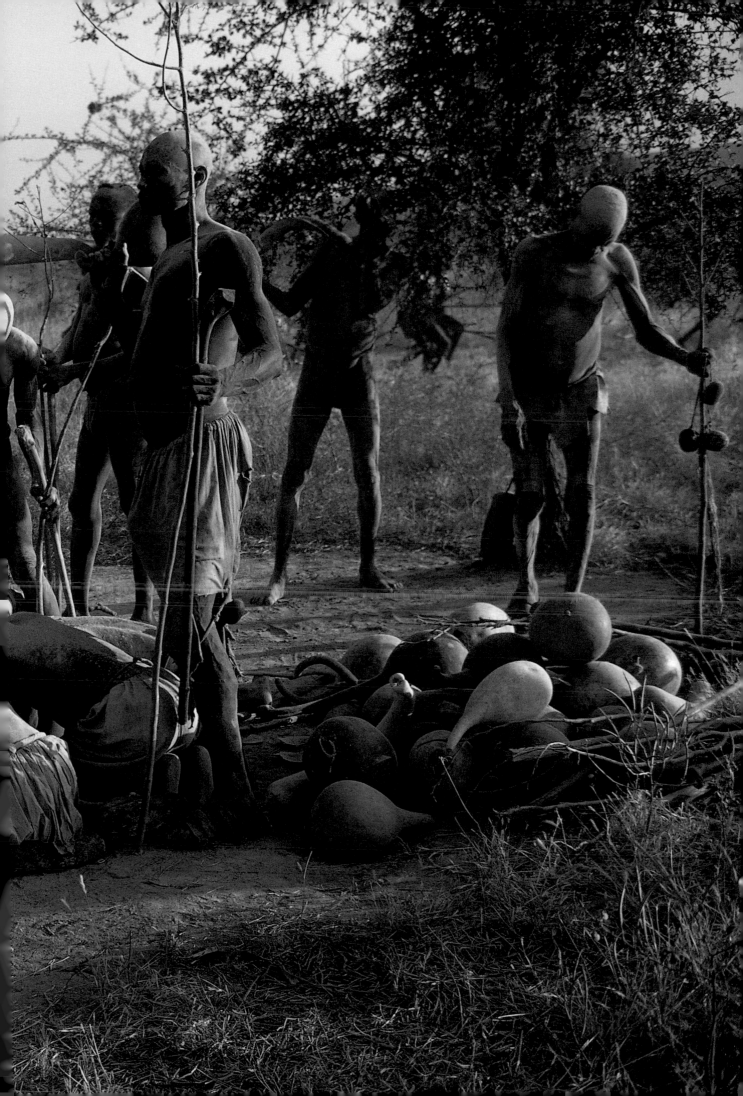

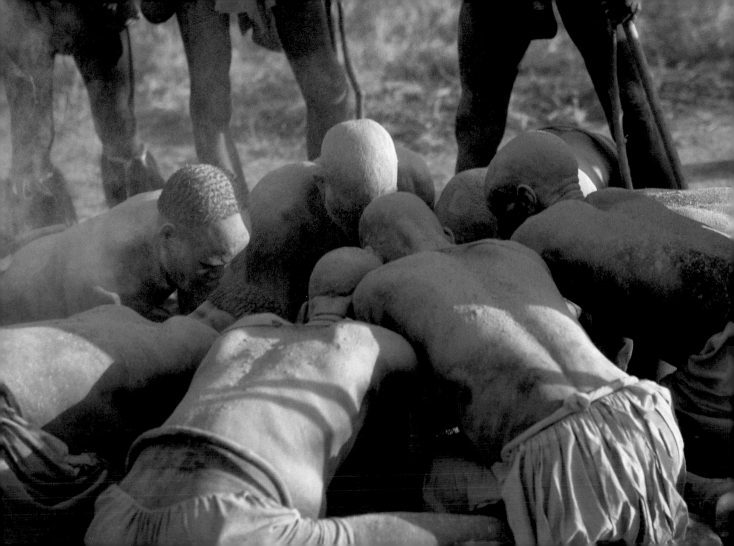

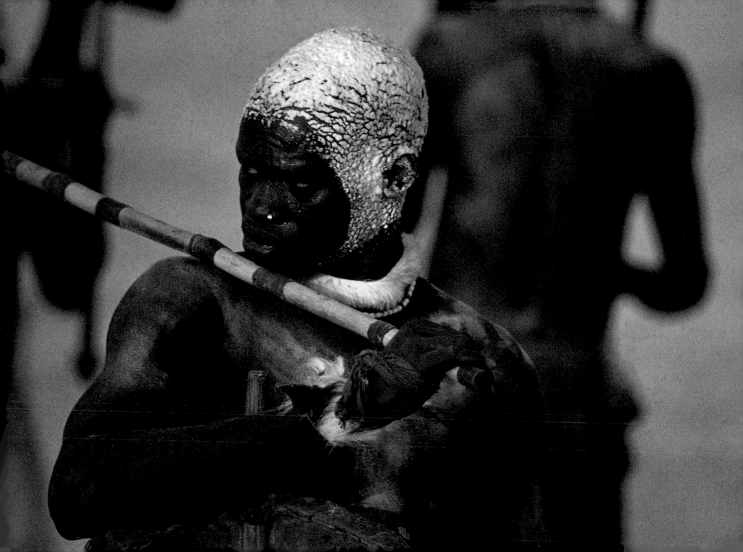

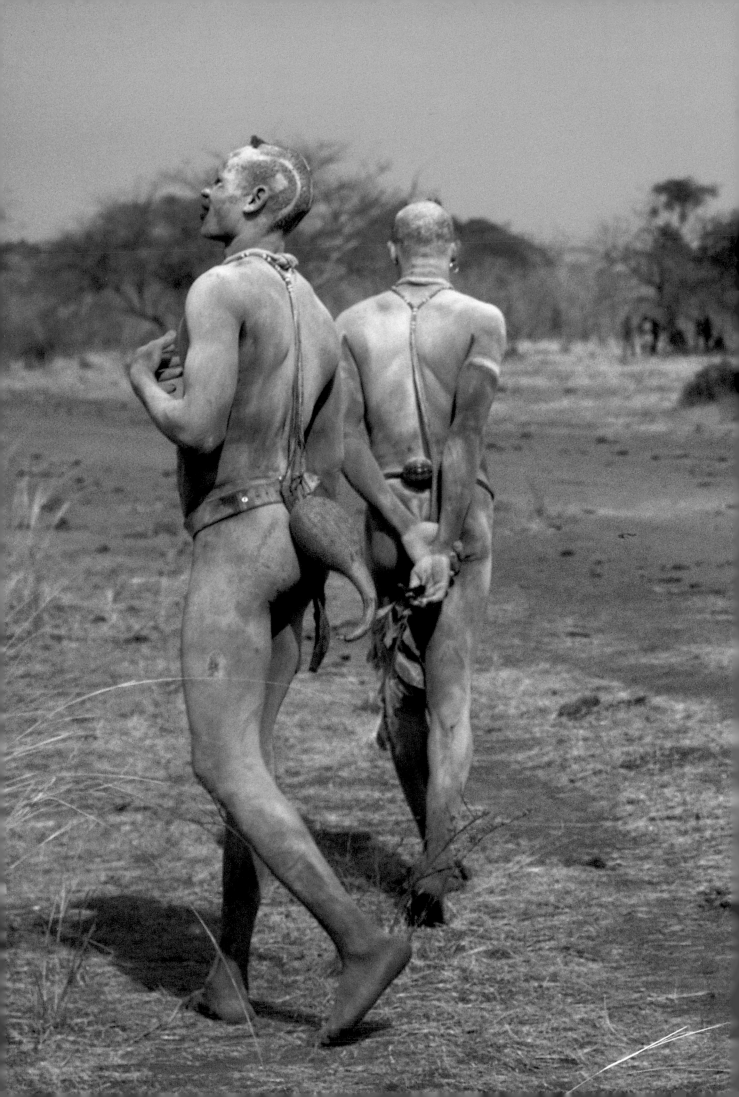

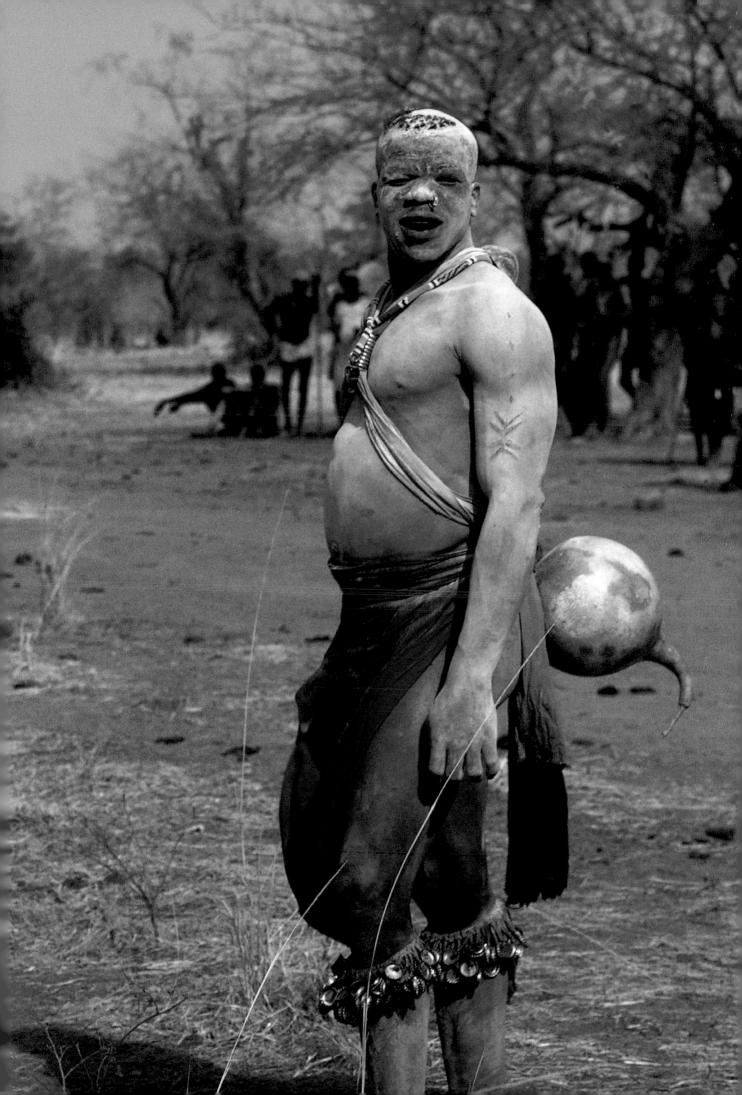

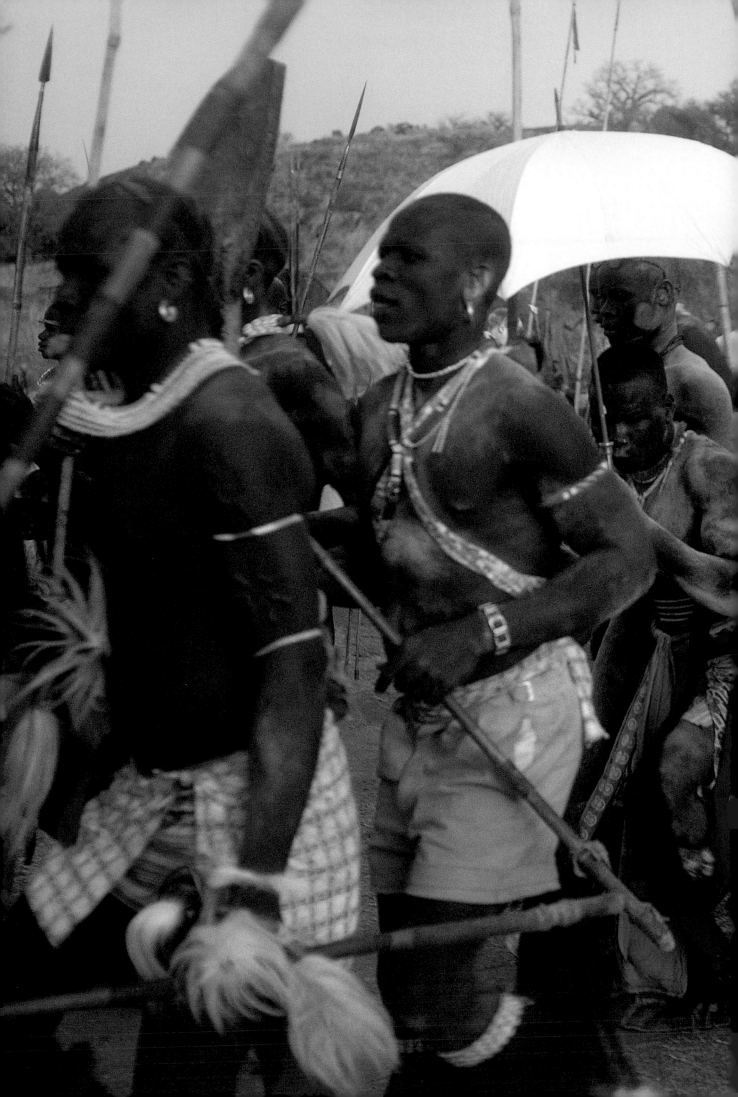

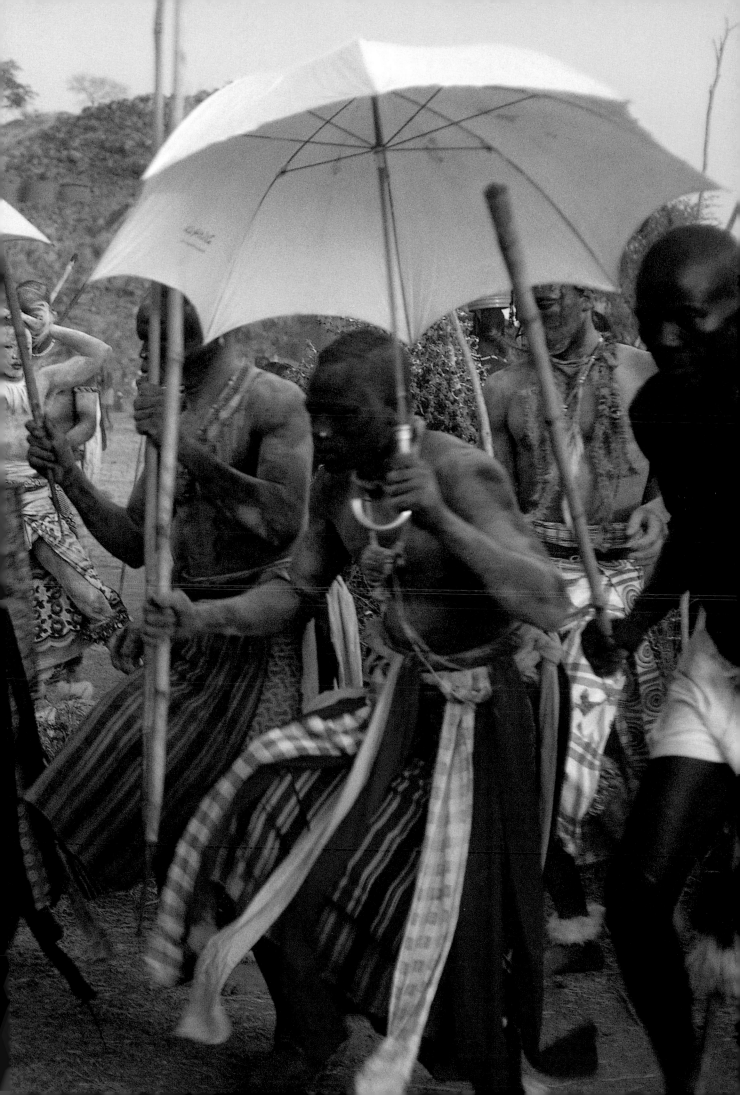

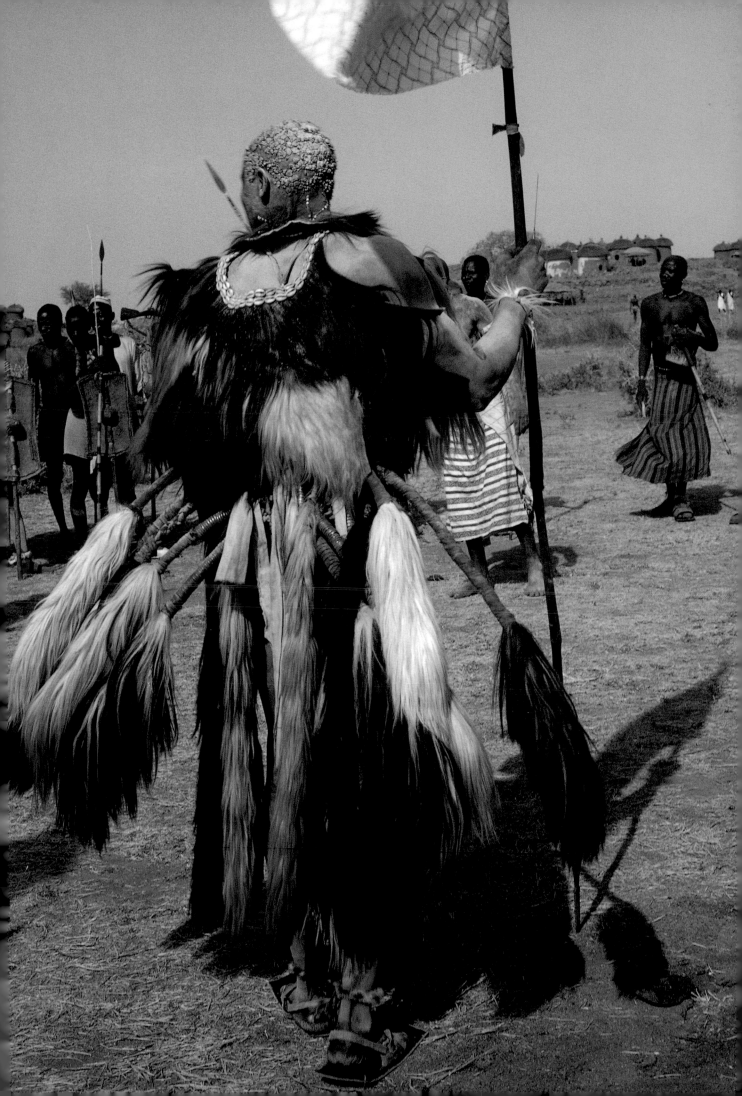

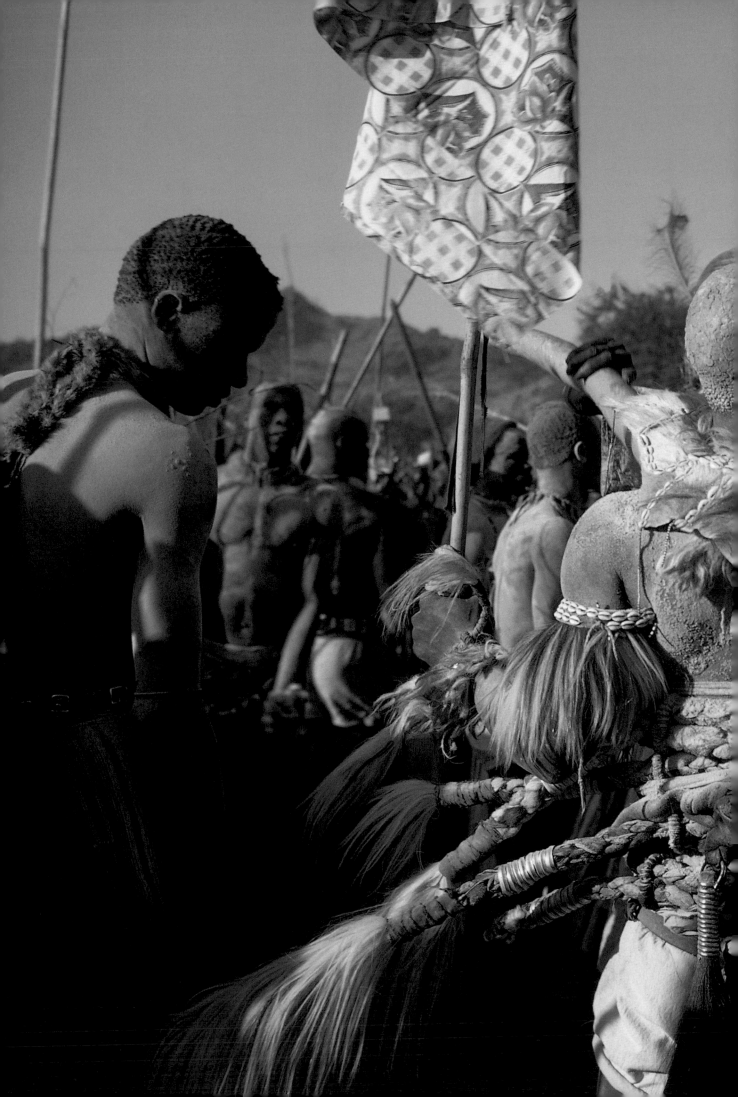

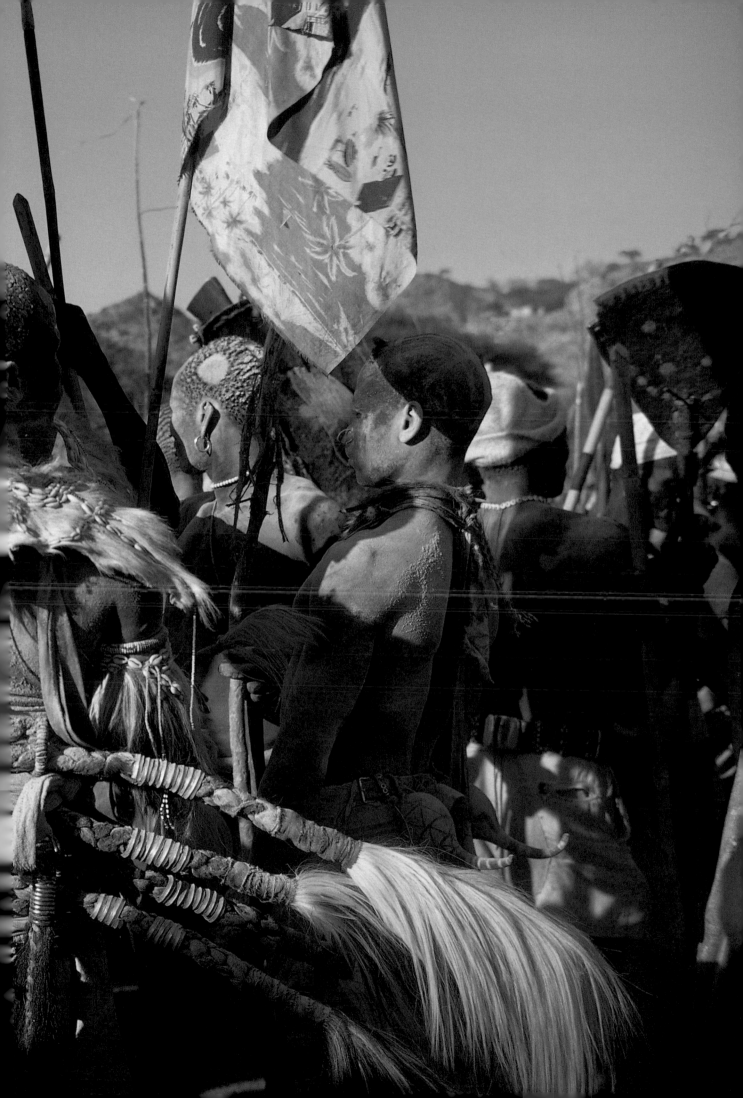

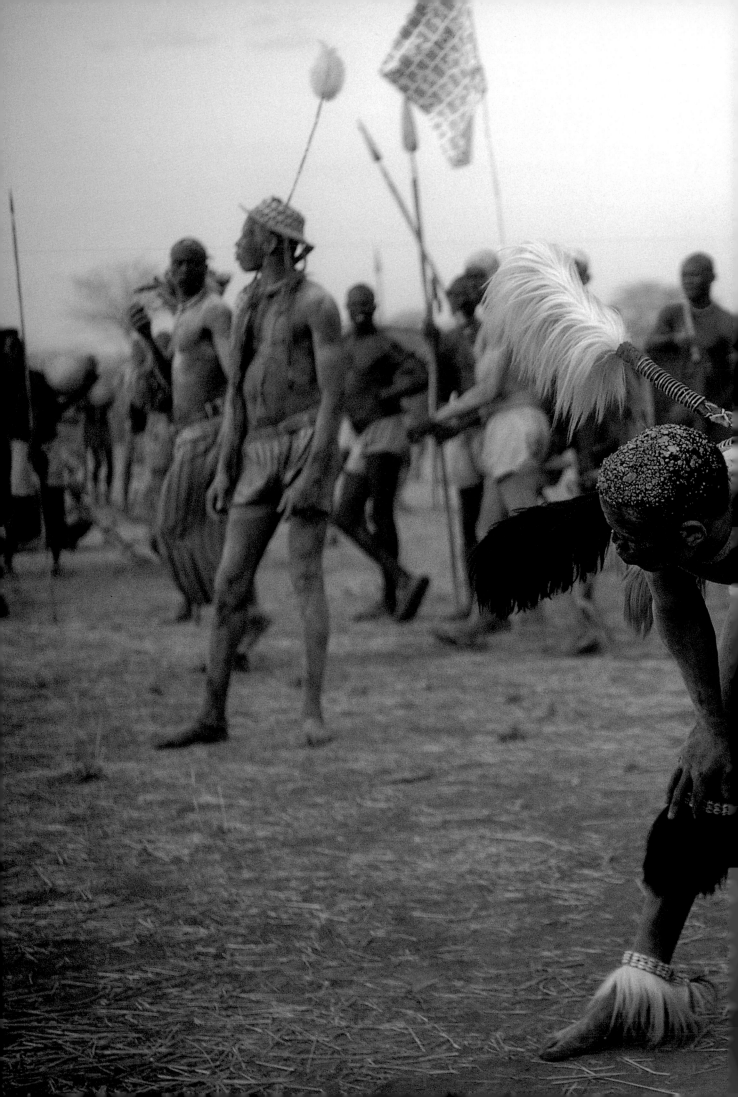

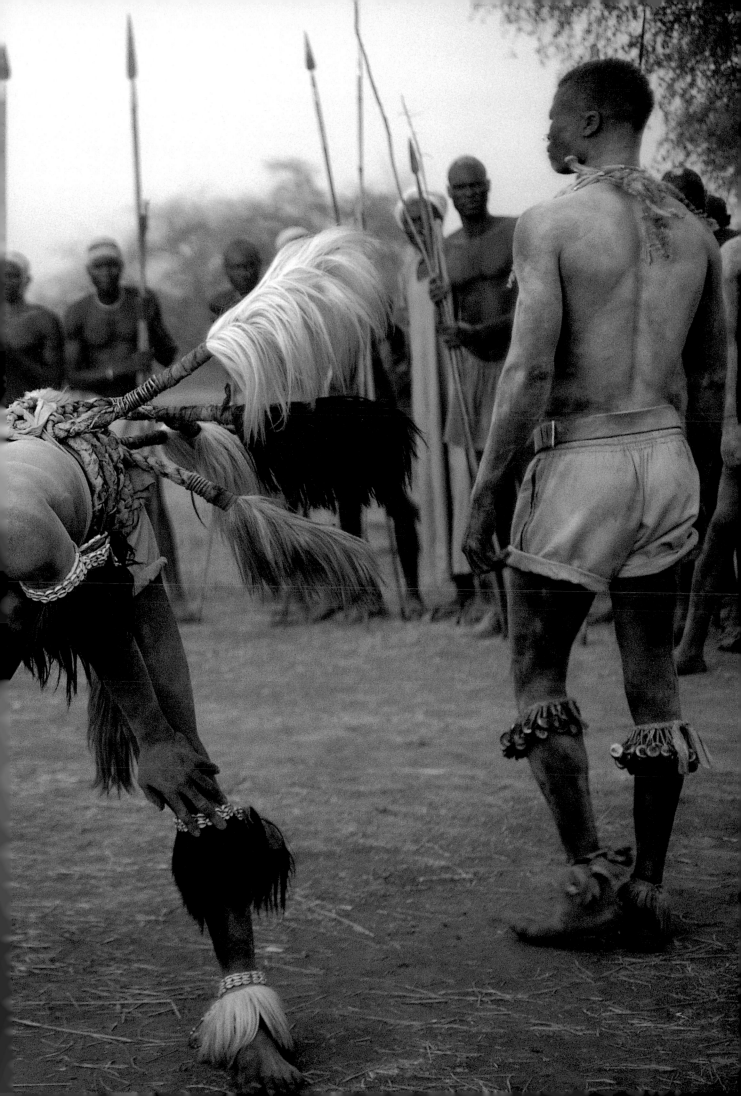

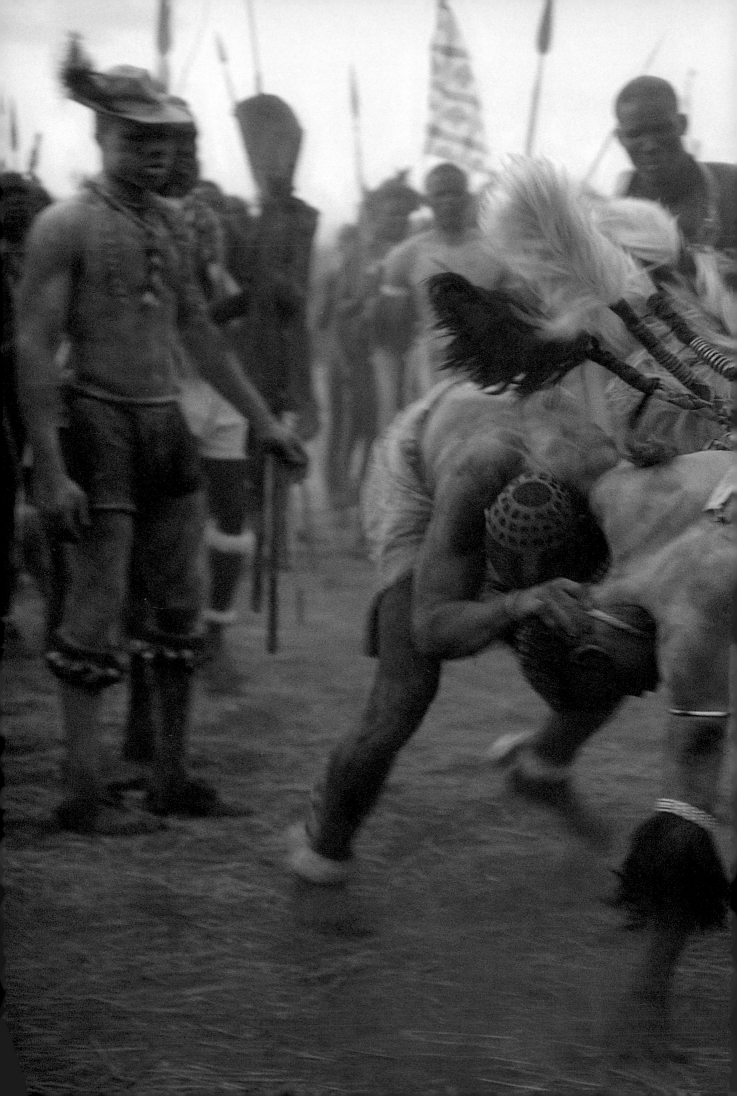

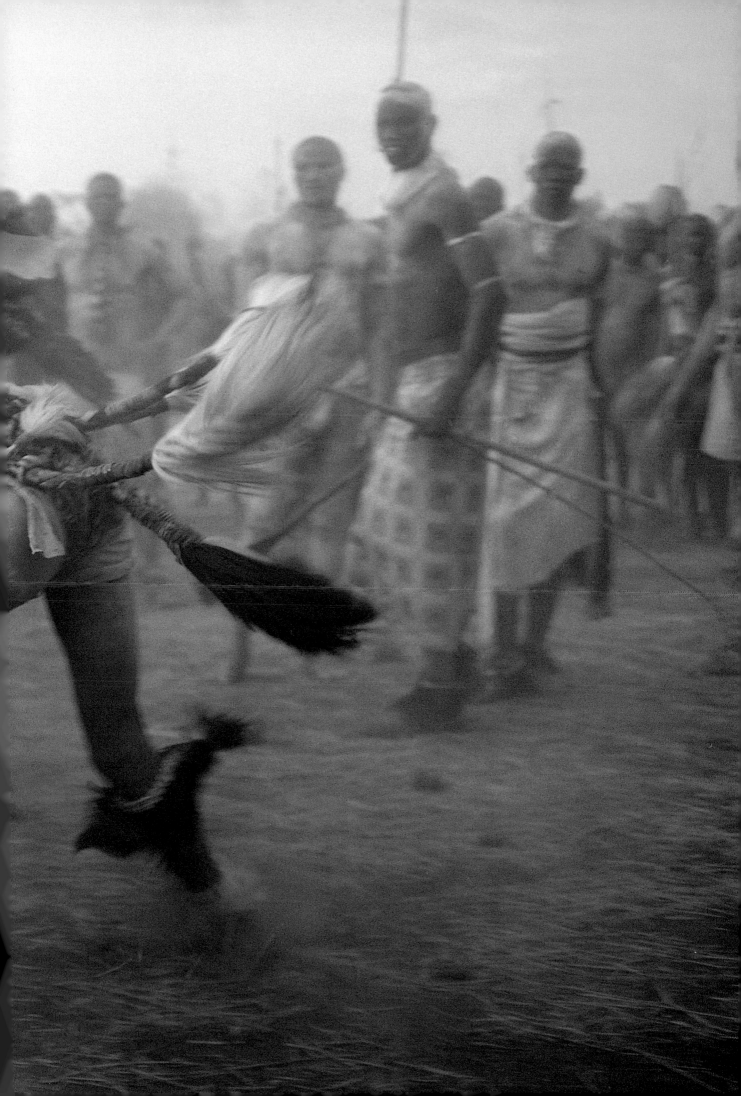

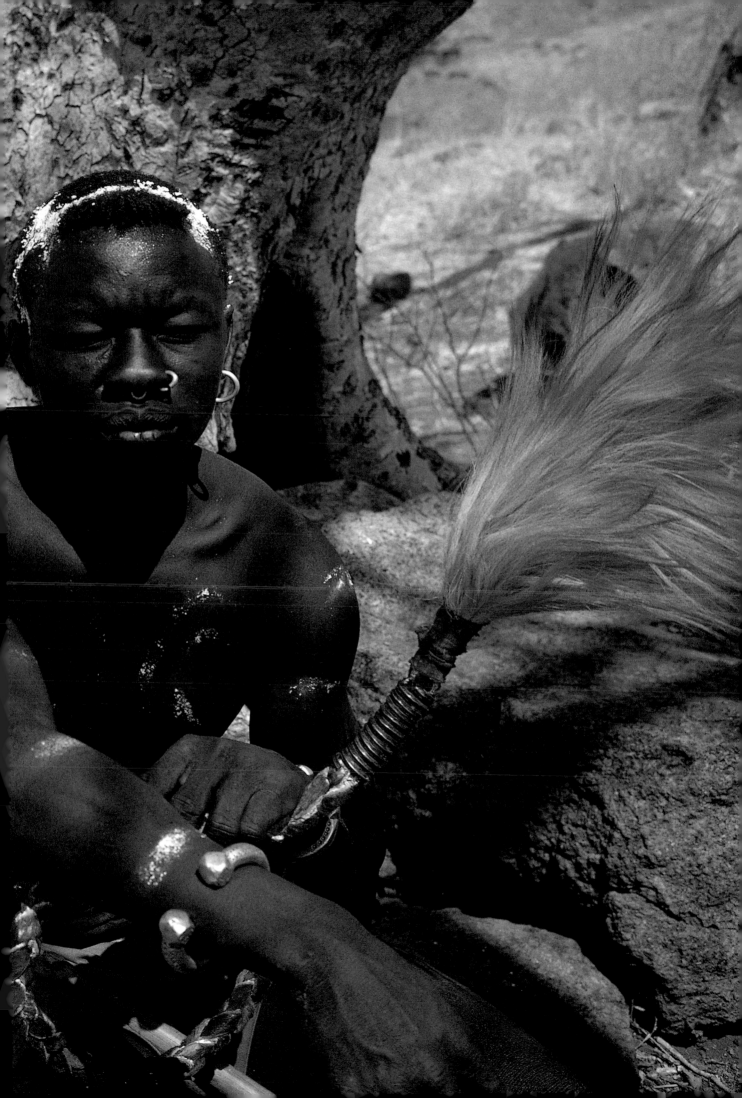

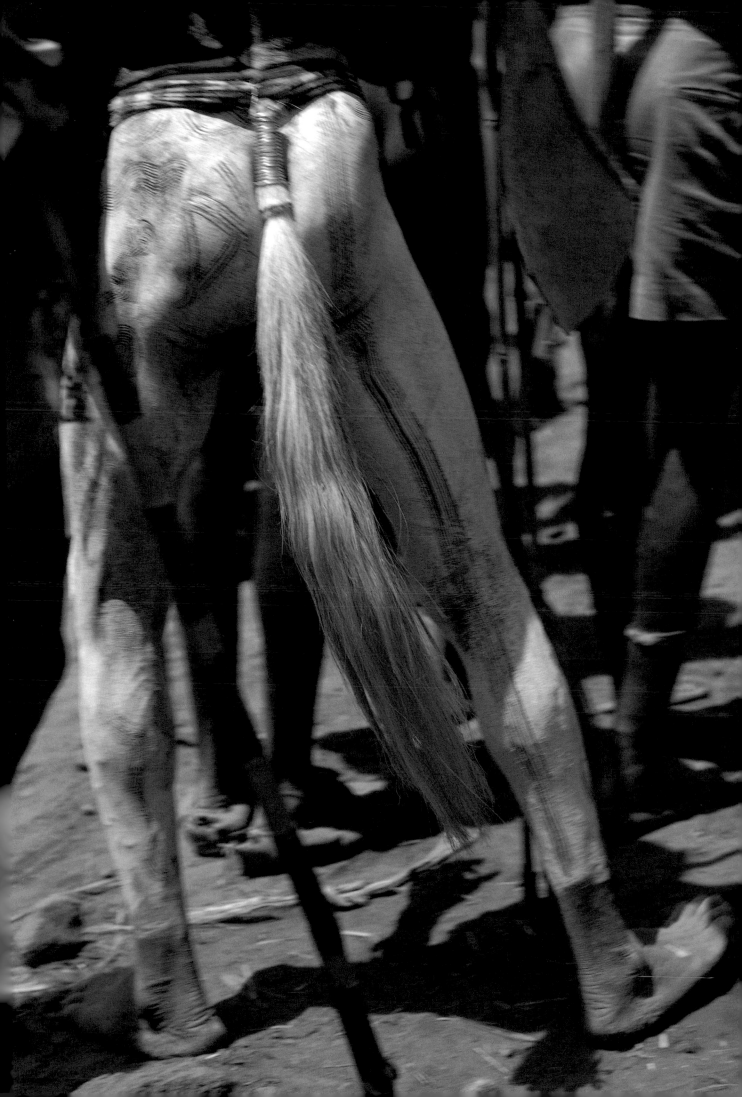

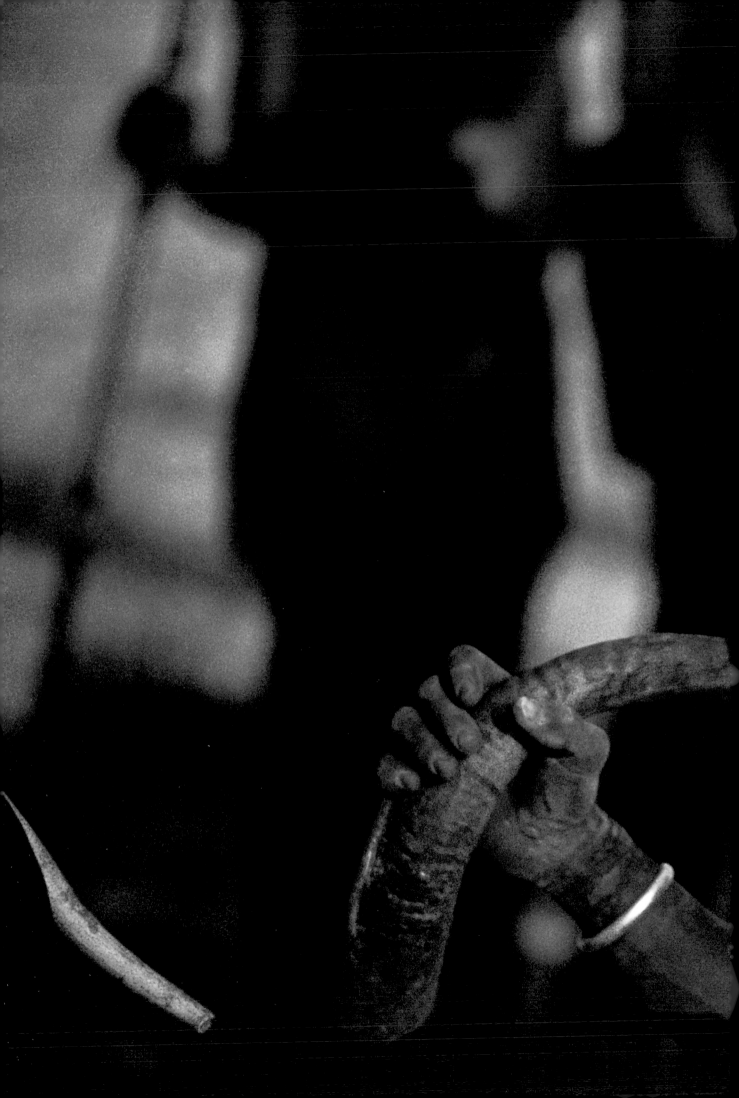

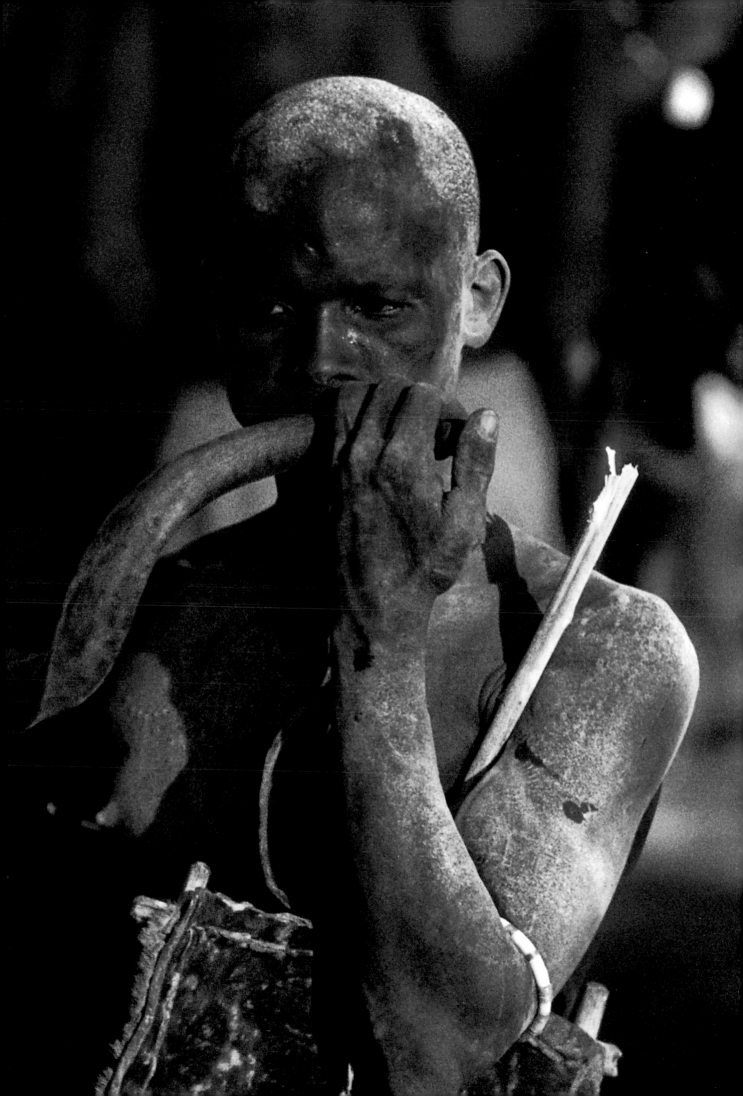

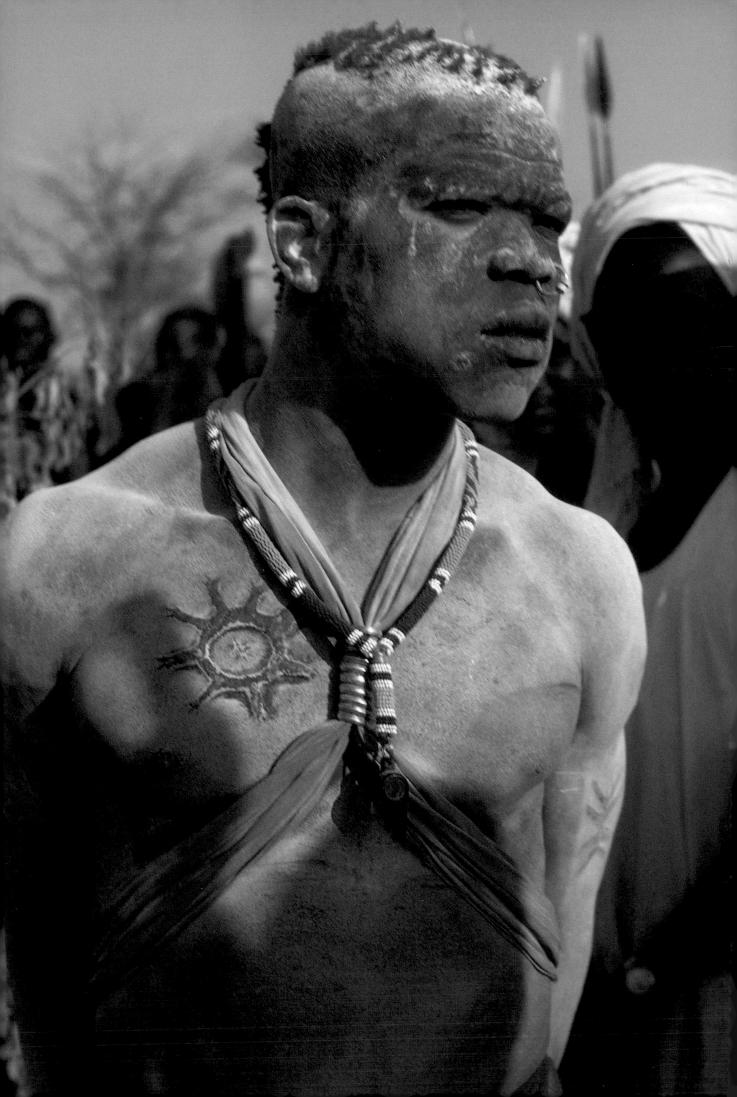

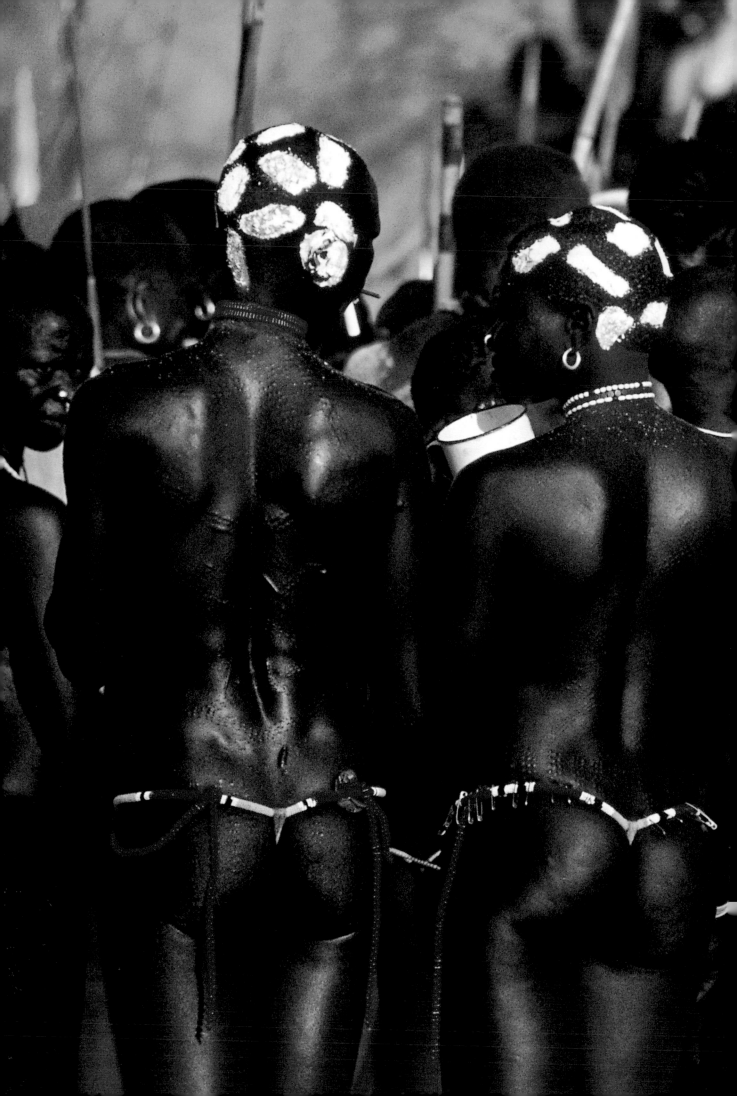

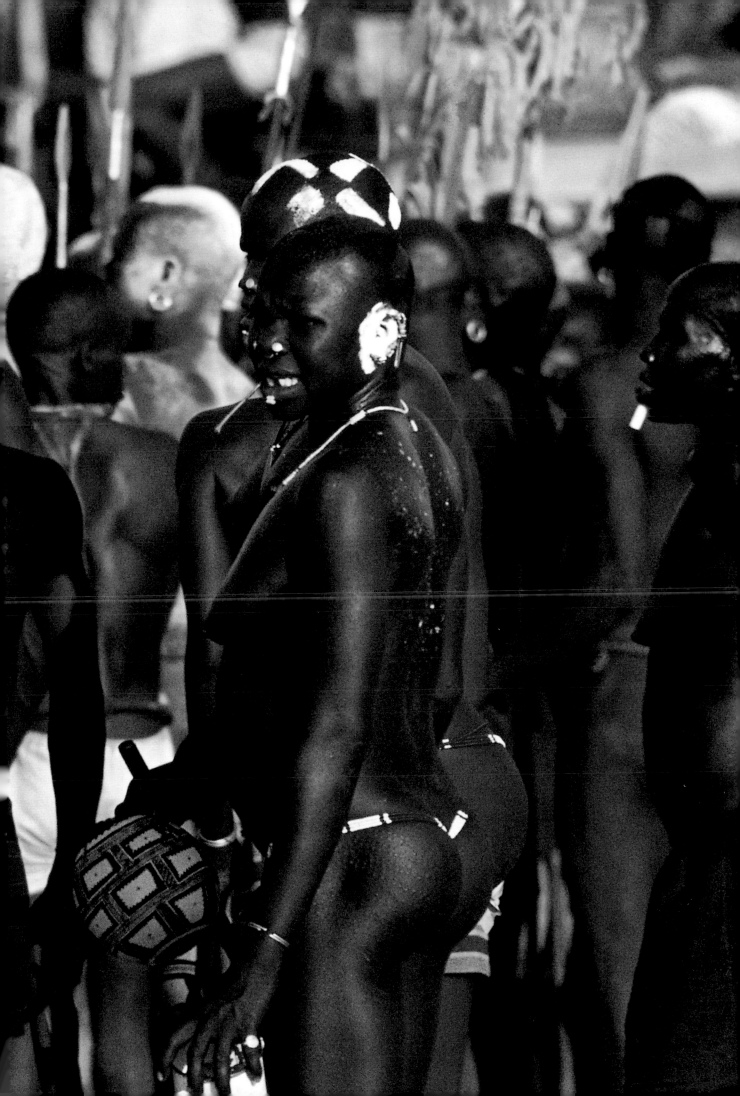

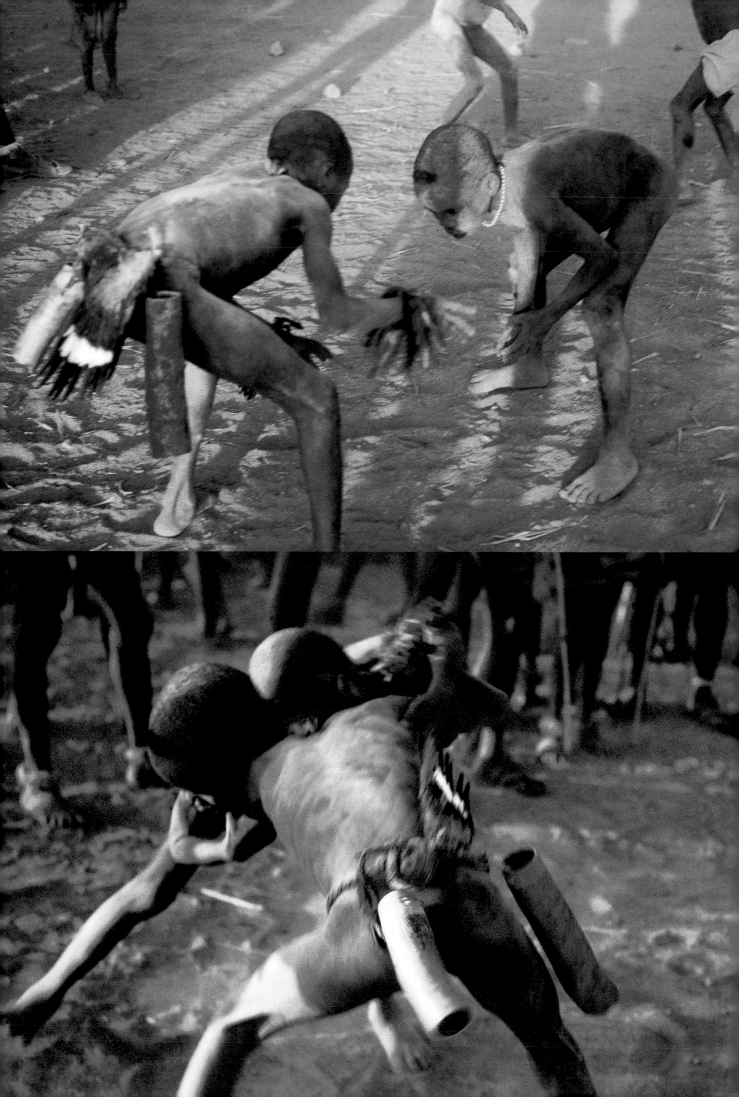

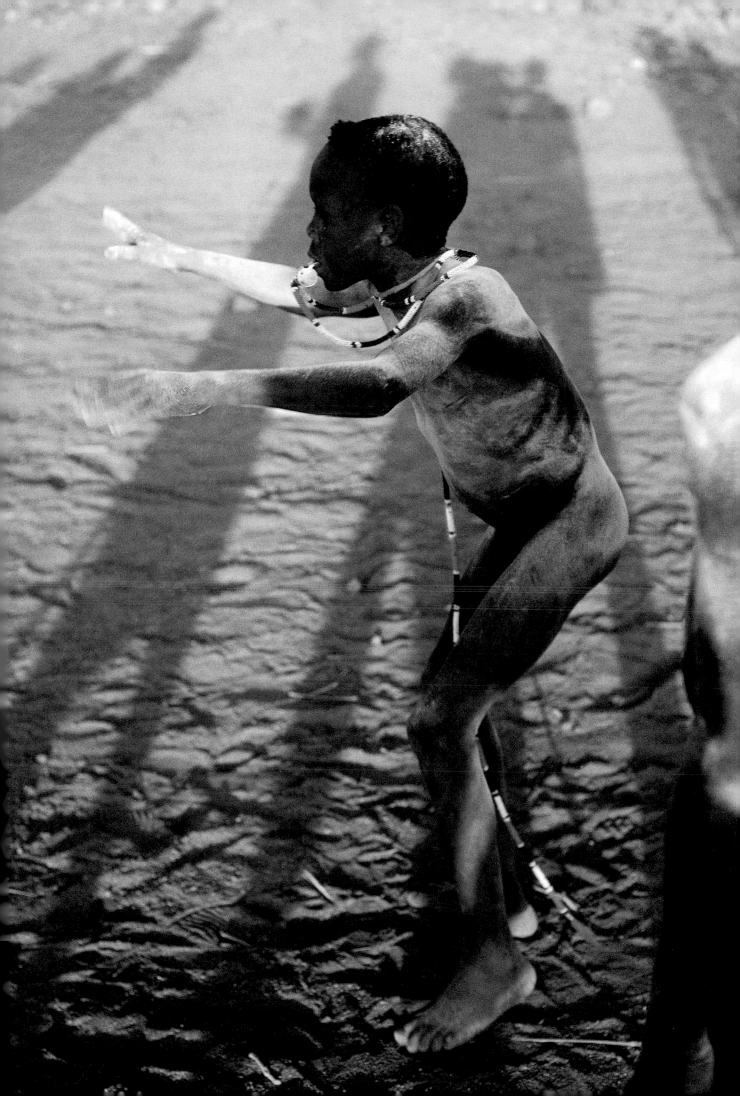

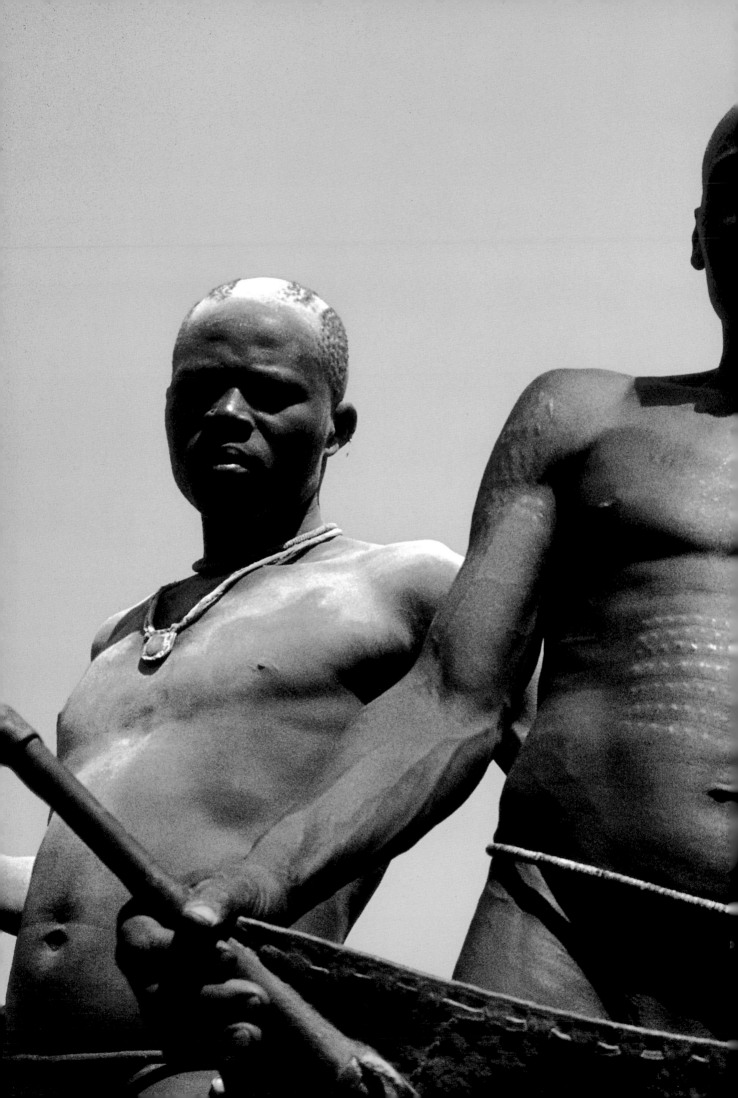

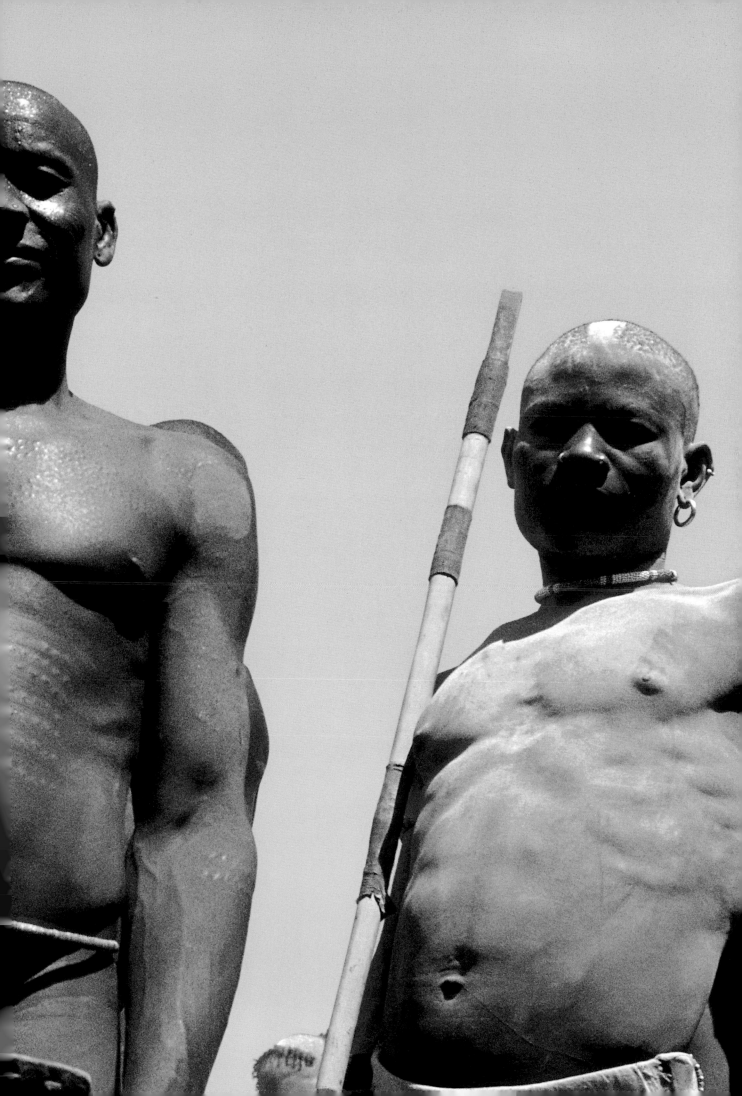

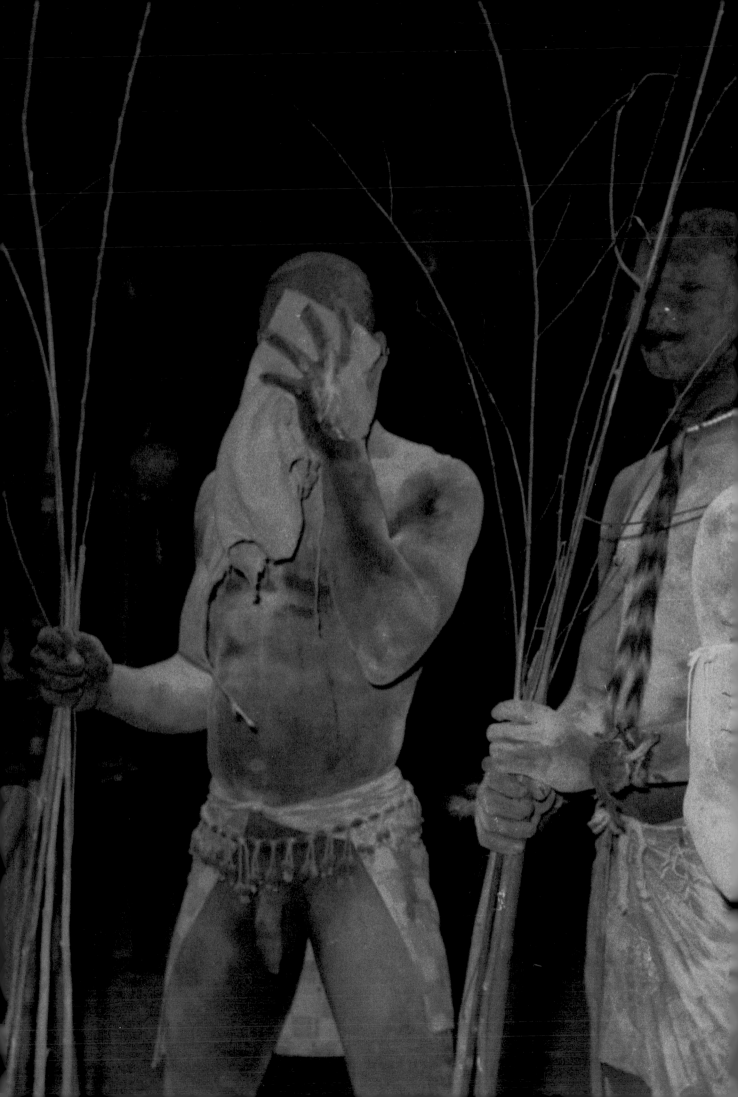

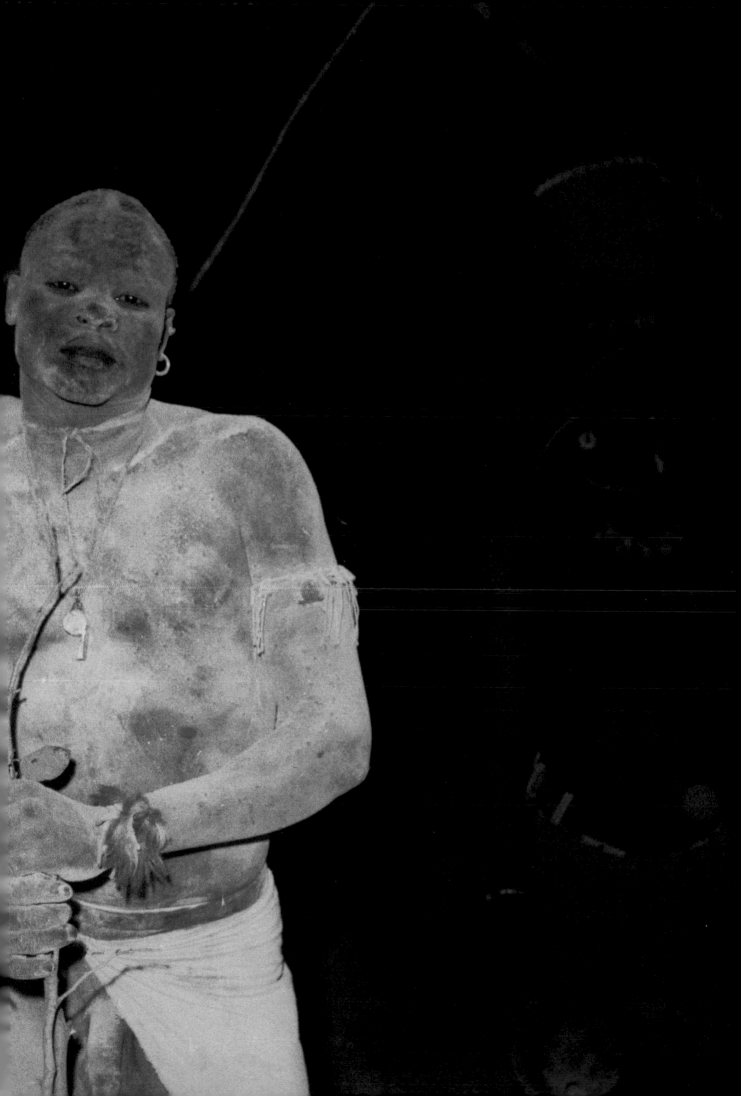

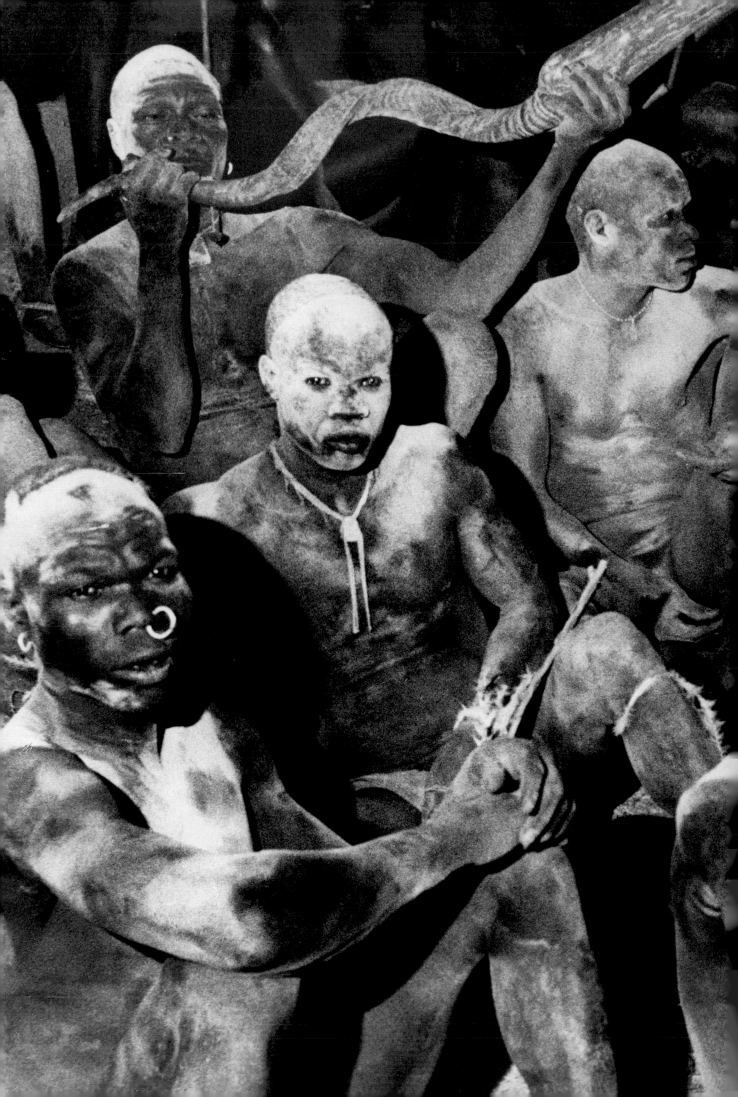

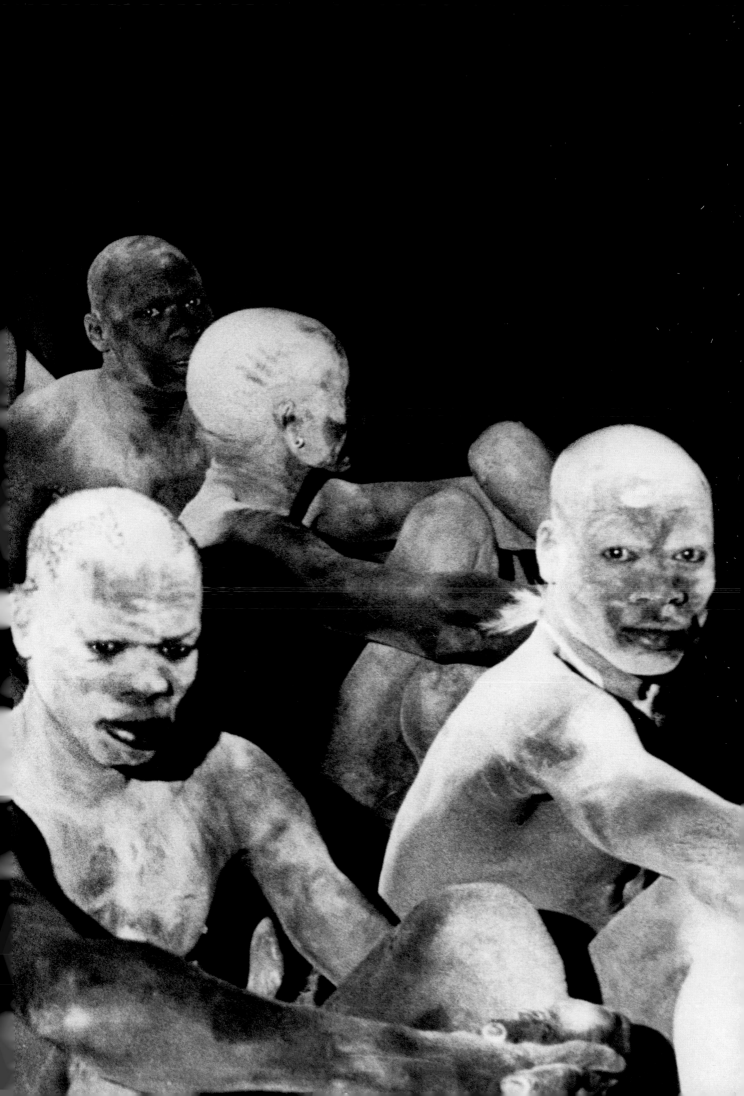

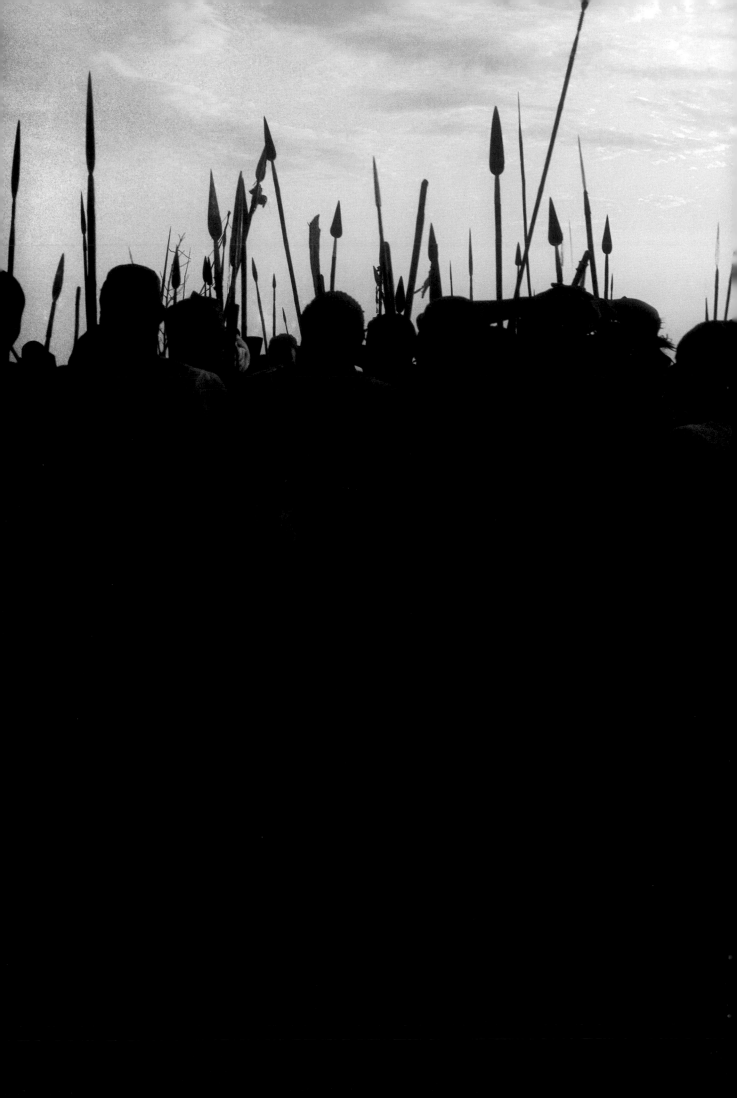

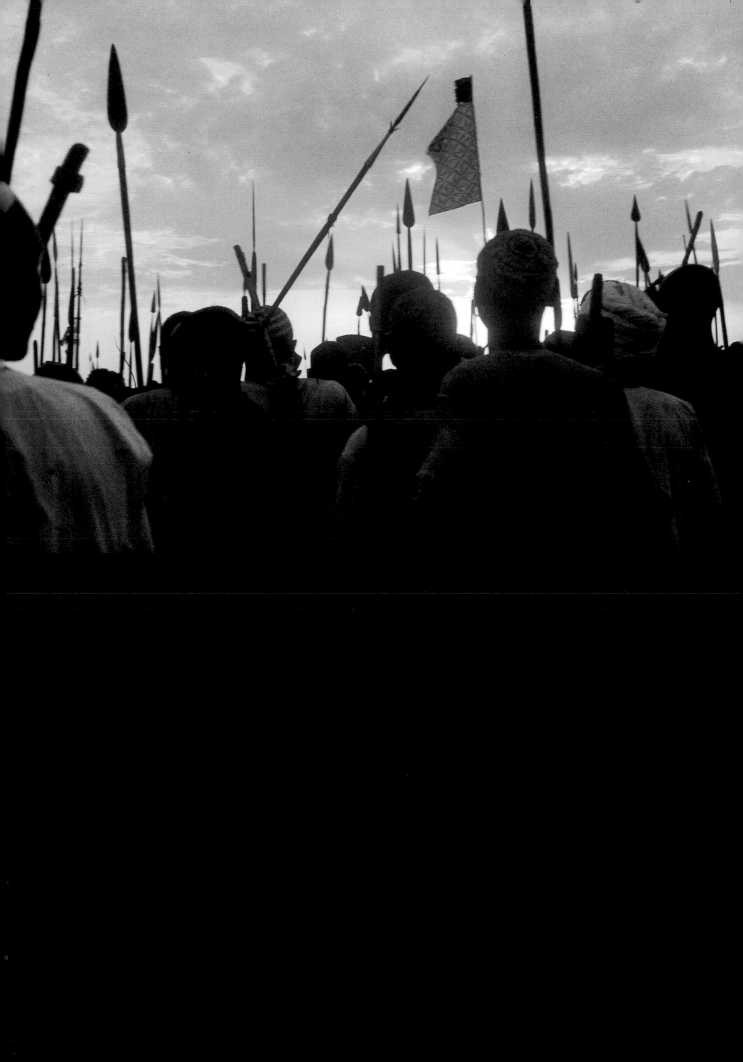

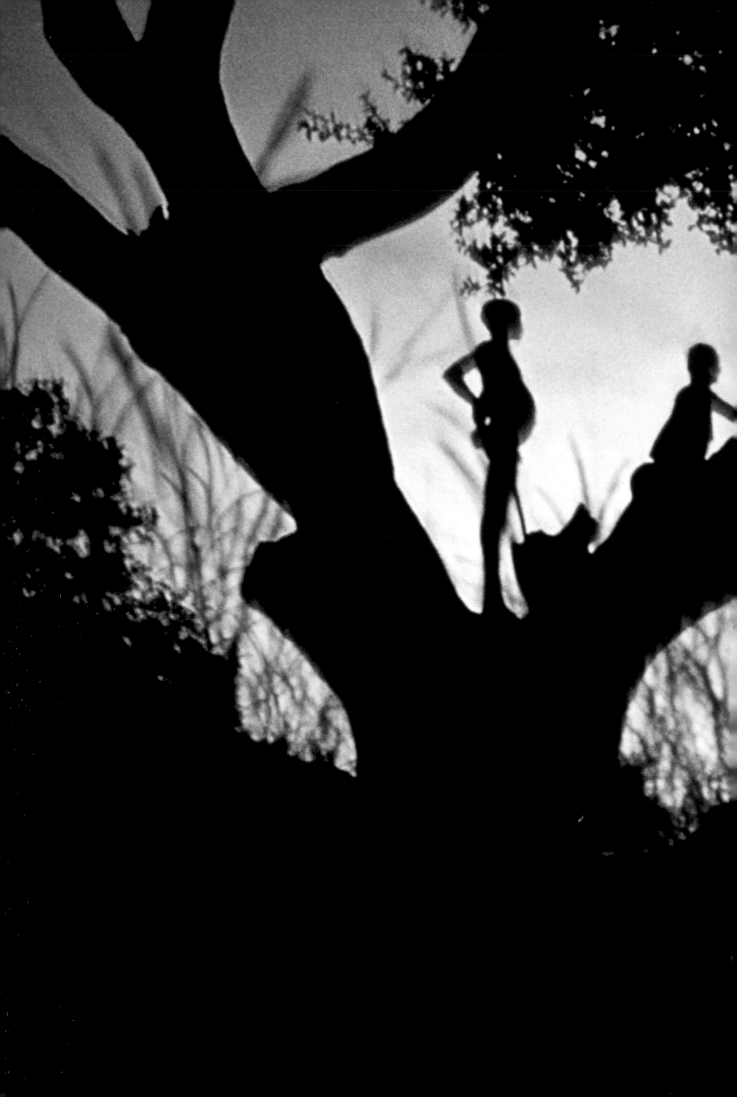

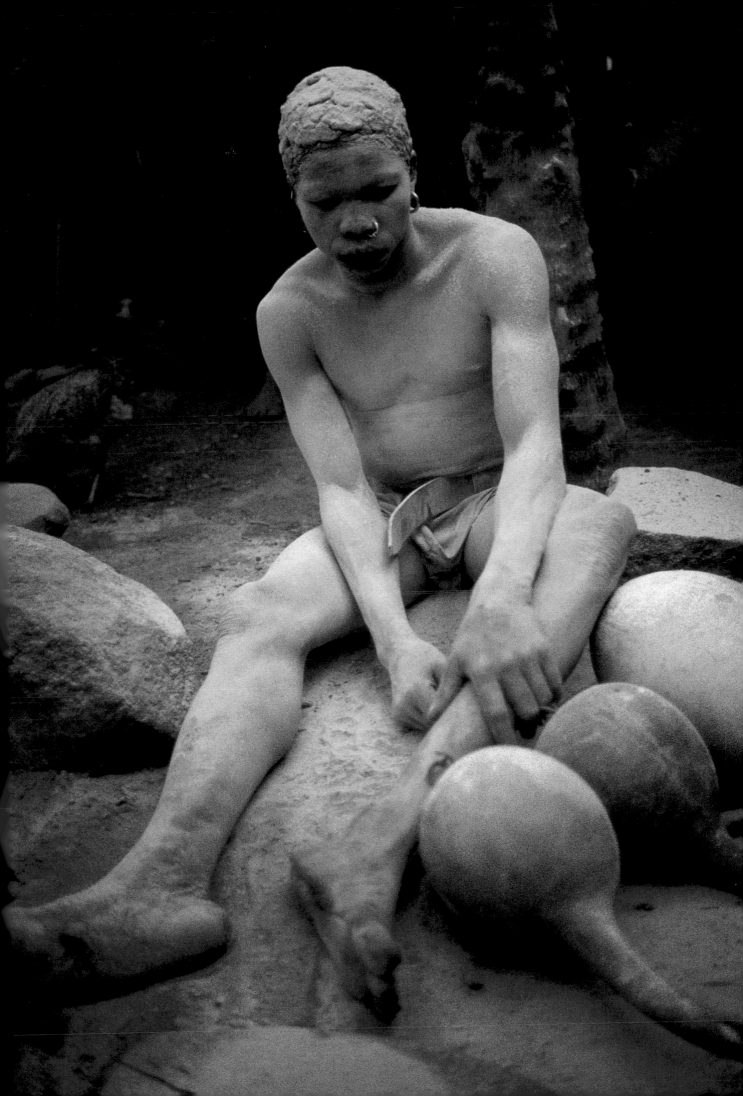

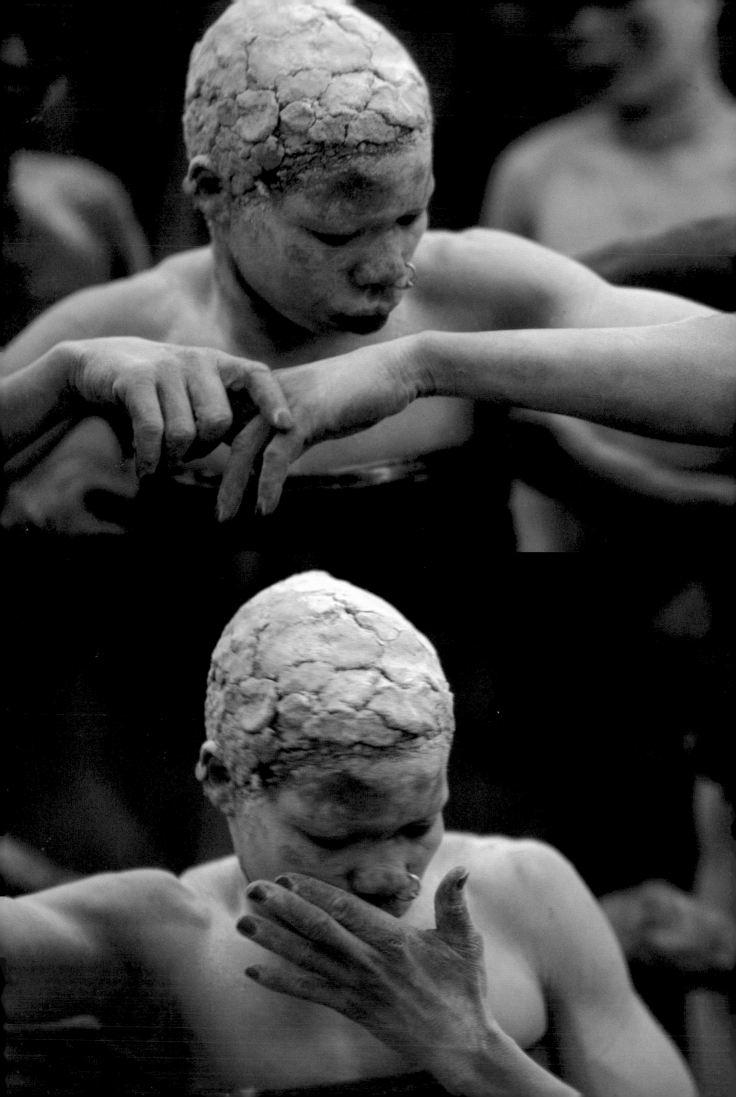

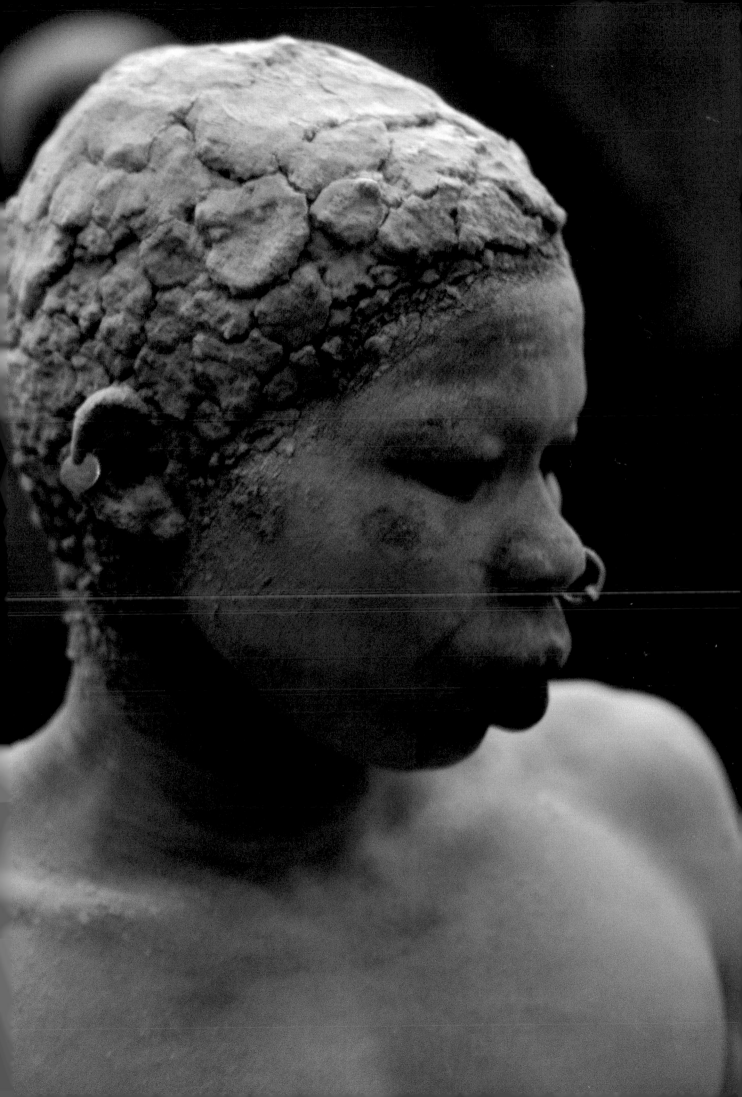

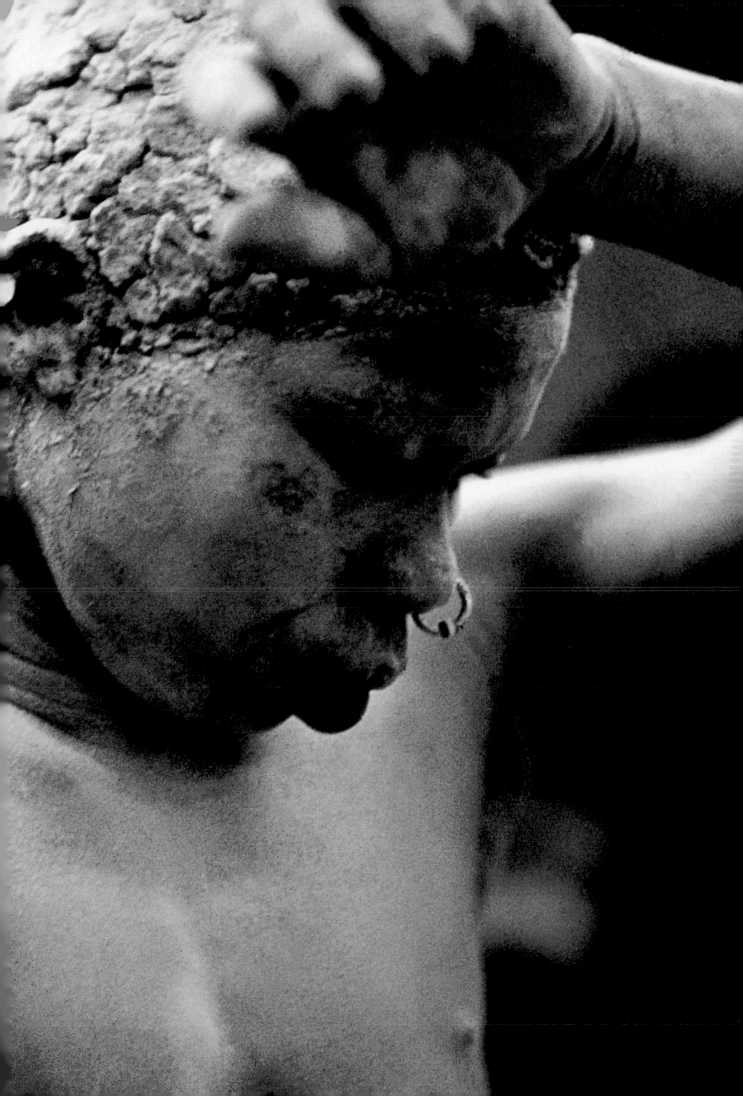

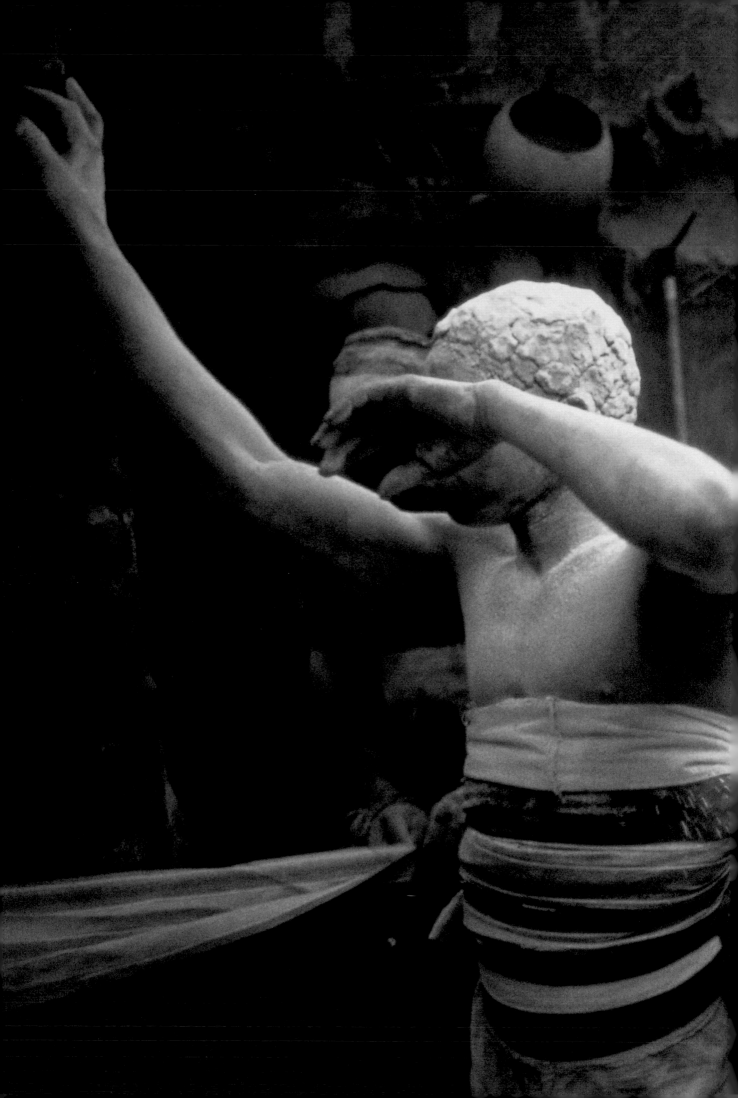

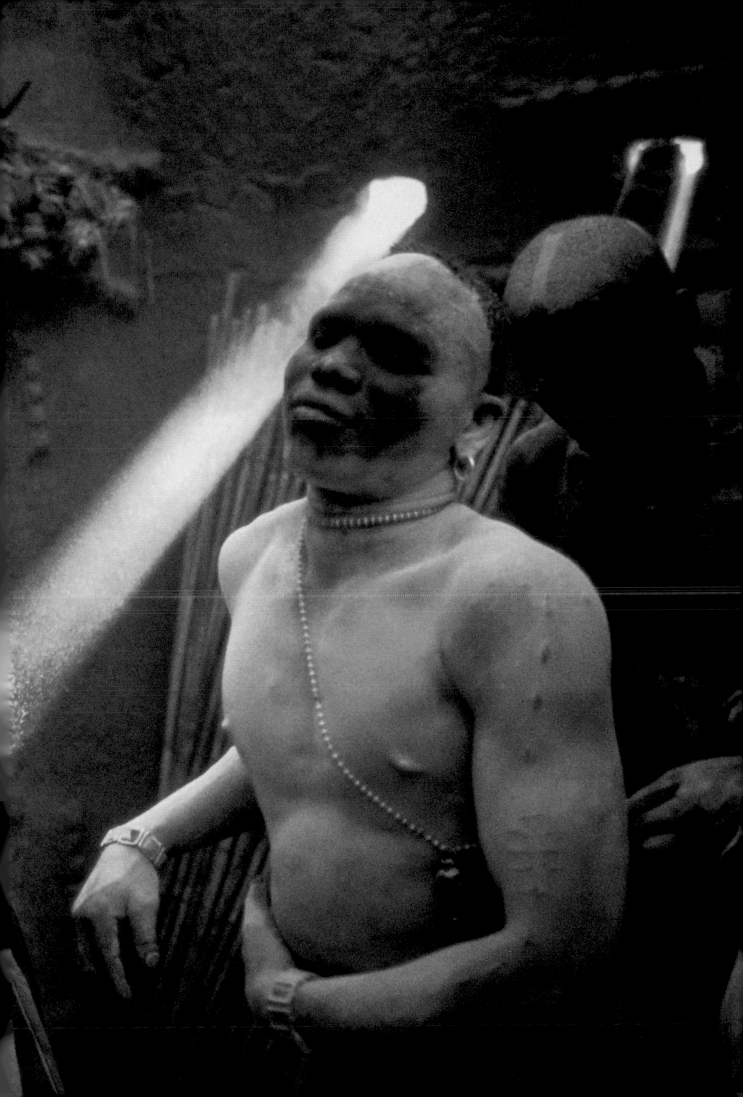

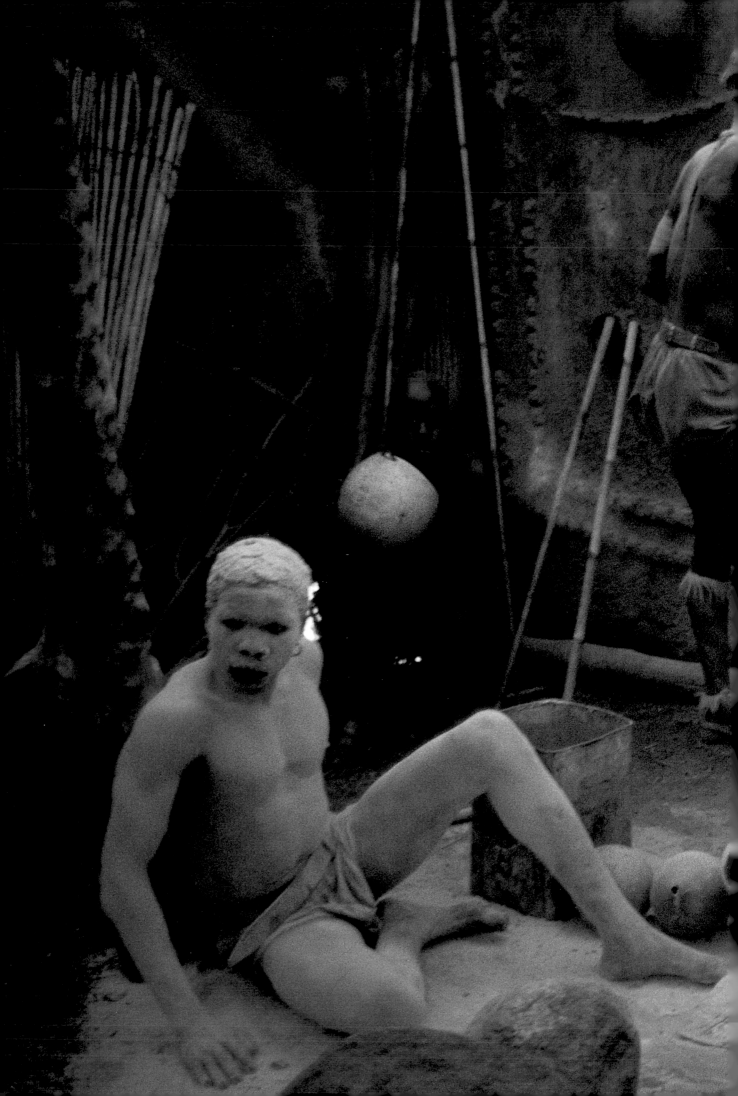

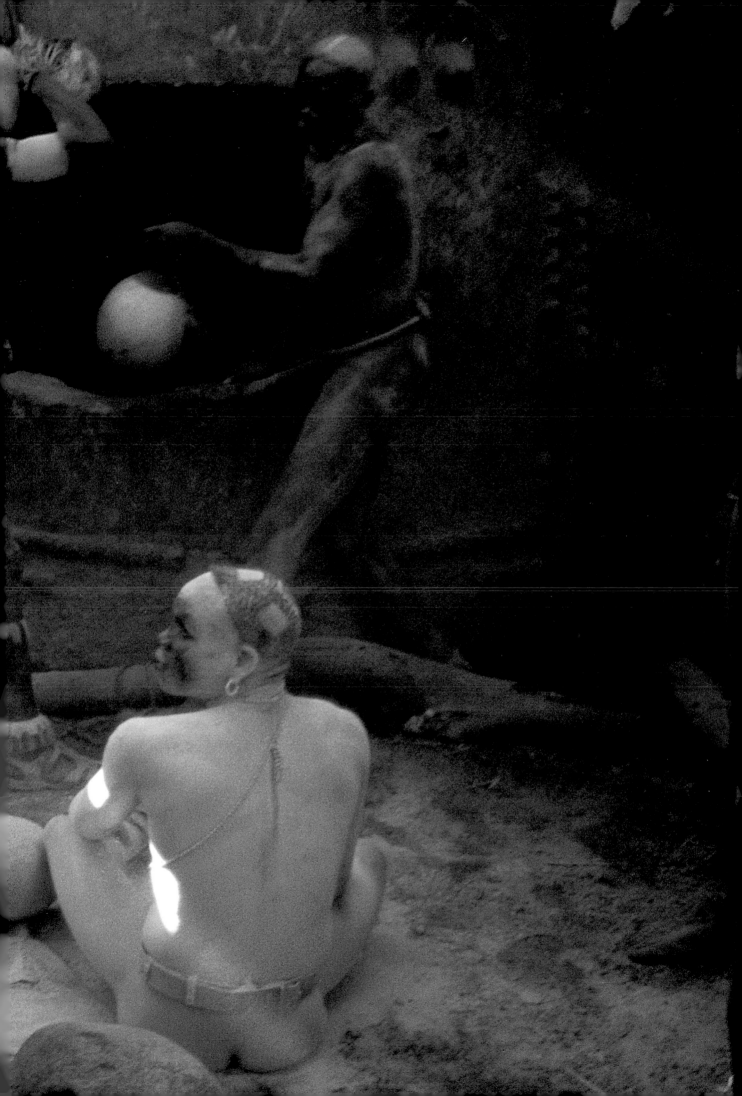

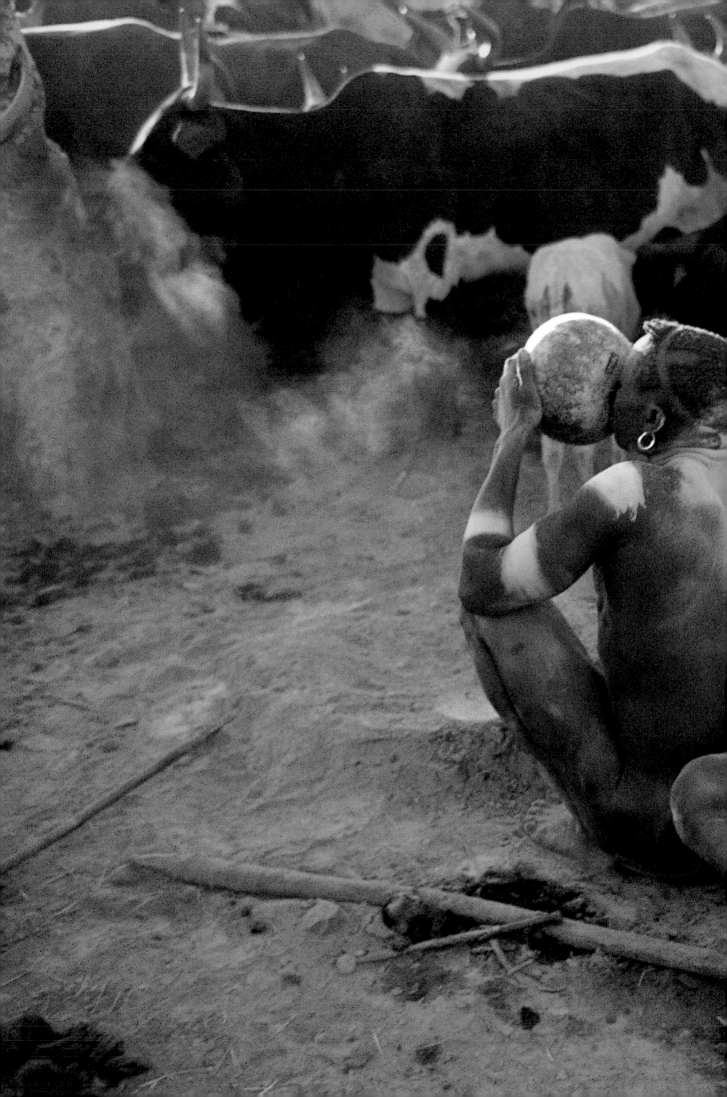

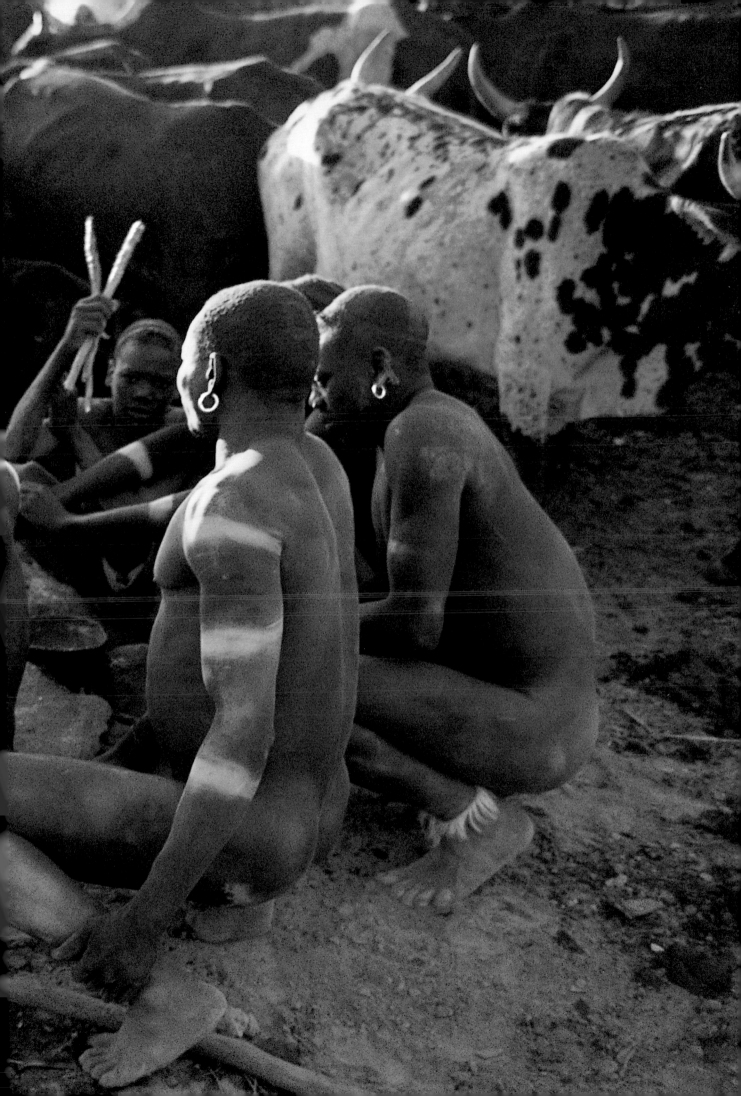

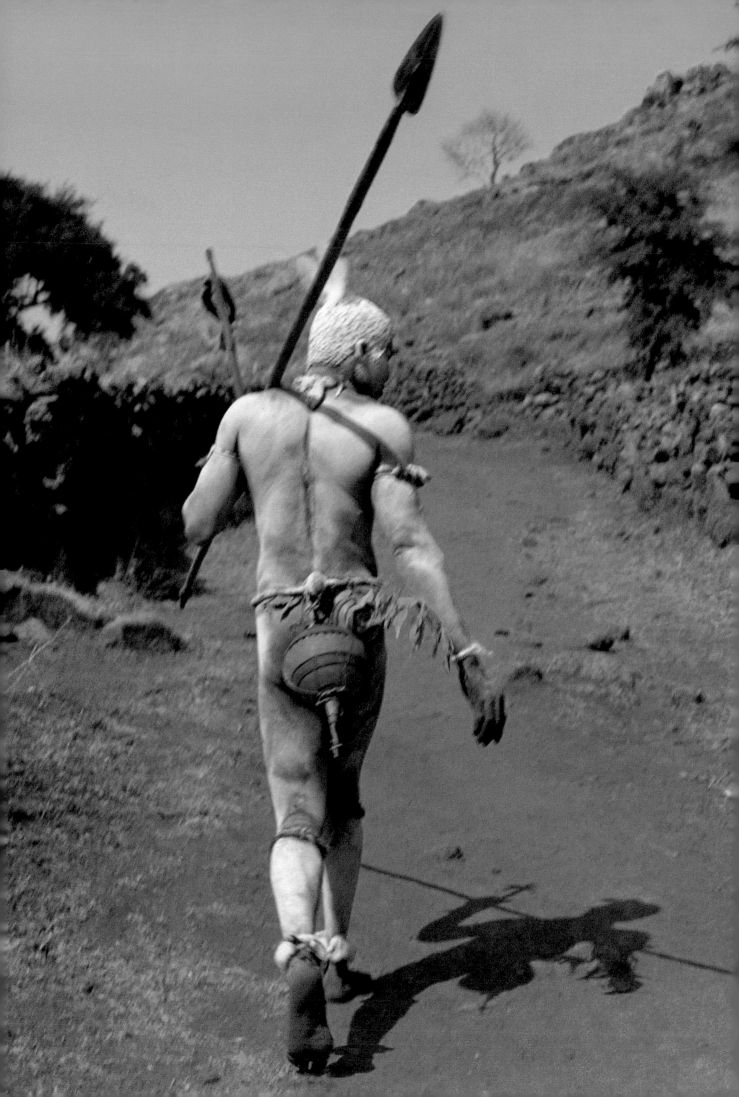

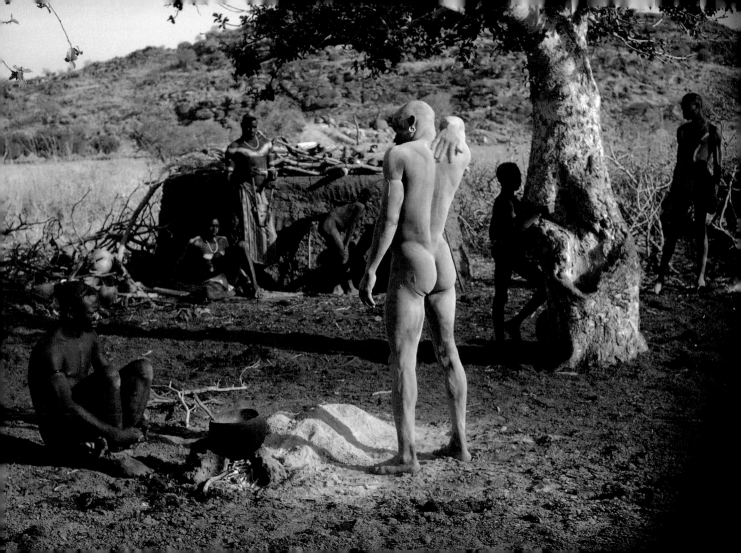

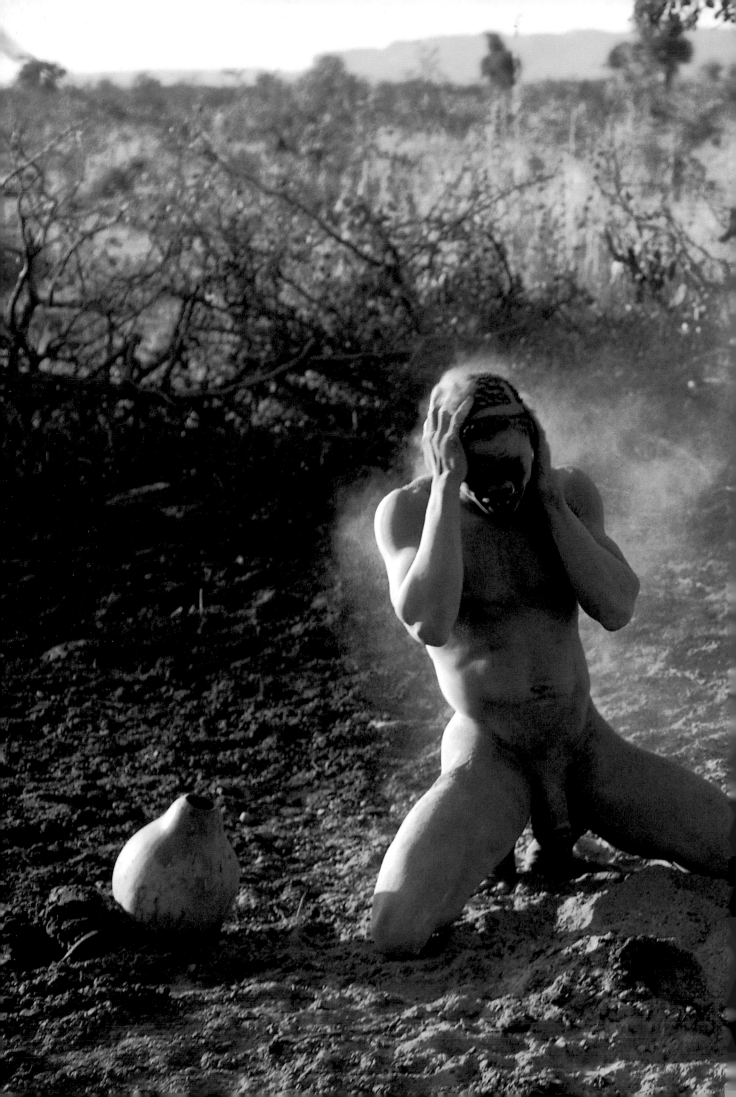

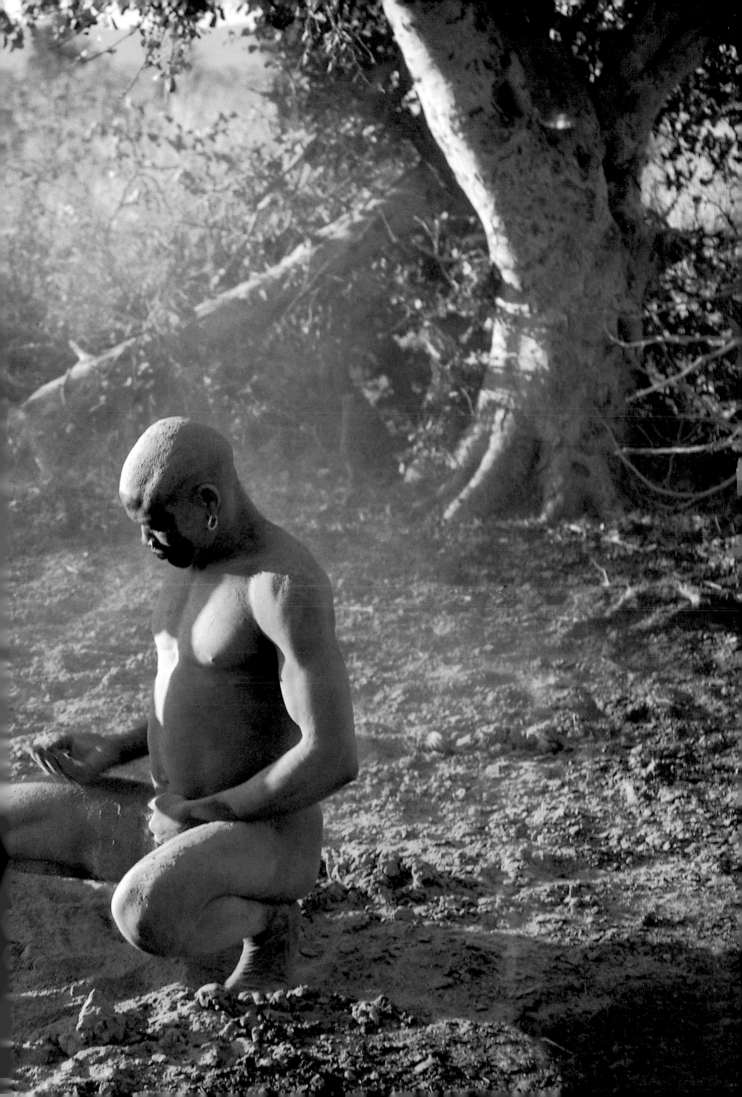

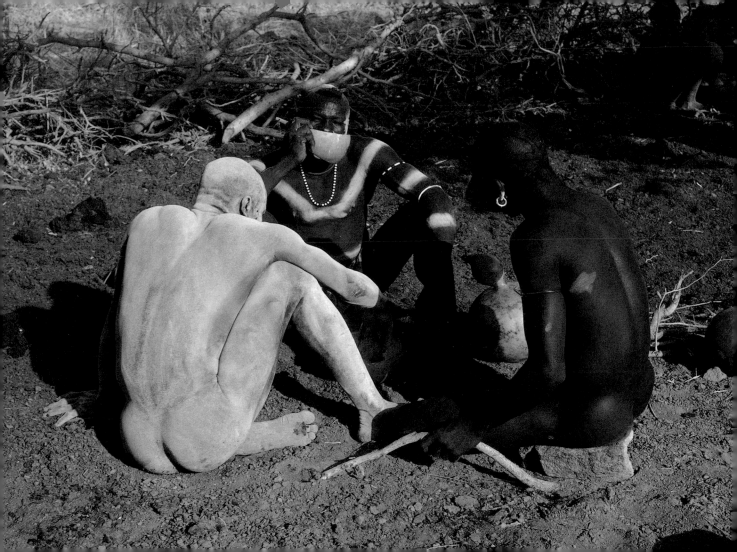

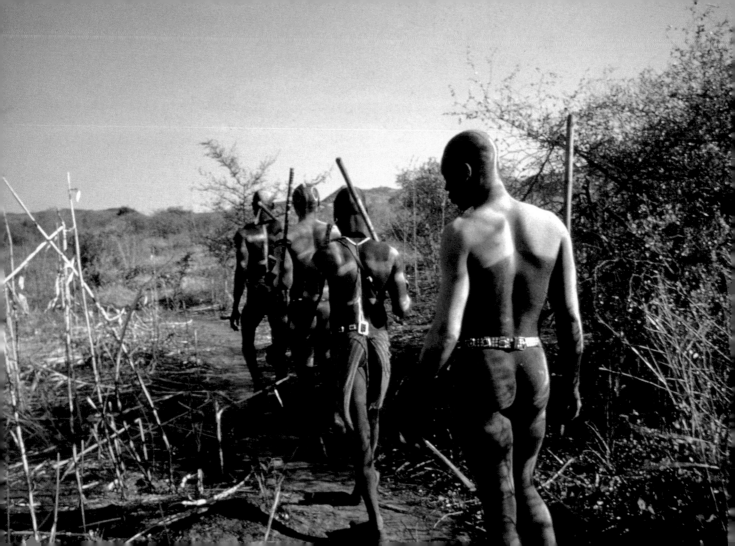

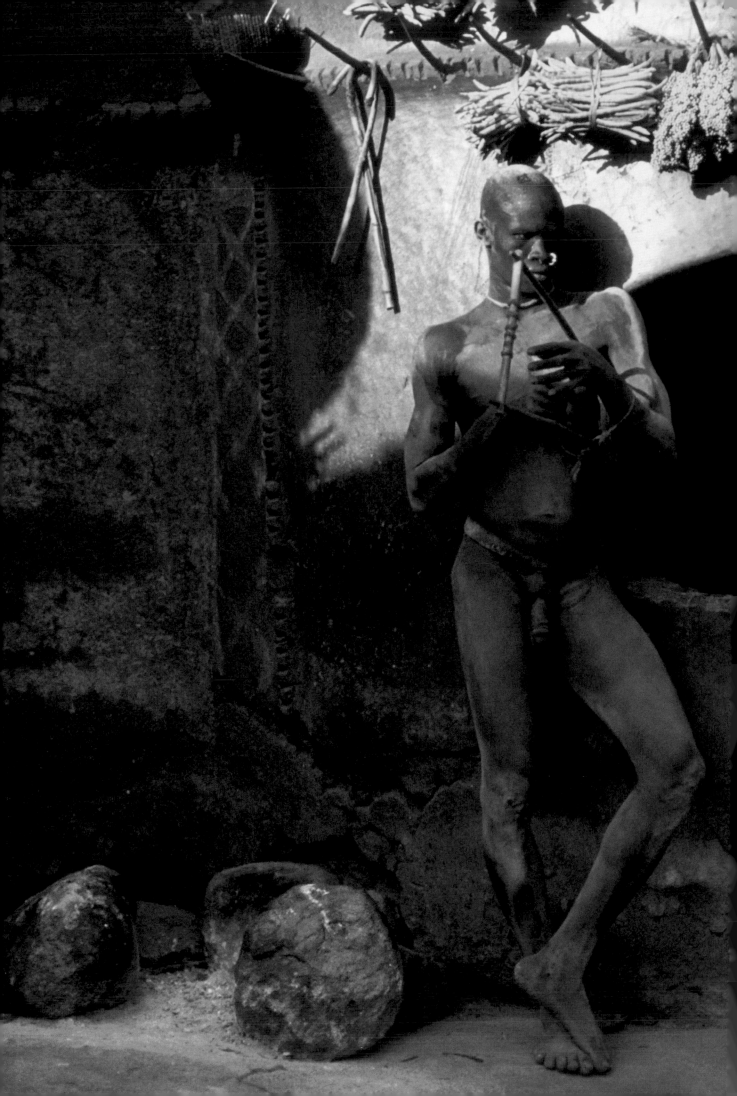

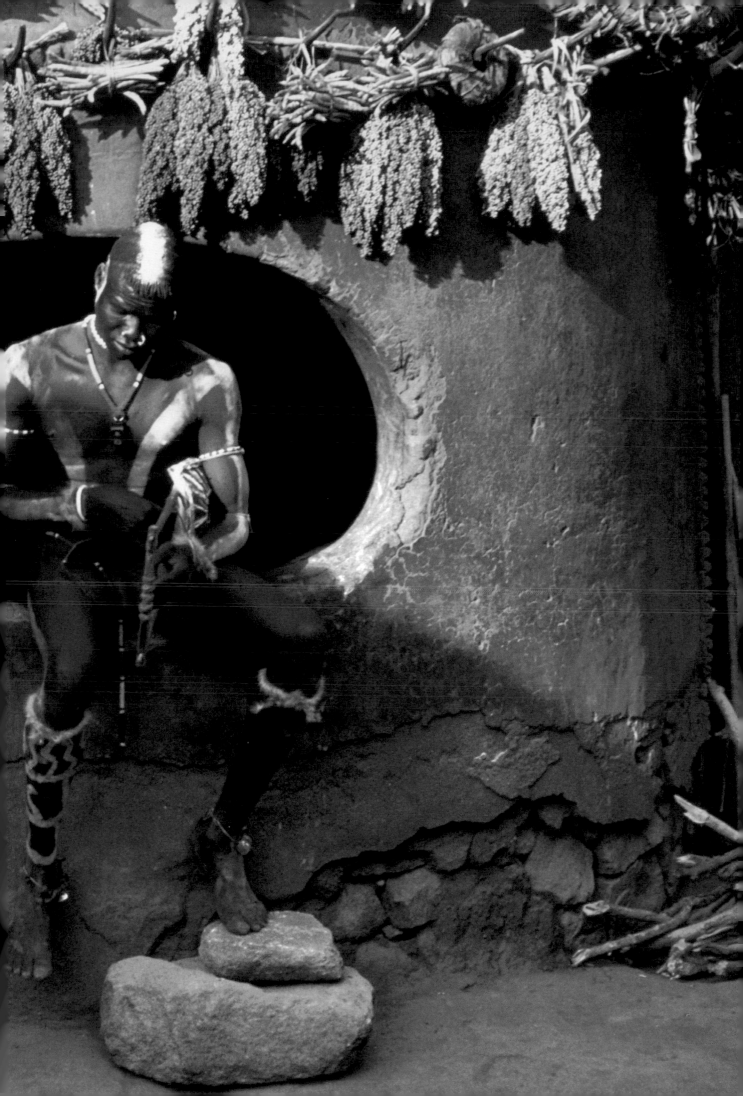

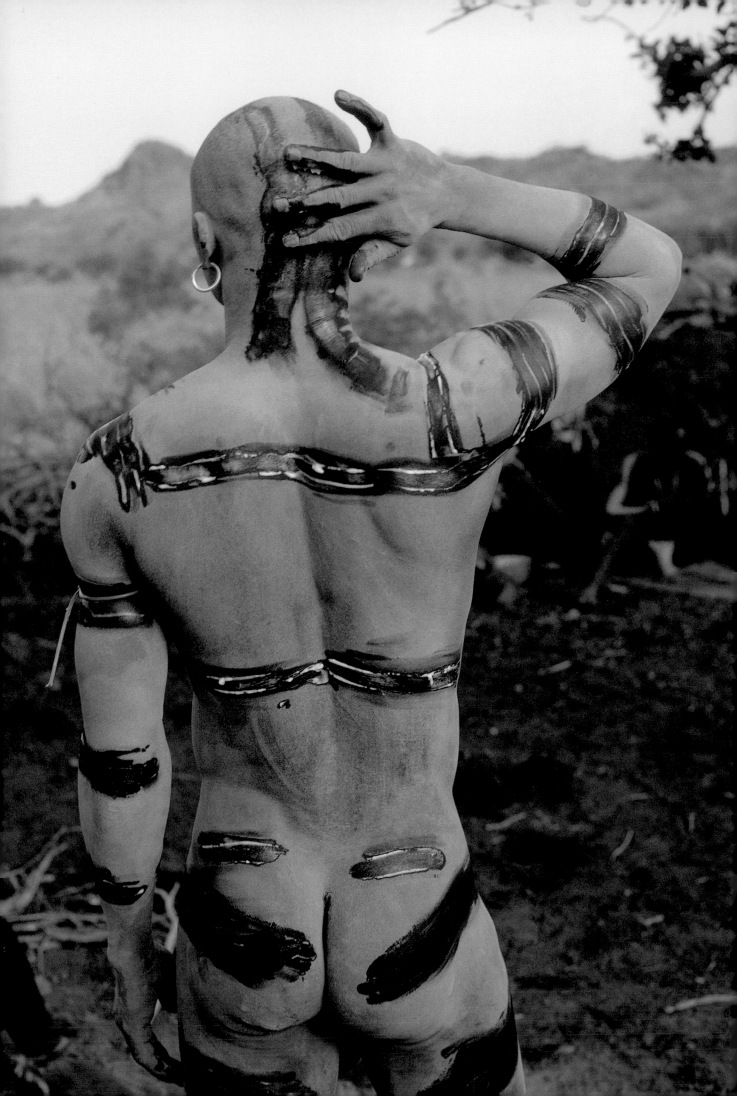

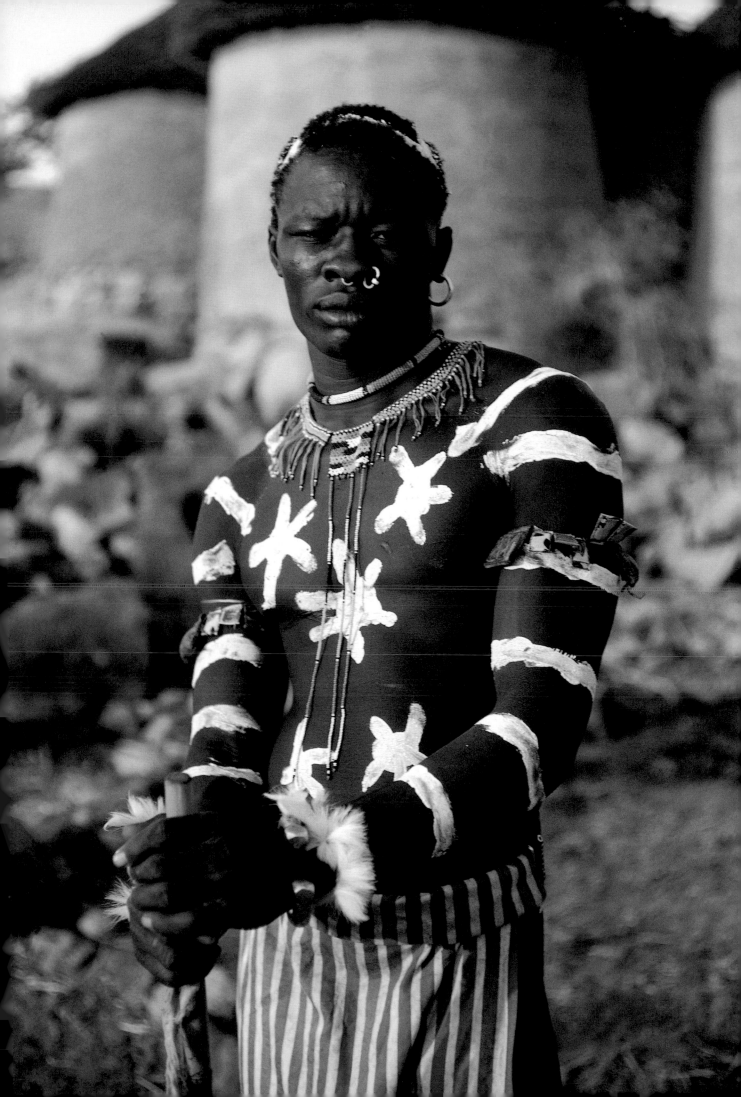

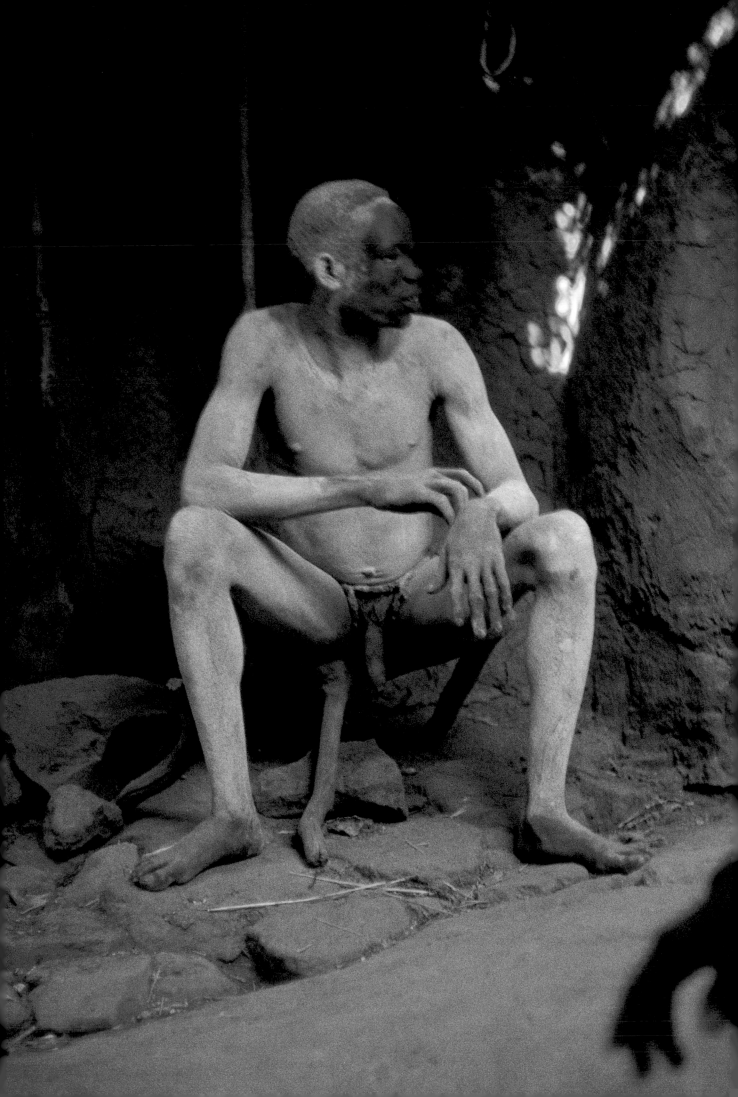

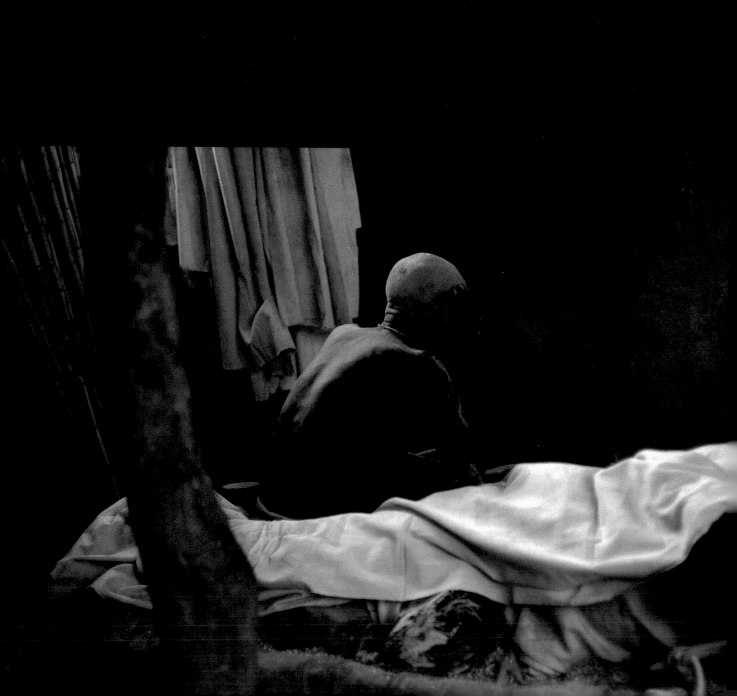

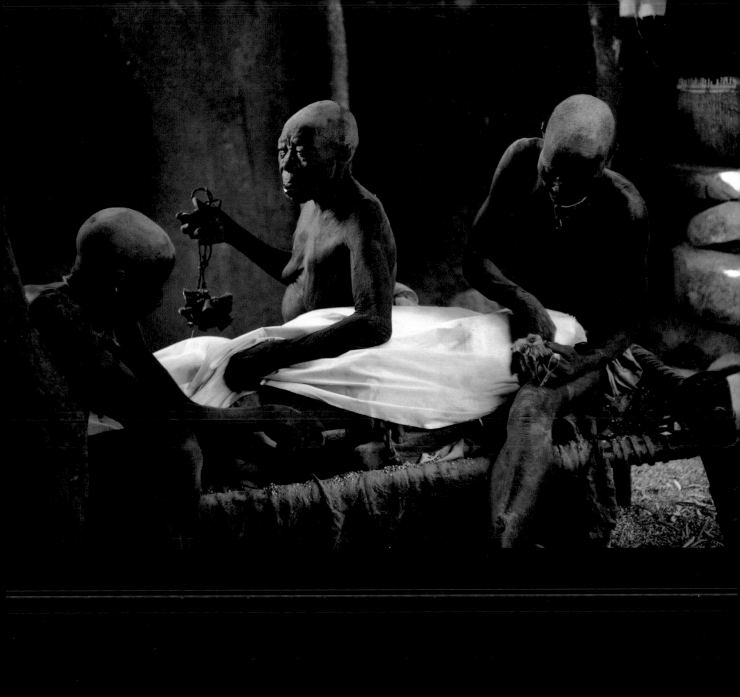

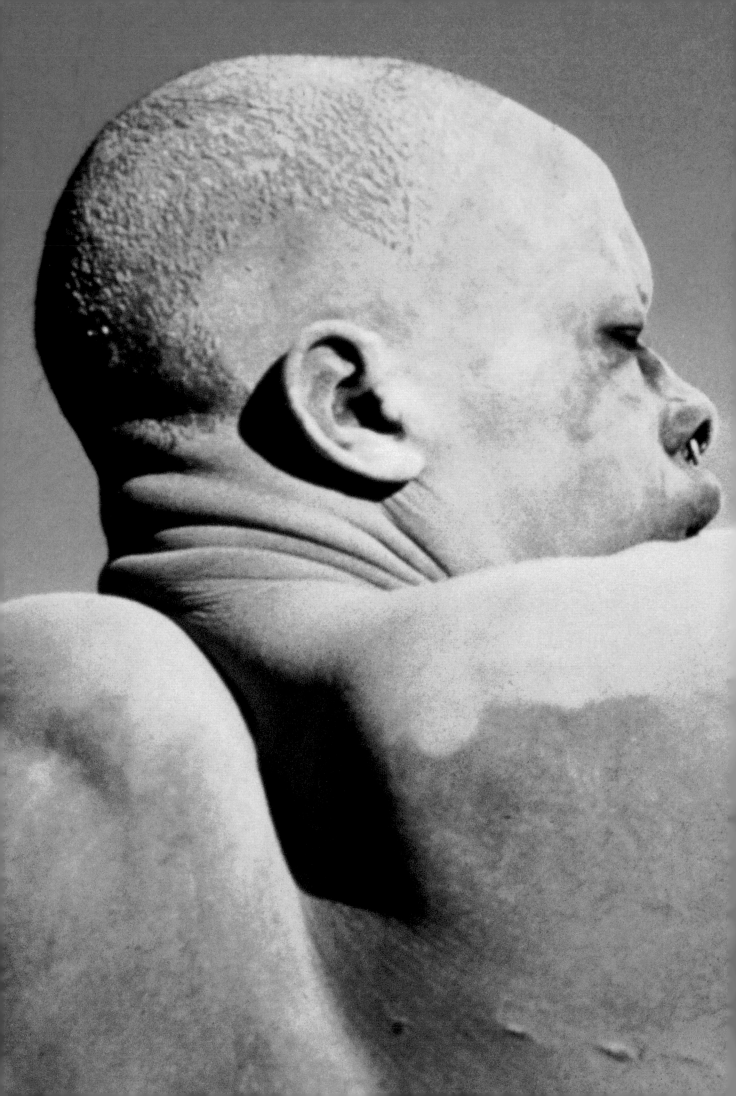

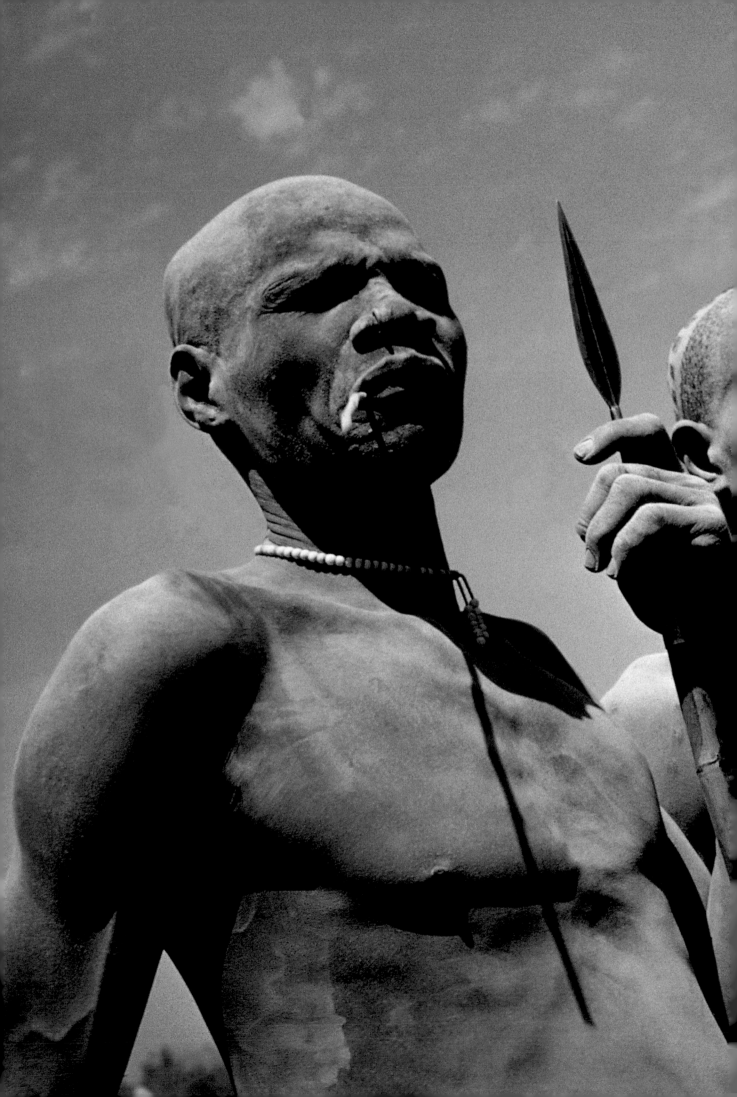

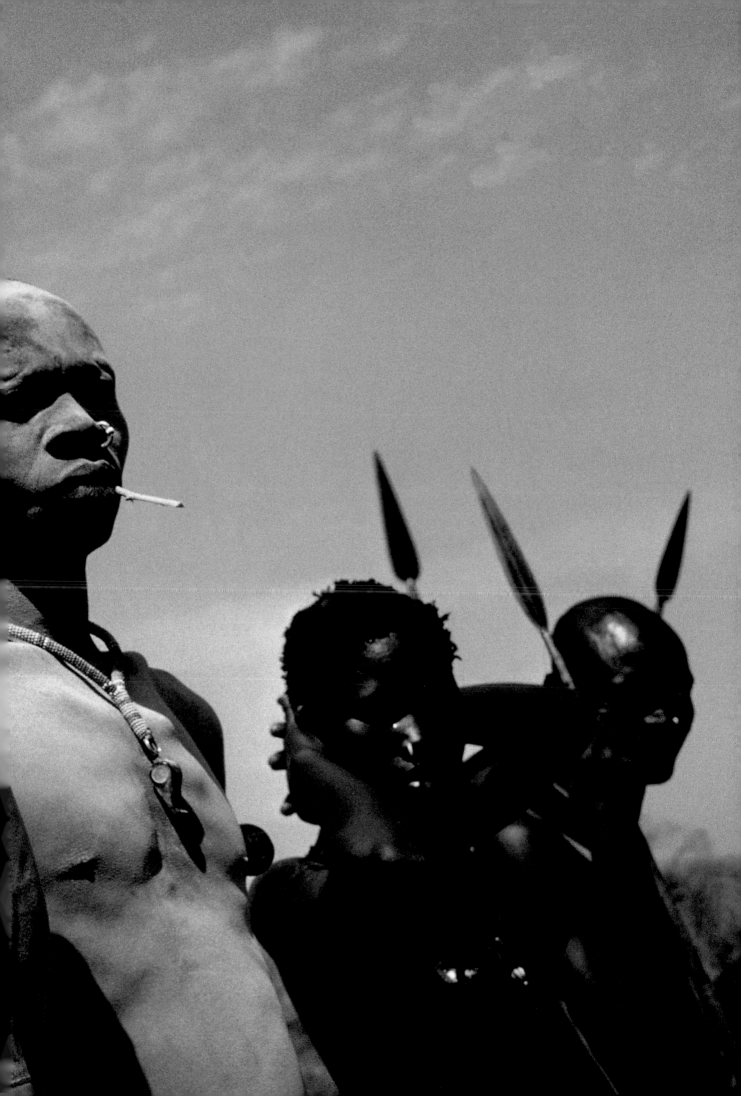

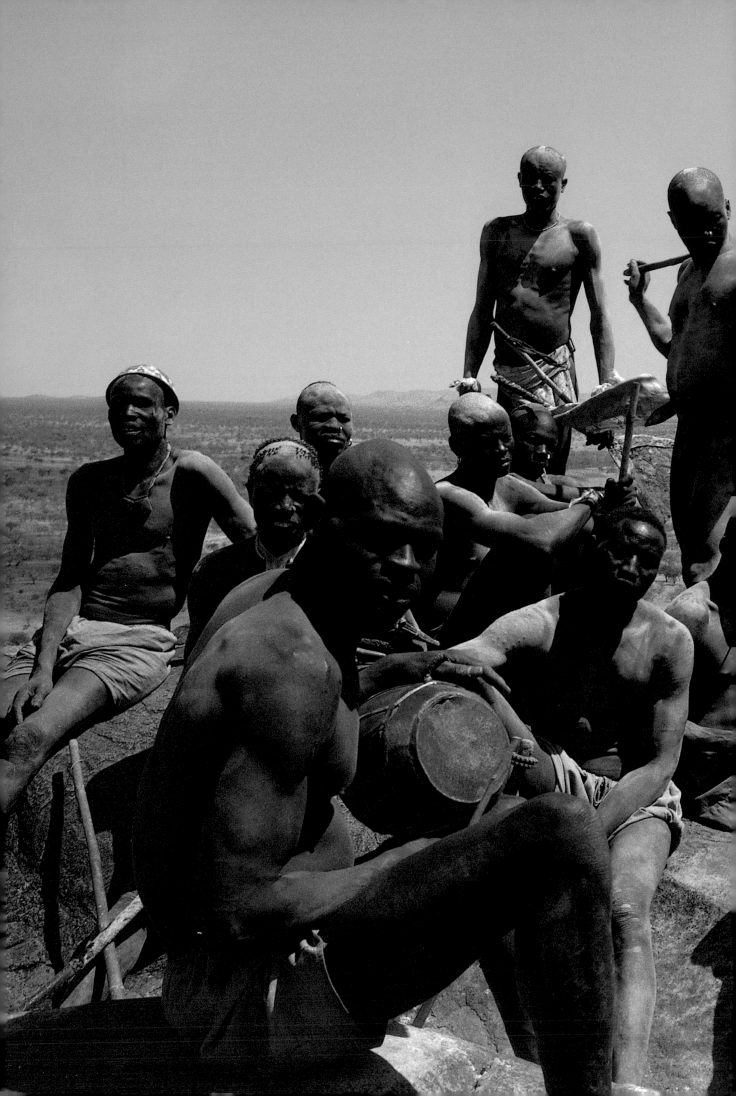

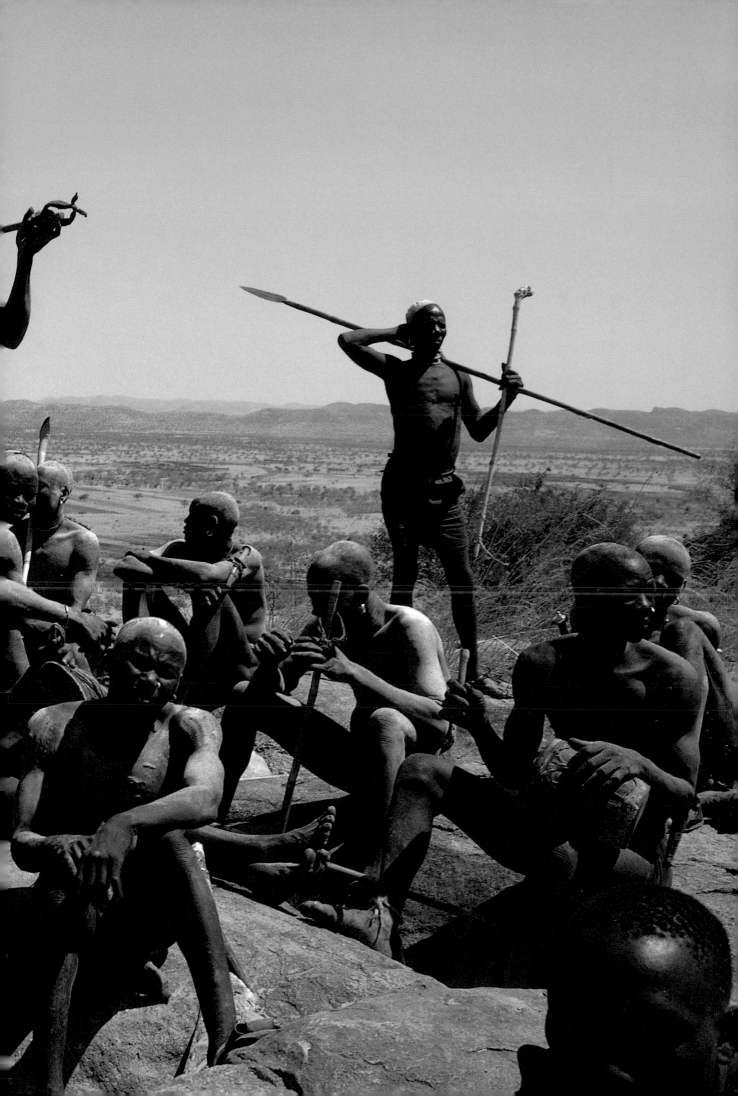

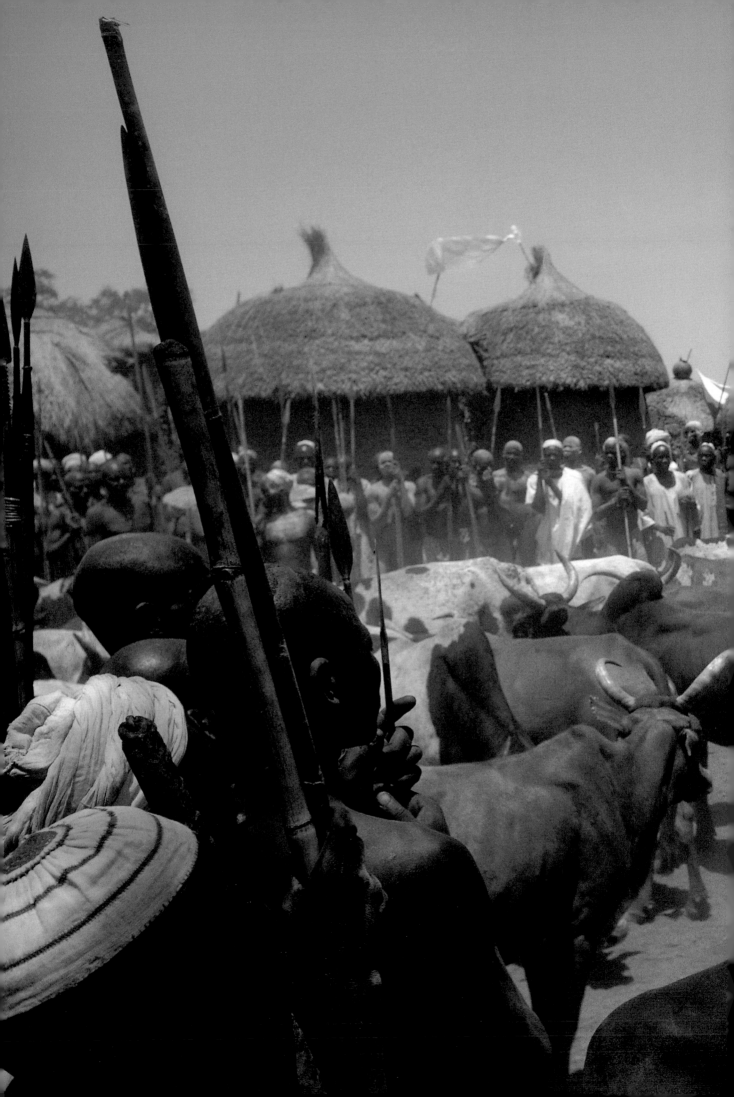

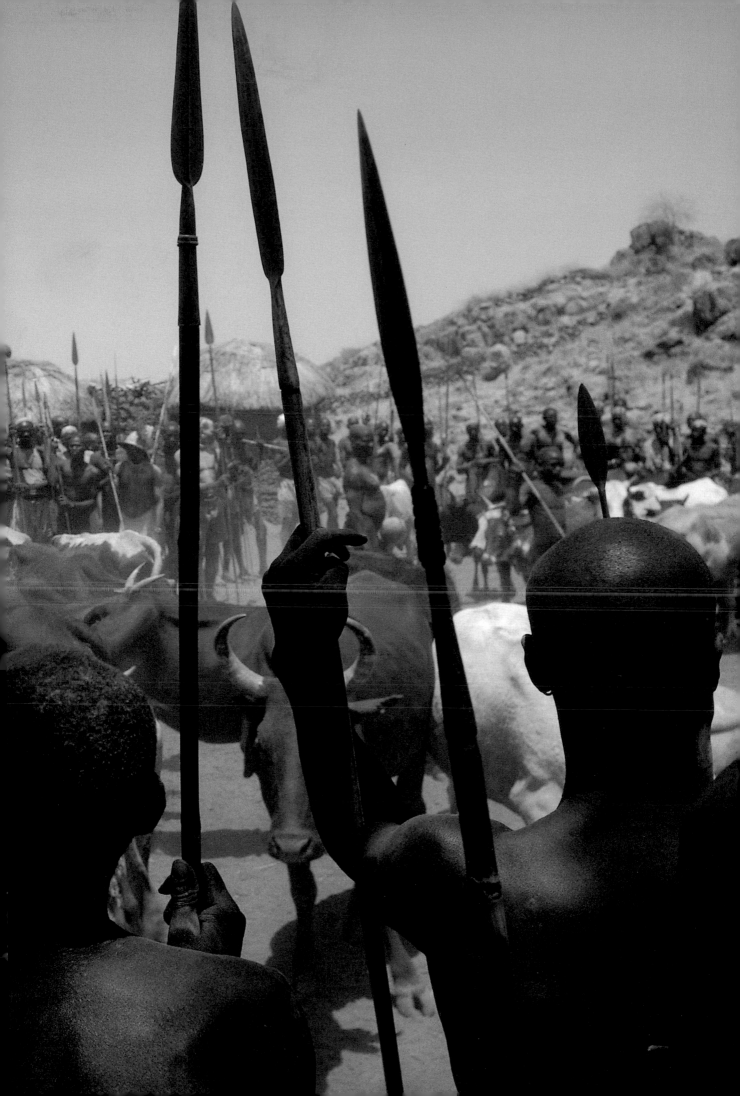

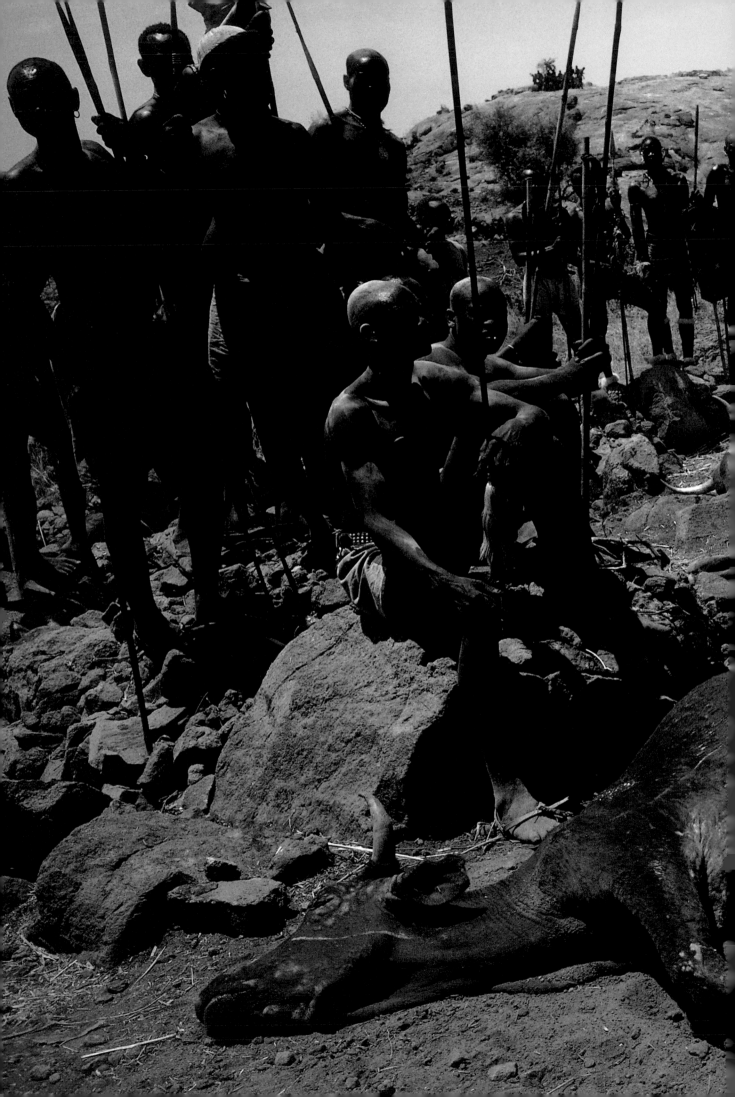

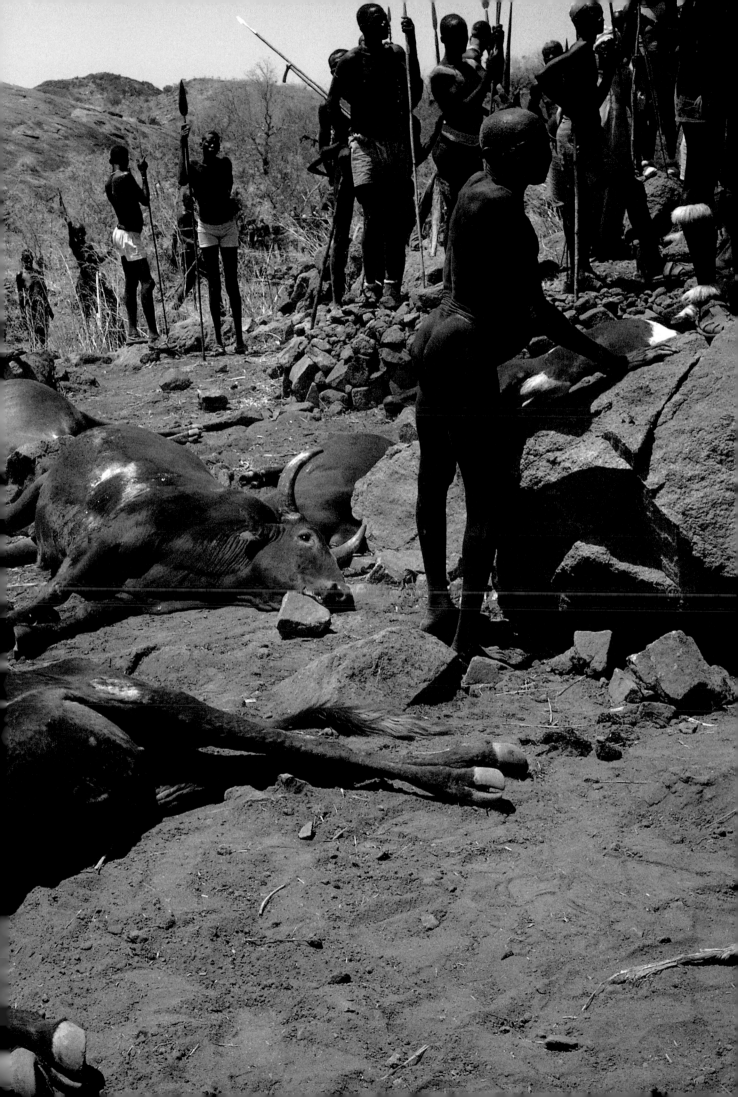

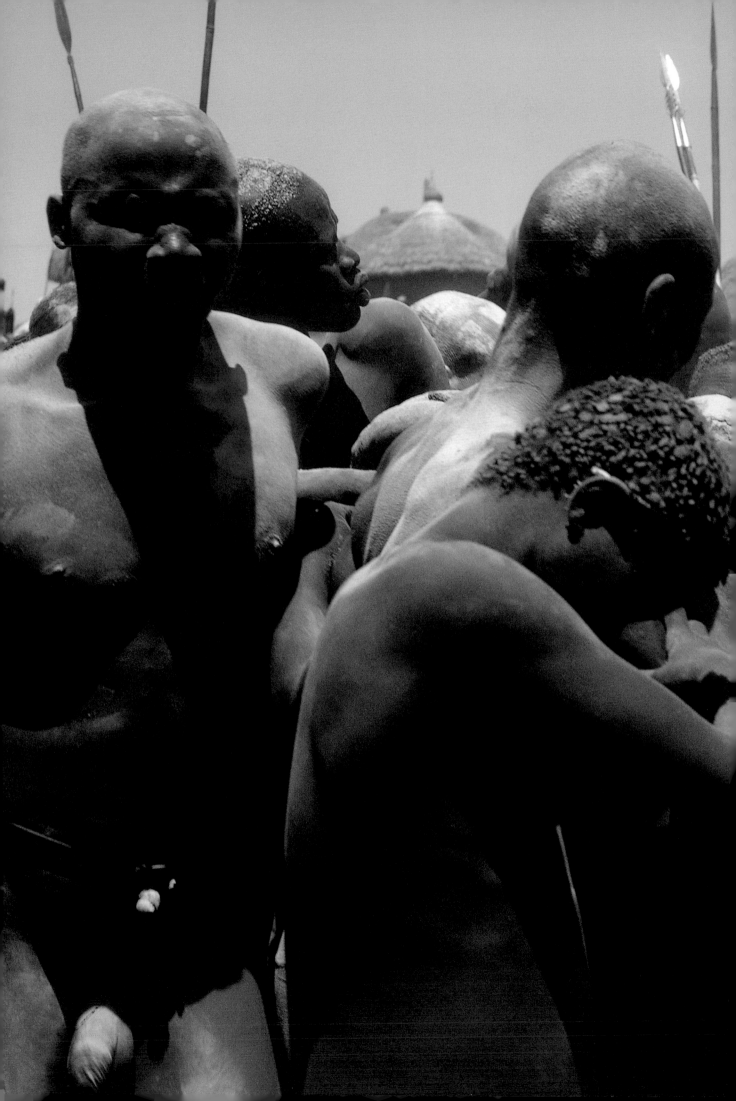

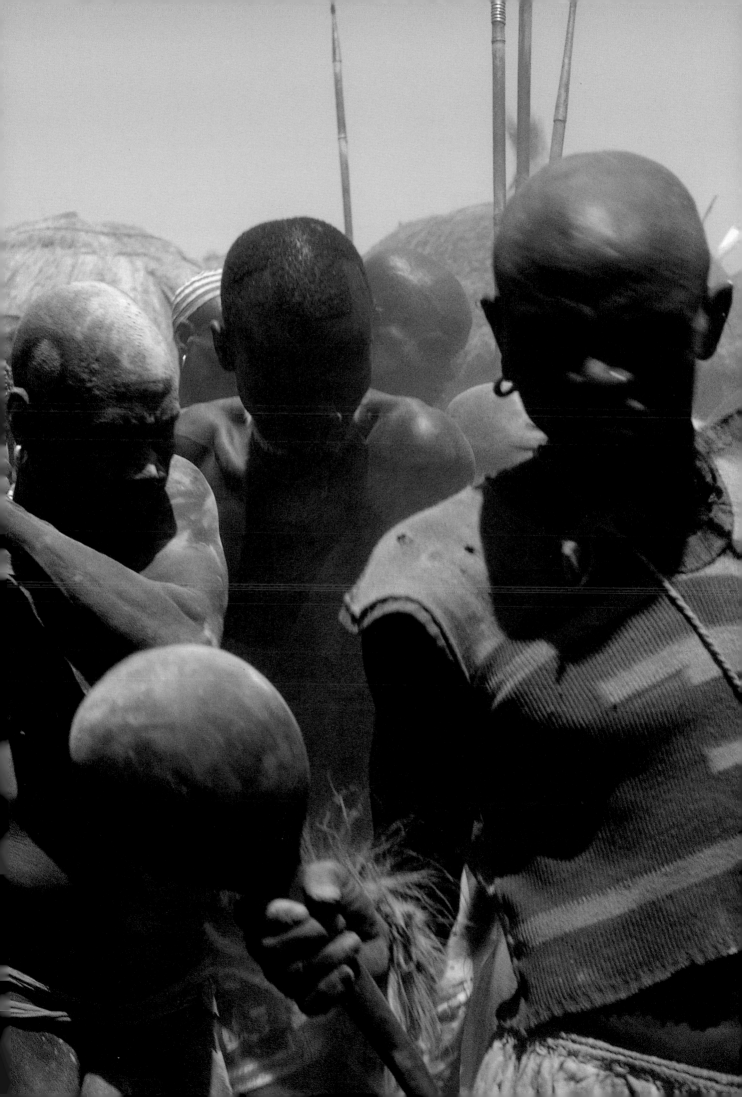

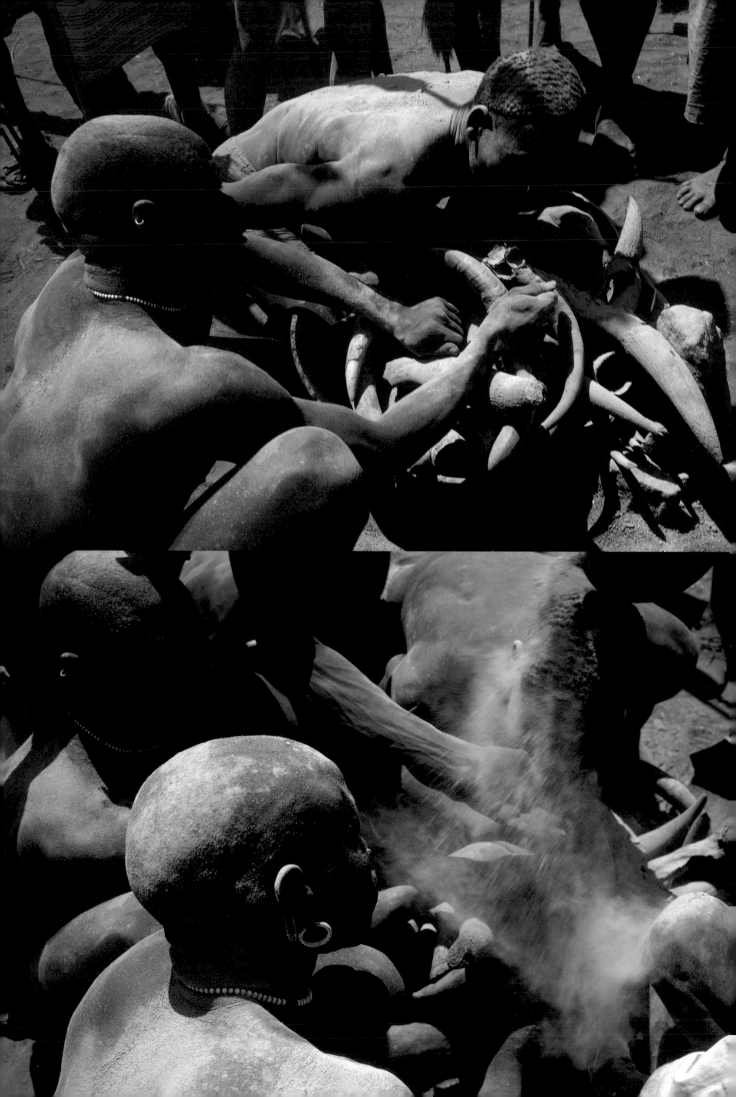

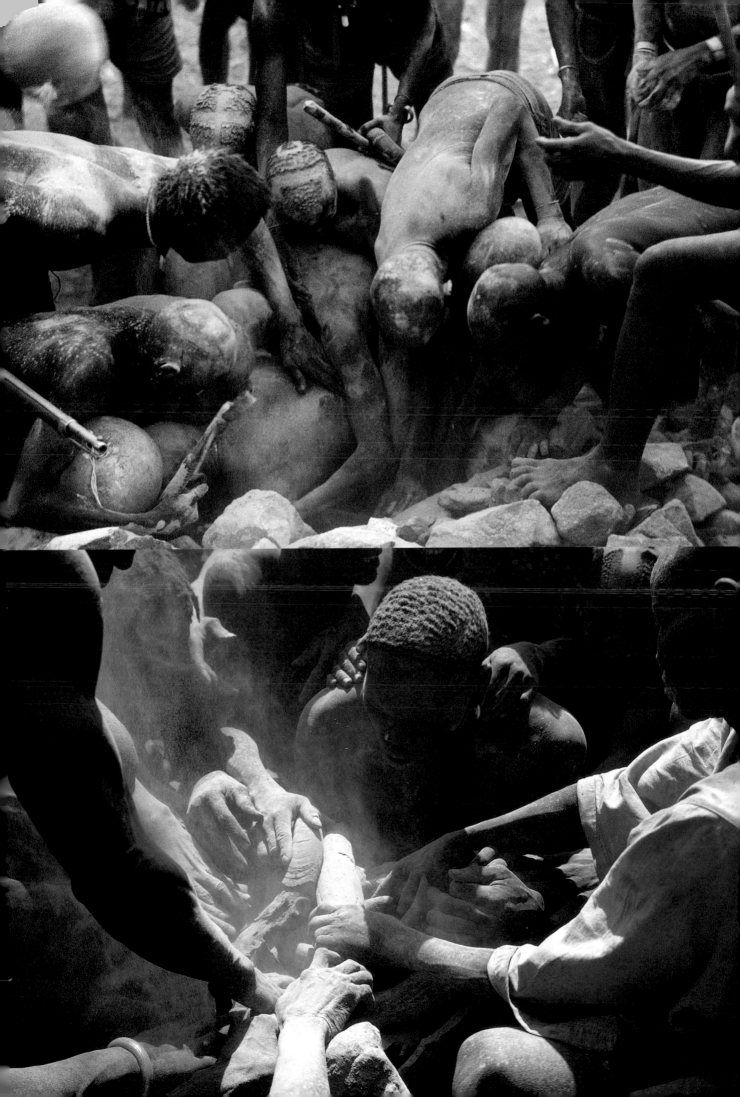

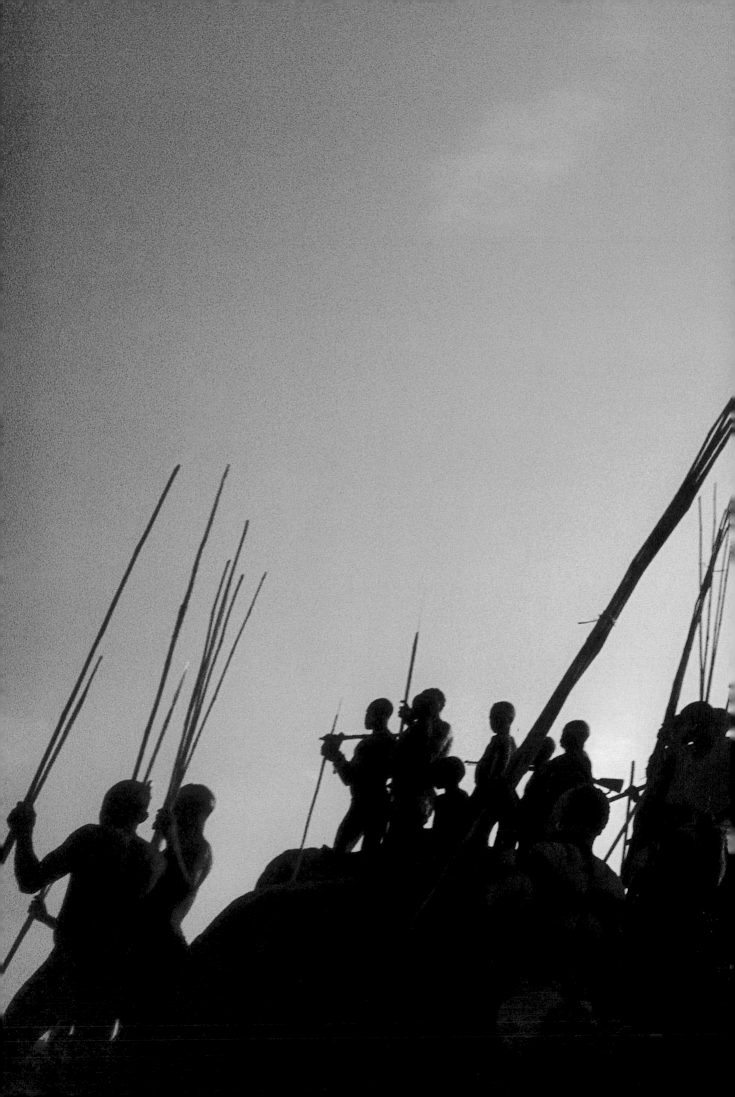

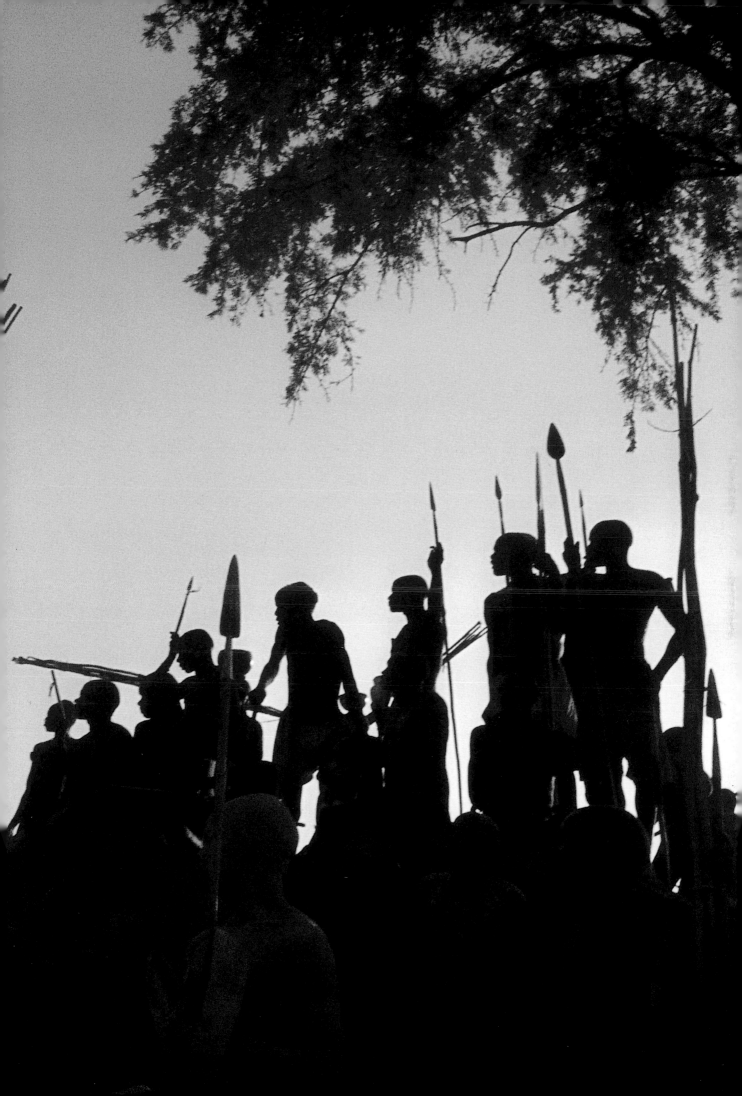

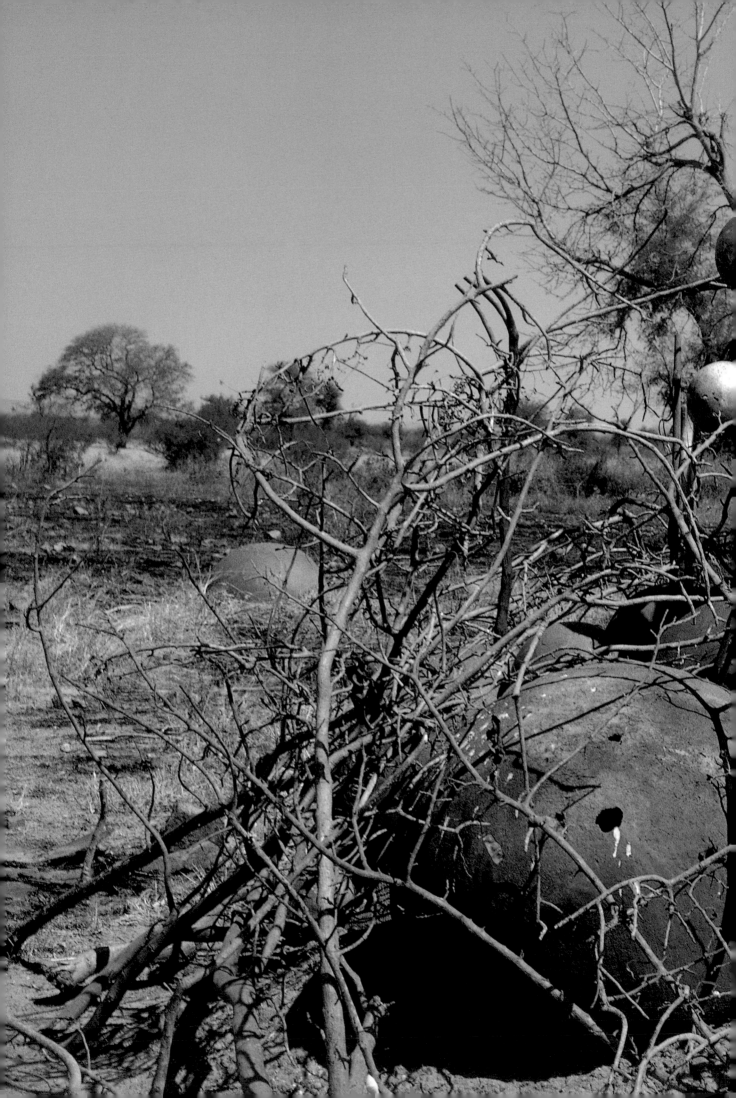

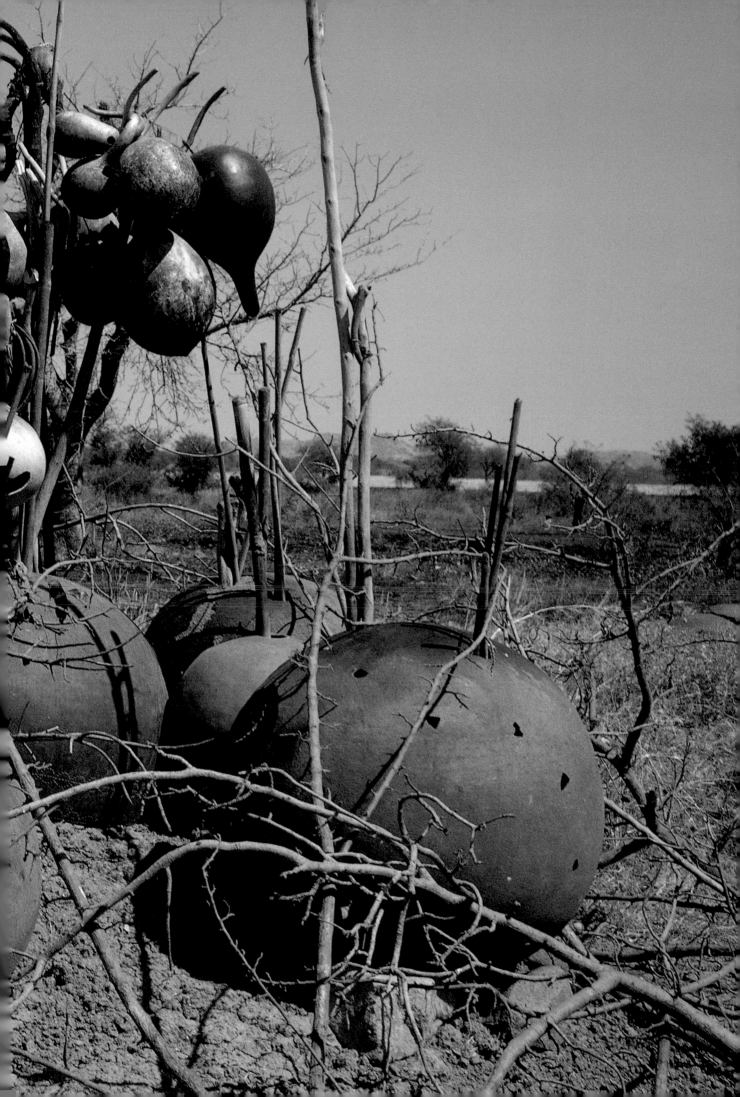

Masai, Samburu and Nomads

Masai, Samburu und Nomaden
Massaï, Samburu et nomades
マサイ、サムブール、そして遊牧民たち

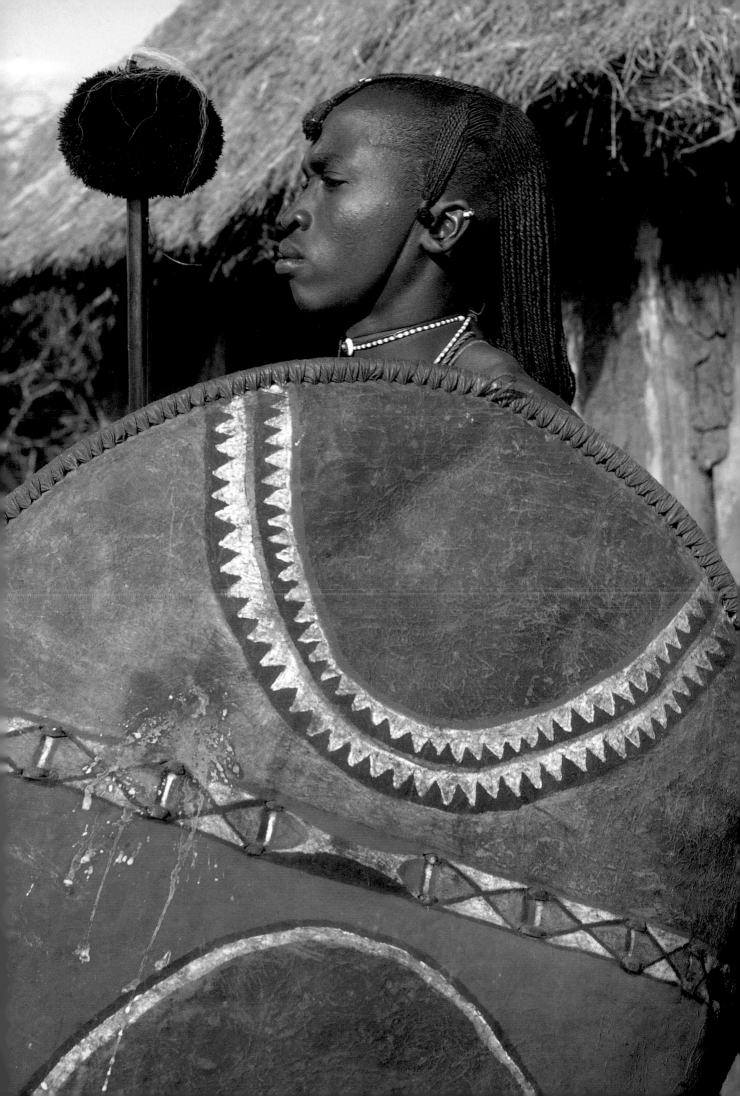

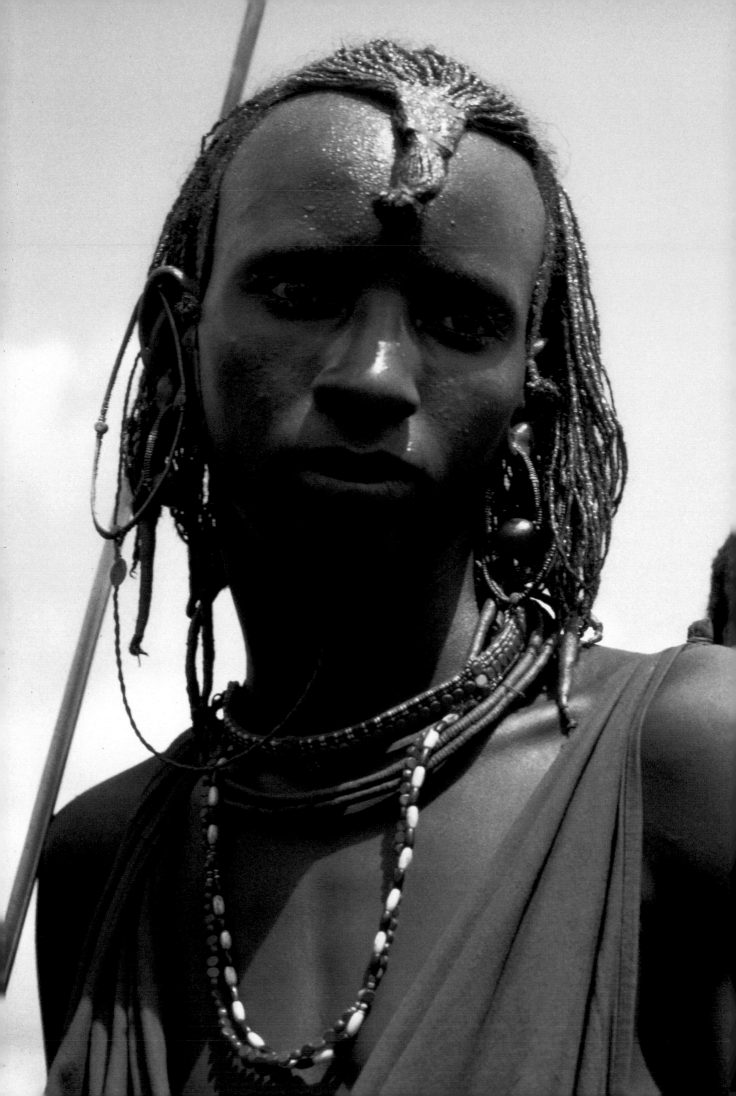

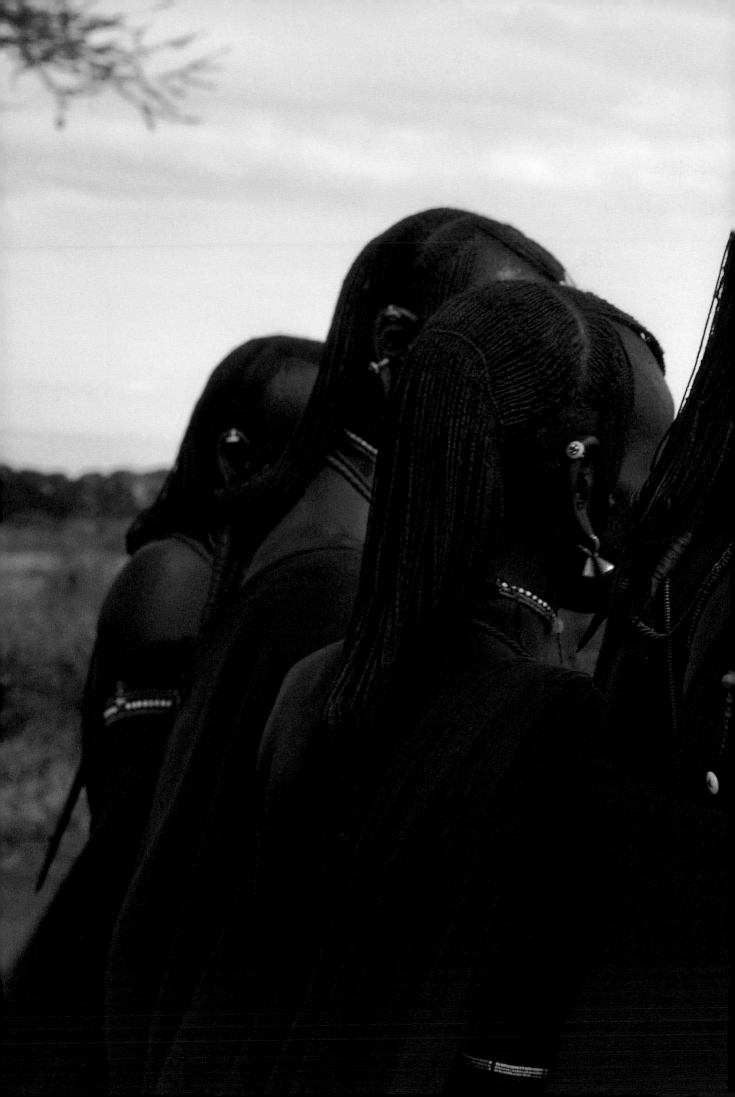

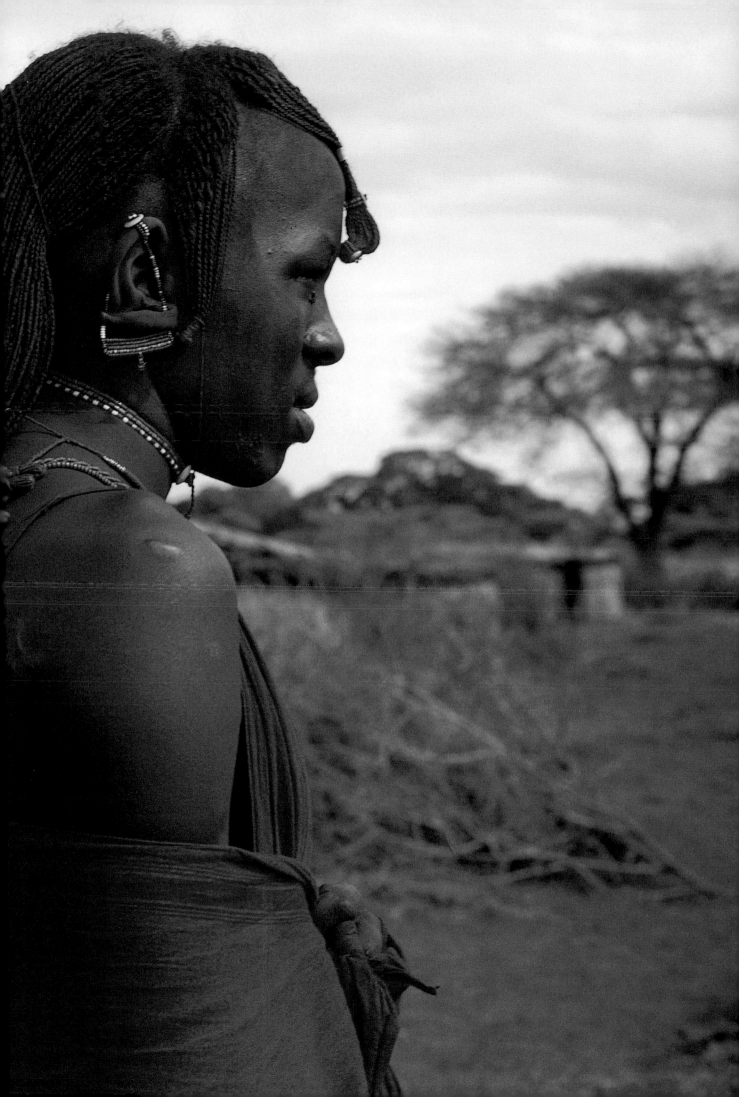

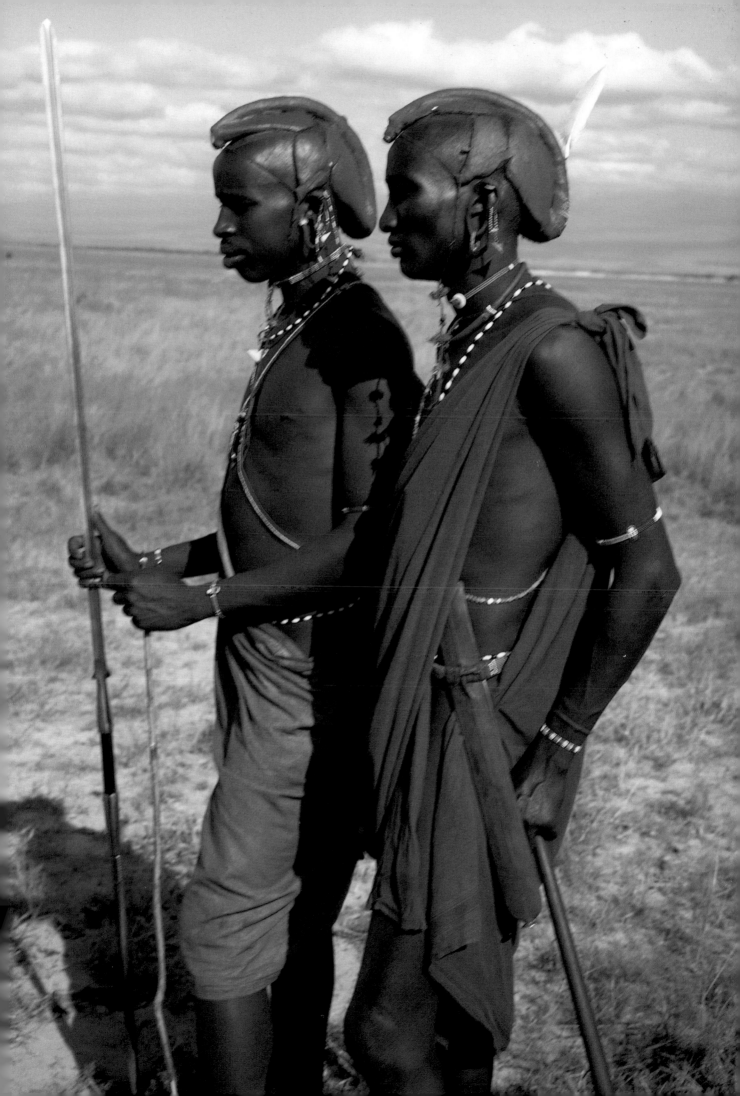

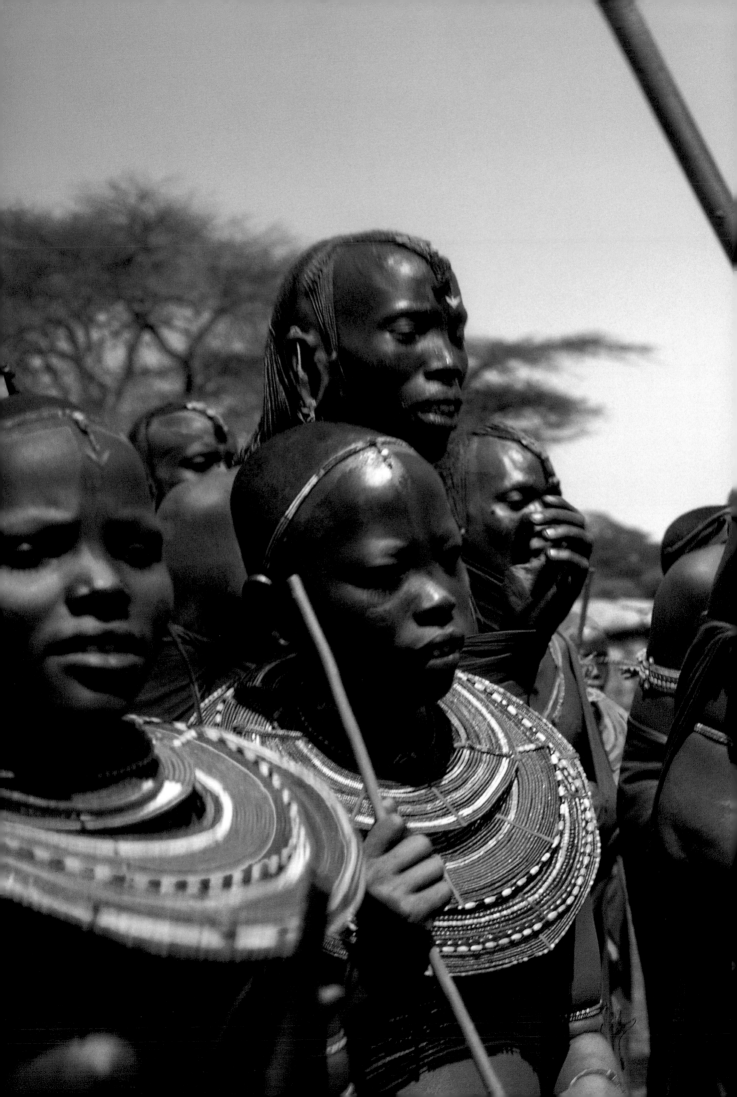

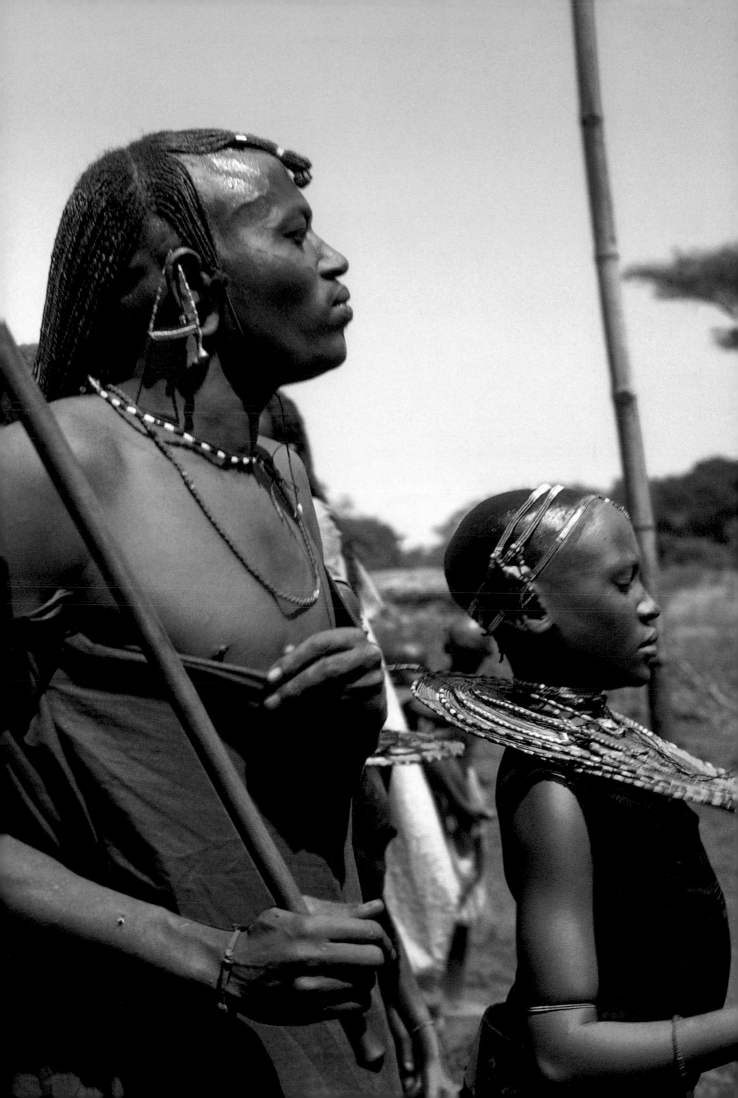

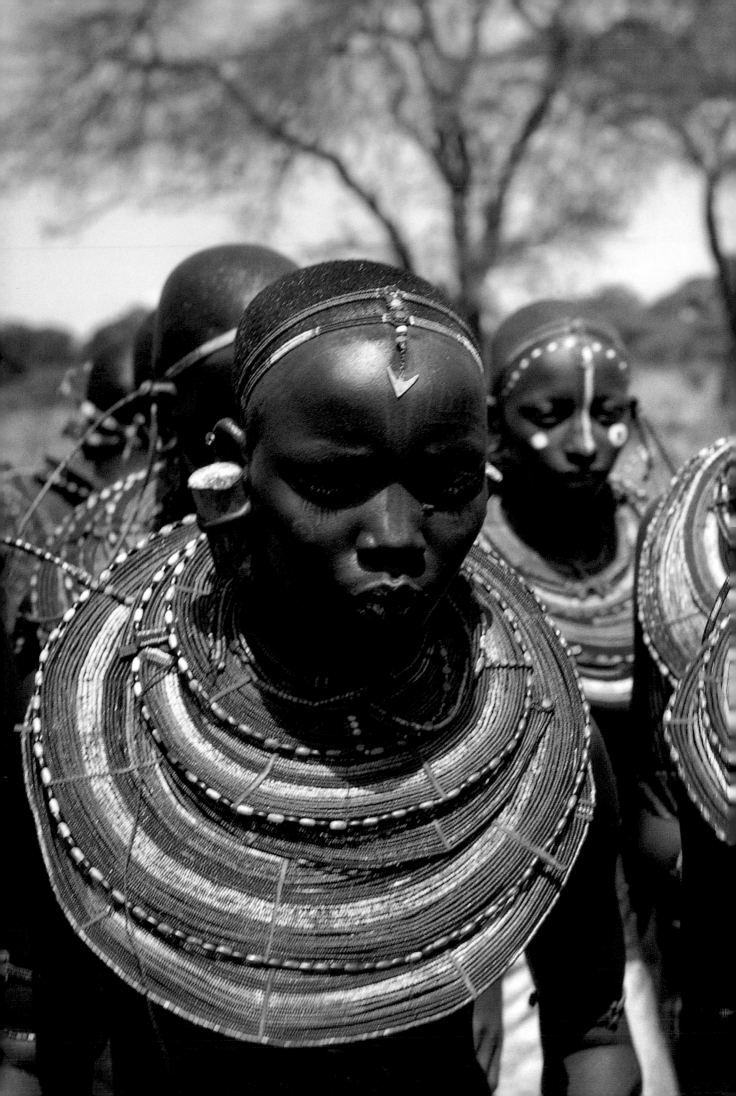

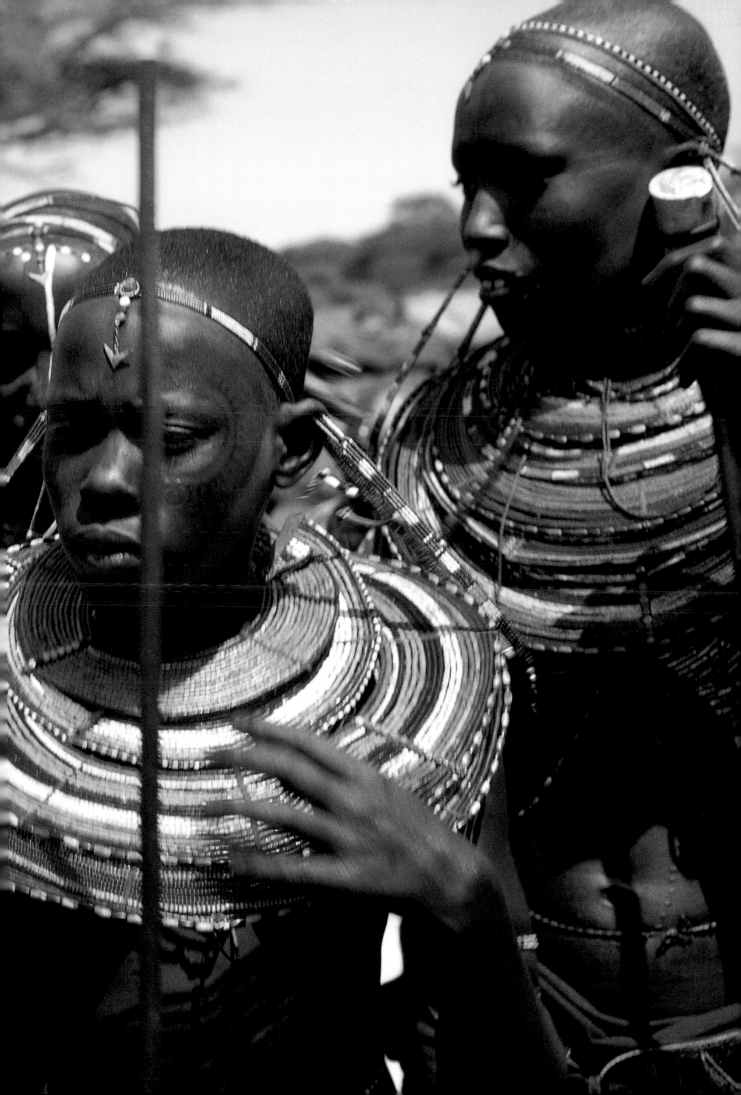

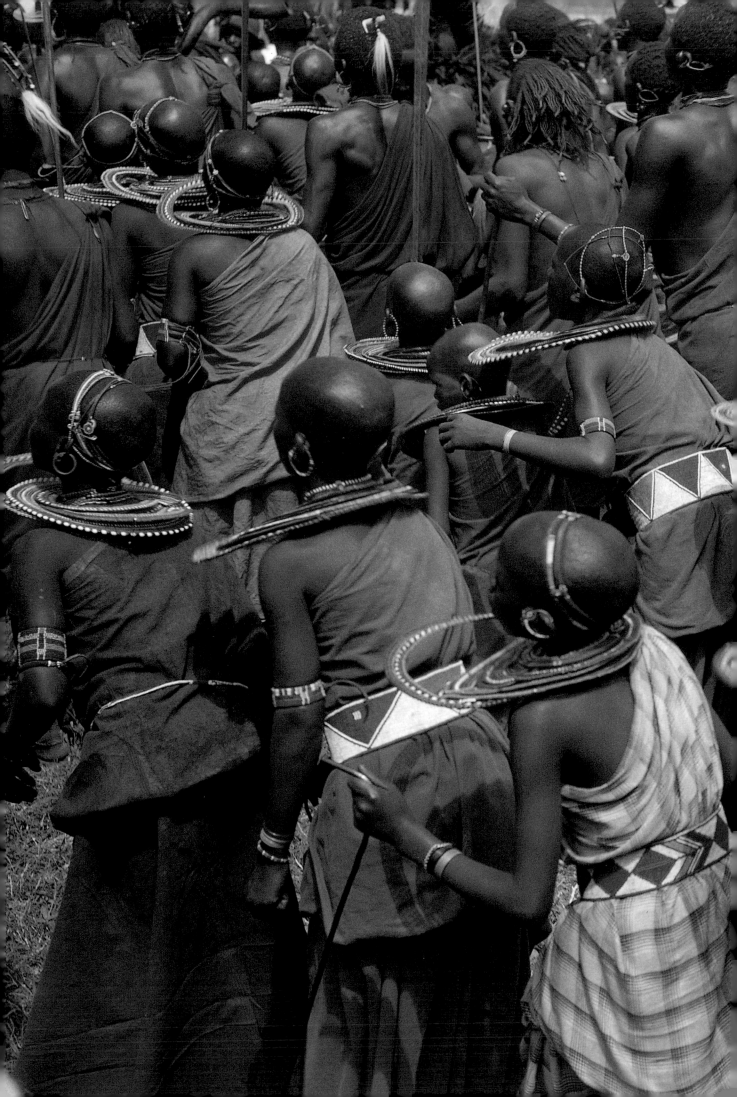

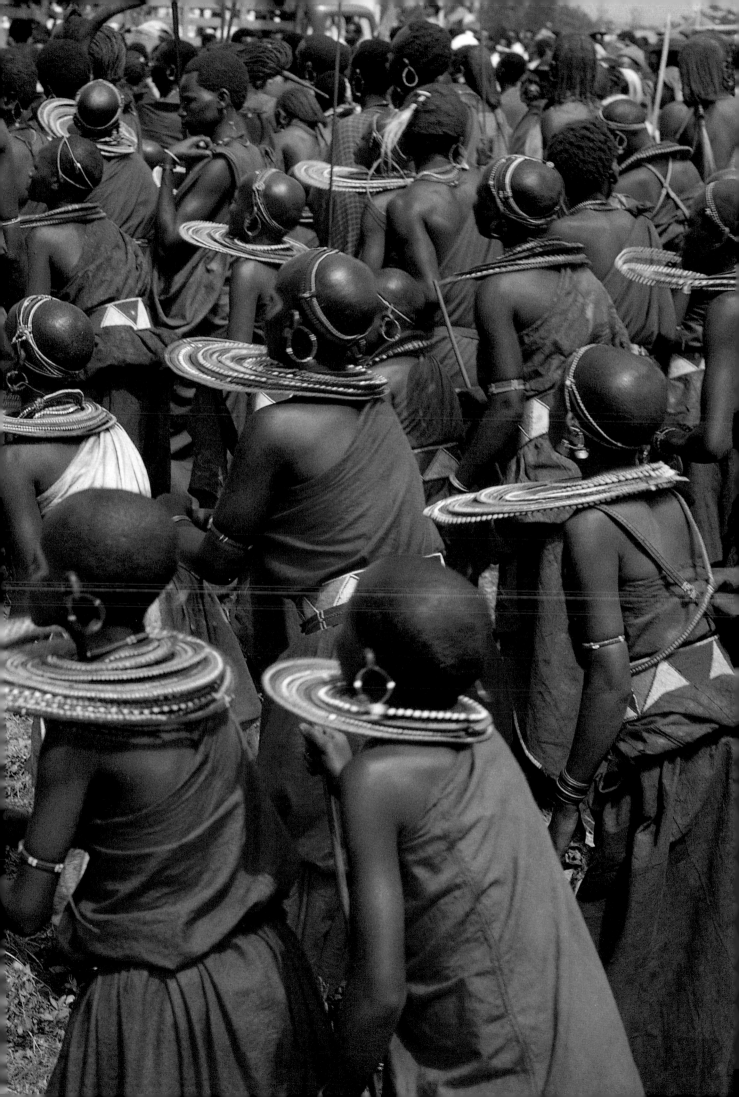

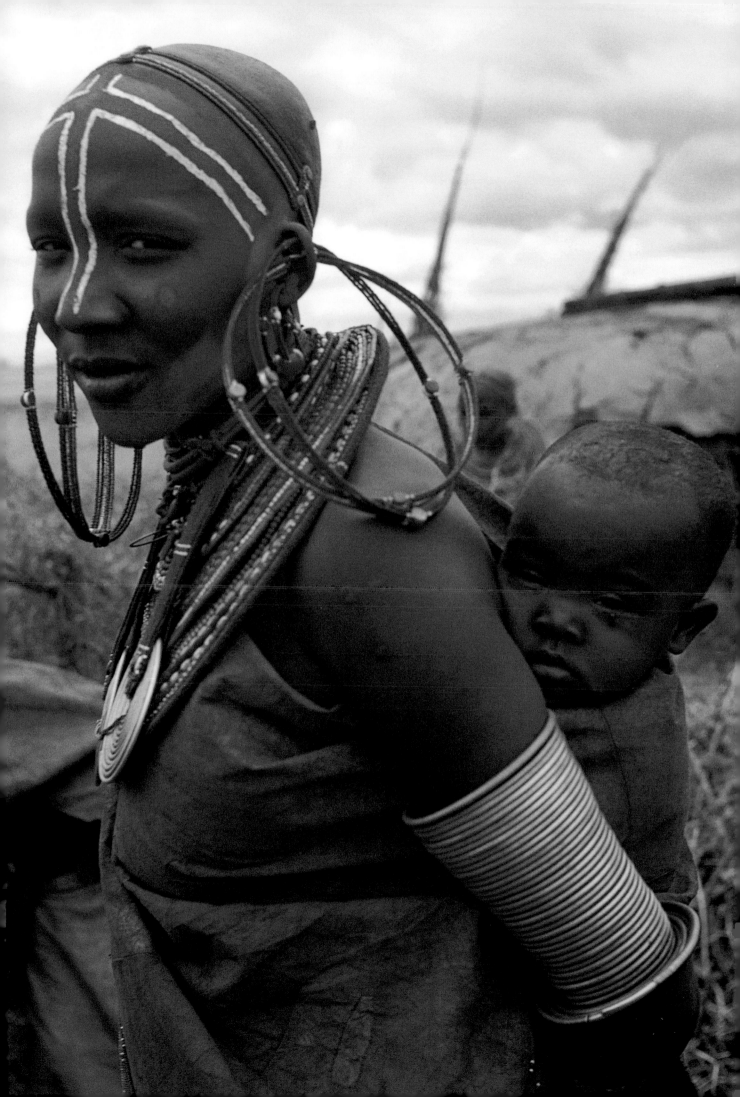

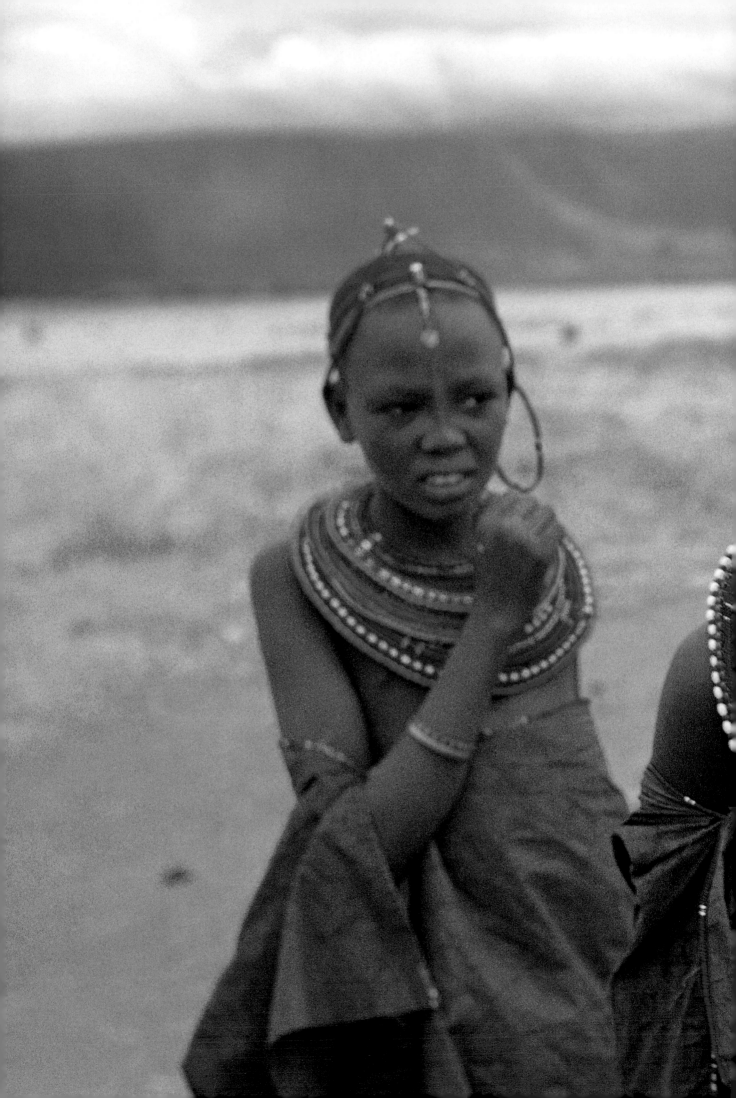

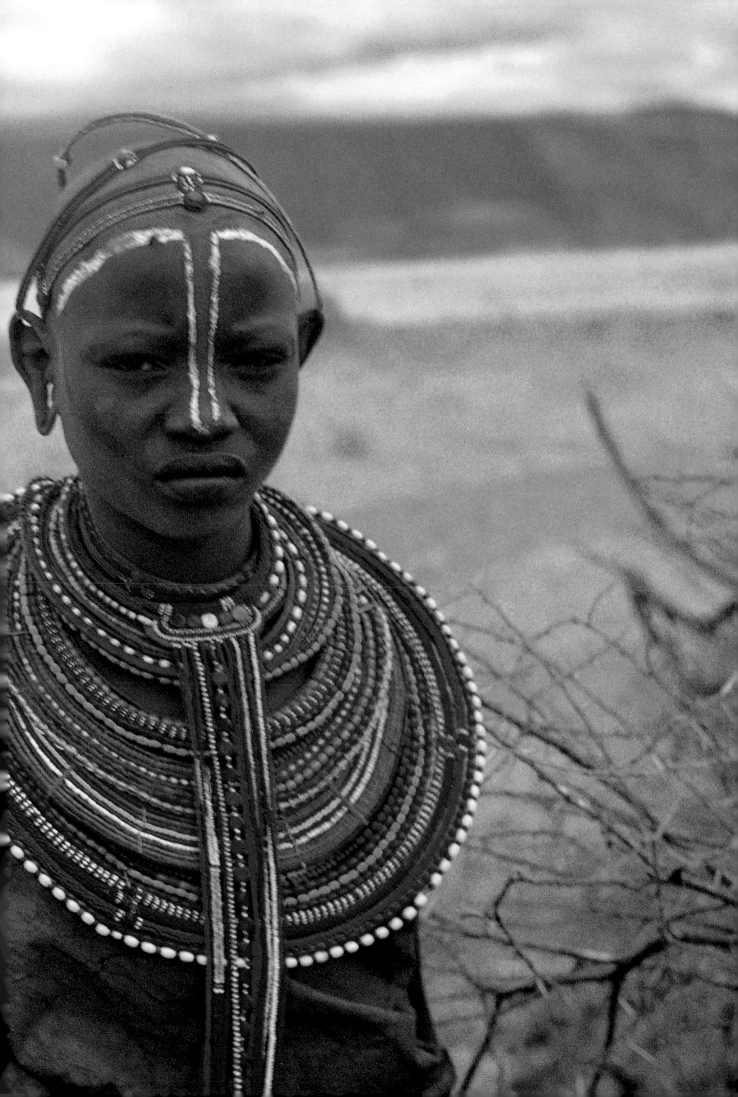

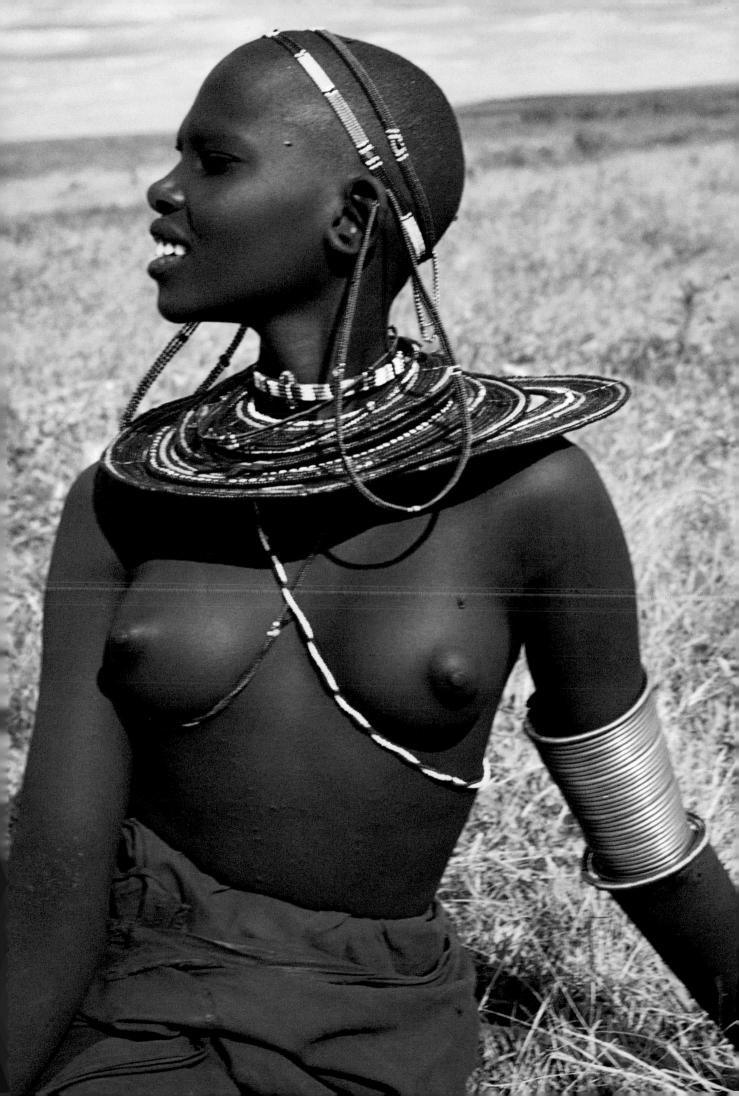

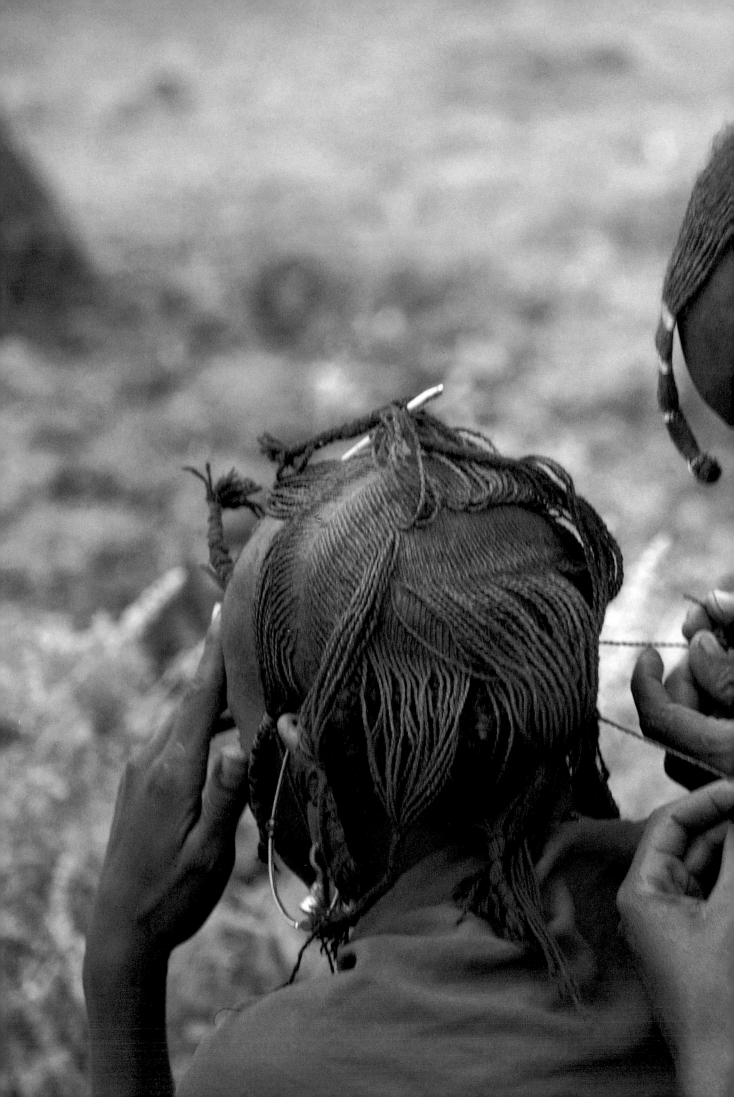

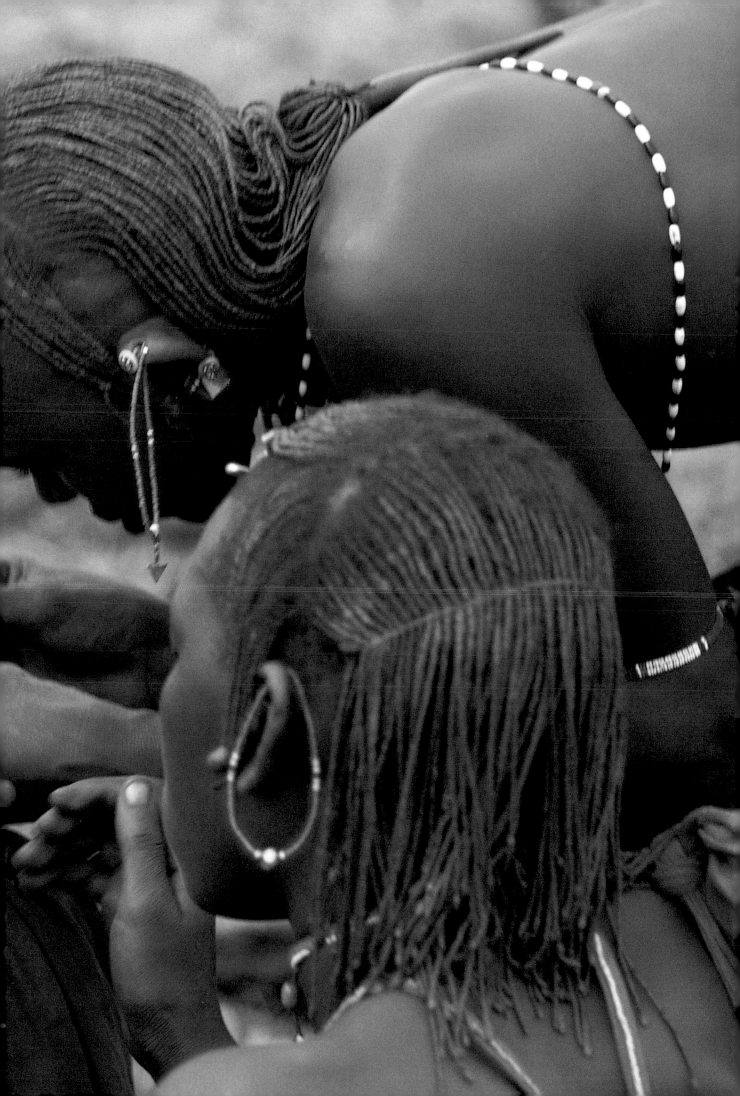

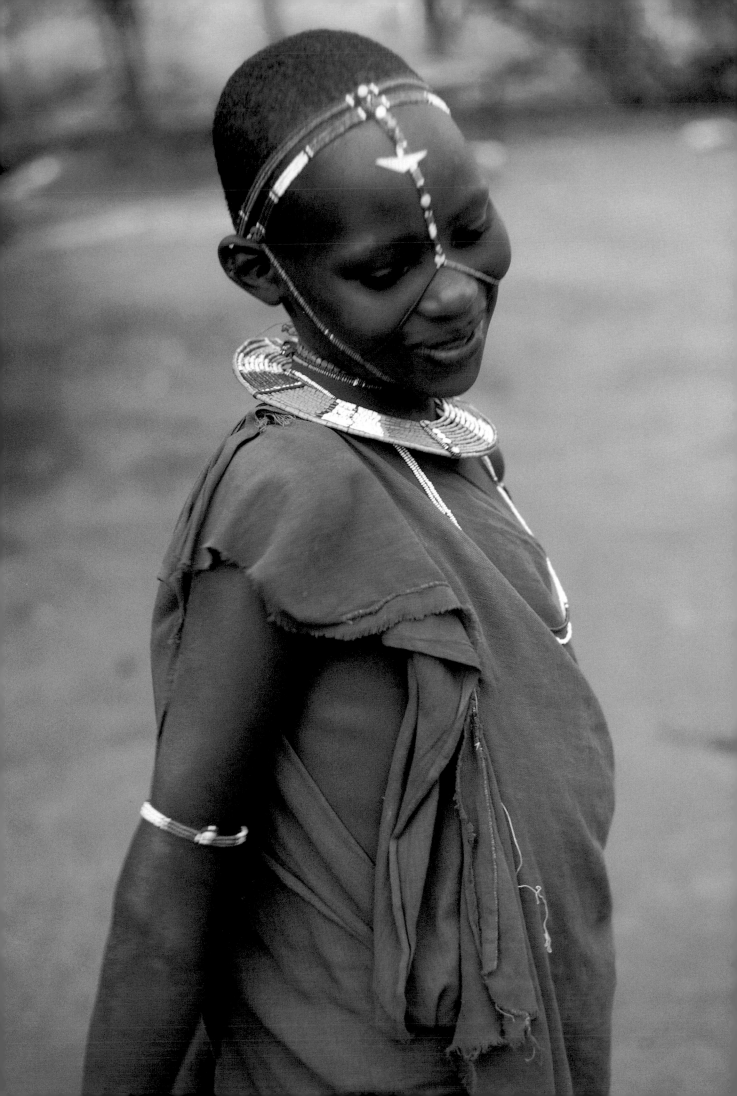

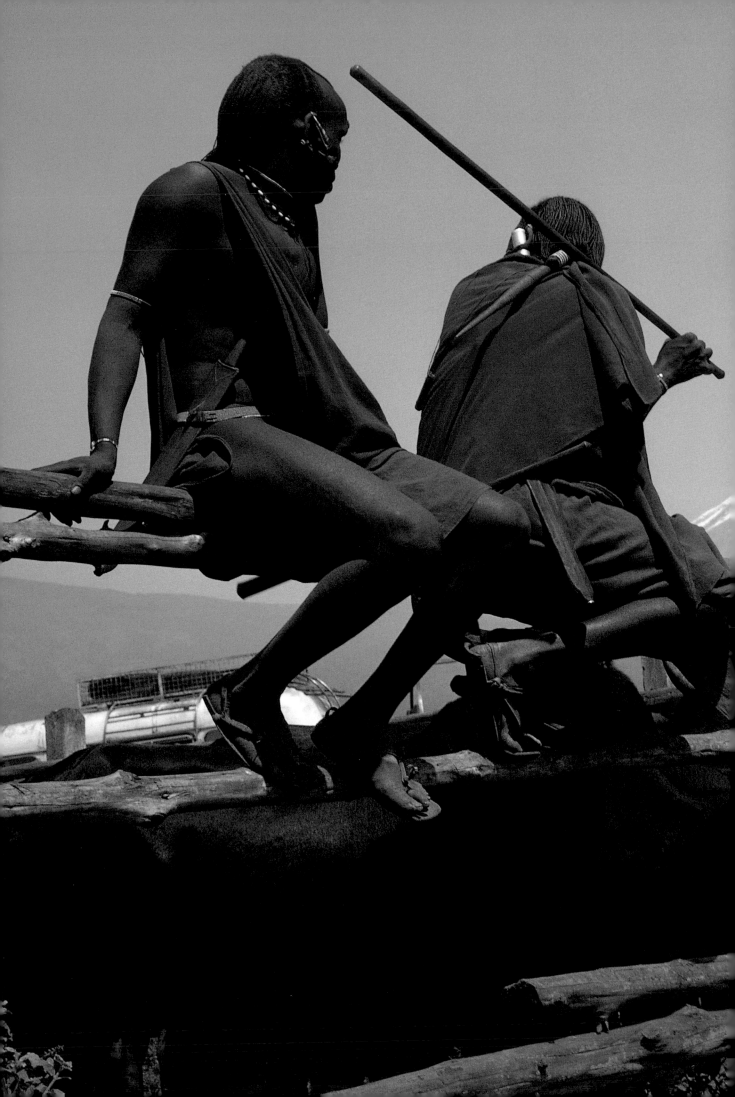

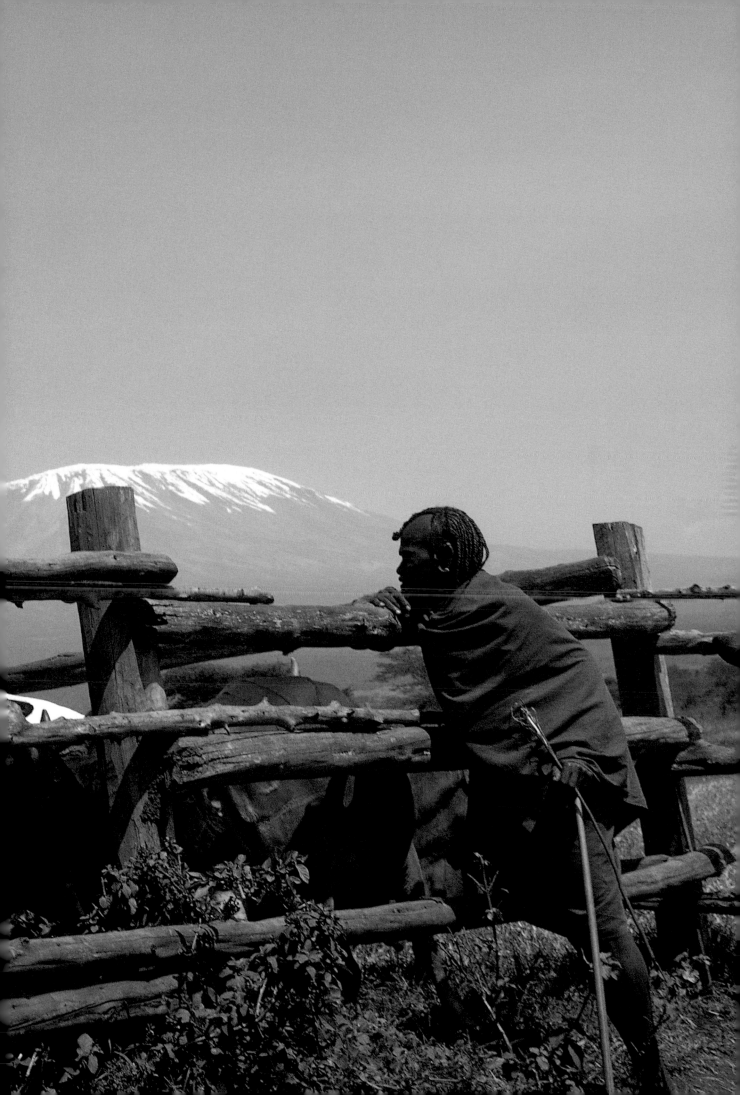

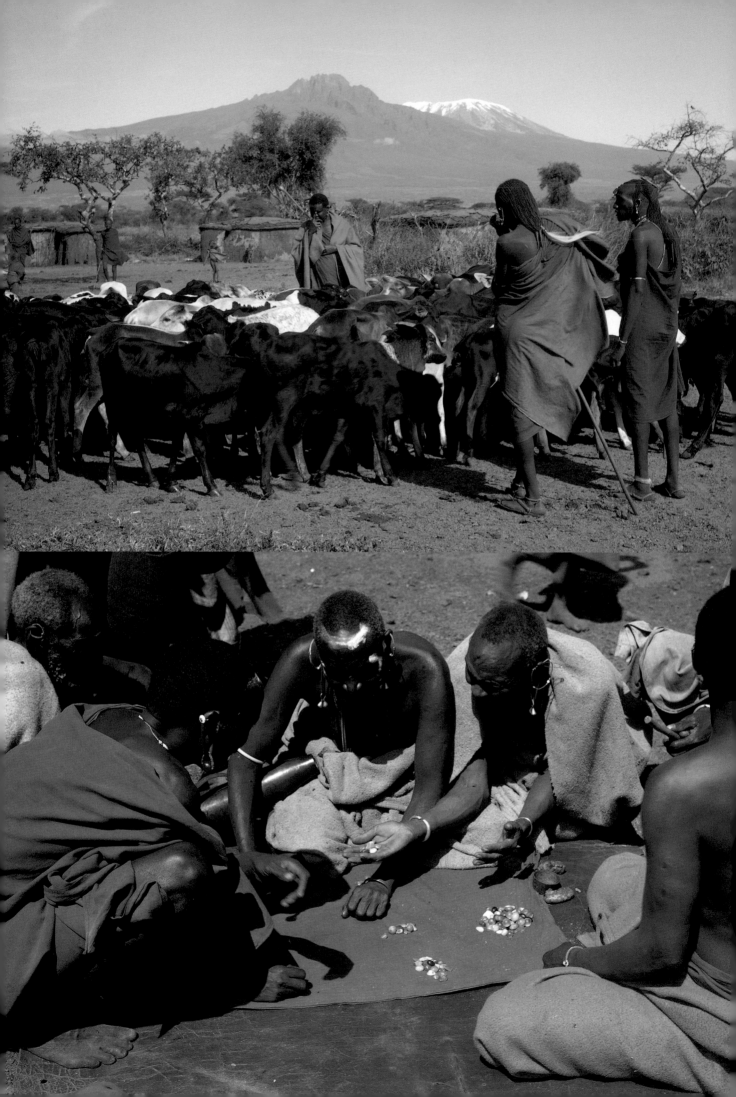

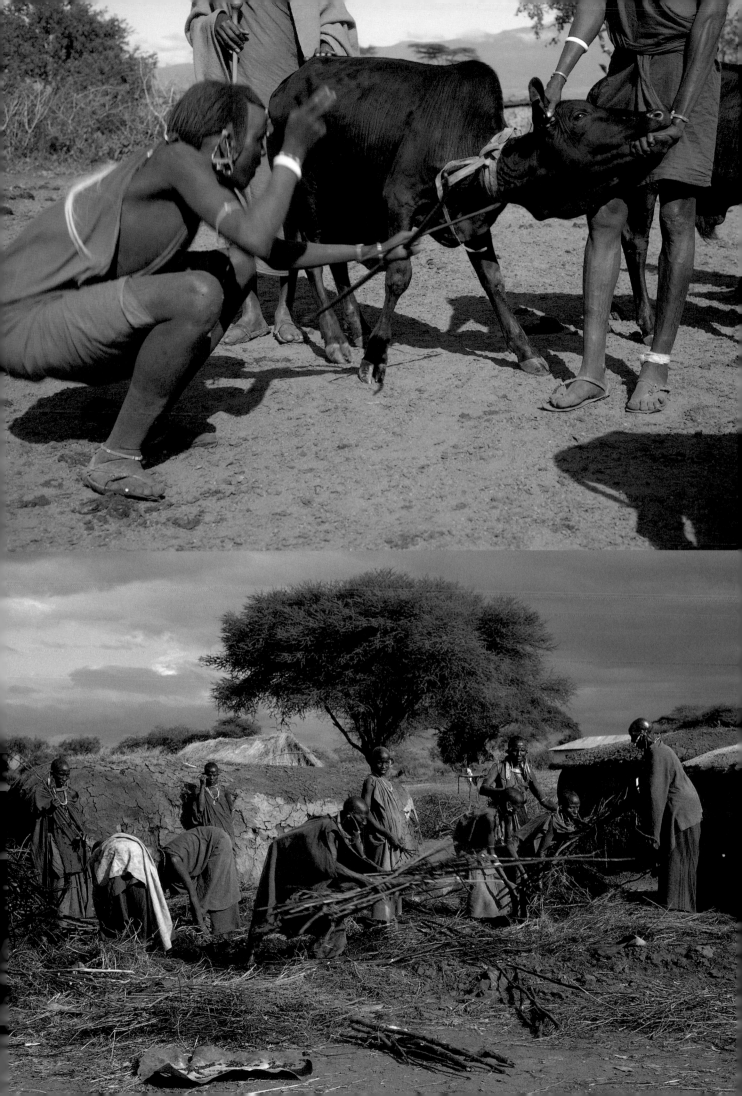

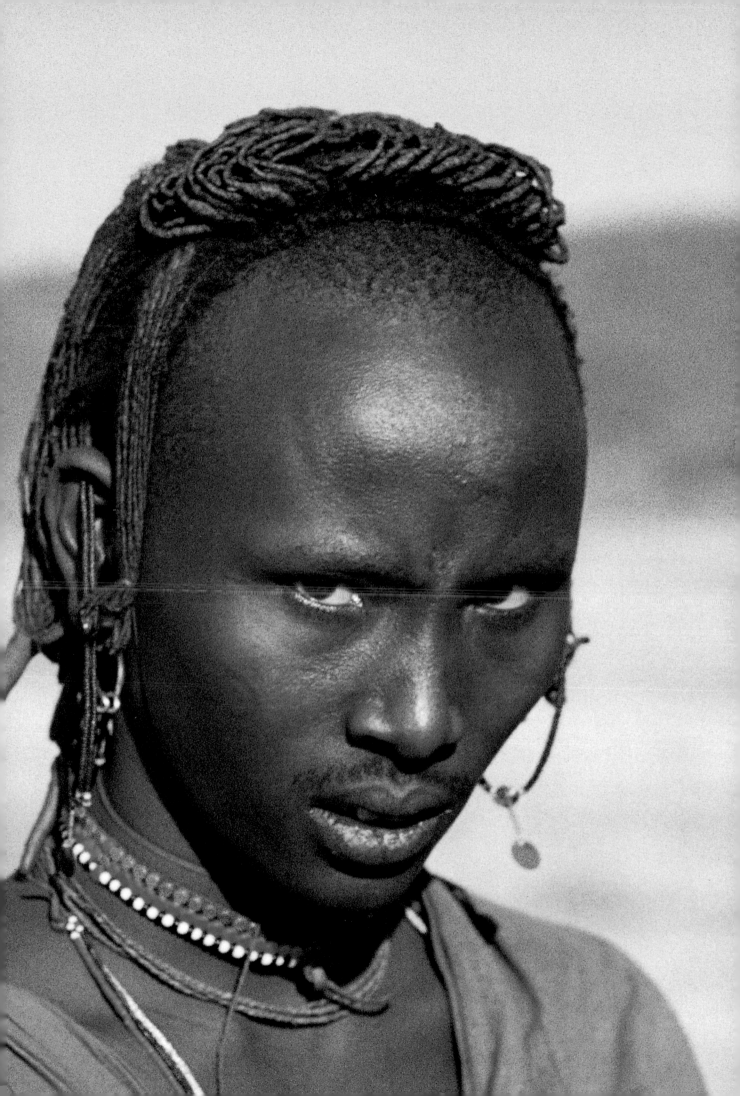

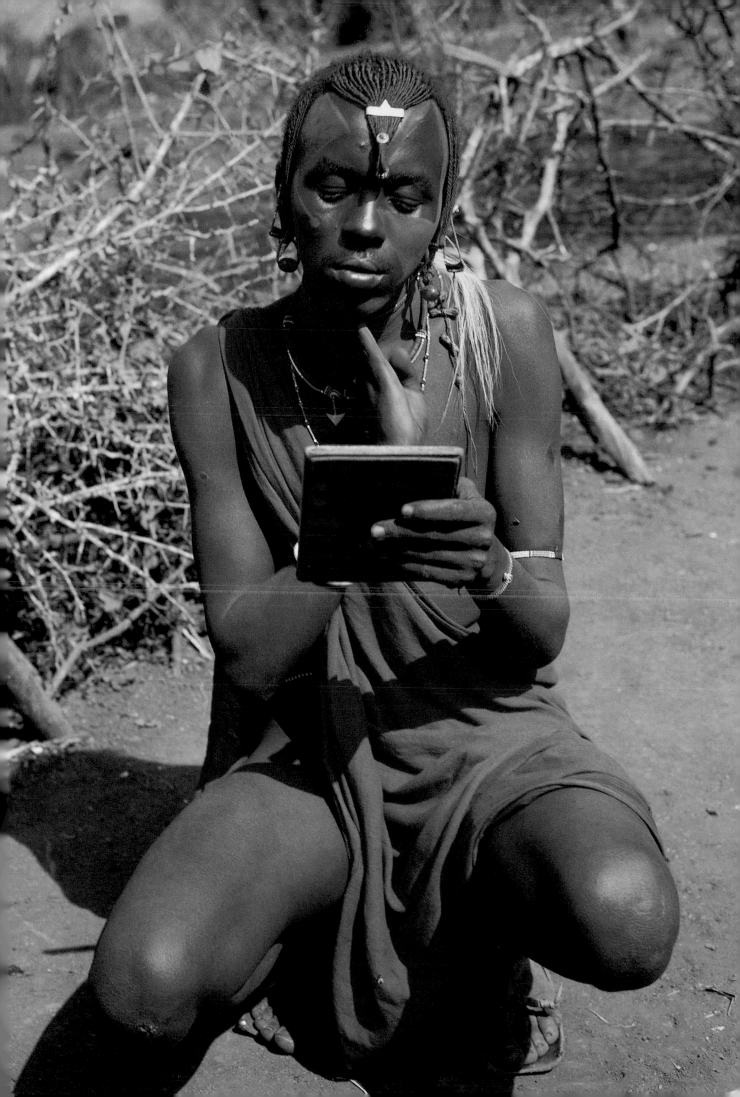

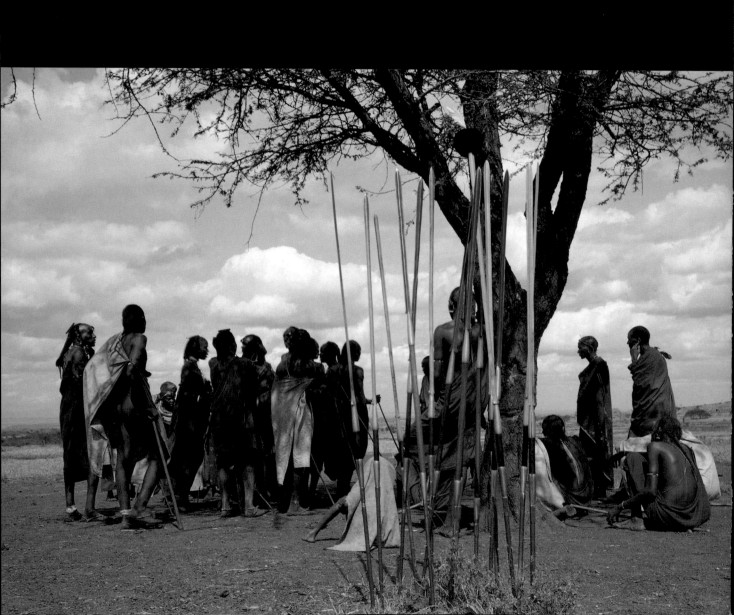

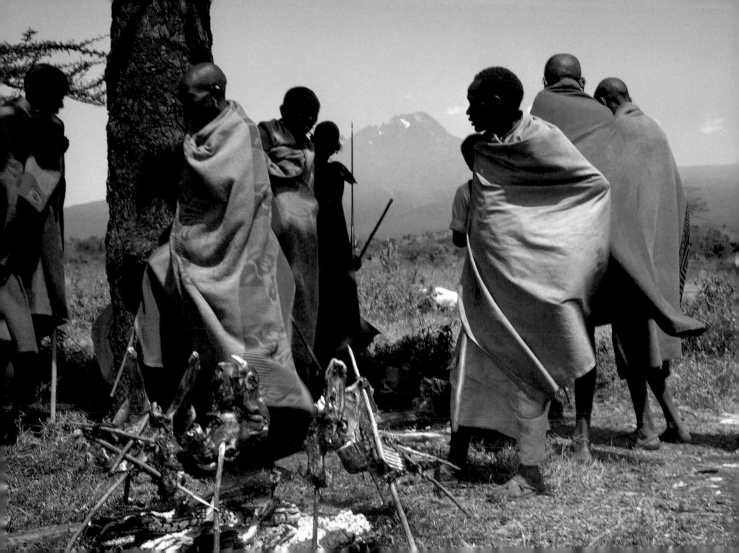

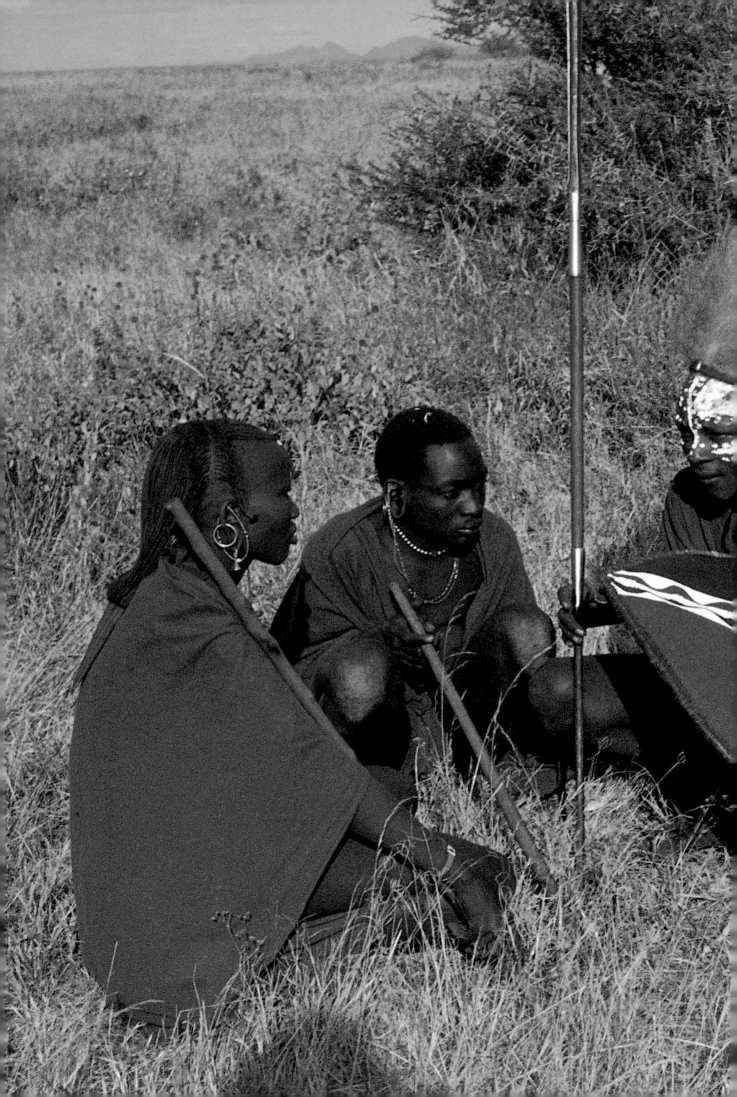

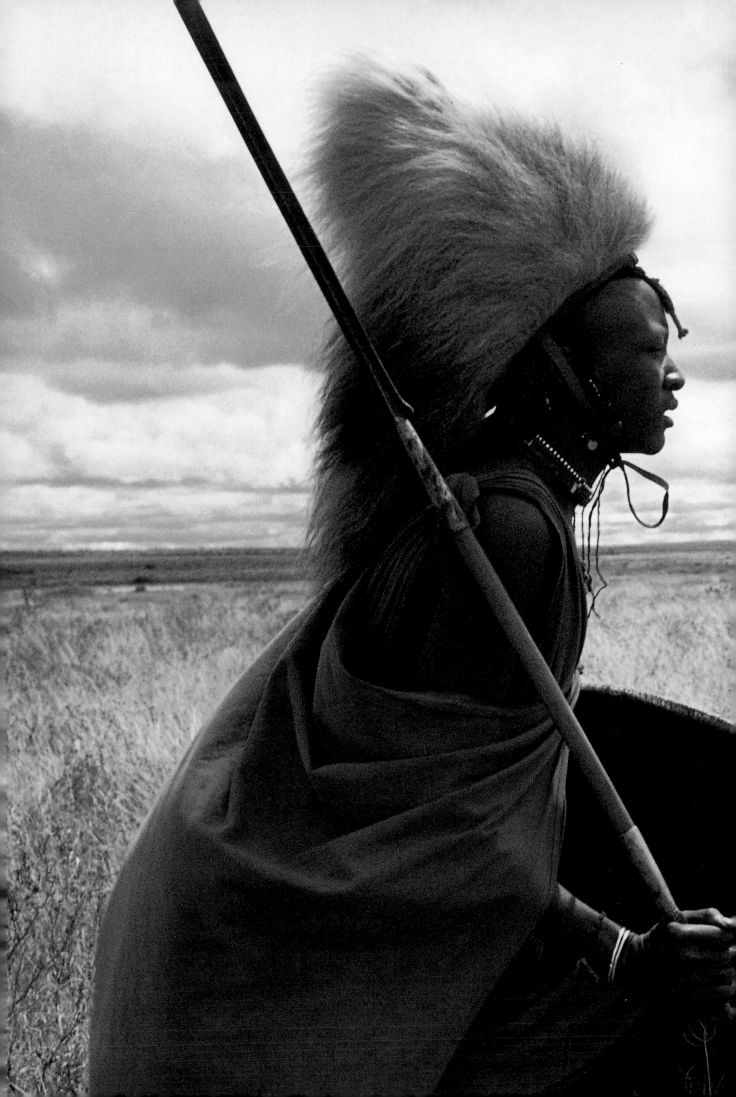

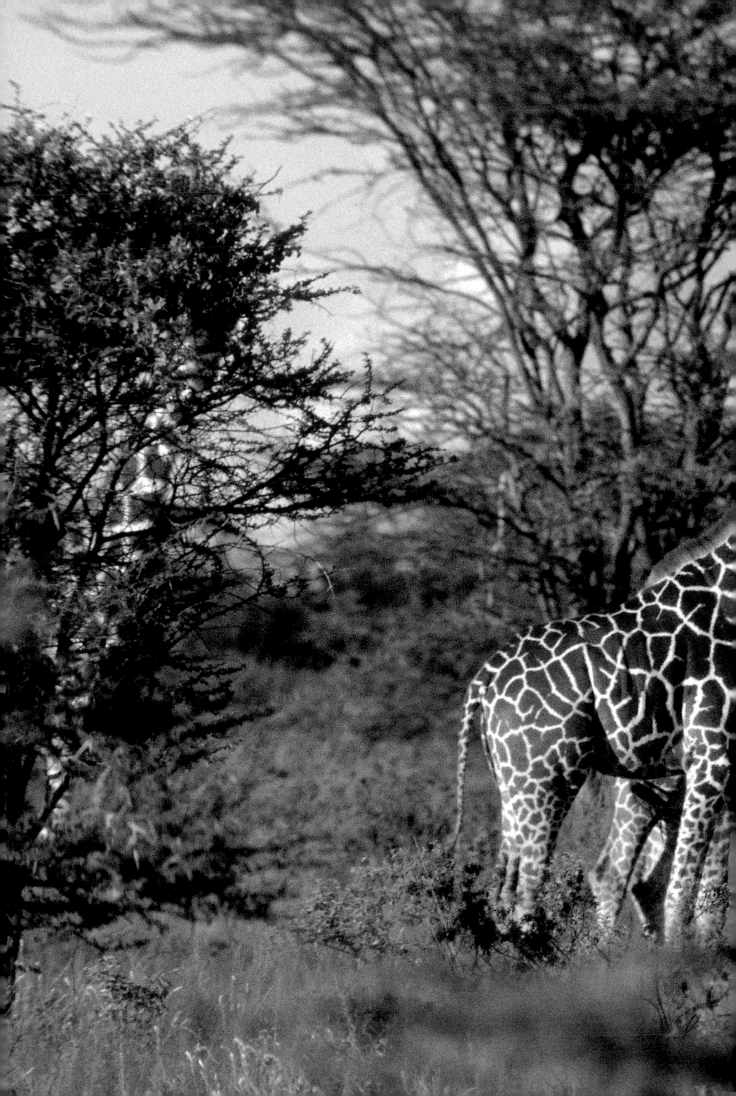

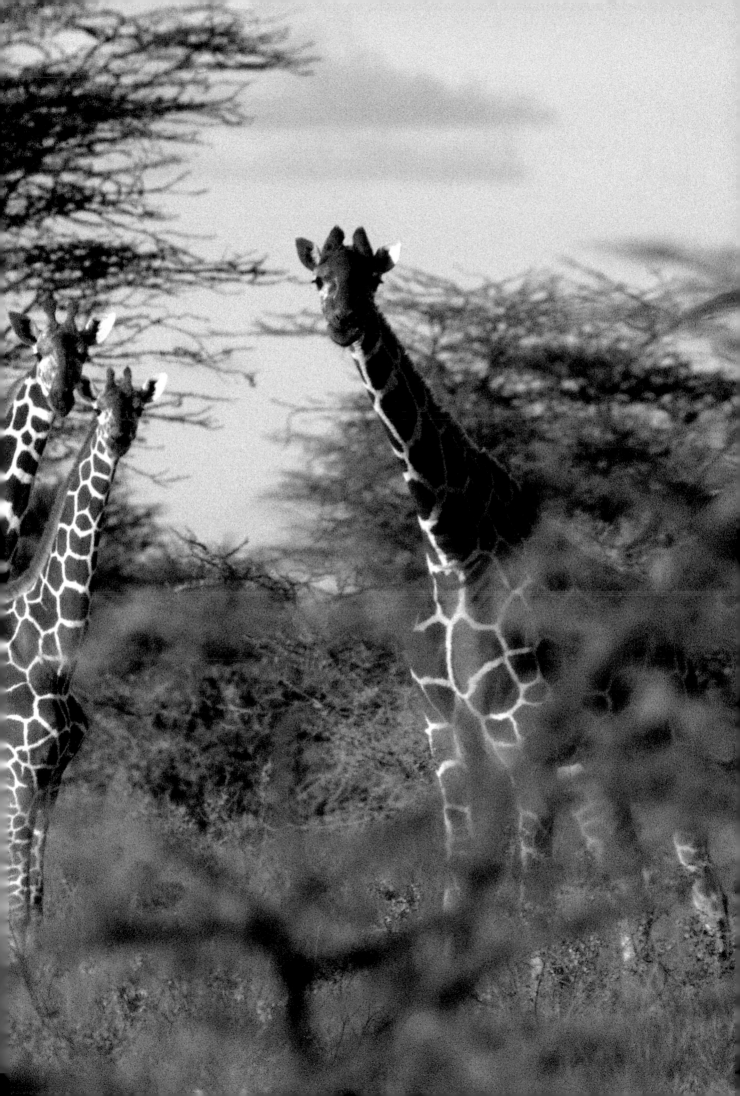

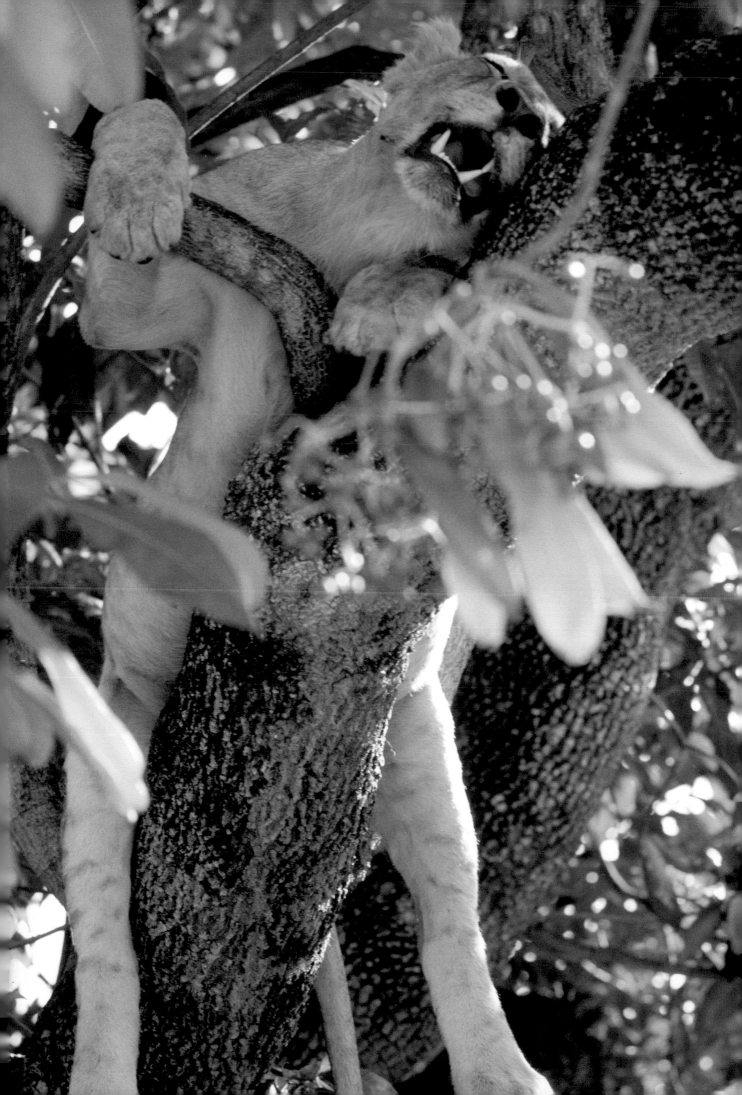

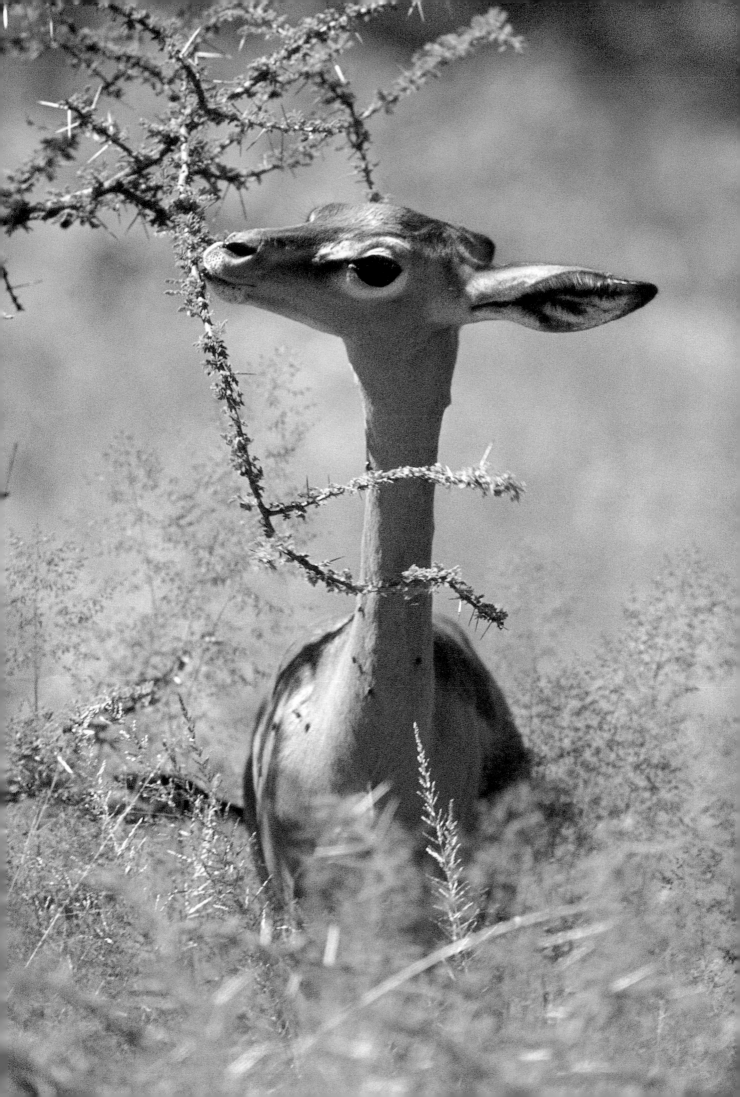

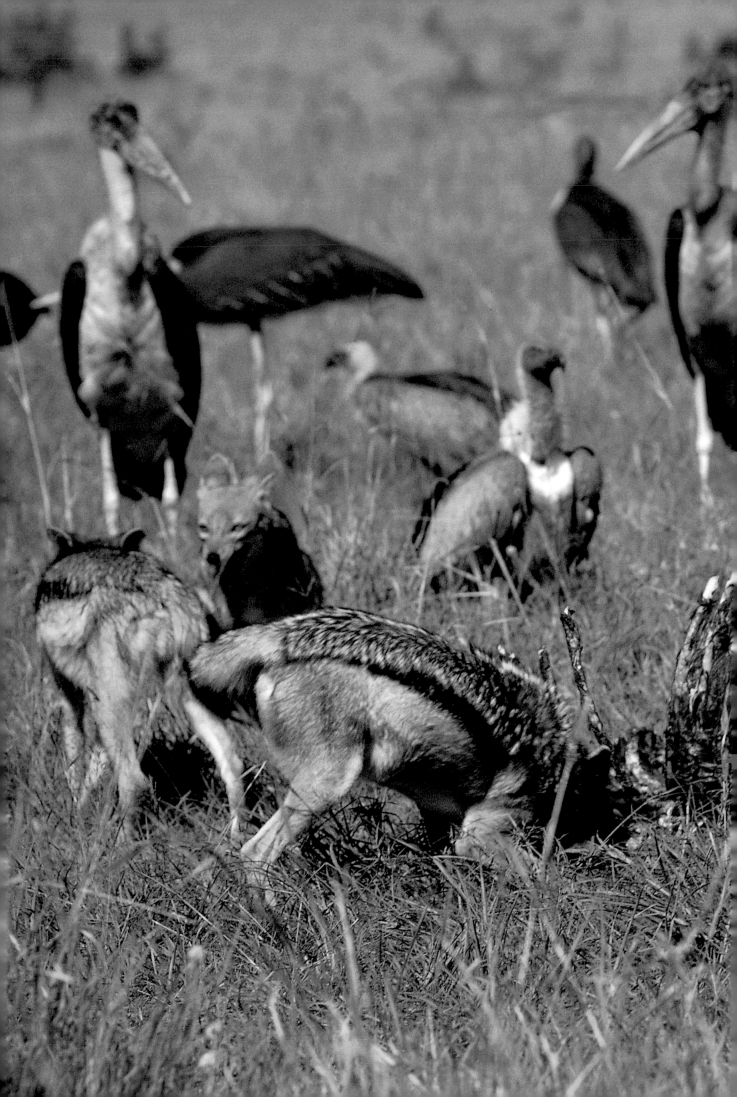

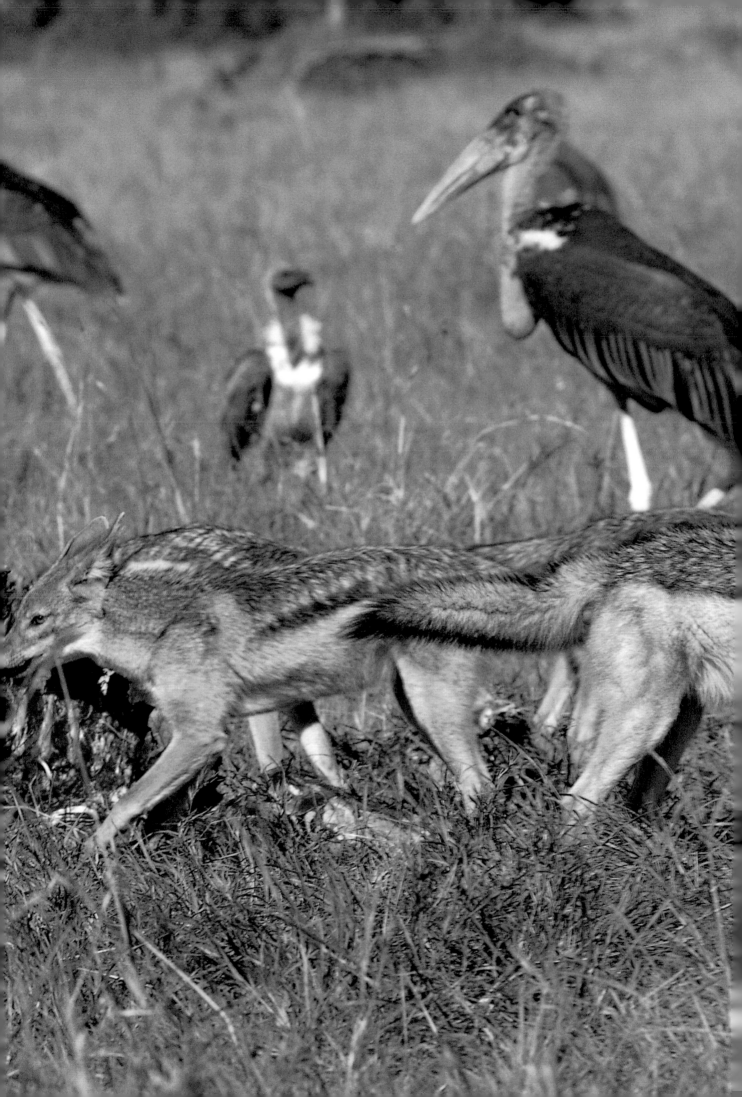

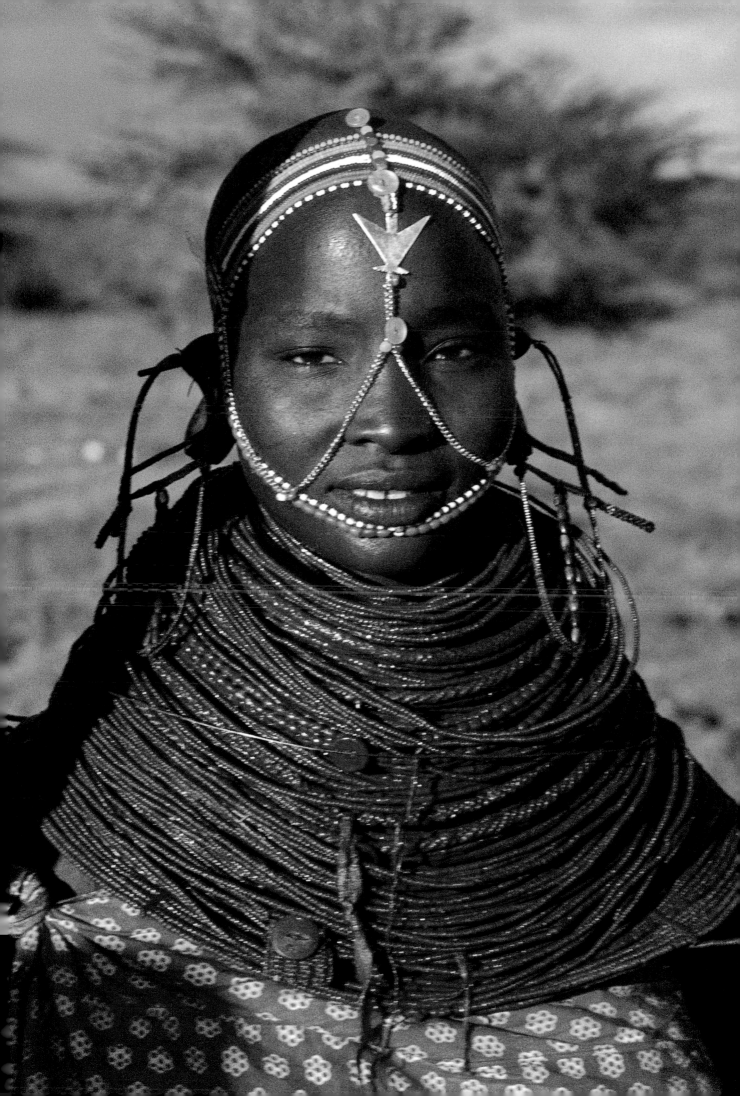

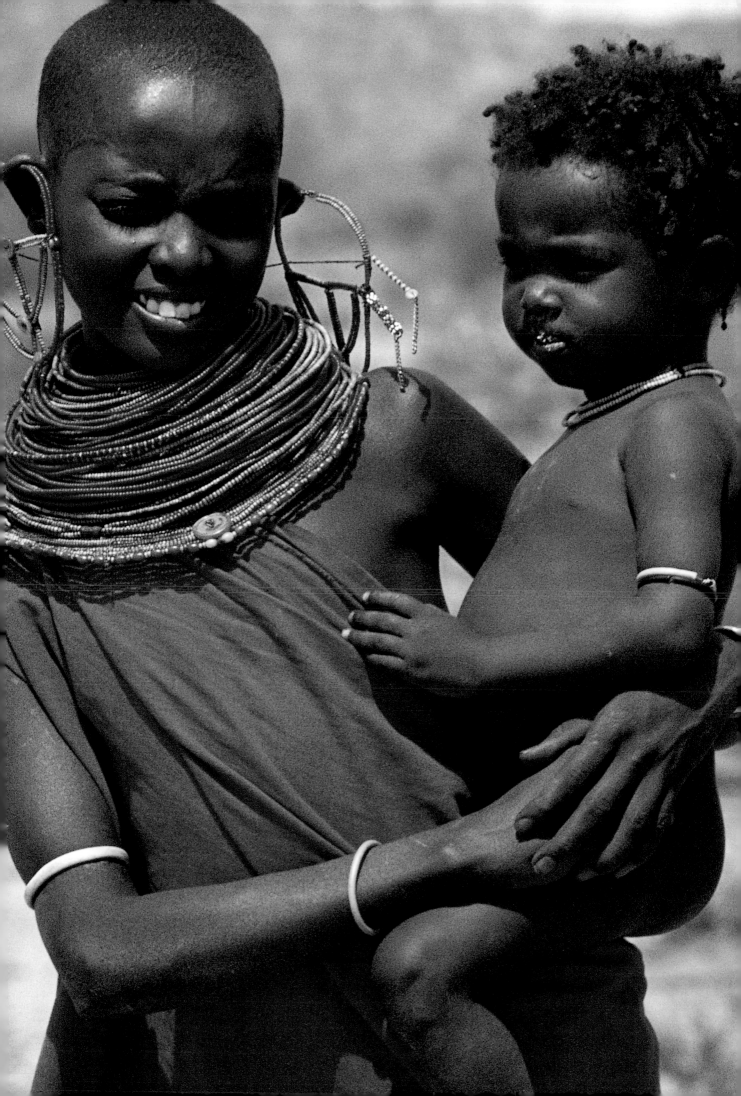

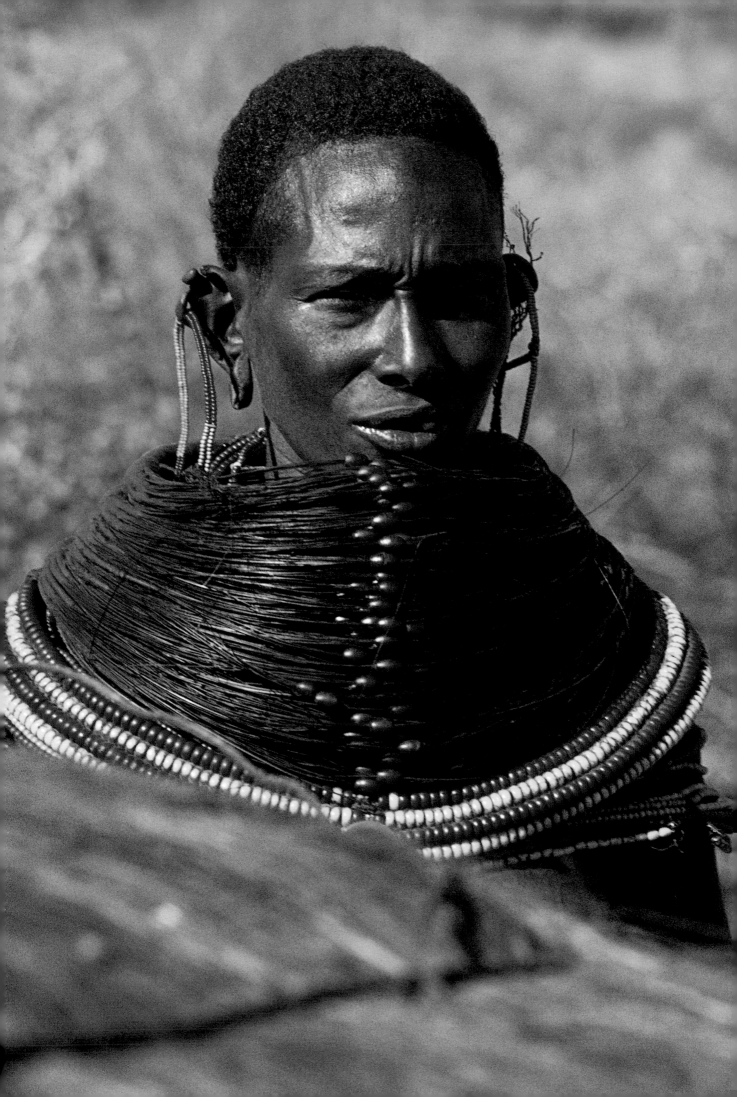

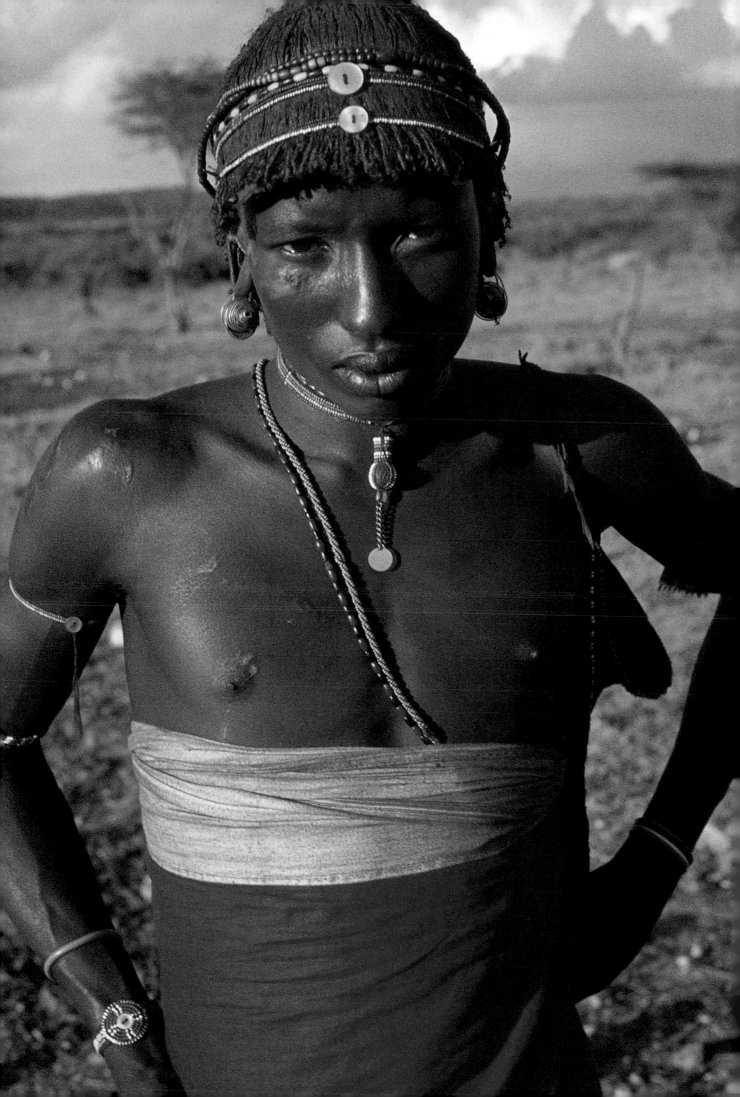

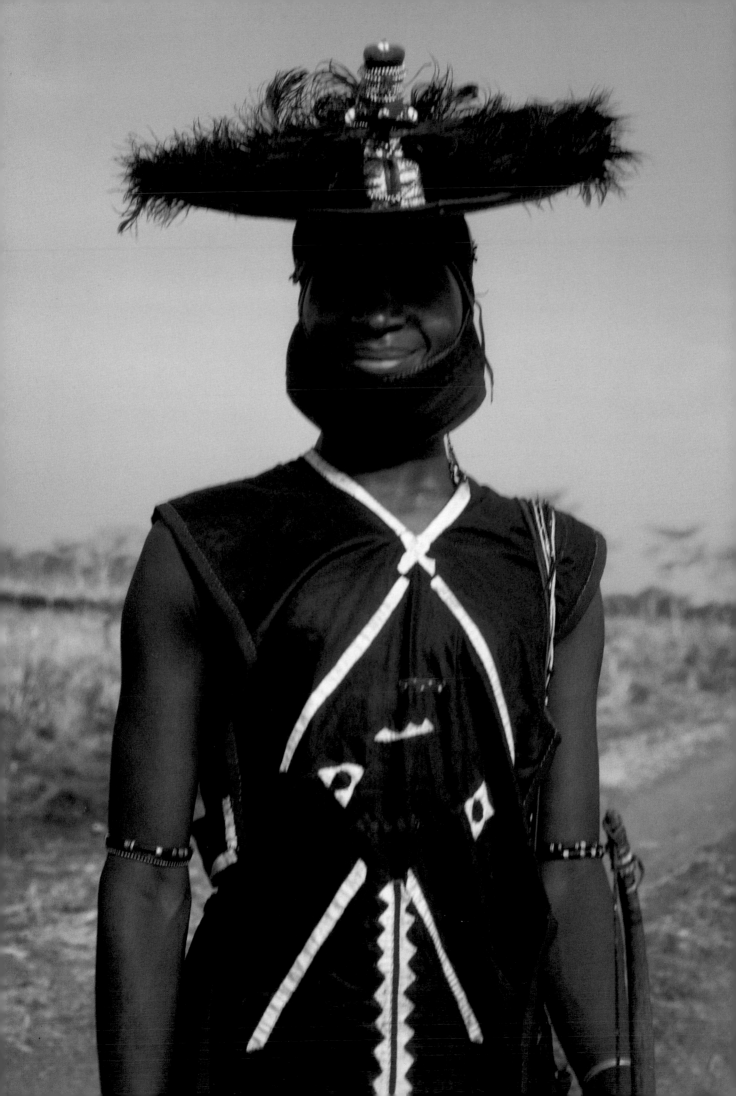

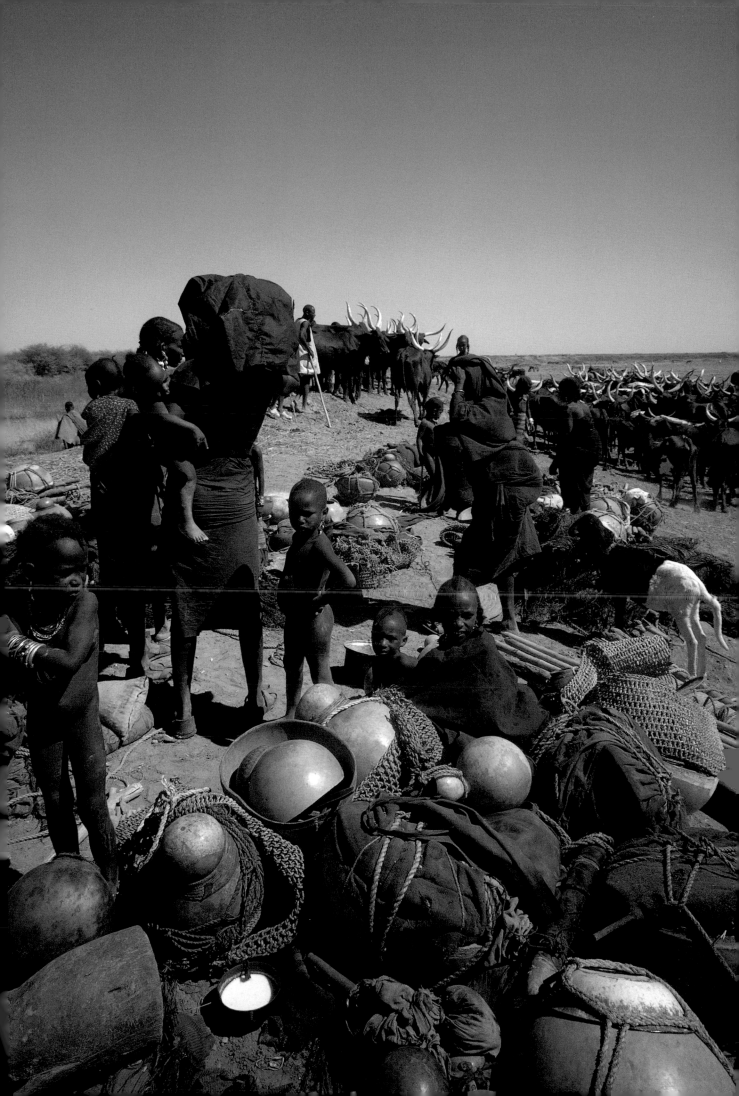

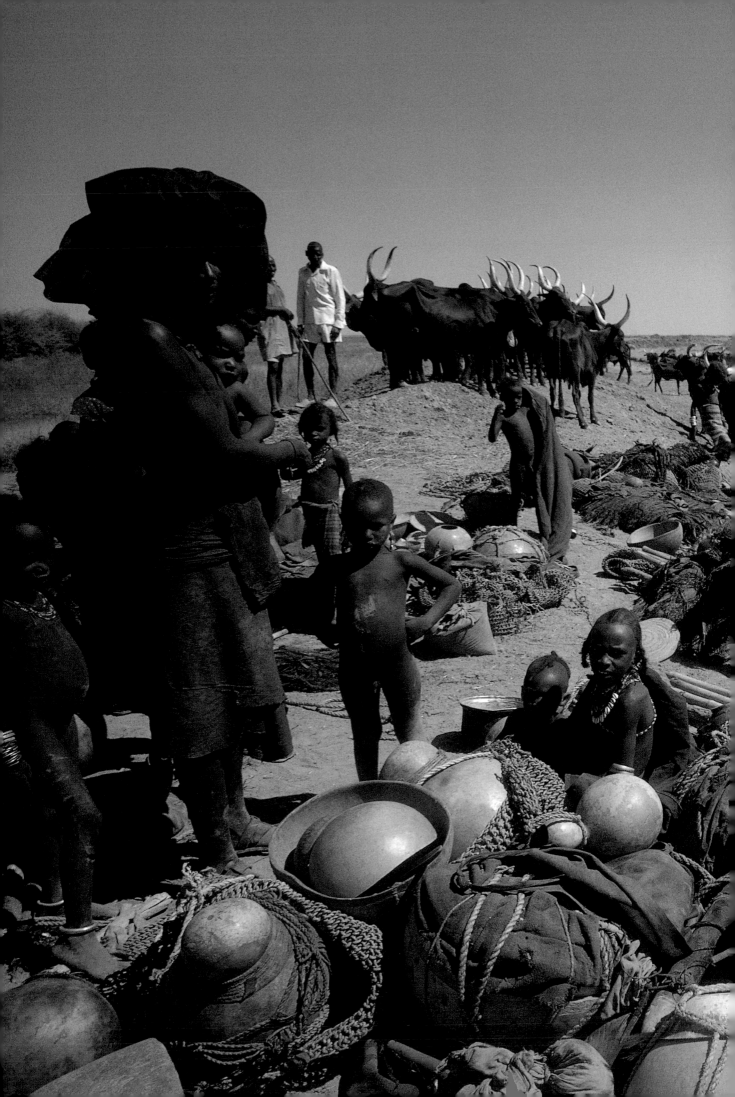

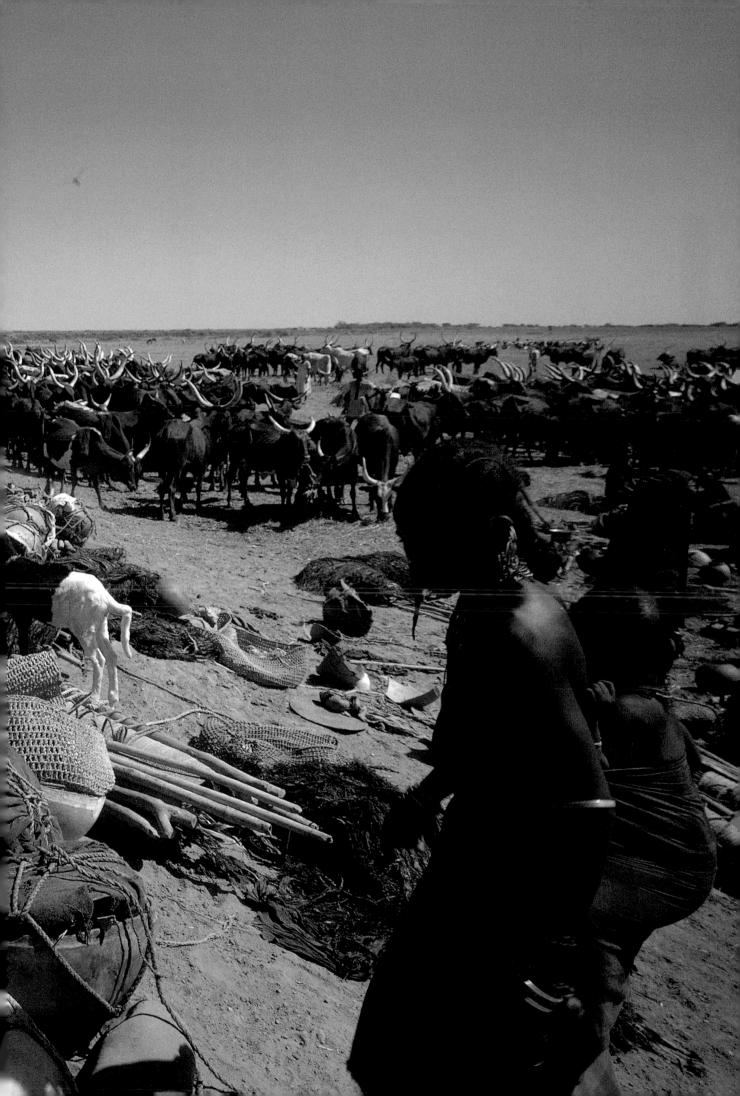

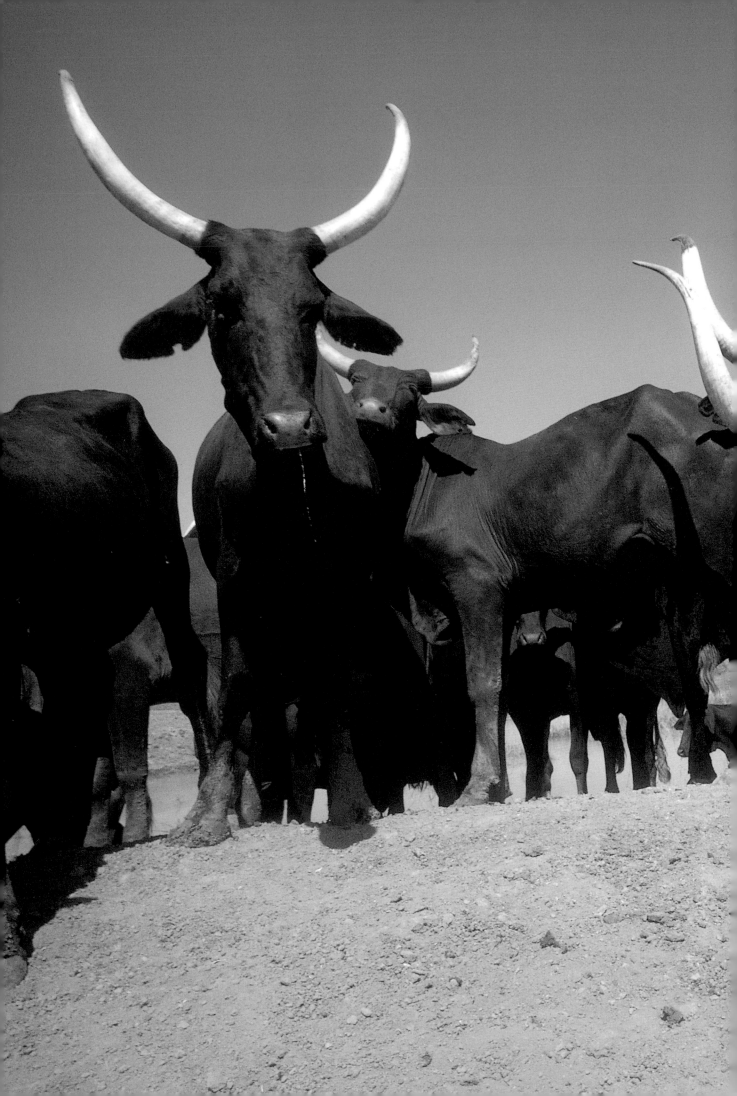

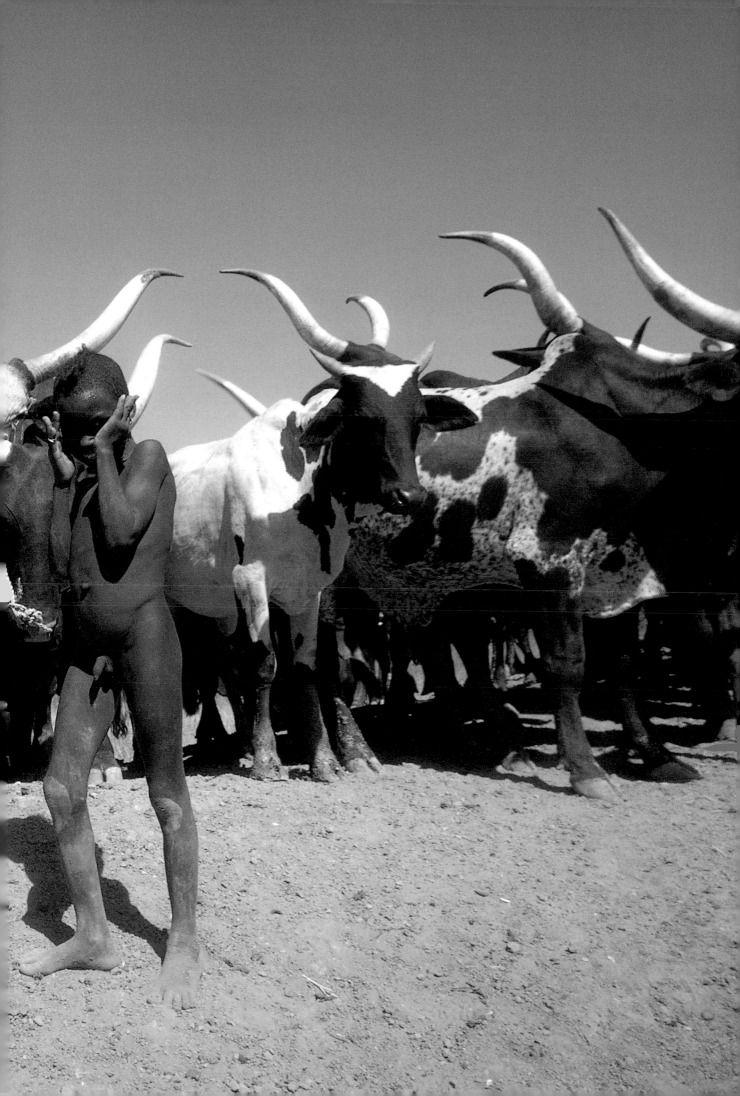

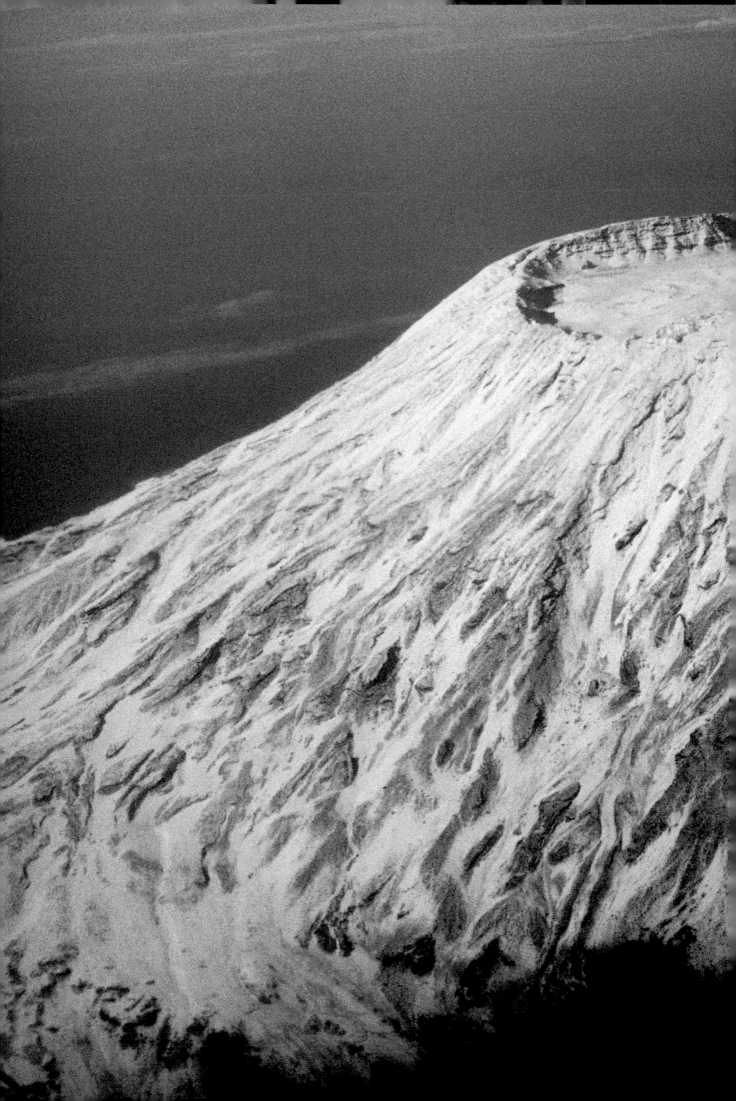

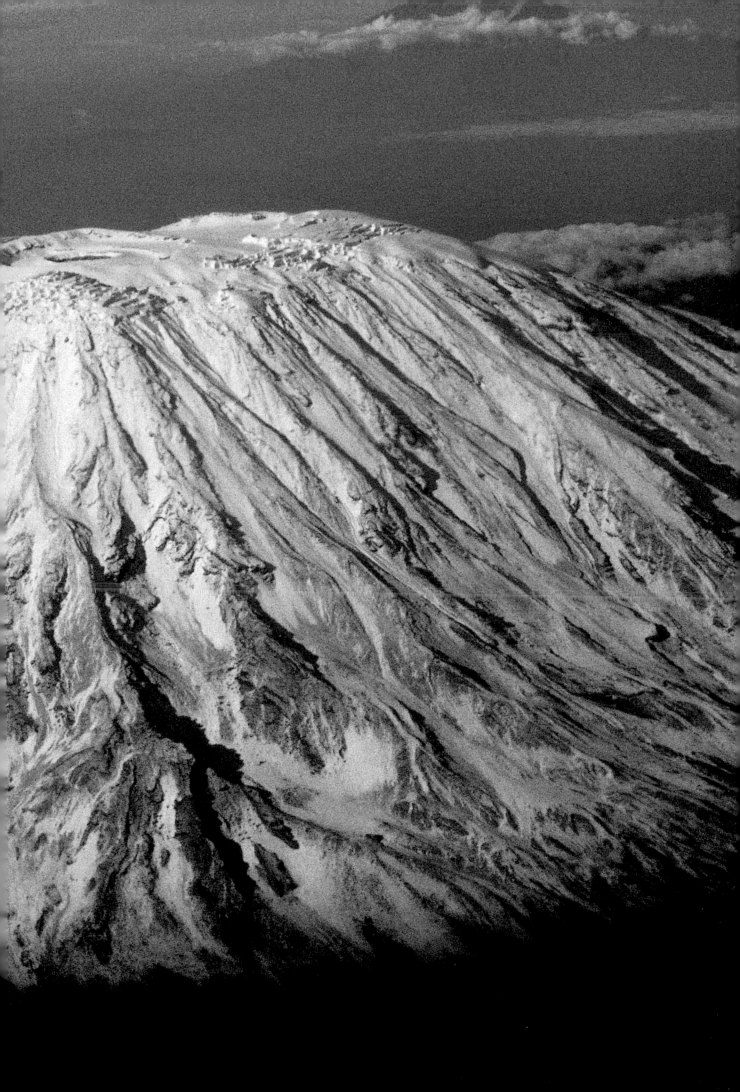

The Shilluk

Die Schilluk
Les Shilluk
シルク

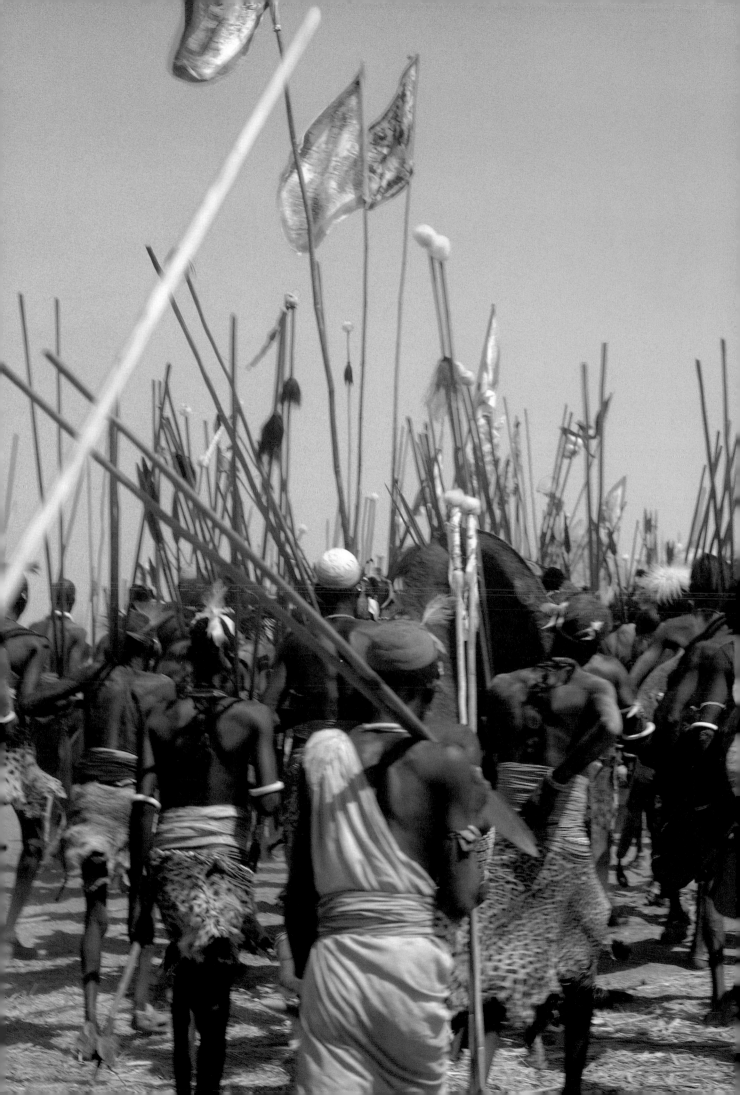

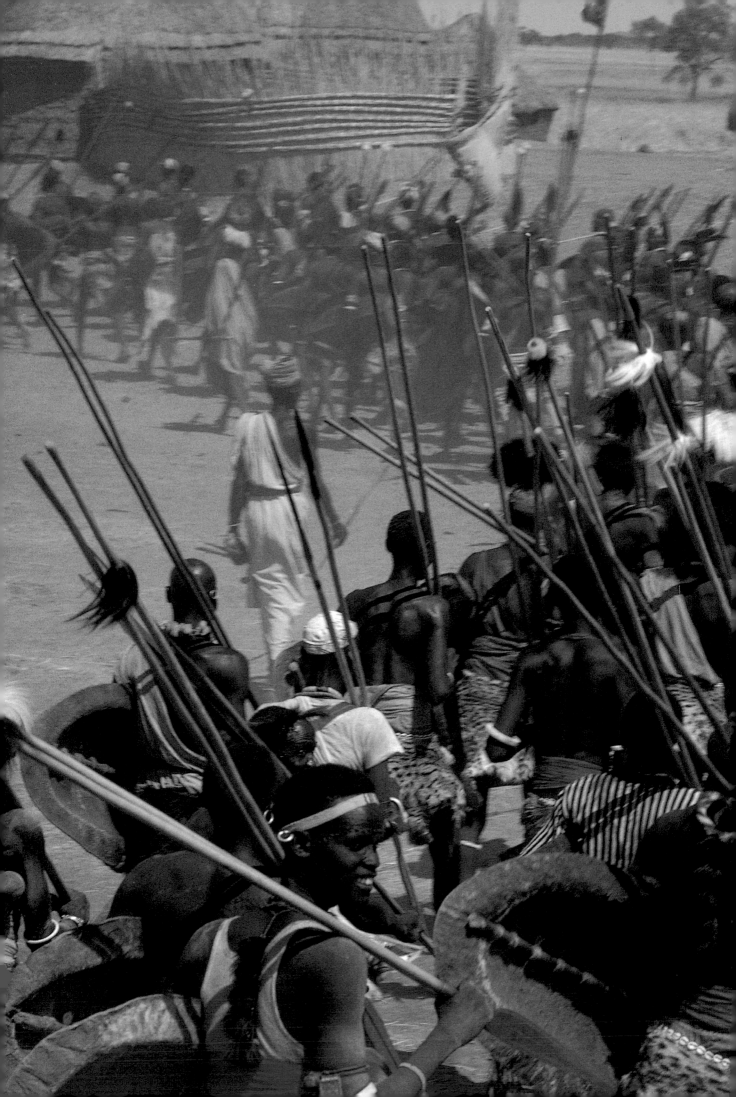

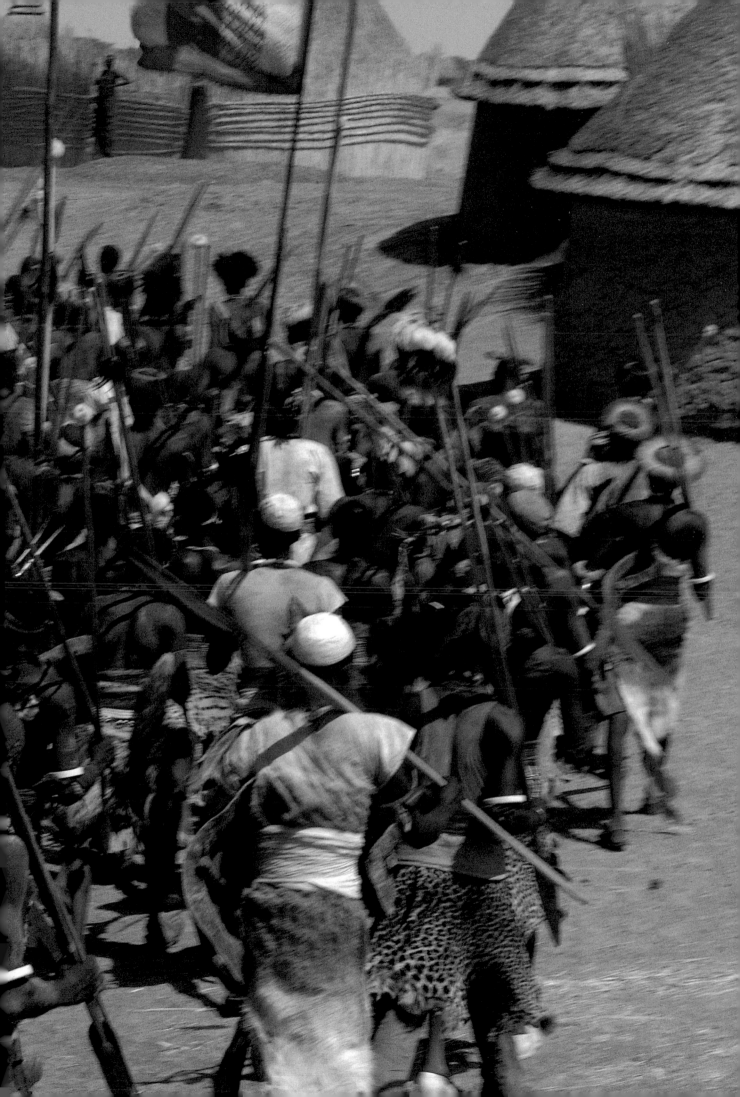

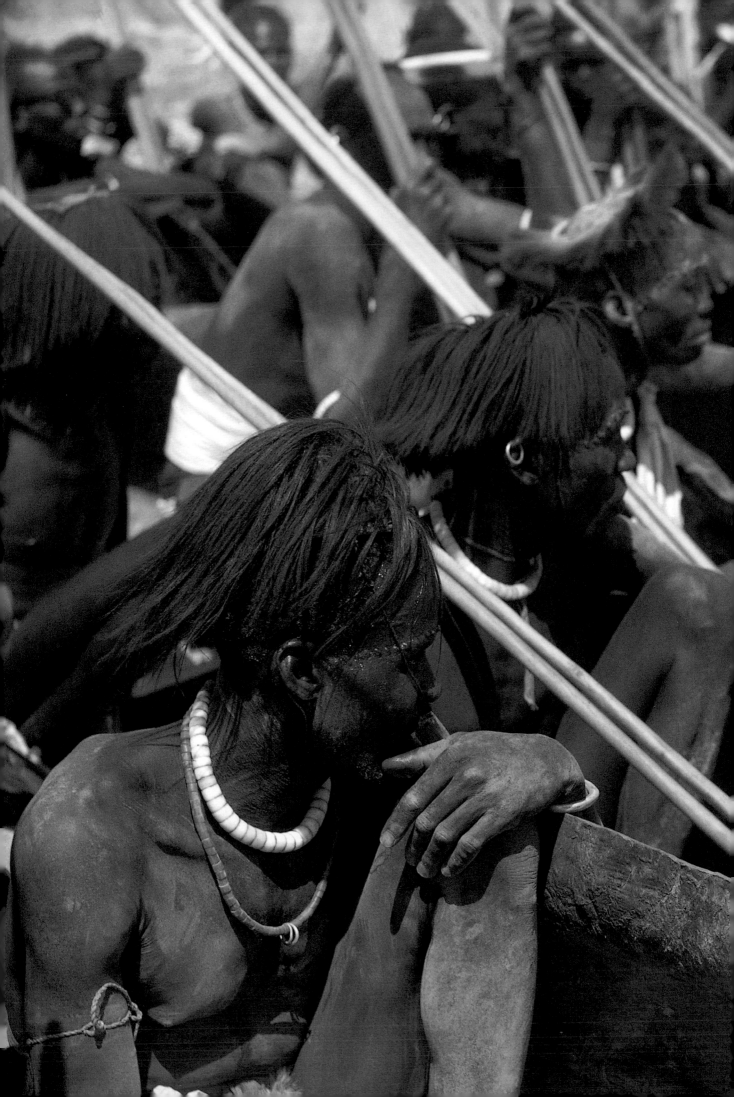

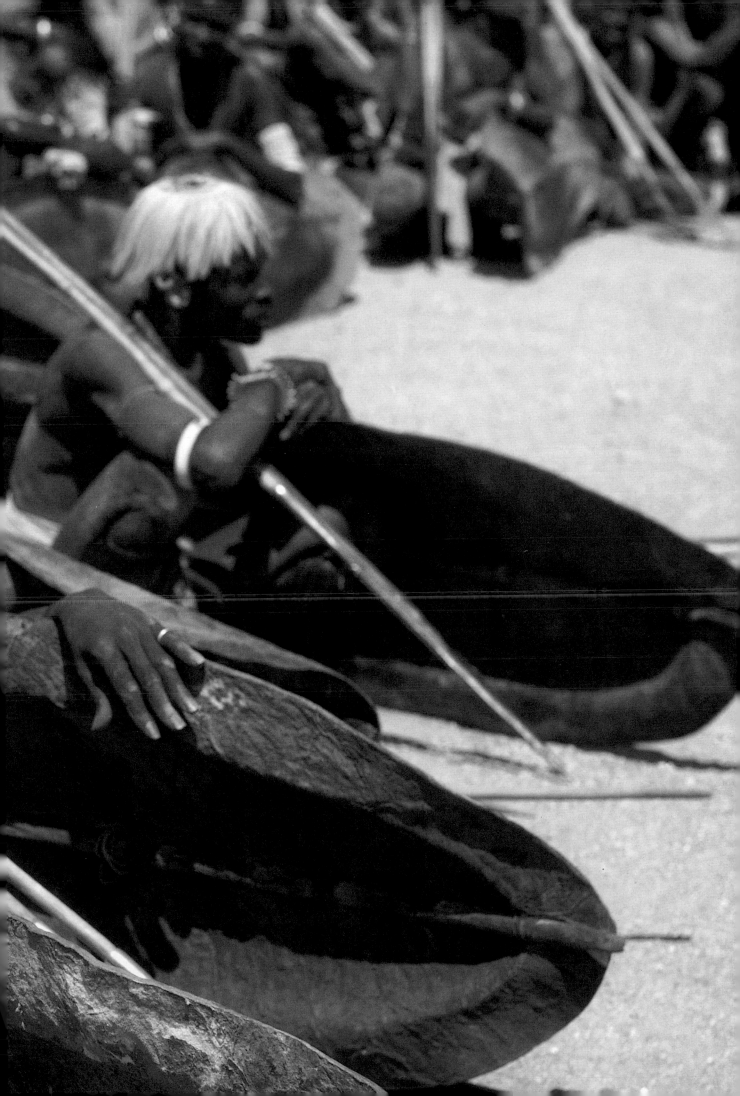

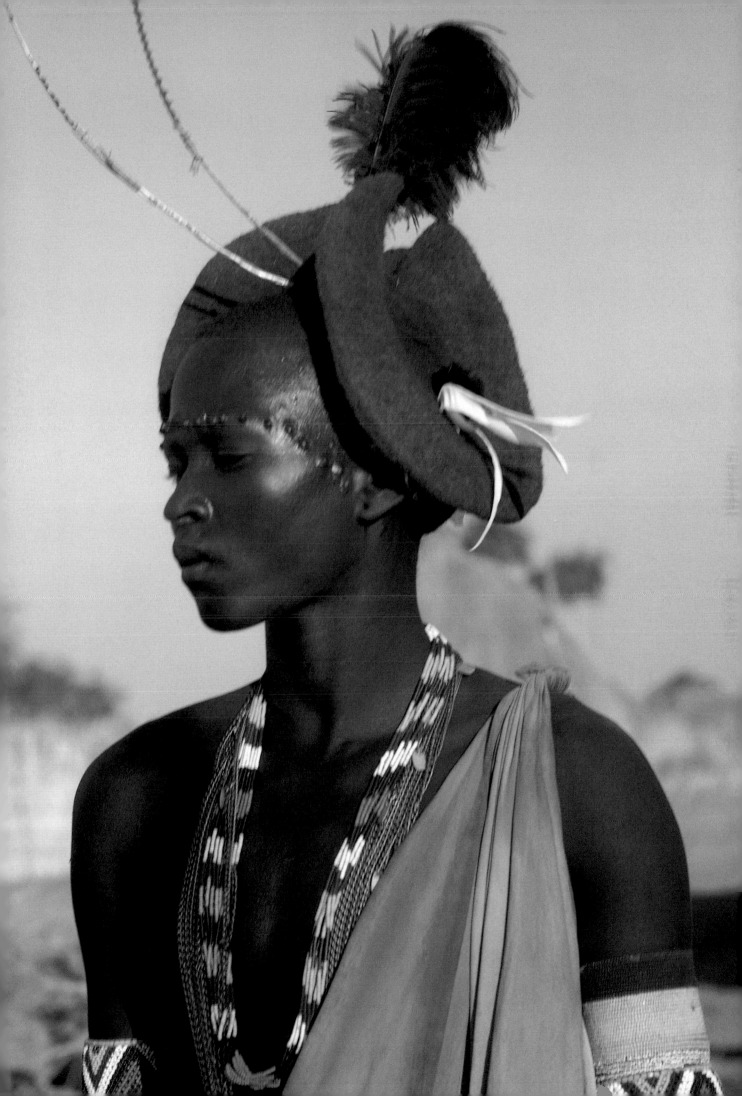

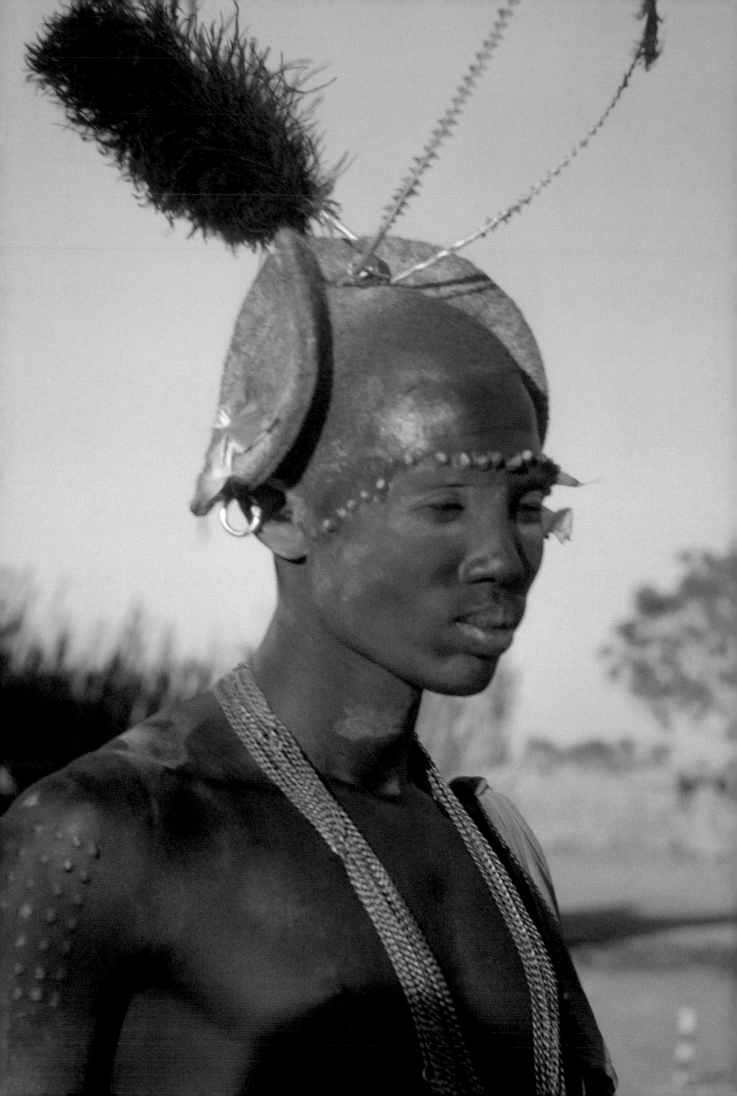

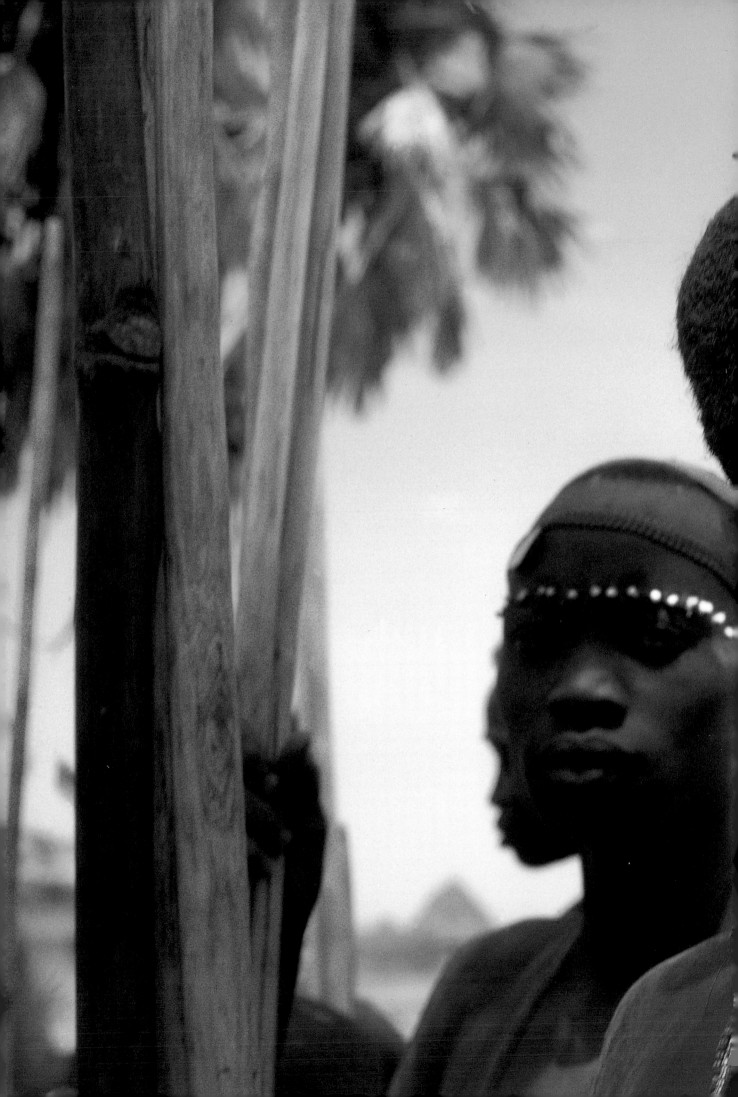

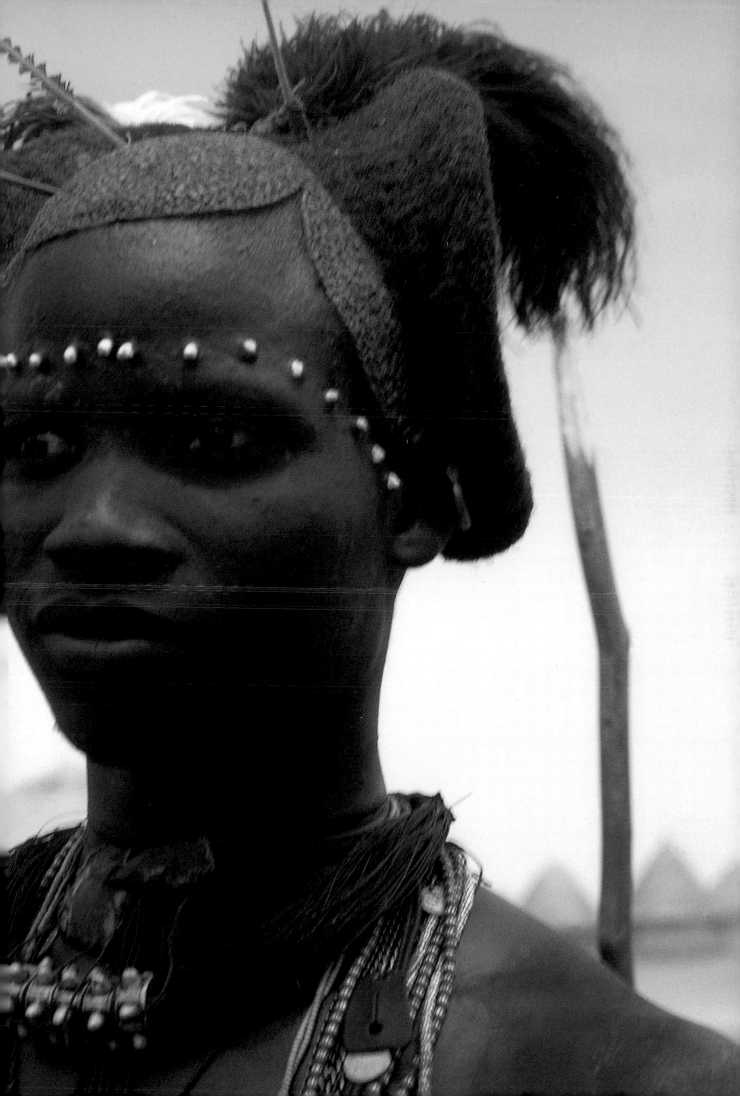

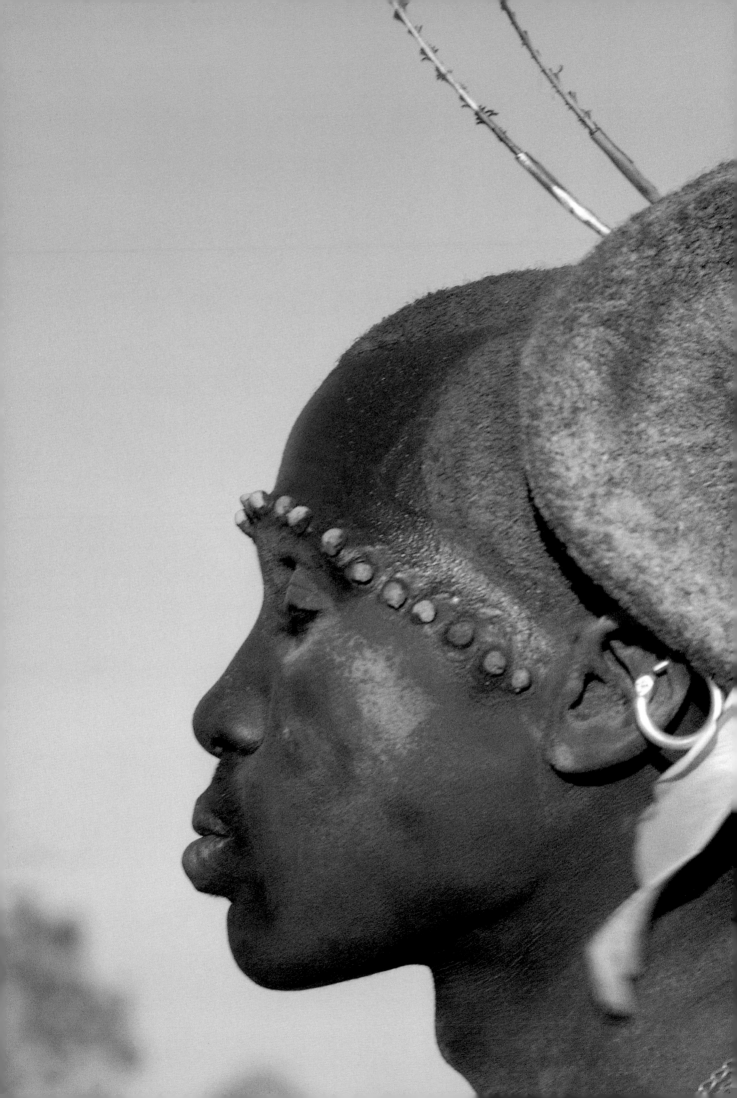

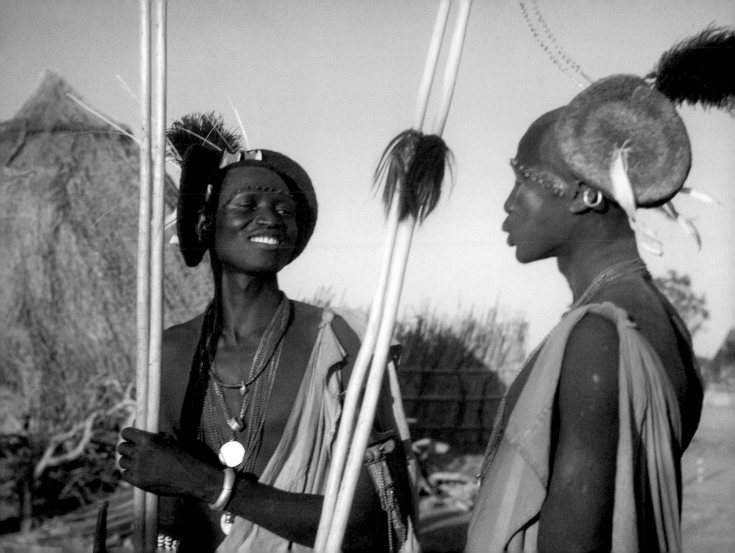

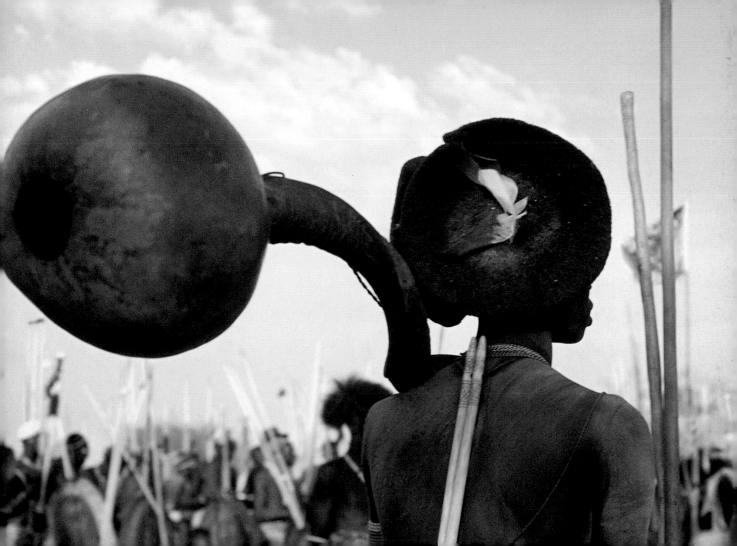

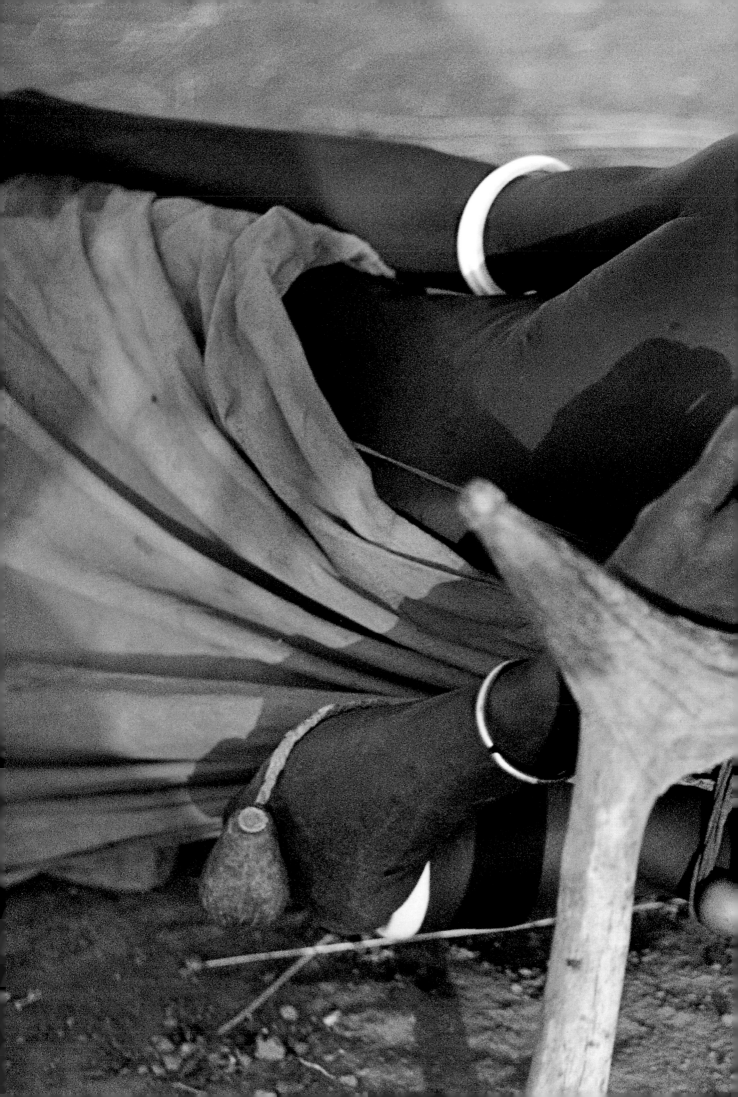

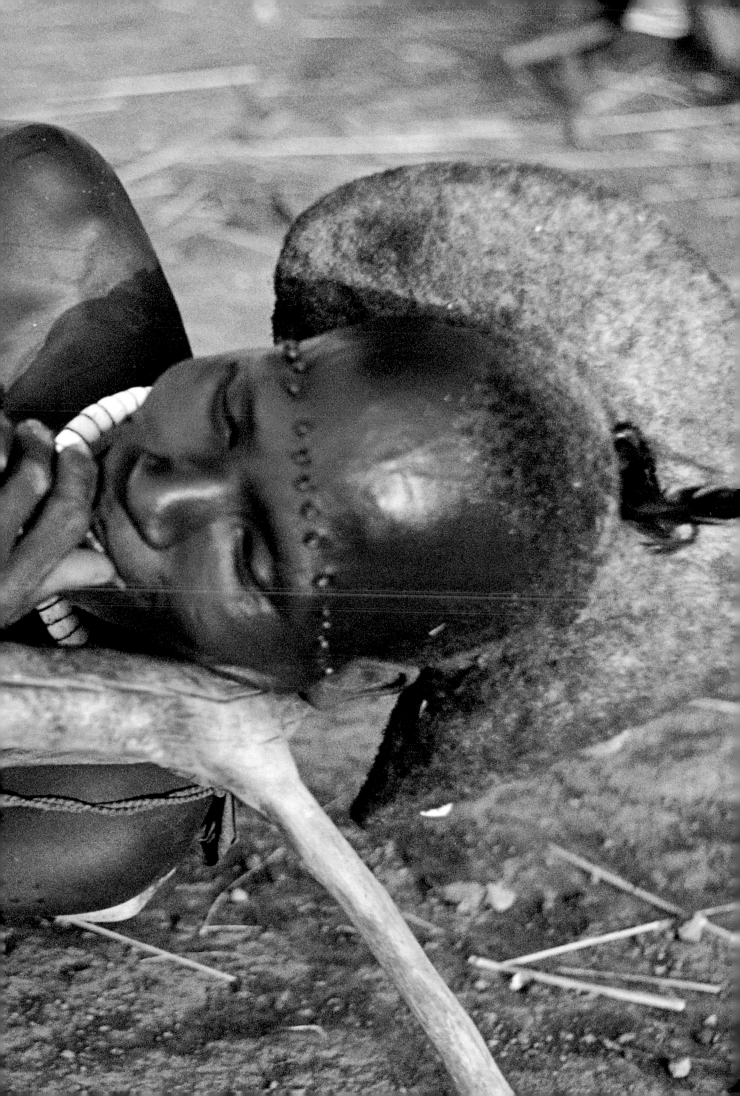

Dink[a]
Mur[le]
Nue[r]
anc[d]
[L]atu[ka]

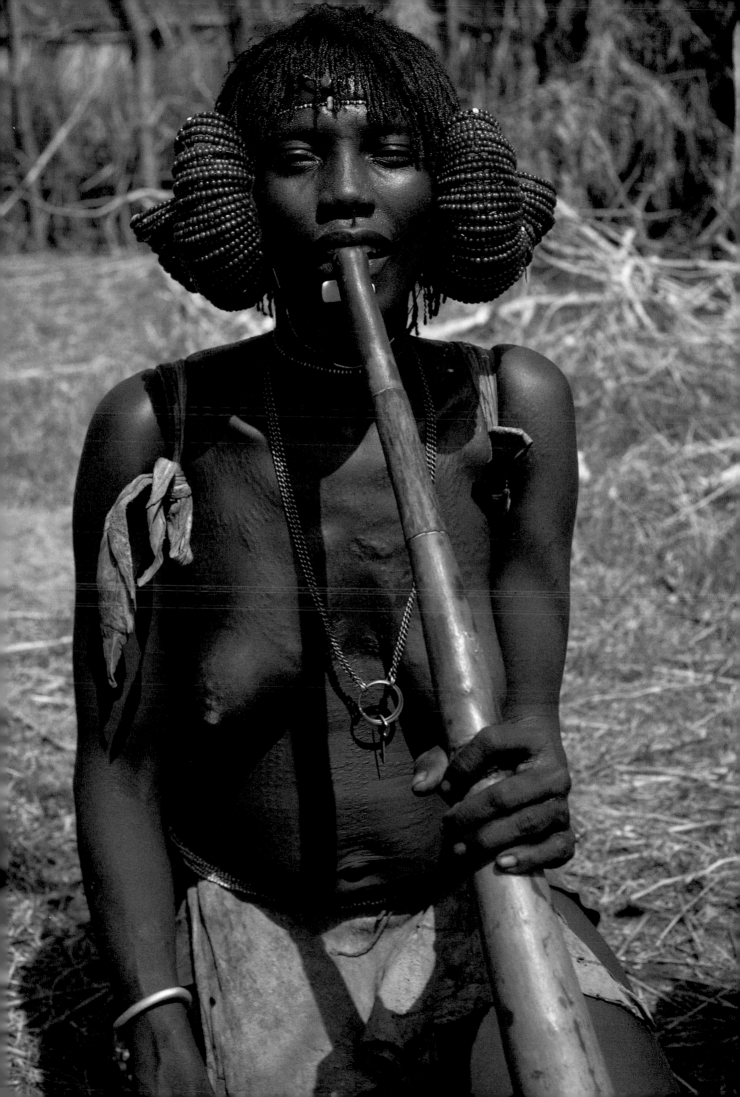

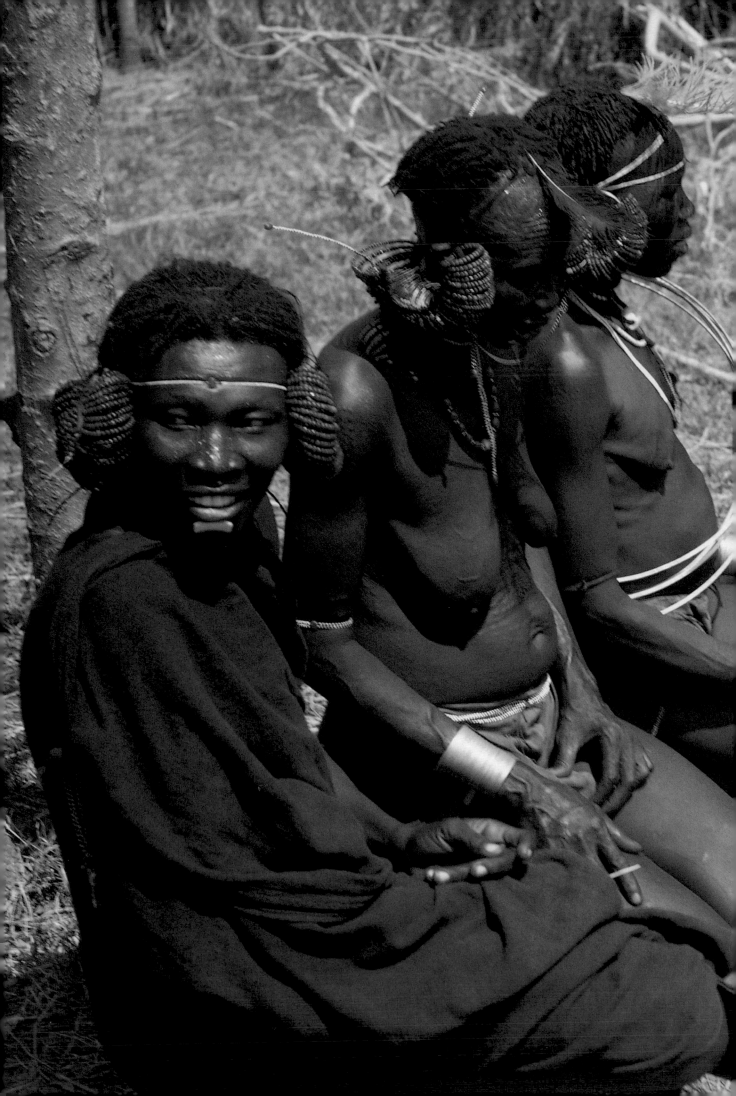

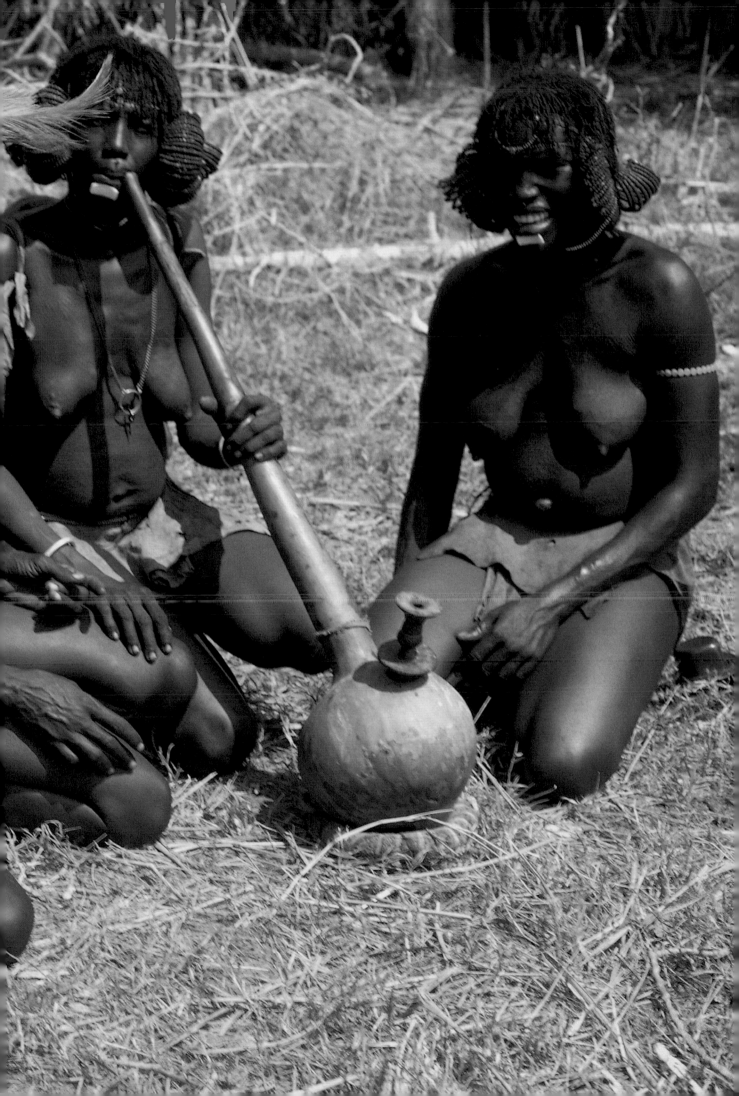

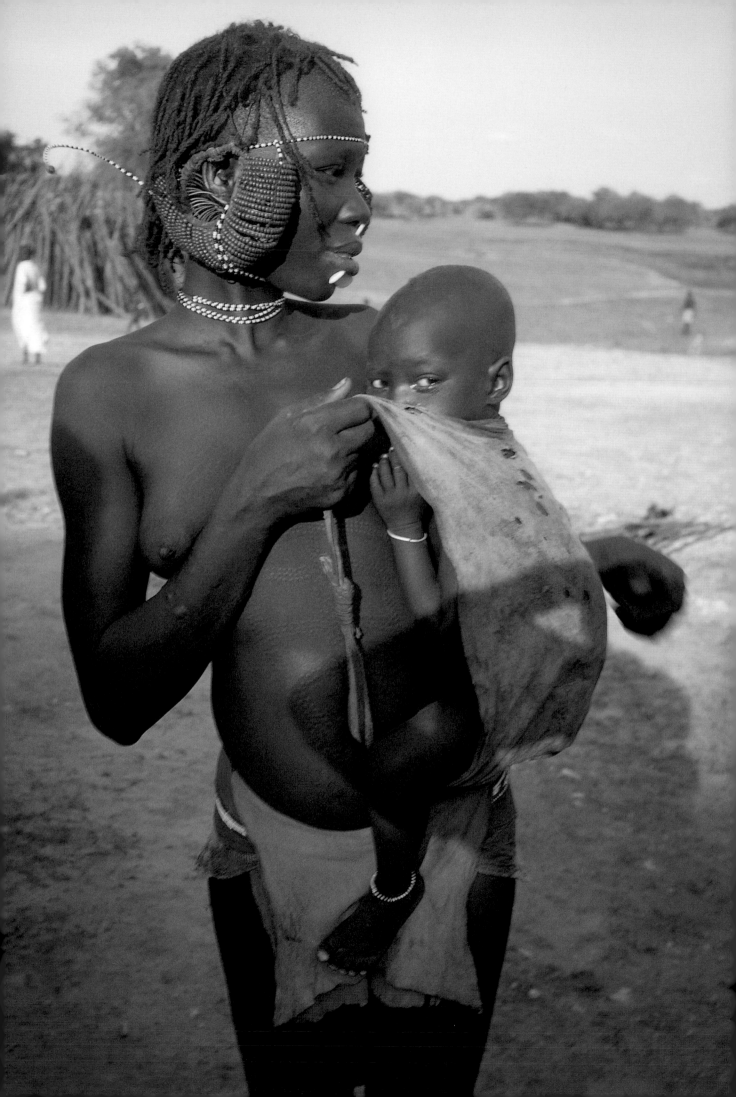

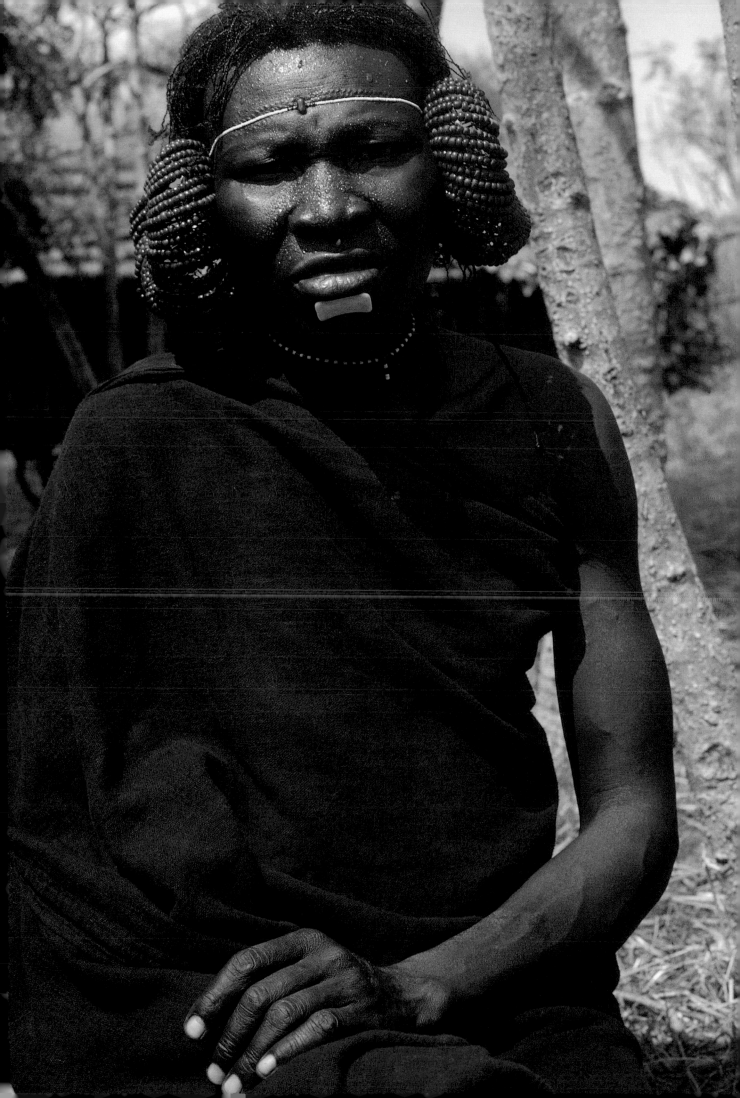

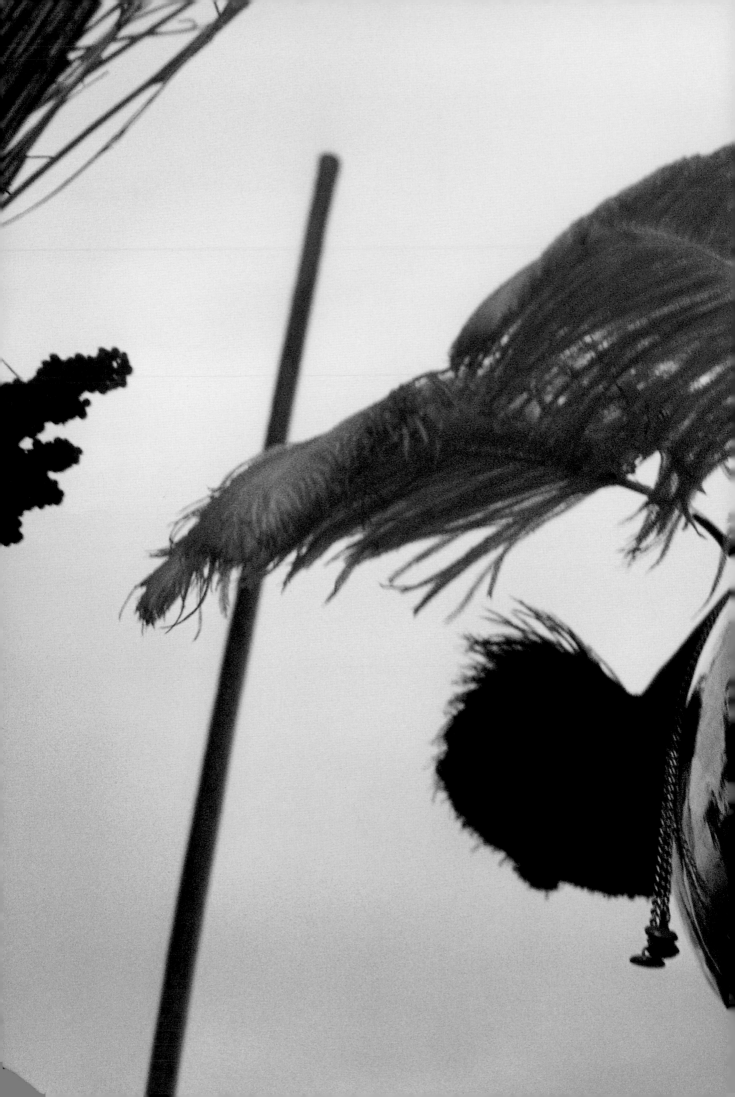

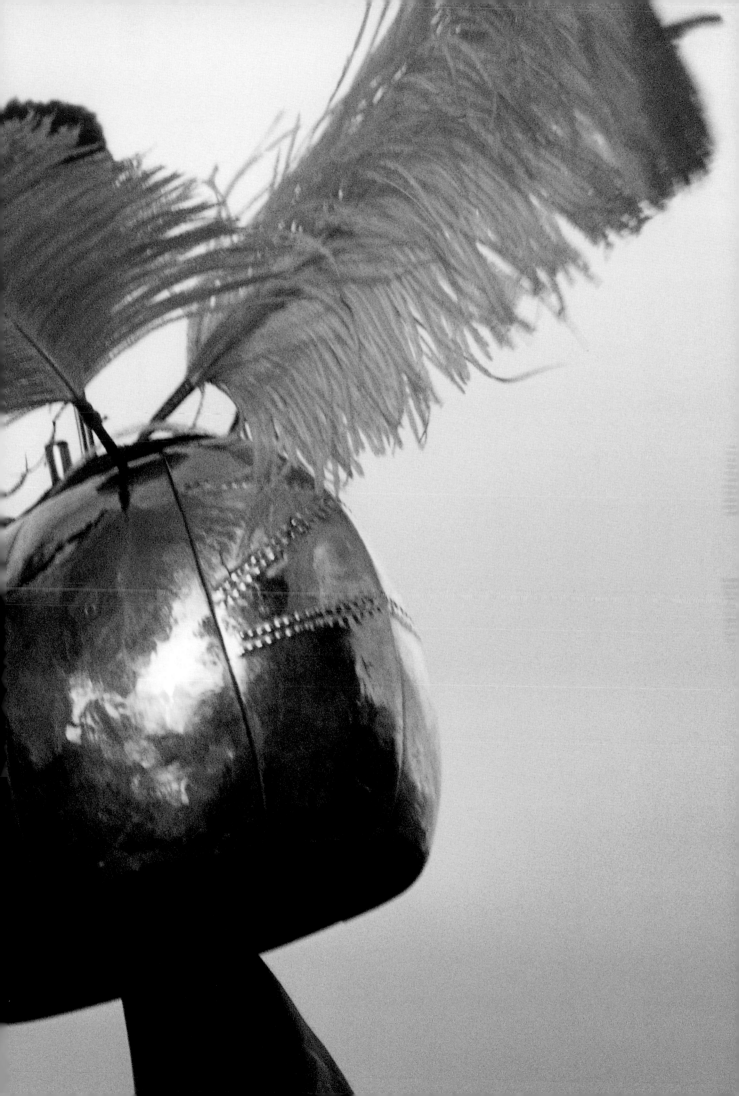

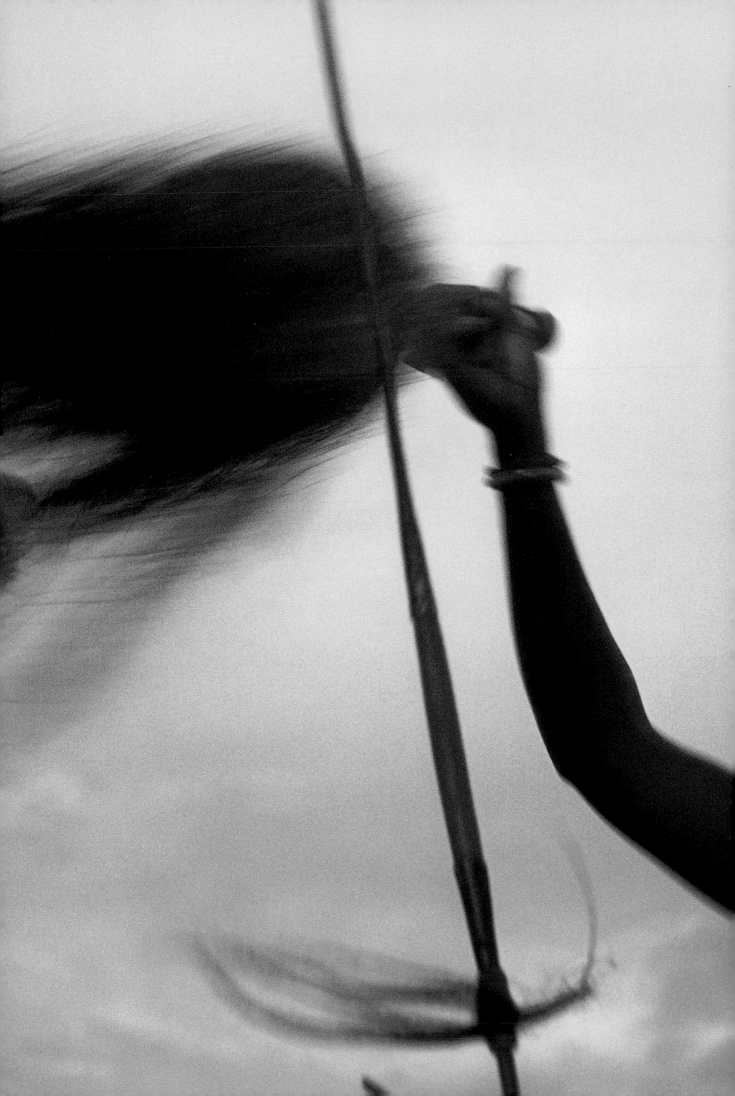

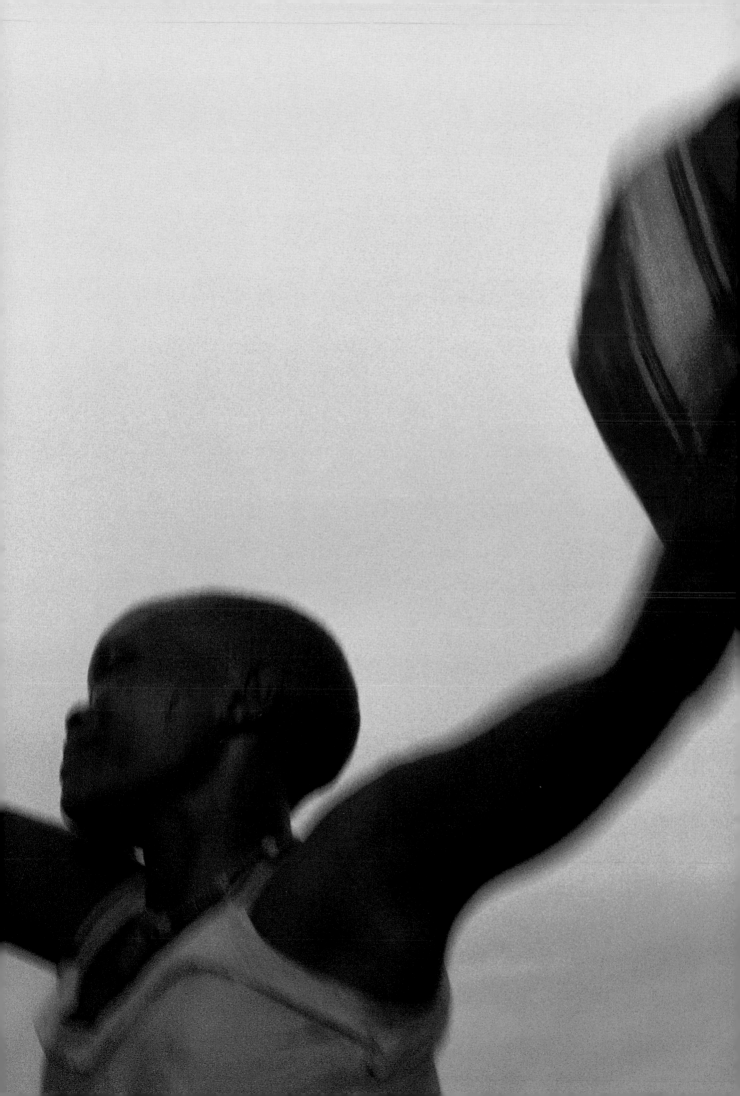

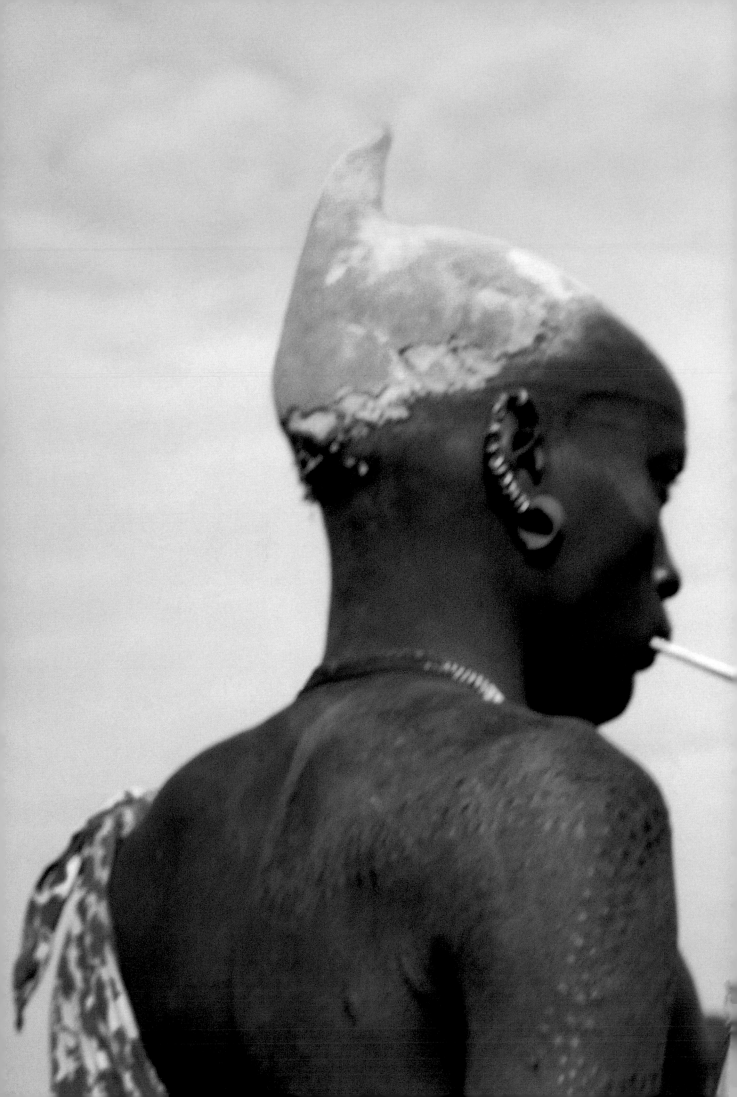

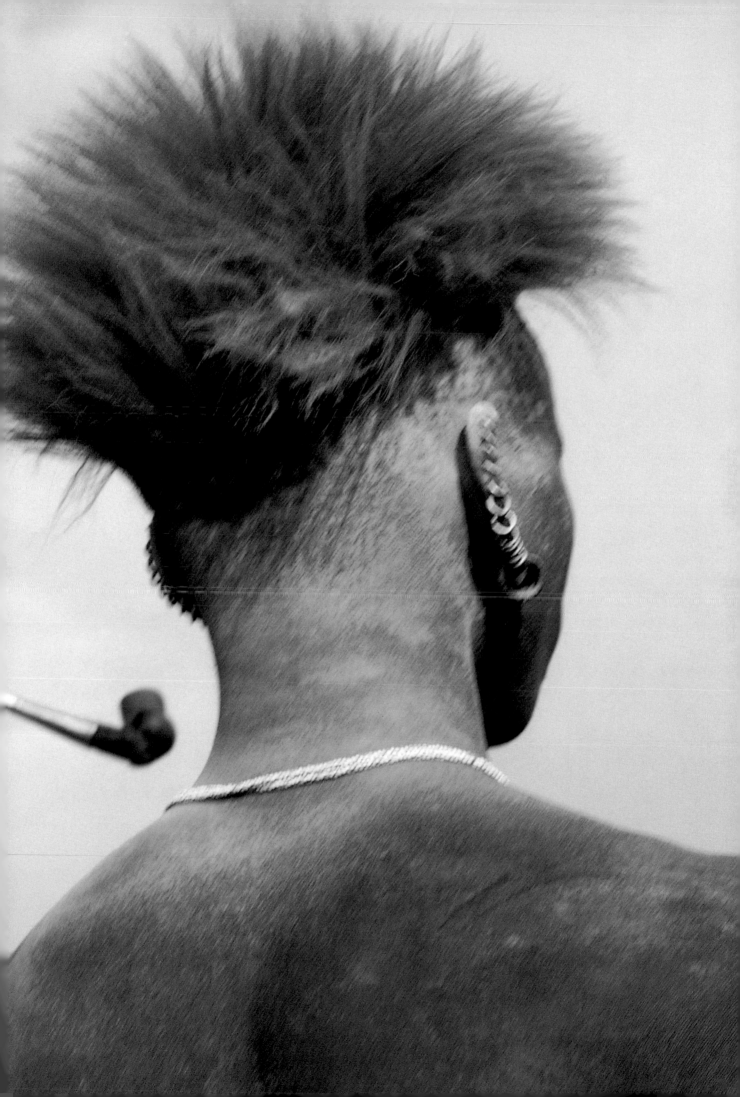

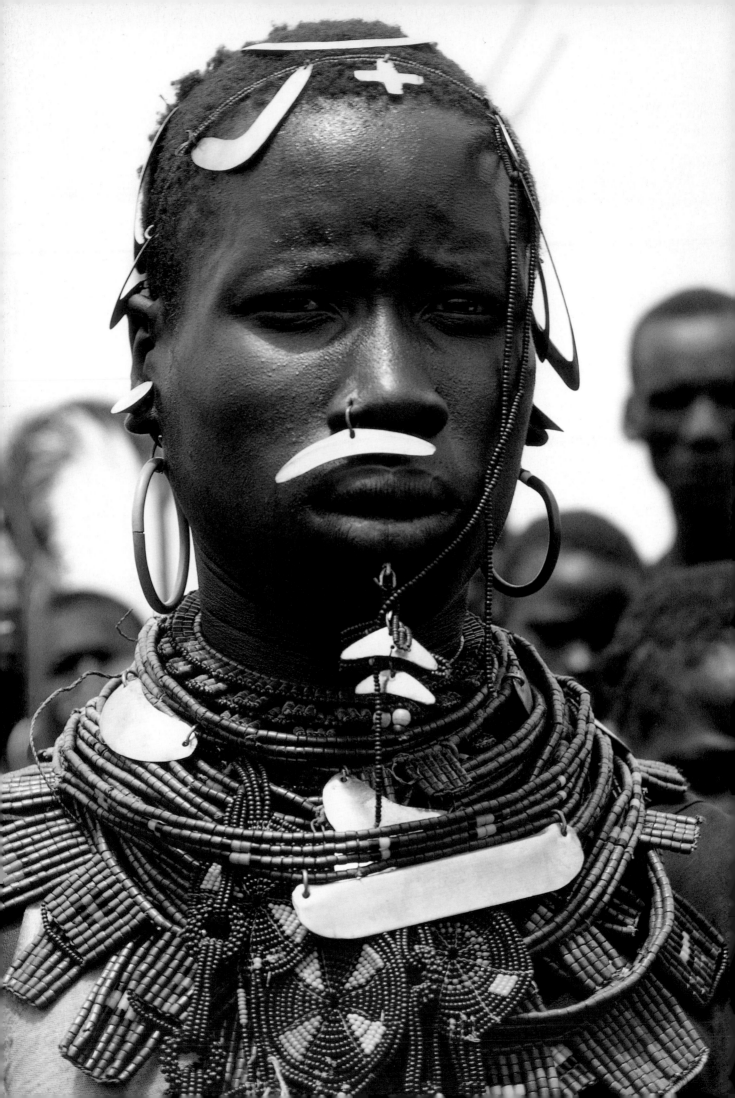

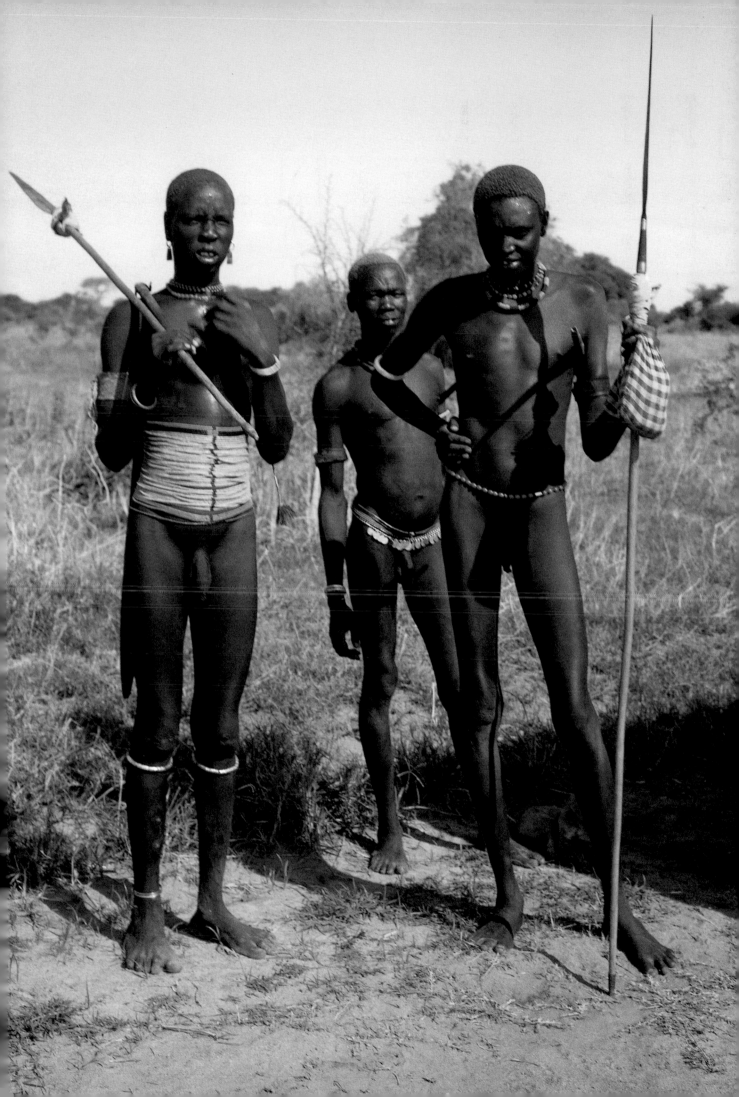

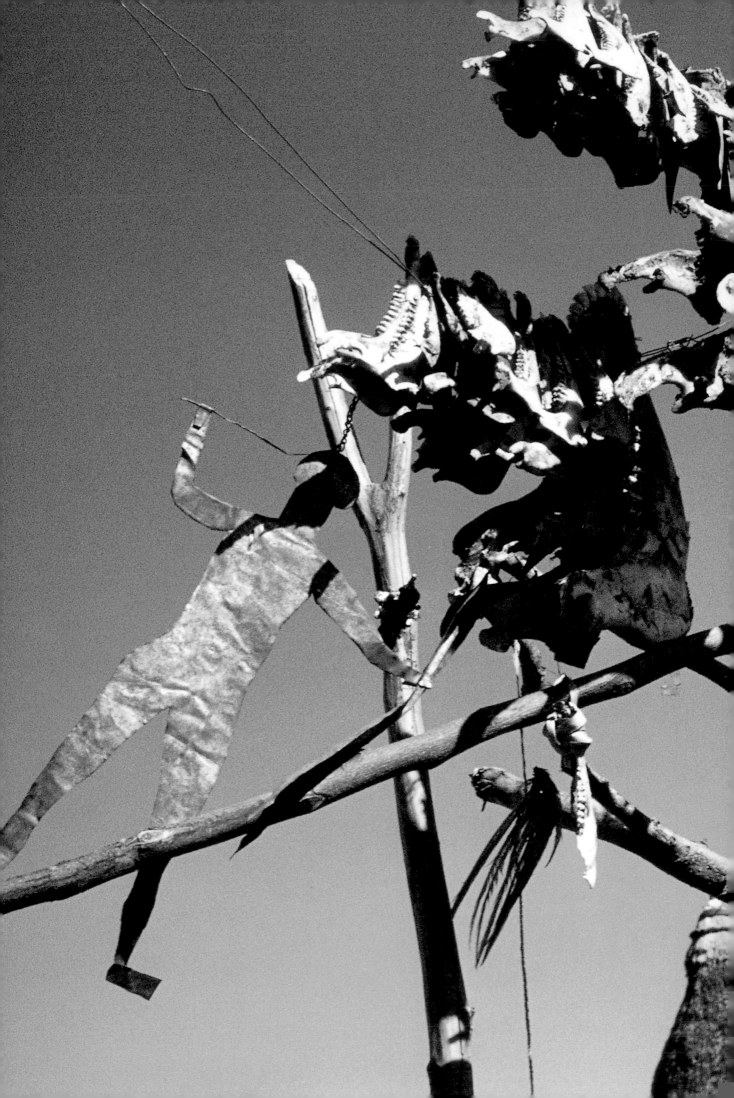

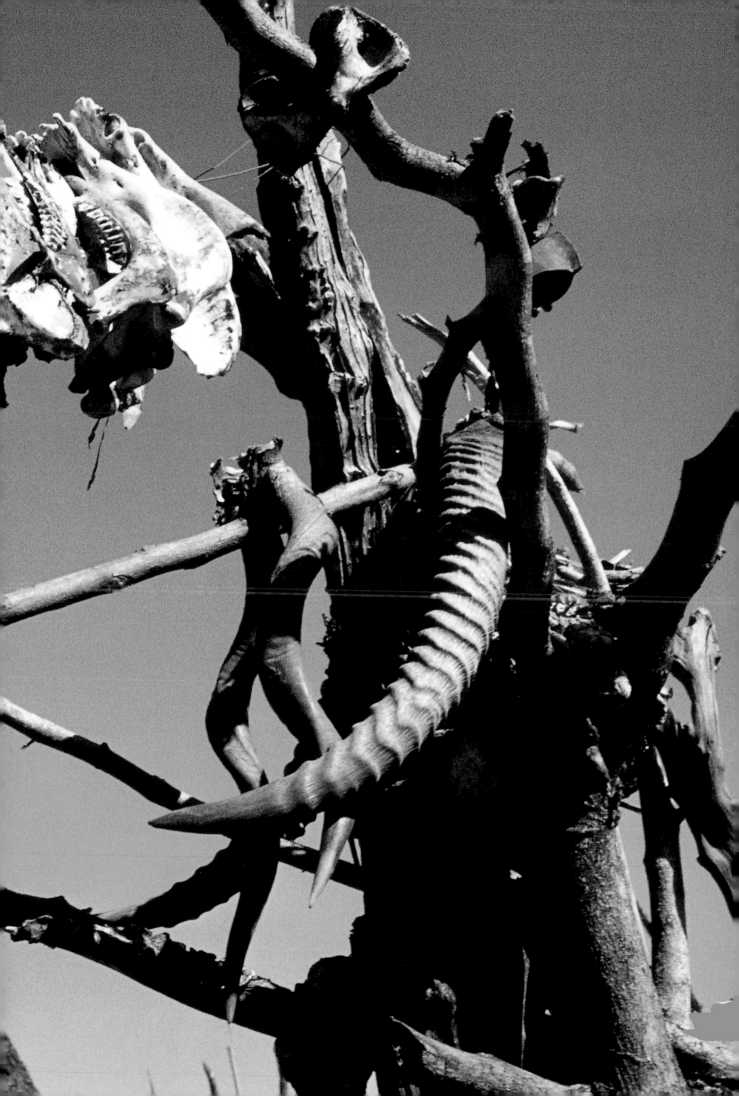

The Nuba of Kau

Die Nuba von Kau
Les Nouba de Kau
カウのヌバ

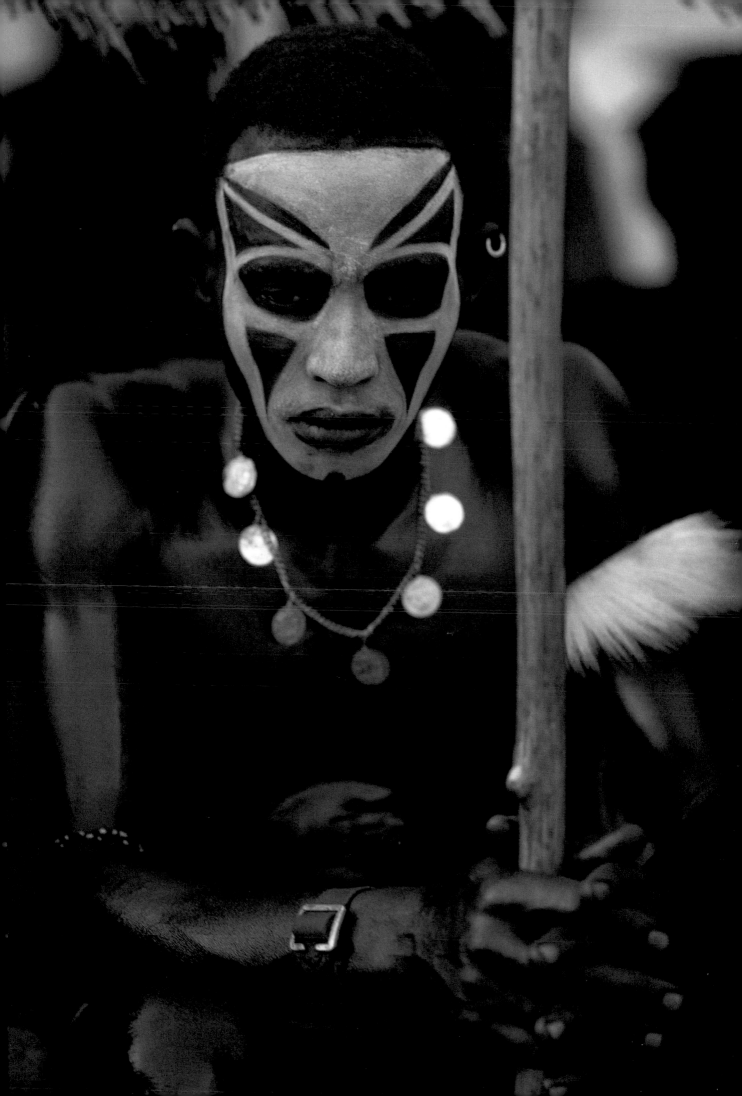

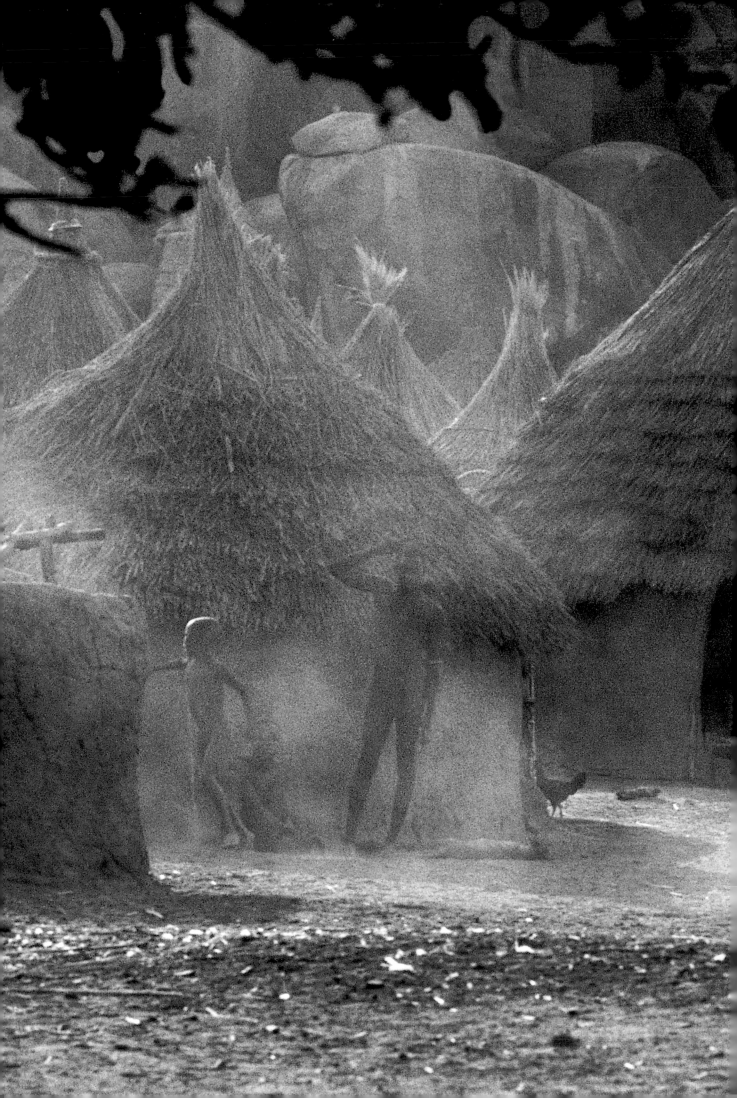

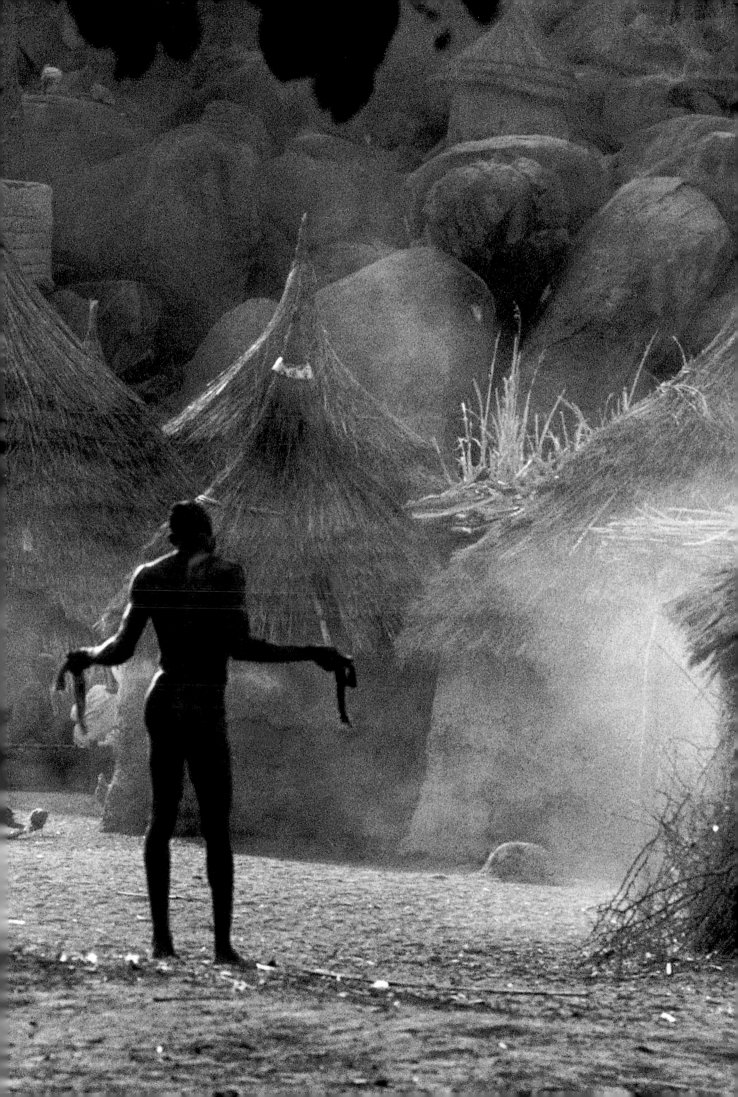

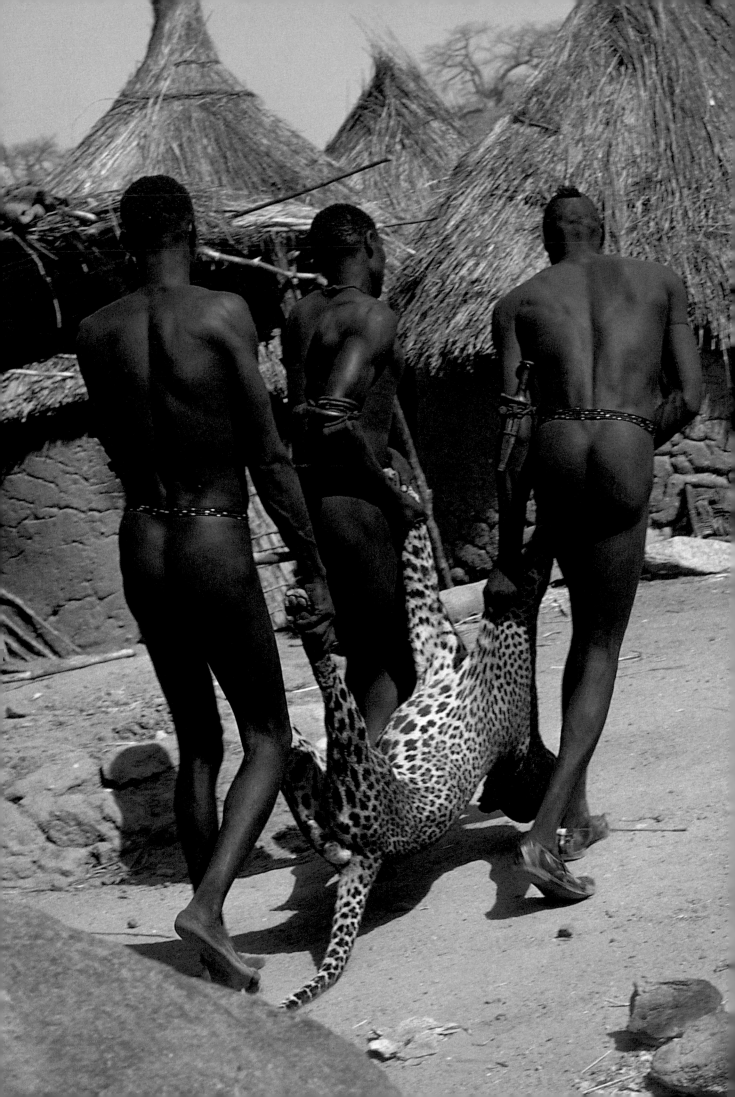

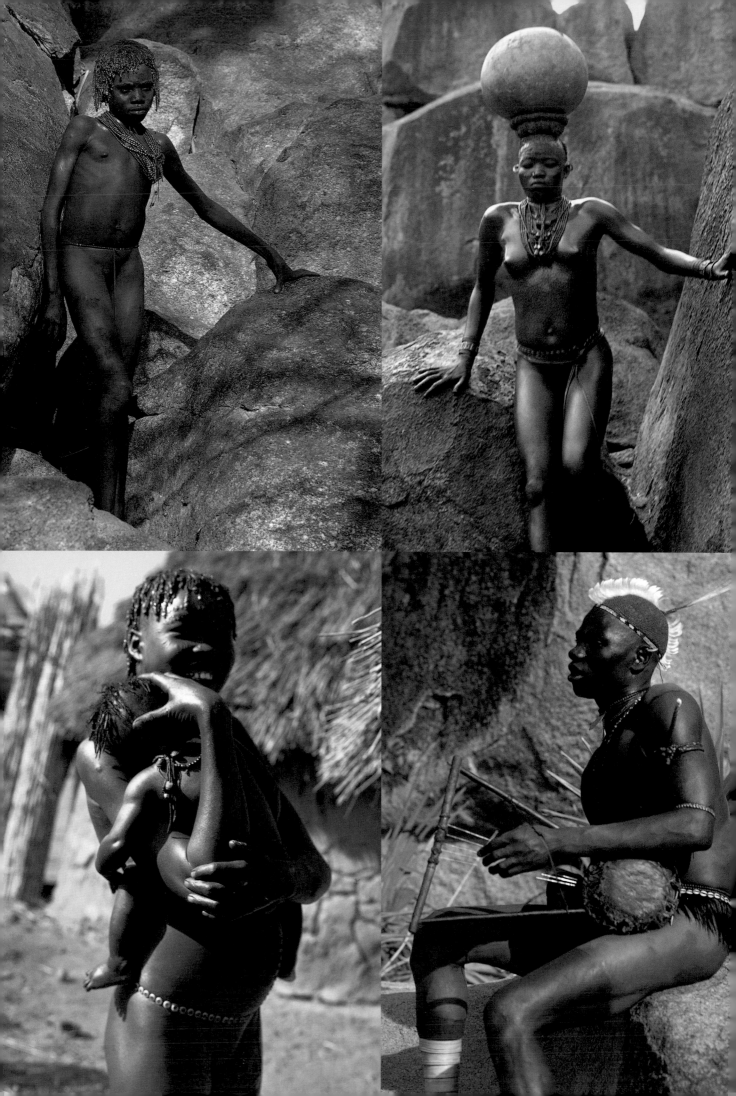

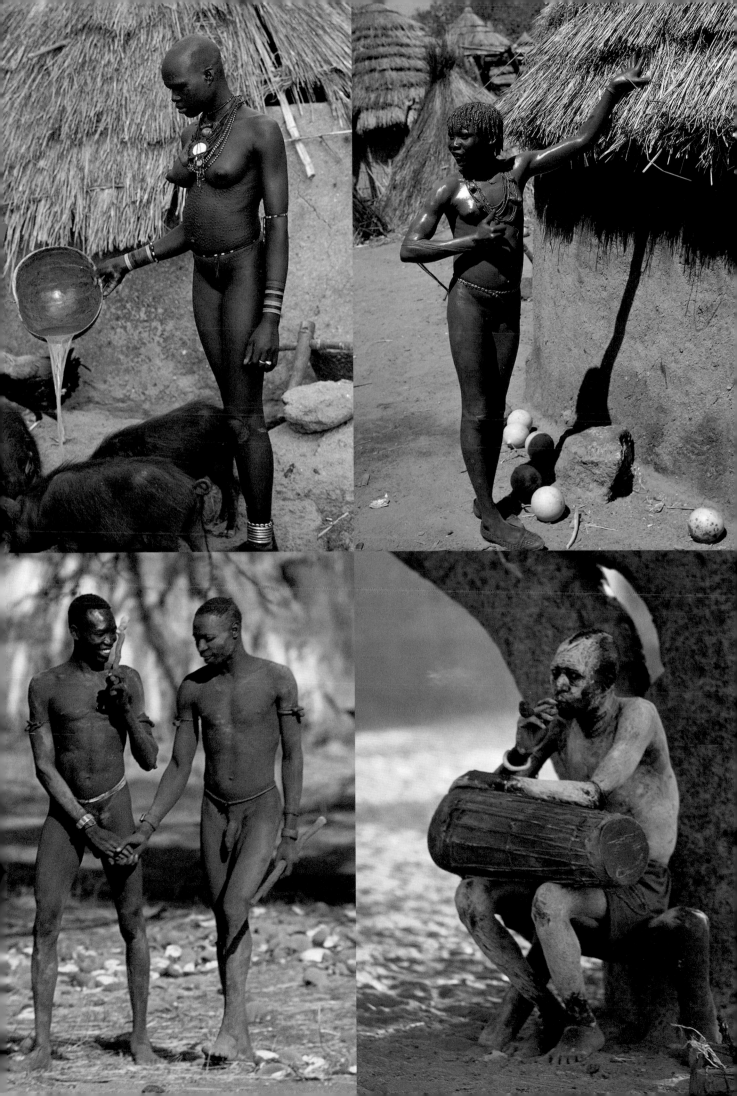

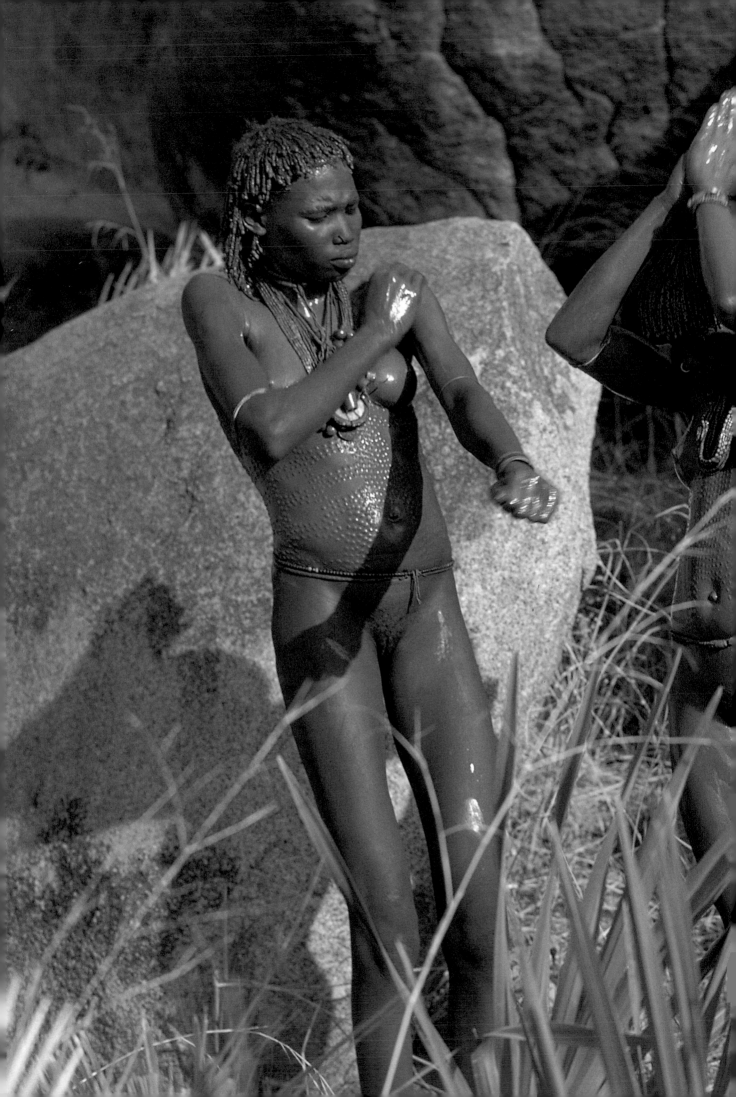

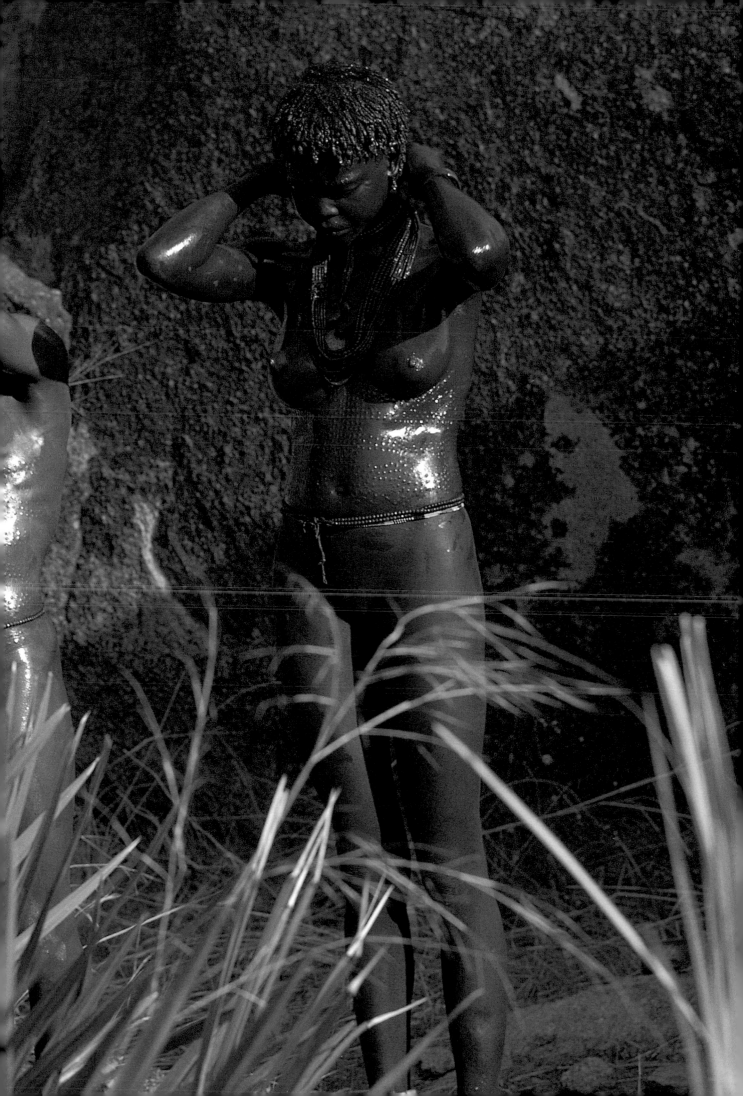

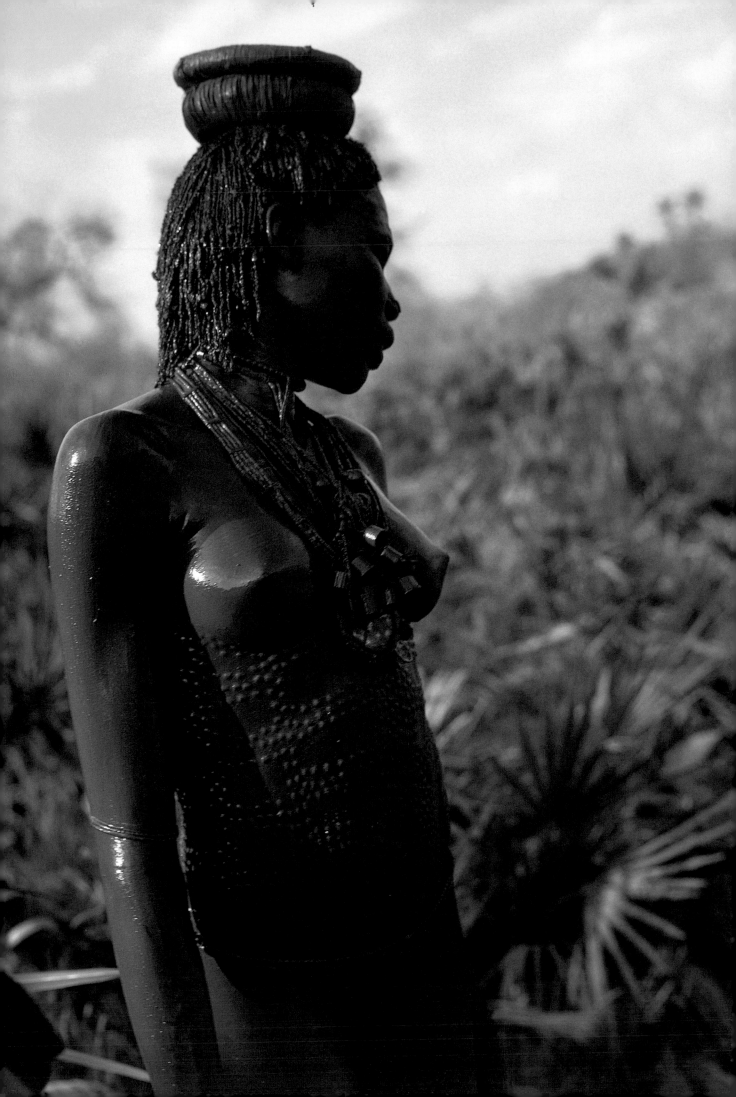

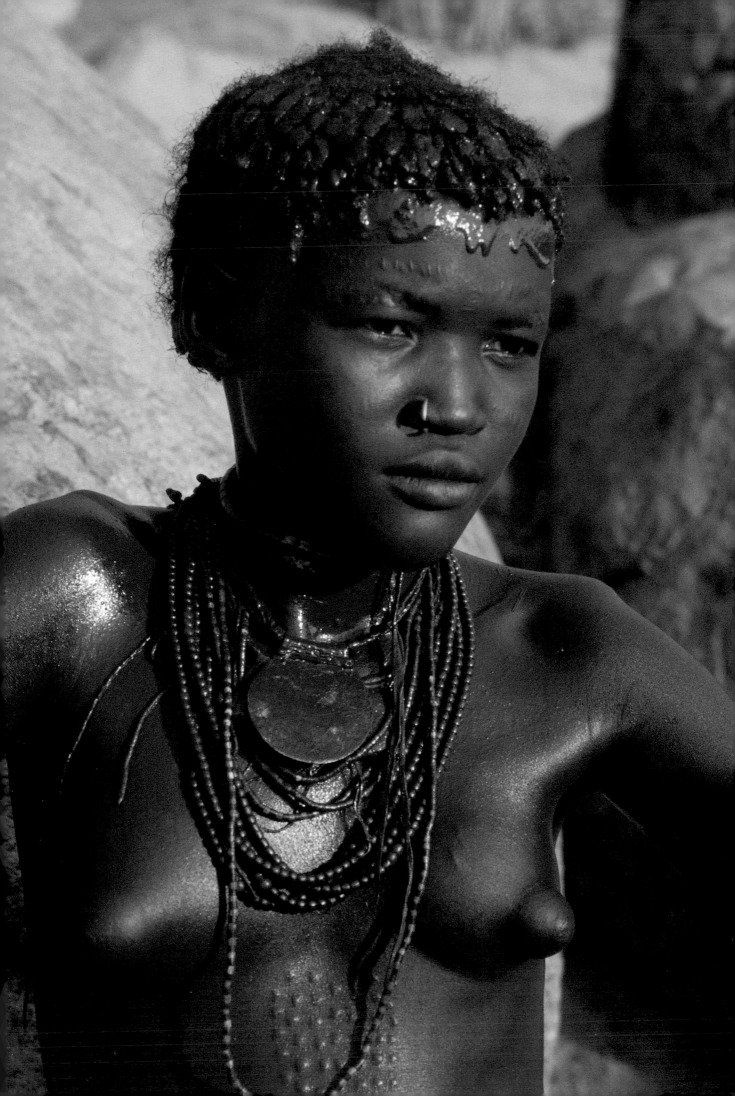

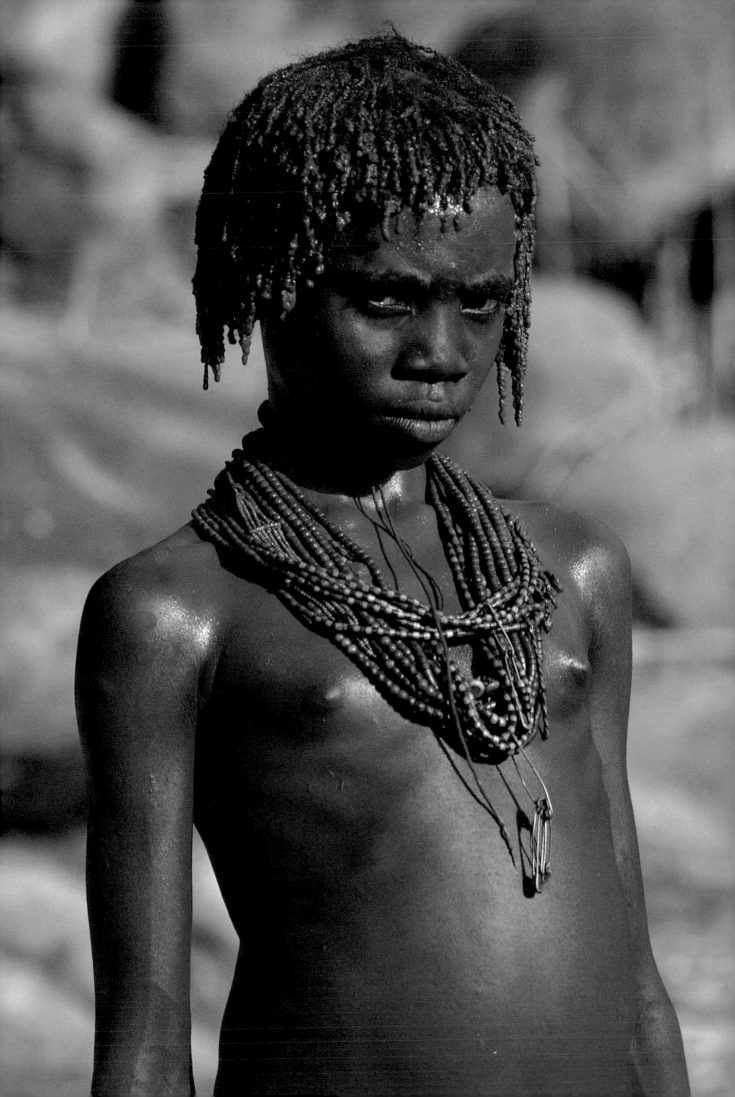

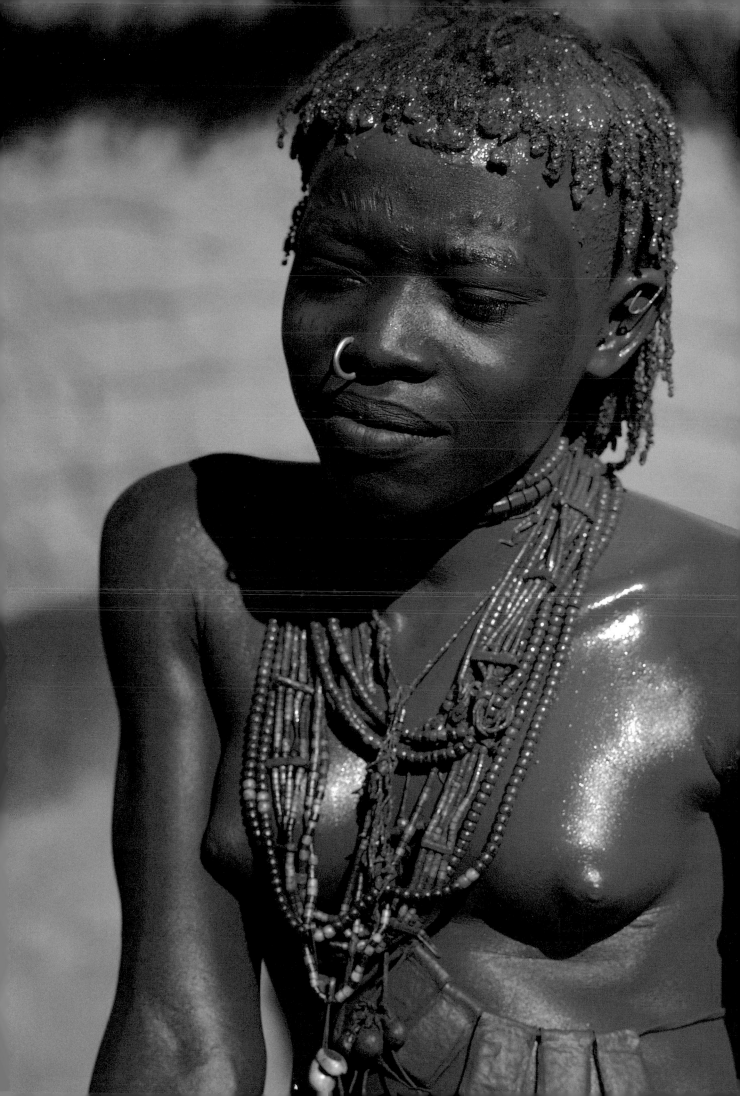

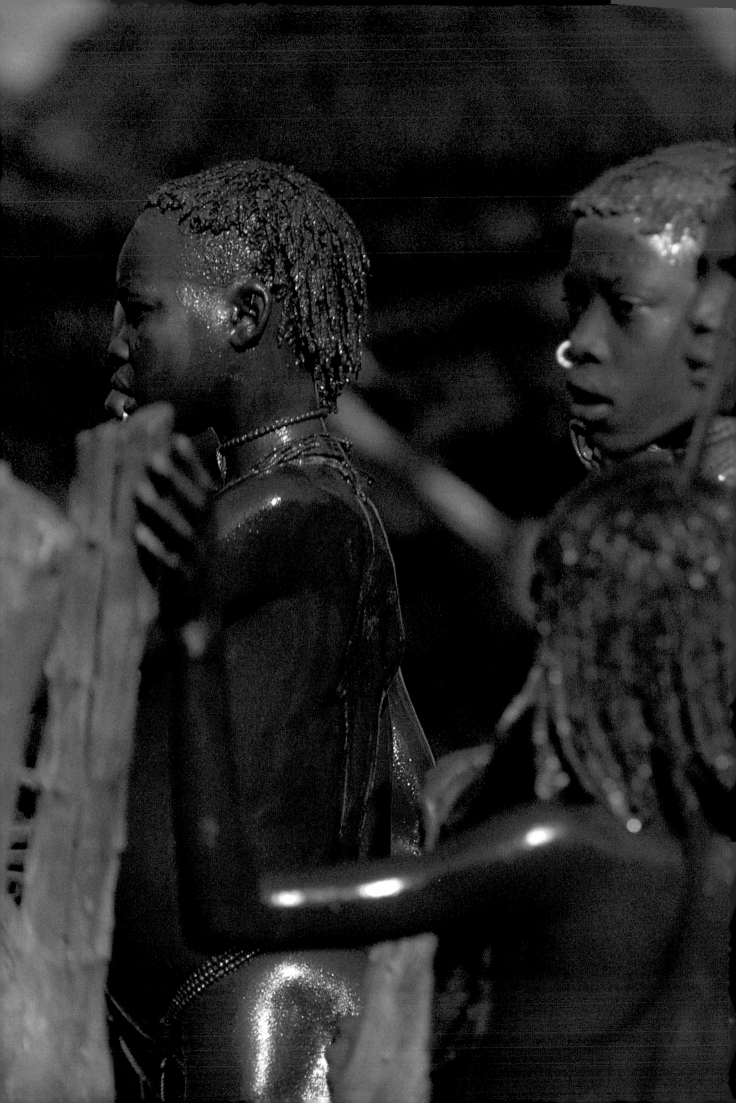

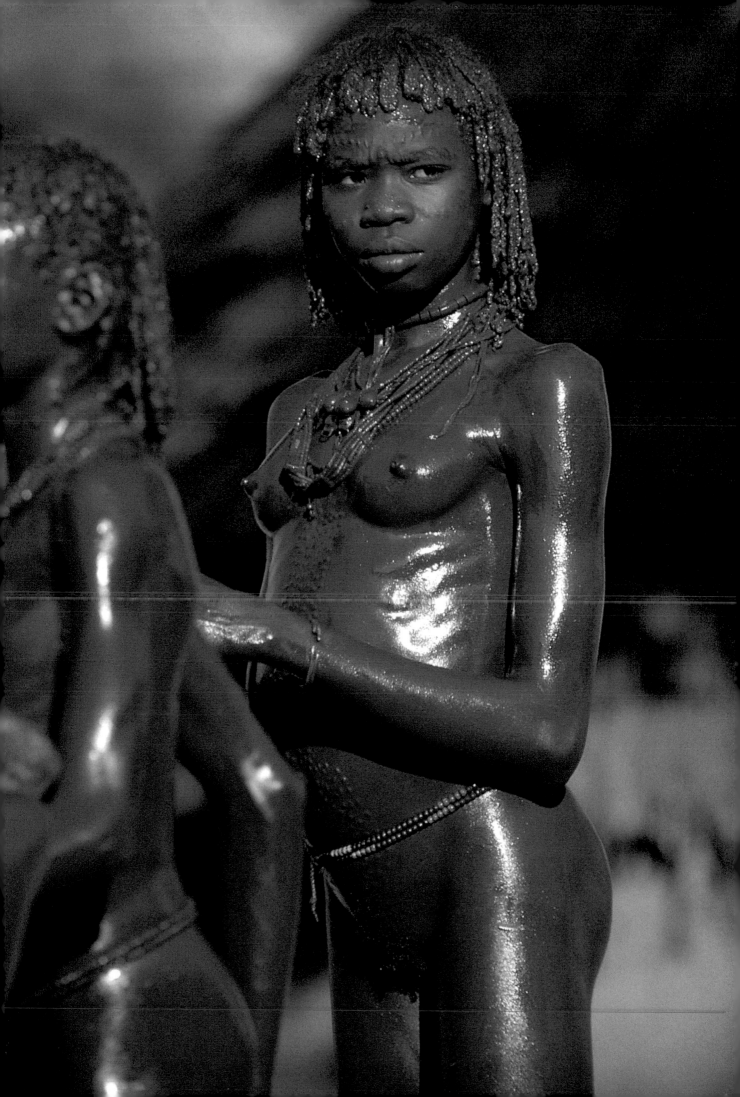

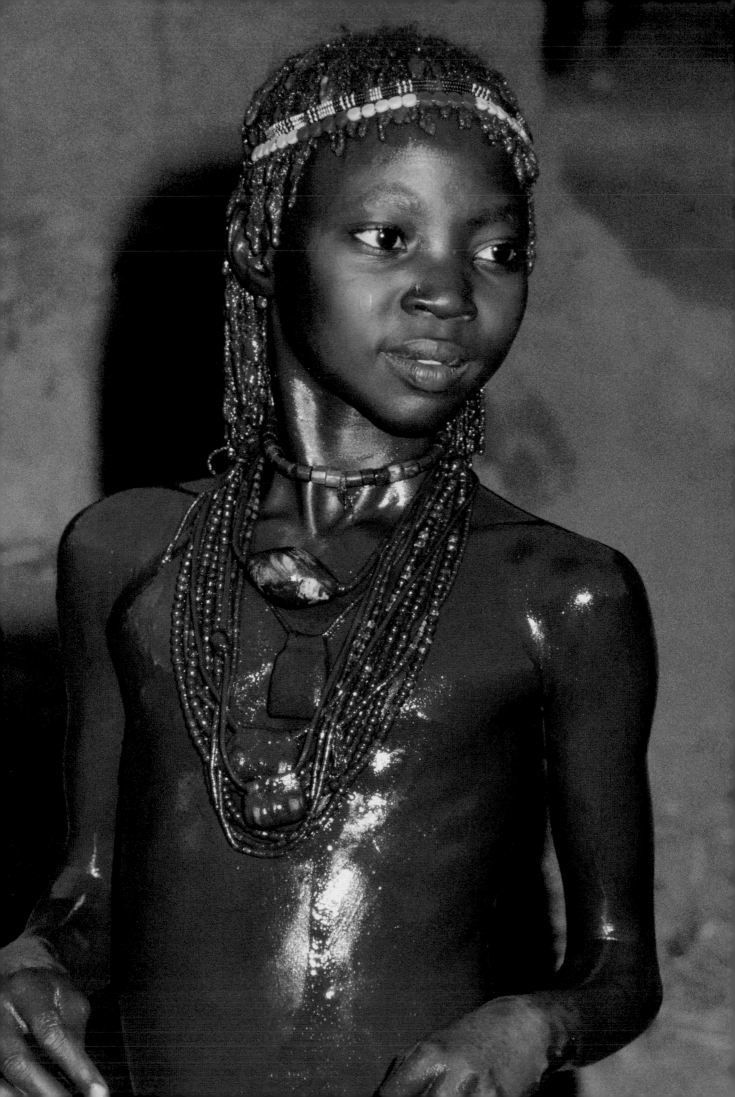

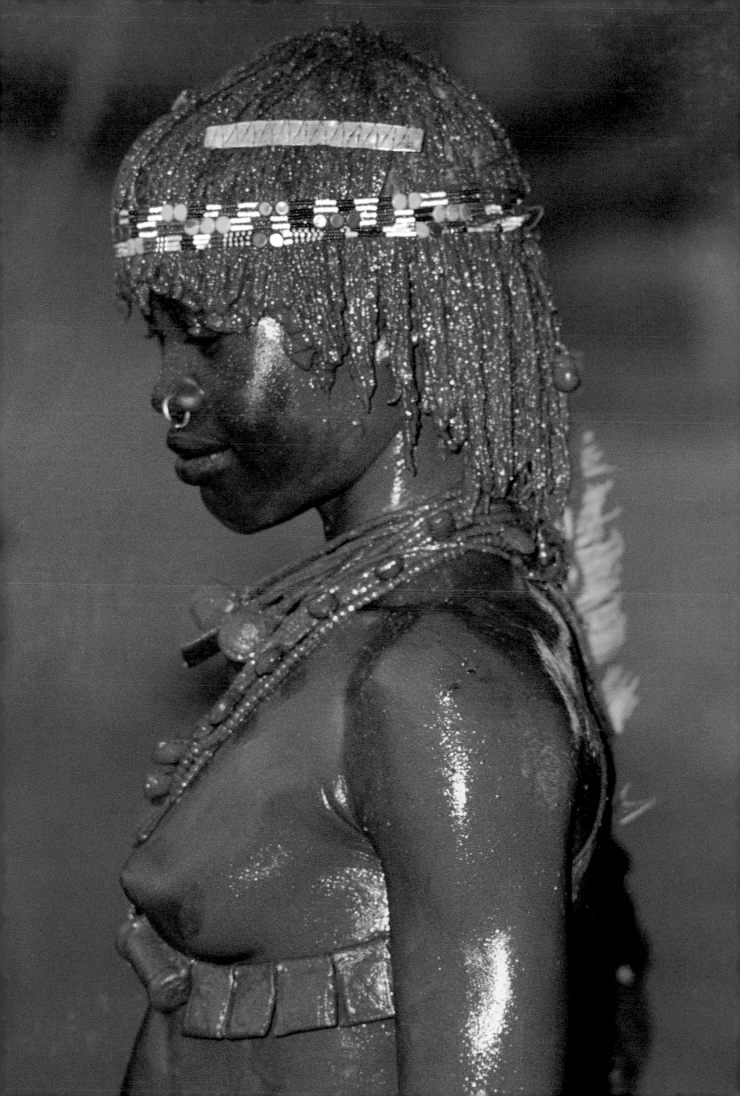

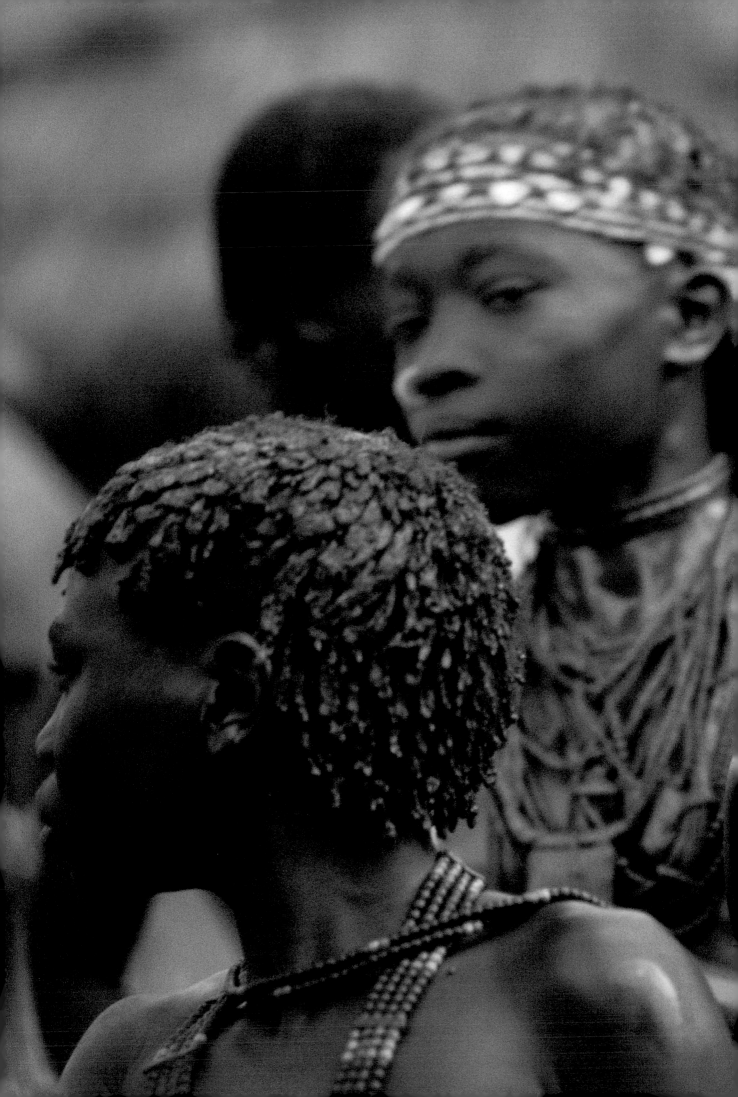

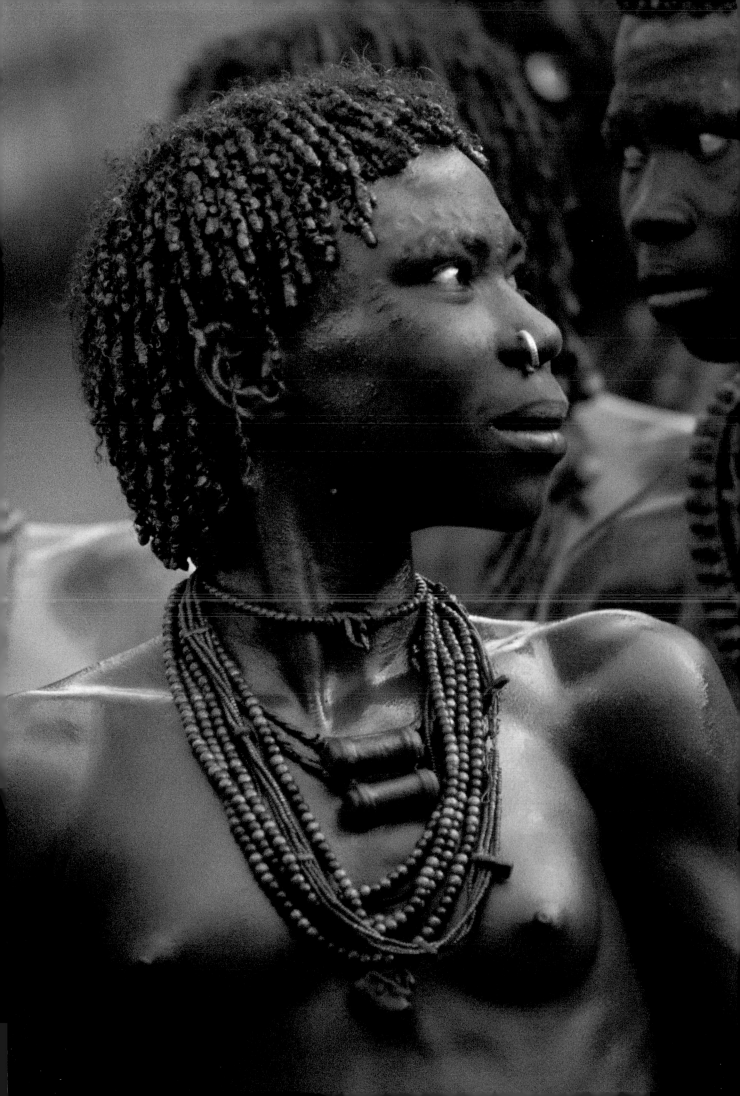

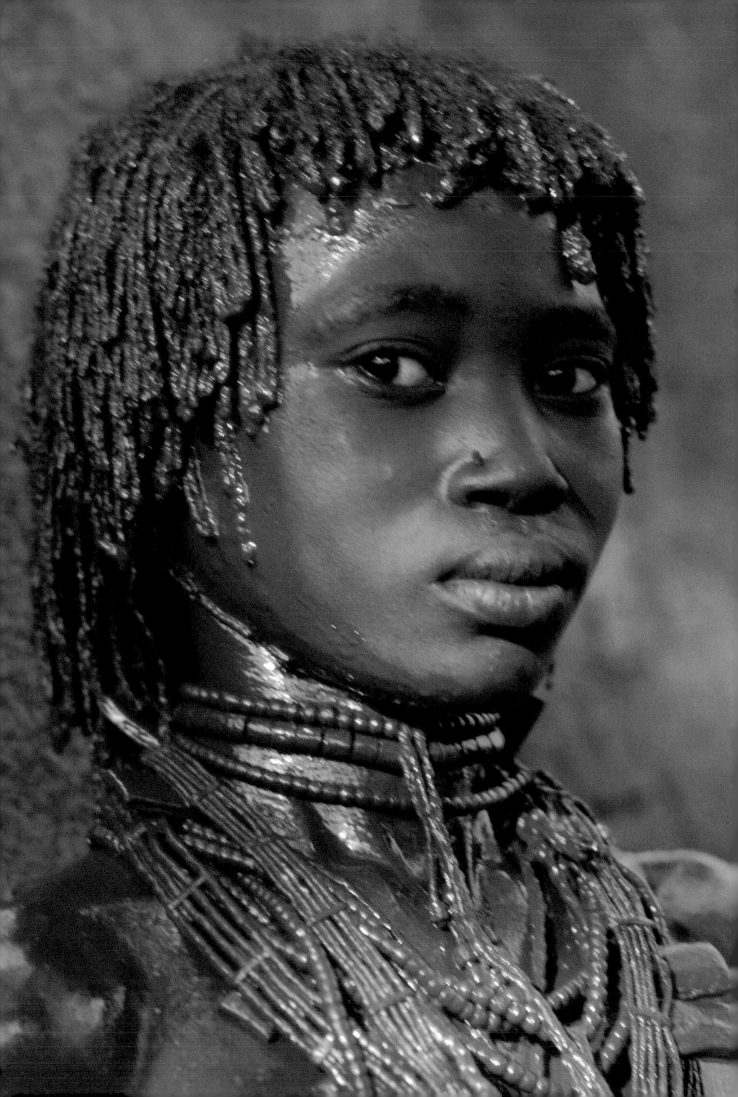

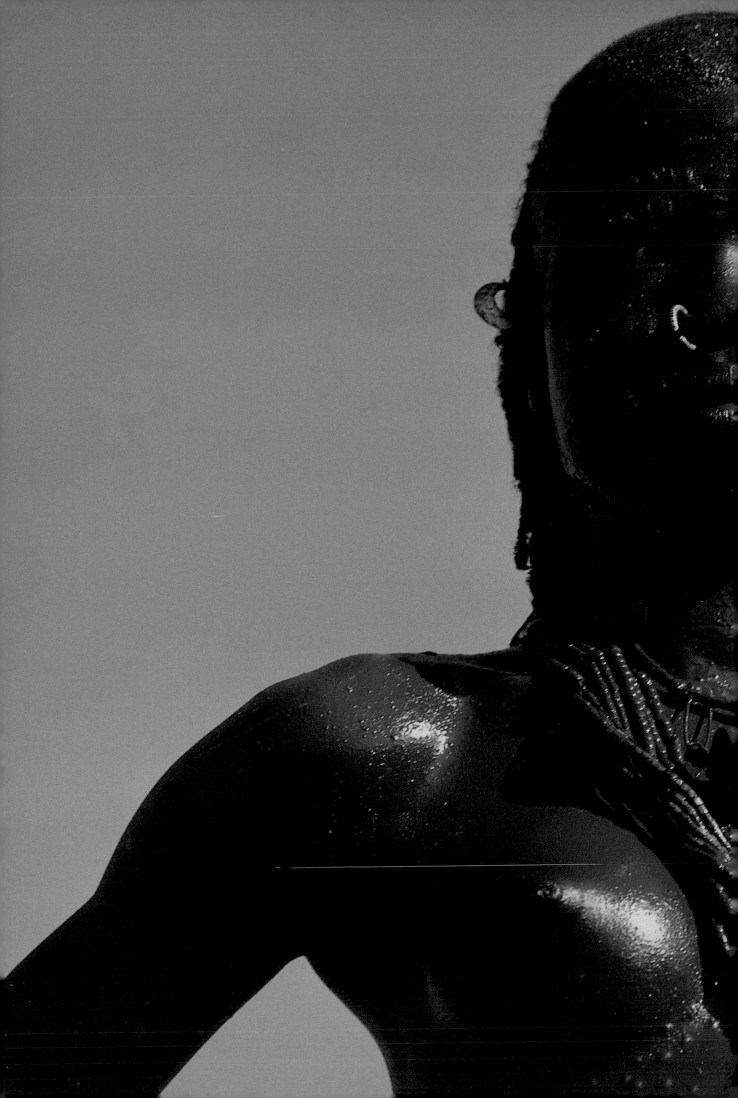

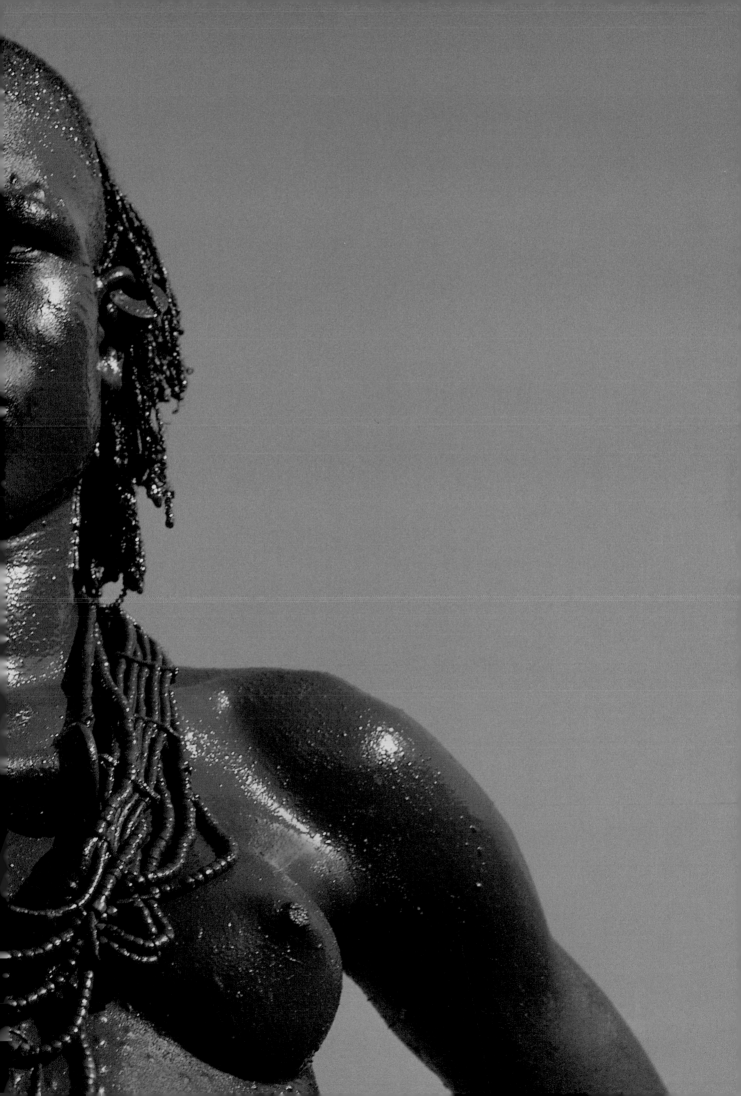

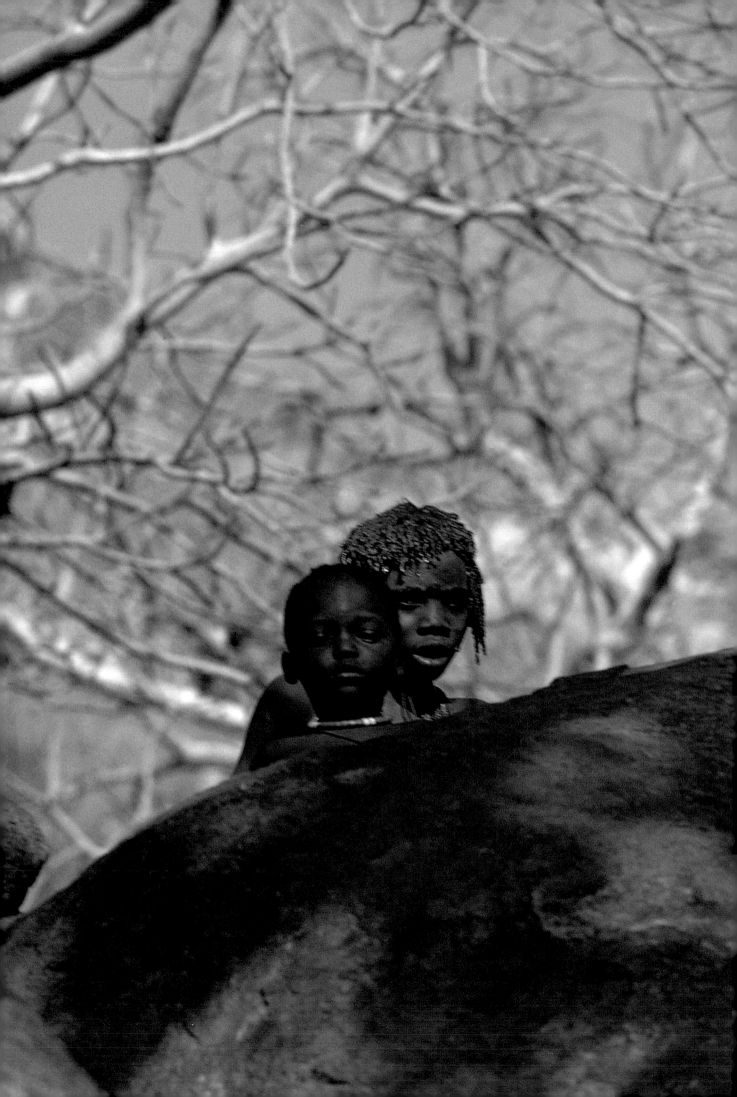

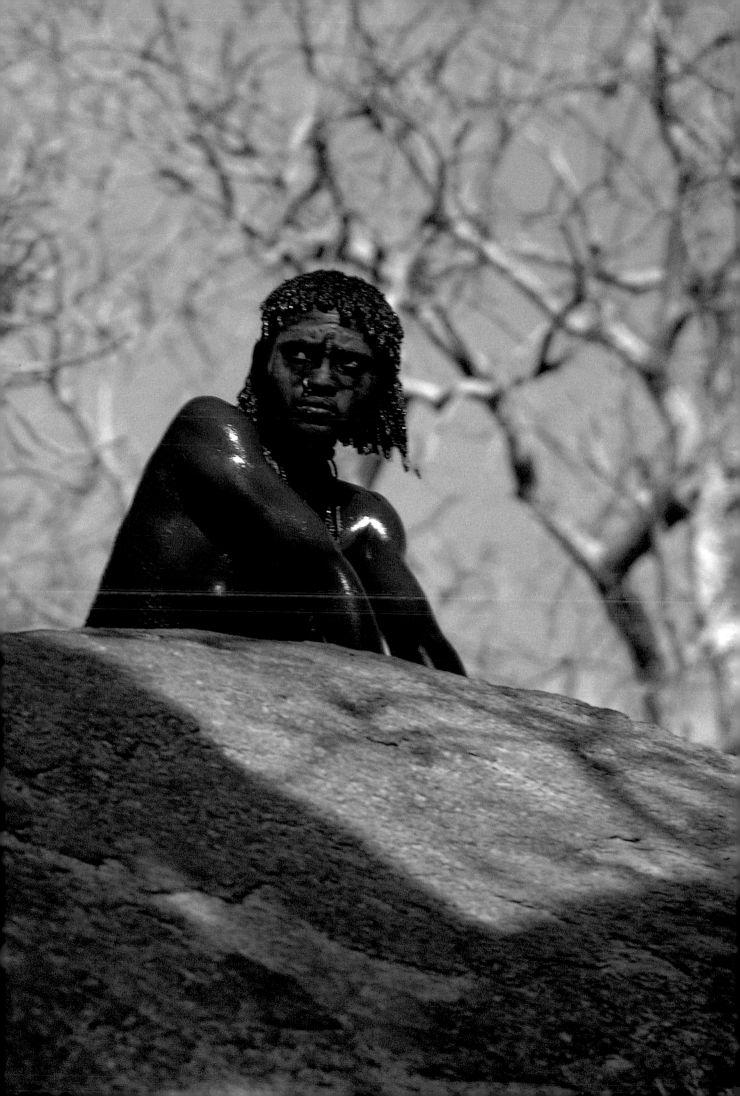

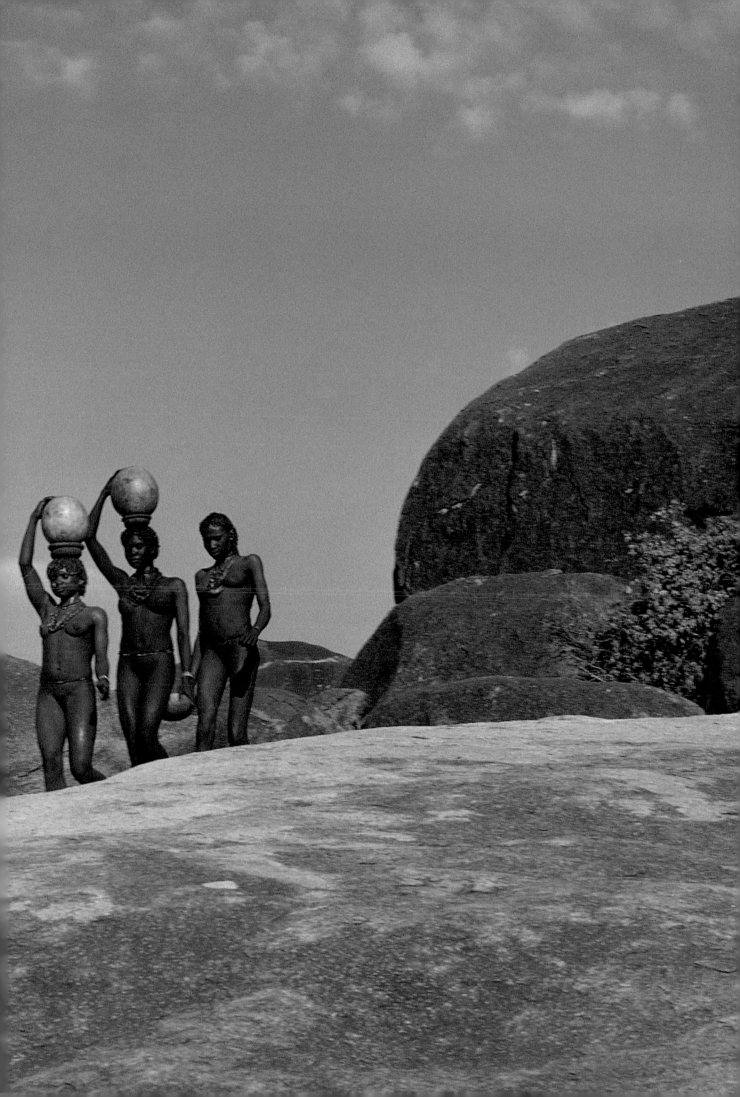

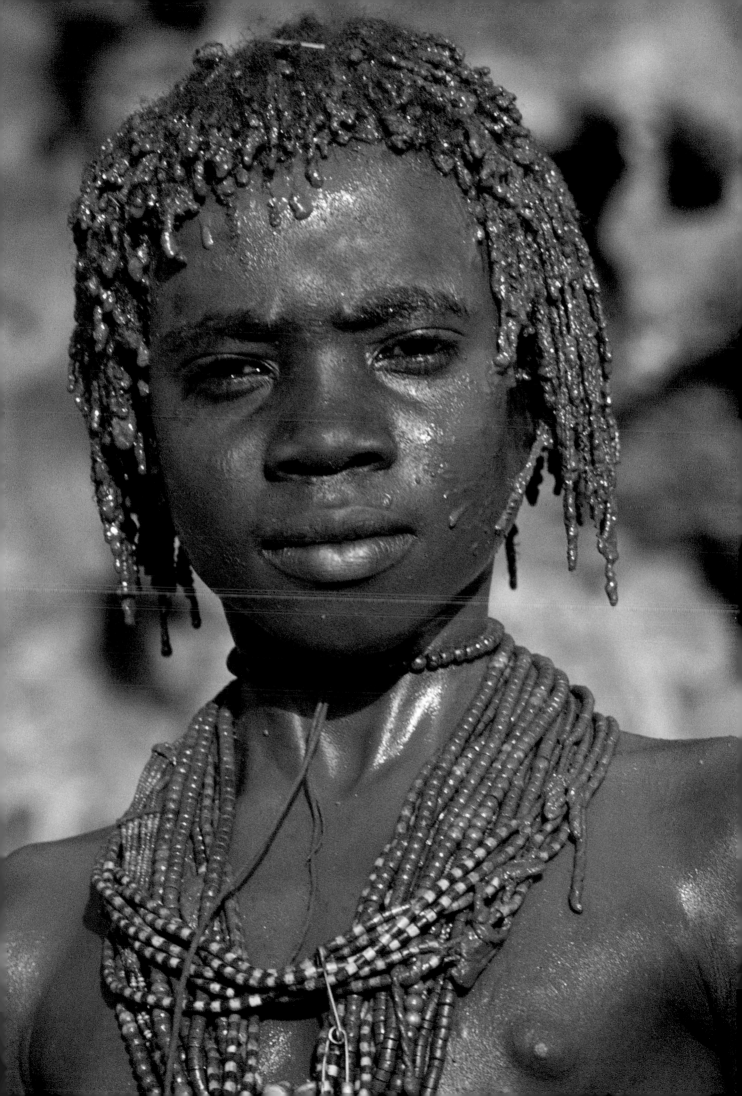

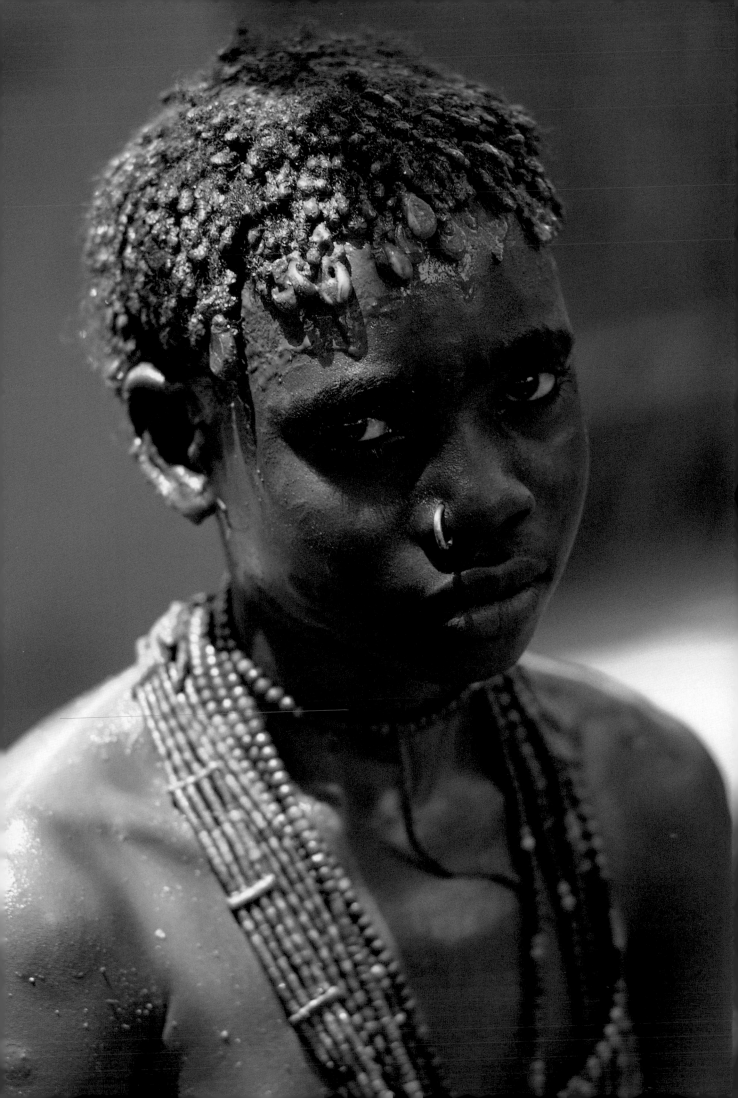

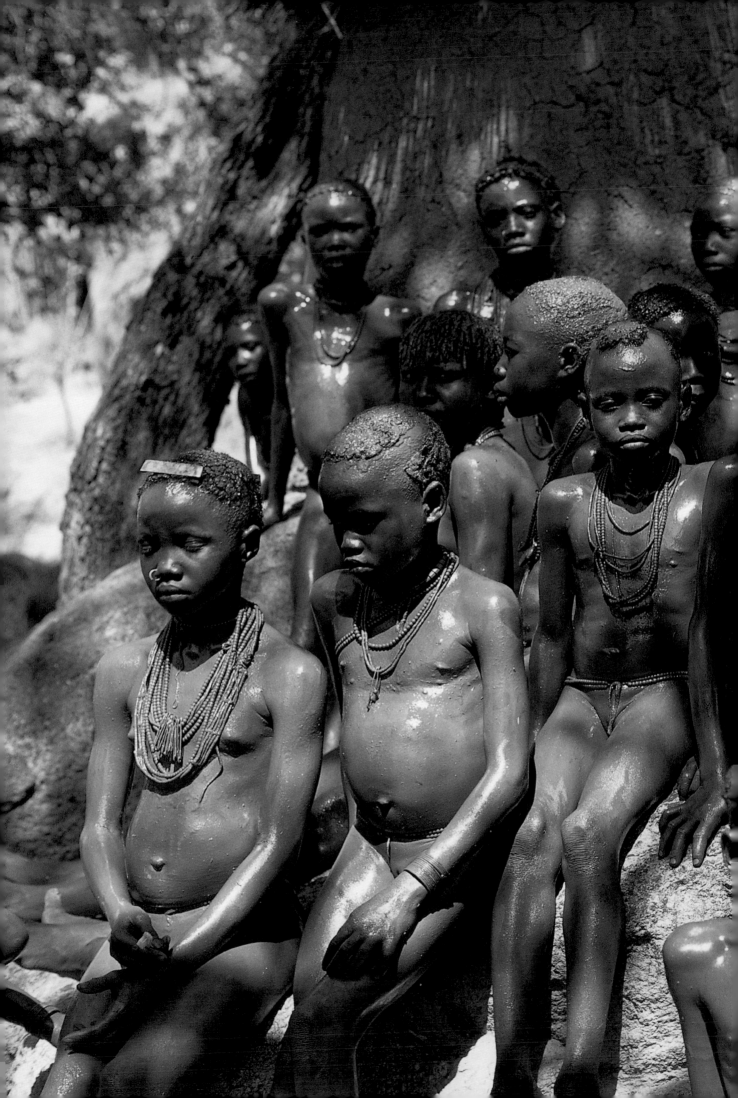

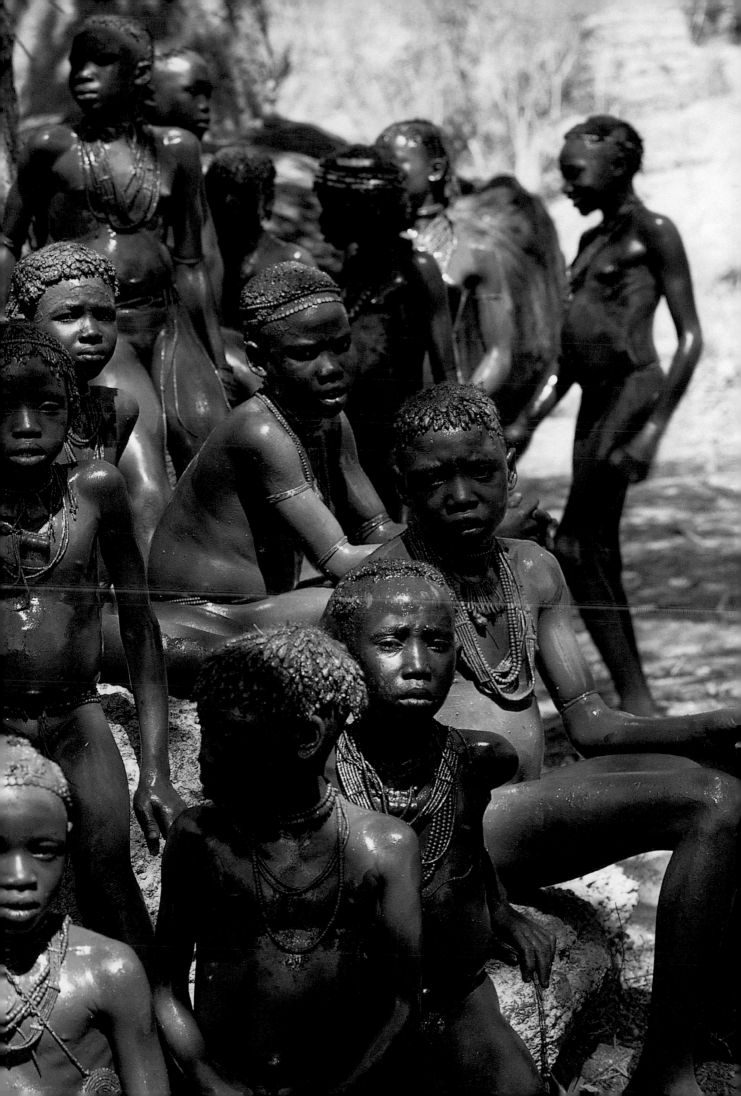

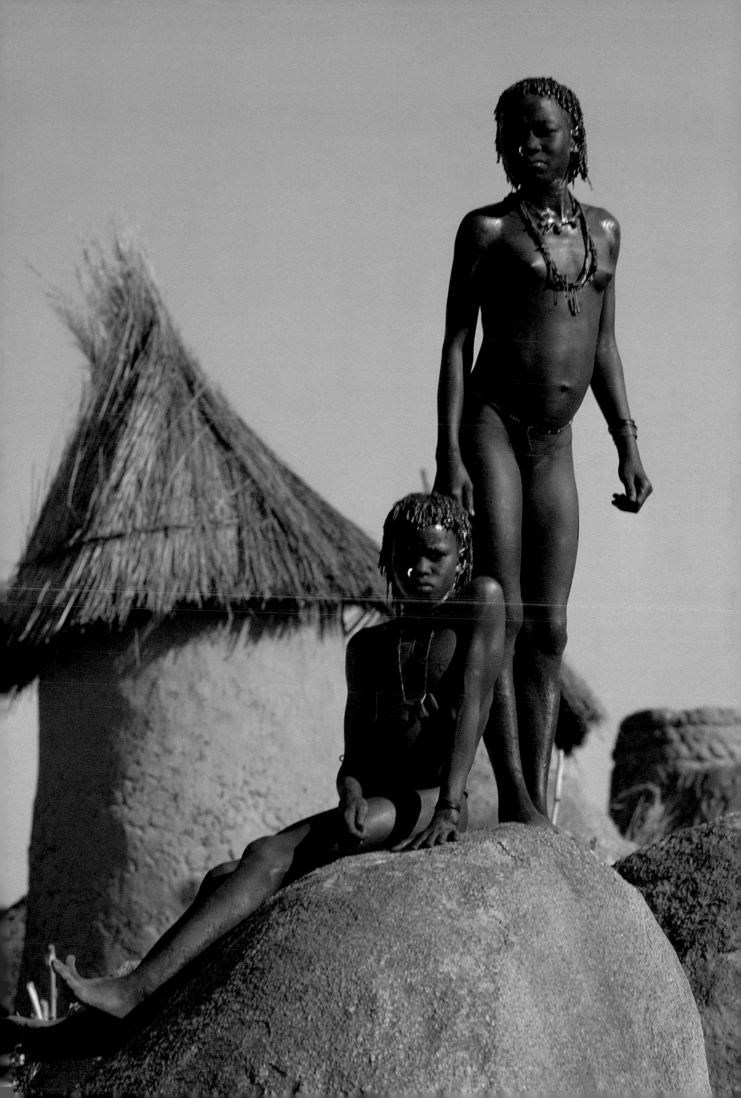

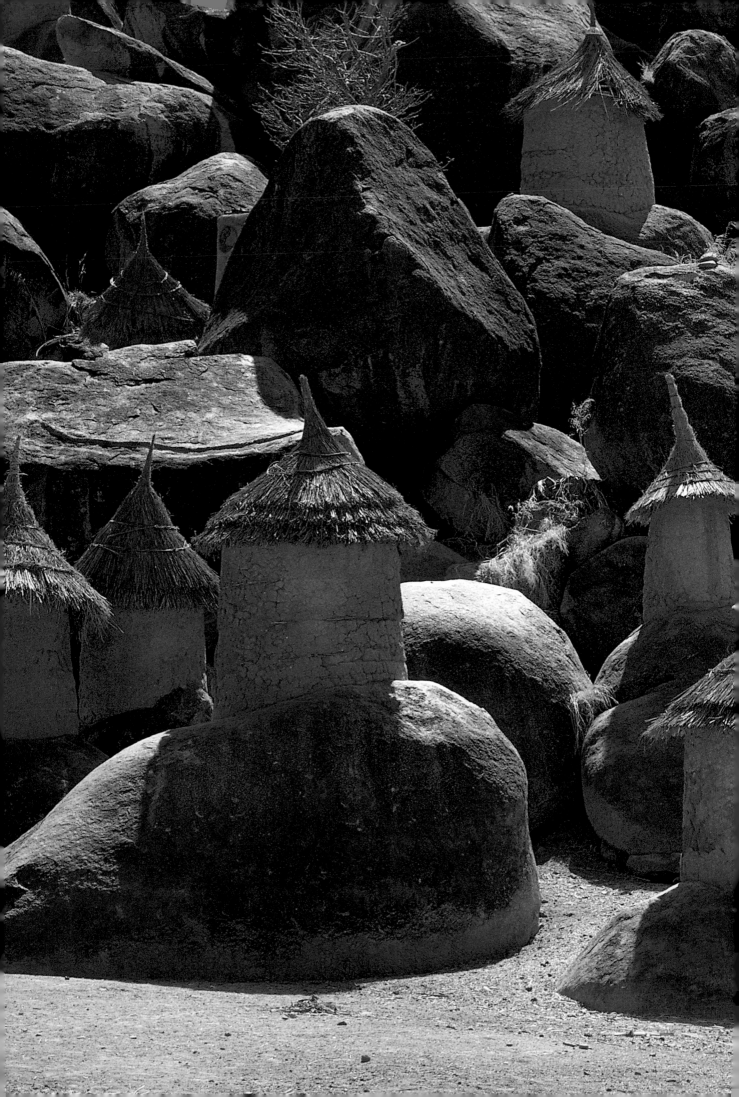

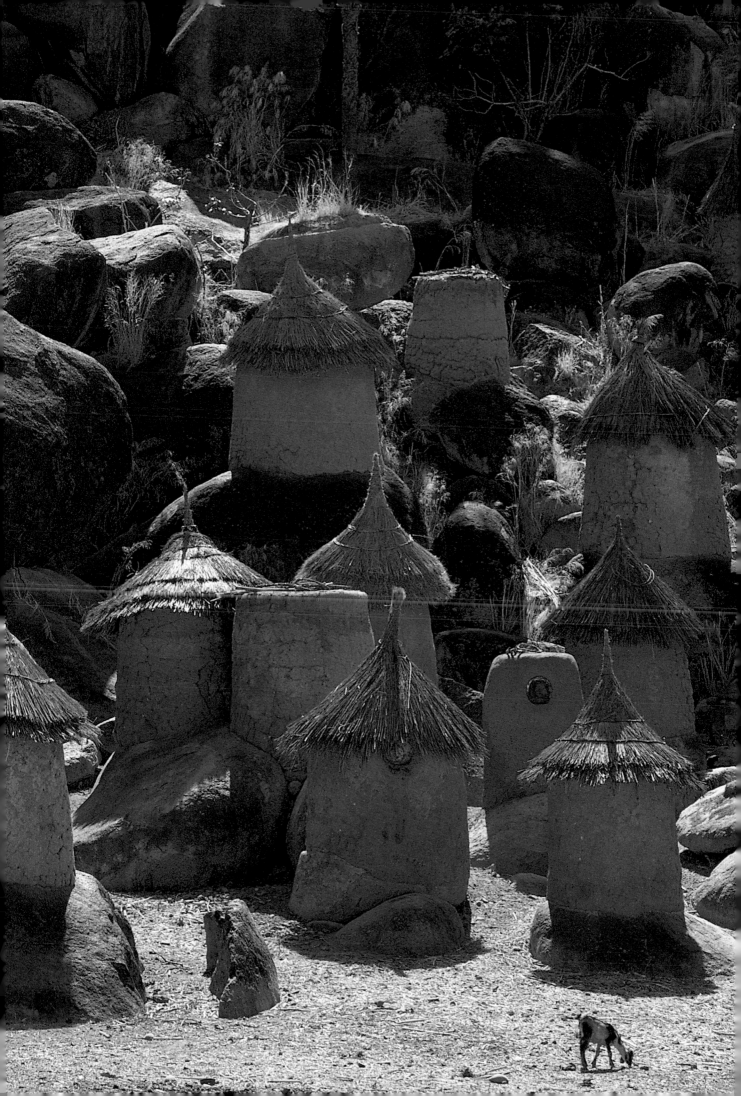

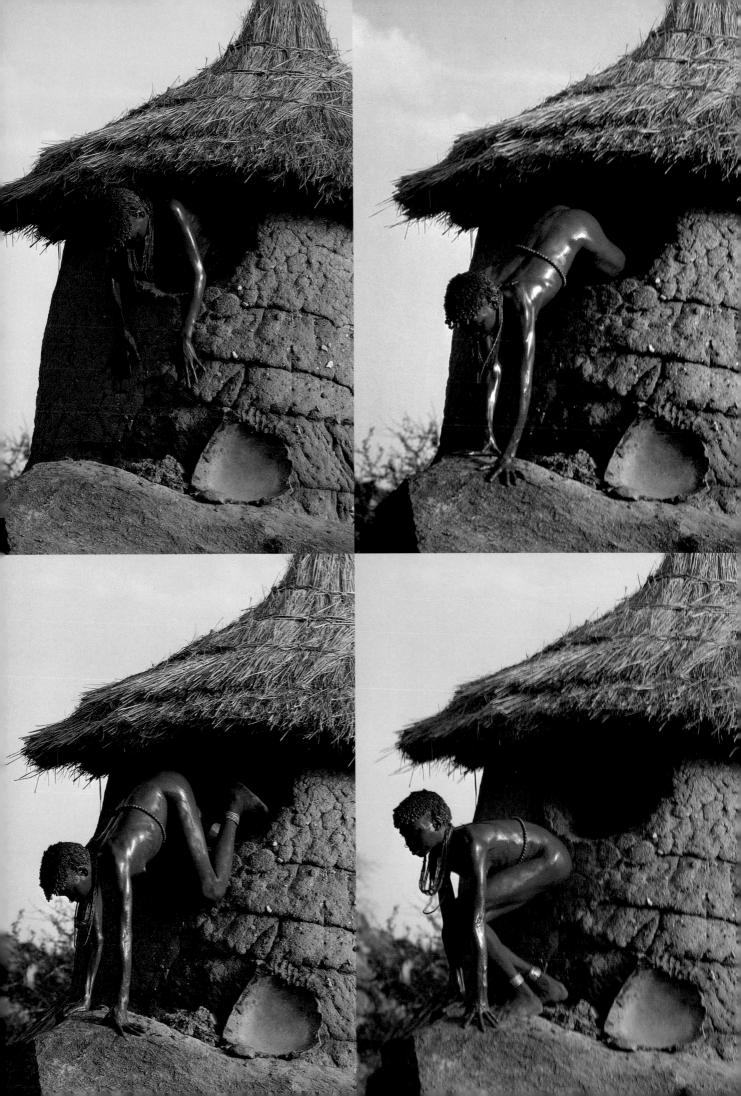

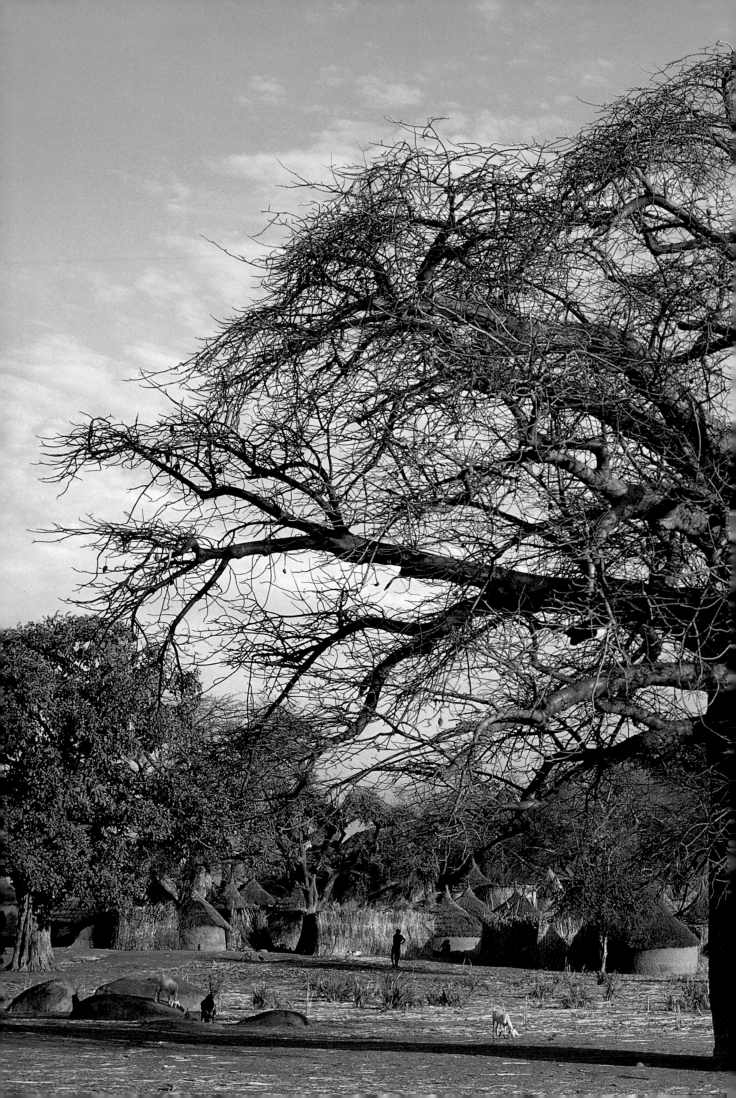

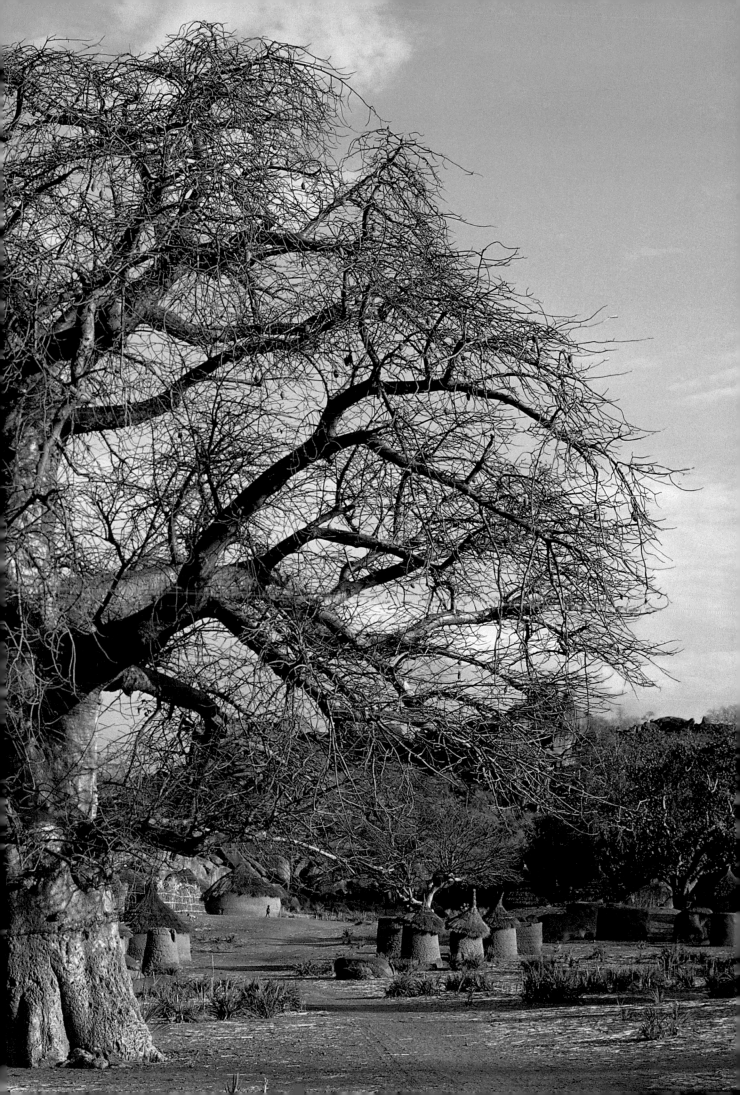

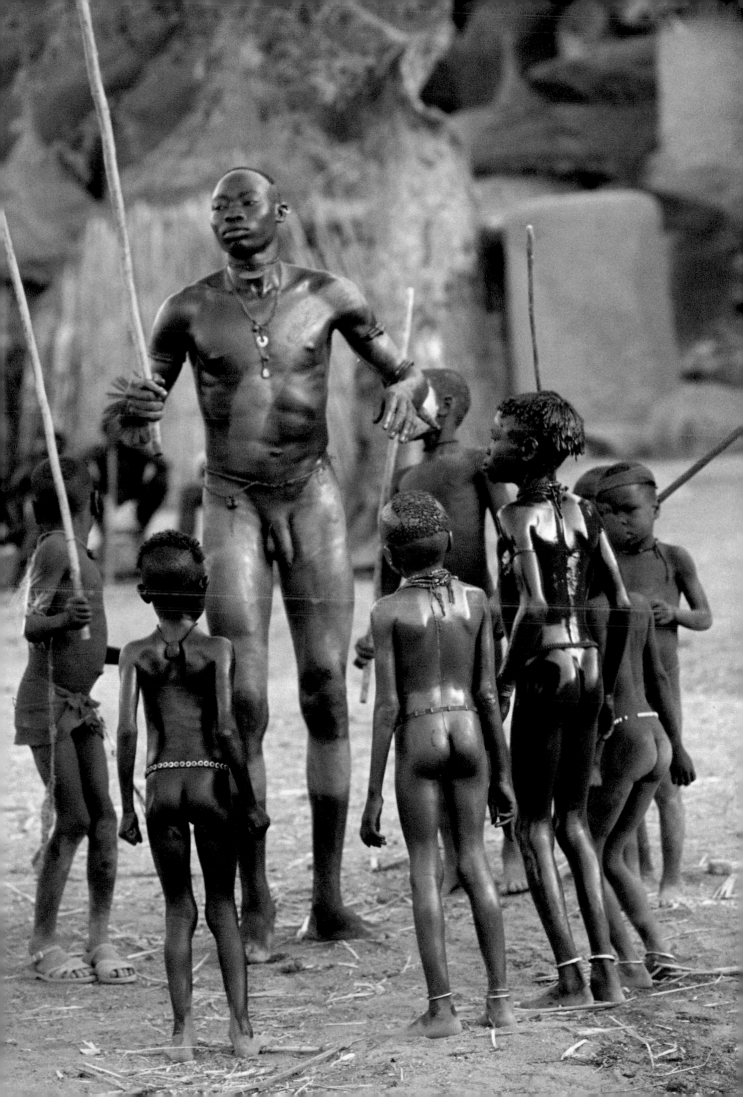

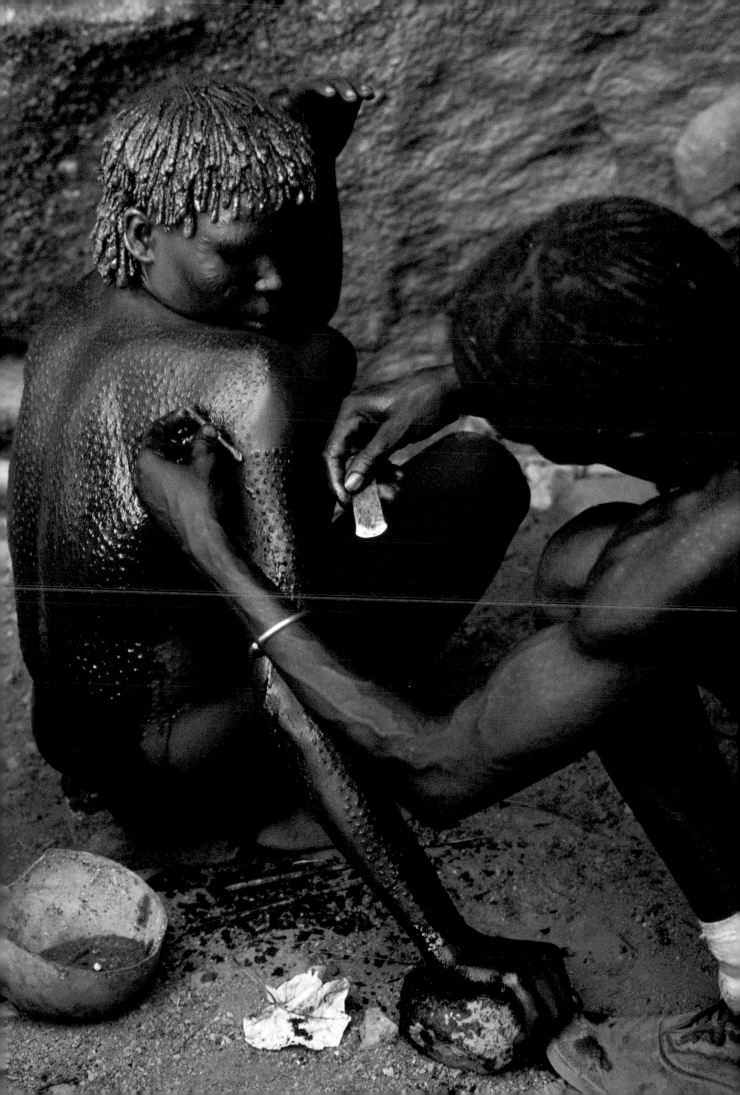

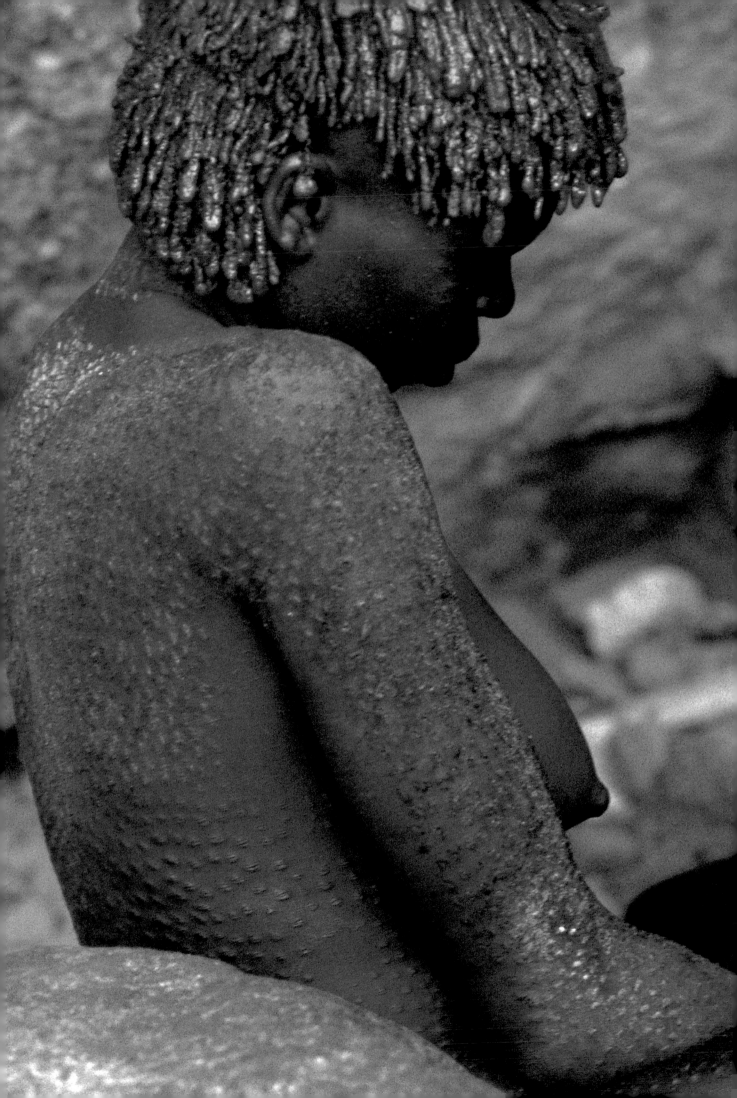

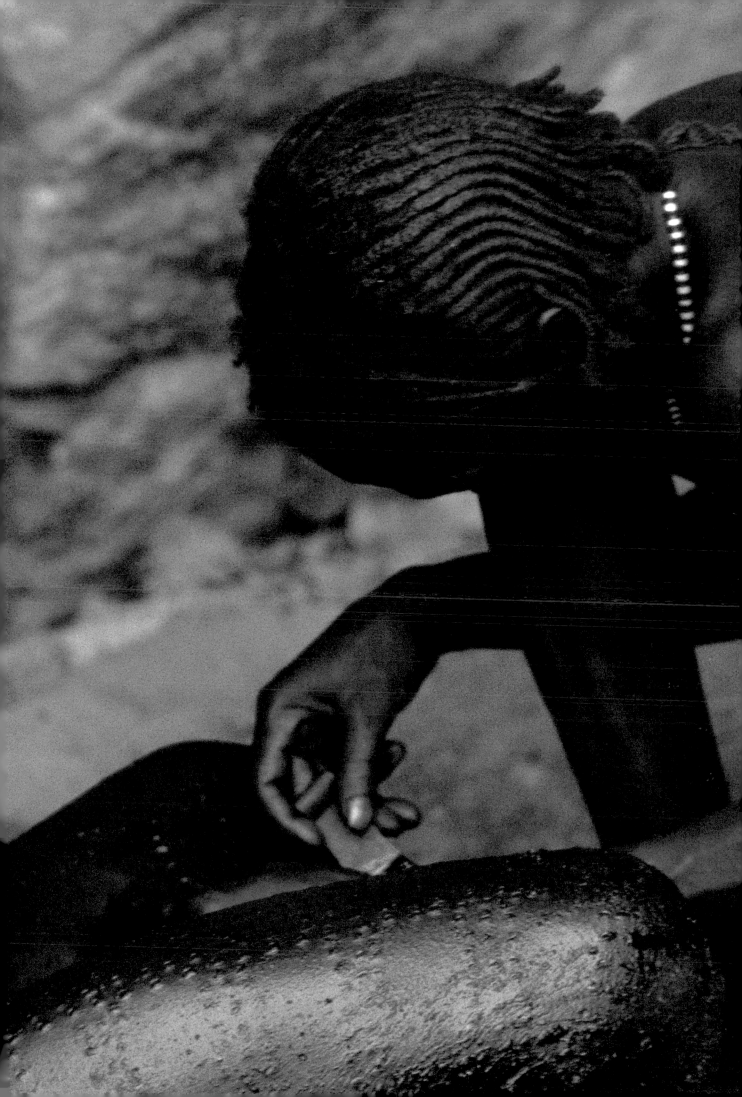

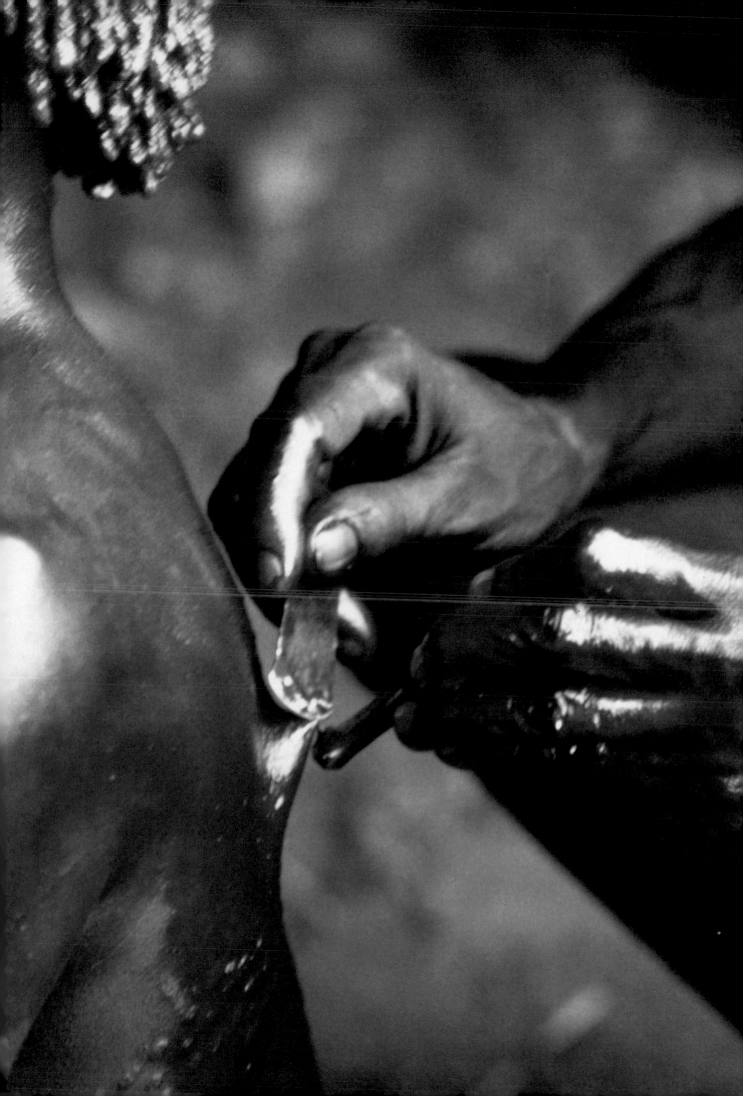

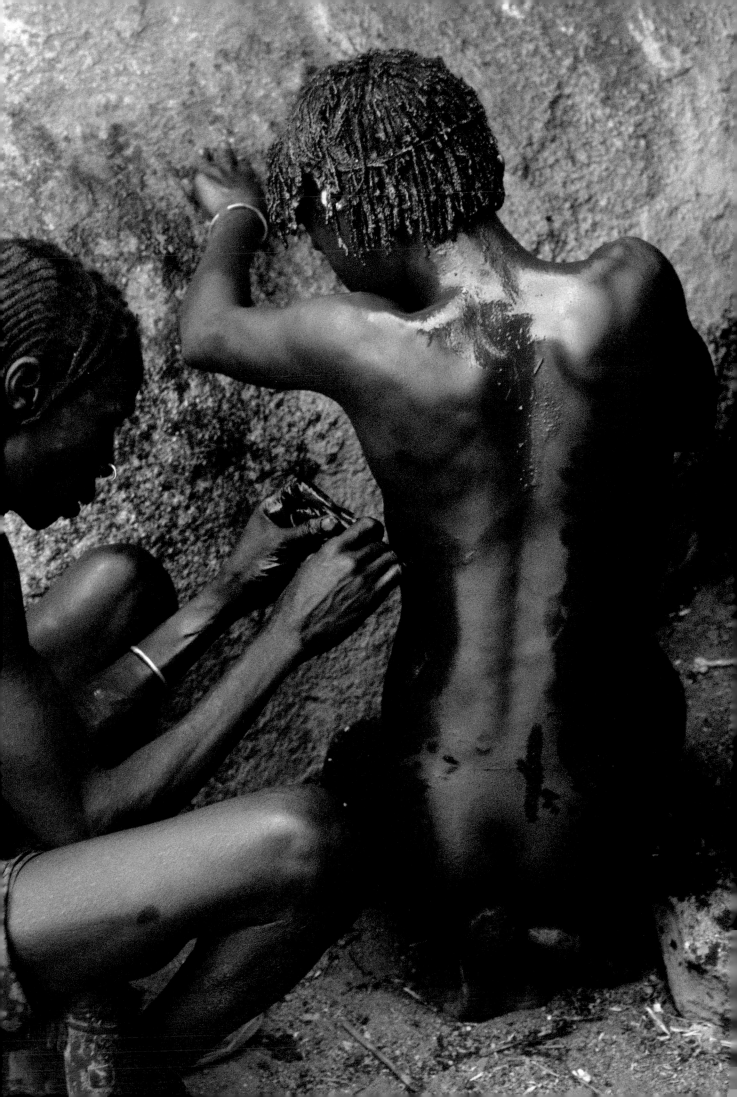

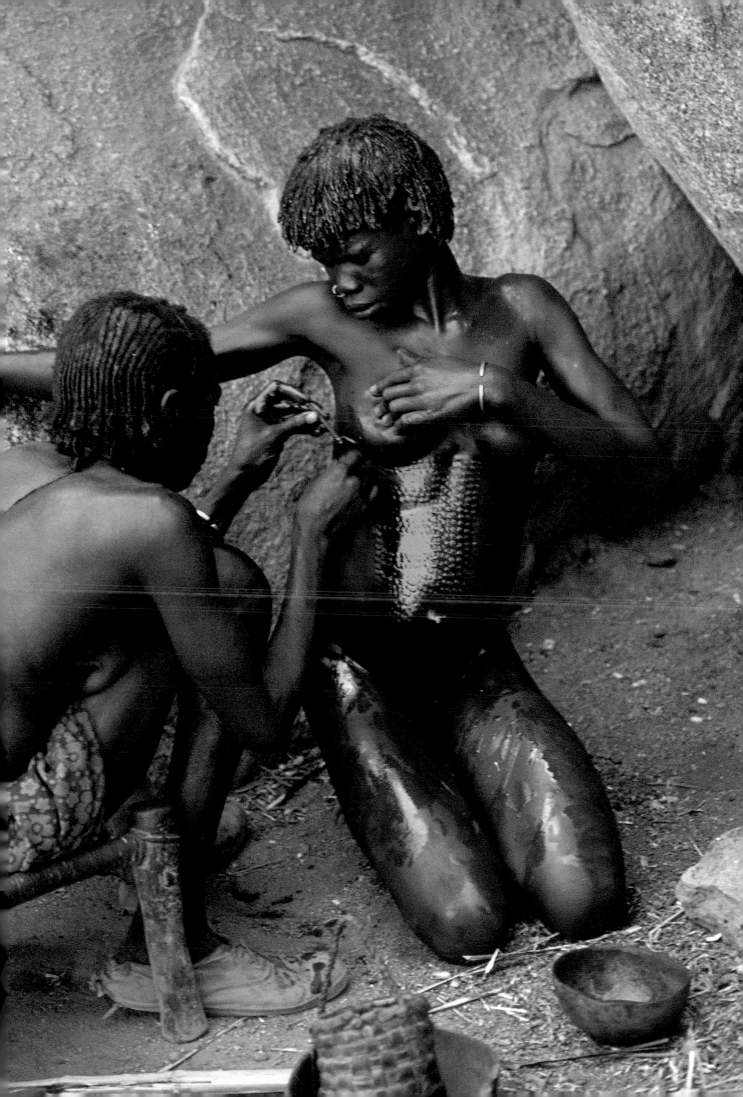

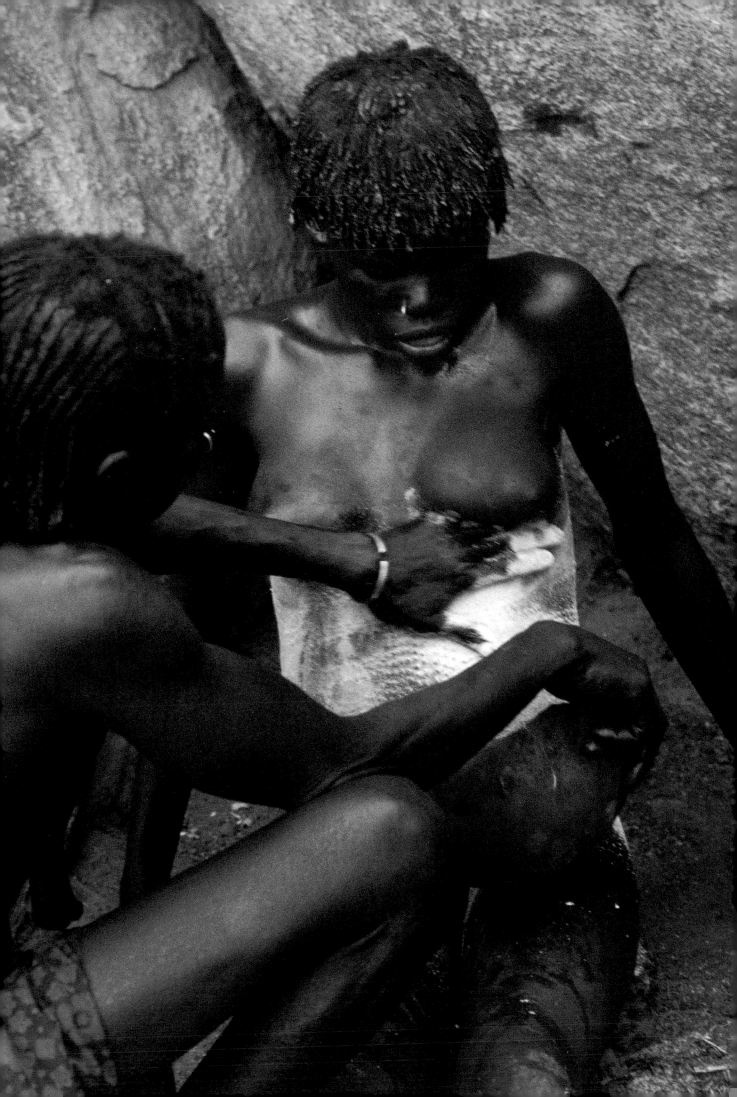

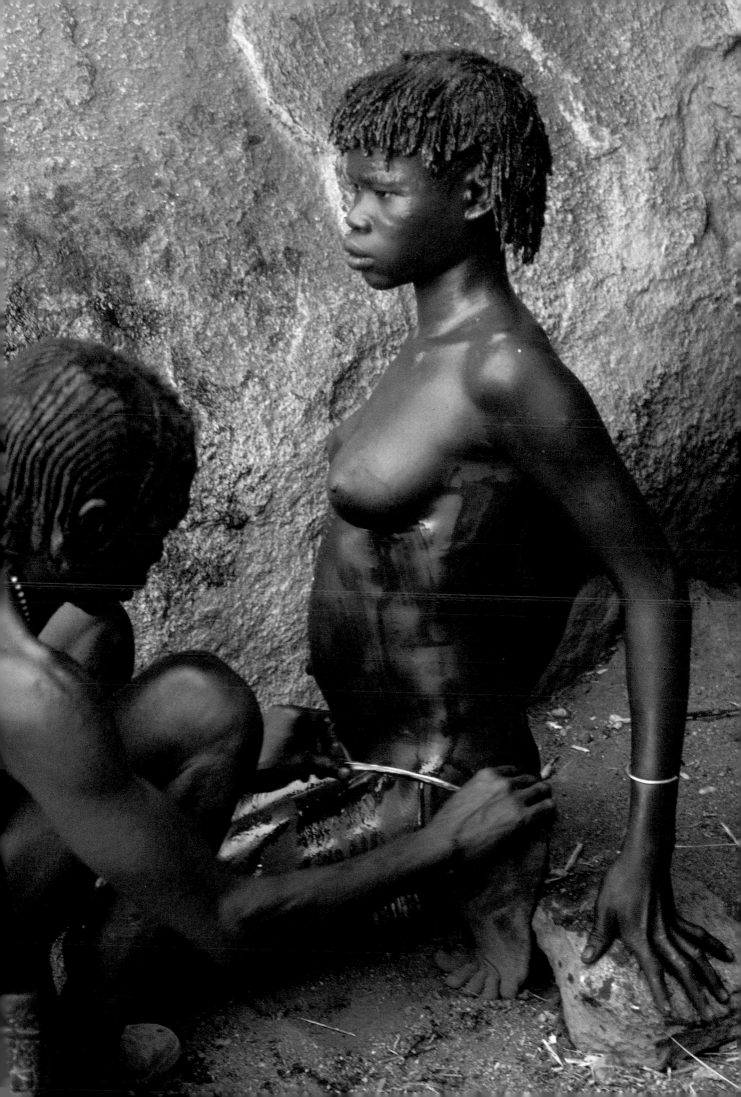

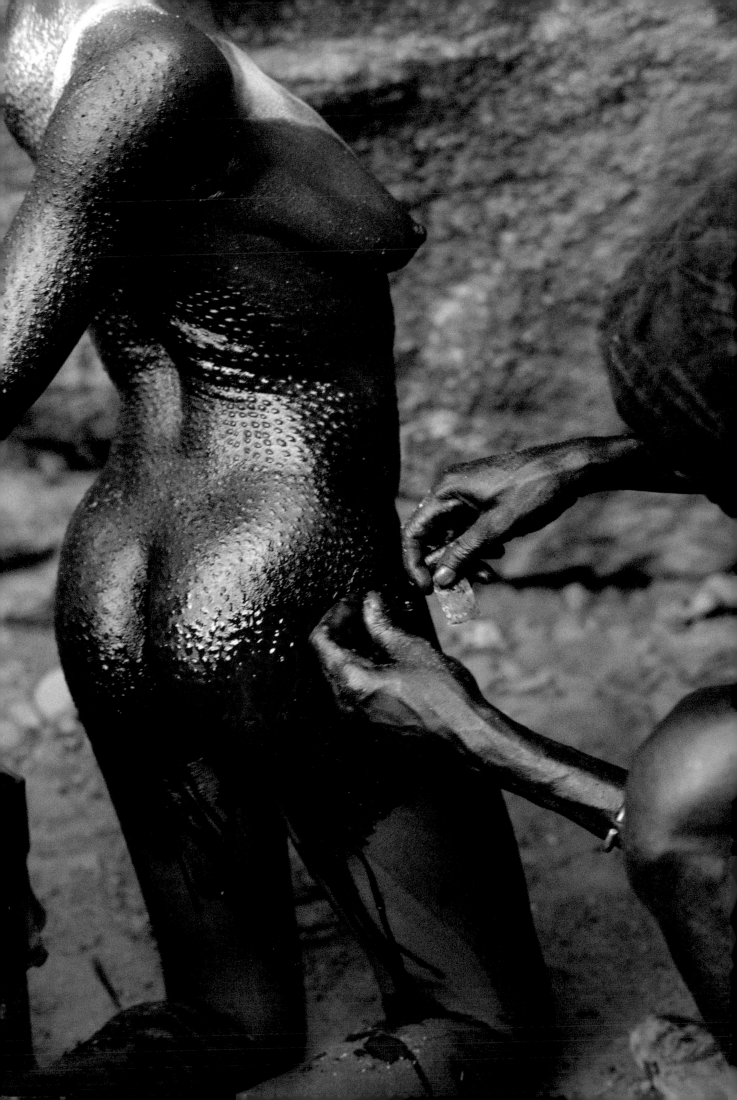

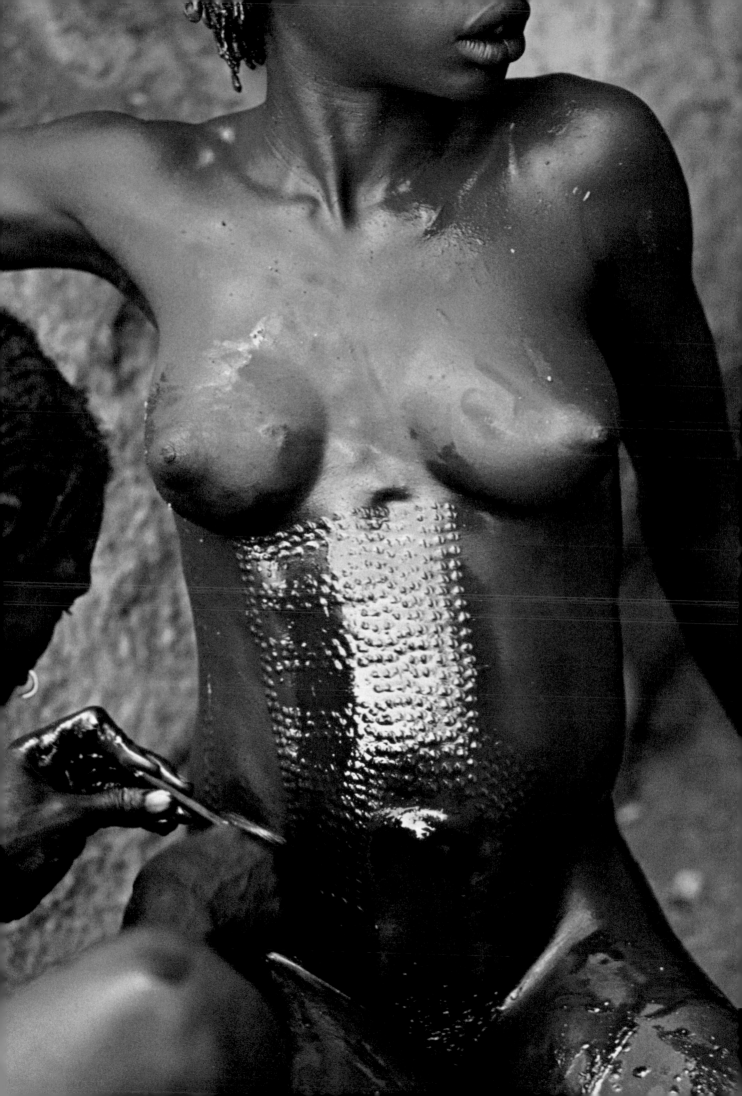

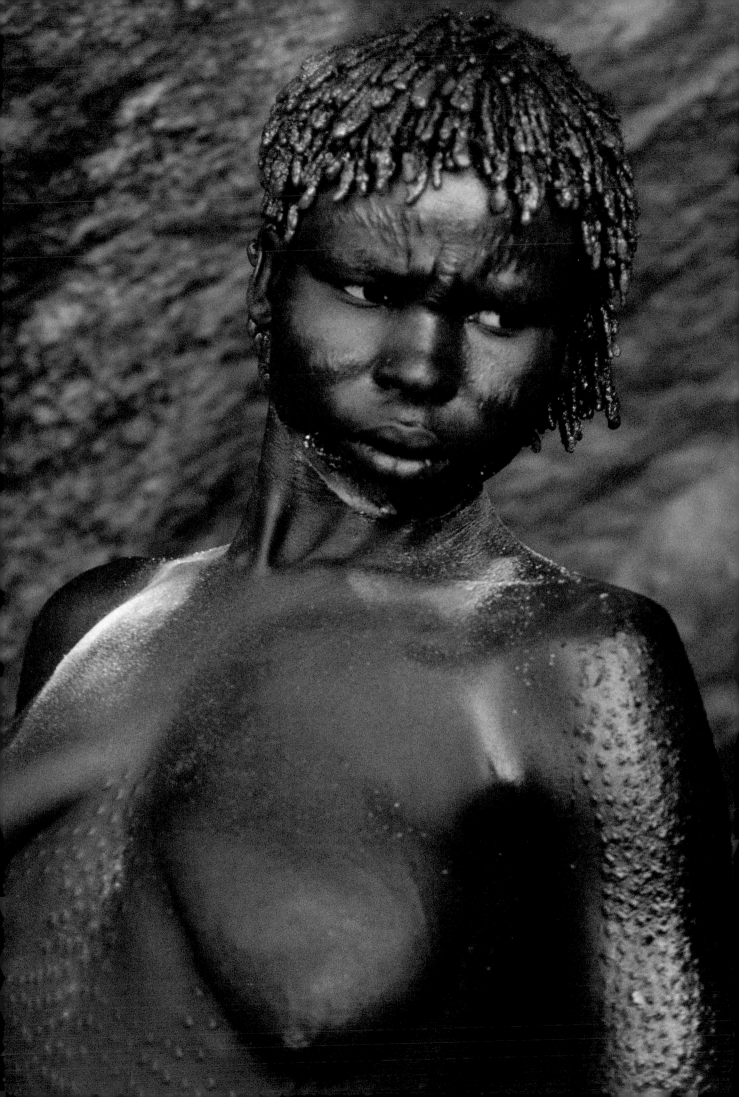

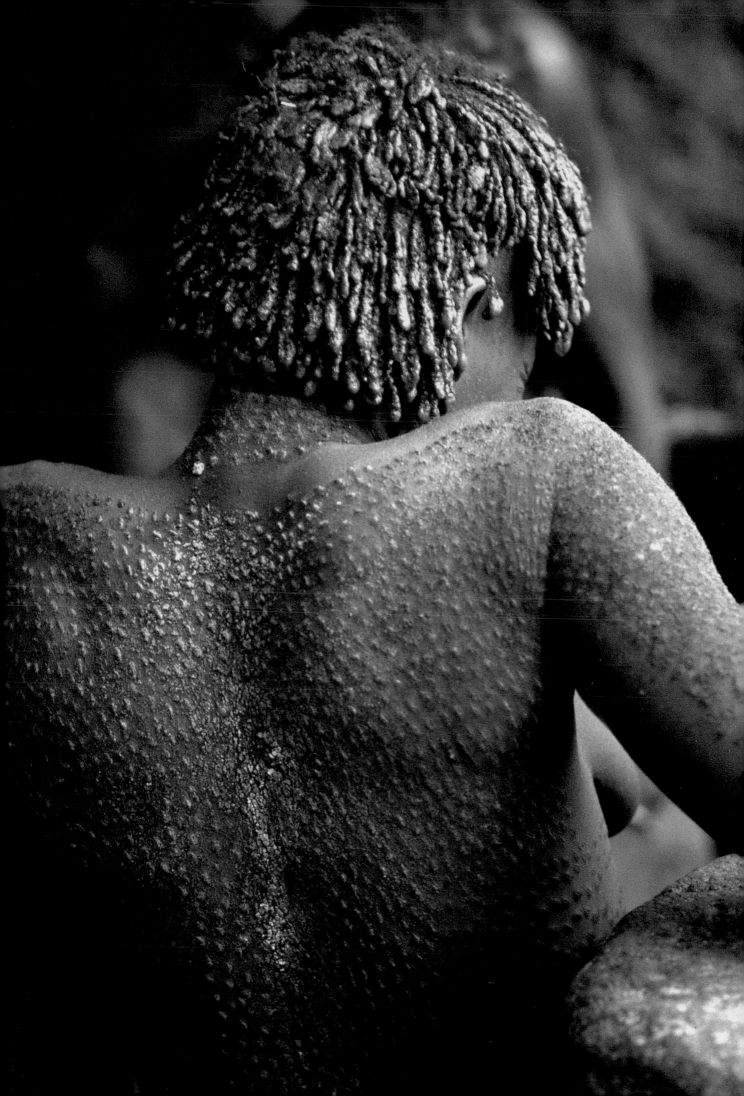

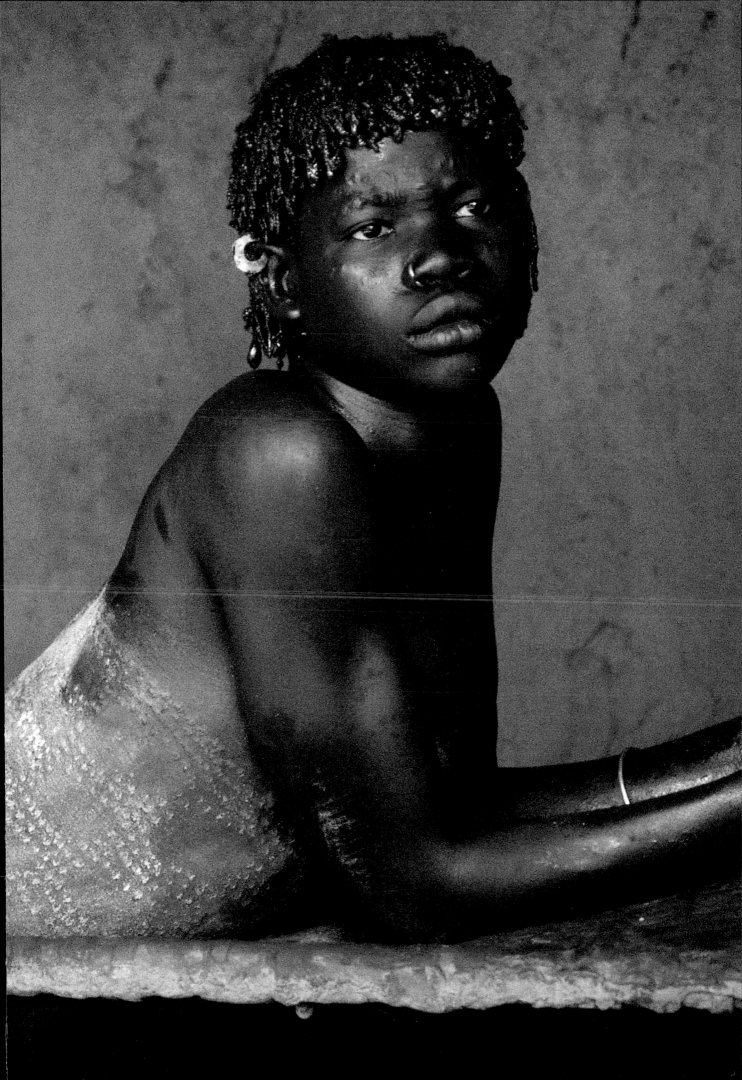

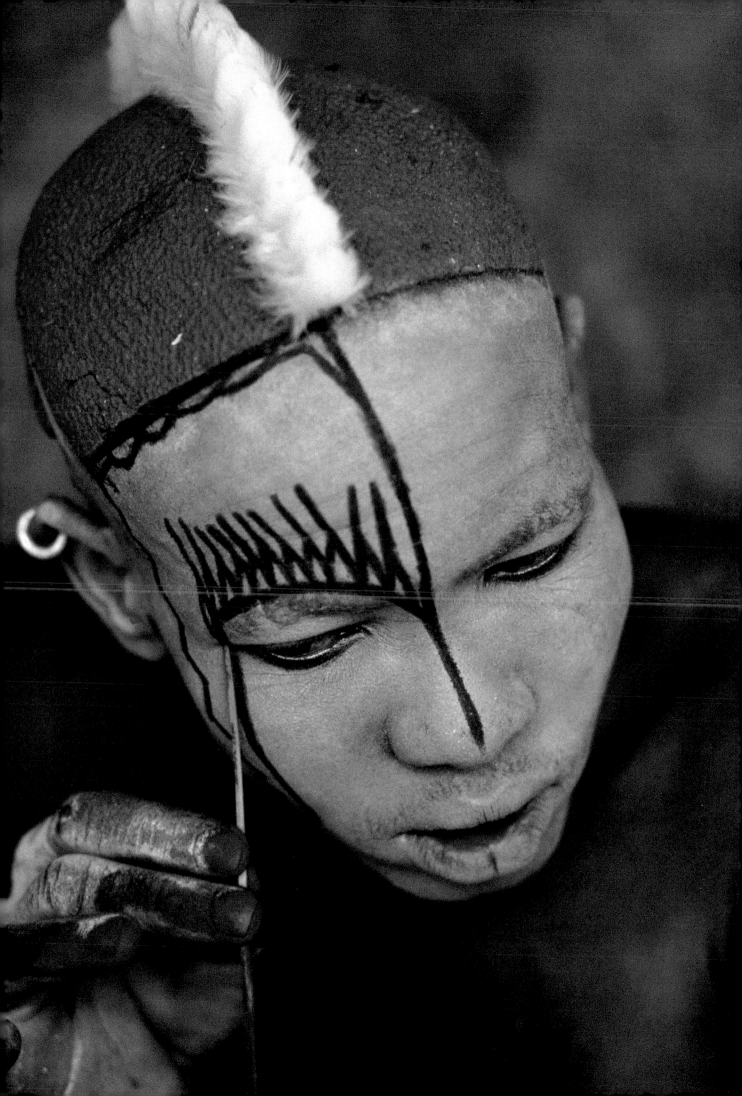

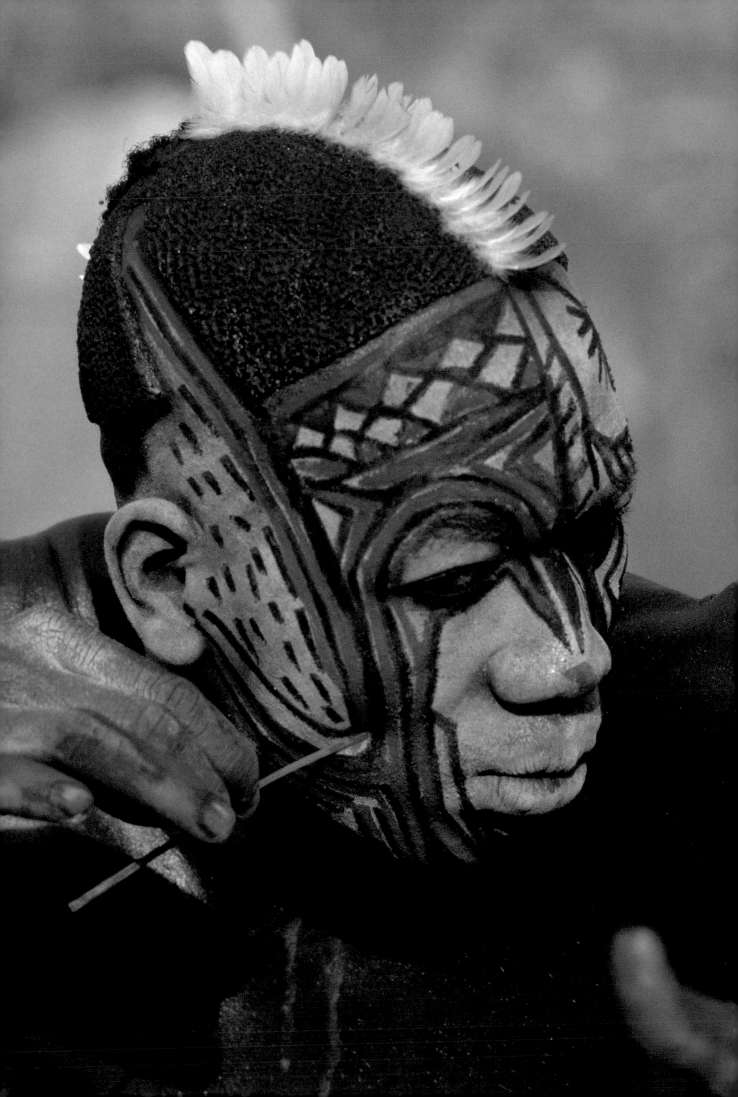

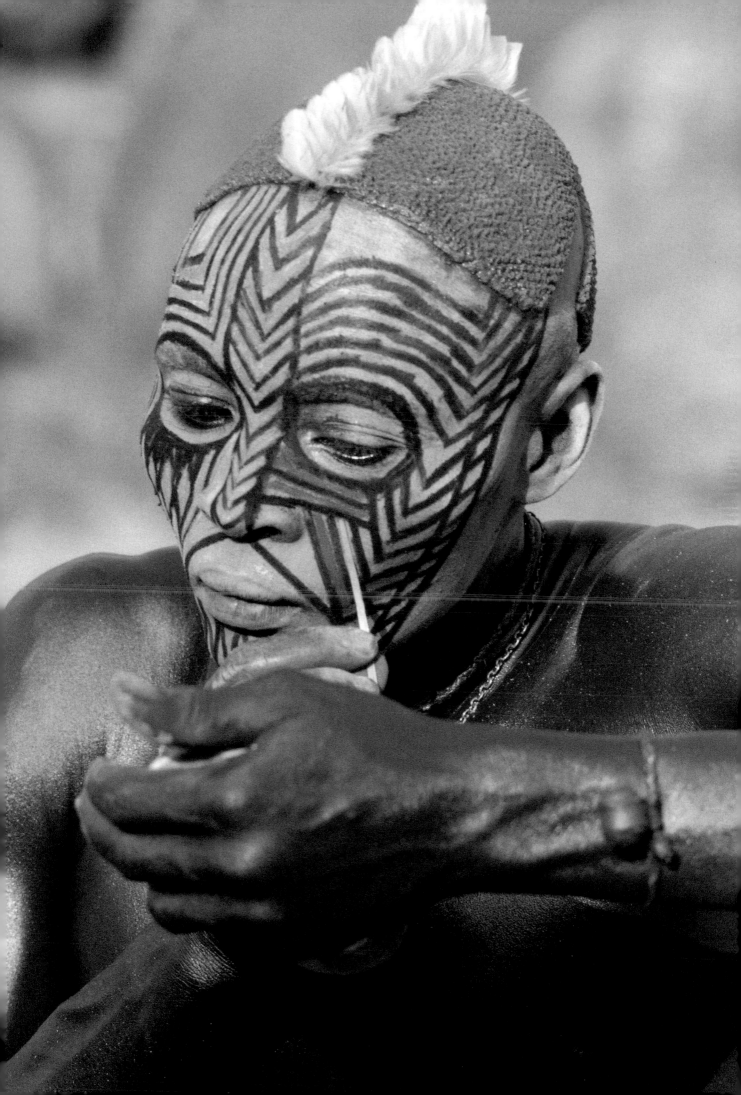

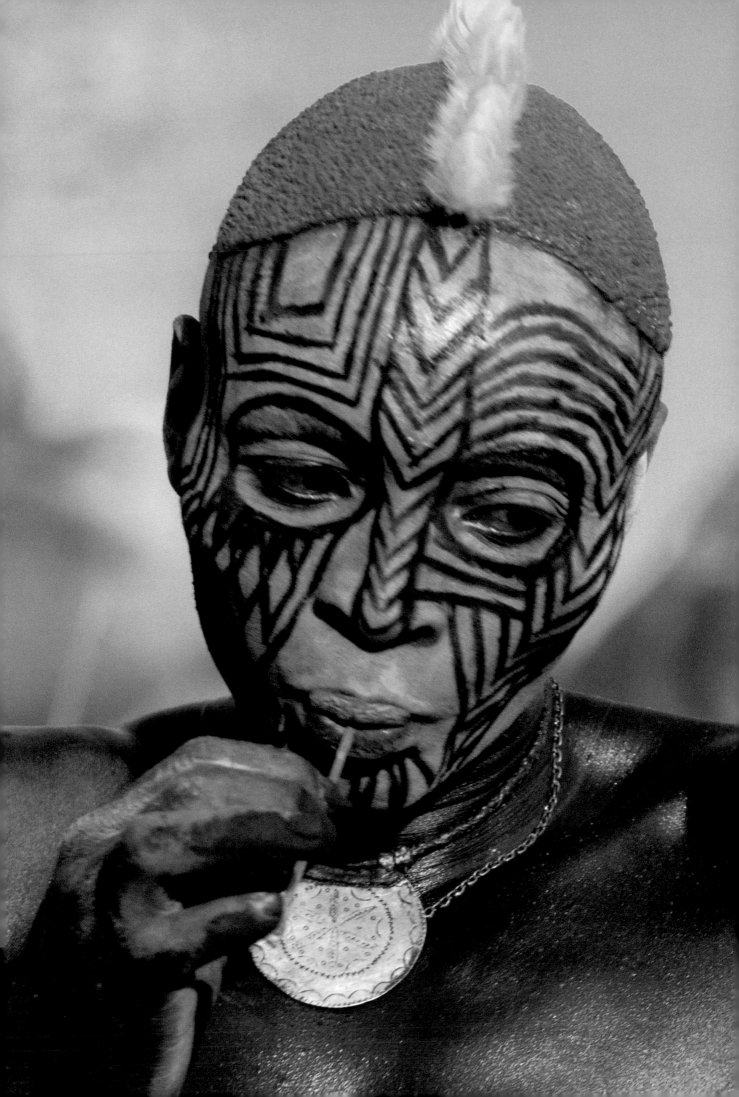

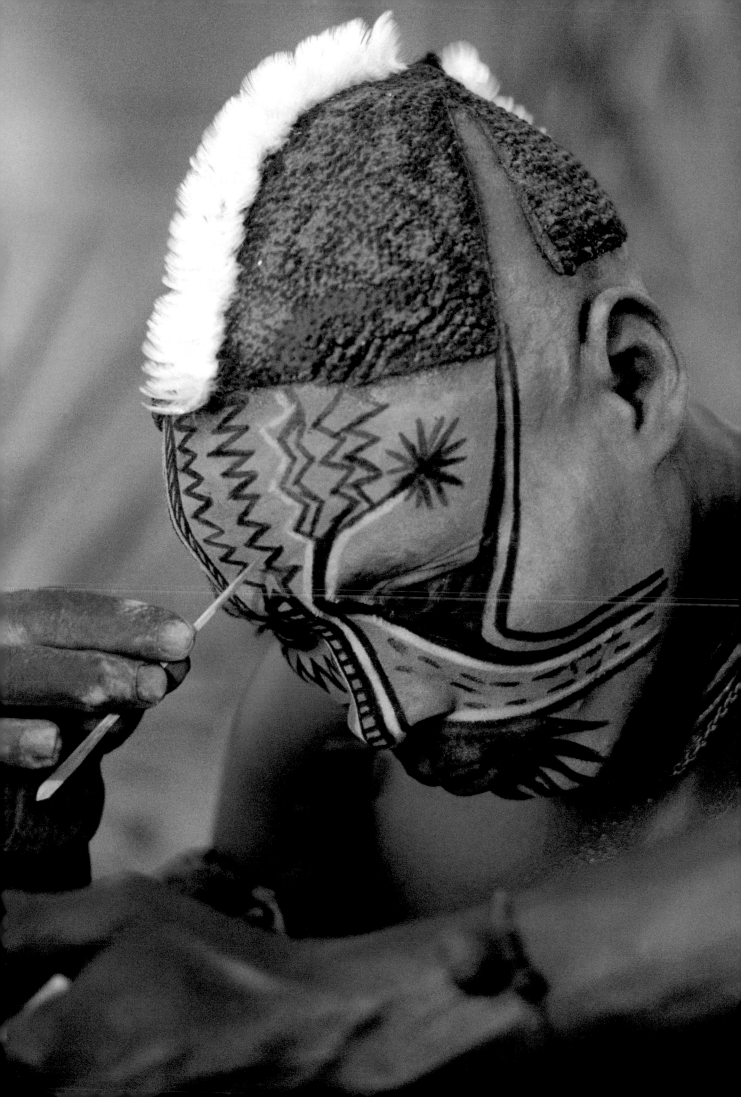

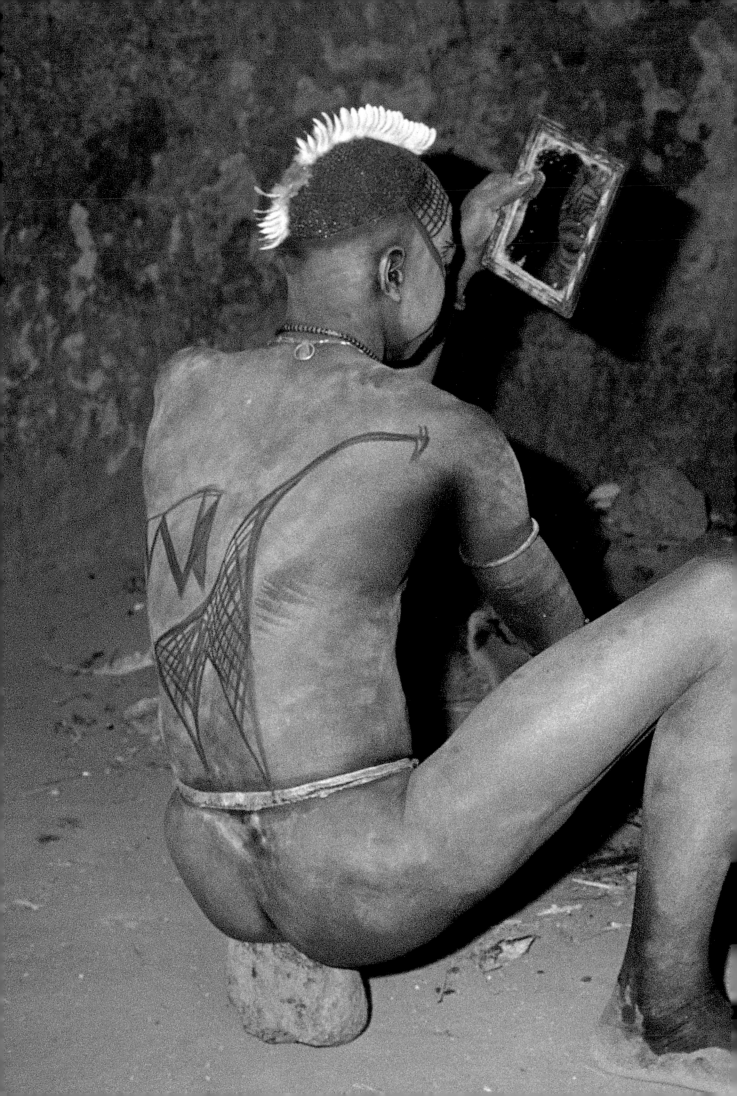

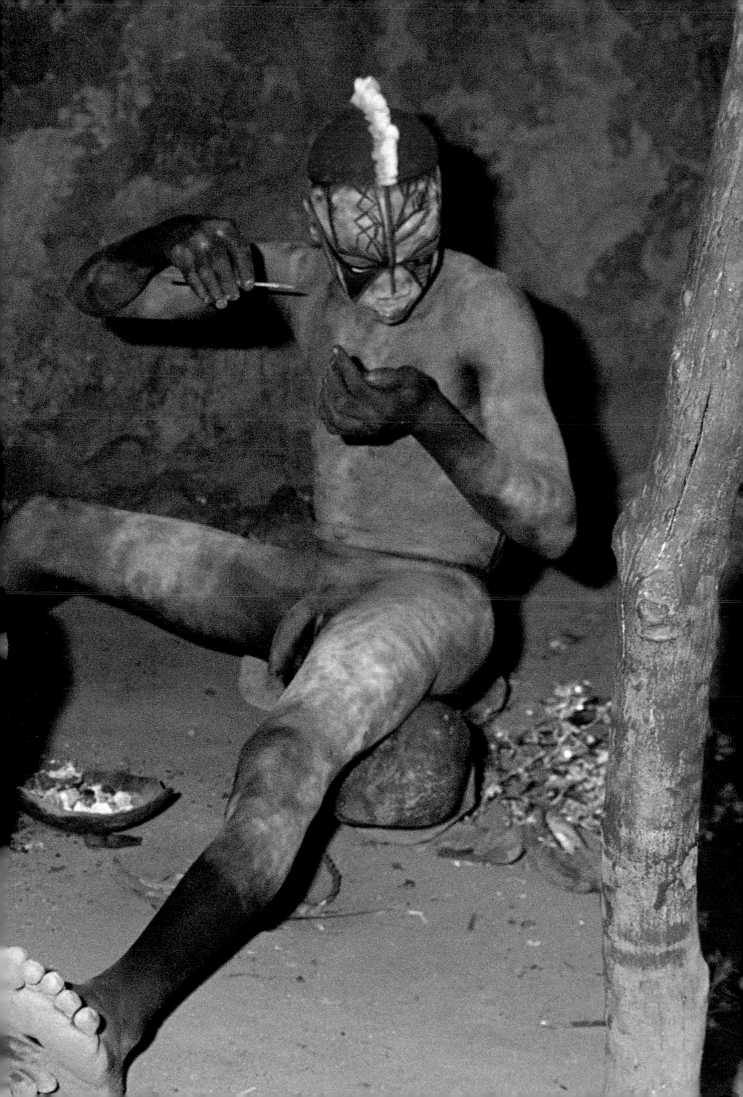

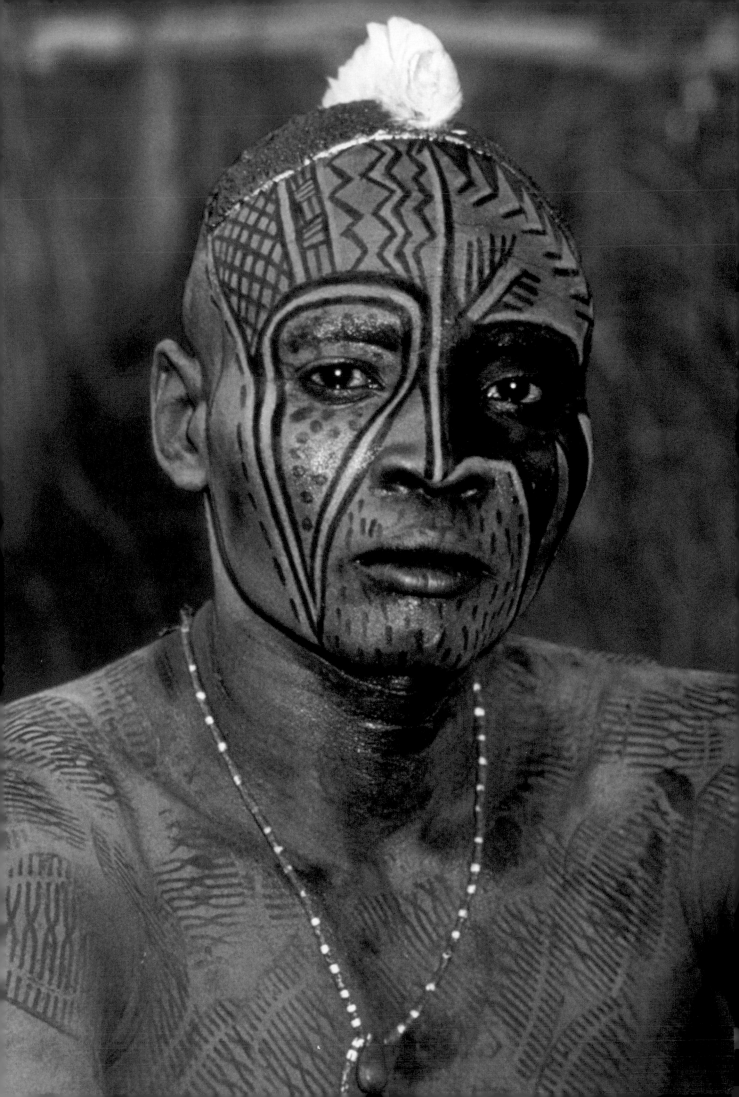

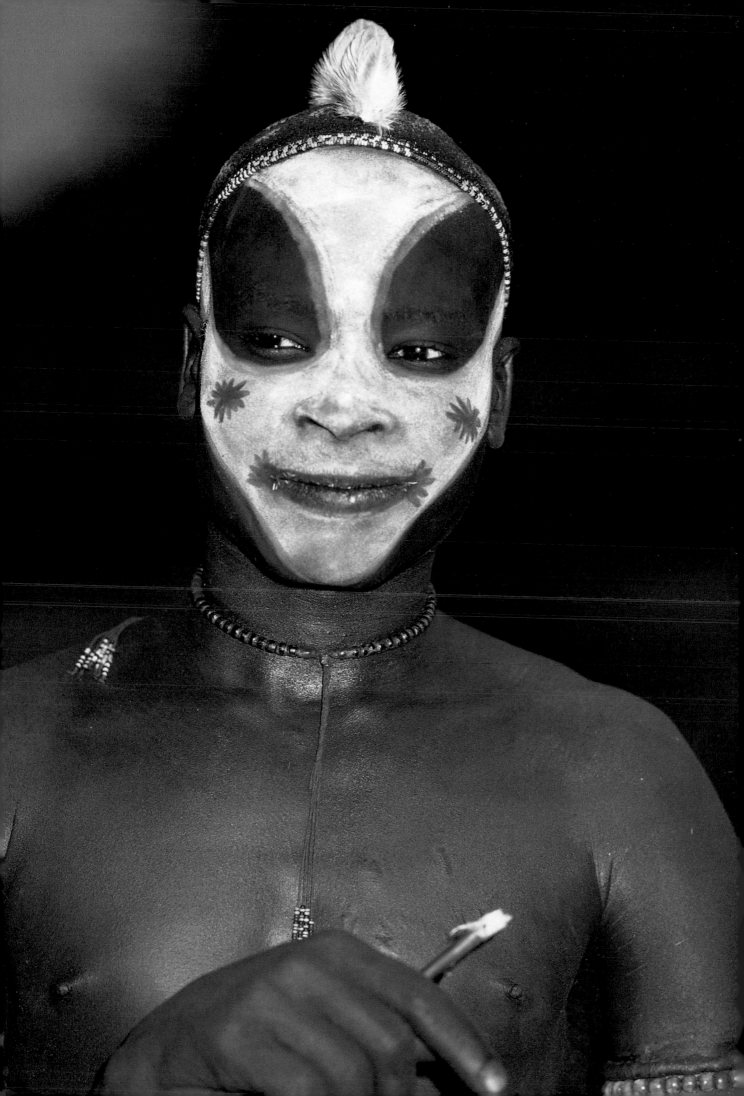

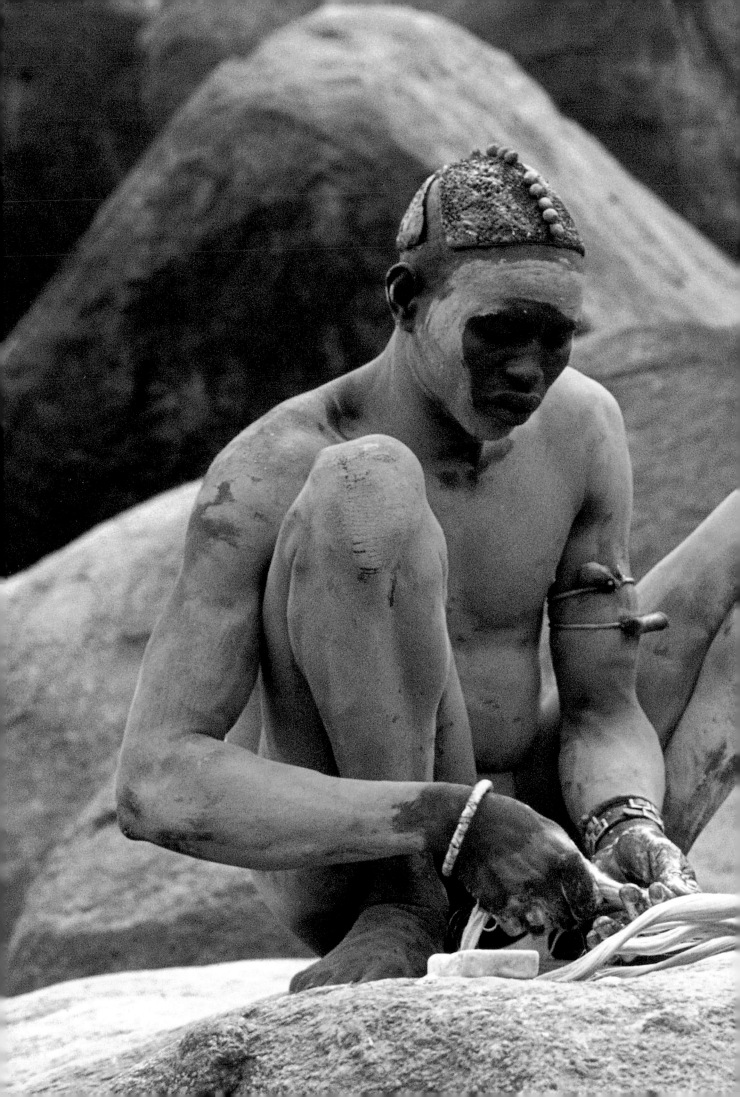

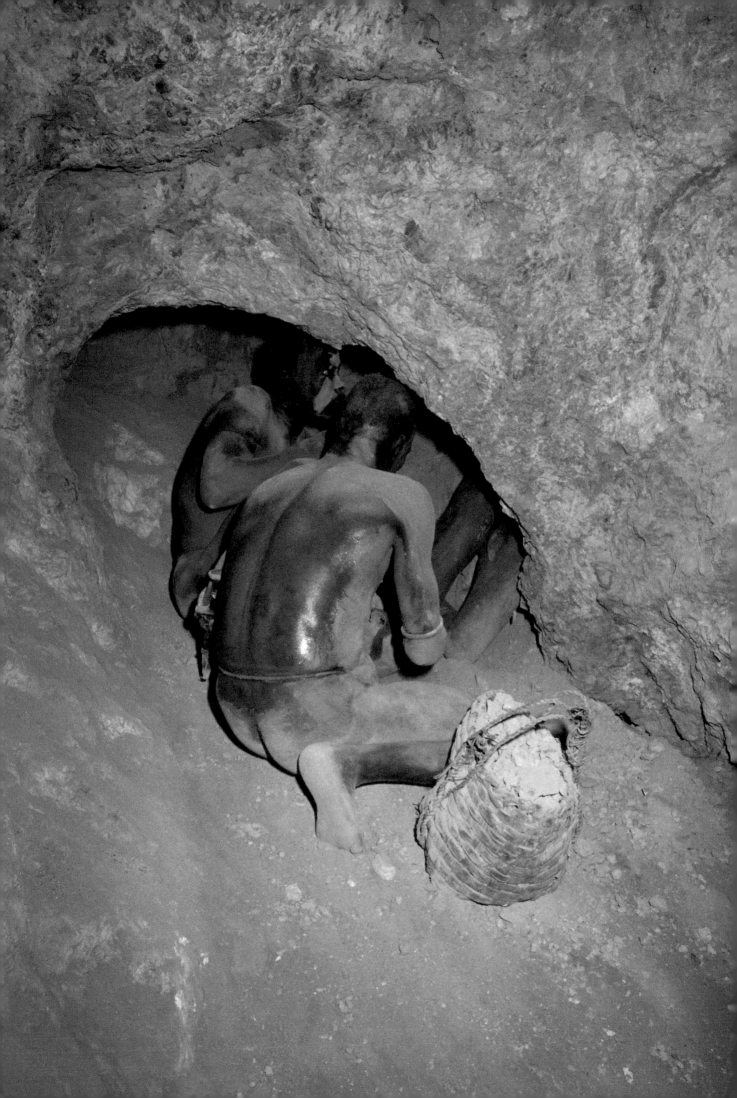

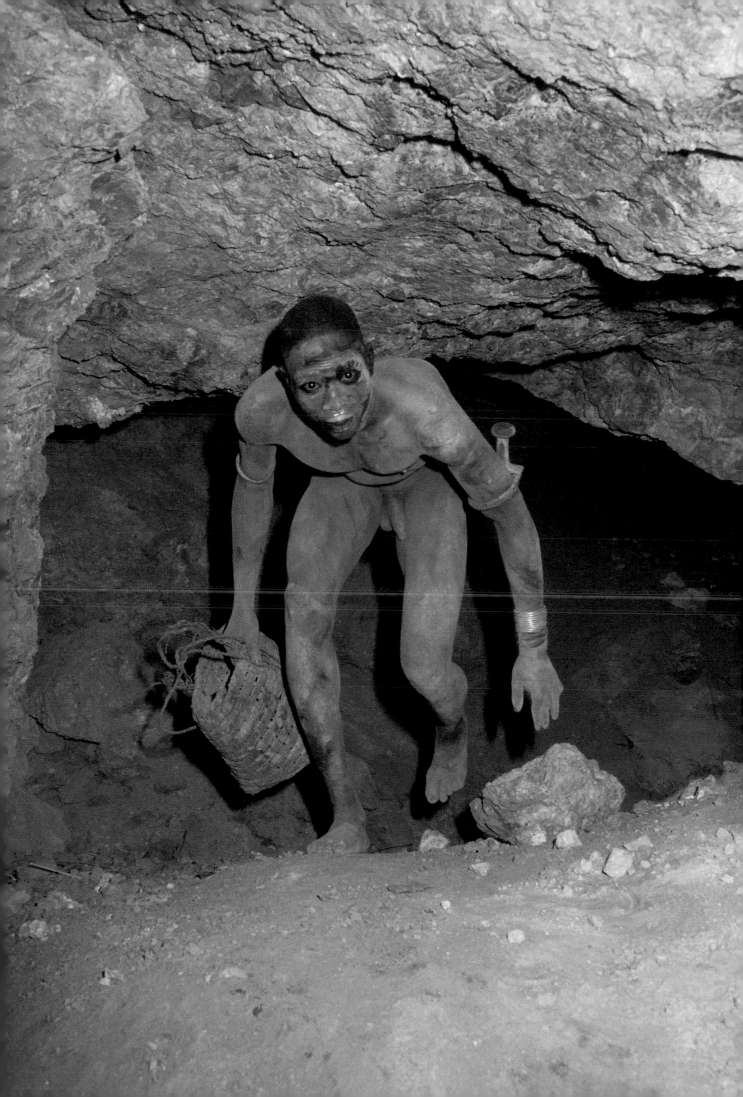

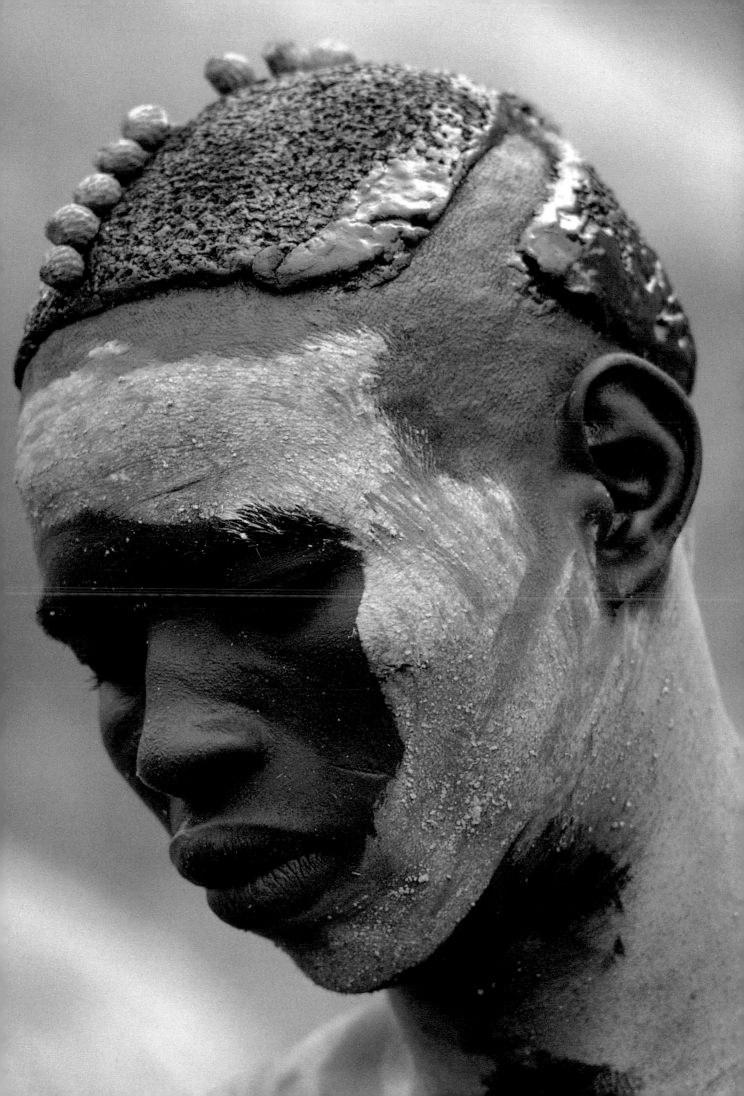

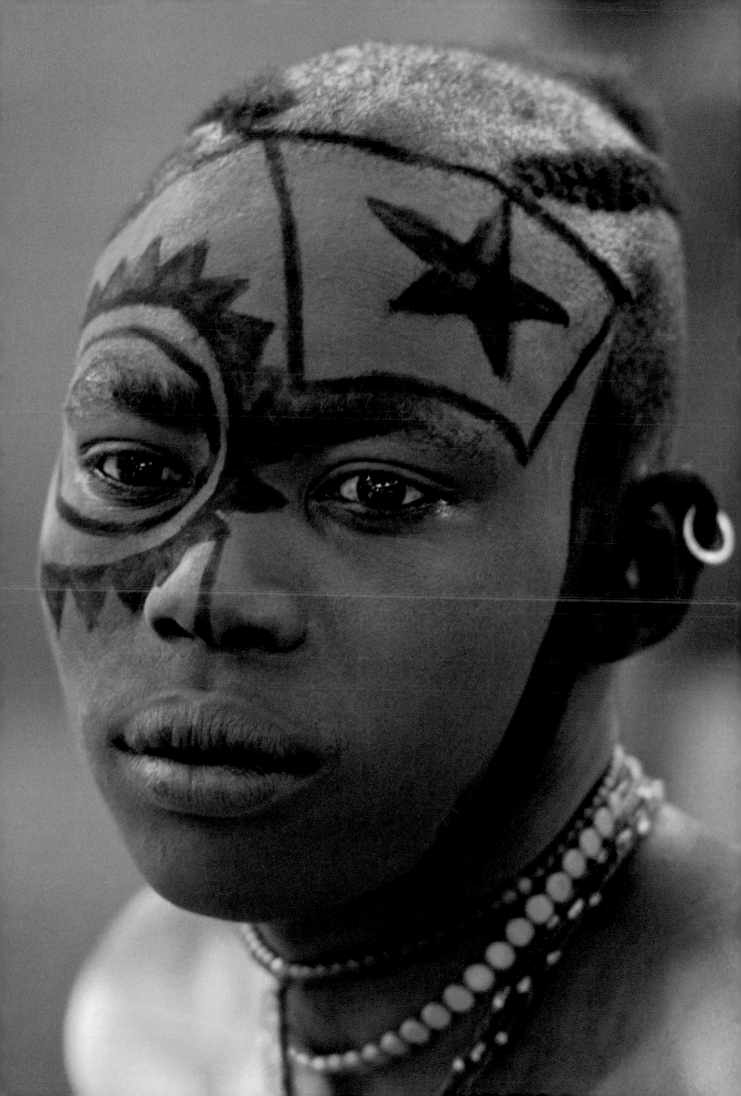

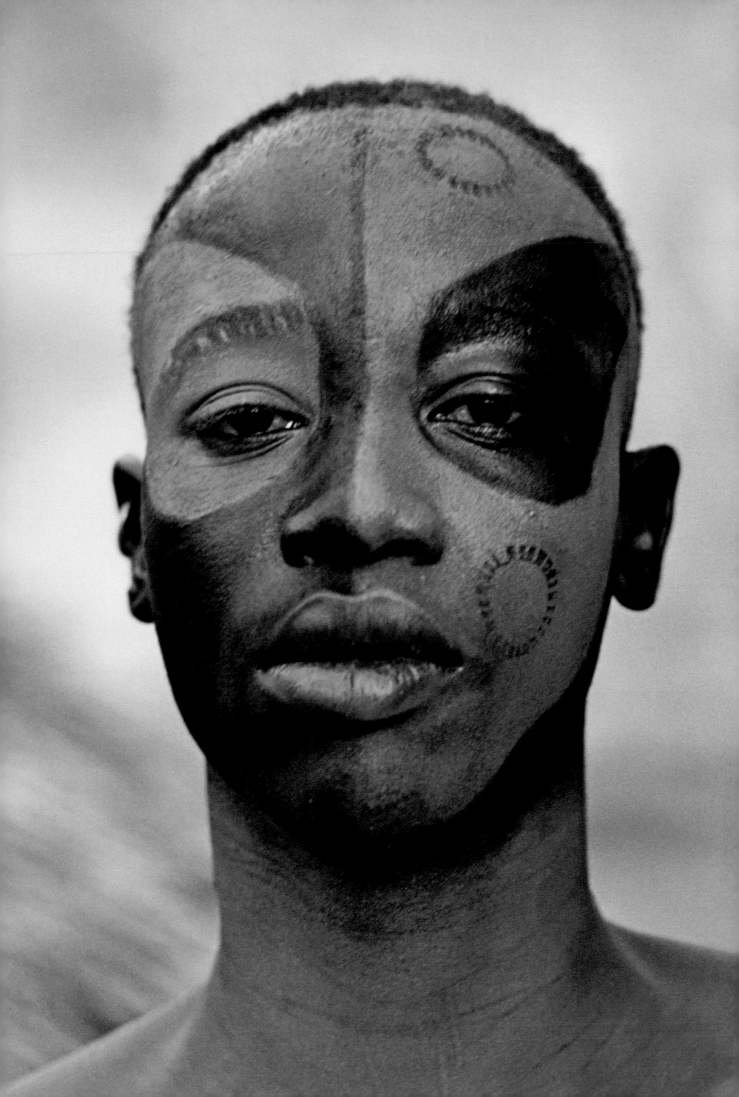

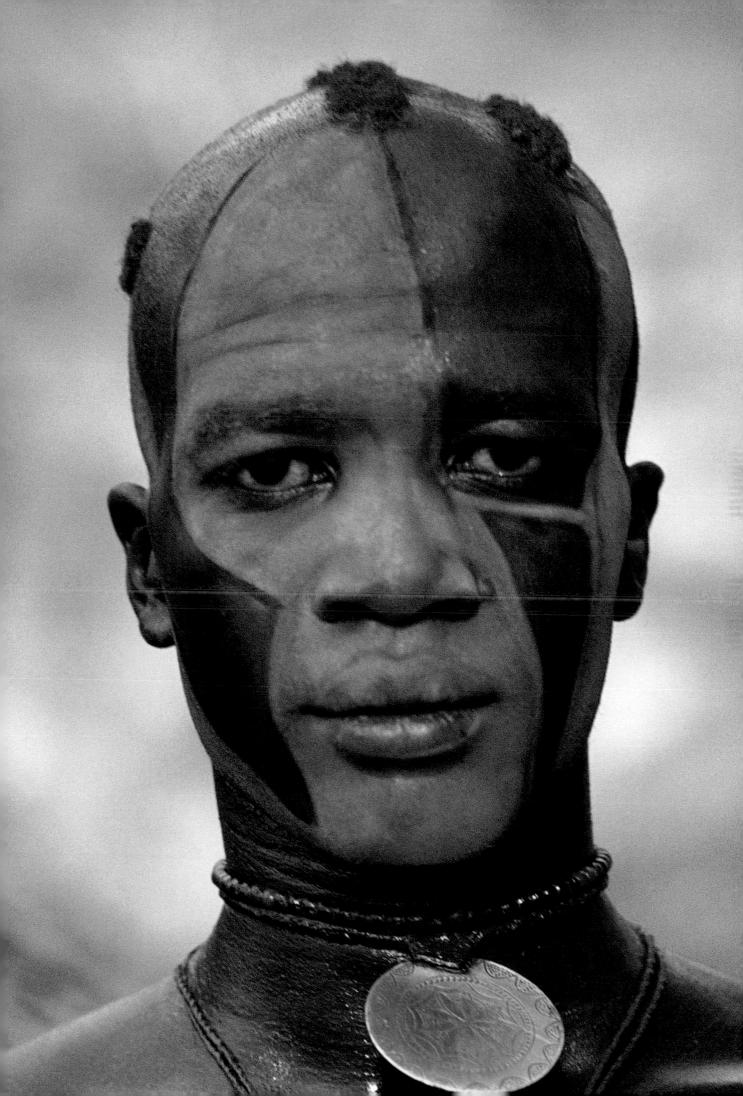

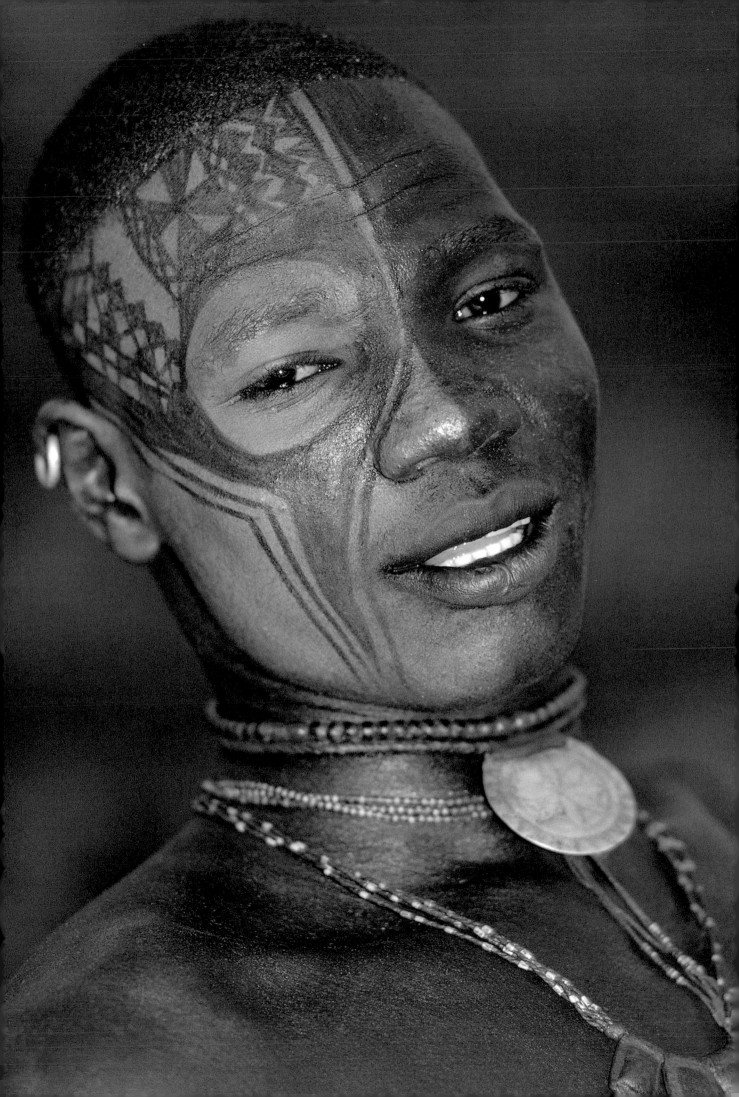

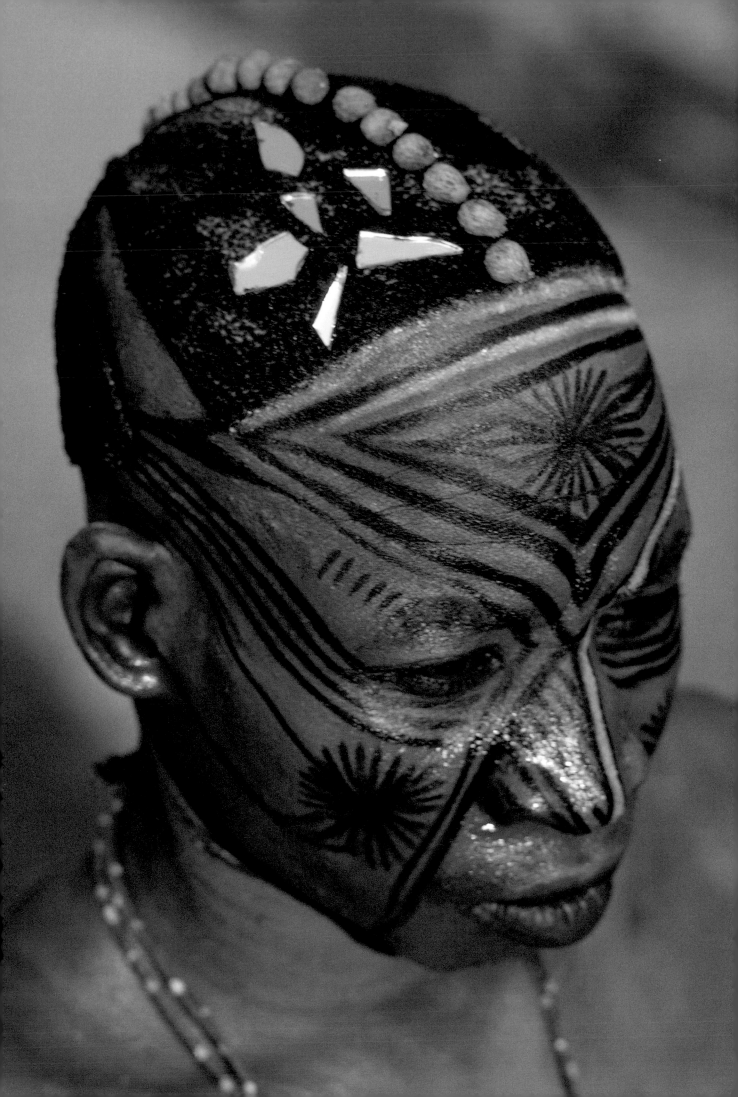

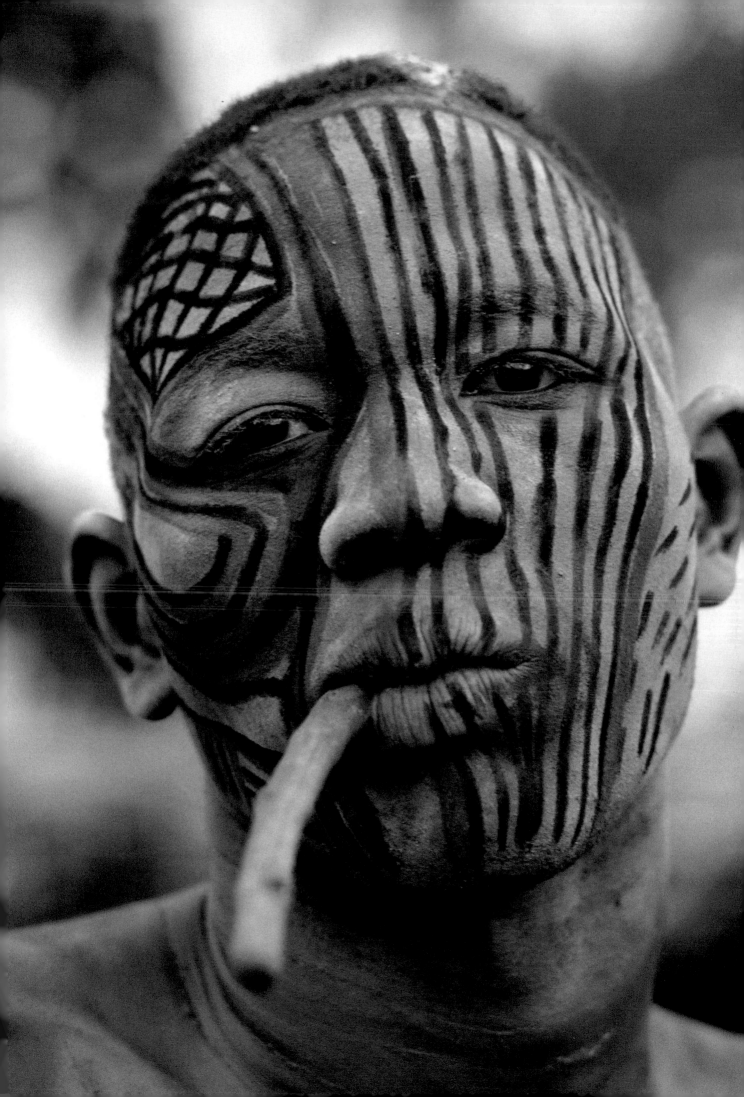

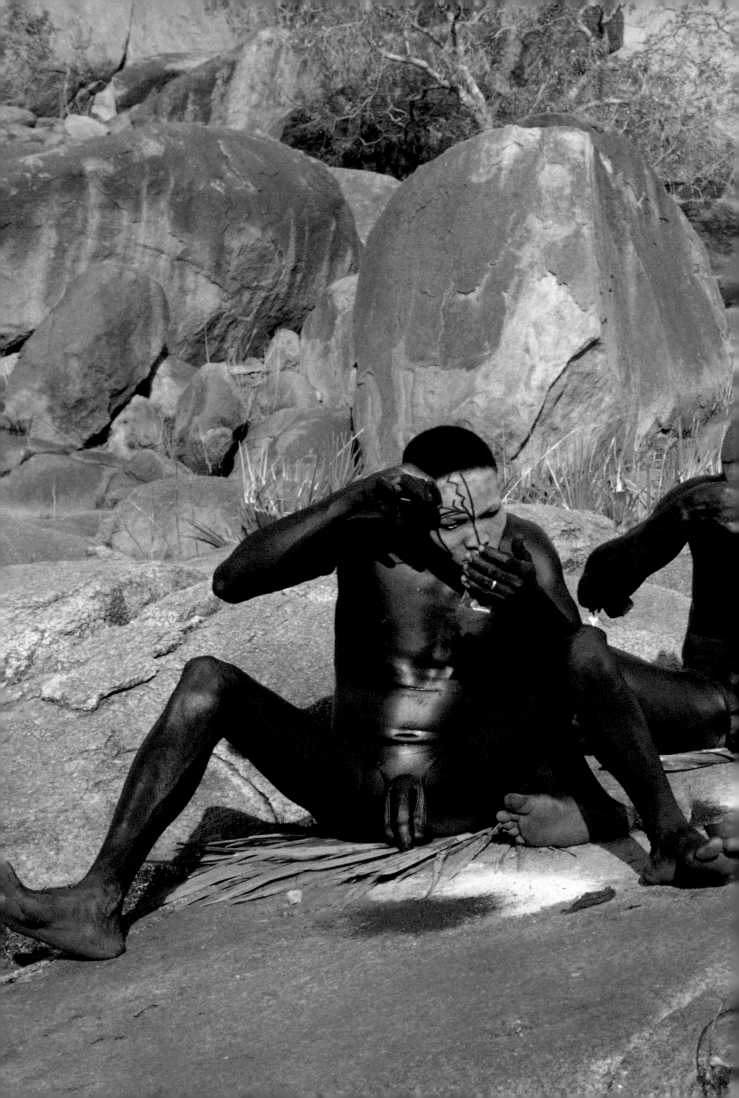

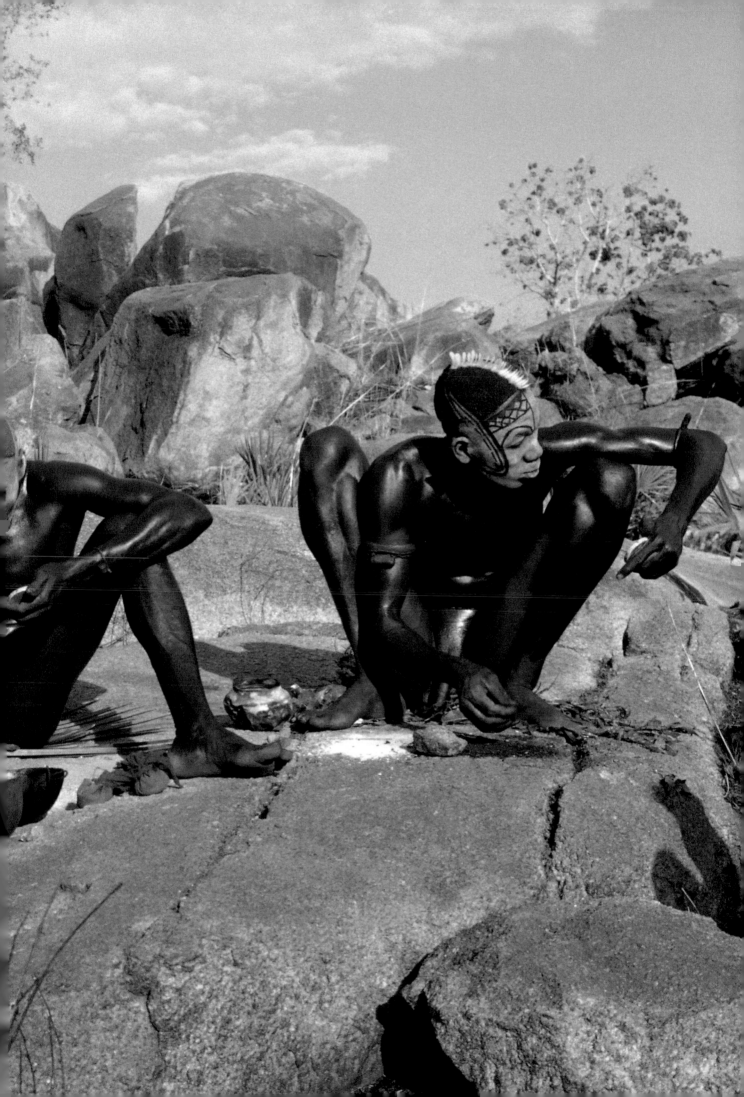

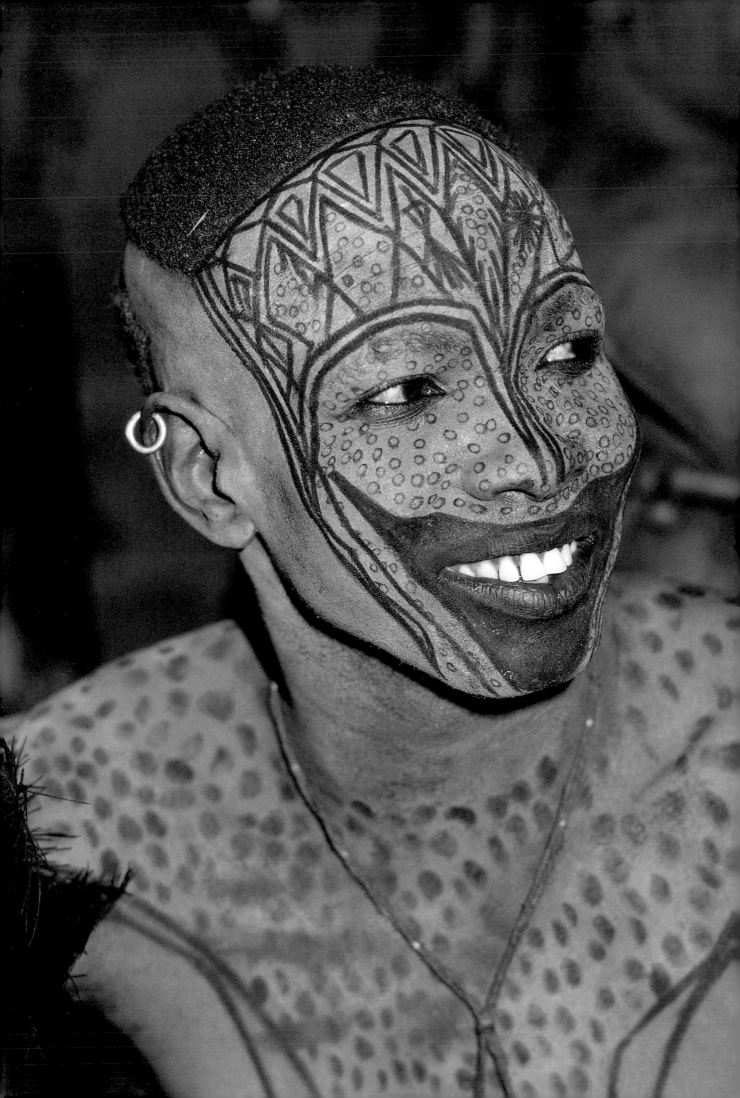

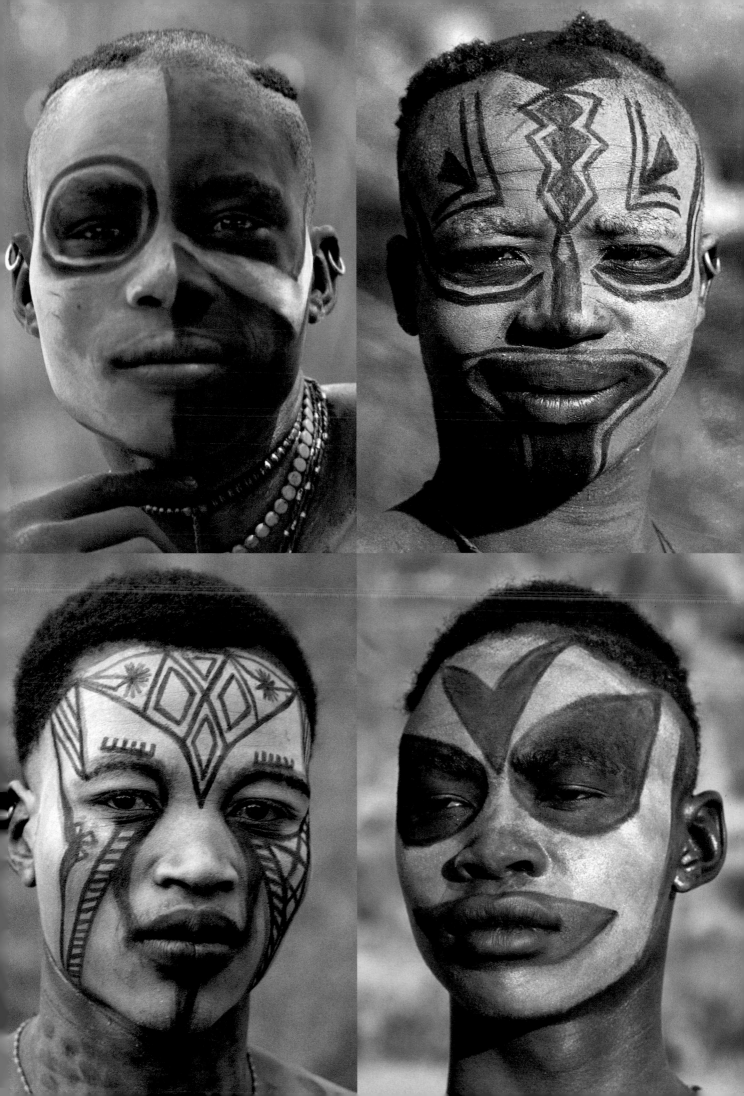

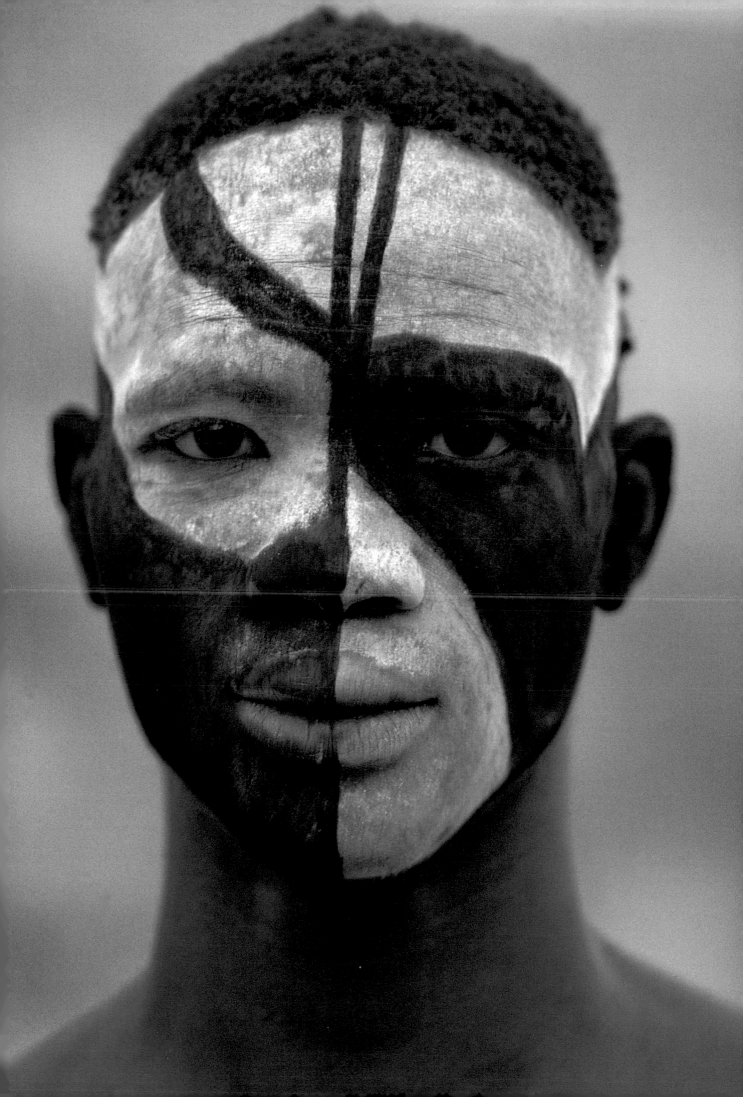

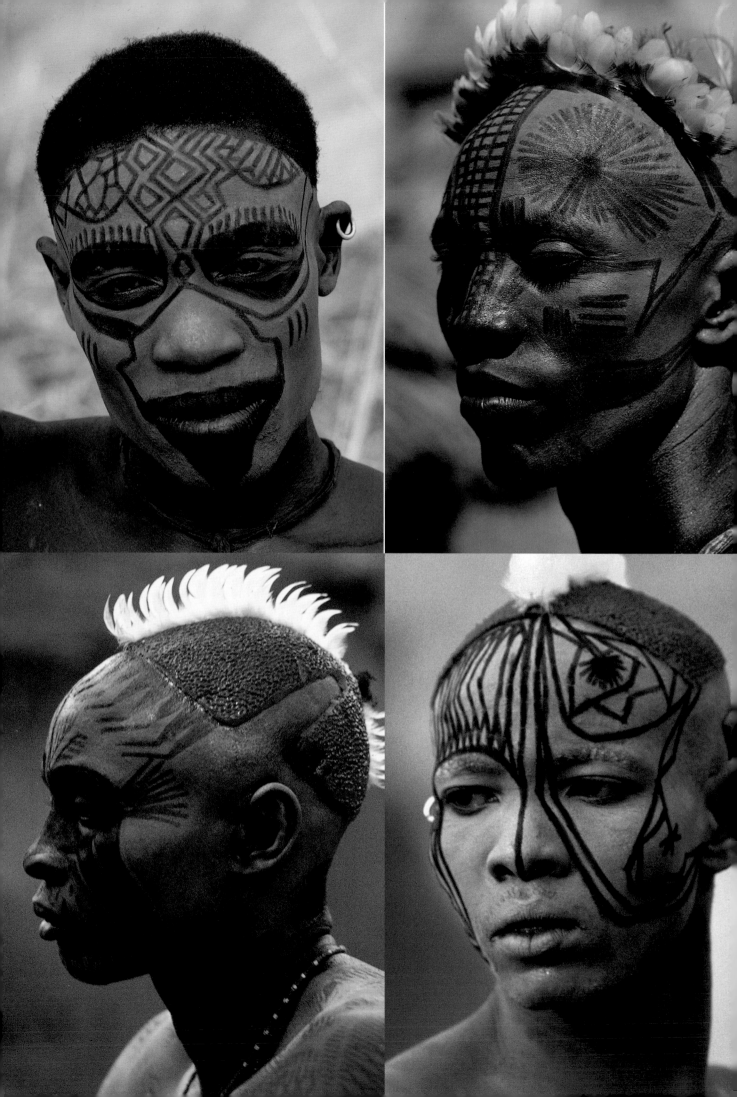

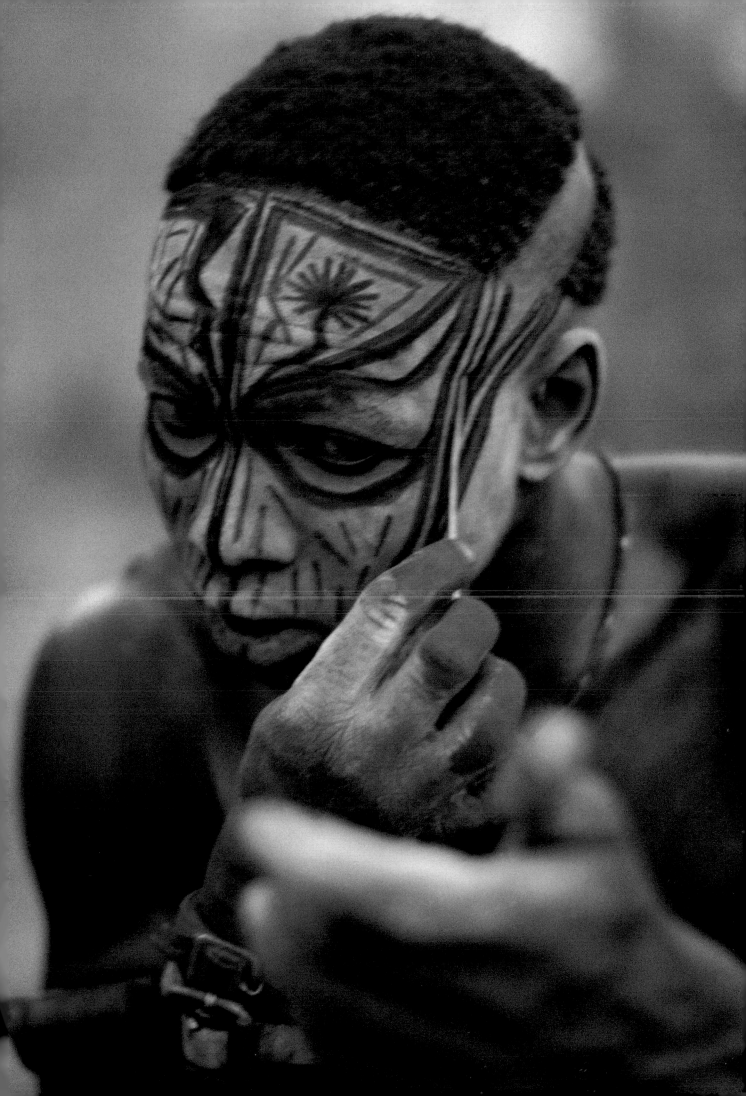

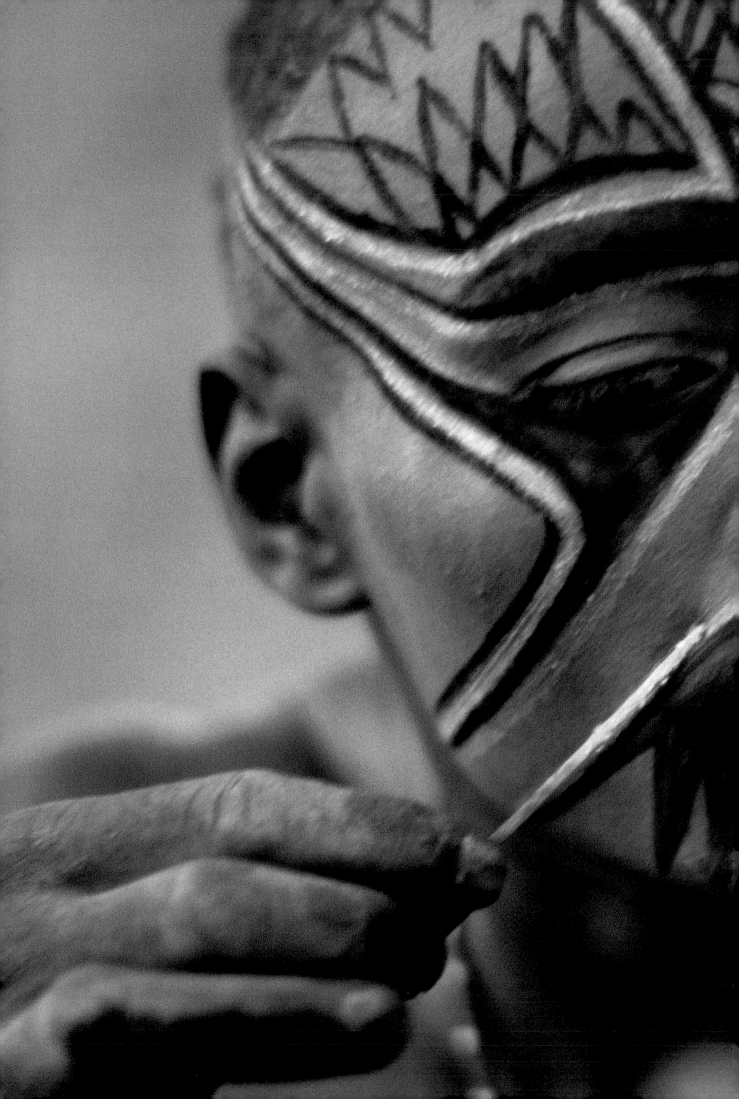

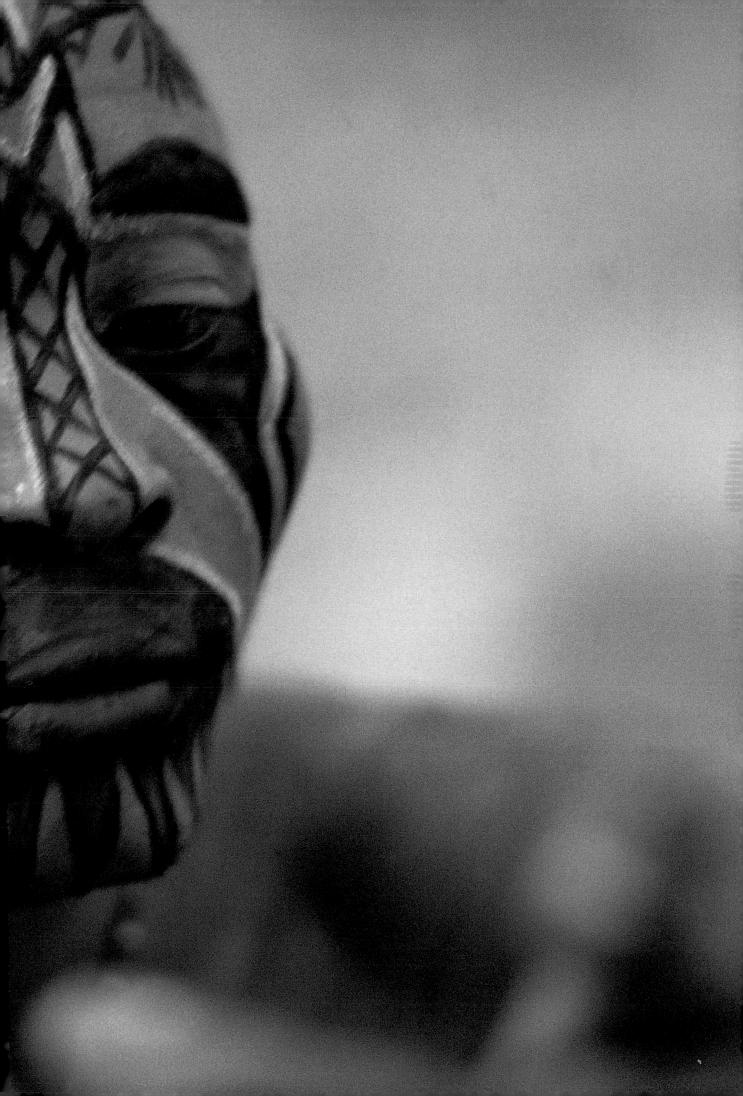

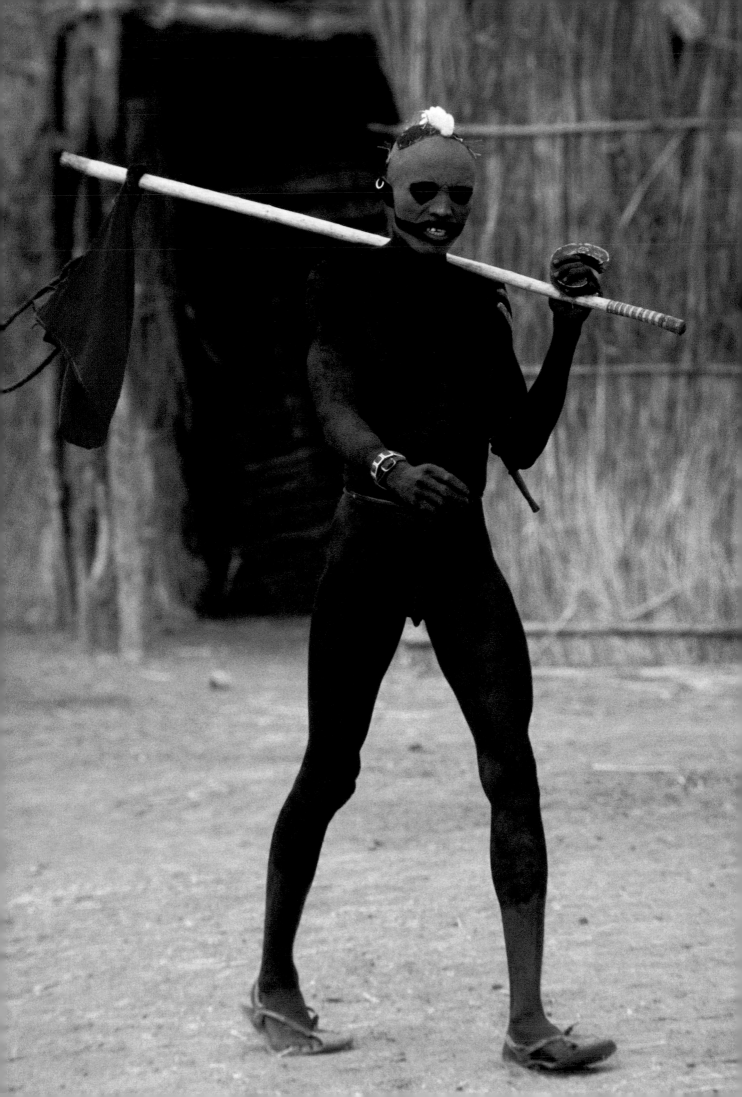

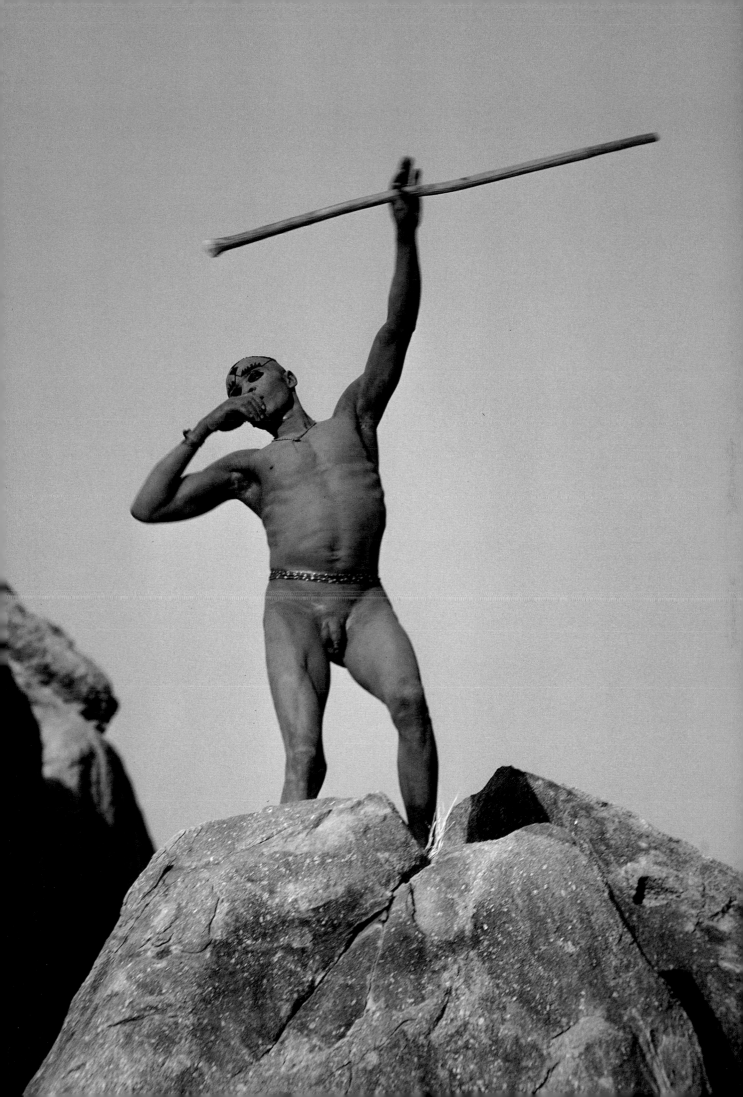

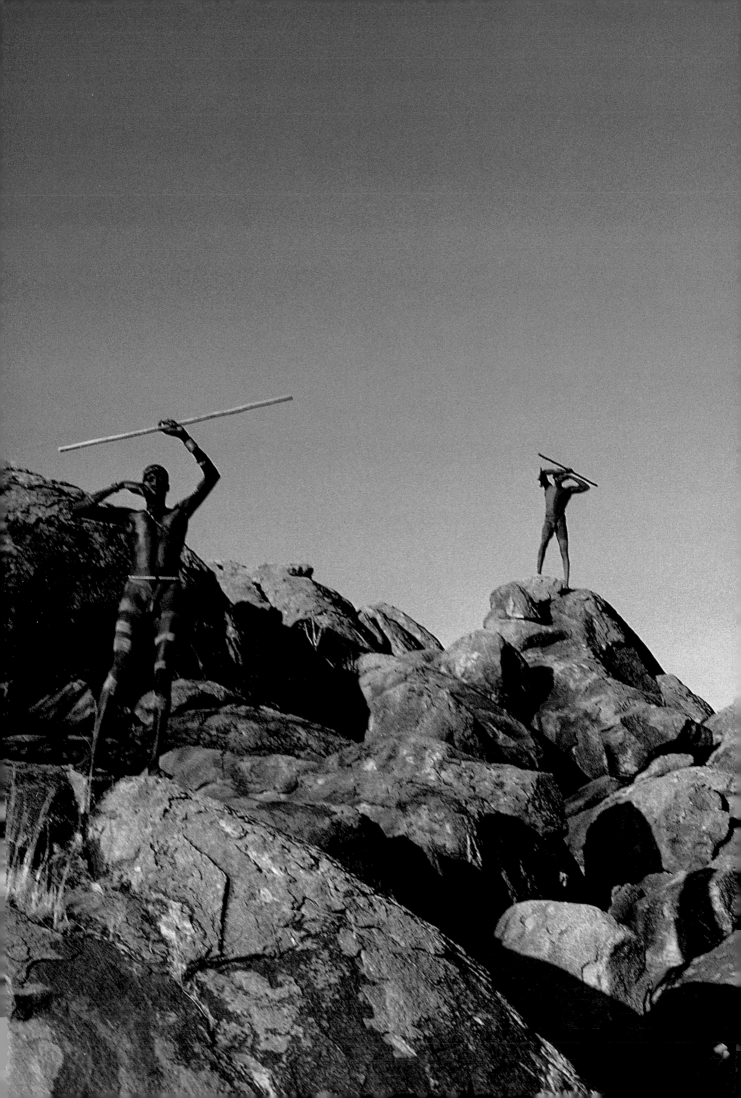

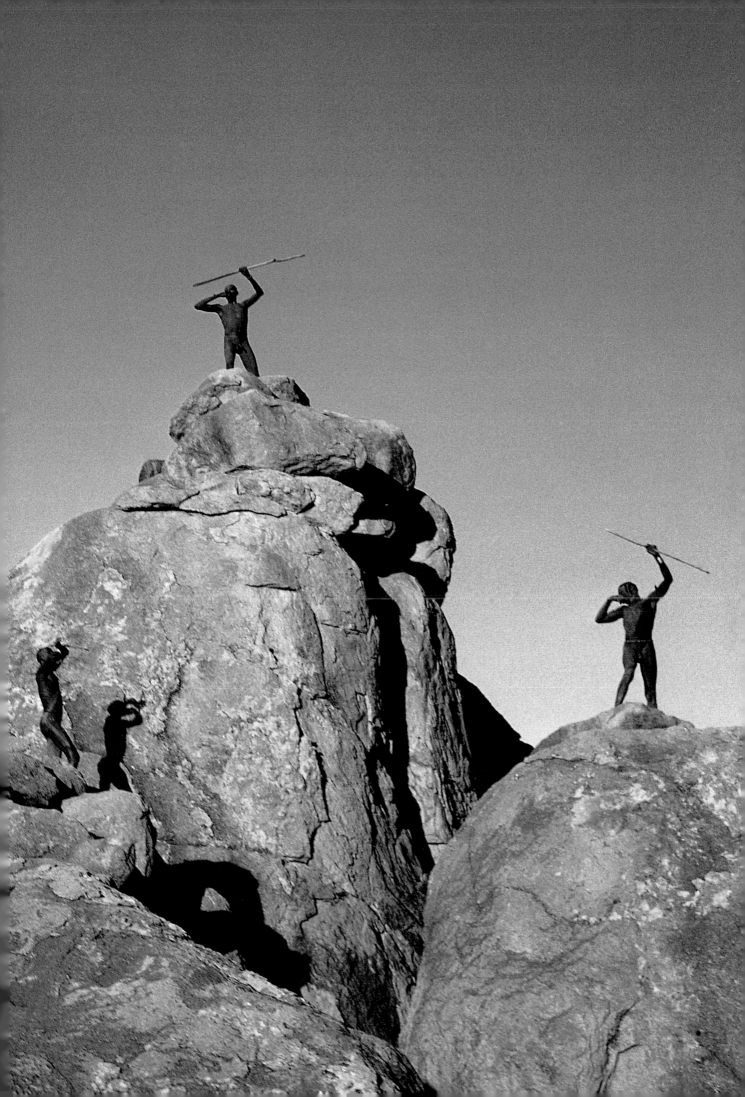

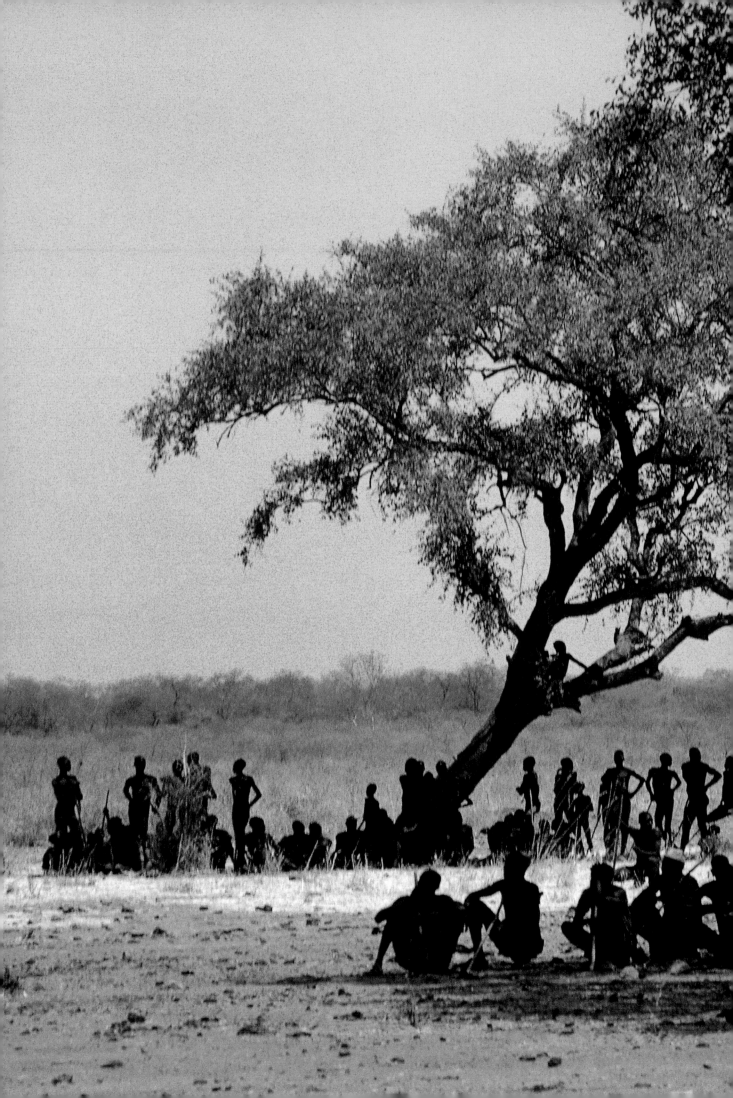

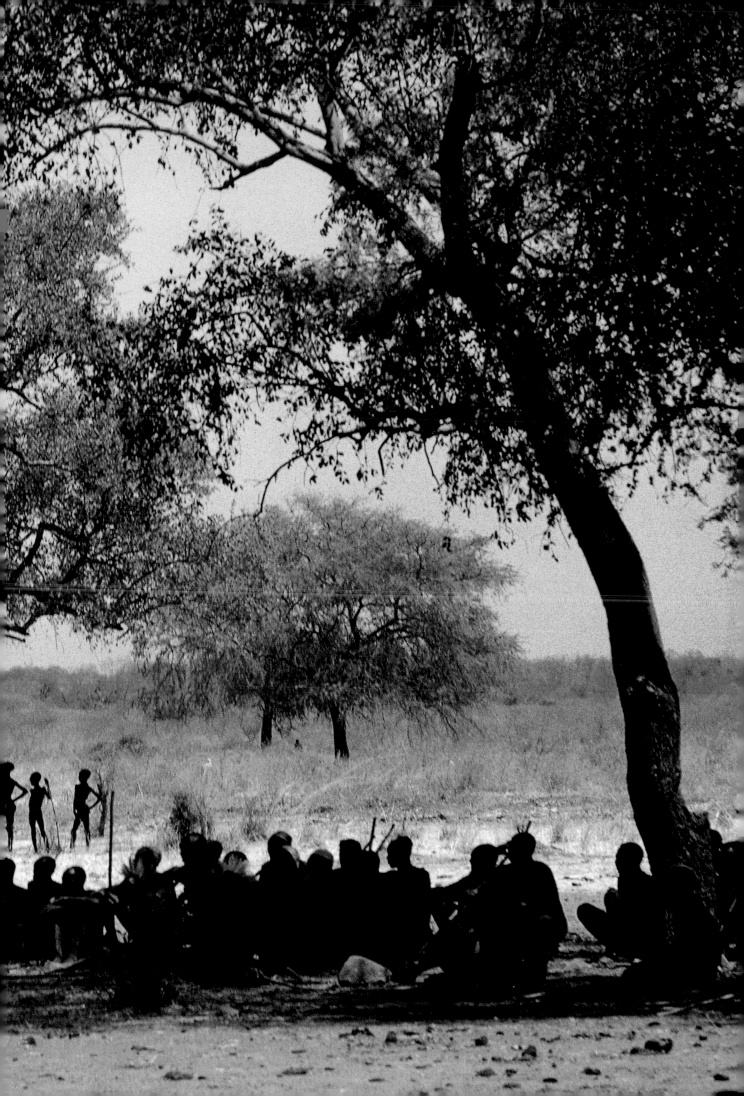

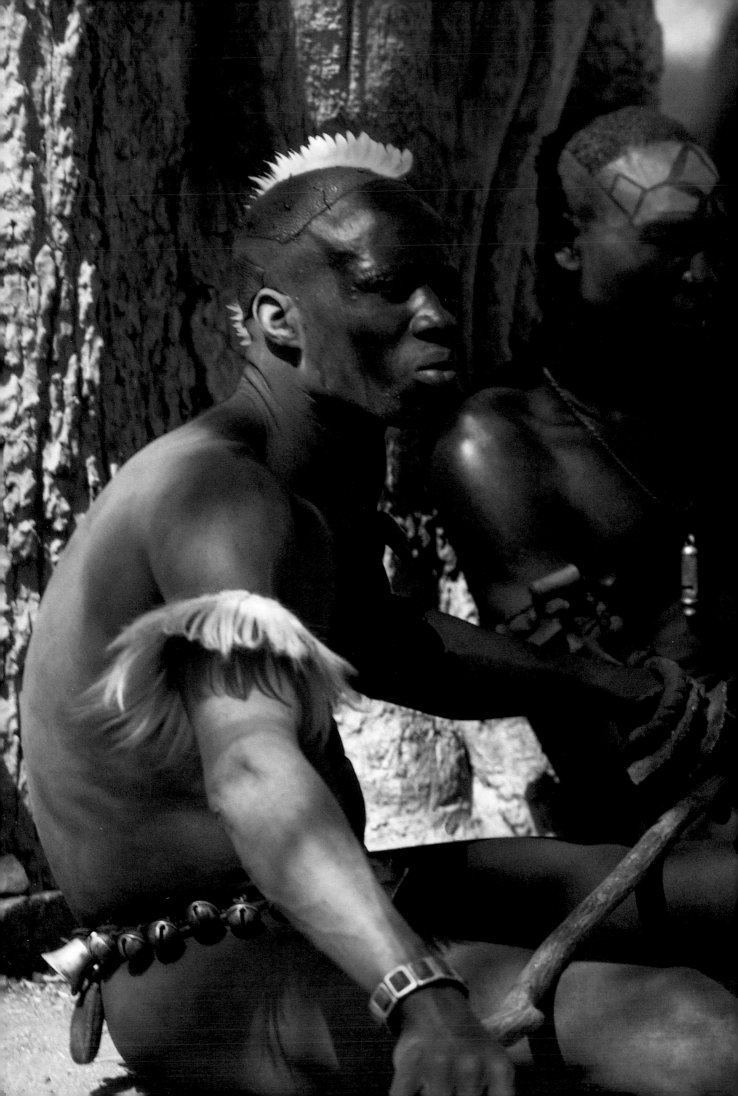

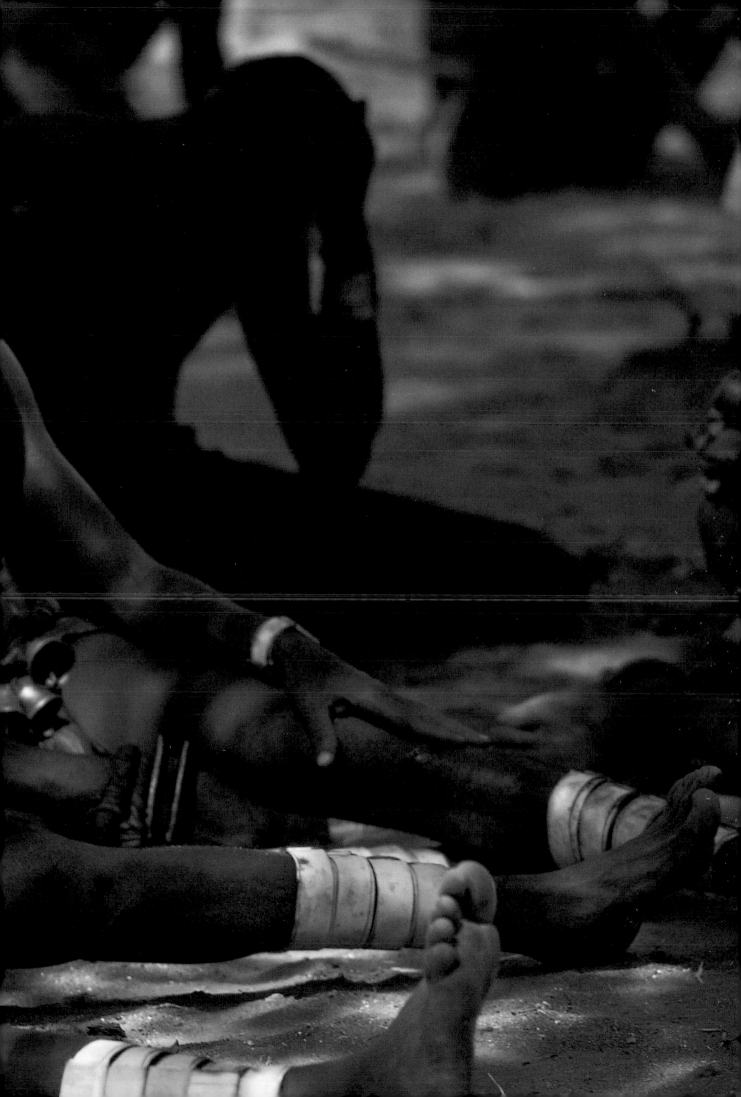

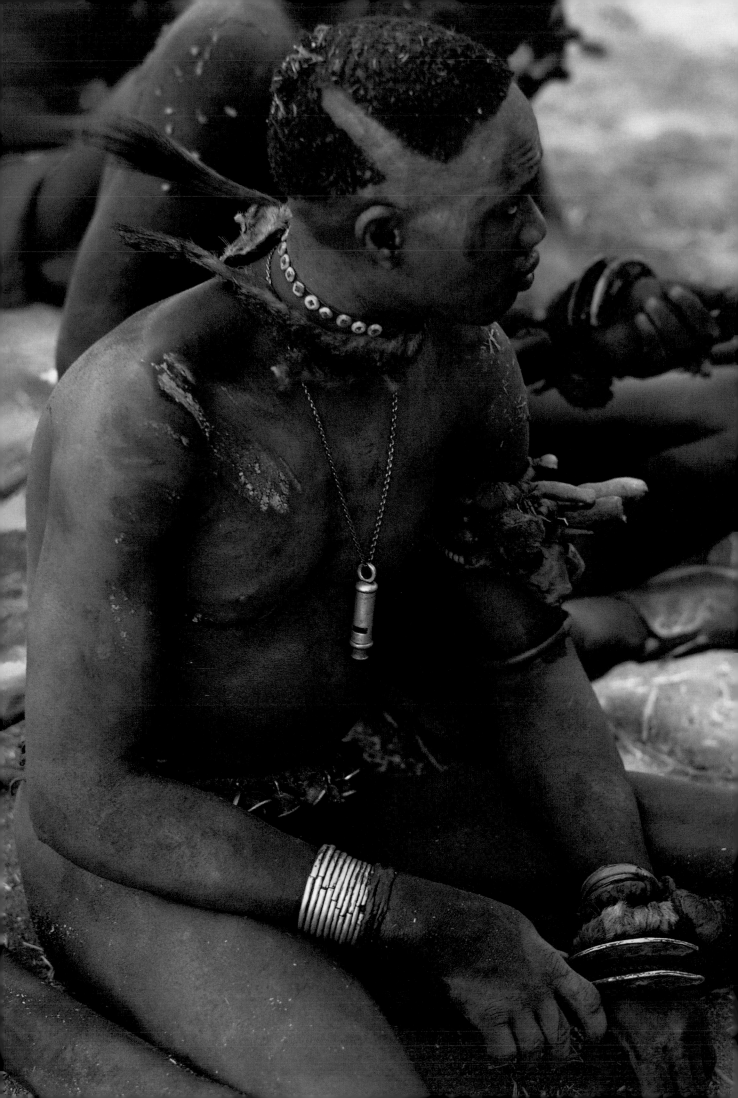

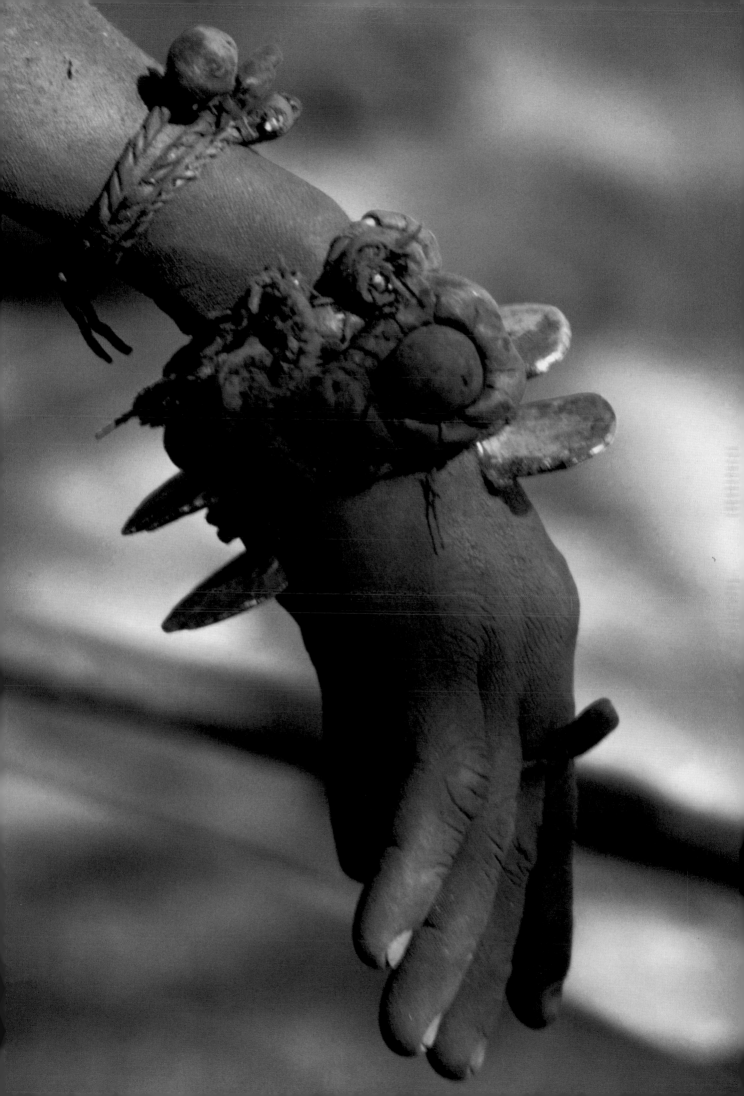

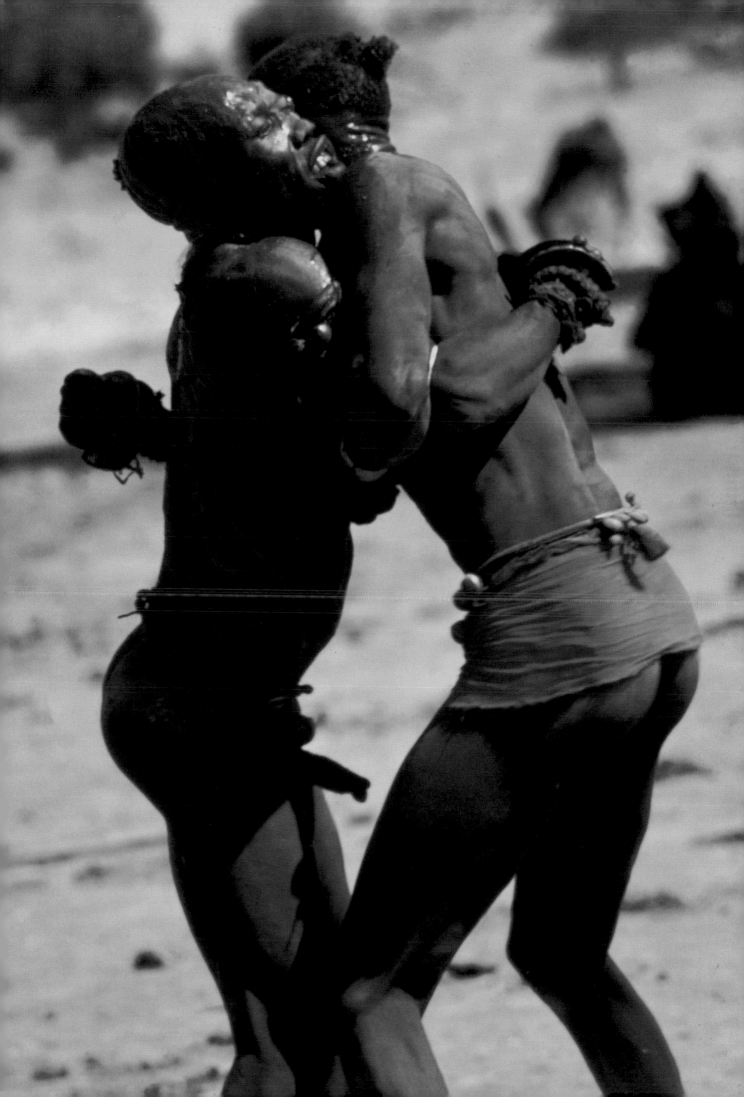

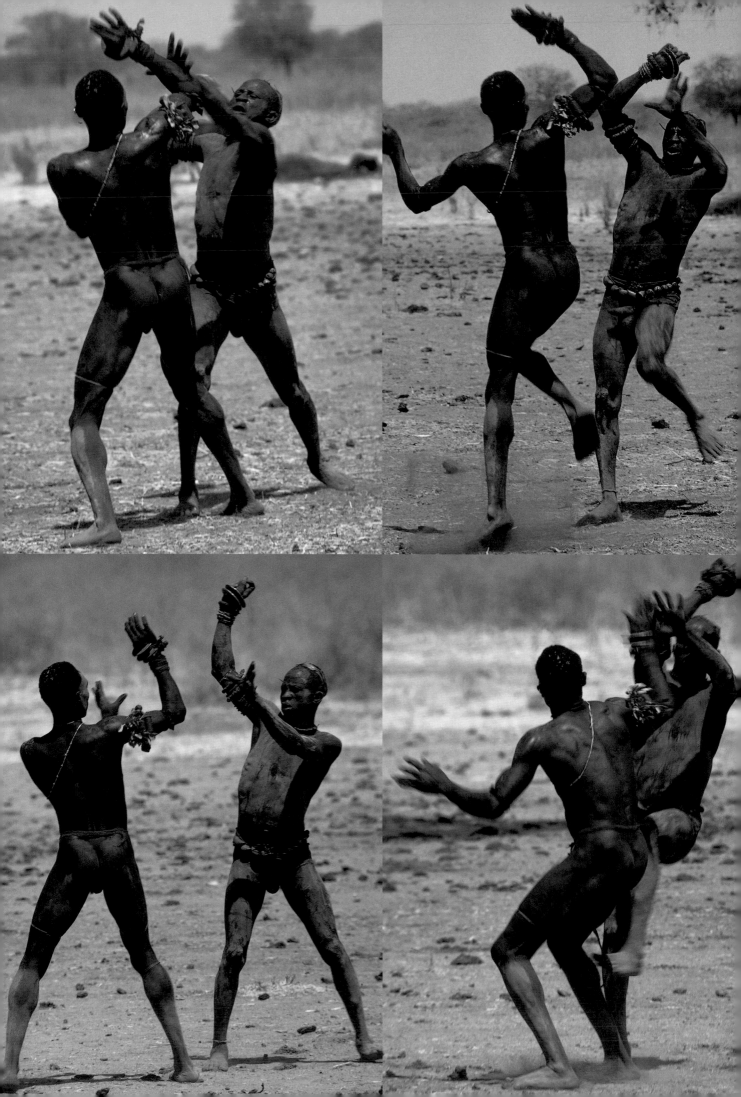

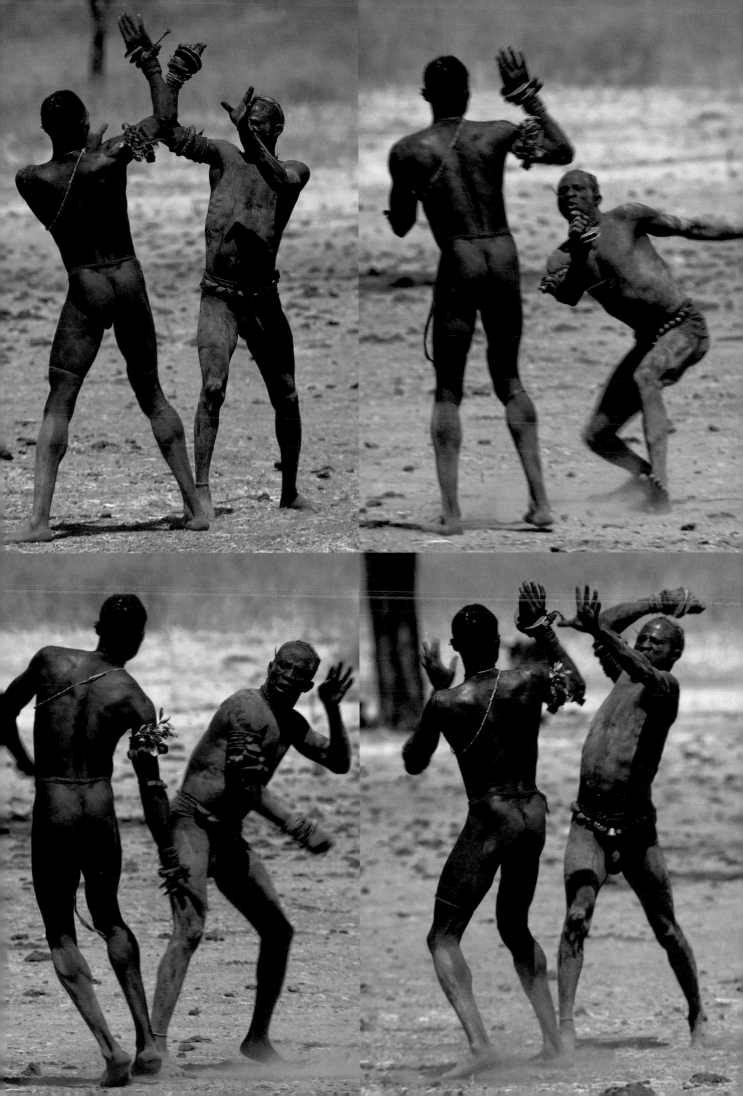

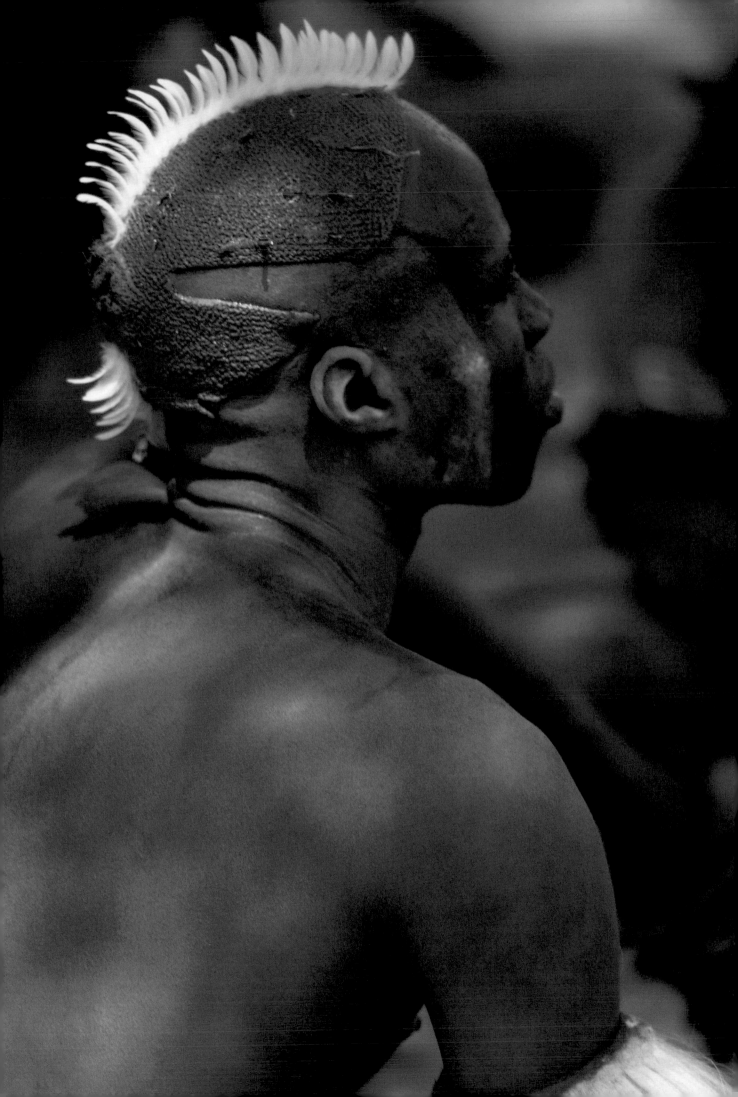

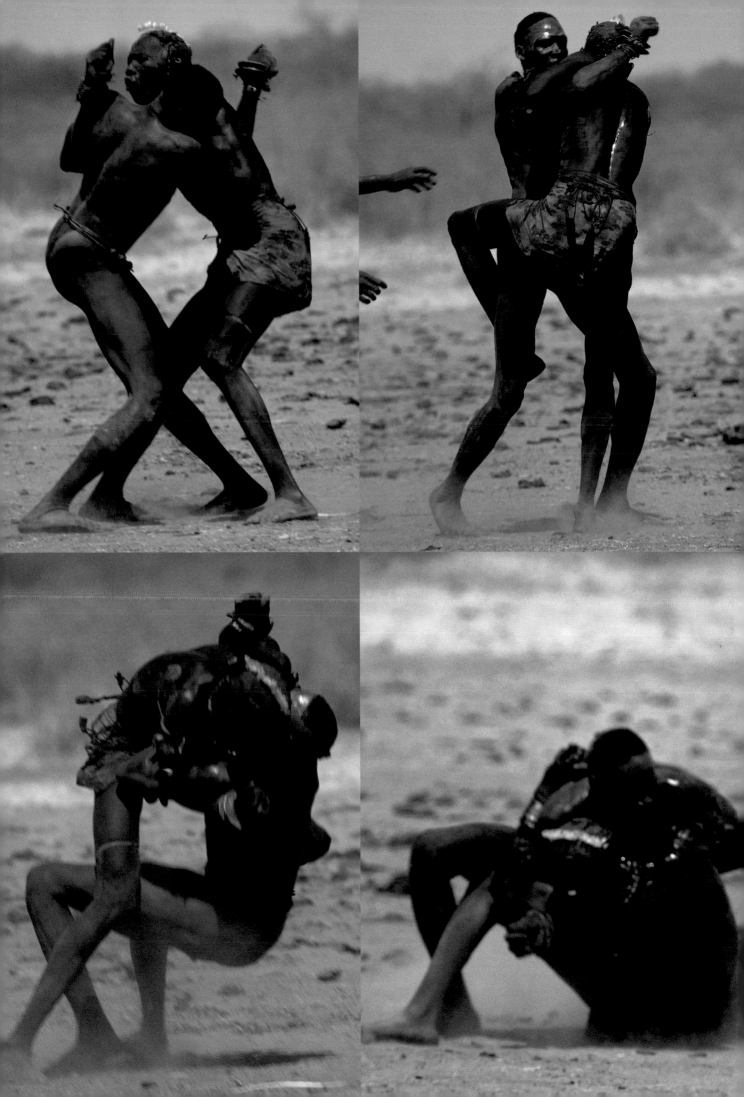

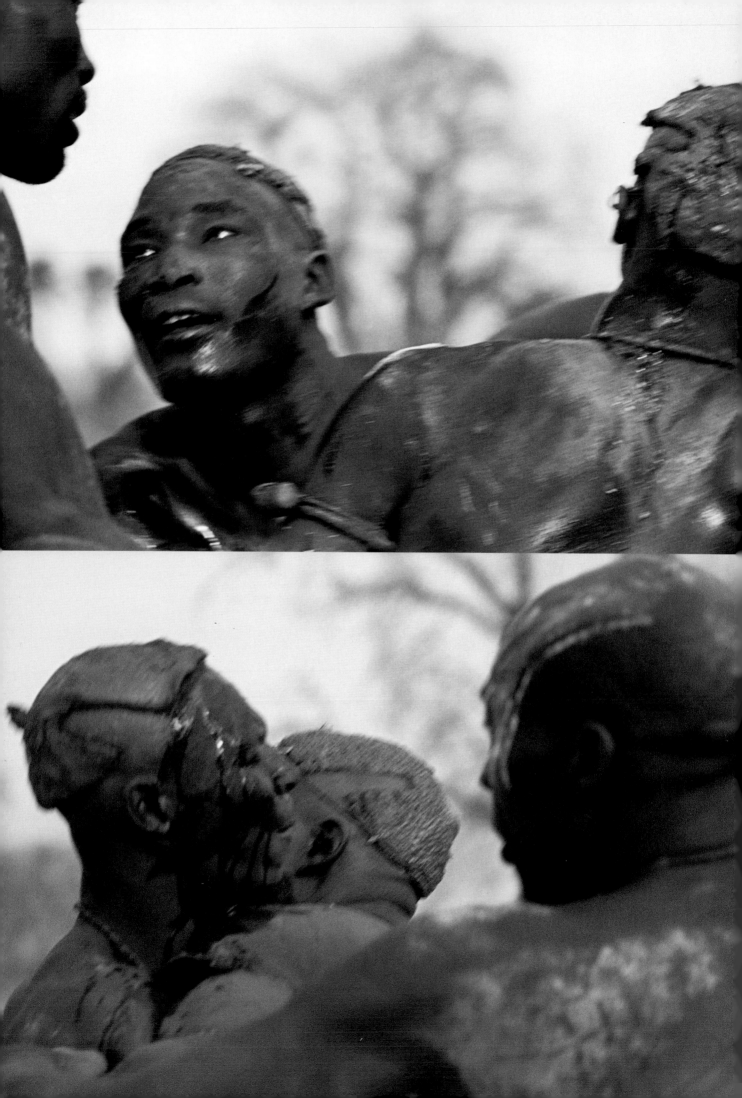

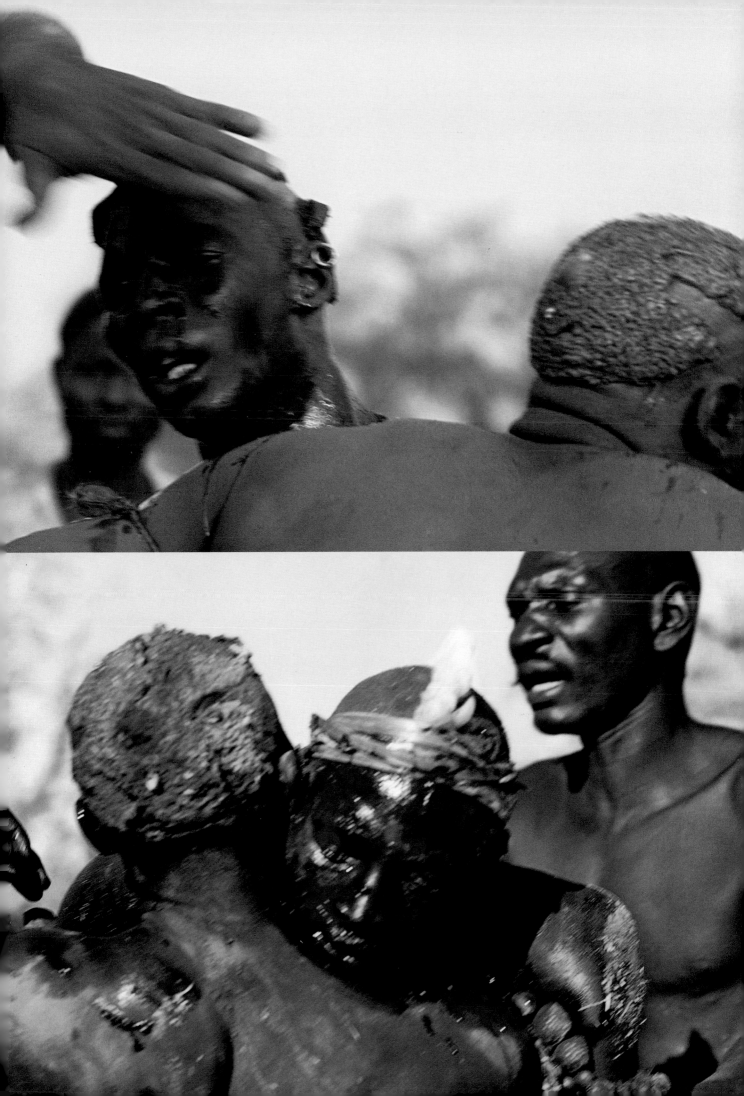

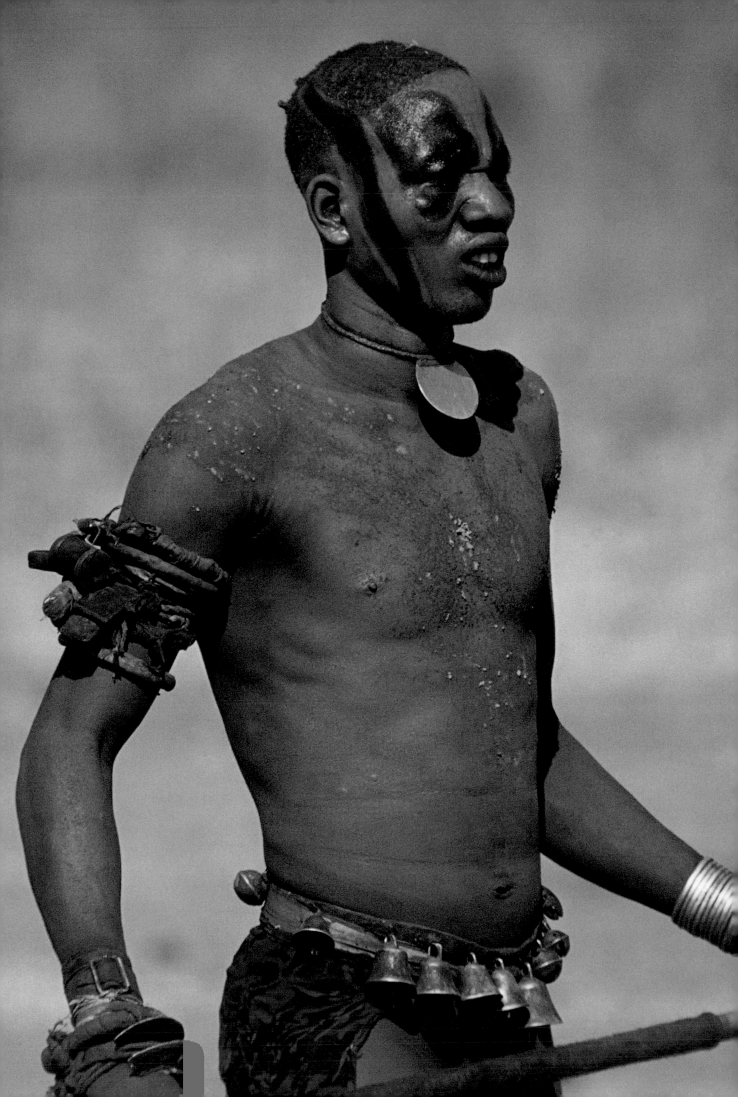

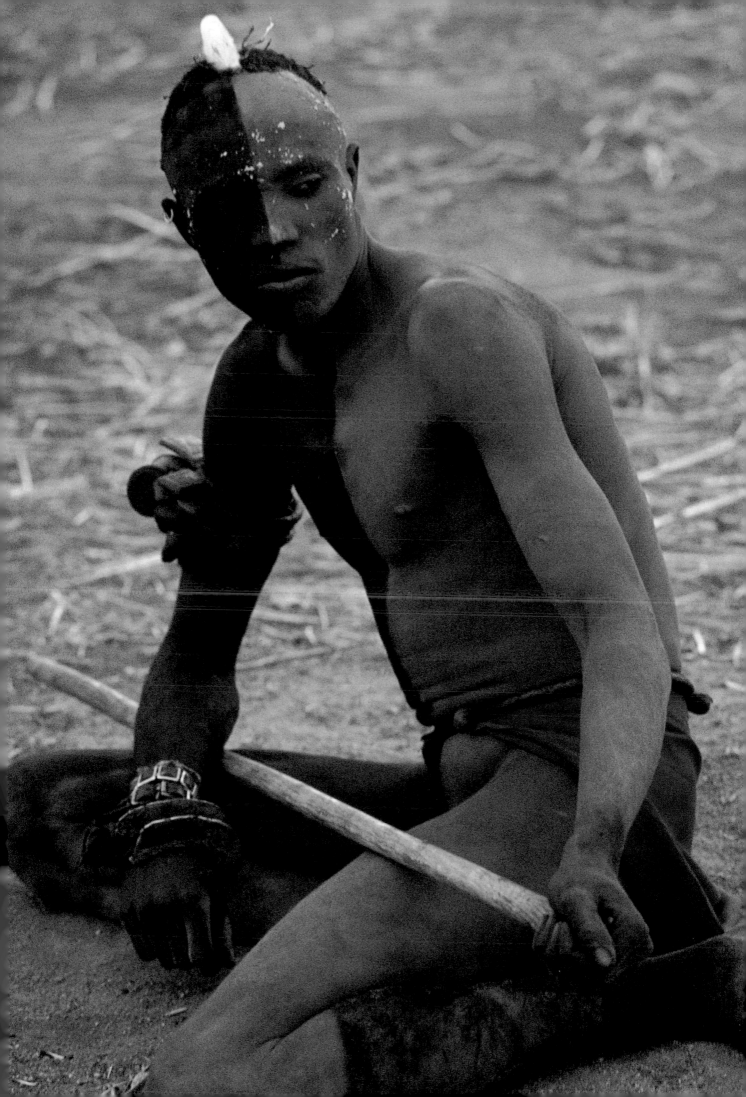

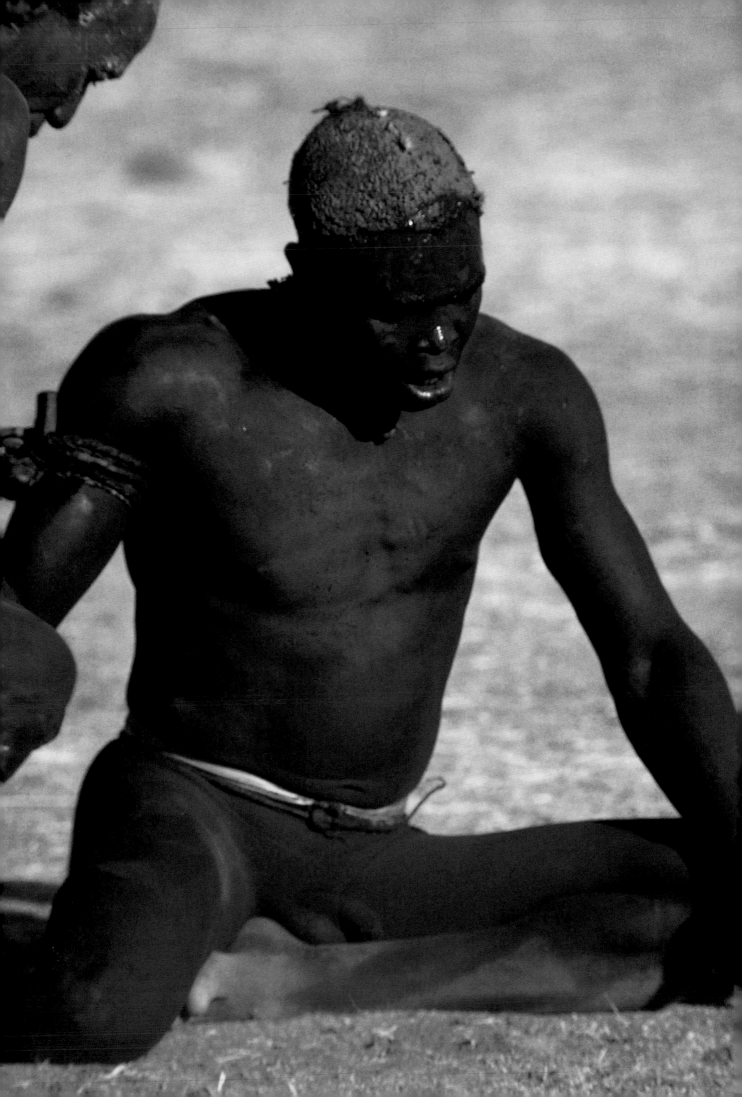

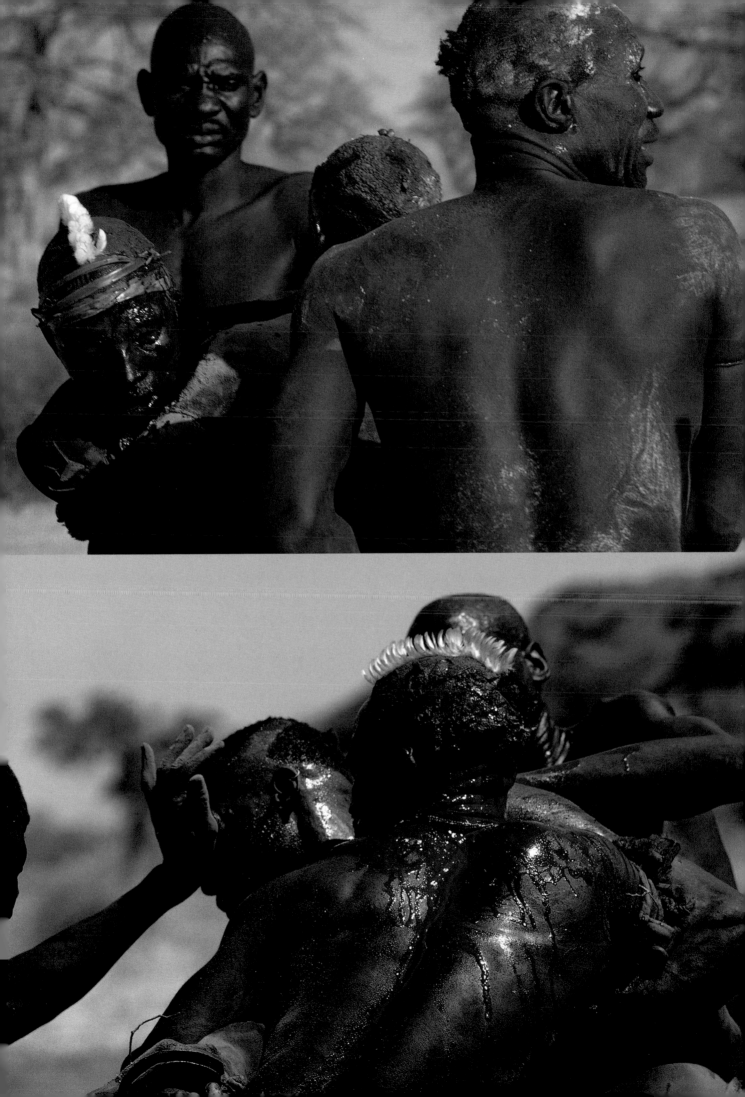

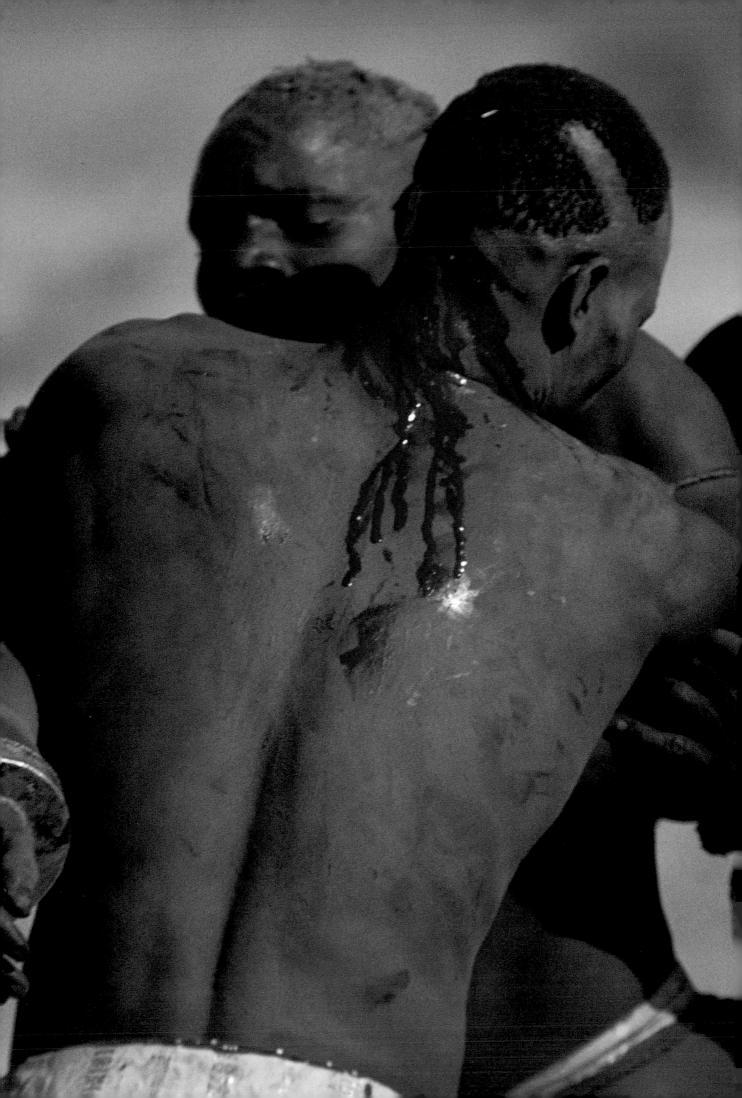

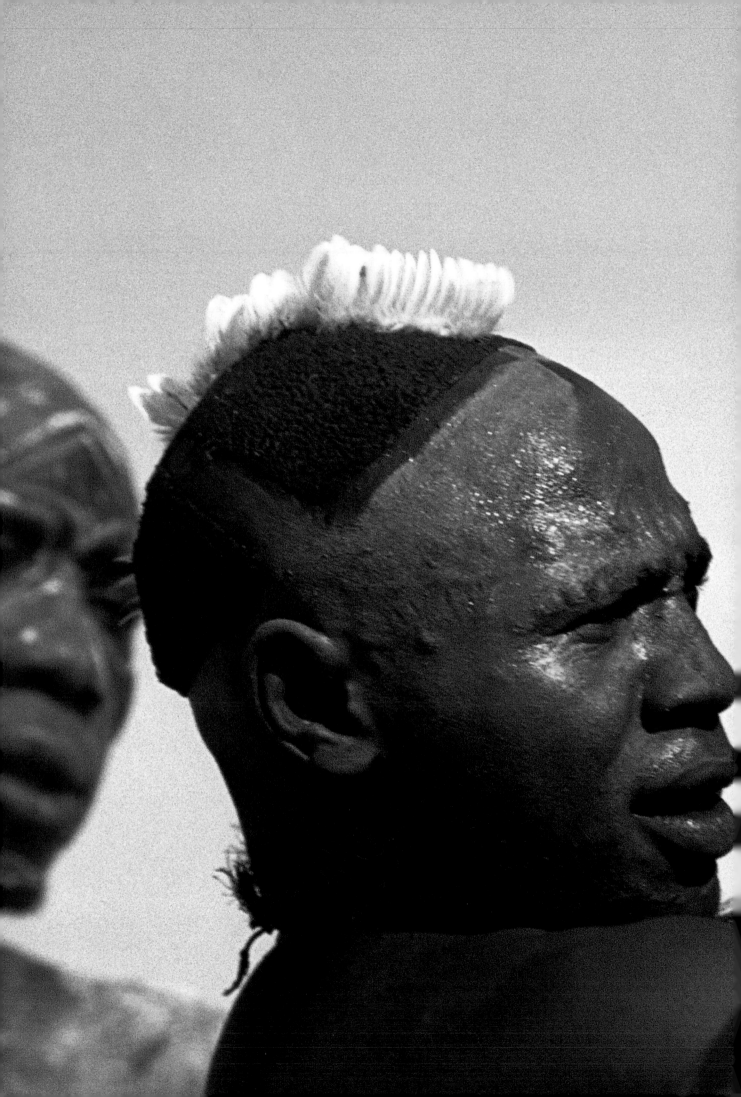

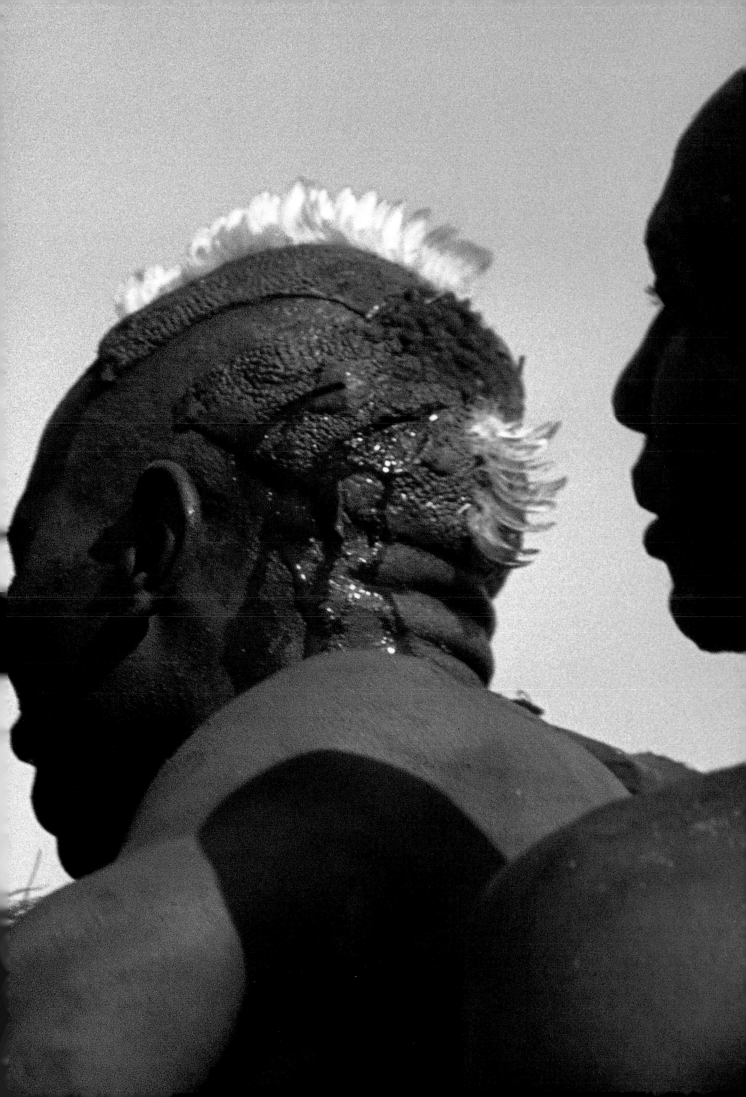

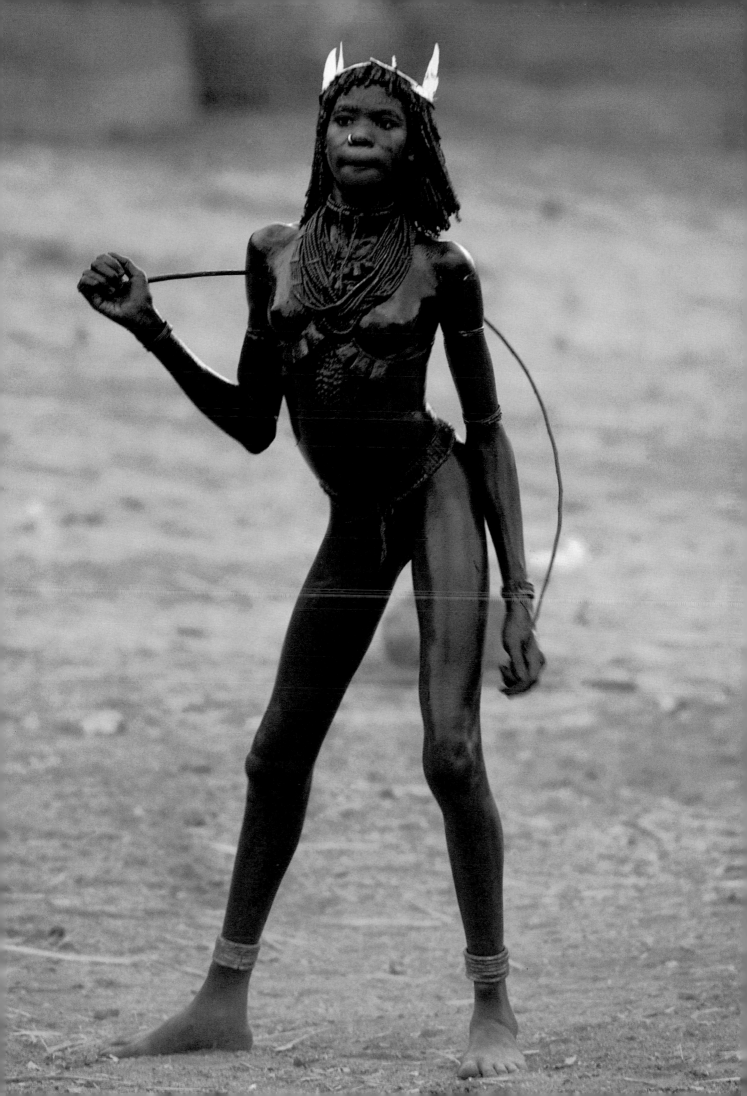

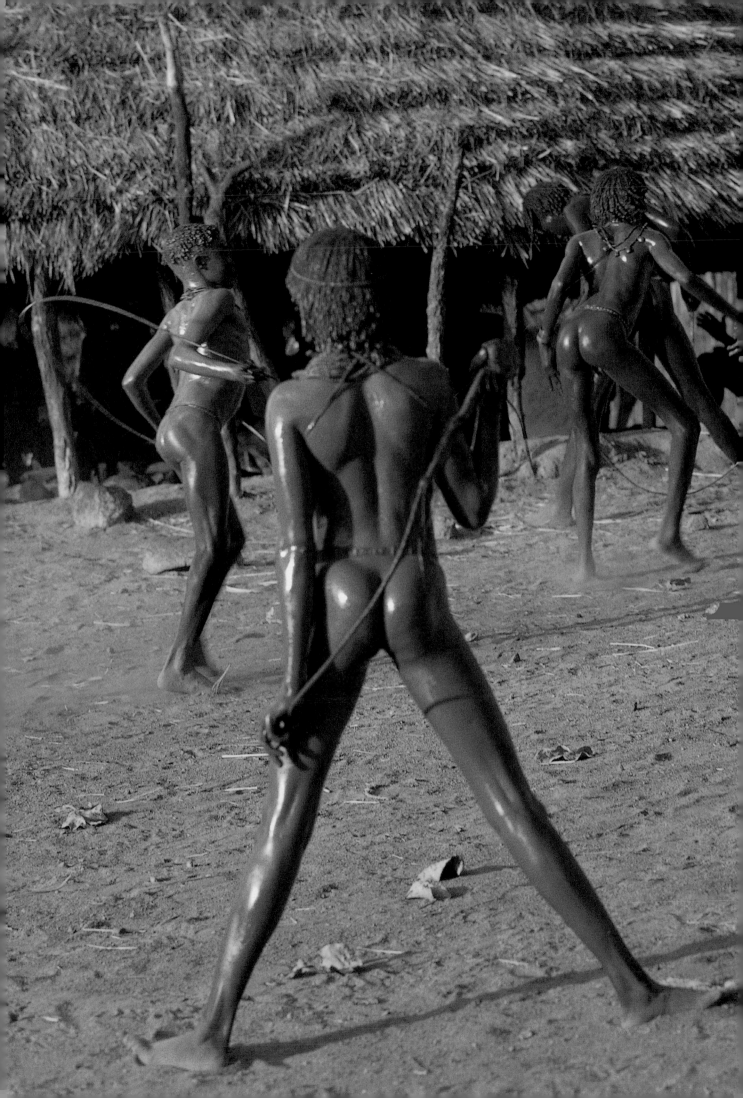

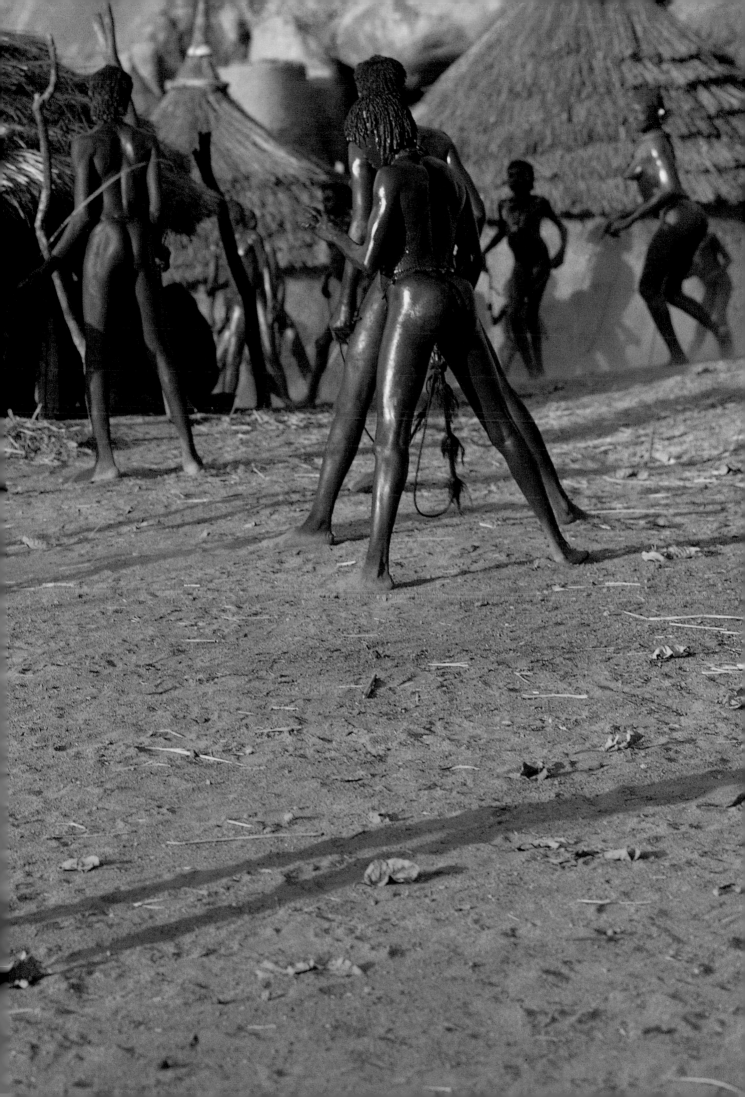

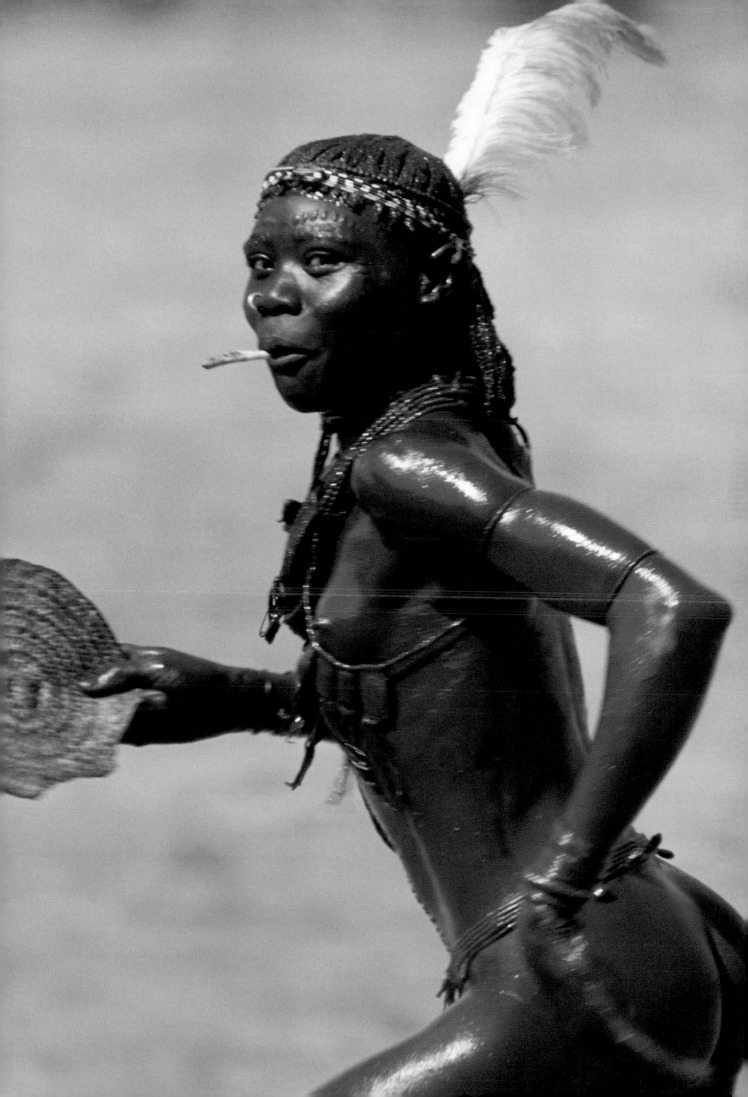

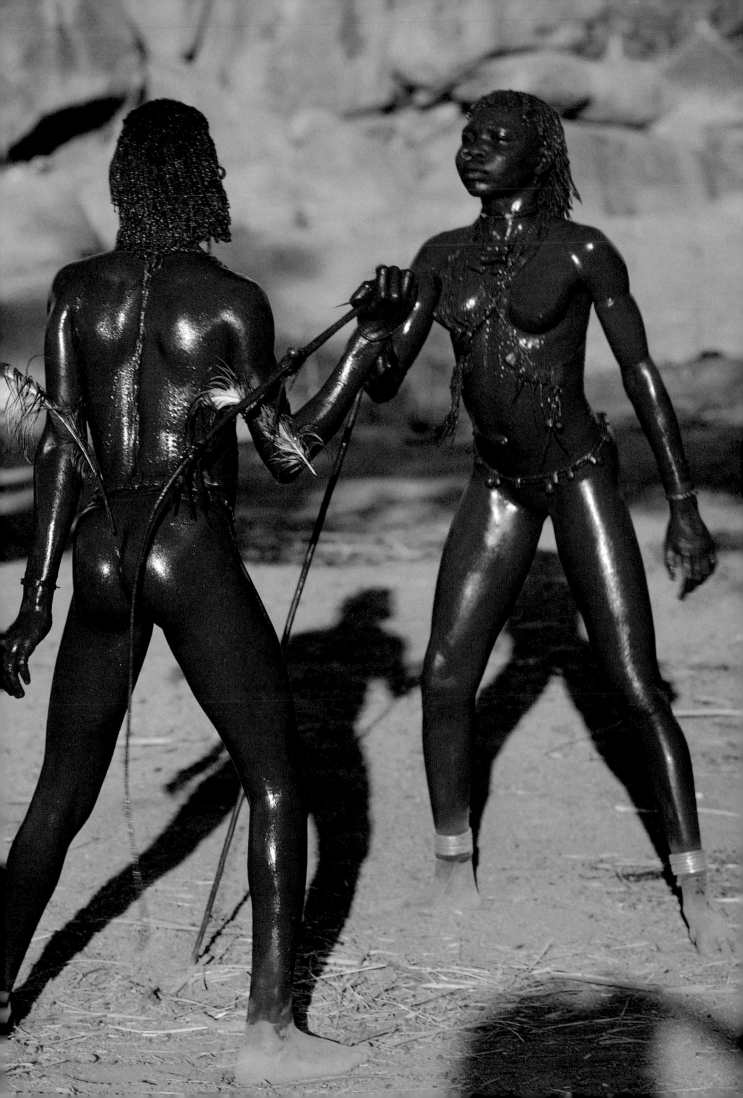

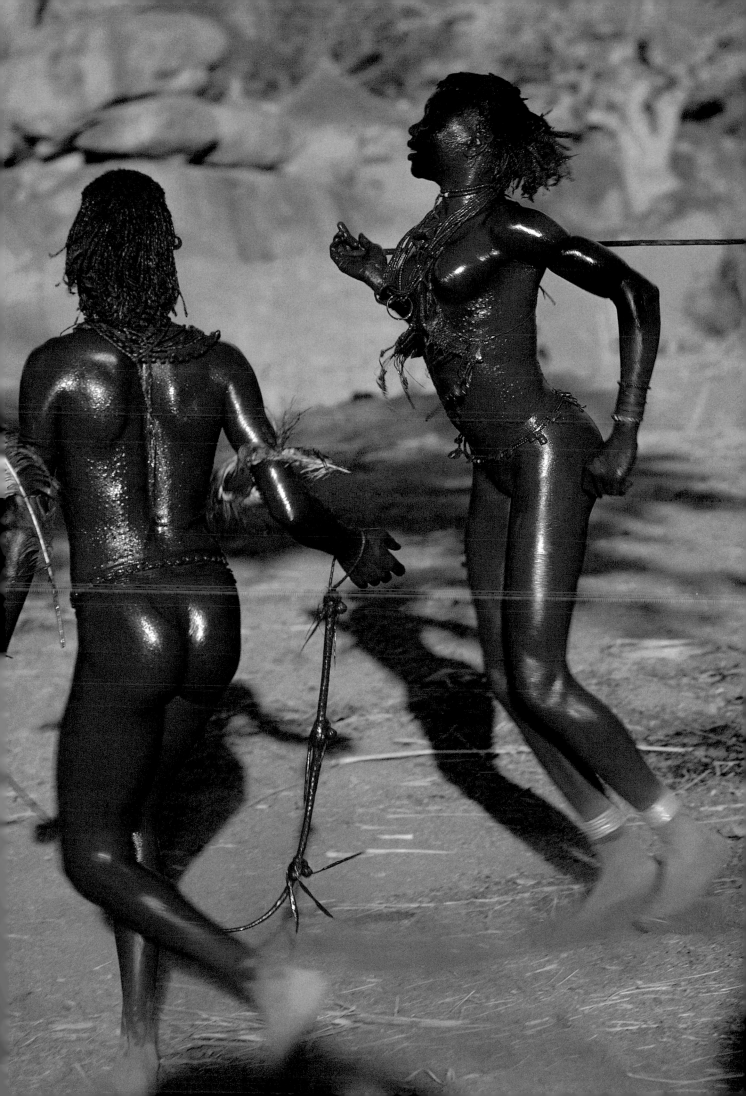

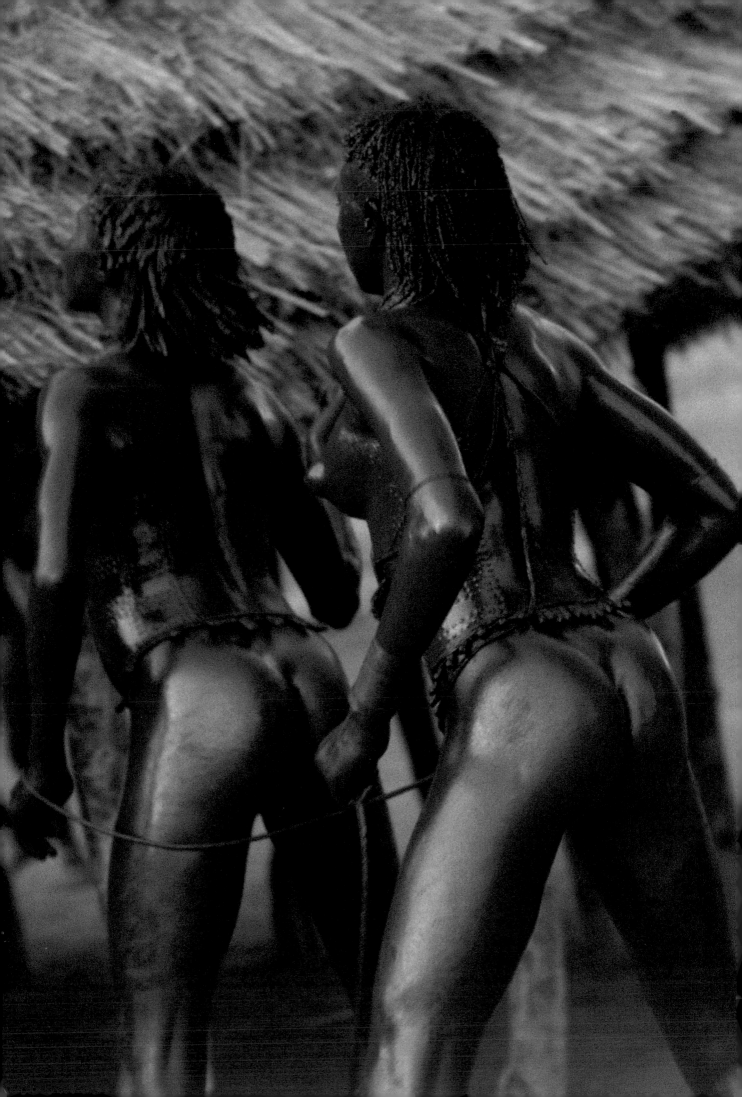

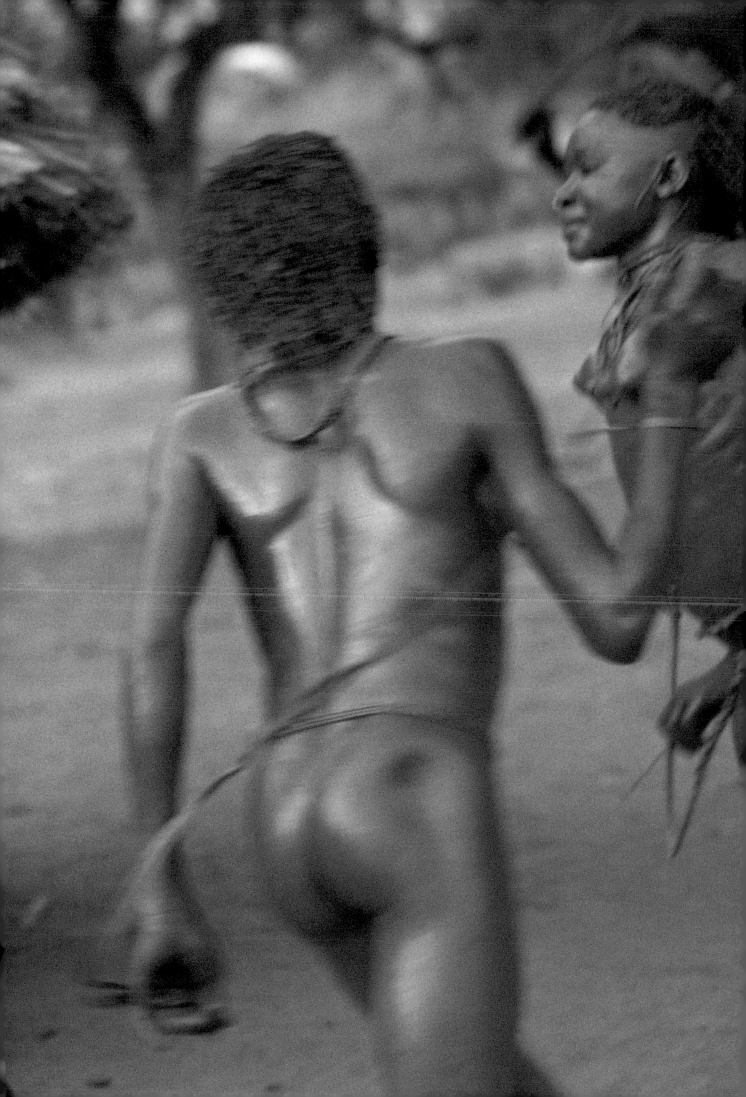

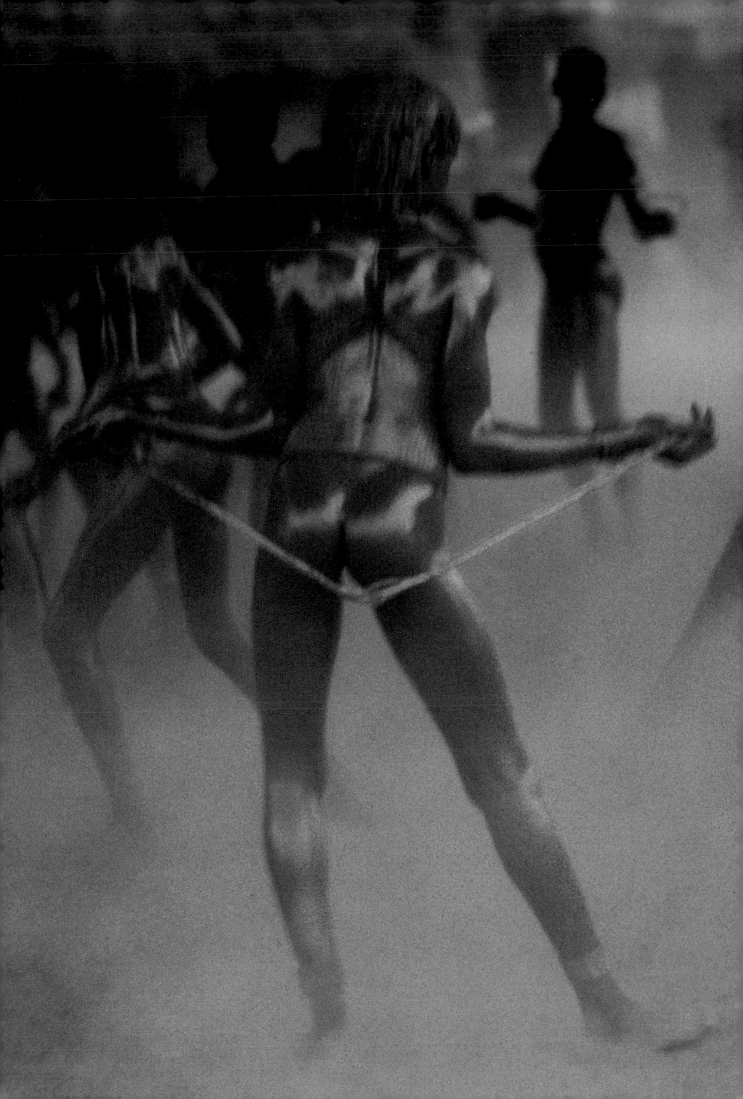

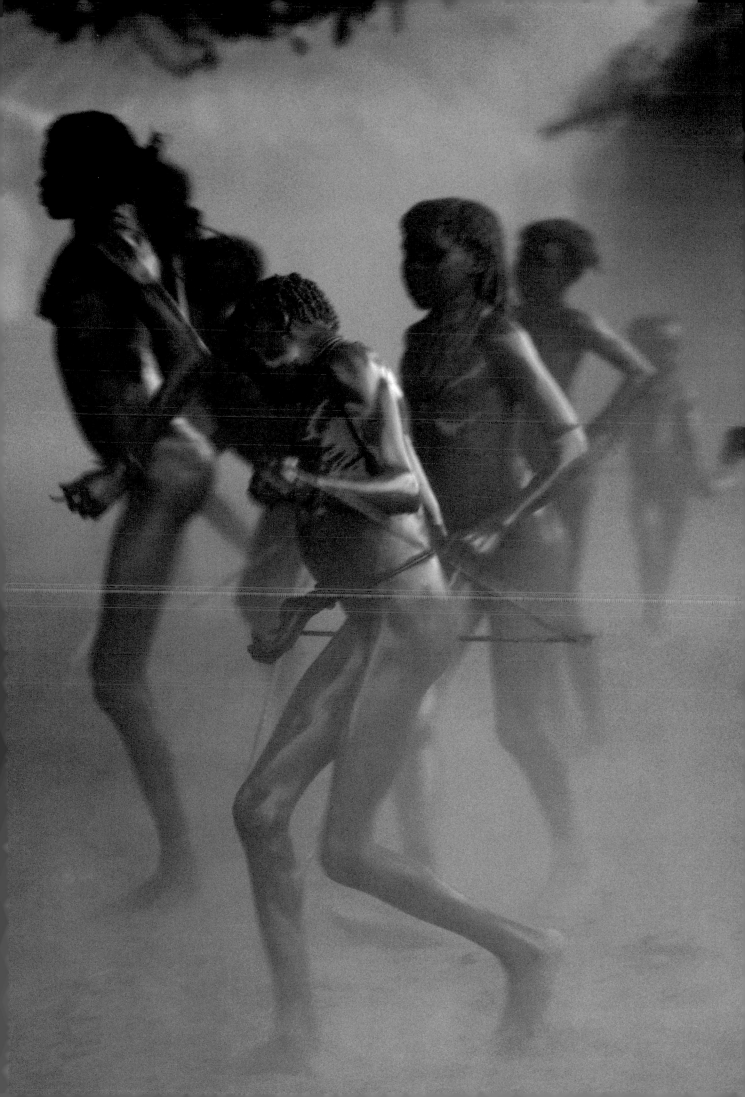

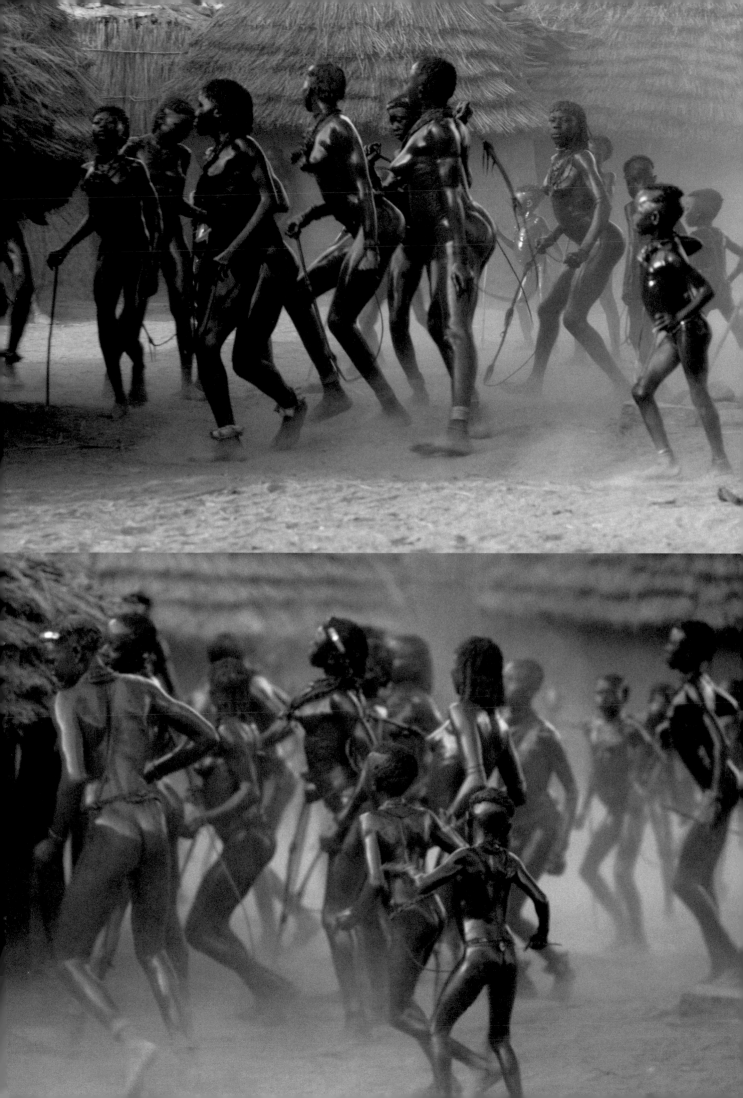

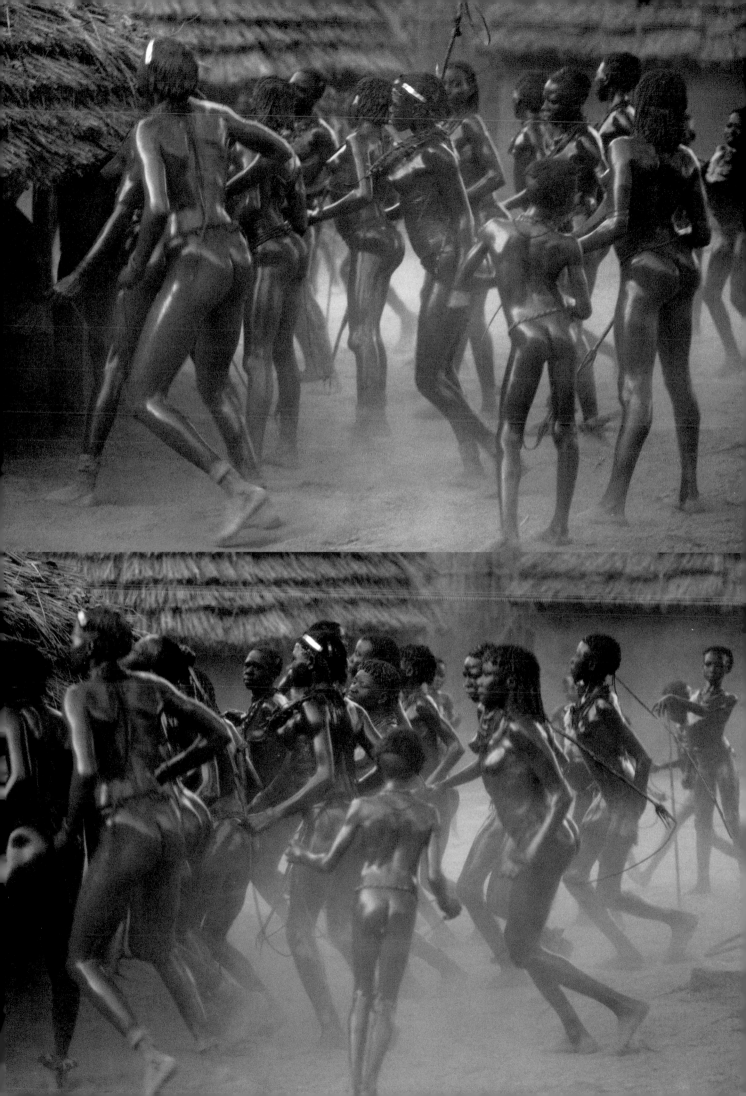

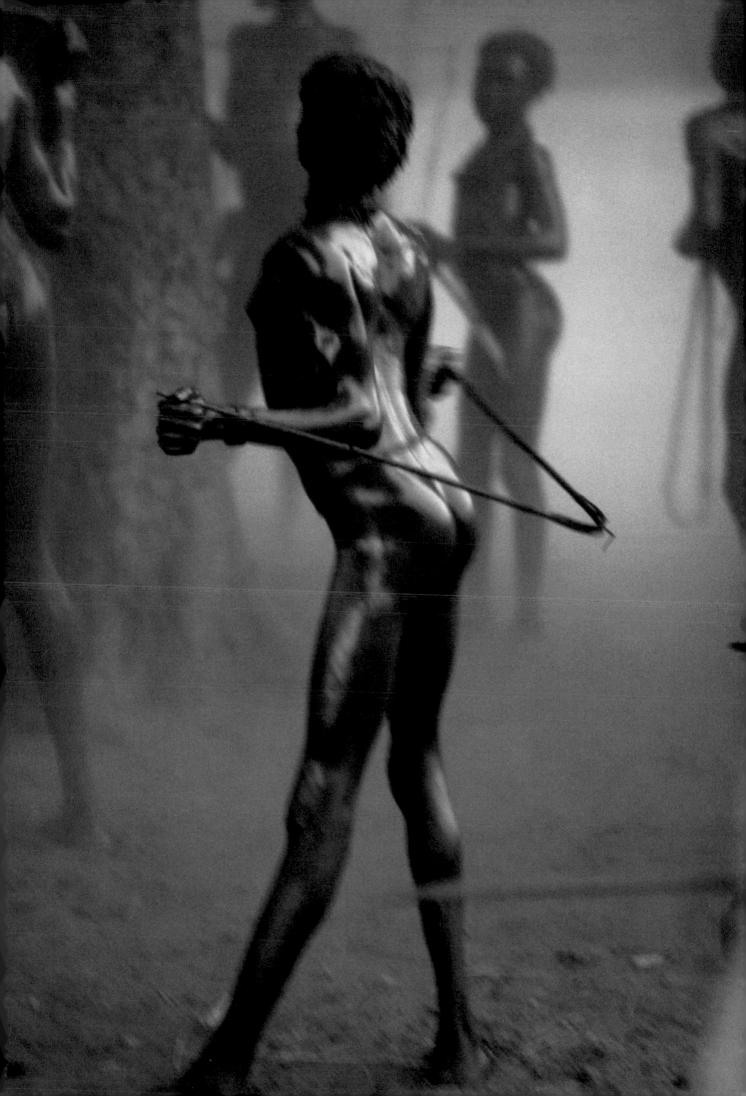

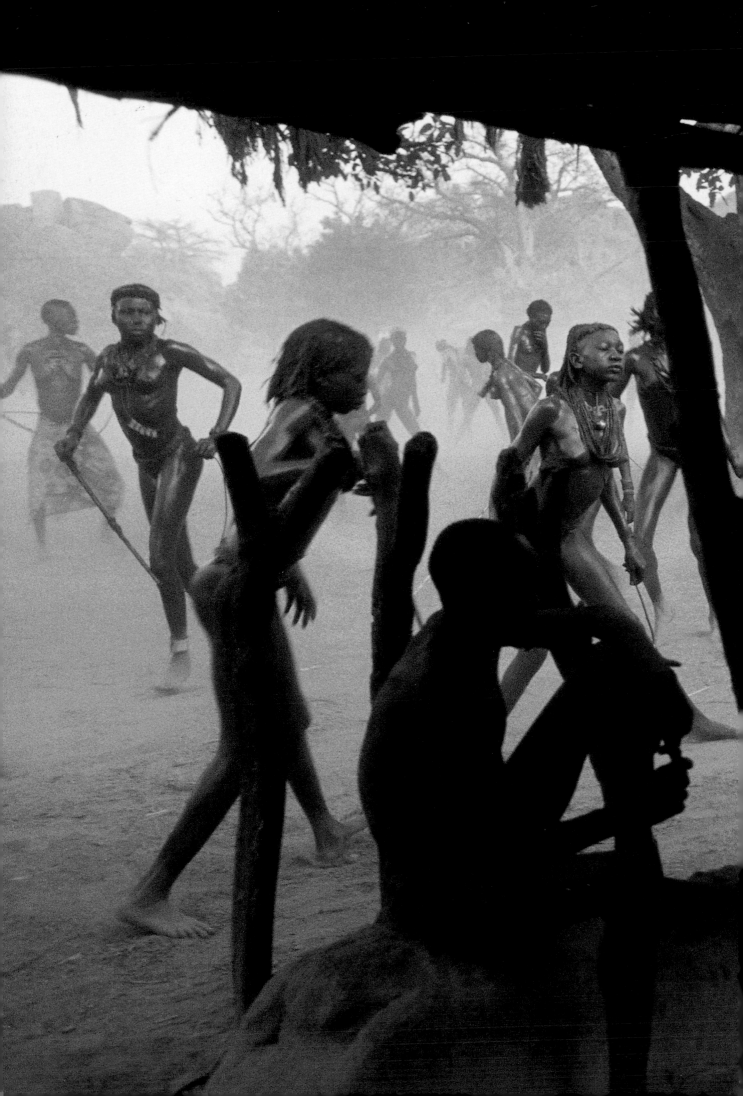

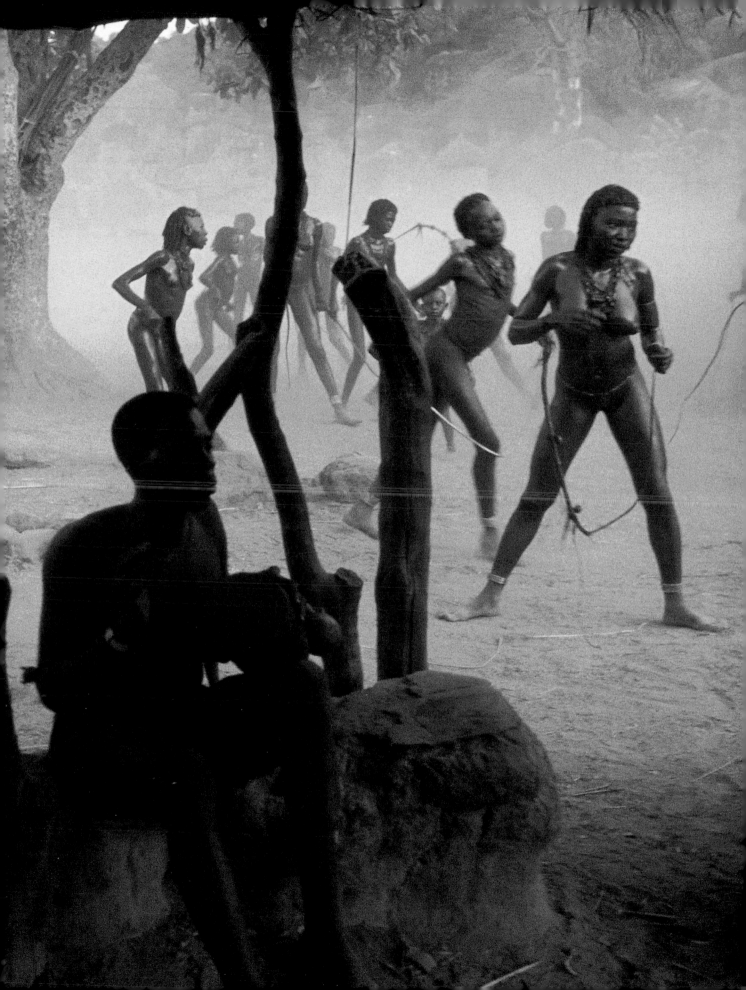

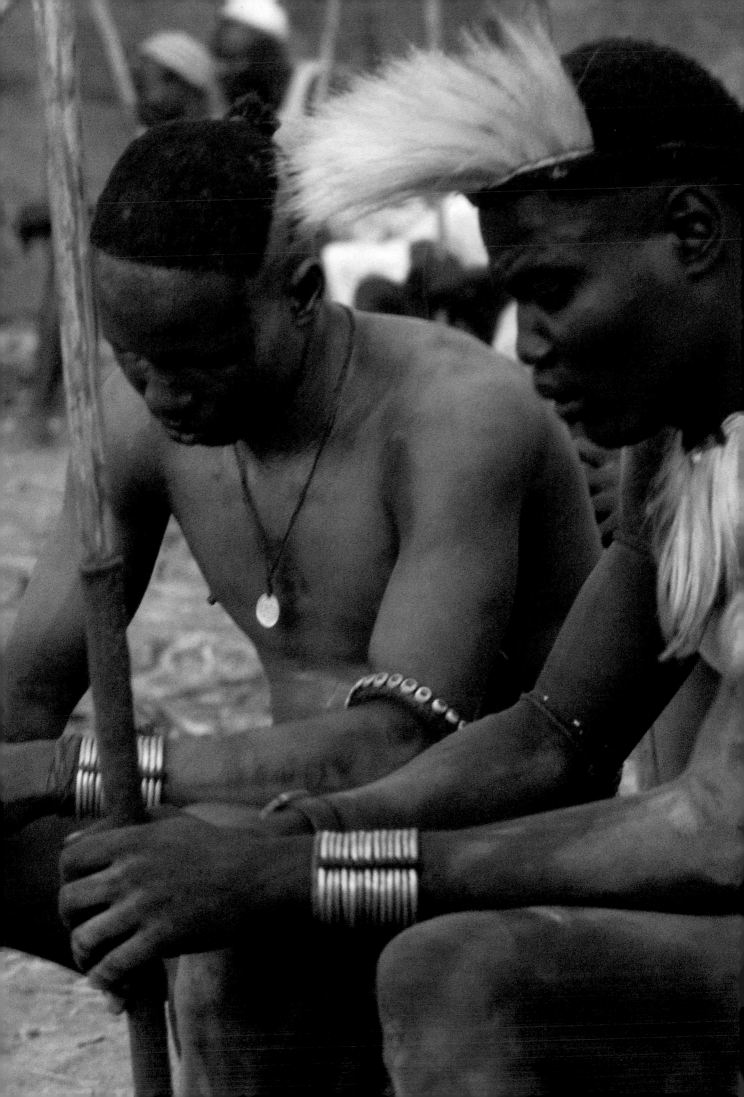

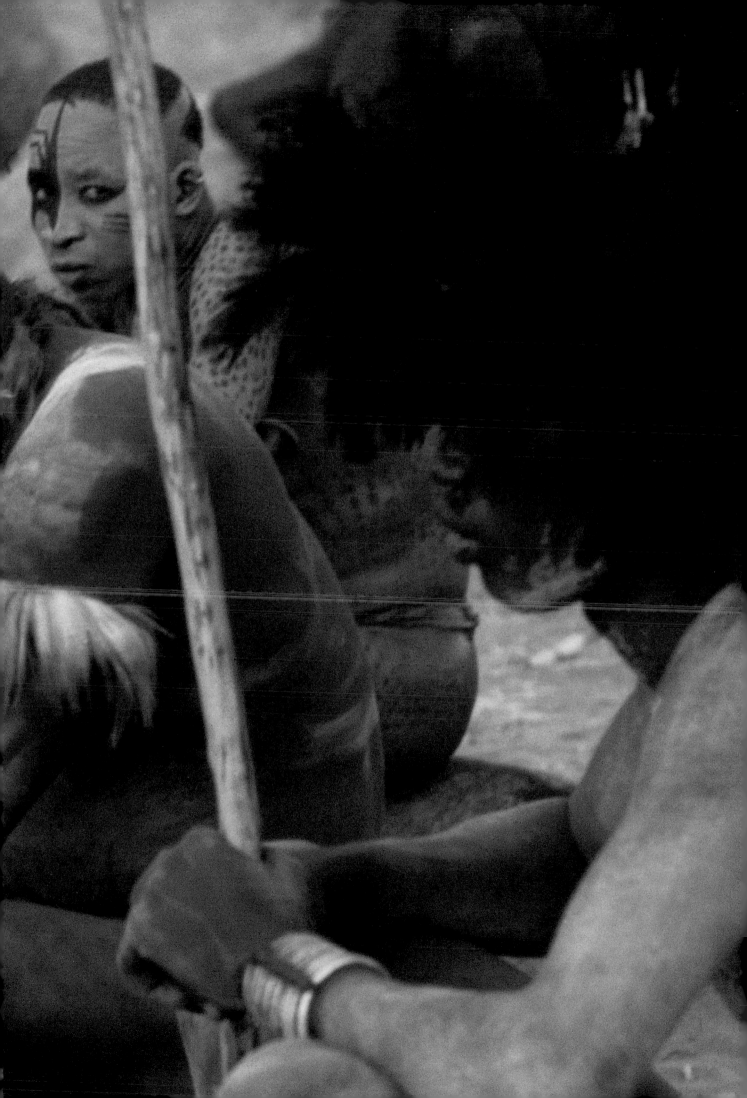

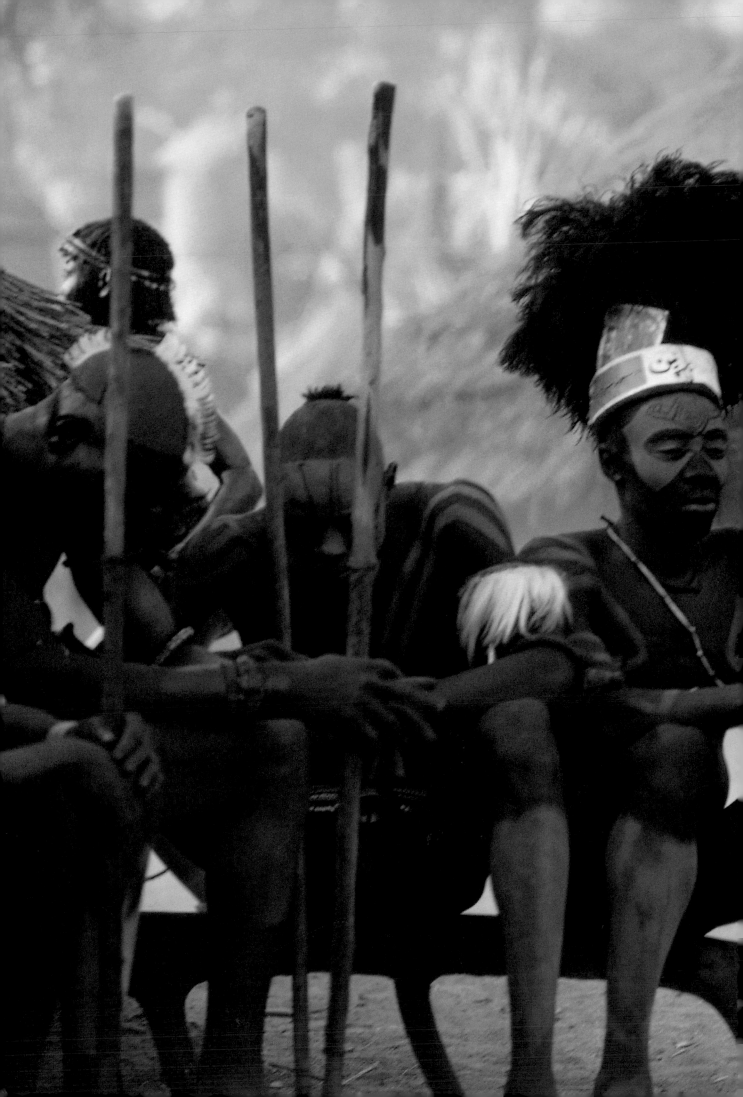

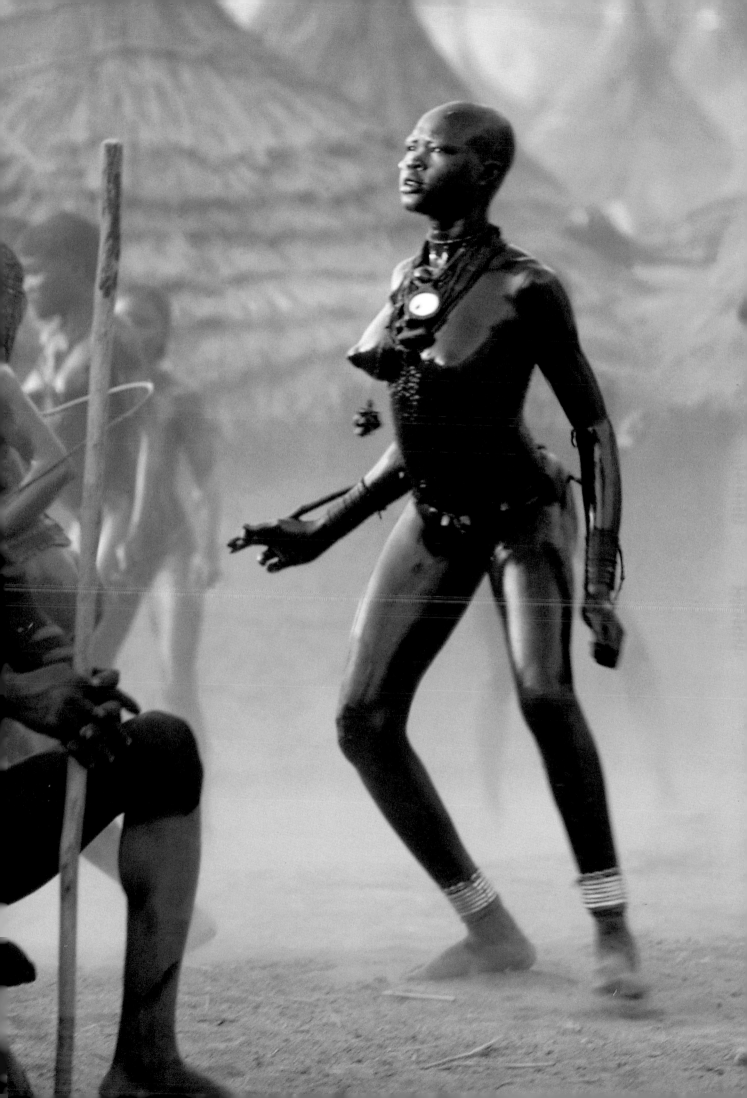

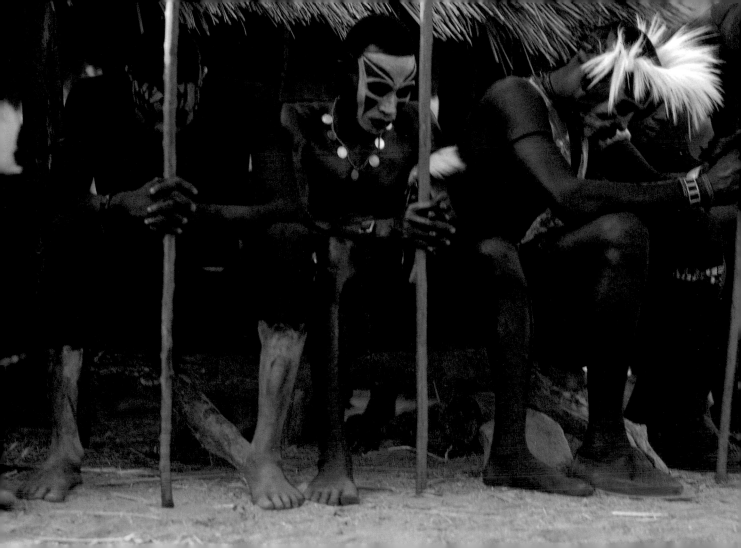

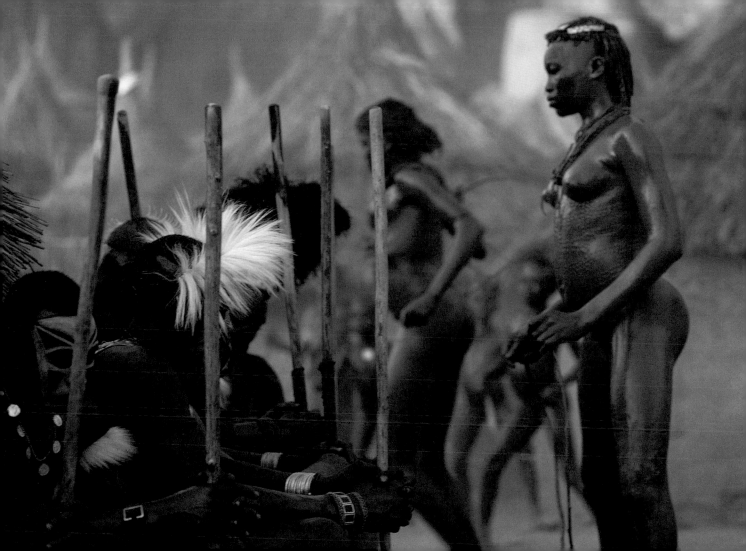

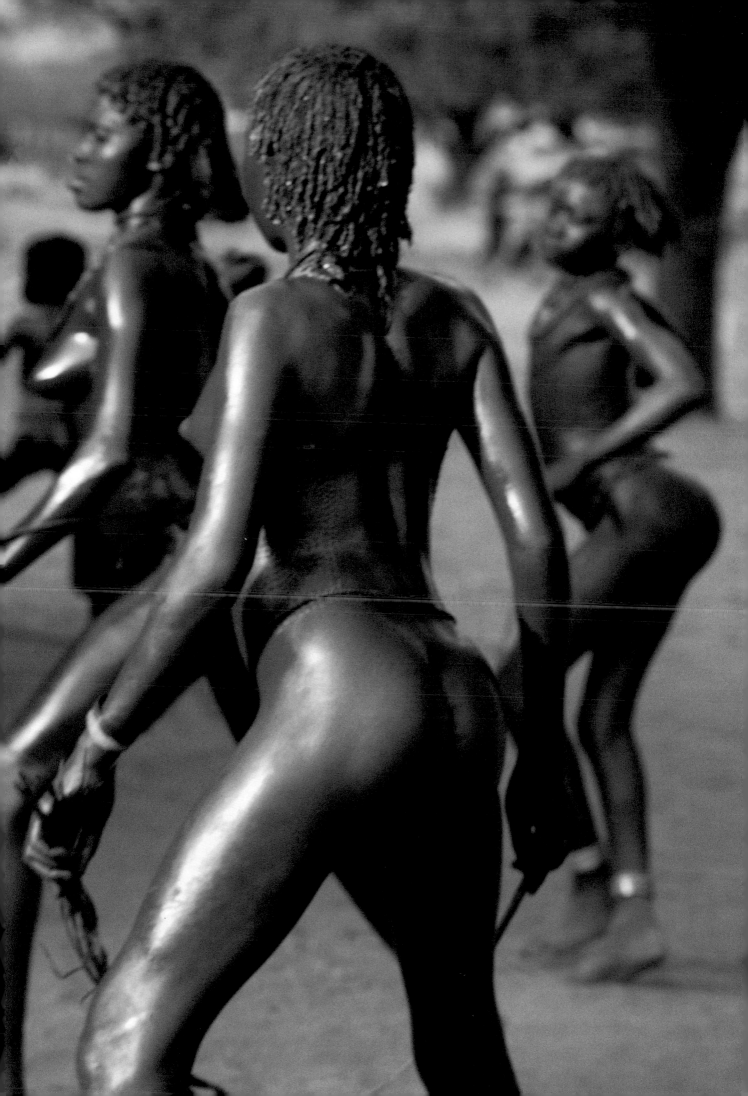

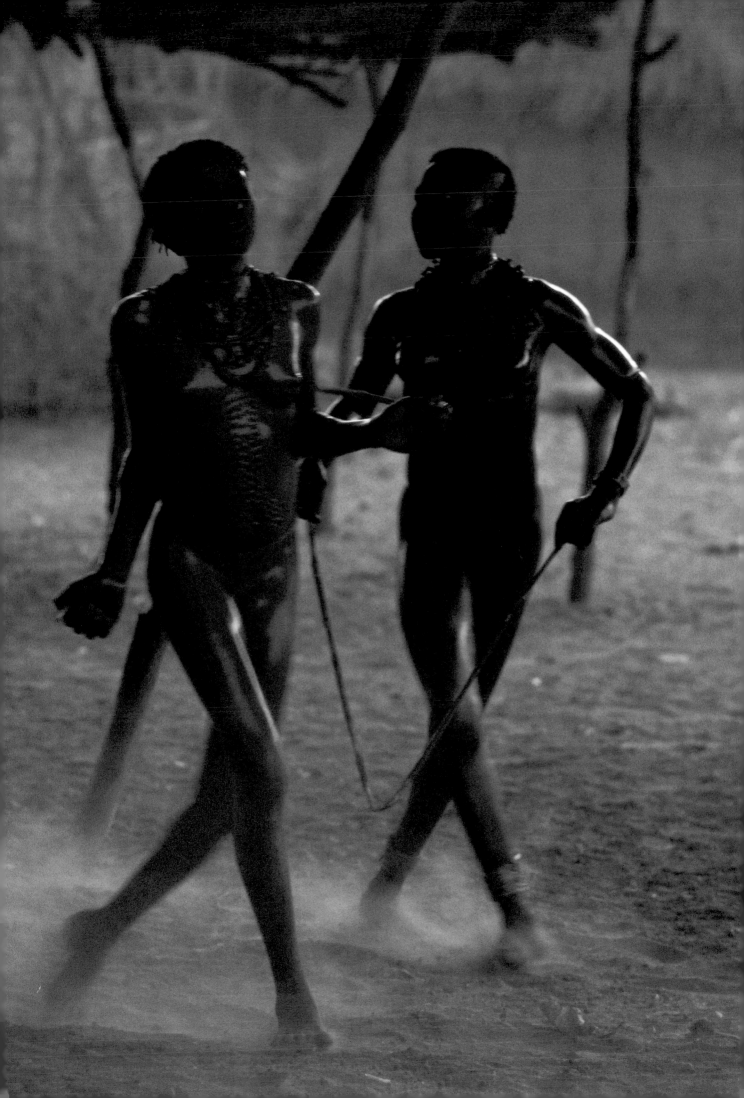

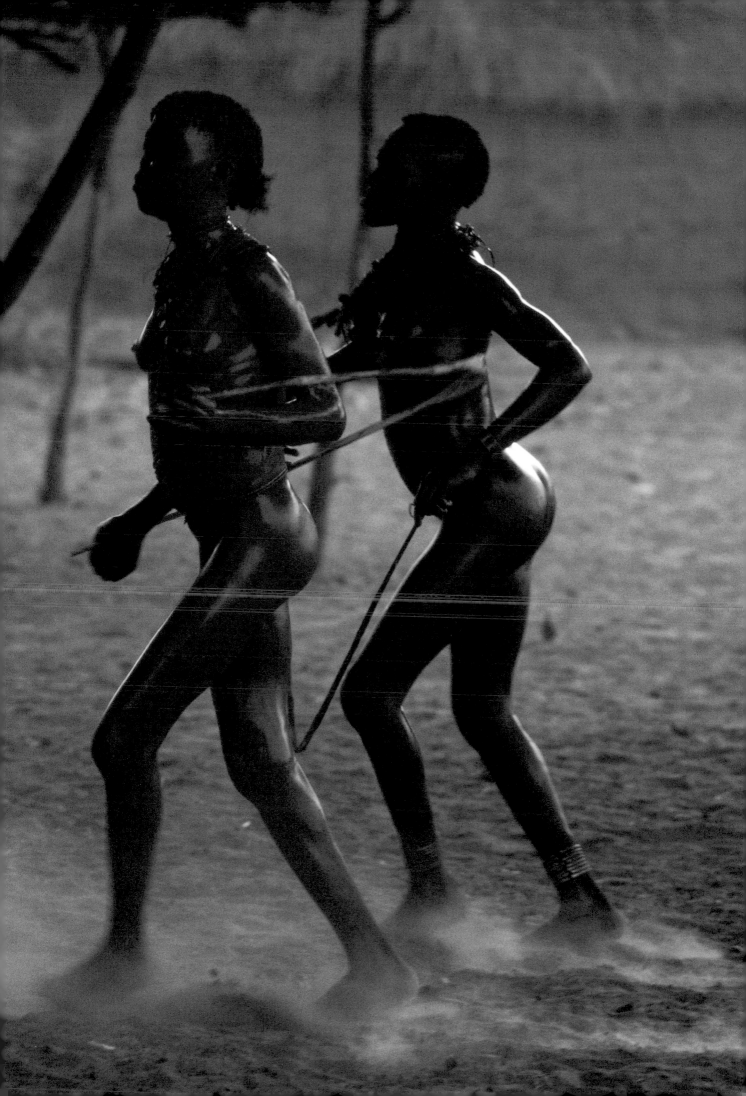

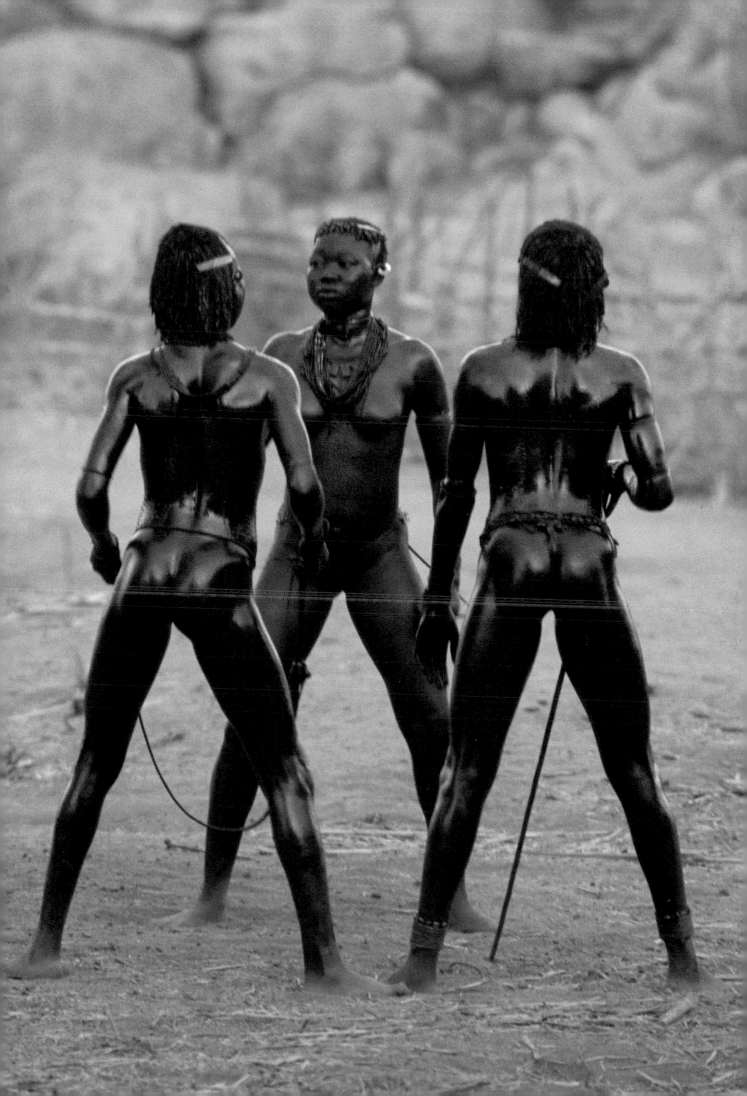

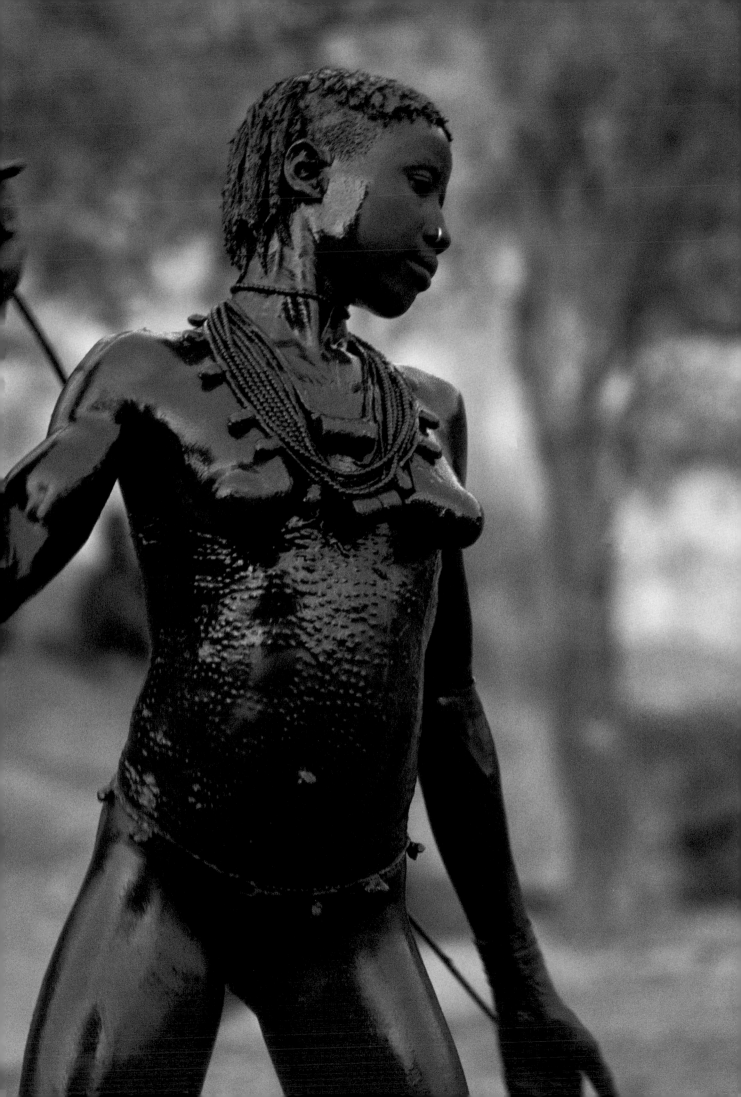

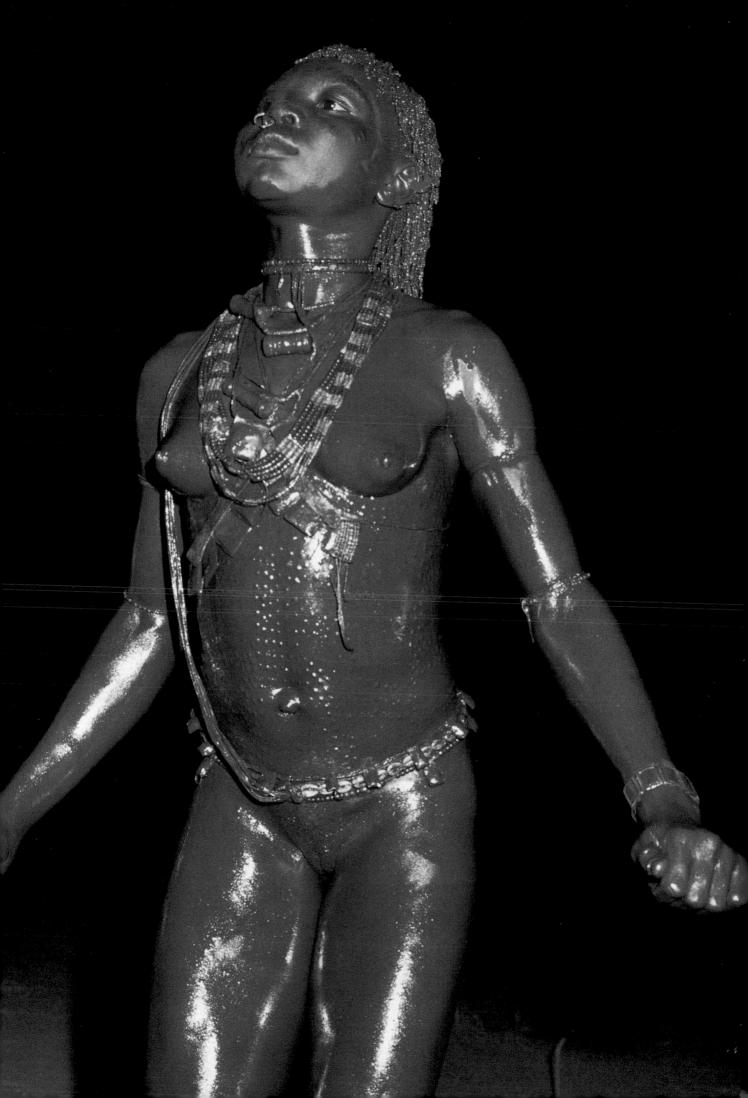

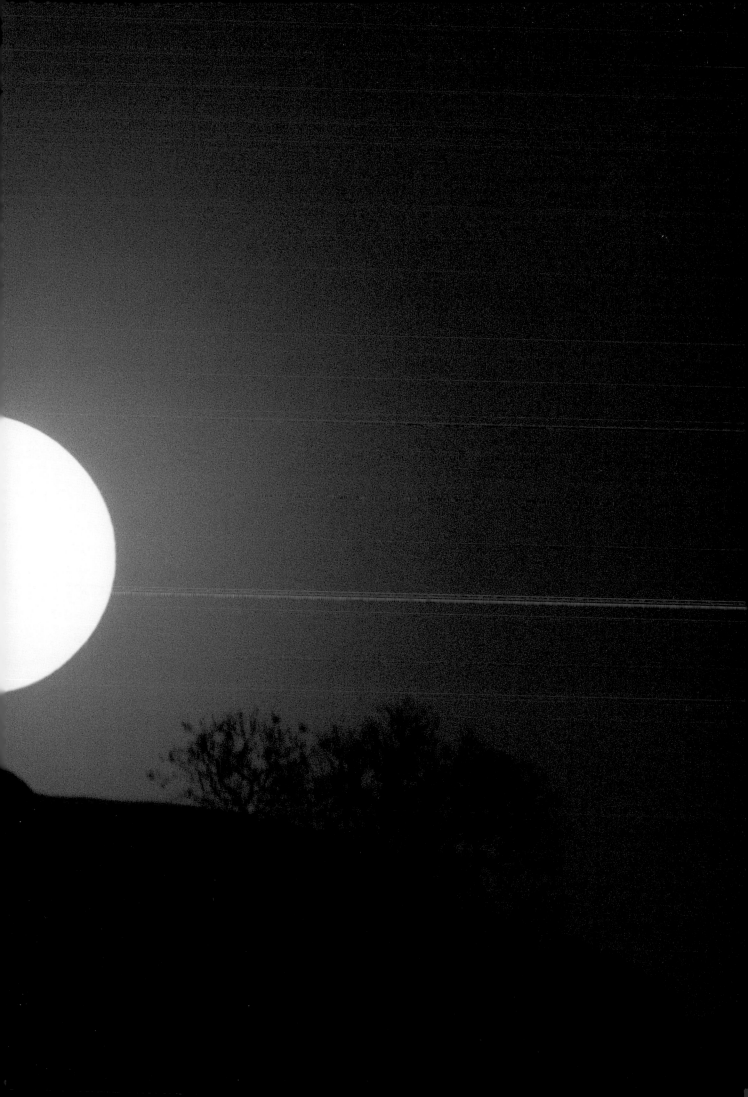

Intro- duction

1

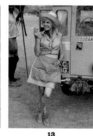

2

3

4

5

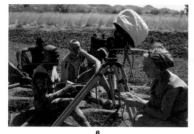

6

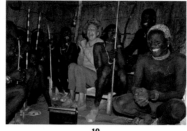

7

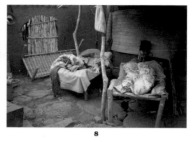

8

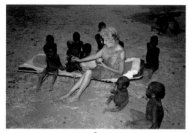

9

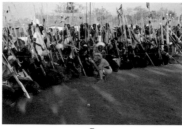

10

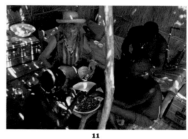

11

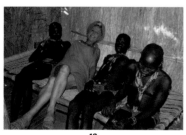

12

13

14

15

Introduction
Einleitung

1 Nuba knife fighter at a dance following the fights.
Messerkämpfer der Nuba bei einem im Anschluss an die Kämpfe stattfindenden Tanzfest.
Nouba luttant au couteau pendant la fête dansée qui suit les combats.

2 Leni Riefenstahl in the inner yard of a Nuba house in Tadoro, 1974.
Leni Riefenstahl im Innenhof eines Nuba-Hauses in Tadoro, 1974.
Leni Riefenstahl dans la cour intérieure d'une maison Nouba à Tadoro, 1974.

3 Inside a Nuba house in Tadoro, 1969.
Im Innern eines Nuba-Hauses in Tadoro, 1969.
L'intérieur d'une case Nouba à Tadoro, 1969.

4 Among the Shilluk people, 1963.
Beim Stamm der Schilluk, 1963.
Dans la tribu des Shilluk, 1963.

5 Portrait of Leni Riefenstahl, among the Mesakin Quissayr Nuba, 1963.
Porträt von Leni Riefenstahl, bei den Masakin-Qisar-Nuba, 1963.
Portrait de Leni Riefenstahl, chez les Nouba Masakin Qisar, 1963.

6 On a shoot in the tobacco fields near Tadoro, 1963.
Bei Aufnahmen auf den Tabakfeldern nahe Tadoro, 1963.
Lors de prises de vues dans des champs de tabac près de Tadoro, 1963.

7 Leni Riefenstahl taking photographs at Shilluk festivities in Malakal, 1963.
Leni Riefenstahl fotografiert während eines Festes der Schilluk in Malakal, 1963.
Leni Riefenstahl photographiant une fête Shilluk à Malakal, 1963.

8 The photographer's bed when staying among the Mesakin Quissayr Nuba, 1963.
Die Bettstatt der Fotografin bei den Masakin-Qisar-Nuba, 1963.
La couche de la photographe chez les Nouba Masakin Qisar, 1963.

9 Leni Riefenstahl giving porridge to little Nuba children in Tadoro, 1963.
Leni Riefenstahl füttert Nuba-Kinder in Tadoro mit Haferbrei, 1963.
Leni Riefenstahl distribue du porridge à de jeunes enfants Nouba, Tadoro, 1963.

10 The photographer in her *rakoba* in Tadoro, 1964.
Die Fotografin in ihrer *rakoba* in Tadoro, 1964.
La photographe dans sa *rakoba* à Tadoro, 1964.

11 Glass beads are very popular with the Nuba, 1969.
Glasperlen sind bei den Nuba sehr begehrt, 1969.
Les Nouba adorent les perles de verre, 1969.

12 The girls of Tadoro teach Leni Riefenstahl the Nuba language, 1969.
Von den jungen Mädchen aus Tadoro lernt Leni Riefenstahl die Nuba-Sprache, 1969.
Leni Riefenstahl apprend la langue Nouba des jeunes filles de Tadoro, 1969.

13 With her Landrover in Tadoro, 1968.
Vor ihrem Landrover in Tadoro, 1968.
Devant sa Landrover à Tadoro, 1968.

14 In her camp in Kau, 1975.
In ihrem Lager in Kau, 1975.
Dans son camp à Kau, 1975.

15 The day of departure from Tadoro, 1977.
Tag der Abreise aus Tadoro, 1977.
Le jour du départ à Tadoro, 1977.

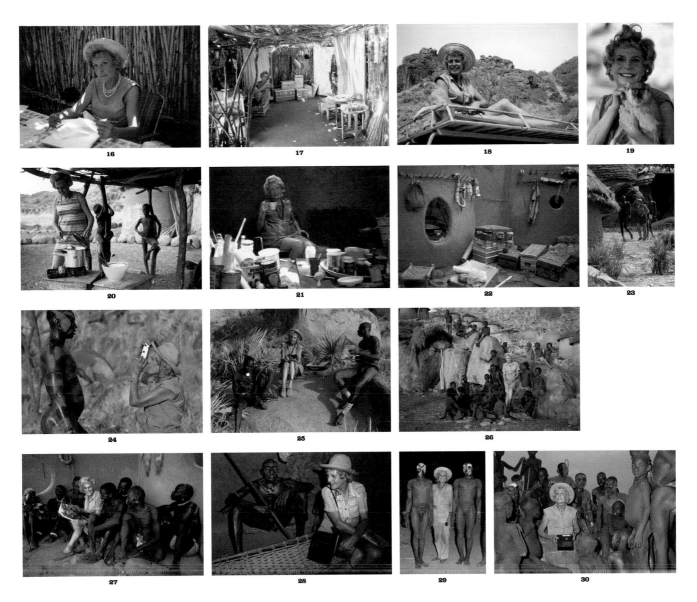

16 Leni Riefenstahl sorting slides in Tadoro, 1969.
Leni Riefenstahl beim Sortieren von Dias in Tadoro, 1969.
Leni Riefenstahl classant des diapositives à Tadoro, 1969.

17 The photographer with her expedition gear in Tadoro, 1969.
Die Fotografin zwischen ihren Expeditionsutensilien in Tadoro, 1969.
La photographe entre ses caisses d'expédition à Tadoro, 1969.

18 On the roof of her Landrover with "Resi" the little monkey, 1969.
Auf dem Dach ihres Landrovers mit Äffchen „Resi", 1969.
Sur le toit de sa Landrover avec le petit singe «Resi», 1969.

19 Portrait of Leni Riefenstahl with "Resi" the little monkey in her arms, 1969.
Porträt von Leni Riefenstahl mit Äffchen „Resi" auf dem Arm, 1969.
Portrait de Leni Riefenstahl, le petit singe «Resi» sur le bras, 1969.

20 The photographer preparing food under her rakoba, 1969.
Die Fotografin bereitet das Essen unter ihrer rakoba zu, 1969.
La photographe prépare le repas sous sa rakoba, 1969.

21 Tea time in Tadoro, 1969.
Teestunde in Tadoro, 1969.
Le thé à Tadoro, 1969.

22 Inner yard of a Nuba house in Tadoro where the expedition crates were stored, 1974.
Innenhof eines Nuba-Hauses in Tadoro, in dem die Expeditionskisten untergestellt sind, 1974.
La cour intérieure de la maison Nouba qui abritait les caisses de l'expédition à Tadoro, 1974.

23 The photographer with two Nuba men of Kau, 1975.
Die Fotografin mit zwei Nuba-Männern aus Kau, 1975.
La photographe avec deux hommes Nouba de Kau, 1975.

24 Leni Riefenstahl photographing an aesthetically painted Nuba of Kau, 1975.
Leni Riefenstahl fotografiert einen kunstvoll bemalten Nuba aus Kau, 1975.
Leni Riefenstahl photographie un Nouba de Kau au corps artistement peint, 1975.

25 A Nuba playing the lyre for the photographer, Nyaro, 1975.
Ein Nuba spielt für die Fotografin auf seiner Leier, Nyaro 1975.
Un Nouba fait de la musique pour la photographe, Nyaro 1975.

26 The Nuba children swiftly make friends with the photographer, 1974.
Die Nuba-Kinder freunden sich schnell mit der Fotografin an, 1974.
Les enfants Nouba ont vite sympathisé avec la photographe, 1974.

27 Looking at her first Nuba photo volume in Tadoro, 1974.
Beim Betrachten ihres ersten Nuba-Bildbandes in Tadoro, 1974.
Regardant son premier album photo sur les Nouba à Tadoro, 1974.

28 The photographer making tape recordings among the Nuba of Kau, 1975.
Die Fotografin macht Tonbandaufnahmen bei den Nuba in Kau, 1975.
La photographe enregistre au magnétophone chez les Nouba à Kau, 1975.

29 With two Nuba men after a nighttime dance in Kau, 1975.
Nach einem nächtlichen Tanzfest mit zwei Nuba-Männern in Kau, 1975.
Après une fête dansée nocturne avec deux Nouba à Kau, 1975.

30 Leni Riefenstahl in Nyaro, playing a cassette recording of Nuba melodies, 1975.
Leni Riefenstahl spielt in Nyaro eine Kassette mit Nuba-Melodien vor, 1975.
Leni Riefenstahl passe une bande magnétique avec des mélodies Nouba, Nyaro 1975.

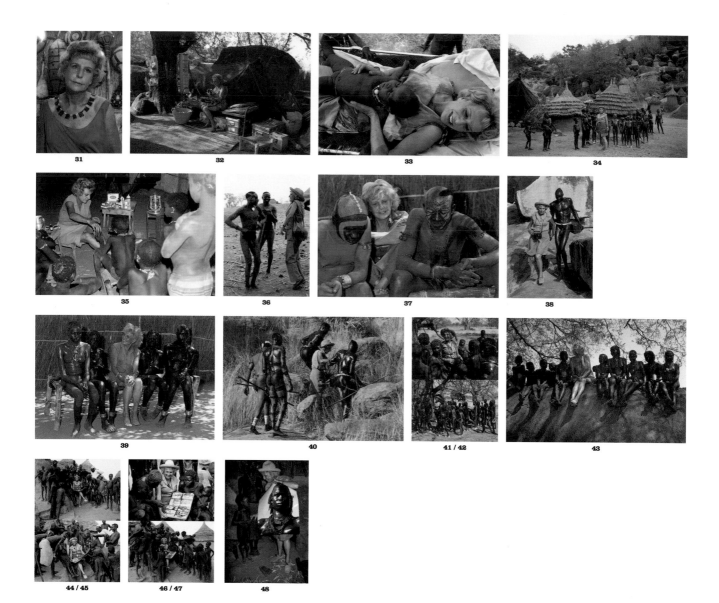

31 The photographer in Tadoro, 1969.
Die Fotografin in Tadoro, 1969.
La photographe à Tadoro, 1969.

32 Her camp in Kau, 1977.
Ihr Lager in Kau, 1977.
Son camp de Kau, 1977.

33 With a Mesakin Quissayr baby in Tadoro, 1969.
Mit einem Masakin-Qisar-Baby in Tadoro, 1969.
Avec un nourrisson Masakin Qisar à Tadoro, 1969.

34 Leni Riefenstahl with the Nuba of Kau, 1975.
Leni Riefenstahl bei den Nuba in Kau, 1975.
Leni Riefenstahl chez les Nouba à Kau, 1975.

35 Tending the sick in the evening at Tadoro, 1969.
Abendlicher Krankendienst in Tadoro, 1969.
Soins du soir aux malades à Tadoro, 1969.

36 Talking with two Nuba men of Nyaro, 1975.
Im Gespräch mit zwei Nuba-Männern aus Nyaro, 1975.
En conversation avec deux Nouba de Nyaro, 1975.

37 With two painted and ornamented Nuba youths of Nyaro, 1975.
Zwischen zwei bemalten und geschmückten Nuba-Jünglingen aus Nyaro, 1975.
Entre deux adolescents Nouba de Tyaro, peints et parés avec art, 1975.

38 Hand in hand with a Nuba man helping her carry her bag of camera equipment, 1975.
Hand in Hand mit einem Nuba-Mann, der ihr beim Tragen der Fototasche hilft, 1975.
Main dans la main avec un Nouba qui l'aide à porter le sac de matériel photo, 1975.

39 Nuba girls from Nyaro visiting Leni Riefenstahl at her *rakoba* in Kau, 1975.
Nuba-Mädchen aus Nyaro besuchen Leni Riefenstahl in ihrer *rakoba* in Kau, 1975.
Les jeunes filles Nouba de Nyaro rendent visite à Leni Riefenstahl dans sa *rakoba* à Kau, 1975.

40 En route to the dancing ground at Nyaro, 1975.
Auf dem Weg zum Tanzplatz von Nyaro, 1975.
En route vers le terrain de danse à Nyaro, 1975.

41 / 42 The photographer with young Nuba girls of Nyaro preparing for a dance, 1975.
Die Fotografin, umgeben von jungen Nuba-Mädchen aus Nyaro, die Vorbereitungen für ein Tanzfest treffen, 1975.
La photographe entourée de jeunes filles Nouba de Nyaro qui préparent une fête dansée, 1975.

43 With Nuba girls of Kau, 1977.
Im Kreise von Nuba-Mädchen aus Kau, 1977.
Dans un cercle de jeunes filles Nouba de Kau, 1977.

44 / 45 / 46 / 47 Leni Riefenstahl shows her second photo volume to the Nuba in Nyaro, 1977.
Leni Riefenstahl zeigt den Nuba in Nyaro ihren zweiten Bildband, 1977.
Leni Riefenstal montre son deuxième album photo aux Nouba, Nyaro 1977.

48 The photographer shows the Nuba a poster of *Jamila*, 1977.
Die Fotografin zeigt den Nuba ein Poster von *Jamila*, 1977.
La photographe montre une affiche de *Jamila* aux Nouba, 1977.

The Mesakin Quissayr

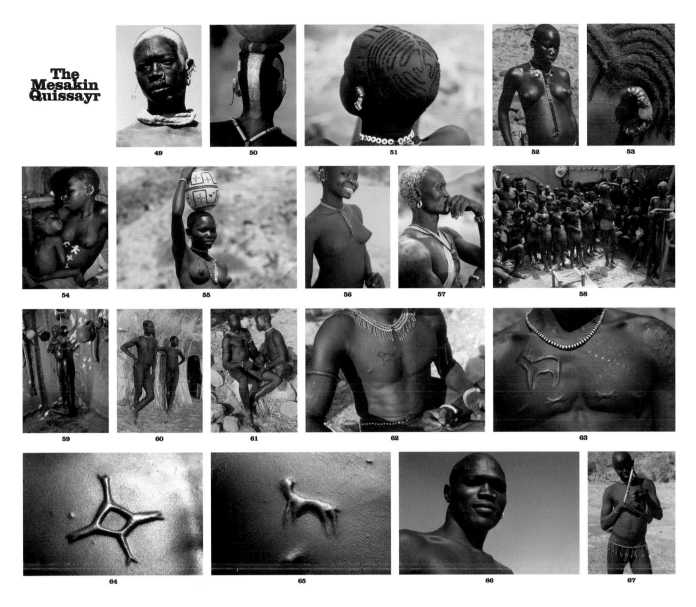

49 50 51 52 53

54 55 56 57 58

59 60 61 62 63

64 65 66 67

The Mesakin Quissayr
Die Masakin-Qisar
Les Masakin-Qisar

49 A Mesakin Quissayr youth from the village of Tamuri. The Mesakin Quissayr tribe live in the Sudan and are a Nuba people.
Ein Masakin-Qisar-Jüngling aus dem Dorf Tamuri. Der Stamm der Masakin-Qisar lebt im Sudan und gehört zum Volk der Nuba.
Un adolescent Masakin-Qisar du village de Tamuri. Les Masakin-Qisar vivent au Soudan et font partie de l'ethnie des Nouba.

50 The Mesakin Quissayr women shave their hair very short, too. They carry pots or baskets (or, here, a gourd) on their heads resting on a circular cloth pad known as a *tuja*.
Auch die Masakin-Qisar-Frauen scheren sich ihre Haare ganz kurz. Die schweren Töpfe und Körbe tragen sie auf einem mit Stoffbändern umwickelten Ring, der *tuja* genannt wird.
Les femmes Masakin-Qisar ont aussi le crâne rasé. Les lourdes jarres et les paniers qu'elles transportent sont posés sur un anneau enveloppé de rubans d'étoffe, le *tuja*.

51 The characteristic designs cut into the hair are known by the Mesakin Quissayr as *manga*. They are forever coming up with new patterns, and no two are likely to be the same.
Manga nennen die Masakin diese für ihren Stamm so typischen Frisuren. Sie erfinden immer wieder neue Formen, selten gleicht ein Muster einem anderen.
Les Masakin appellent *manga* ces coiffures caractéristiques de leur tribu. Ils ne cessent d'inventer de nouveaux dessins, chaque motif est génériquement unique.

52 The body of this Korongo woman is finely laced by the cicactrice design. The Korongo are a neighbouring tribe of the Mesakin Quissayr, whose women also adorn themselves with decorative scars.
Eine Korongo-Frau, deren Schmucknarben ihren Körper wie eine Spitze überziehen. Die Korongo sind

Nachbarn der Masakin-Qisar, deren Frauen sich ebenfalls mit Narben schmücken.
Les femmes Nouba portent aussi des scarifications. Ici, telle une dentelle délicate, celles-ci recouvrent le corps d'une femme Korongo, une tribu voisine des Masakin-Qisar.

53 When girls are just four years old, their ears are pierced with thorns, and subsequently beads, metal platelets and coins are hung by fine wire.
Bereits im Alter von etwa vier Jahren werden die Ohrmuscheln der Mädchen mit Dornen durchbohrt, um später Perlen, Metallplättchen und Münzen mit einem feinen Draht in den Löchern zu befestigen.
Dès que les fillettes sont âgées de quatre ans, on perce l'ourlet de leurs oreilles à l'aide d'épines. Plus tard, elles pourront y fixer avec un mince fil de fer des perles, des plaquettes de métal et des pièces de monnaie.

54 The white markings on this young mother's abdomen indicate that she is menstruating. At this time, women are considered unclean and may not be touched.
Die weißen Zeichen auf dem Bauch der jungen Mutter bedeuten, dass sie ihre Periode hat. Während dieser Tage gelten die Frauen als unrein, niemand darf sie berühren.
Les motifs blanches sur le ventre de la jeune mère indiquent qu'elle a ses règles, ce qui la rend impure pendant plusieurs jours. Personne ne doit la toucher.

55 Most of the young girls lead a life free of duties, with few chores to perform apart from fetching water.
Ein besonders ungebundenes Leben führen die meist sehr hübschen, jungen Mädchen. Außer Wasserholen gehen sie kaum einer Beschäftigung nach.
Les jeunes filles souvent ravissantes mènent une vie particulièrement libre. Elles n'ont guère d'activités, sinon aller chercher de l'eau au puits.

56 *Tutu* from the village of Tadoro. Red glass beads and small metal platelets adorn her ears, nostrils and lower lip—the traditional jewellery of the Mesakin Quissayr women.

Tutu aus dem Dorf Tadoro. Rote Glasperlen und kleine Metallplättchen schmücken Ohren, Nasenflügel und Unterlippe – es ist der traditionelle Schmuck der weiblichen Masakin-Qisar.
Tutu du village Tadoro. Les bijoux traditionnels des femmes Masakin-Qisar – des perles de verre rouges et de petites plaques de métal – ornent ses oreilles, les ailes de son nez et sa lèvre inférieure.

57 Like all the Mesakin Quissayr men, *Dia* from Taballa has a silver ring in his ear. Like the heavy brass arm bands, the rings are bartered from traders and subsequently handed down to the sons.
Dia aus Taballa trägt wie alle Männer der Masakin-Qisar einen Silberring am Ohr. Die Ringe werden ebenso wie die schweren Armreifen aus Messing durch Tauschhandel erworben und später an die Söhne vererbt.
Comme tous les hommes Masakin-Qisar, *Dia* de Taballa arbore une boucle d'oreille en argent. Les anneaux, tout comme les lourds bracelets de laiton, sont obtenus par échange et légués plus tard aux fils.

58 In their first three years of life, the children are especially at risk. Infant mortality in this period runs at about 50 percent.
Die Kinder sind in den ersten drei Lebensjahren besonders gefährdet. In dieser Zeit liegt die Sterblichkeitsrate ungefähr bei 50 Prozent.
Les trois premières années sont particulièrement dangereuses pour les enfants. Près d'un enfant sur deux meurt durant cette période.

59 Water is precious, and a "shower" consists of a gourd on the shower-hut wall, with a hole that provides a steady stream.
Wasser ist ein sehr wertvolles Gut, beim Duschen fließt es durch die kleine Öffnung einer Kalebasse, die an der Wand des Duschplatzes angebracht ist.
L'eau est un bien précieux. Elle coule parcimonieusement par le trou d'une calebasse disposée sur la paroi du coin-douche.

60 Couples are not forcibly brought together among

the Mesakin Quissayr. None of the girls is obliged to marry a particular man, even if he is the parents' choice.
Die Paare der Masakin-Qisar entstehen nicht durch Zwang. Keines der Mädchen muss einen bestimmten Mann heiraten, selbst wenn die Eltern ihn ausgewählt haben.
Les mariages des Masakin-Qisar ne sont pas arrangés. Les jeunes filles ne sont pas obligées d'épouser un homme, même si leurs parents l'ont choisi.

61 Cutting decorative scars into the skin is traditional among most of the indigenous peoples of the Sudan. The patterns are either tribal insignia or, as with the Nuba, serve aesthetic purposes.
Das Einschneiden von Schmucknarben ist bei den meisten Eingeborenen des Sudan Tradition. Die Muster sind entweder Stammeszeichen oder dienen – wie bei den Nuba – der Schönheit.
La scarification est une pratique traditionnelle chez la plupart des autochtones soudanais. Les motifs symbolisent l'appartenance ethnique ou ont un but esthétique, comme c'est le cas chez les Nouba.

62 In the dry heat, wounds heal quickly. Within minutes of an incision being made, the blood has stopped flowing.
Durch die trockene Hitze heilen die Wunden schnell. Schon wenige Minuten nach dem Einschnitt fließt kein Blut mehr.
L'air chaud et sec est propice aux blessures. Quelques minutes après l'incision, le sang a cessé de couler.

63 The raised nature of the scar is caused by ash being rubbed into the open wounds.
Die plastische Form entsteht dadurch, dass Asche in die offenen Wunden gestreut wird.
On obtient des motifs en relief en introduisant de la cendre dans les incisions.

64 / 65 Some decorative scars recall Christian symbols. From the 6th to 14th centuries there were Christian kingdoms in the northern part of the Nubian Nile valley.

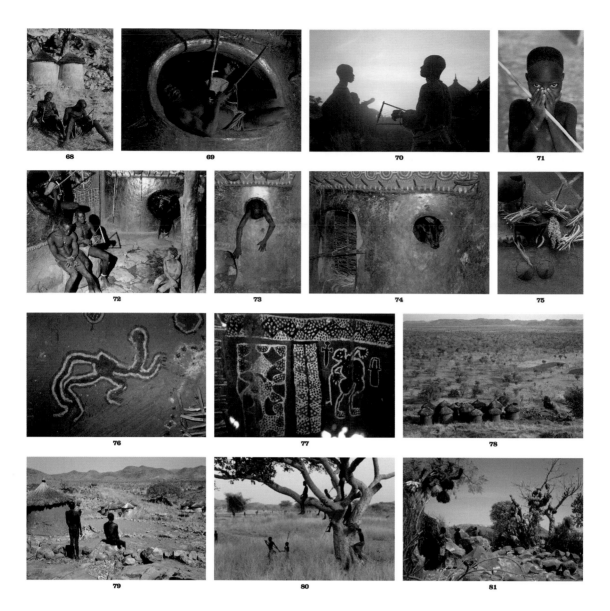

68 **69** **70** **71**

72 **73** **74** **75**

76 **77** **78**

79 **80** **81**

Manche Schmucknarben erinnern an christliche Symbole. Vom 6. bis 14. Jahrhundert gab es im nördlichen Niltal Nubiens christliche Königreiche.
Certaines scarifications évoquent des symboles chrétiens. Du 6e au 14e siècle, des royaumes chrétiens ont existé au nord des régions où se joignent le Nil blanc et le Nil bleu.

66 *Gua* is the strongest wrestler from Tosari—he has never been defeated.
Gua ist der stärkste Ringkämpfer aus Tosari – er wurde nie besiegt.
Gua est le meilleur lutteur de Tosari – il n'a jamais été vaincu.

67 The young shepherds wear a simple belt of thongs and nut-like fruits by way of adornment.
Die jungen Hirten tragen als Schmuck einen Gürtel aus Schnüren und nussähnlichen Früchten um ihre Hüften.
Les jeunes bergers se ceignent les hanches de simples cordelettes où sont suspendus des fruits ressemblant à des noix.

68 The Mesakin Quissayr delight in making music.
Das Musizieren gehört zu den Lieblingsbeschäftigungen der Masakin-Qisar.
Faire de la musique est l'une des occupations favorites des Masakin-Qisar.

69 The Nuba work hard much of the time, but they never forget how to relax.
Die Nuba arbeiten die meiste Zeit sehr schwer, aber sie vergessen nie, sich zu entspannen.
Les Nouba travaillent dur la plupart du temps, mais ils n'oublient jamais de se détendre.

70 At nighttime festivities the singing and dancing often goes on for hours. A choir will improvise new words to familiar tunes, telling of the events of the day.
Bei den nächtlichen Festen wird oft stundenlang gesungen und getanzt. Ein Chor singt bekannte Melodien mit improvisierten Texten, die die Ereignisse des Tages wiedergeben.

Pendant les fêtes nocturnes, on danse et on chante souvent pendant des heures. Une chorale joue des mélodies connues accompagnées de textes improvisés qui racontent les événements de la journée.

71 *Nolli*, a little Nuba girl.
Nolli, ein kleines Nuba-Mädchen.
Nolli, une fillette Nouba.

72 Typically the round houses are built in groups of five or six, and such a house-compound resembles a miniature castle. The walls are 6 to 10 feet high and the interior is 15 to 25 feet in diameter.
Eine typische Häusergruppe besteht aus fünf bis sechs Rundhäusern, die alle miteinander verbunden sind. Die Höhe der Wände beträgt zwei bis drei Meter, der Innenhof hat einen Durchmesser von fünf bis acht Metern.
Une «concession» typique est composée de cinq à six cases circulaires toutes reliées entre elles. Les murs font deux à trois mètres de hauteur, la cour intérieure a un diamètre de cinq à huit mètres.

73 The entrance to store rooms or sleeping quarters is only 12 to 14 inches in diameter. This keeps these areas pleasantly cool in the heat of the day but retains warmth during cold nights. The small opening can easily be stopped with stones and straw.
Der Eingang in die Vorratskammern und Schlafräume hat einen Durchmesser von 30 bis 35 Zentimetern. So bleiben die Räume in der Hitze des Tages kühl und halten die Temperatur in kalten Nächten. Die Öffnung lässt sich mit Steinen und Stroh verschließen.
L'entrée des pièces à provisions et des espaces de repos fait 30 à 35 centimètres de diamètre. Les pièces restent ainsi agréablement fraîches durant la journée, et la température reste constante pendant les nuits froides. La petite ouverture peut être facilement close avec des pierres et de la paille.

74 To decorate their round houses, the Nuba rub graphite on the mud walls. For days they patiently smooth the graphite-impregnated walls with the balls of their thumbs, till they gleam like marble.

Um ihre Rundhäuser zu verschönern, reiben die Nuba Graphit auf die Lehmwände. Tagelang glätten sie geduldig mit den Daumenballen die graphithaltige Erde, bis die Wände wie Marmor glänzen.
Pour décorer leurs cases circulaires, les Nouba frottent du graphite sur les murs d'argile. Ensuite, ils les lissent patiemment avec la paume des mains jusqu'à ce que les parois brillent comme du marbre.

75 In many Nuba huts one can see stylised representations of the female breast, as a sign of veneration for Woman. Anthropologists believe this indicates that in the remote past the Nuba had a matriarchal society.
In vielen Hütten findet man als Zeichen für die Verehrung der Frau die plastisch stilisierte Form einer weiblichen Brust. Anthropologen vermuten deshalb, dass bei den Nuba in Urzeiten das Mutterrecht herrschte.
Dans de nombreuses huttes, des seins stylisés signalent la vénération dont la femme est l'objet. Les anthropologues supposent pour cette raison qu'à l'origine la filiation était matrilinéaire chez les Nouba.

76 / 77 Wall paintings showing abstract geometrical patterns, but also representing objects, adorn the house interiors. Natural earth colours—ochres and reds mainly—are supplemented by white from lime and black from soot or charcoal.
Wandmalereien aus geometrischen Formen und gegenständlichen Motiven zieren das Innere der Rundhäuser. Natürliche Erdfarben wie Ocker und Rot werden durch Weiß (Kalk) und Schwarz (Ruß oder Holzkohle) ergänzt.
Des peintures murales aux formes géométriques et des motifs figuratifs décorent l'intérieur des cases. Les couleurs naturelles terreuses comme l'ocre et le rouge sont complétées de blanc (calcaire) et de noir (suie ou charbon de bois).

78 The Mesakin Quissayr live in the remotest hills and valleys of the southern Nuba mountains and for this reason have had little exposure to the influences of civilisation.

Die Masakin-Qisar leben in den entlegensten Tälern und Hügelketten der südlichen Nuba-Berge und waren noch kaum den Einflüssen der Zivilisation ausgesetzt.
Les Masakin-Qisar vivent dans les vallées et les collines les plus retirées du sud des monts Nouba et n'avaient pratiquement jamais été confrontés aux influences de la civilisation.

79 / 80 Nuba children and youngsters lead a carefree life. The little ones play all day in the shade of the trees, watched and washed and fed by their elder siblings.
Die Kinder und Jugendlichen der Nuba führen ein unbeschwertes Leben. Die Kleinen spielen den ganzen Tag im Freien unter schattigen Bäumen und werden von den älteren Geschwistern beaufsichtigt, gewaschen und gefüttert.
Les enfants et les adolescents Nouba mènent une vie insouciante. Les plus jeunes jouent toute la journée à l'ombre des arbres et sont gardés, lavés et nourris par leurs sœurs plus âgées.

81 In the hot months of the dry season, temperatures easily reach 104° F. The risk of bush fires which could destroy the crops and homes of the Nuba is great.
In den heißen Monaten der Trockenzeit erreichen die Temperaturen bis zu 40° C. Die Gefahr, dass Steppenbrände die Felder und Häuser der Nuba vernichten, ist sehr groß.
Durant les mois les plus chauds de la saison sèche, la température atteint 40° C. Les feux de brousse représentent un grave danger pour les champs et les cases des Nouba.

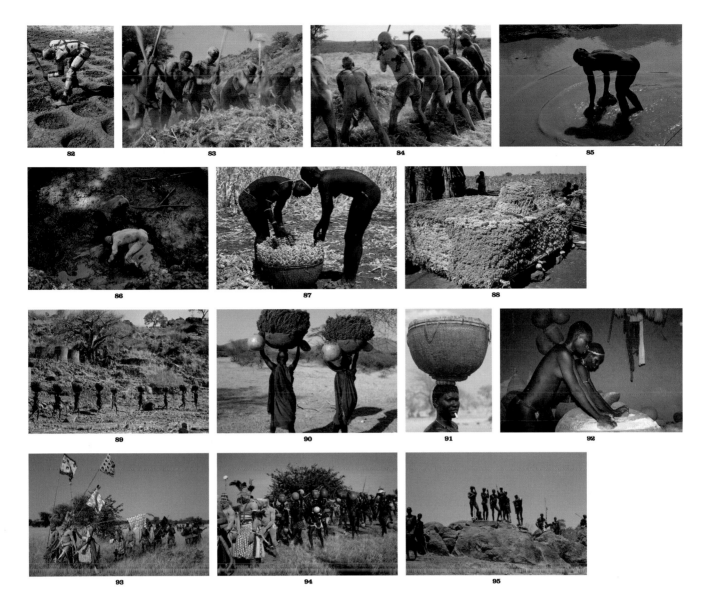

82 A young Mesakin Quissayr man working in a tobacco field. The white ash painting on the man's body has ritual significance. He is a *kaduma*, a young wrestler, who lives in the herdsmen's compound.
Ein junger Masakin-Qisar bei der Arbeit auf dem Tabakfeld. Der mit weißer Asche bemalte Körper des Mannes hat kultische Bedeutung. Er ist ein *kaduma*, ein junger Ringkämpfer, der im Hirtenlager lebt.
Un jeune Masakin-Qisar au travail dans un champ de tabac. C'est un *kaduma*, un jeune lutteur, qui vit dans le camp des bergers. La cendre blanche qui recouvre son corps a une signification rituelle.

83 The Nuba live off the land, chiefly eating sorghum (or dura).
Die Nuba leben von der Landwirtschaft, sie ernähren sich hauptsächlich von Dura, der so genannten Sorghumhirse.
Les Nouba vivent de l'agriculture et se nourrissent principalement de durra, ou gros mil, une espèce de sorgho à grain.

84 The men thresh the dura heads on threshing grounds specially prepared by the women for the purpose. The work begins at sunrise and does not end till dusk.
Die Männer dreschen die Durakolben auf Dreschplätzen, die die Frauen hergerichtet haben. Diese Arbeit beginnt bei Sonnenaufgang und endet erst nach Einbruch der Dämmerung.
Les hommes battent les épis de durra sur les aires de battage que les femmes ont aménagées. Ils commencent à l'aube et ne cessent de travailler qu'après le coucher du soleil.

85 One of the few larger water-holes near the tobacco fields. Water is transported in gourds to the tobacco plants.
Eine der wenigen, größeren Wasserstellen in der Nähe der Tabakfelder. Mit dem Wasser in den Kalebassen werden die Tabakpflanzen gegossen.
Un des rares grands points d'eau à proximité des champs de tabac. Les plants sont arrosés à l'aide de calebasses.

86 Given the extreme scarcity of water, the men have to dig for ground water—sometimes as deep as 25 to 32 feet.
Wegen der großen Wasserknappheit müssen die Männer nach Grundwasser graben – manchmal acht bis zehn Meter tief.
L'eau est très rare et les hommes doivent aller la chercher dans la nappe phréatique parfois située à huit, dix mètres de profondeur.

87 While the men do the hard work in the fields, the women help with planting and weeding and gather the dura heads harvested by the men.
Während die Männer die schwere Feldarbeit verrichten, helfen die Frauen beim Anpflanzen, jäten Unkraut und sammeln die von den Männern geernteten Durakolben ein.
Pendant que les hommes exécutent les travaux agricoles les plus durs, les femmes aident à repiquer, sarclent et rassemblent les épis de durra récoltés par les hommes.

88 The dura harvest is dried here.
Auf diesem Platz wird die Dura-Ernte getrocknet.
C'est ici que la durra est mise à sécher.

89 Twice a day the women carry the newly harvested dura to be dried as well.
Zweimal am Tag tragen die Frauen die Ernte zu den Sammelplätzen, wo sie auch getrocknet wird.
Deux fois par jour, les femmes viennent déposer la récolte à des endroits aménagés à cet effet, où on la laisse aussi sécher.

90 The baskets weight 75 to 90 pounds and have to be carried three to four and a half miles. The gourds are for water.
Die Körbe wiegen 35 bis 40 Kilo und müssen fünf bis sieben Kilometer weit getragen werden. Die Kalebassen enthalten Wasser.
Les paniers de 35 à 40 kilos doivent être transportés sur des distances de cinq à sept kilomètres. Les calebasses que portent les femmes contiennent de l'eau.

91 The Mesakin Quissayr women work almost as hard as the men, and have an almost equal position to them in their society, in contrast to many other African tribes.
Die Masakin-Qisar-Frauen arbeiten fast genauso hart wie die Männer und nehmen, anders als bei vielen anderen afrikanischen Stämmen, eine fast gleichberechtigte Stellung ein.
Les femmes Masakin-Qisar travaillent presque aussi dur que les hommes et, contrairement à nombre d'autres tribus africaines, elles sont pratiquement leurs égales.

92 After threshing and sifting, the dura is stored in the granary. The women and girls use stones to grind it into flour as it is needed, from which they prepare a dura porridge with water or milk.
Nach dem Dreschen und Sieben wird die Dura im Kornhaus eingelagert. Je nach Bedarf werden die Körner von den Mädchen und Frauen mit einem Stein zu Mehl zermahlen, aus dem mit Wasser oder Milch der Durabrei gekocht wird.
Après l'égrenage et le tamisage, la durra est stockée dans le grenier. Les fillettes et les femmes pileront les grains à l'aide d'une pierre selon les besoins. La farine obtenue est mélangée à de l'eau ou du lait et cuite en bouillie, nommée aussi durra.

93 The people of a Nuba village on their way to a *szanda* or wrestling match. Wrestling is much more than a sporting event. For the Nuba, it is the very hub of their lives. The strongest wrestlers lead the procession and carry the village flag.
Die Bewohner eines Nuba-Dorfes auf dem Weg zur *szanda*, dem Ringkampffest. Der Ringkampf ist weit mehr als ein sportliches Ereignis, er ist für die Nuba das Zentrum ihres Lebens. Die vier stärksten Kämpfer führen den Zug an und tragen die Fahne des Dorfes.
Les villageois se rendent à la fête de la *szanda*, un concours de lutte. Bien plus qu'un événement sportif, c'est le centre d'intérêt majeur des Nouba. Les quatre lutteurs les plus vigoureux mènent le cortège et portent le drapeau du village.

94 The Nuba contingent from Tadoro in procession, led by the strongest wrestlers: *Natu*, *Tukami*, *Napi*, *Gumba* and *Gorände*. In the calabashes the women are carrying water, marissa beer and dura porridge.
Festzug der Nuba aus Tadoro. An der Spitze die stärksten Kämpfer: *Natu*, *Tukami*, *Napi*, *Gumba* und *Gorände*. Die Frauen tragen in den Kalebassen Wasser, Marissabier und Durabrei.
Le cortège des Nouba de Tadoro. En tête, les meilleurs lutteurs qui s'appellent *Natu*, *Tukami*, *Napi*, *Gumba* et *Gorände*. Dans les calebasses, les femmes transportent de l'eau, de la marissa, une bière locale, et de la durra.

95 The spectators and wrestlers wait in tense excitement for the match to begin.
Gespannt warten Zuschauer und Kämpfer auf den Beginn des Festes.
La tension est grande chez les spectateurs et les lutteurs qui attendent que la fête commence.

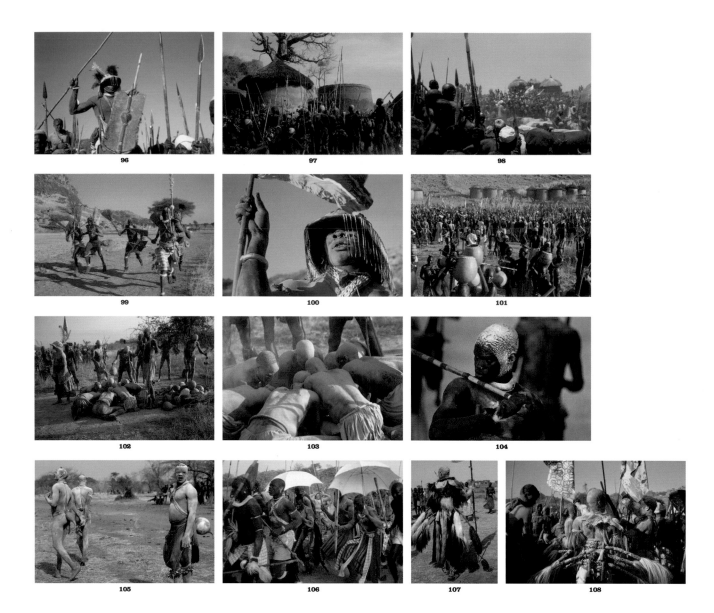

96

97

98

99

100

101

102

103

104

105

106

107

108

96 Nuba men are fond of fantastical headgear. The strongest wrestlers wear solar topees from British colonial times, with strings of beads attached.
Die Nuba-Männer haben eine besondere Vorliebe für fantasievolle Kopfbedeckungen. Die stärksten Kämpfer bevorzugen die alten Tropenhelme der Engländer, die sie mit langen Perlenschnüren schmücken.
Les hommes Nouba adorent les couvre-chefs origi-naux. Les meilleurs lutteurs ont un faible pour les vieux casques coloniaux des Anglais auxquels ils suspendent de longues rangées de perles.

97 / 98 As many as 4,000 Nuba gather at big festiv-ities. The tribes from the broader region cover as much as 30 miles on foot.
Bis zu 4000 Nuba kommen bei den großen Festlich-keiten zusammen. Die Stämme aus der weiteren Umgebung legen zu Fuß Strecken bis zu 50 Kilo-metern zurück.
Les grandes festivités rassemblent jusqu'à 4000 Nouba. Les tribus avoisinantes viennent à pied d'en-droits situés à une cinquantaine de kilomètres.

99 Running to the wrestling match.
Im Laufschritt zum Ringkampffest.
La course vers le concours de lutte.

100 *Natu*, the best wrestler in his village, carries the flag throughout the festivities. At other times it is kept with other props in a special hut in the village.
Natu, der beste Ringkämpfer seines Dorfes, trägt während des Festes die Fahne. Den übrigen Zeit wird sie mit anderen Requisiten in einem eigens dafür vorgesehenen Haus im Dorf aufbewahrt.
Natu, le meilleur lutteur son village, porte le dra-peau pendant la fête. Le reste du temps, celui-ci est conservé avec d'autres accessoires dans une case du village réservée à cet effet.

101 A wrestling match in the village of Tolabe. Wrestlers from different Nuba villages have assem-bled in readiness for the traditional festivities.
Ringkampffest im Dorf Tolabe. Die Kämpfer der verschiedenen Nuba-Dörfer kommen zusammen, um sich auf das traditionelle Fest vorzubereiten.
Un concours de lutte à Tolabé. Les lutteurs des divers villages Nouba se rassemblent pour se préparer à la fête traditionnelle.

102 Nuba men crouch on the ground while others sprinkle ash from calabashes on them and the men intone an incantation.
An einer Stelle kauern mehrere Nuba am Boden. Die jungen Männer hinter ihnen, streuen Asche aus Kalebassen über die Gruppe. Hierbei summen die Männer im Chor.
A un endroit, plusieurs Nouba sont accroupis sur le sol. Des jeunes gens font pleuvoir sur eux des cen-dres contenues dans des calebasses et fredonnent en chœur

103 The incantation asks for the blessing of the ancestors for the victory of their best wrestler. The Nuba call this ceremony *tobbo* (prayer).
Die Gruppe erfleht den Segen der Ahnen für den Sieg ihres besten Ringkämpfers. Die Nuba nennen diese Zeremonie *tobbo* (Gebet).
Les jeunes gens prient les ancêtres d'accorder leurs faveurs à leur meilleur lutteur. Les Nouba nomment cette cérémonie le *tobbo* (la prière).

104 Every wrestler can choose his opponent. If the chosen man feels that his challenger is obviously superior, or if he is a friend, he can refuse the bout.
Jeder Kämpfer kann sich seinen Gegner auswählen. Erscheint dem anderen der Herausforderer zu über-legen oder handelt es sich um einen Freund, kann er den Kampf ablehnen.
Chaque lutteur peut choisir son adversaire qui, de son côté, peut refuser de se battre, si celui qui le défie lui semble trop supérieur en force ou s'il s'agit d'un ami.

105 On the way to the wrestling ground. The cala-bashes the Nubian wrestlers have tied to their belts convey a message. The bigger the calabash, the greater the fame of the wrestler. If it breaks, his defeat is as-sured.
Auf dem Weg zum Festplatz. Die Kalebassen, die die Nuba-Kämpfer an ihrem Gürtel tragen, sind ein Fest-schmuck. Je größer die Kalebasse, desto größer der Ruhm des Kämpfers. Zerbricht sie, ist seine Nieder-lage besiegelt.
En route vers la place des fêtes. La calebasse que les lutteurs Nouba portent à la ceinture est une parure de fête. Sa taille correspond à la renommée du lutteur. Si elle se brise, la défaite est irrévocable.

106 Near the wrestling ground the Nuba begin to dance. They stamp their feet on the ground and utter cries intended to imitate the bellow of bulls.
In der Nähe des Kampfplatzes beginnen die Nuba mit ihren Tänzen. Dabei stampfen sie mit den Füßen auf den Boden und stoßen dumpfe Laute aus, mit denen sie die Rufe von Stieren imitieren.
Les Nouba commencent à danser à proximité du ter-rain de lutte. Ils piétinent le sol et émettent des cris sourds imitant le beuglement du taureau.

107 The Nuba call the goatskin "tails" *merre*. Only the strongest wrestlers wear them. These "tails" are very cumbersome while fighting; but the more tails a wrestler wears, the more invincible he feels.
Märre nennen die Nuba den Fellschmuck, den nur die ganz starken Ringkämpfer tragen. Diese Schweife stellen beim Kampf eine beträchtliche Behinderung dar. Je mehr Schweife ein Kämpfer trägt, desto unbe-siegbarer fühlt er sich.
Les Nouba appellent *mèrre* la parure de fourrure réservée aux plus grands lutteurs. Ces queues repré-sentent un handicap considérable pour le lutteur. Plus elles sont nombreuses, plus il se sent invulnéra-ble.

108 The "tails" can be two feet long and are at-tached to a round, woven leather belt. Some wrestlers wear as many as eight of these *merre* and, if they win despite this encumbrance, they are acclaimed all the more by the spectators.
Die Schweife haben zum Teil eine Länge von einem halben Meter und sind an einem runden geflochte-nen Ledergürtel befestigt. Manche Kämpfer tragen bis zu acht Stück davon, siegen sie trotzdem, werden sie umso mehr gefeiert.
Les queues, qui peuvent mesurer 50 cm de long, sont fixées à une ceinture ronde en cuir tressé. Certains lutteurs en portent jusqu'à huit. S'ils réussis-sent malgré tout à vaincre leur adversaire, ils n'en sont que plus fêtés.

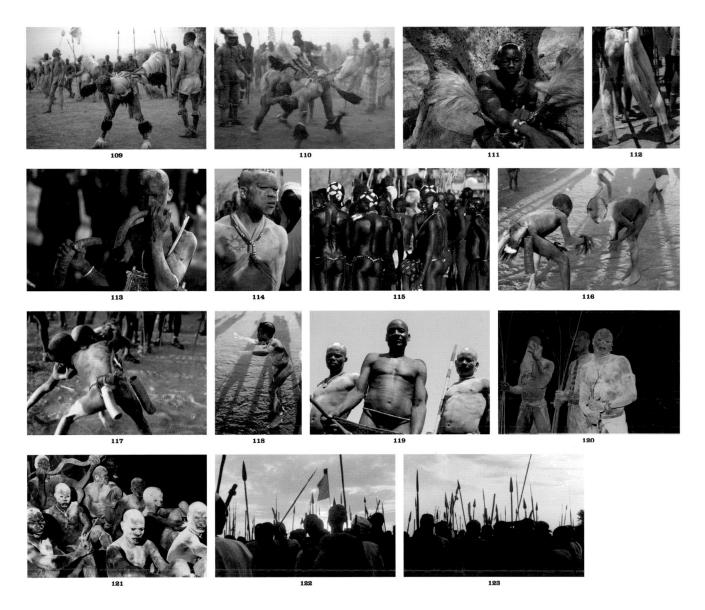

109 This wrestler is preparing, rehearsing a typical attack position.
Dieser Kämpfer bereitet sich vor: Er nimmt die typische Angriffsstellung ein.
Ce lutteur se prépare et adopte la position caractéristique de l'attaque.

110 The bout has begun. The winner is he who throws his opponent down on his back.
Der Kampf hat begonnen. Wer zuerst mit der Rückseite den Boden berührt, hat verloren.
Le combat a commencé. Le premier dont le dos touchera le sol a perdu.

111 *Natu*, the strongest wrestler from Tadoro, hosts a big ringside festivity.
Natu, der stärkste Ringkämpfer aus Tadoro, ist Gastgeber eines großen Ringkampffestes.
Natu, le lutteur le plus fort de Tadoro, a invité les gens à un grand concours de lutte.

112 Every wrestler chooses his own festive garb. This one has chosen a "tail" much like a horse's.
Jeder Ringkämpfer wählt eine andere Festkleidung. Dieser hier hat sich für einen Schweif entschieden, der dem eines Pferdes ähnelt.
Chaque lutteur choisit sa parure de fête. Celui-ci a opté pour une queue qui ressemble à celle d'un cheval.

113 A Nuba blows his *dubberre*, a horn of the kudu (a kind of antelope). These horn blasts signal the beginning and end of a match.
Ein Nuba bläst auf seiner *dubberre*, einem Horn der Kudu-Antilope. Die dumpfen Klänge verkünden Beginn und Ende der Kämpfe.
Un Nouba souffle dans sa *dubberre*, une corne de koudou. Le son étouffé annonce l'ouverture et la fin des combats.

114 One Korongo wrestler watches the bout closely.
Ein Ringkämpfer der Korongo beobachtet konzentriert einen Kampf.
Le lutteur des Korongo observe un combat avec une grande concentration.

115 During the wrestling period, the women avoid any intimacy that might cost their wrestling menfolk their strength. They keep their distance and flirt with their eyes only.
Die Frauen der Ringkämpfer vermeiden während der Zeit der Kämpfe jede intime Berührung, die ihre Männer Kraft kosten könnte. Sie halten Abstand und flirten nur mit den Augen.
A l'époque des combats, les épouses des lutteurs évitent tout geste intime qui pourrait affaiblir leur époux. Elles restent à distance et se contentent de flirter avec les yeux.

116 / 117 / 118 Boys play at wrestling from infancy, imitating the movements of their fathers, brothers and uncles.
Von klein auf üben sich die Jungen spielerisch im Ringkampf. Sie ahmen die Bewegungen ihrer Väter, Brüder oder Onkel nach.
Dès leur plus jeune âge, les garçons apprennent à lutter en jouant. Ils imitent les gestes de leurs pères, de leurs frères ou de leurs oncles.

119 The Nuba take pride in their wrestling abilities, and fight to enjoy the prestige of being exemplary to their tribes.
Die Nuba sind stolze Kämpfer. Sie kämpfen, um innerhalb der Stammesgemeinschaft an Ansehen zu gewinnen.
Les Nouba sont de fiers lutteurs. Ils se battent afin que l'on dise d'eux qu'ils sont des modèles pour leur tribu.

120 Often the bouts go on into the night. These winners are holding their prizes and wiping the perspiration from their faces.
Oft kämpfen die Nuba bis in die Nacht hinein. Die Sieger halten ihren Preis stolz in den Händen und wischen sich den Schweiß aus dem Gesicht.
Les combats durent souvent jusqu'à la tombée de la nuit. Les vainqueurs tiennent leurs prix et essuient la sueur qui ruisselle de leur visage.

121 In the darkness, the ash-covered bodies of the men are like ghostly apparitions. The kudu horn has been blown, the match is over, and the men are resting in exhaustion before returning to their villages.
In der Dunkelheit wirken die eingeaschten Körper gespenstisch. Mit dem Blasen in das Kuduhorn sind die Kämpfe beendet und die Männer warten erschöpft auf die Rückkehr.
Dans l'obscurité, les corps blafards ont l'air fantomatique. La corne de koudou a retenti, les combats sont terminés et les hommes épuisés attendent de rentrer chez eux.

122 / 123 Before dawn the Nuba set off on the homeward stretch, bearing spears and the flag of their village.
Noch vor Morgengrauen treten die Nuba den Heimweg an. In den Händen halten sie ihre Speere und die Fahne des Dorfes.
Les Nouba prennent le chemin du retour avant le lever du soleil, la lance au poing et emportant le drapeau de leur village.

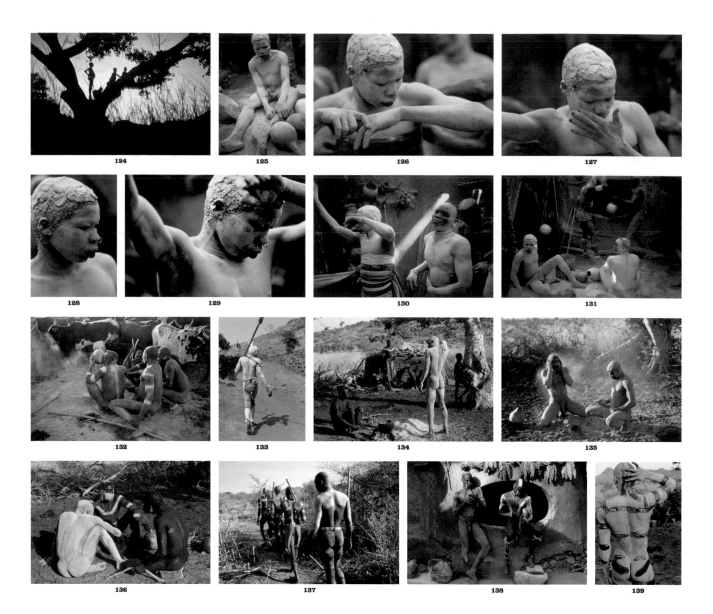

124 The children watch from trees as the wrestling goes on till nightfall.
Die Kinder beobachten von den Bäumen aus die Kämpfe, die bis in die Nacht gehen.
Installés dans les arbres, les enfants contemplent les combats qui durent jusqu'au crépuscule.

125 An important ritual in the life of the Nuba is the initiation of young men. Only the strongest and most skilful wrestlers take part in this ceremony. Today *Dia* from Totsulo will be doing so. He is immersed in deep meditation.
Ein wichtiges Ritual im Leben der Nuba ist die Weihe der Jünglinge. Nur die stärksten und geschicktesten Ringkämpfer erleben diese Zeremonie. *Dia*, aus Totsulo, vollzieht sie heute: Er ist in tiefer Trance versunken.
L'initiation des jeunes garçons est un rituel important chez les Nouba. Seuls les lutteurs les plus forts et les plus habiles participent à cette cérémonie. Aujourd'hui, c'est le tour de *Dia*, de Totsulo. Il est entré en transe.

126 / 127 / 128 For the initiation, youths cover their bodies in ash and their heads with a paste made of ash and cream.
Für die Weihe reibt der Jüngling seinen Körper mit Asche ein und bedeckt den Kopf mit einem Brei aus Rahm und Asche.
Pour la cérémonie, le jeune garçon frotte son corps de cendres et enduit son crâne d'une bouillie de crème et de cendres.

129 Till he dresses, *Dia* is in a trance-like state. For every Nuba man who participates in the ceremony, the initiation ritual is the most important event in his life.
Bis zur Einkleidung befindet sich *Dia* in einem medialen Zustand. Für jeden männlichen Nuba, dem die Weihe zuteil wird, ist sie der Höhepunkt seines Lebens.
Dia se trouve dans un état second jusqu'à ce qu'on l'ait habillé de neuf. L'initiation est l'apogée de l'existence du Nouba.

130 A sunbeam increases the mystical atmosphere of the youth's clothing ceremony. The many lengths of coloured fabric are the festive dress he will now wear in contest against the top wrestlers.
Ein Sonnenstrahl unterstreicht die mystische Atmosphäre bei der Einkleidung des Jünglings. Die bunten Stoffbänder wird er von nun an bei seinen Kämpfen gegen die älteren Ringkämpfer tragen.
Un rayon de soleil souligne l'atmosphère mystique qui baigne la cérémonie. A partir de maintenant, le jeune garçon portera les bandes de tissu multicolores lorsqu'il se mesurera avec les lutteurs plus âgés.

131 Every youth is initiated together with his best friend, who is also covered in white ash head to toe for the ceremony.
Die Weihe erlebt jeder Jüngling mit seinem besten Freund, der sich für diese Zeremonie ebenfalls von Kopf bis Fuß mit weißer Asche bedeckt.
Chaque jeune garçon vit son initiation en compagnie de son meilleur ami qui s'est également frotté de cendre blanche de la tête aux pieds pour la cérémonie.

132 The fighters live in a camp or *zariba* where, as well as tending the livestock, the men have plenty of time for socializing. The camp is for men only, and no women are admitted.
Die Kämpfer leben im Hirtenlager, der *seribe*. Neben der Betreuung der Rinder haben die Männer noch genügend Zeit für ein geselliges Beisammensein. Das Lager ist eine reine Männergemeinschaft, Frauen dürfen es nicht betreten.
Les lutteurs vivent au camp des bergers, le *séribé*, où les femmes n'ont pas le droit de pénétrer. Même si le bétail demande beaucoup de soins, les hommes ont assez de temps pour s'amuser ensemble.

133 *Gogo* is from the Korongo mountains. There too, young men live in a *zariba*. They are seen as the strongest fighters in all the Nubian mountains.
Gogo stammt aus den Korongo-Bergen. Auch dort leben die jungen Männer in der *seribe*. Sie gelten als die stärksten Kämpfer der Nuba-Berge.
Gogo est originaire des monts Korongo. Là aussi, les jeunes gens vivent dans le *séribé*. On dit qu'ils sont les meilleurs lutteurs des monts Nouba.

134 The *zariba* is almost always a few miles from its village. The men live in seclusion from the village community, in order to prepare in peace and quiet for the traditional wrestling matches.
Das Hirtenlager ist fast immer einige Kilometer von den Dörfern entfernt. Die Männer leben hier abgeschieden von der Dorfgemeinschaft, um sich in Ruhe auf die traditionellen Ringkämpfe vorzubereiten.
Le camp des bergers est toujours situé à quelques kilomètres des villages. Ici, les hommes vivent à l'écart de la communauté villageoise pour se préparer en toute tranquillité aux concours de lutte traditionnels.

135 As an outward sign that they live in the *zariba*, the young wrestlers cover themselves in white ash. This has its practical side: ash cools the skin and affords protection from the sun and from vermin.
Um auch äußerlich zu zeigen, dass sie *seribe*-Bewohner sind, bedecken sich die jungen Kämpfer mit weißer Asche. Das hat auch einen praktischen Nutzen: Die Asche kühlt die Haut und schützt vor Sonne und Ungeziefer.
Pour bien montrer qu'ils habitent au *séribé*, les jeunes lutteurs frottent leur corps de cendre blanche. Cette pratique est utile, car la cendre rafraîchit la peau et la protège du soleil et des parasites.

136 Visitors from a neighbouring *zariba* are given dura porridge to eat.
Besucher aus einer benachbarten *seribe* werden mit Durabrei bewirtet.
Les habitants du *séribé* voisin en visite sont invités à partager la durra.

137 At times the young wrestlers visit their families, but in the evenings they return to the *zariba*.
Ab und zu besuchen die jungen Ringkämpfer ihre Familien. Abends kehren sie in die *seribe* zurück.
De temps en temps, les jeune lutteurs vont rendre visite à leurs familles. Le soir, ils rentrent au *séribé*.

138 In the inner courtyard of a house compound, two young Nuba play the lyre.
Im Innenhof eines Hauses spielen zwei junge Nuba auf der Leier.
Deux jeunes Nouba jouent de la lyre dans la cour intérieure d'une habitation.

139 Lines are applied to the ash-covered body with cream. These lines have no ritual significance and are merely decorative.
Linien auf dem eingeaschten Körper werden mit zu Rahm geschlagener Milch aufgetragen. Diese hier haben keine kultische Bedeutung, sie sollen nur den Körper schmücken.
Des lignes sont tracées en crème de lait sur le corps cendré. Elles n'ont aucune signification rituelle et sont uniquement décoratives.

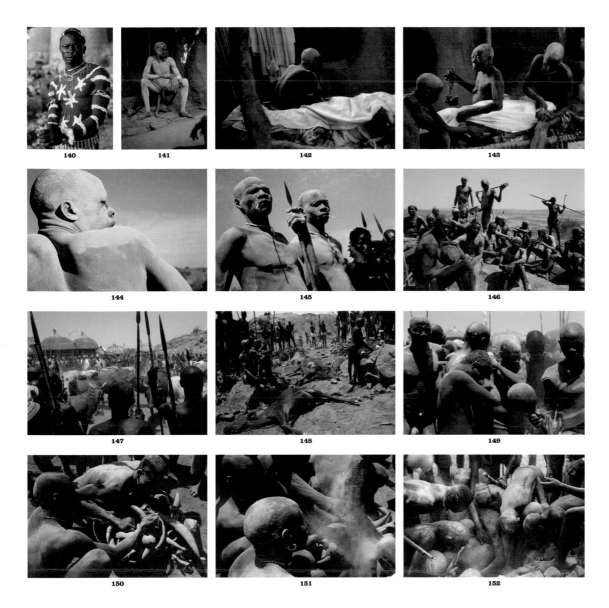

140 The white stars on the body express grief. *Natu* has lost a friend from the *zariba*.
Die weißen Sterne auf dem Oberkörper sind Symbole der Trauer. *Natu* hat einen Freund aus der *seribe* verloren.
Les étoiles blanches sur la poitrine de *Natu* indiquent qu'il est en deuil. Il a perdu un ami du *séribé*.

141. *Napi*, a wrestler, died of the bite of a venomous snake. While his body is prepared for burial, many Nuba gather outside his house. As a sign of mourning, they have covered their bodies with ash.
Der Ringkämpfer *Napi* ist am Biss einer giftigen Schlange gestorben. Während er für die Bestattung vorbereitet wird, versammeln sich vor seinem Haus viele Nuba. Zum Zeichen der Trauer haben sie ihre Körper mit Asche bedeckt.
Le lutteur *Napi* est mort de la piqûre d'un serpent venimeux. Pendant qu'on l'apprête pour l'inhumation, de nombreux Nouba se rassemblent devant sa case. En signe de deuil, leur corps est recouvert de cendres.

142 / 143 The mother of the deceased sings a dirge and holds over his body the rattles he wore when wrestling, while the womenfolk of the family enshroud the body in white linen for interment.
Die Mutter des Verstorbenen singt das Klagelied und schwingt über dem Toten die Glocken, die er bei seinen Ringkampffesten getragen hat. Währenddessen wickeln ihn seine Freunde für die Beisetzung in ein weißes Leinentuch.
La mère de *Napi* a entonné la complainte funèbre et fait sonner au-dessus du défunt les cloches qu'il a portées pendant les concours de lutte. Pendant ce temps, ses amis l'enveloppent dans un drap de lin blanc.

144 Whitened in this way, this Nuba wrestler has something of a stone monument.
In seiner weißen Bemalung wirkt dieser Nuba-Ringer wie ein steinernes Denkmal.
Avec son corps blanchi à la cendre, ce lutteur Nouba évoque une statue de pierre.

145 Those who cover themselves with white ash for the funeral are indicating that they are close relatives or friends of the deceased.
Wer sich zur Totenfeier mit weißer Asche bestäubt, zeigt, dass er ein naher Verwandter oder ein enger Freund des Toten ist.
Celui qui se couvre le corps de cendre blanche pour la cérémonie funèbre montre qu'il est un parent proche ou un grand ami du mort.

146 The friends of *Napi*, his relatives, and mourners from neighbouring villages, have assembled and are waiting for the funeral ceremony to begin.
Napis Freunde, seine Verwandten und Trauernde aus benachbarten Dörfern haben sich versammelt und warten auf den Beginn der Totenfeier.
Les amis de *Napi*, sa famille et les gens éplorés des villages voisins se sont rassemblés et attendent le début de la cérémonie funèbre.

147 Outside the deceased's house, on which a white flag flies, a circle is formed into which cattle are driven. Since the Nuba believe in the immortality of the soul, the livestock are sacrificed to the dead.
Vor dem Totenhaus, auf dem eine weiße Fahne weht, hat sich ein Kreis gebildet, in den Rinder getrieben werden. Da die Nuba an die Unsterblichkeit der Seele glauben, werden die Tiere den Toten geopfert.
Devant la case de *Napi* sur laquelle flotte un drapeau blanc, les hommes forment un cercle dans lequel on rabat les bovins qui seront sacrifiés au défunt, car les Nouba croient à l'immortalité de l'âme.

148 The cattle are killed with a thrust of a spear, and the meat eaten by friends and distant relatives. Those of the deceased's own clan do not partake of the sacrificial meat.
Das Fleisch der mit dem Speer getöteten Rinder wird an Freunde und entfernte Verwandte verteilt. Die nahen Verwandten des Toten essen nichts von den geopferten Tieren.
Les bovins ont été tués d'un coup de lance. Leur viande est distribuée aux amis et aux parents éloignés. Les parents proches du défunt ne mangent pas la chair des animaux sacrifiés.

149 The grief of the Nuba at the death of the departed is real and profound. Both men and women weep unrestrainedly.
Der Schmerz der Nuba um ihre Toten ist echt und tief empfunden. Hemmungslos weinen Männer und Frauen.
La douleur des Nouba est authentique et profonde. Les hommes et les femmes pleurent leurs morts sans retenue.

150 Close to the grave, a memorial place is created, where wrestling matches will be held in future years in memory of the deceased. The cattle horns contain the ash which *Napi* had kept from his burnt victory branches.
Wenige Meter neben dem Grab wird eine Gedenkstätte errichtet, an der in den nächsten Jahren zu Ehren des Toten Ringkampffeste ausgetragen werden. Die Rinderhörner enthalten die Asche von *Napis* verbrannten Siegerzweigen.
Un lieu commémoratif est aménagé à quelques mètres de la tombe. Les concours de lutte y auront lieu dans les années à venir en l'honneur du mort. Les cornes de vaches contiennent la cendre des branches d'acacia que *Napi* avait gagnées à l'issue des concours.

151 The ash is strewn in the hollow where the horns will be buried.
Die Asche wird in die Grube gestreut, in der die Hörner vergraben werden.
La cendre est dispersée dans le fossé dans lequel les cornes seront enterrées.

152 / 153 Before the hollow is filled in, the Nuba throw themselves to the ground and plunge their hands in, in order to touch the deceased one last time through the medium of the ash.
Bevor die Gedenkstätte zugeschüttet wird, werfen sich die Nuba darüber und greifen tief in das Erdloch, um zum letzten Mal, durch das Medium der Asche, einen Kontakt mit dem Toten herzustellen.
Avant de combler le lieu commémoratif, les Nouba se jettent sur le sol et plongent les bras dans le trou pour tenter une dernière fois, par le biais de la cendre, d'entrer en contact avec le mort.

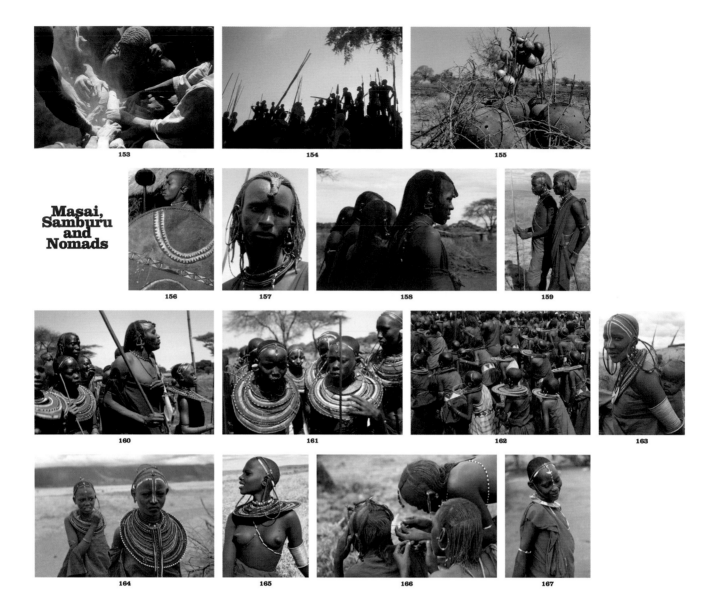

153

154

155

Masai, Samburu and Nomads

156

157

158

159

160

161

162

163

164

165

166

167

154 The mourners wait in reverent, compassionate silence till nightfall.

Die Besucher der Totenfeier verharren still und voller Anteilnahme bis zum Einbruch der Dunkelheit.

Ceux qui ont assisté à la cérémonie funèbre participent à la douleur de la famille et restent debout en silence, jusqu'à la tombée de la nuit.

155 The grave is adorned with large pots, calabashes and broken spear shafts. The spear tips are preserved in the homes of relatives in remembrance of the deceased. A thorn hedge is planted around the grave to keep off marauding animals.

Das Grab ist mit großen Tontöpfen, Kalebassen und abgebrochenen Speerenden geschmückt. Die Speerspitzen werden zum Andenken an den Toten in den Häusern der Verwandten aufbewahrt. Die Dornenhecke um den Grabhügel soll das Grab vor Tieren schützen.

Des jarres, des calebasses et des hampes de lances brisées décorent la tombe. Les fers de lance sont conservés dans les cases des membres de la famille en souvenir du défunt. Les branches épineuses qui entourent la tombe doivent la protéger des animaux.

Masai, Samburu and Nomads
Masai, Samburu und Nomaden
Massaï, Samburu et nomades

156 A *moran*, a Masai warrior from Kenya, with spear and shield. The ball of clipped ostrich feathers fixed on the spear-tip indicates that he has no warlike intent.

Ein *moran*, ein Masai-Krieger aus Kenia, mit Speer und Schild. Die auf der Speerspitze befestigte Kugel aus gestutzten Straußenfedern bedeutet, dass er keine kriegerische Absicht hegt.

Un *moran*, un guerrier Massaï du Kenya avec son bouclier et sa lance. La boule de plumes d'autruche taillées fixée au sommet de celle-ci indique qu'il n'a pas d'intention belliqueuse.

157 A Masai with bead ornaments. These proud warriors have strikingly feminine facial features.

Ein Masai mit Perlenschmuck. Auffallend sind die feinen Gesichtszüge dieser stolzen Krieger.

Un Massaï et sa parure de perles. On remarque les visages aux traits délicats de ces fiers guerriers.

158 The characteristic hairstyle of a Masai man is worn for nine years. After that time, his head is shaven at a great ceremony. He is then no longer a member of the warrior caste but is numbered among the elders and may have a family.

Die Zopffrisur trägt ein Masai-Mann neun Jahre lang. Nach Ablauf dieser Zeit wird ihm während einer großen Zeremonie der Kopf kahl geschoren. Er gehört dann nicht mehr zur Kriegerkaste, sondern zu den Älteren und kann Familienvater werden.

Un Massaï porte sa coiffure nattée caractéristique pendant neuf ans. Ensuite sa tête sera rasée au cours d'une grande cérémonie. A l'issue de celle-ci, il ne fait plus partie de la caste des guerriers mais des anciens et peut devenir père de famille.

159 The helmet hairstyle using red mud is like a beauty pack for the hair. The oil it contains makes the hair soft so that it can be plaited better. A hairstyle of this kind is worn for about two weeks.

Die Helmfrisur aus rotem Lehm ist für das Haar wie eine Schönheitspackung. Das enthaltene Öl macht die Haare weich, so dass sie sich besser flechten lassen. Eine solche Frisur wird ungefähr vierzehn Tage lang getragen.

L'argile rouge qui enduit les cheveux est une véritable cure de beauté. L'huile qu'elle contient rend les cheveux souples et plus faciles à tresser. Ce genre de coiffure est porté une quinzaine de jours.

160 Warriors and girls at a dance during a ceremony.

Krieger und Mädchen beim Tanz während einer Zeremonie.

Un guerrier et une fillette pendant la danse au cours d'une cérémonie.

161 All Masai women wear these colourful circular ornaments around their necks.

Alle Masai-Frauen tragen diesen farbenfrohen tellerförmigen Halsschmuck.

Toutes les femmes Massaï portent autour du cou cette large parure circulaire aux couleurs vives.

162 For major ceremonies, hundreds of Masai will assemble. For hours they dance rhythmically till they enter a state of trance.

Bei großen Zeremonien strömen die Masai zu Hunderten zusammen. Über Stunden steigern sie sich so in ihre rhythmischen Tänze, dass viele von ihnen in Trance verfallen.

Les cérémonies importantes rassemblent des centaines de Massaï. Pendant des heures, ils se laissent tellement emporter par le rythme des danses qu'ils sont nombreux à entrer en transe.

163 This young mother is carrying her baby on her back, as is customary among many indigenous peoples the world over.

Diese junge Mutter trägt ihr Baby, wie bei vielen eingeborenen Stämmen üblich, auf dem Rücken.

Une jeune mère porte son enfant sur le dos, comme c'est la coutume dans de nombreuses tribus.

164 Unlike the warriors, the Masai girls and women are shaven-headed.

Im Gegensatz zu den Häuptern der Krieger sind die Köpfe der Masai-Mädchen und -Frauen geschoren.

Les jeunes filles et les femmes Massaï ont la tête rasée contrairement aux guerriers.

165 The young, unmarried women enjoy great freedom. Before marriage they can have numerous lovers without risking either their honour or their prospects of marriage.

Die jungen, unverheirateten Frauen genießen große Freiheiten. Sie können vor der Ehe mehrere Liebhaber haben, ohne deshalb Ehre oder Heiratschancen aufs Spiel zu setzen.

Les jeunes femmes célibataires jouissent d'une grande liberté. Elles peuvent avoir plusieurs amants avant de se marier sans compromettre leur réputation ou réduire leurs chances de trouver un époux.

166 When a Masai is made a warrior, which is an honour, he lets his hair grow and has it braided into fine plaits by other warriors. The women never dress the warriors' hair.

Wenn ein Masai die Kriegerwürde erhält, lässt er sein Haar wachsen und von anderen Kriegern zu ganz feinen Zöpfen flechten. Die Frauen frisieren die Krieger nie.

Quand un Massaï acquiert le statut de guerrier, il se laisse pousser les cheveux et les autres guerriers lui font des nattes très fines. Les femmes ne coiffent jamais les guerriers.

167 A young Masai girl, whose main duty is to look after her little siblings.

Ein junges Masai-Mädchen, dessen Hauptaufgabe es ist, sich um die kleinen Geschwister zu kümmern.

Une fillette Massaï, dont la tâche principale est de veiller sur ses frères et sœurs plus jeunes.

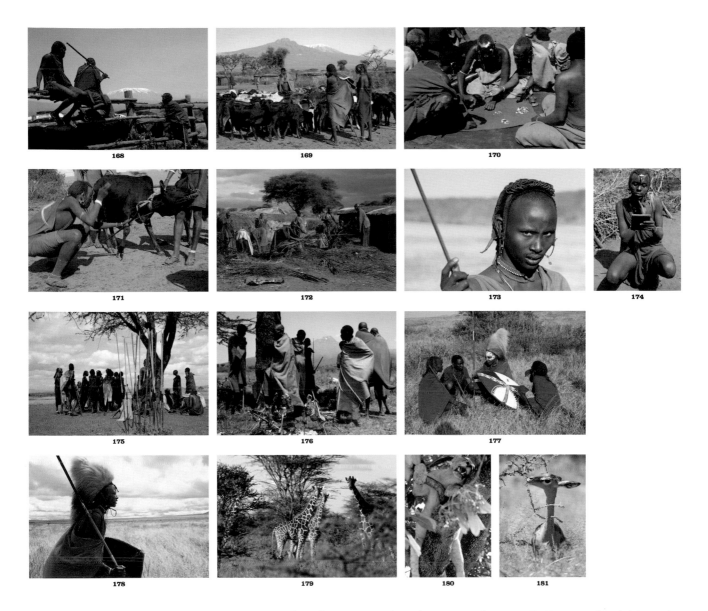

168 Masai at a kraal, with Kilimanjaro in the background. Cattle are sacred to the Masai and are central to their life and religion. Often their favourite animals mean more to them than the most beautiful of women.
Masai vor einem Kral, im Hintergrund der Kilimandscharo. Rinder sind den Masai heilig, sie stehen im Mittelpunkt ihres Lebens und ihrer Religion. Die Lieblingstiere bedeuten ihnen oft mehr als die schönsten Frauen.
Des Massaï devant un kraal; au loin on aperçoit le Kilimandjaro. Le bétail est sacré aux yeux des Massaï, il est le centre de leur existence et de leur religion. Ils attachent souvent plus d'importance à leurs animaux préférés qu'aux plus jolies femmes.

169 The cattle are rounded up to extract blood. The warriors' favourite drink is fresh cattle blood half-diluted with milk. They believe this nutrition gives them especial strength.
Die Rinder werden zusammengetrieben, um eine Blutentnahme vorzunehmen. Das Lieblingsgetränk der Krieger ist frisches Rinderblut zur Hälfte mit Milch gemischt. Sie glauben, durch diese Nahrung besonders stark zu werden.
Le bétail est rassemblé pour être saigné. Le sang frais mélangé à autant de lait est la boisson préférée des guerriers. Ils croient que cette nourriture leur donne une vigueur particulière.

170 Masai men being counselled by a *laibon*, the high priest and leader of a Masai group, to whom magical powers are attributed. He is identifiable by the white mark on his forehead.
Masai-Männer lassen sich von einem *laibon* beraten. Diesem hohen Priester und Anführer einer Masai-Gruppe werden magische Kräfte nachgesagt. Er ist am weißen Zeichen auf seiner Stirn zu erkennen.
Des Massaï demandent conseil à un *laibon*, le grand prêtre, devin et guérisseur du groupement Massaï. Il est reconnaissable à la marque blanche qui orne son front.

171 To draw blood, the animal's carotid artery is tied and then opened with a spear-tip.
Zur Blutentnahme wird die Halsschlagader des Tieres abgeschnürt und anschließend mit einer Pfeilspitze geöffnet.
Pour saigner l'animal, on ligature la veine jugulaire et on la perce avec une pointe de flèche.

172 Masai women preparing a move. The Masai are nomads and move on as soon as their herds of cattle have exhausted their grazing grounds.
Masai-Frauen, die einen Umzug vorbereiten. Die Masai sind Nomaden. Sie ziehen weiter, sobald die Rinderherden ihre Weiden abgegrast haben.
Les femmes Massaï préparent le départ. En effet, les Massaï sont des nomades et quittent les lieux quand leurs troupeaux ont brouté toute l'herbe.

173 This warrior was full of scepticism for the photographer, but never batted an eyelid when he passed a lion's den.
Dieser Krieger stand der Fotografin mit großer Skepsis gegenüber, bevor er völlig unbeeindruckt eine Löwengrube passierte.
Ce guerrier a jeté un regard très sceptique à la photographe mais est passé sans broncher à côté d'une fosse aux lions.

174 Young Masai warriors place great value upon their appearance. This youth is painting his face with a mixture of oil and ground ochre.
Junge Masai-Krieger legen großen Wert auf ihr Aussehen. Mit einem Gemisch aus Öl und zerriebenem Ockergestein bemalt dieser Jüngling sein Gesicht.
Les jeunes guerriers Massaï attachent une grande importance à leur apparence. Cet adolescent enduit son visage d'un mélange d'huile et d'ocre pilé.

175 A gathering of Masai warriors at the preparations for festivities.
Versammlung von Masai-Kriegern bei der Vorbereitung für ein Fest.
Des guerriers Massaï se rassemblent pour préparer des festivités.

176 Masai warriors in a cattle kraal.
Masai-Krieger in einem Rinderkral.
Des guerriers Massaï dans un kraal.

177 A group of Masai warriors before a lion hunt in Tanzania. A lion has attacked the herd of cattle and taken a calf. The warriors plan to pursue the lion and kill it with their spears.
Eine Gruppe von Masai-Kriegern vor einer Löwenjagd in Tansania. Ein Löwe ist in die Rinderherde eingebrochen und hat ein Kalb gerissen. Die Krieger werden ihn verfolgen und anschließend mit ihren Speeren töten.
Des guerriers Massaï s'apprêtent à partir à la chasse aux lions en Tanzanie. Un lion a attaqué le troupeau et tué un veau. Les guerriers vont le suivre et l'abattre à coups de lance.

178 A Masai warrior in the vast bush, hunting a lion. Only a hunter who has killed a lion with a spear, unassisted by any other huntsman, may wear the lion's mane on his head.
Ein Masai-Krieger in der weiten Steppe auf Löwenjagd. Die Löwenmähne auf dem Kopf darf nur tragen, wer ohne Hilfe eines Jagdgefährten einen Löwen mit seinem Speer erlegt hat.
Un guerrier Massaï chasse le lion dans la savane qui s'étend à perte de vue. Seul celui qui a tué de sa lance un lion sans l'aide d'un compagnon de chasse peut porter la crinière de l'animal sur sa tête.

179 Giraffes and spreading acacias are the hallmark of the East African landscape. Giraffes live in large herds, and can even defend themselves against lions with their hooves.
Giraffen und Schirmakazien sind das Wahrzeichen der ostafrikanischen Landschaft. Die Tiere leben in großen Herden und können sich dank ihrer Hufe auch gegen Löwen verteidigen.
Les girafes et les acacias parasols caractérisent les paysages d'Afrique orientale. Les animaux vivent en troupeaux et savent se défendre – les lions craignent leurs sabots.

180 A lioness is sleeping at a safe height above the ground.
Eine Löwin schläft in sicherer Höhe.
Une lionne s'est endormie à bonne hauteur.

181 A gerenuk looking for something to eat.
Ein Gerenuk auf Nahrungssuche.
Une gazelle girafe en quête de nourriture.

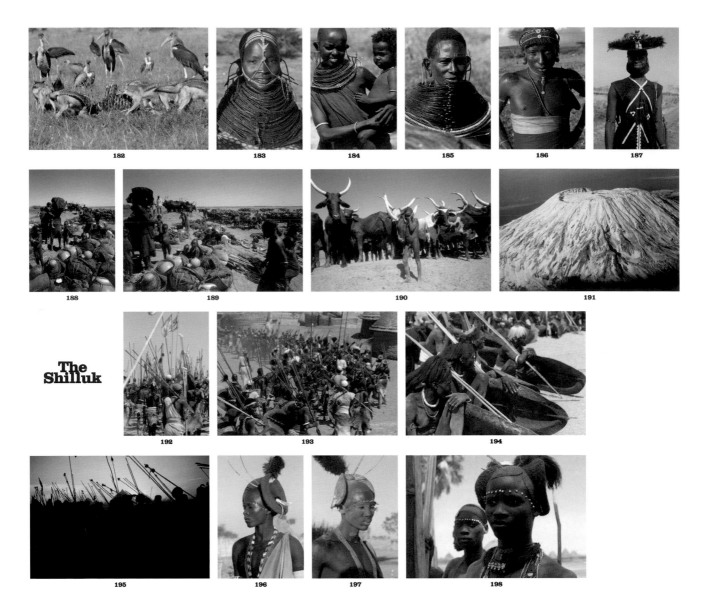

182 – 187: (row of photographs)

188 – 191: (row of photographs)

The Shilluk

192 – 194: (row of photographs)

195 – 198: (row of photographs)

182 Jackals, vultures and marabous share what is left of a lion's meal.

Schakale, Geier und Marabus teilen sich die Reste einer Löwenmahlzeit.

Les chacals, les vautours et les marabouts se partagent les vestiges du repas d'un lion.

183 A Samburu girl. The Samburu are related to the Masai. They too are a people who tend herds. They live in northern Kenya.

Samburu-Mädchen. Die Samburu sind Verwandte der Masai. Auch sie sind ein Hirtenvolk und leben im Norden Kenias.

Une fillette Samburu. Les Samburu, un peuple pasteur, vivent au nord du Kenya et sont apparentés aux Massaï.

184 The women and girls adorn themselves with unusually large and lovely neck ornaments consisting of numerous bead necklaces.

Die Mädchen und Frauen schmücken sich mit einem ungewöhnlich großen und schönen Halsschmuck, der aus vielen Perlenketten besteht.

Les jeunes filles et les femmes portent de nombreux colliers de perles qui forment tous ensemble une parure exceptionnelle.

185 The neck ornament of this Samburu woman is elephant hair, which means that she ejoys high standing in her tribe.

Der Halsschmuck dieser Samburu-Frau ist aus Elefantenhaar, was bedeutet, dass sie hohes Ansehen in ihrem Stamm genießt.

Le collier de cette femme Samburu est en poils d'éléphant, ce qui signifie qu'elle jouit d'un grand crédit dans sa tribu.

186 Samburu youth.

Samburu-Jüngling.

Un adolescent Samburu.

187 A medicine man of the Falata nomads, in the southern Sudan.

Ein Medizinmann der Falata-Nomaden, sie leben im südlichen Sudan.

Un guérisseur Falata. L'ethnie Falata est composée de nomades vivant dans le sud du Soudan.

188 / 189 Falata nomads on the White Nile. They are forever on the move, looking for suitable pasture and water holes for their immense herds of livestock. These are affluent nomads. Not only the women but also the children wear genuine gold and silver bands on their arms and legs.

Falata-Nomaden am Weißen Nil. Sie sind immer auf Wanderschaft, um für ihre riesengroßen Tierherden geeignete Wasser- und Weideplätze zu suchen. Diese Nomaden sind reich. Nicht nur die Frauen, sondern auch die Kinder tragen echte Gold- und Silberreifen an Armen und Beinen.

Des Falata sur les rives du Nil blanc. Ces nomades sont toujours à la recherche de pâturages et de points d'eau adaptés à leurs troupeaux gigantesques. Ils sont riches: les femmes, mais aussi les enfants, portent des anneaux d'or et d'argent aux bras et aux chevilles.

190 The Falata nomads take pride in breeding cattle with as daunting horns as possible. A single extended family's herd may often number as many as a thousand head of cattle.

Der Stolz der Falata-Nomaden ist es, Rinder zu züchten, die möglichst gewaltige Hörner haben. Die Herde einer Großfamilie zählt oft bis zu tausend Rindern.

Les cornes colossales des vaches qu'ils élèvent font toute la fierté des Falata. Un clan possède souvent jusqu'à mille têtes de bétail.

191 Fresh snowfall on the peak of Kilimanjaro, photographed from a plane.

Der mit Neuschnee bedeckte Gipfel des Kilimandscharo aus dem Flugzeug fotografiert.

Le sommet enneigé du Kilimandjaro photographié de l'avion.

The Shilluk
Die Schilluk
Les Shilluk

192 A Shilluk ceremonial procession in honour of their king. The Shilluk are the only tribe in the Sudan to have been a monarchy since primeval times.

Ein Festzug der Schilluk zu Ehren ihres Königs. Die Schilluk sind der einzige Stamm im Sudan, der seit Urzeiten in einer Monarchie lebt.

Le cortège des Shilluk en l'honneur de leur roi. Les Shilluk sont la seule ethnie du Soudan à vivre en monarchie depuis l'aube des temps.

193 The Shilluk tribe number about 100,000. Despite their highly developed warrior abilities, they are of a very friendly disposition.

Der Stamm der Schilluk zählt ungefähr 100 000 Menschen. Trotz ihrer stark ausgeprägten kriegerischen Fähigkeiten, haben sie ein sehr freundliches Wesen.

L'ethnie Shilluk compte environ 100 000 personnes. Bien que montrant un talent marqué pour l'art de la guerre, ils ont un naturel fort aimable.

194 Almost all Shilluk fighters possess these large defensive shields made of crocodile leather. For the festivities, the men wear wigs of monkey hair.

Fast alle Schilluk-Krieger besitzen diese großen Verteidigungsschilde, die aus Krokodilleder gefertigt sind. Die Männer tragen anlässlich des Festes eine Perücke aus Affenhaaren.

Presque tous les guerriers Shilluk possèdent ces grands boucliers en cuir de crocodile. A l'occasion des réjouissances, les hommes portent des perruques en poil de singe.

195 The festivities of the spear-bearing fighters go on till night has fallen.

Die mit langen Speeren bewaffneten Krieger feiern bis zum Anbruch der Dunkelheit.

Armés de longues lances, les guerriers fêtent jusqu'à la tombée de la nuit.

196 The favourite son of the late Shilluk king, *Kur*.

Der Lieblingssohn des verstorbenen Schilluk-Königs *Kur*.

Le fils préféré de *Kur*, le roi Shilluk défunt.

197 All the fighters of the Shilluk tribe wear animal hair wigs interwoven with their own hair and ostrich-feather adornment. After a while, the wig is replaced by a new, larger one.

Alle Krieger des Schilluk-Stammes tragen Perücken aus Tierhaaren, die mit ihrem eigenen Haar verknüpft und mit Straußenfedern geschmückt werden. Nach einiger Zeit wird die Perücke gegen eine neue, größere ausgetauscht.

Tous les guerriers de l'ethnie Shilluk portent des perruques en poils d'animaux nouées à leurs propres cheveux et décorées de plumes d'autruche. Au bout de quelque temps, cette perruque est échangée contre une nouvelle, plus grande.

198 All the Shilluk men and women have the tribal tattoo on their foreheads, resembling a string of beads. These fighters have heightened the decorative effect of their tattoos with white paint.

Die Schilluk-Männer und -Frauen tragen als Stammeszeichen eine Tätowierung auf der Stirn, die wie eine Perlenkette aussieht. Diese Krieger haben ihre Tätowierung durch weiße Farbe noch dekorativer gemacht.

Tous les Shilluk, hommes et femmes, portent sur le front une scarification en forme de rangée de perles qui signale leur appartenance ethnique. Ces guerriers l'ont rendue encore plus décorative à l'aide de couleur blanche.

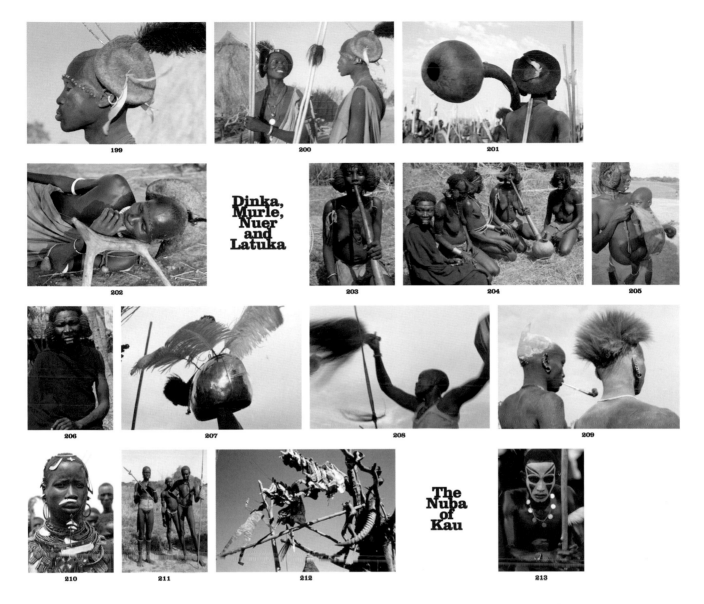

199

200

201

**Dinka,
Murle,
Nuer
and
Latuka**

202

203

204

205

206

207

208

209

210

211

212

**The
Nuba
of
Kau**

213

199 The artistic hairstyle and his striking profile lend this fighter a statue-like quality.
Durch die kunstvolle Frisur und das markante Profil wirkt dieser Krieger wie eine Statue.
Sa coiffure sophistiquée et son profil marquant donnent à ce guerrier l'air d'une statue.

200 / 201 Like the Masai, Dinka and Nuer, the Shilluk are a Nilotic people. They are nomads originating in Egypt, and in times long past they settled north-west of Malakal on the fertile banks of the Nile to keep livestock, fish, and till the land.
Die Schilluk gehören ebenso wie die Masai, Dinka und Nuer zu den Niloten. Sie sind Nomaden, die aus Ägypten stammen und sich vor langer Zeit nordwestlich von Malakal an den fruchtbaren Ufern des Nils als Viehzüchter, Fischer und Bauern niedergelassen haben.
Les Shilluk sont des Nilotes, à l'instar des Massaï, Dinka et Nuer. Nomades originaires d'Egypte, ils se sont établis comme éleveurs, pêcheurs et agriculteurs, il y a longtemps de cela au nord-ouest de Malakal sur les rives fertiles du Nil.

202 So that his elaborately styled hair will remain in shape, this Shilluk fighter is sleeping on a specially made wooden frame.
Damit die ausladende Haartracht ihre Form behält, schläft dieser Schilluk-Krieger auf einem extra hierfür angefertigten Holzgestell.
Pour préserver la forme de sa coiffure volumineuse, ce guerrier Shilluk dort en utilisant un appui-tête conçu à cet effet.

Dinka, Murle, Nuer and Latuka
Dinka, Murle, Nuer und Latuka
Dinka, Murle, Nuer et Latuka

203 Murle woman with hookah. The Murle people live in south-eastern Sudan near the Ethiopian border. The region is rendered difficult of access by marshlands that extend unbroken for kilometres.
Murle-Frau mit Wasserpfeife. Der Stamm der Murle lebt im Südosten des Sudan in der Nähe der äthiopischen Grenze. Das Gebiet ist durch kilometerlange Sumpfgebiete schwer zugänglich.
Une femme Murle fumant la pipe. Les Murle vivent au sud-est du Soudan près de la frontière éthiopienne. Entouré de marécages sur plusieurs kilomètres, leur territoire est difficilement accessible.

204 The Murle are extremely fond of smoking their large kind of hookah or water-pipe. They are friendly and open towards strangers.
Die Murle rauchen leidenschaftlich gern große Wasserpfeifen. Fremden gegenüber sind sie freundlich und aufgeschlossen.
Les Murle adorent fumer et utilisent de grandes pipes à eau. Ils se montrent accueillants et aimables envers les étrangers.

205 / 206 All the female members of the tribe wear a fairly heavy head-dress of blue beads secured with a leather strap.
Alle weiblichen Stammesmitglieder tragen einen Kopfschmuck aus blauen Perlen, der ziemlich schwer ist und durch einen Lederriemen gehalten werden muss.
Toutes les femmes de la tribu portent sur la tête une parure de perles bleues relativement lourde et suspendue à une lanière de cuir.

207 The metal helmet of a Latuka fighter. These helmets are lined with felt and are individually crafted to fit each fighter.
Der Metallhelm eines Latuka-Kämpfers. Diese Helme sind innen mit Filz gefüttert und werden für jeden Kämpfer maßgerecht angefertigt.
Le casque de métal d'un guerrier Latuka. Les casques sont doublés de feutre et fabriqués sur mesure.

208 The Latuka live in south-eastern Sudan. The fighters are greatly feared for their strength and bravery.
Die Latuka leben im südöstlichen Gebiet des Sudan. Die Krieger sind wegen ihrer Kraft und ihres Mutes außerordentlich gefürchtet.
Les Latuka vivent au sud-est du Soudan. Les guerriers sont extrêmement redoutés pour leur force et leur courage.

209 Two Nuer. As with the Dinka, their brows are ornamented with cicatrices. Their hair is bleached with cow dung.
Zwei Nuer. Ähnlich wie bei den Dinka ist ihre Stirn durch Schmucknarben gezeichnet. Die Haare bleichen sie mit Kuhmist.
Deux Nuer. Comme les Dinka, leurs fronts sont ornés de scarifications. Ils se décolorent les cheveux à l'aide de bouse de vache.

210 Dinka woman with wedding jewellery.
Dinka-Frau mit Hochzeitsschmuck.
Une femme Dinka en parure de noces.

211 Dinka from southern Sudan with their traditional bead belts. Taking this picture was the only occasion in all her African travels when the photographer was in mortal danger from the indigenous peoples.
Dinka aus dem südlichen Sudan mit ihrem traditionellen Perlengürtel. Bei dieser Aufnahme war die Fotografin das einzige Mal während ihrer Afrikareisen durch Eingeborene in Lebensgefahr.
Des Dinka du Soudan méridional portant leur ceinture de perles traditionnelle. La photographe vit ici pour la première fois durant ses voyages en Afrique son existence menacée par les autochtones.

212 These objects are used by the Latuka for rituals at their festivities.
Diese Gegenstände verwenden die Latuka für rituelle Handlungen bei ihren Festen.
Les Latuka utilisent ces petits fétiches pendant leurs fêtes.

The Nuba of Kau
Die Nuba von Kau
Les Nouba de Kau

213 A Nuba with a painted face. The Nuba of Kau belong to the South East Nuba, for they live in the south-eastern part of the Sudanese province of Kordofan. This tribe has little in common with the Mesakin Quissayr Nuba, and the language spoken is different.
Ein Nuba mit Gesichtsbemalung. Die Nuba von Kau gehören zu den Südost-Nuba, denn sie leben im südöstlichen Teil der sudanesischen Provinz Kordofan. Dieser Stamm hat nur wenig mit den Masakin-Qisar-Nuba gemein, er spricht auch eine andere Sprache.
Un beau masque. Les Nouba de Kau font partie des Nouba du Sud-Est, car ils vivent au sud-est de la province soudanaise Kordofan. Cette tribu a peu de choses en commun avec les Masakin-Qisar et sa langue est différente de la leur.

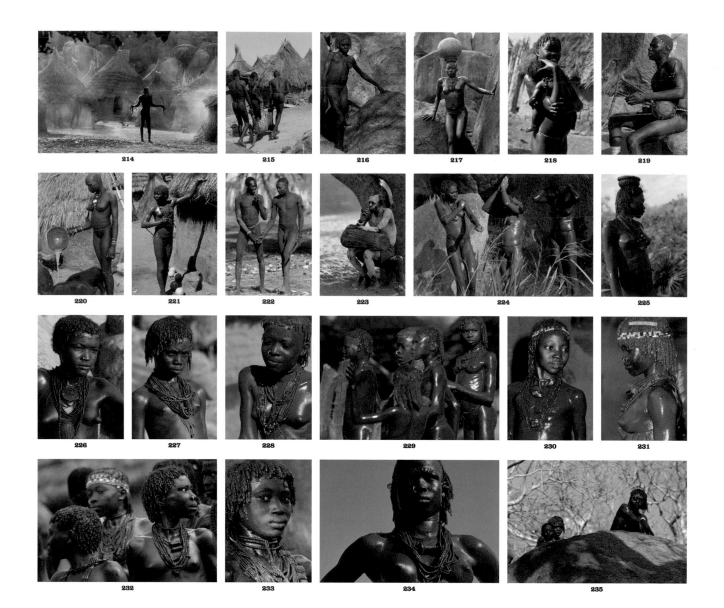

214 The village square in Kau: still untouched by
Arab or Western civilisation.
Der Dorfplatz von Kau: noch unberührt von der ara-
bischen und westlichen Zivilisation.
La place du village: la civilisation arabe et occidentale
n'est pas encore entrée à Kau.

215 Some of the people of Kau are excellent hunts-
men. They kill antelopes and large and small wild cats.
Unter den Bewohnern von Kau gibt es ausgezeich-
nete Jäger. Zu ihrer Beute gehören Antilopen sowie
kleine und große Wildkatzen.
Parmi les habitants de Kau, il y a des chasseurs remar-
quables. Ils rapportent des antilopes ainsi que des
chats sauvages plus ou moins grands.

216 – 222 These Nuba are very fond of adorning
themselves and making up. One would never see ei-
ther a girl or a man without oil on their skin, paint
on their body, or a belt.
Diese Nuba lieben es, sich zu schmücken und zu
schminken. Niemals würde man ein Mädchen oder
einen Mann ohne eingeölte Haut, Farbe am Körper
oder einen Gürtel sehen.
Ces Nouba aiment se maquiller et se parer. Jamais on
ne verra une jeune fille ou un homme dont la peau
n'est pas huilée, sans peinture corporelle ou sans
ceinture.

223 An older Nuba waits with his drum for a dance
to begin.
Ein älterer Nuba wartet mit seiner Trommel auf den
Beginn eines Tanzes.
Un Nouba âgé attend avec son tam-tam que la danse
commence.

224 From their fourth year, all the girls oil their
bodies, face and hair daily. They blend natural pig-
ments into the oil, which de-natures their physical
appearance.
Ab dem vierten Lebensjahr ölen alle Mädchen täglich
Körper, Gesicht und Haare ein. Das Öl mischen sie
mit natürlichen Farbstoffen, was ihnen ein fremdar-
tiges Aussehen verleiht.

A partir de quatre ans, les fillettes oignent tous les
jours leur corps et leurs cheveux d'huile mélangée à
des pigments naturels, ce qui leur donne une appa-
rence étrange.

225 The pigments mixed into the oil (which de-
rives chiefly from ground-nuts) range from red
through ochre to yellow. Every family clan has its
designated hue, which it must abide by.
Die Farben, die dem vorwiegend aus Erdnüssen
gewonnenen Öl beigemischt werden, reichen von
Rot über Ocker bis Gelb. Für jeden Familienclan ist
eine bestimmte Farbschattierung vorgesehen, an die
er sich zu halten hat.
Les couleurs qu'elles mélangent à l'huile – l'huile
d'arachide prédomine – vont du rouge au jaune en
passant par l'ocre. Une teinte particulière est prévue
pour chaque clan et il doit s'y tenir.

226 Strings of beads are essential ornament for the
girls and women, and many wear rings in their noses
and ears.
Perlenketten gehören unabdingbar zum Schmuck der
Mädchen und Frauen, viele tragen auch Ringe in
Nase und Ohren.
Les femmes et les jeunes filles portent inéluctable-
ment des colliers de perles. Elles arborent aussi sou-
vent des boucles d'oreilles et un anneau dans le nez.

227 / 228 The Nuba of Kau are much less trusting
than the Mesakin Quissayr Nuba, who were glad to
be photographed.
Die Nuba von Kau sind misstrauischer als die Masa-
kin-Qisar-Nuba, die sich gerne fotografieren ließen.
Les Nouba de Kau sont beaucoup plus méfiants que
les Masakin-Qisar qui se laissent volontiers photogra-
phier.

229 Their ideal is a young, beautiful body. They
cease adorning themselves and going naked when
the body begins to show signs of age.
Ihr Ideal ist der junge und schöne Körper. Sie hören
auf, sich zu schmücken und nackt herumzulaufen,
wenn der Körper anfängt zu altern.

Leur idéal est un corps beau et jeune. Ils cessent de se
parer et de déambuler nu quand leur corps com-
mence à vieillir.

230 / 231 A great deal of imagination goes into the
body ornaments they fashion out of leather, wood,
roots, feathers, ground-nuts and dried fruits.
Mit viel Fantasie fertigen sie ihren Schmuck aus
Leder, Holz, Wurzeln, Federn, Erdnüssen und ge-
trockneten Früchten.
Avec beaucoup d'imagination, ils fabriquent leurs
bijoux avec du cuir, du bois, des racines, des plumes,
des cacahuètes et des fruits secs.

232 The oiled hair of the female Nuba of Kau is
worn in various lengths.
Die weiblichen Nuba von Kau tragen ihre gefetteten
Haare in unterschiedlichen Längen.
Les femmes Nouba de Kau portent leurs cheveux
graissés en différentes longueurs.

233 This beautiful girl from Kau is called Haua and
is about 12 here.
Dieses schöne Mädchen aus Kau heißt Haua und ist
hier ungefähr 12 Jahre alt.
Cette jolie fillette de Kau à ici une douzaine d'années
et s'appelle Haua.

234 In a 1998 article for ZEIT-Magazin, the photog-
rapher nominated this portrait of Jamila as her photo
of the century.
In einem Artikel des ZEIT-Magazins bezeichnet die
Fotografin 1998 dieses Porträt von Jamila als ihr Foto
des Jahrhunderts.
Dans un article pour le ZEIT-Magazin, la photogra-
phe déclarait en 1998 que ce portrait de Jamila était
sa photo du siècle.

235 Many of the pictures had to be taken from a
distance using a telephoto lens, because these Nuba
were extremely wary of the camera. At times the women
hid, and some men even responded aggressively.
Viele Aufnahmen konnten nur aus größerer Entfer-
nung mit einem Teleobjektiv gemacht werden, denn

diese Nuba waren zum Teil sehr kamerascheu. Die Frauen ha-
ben sich zum Teil versteckt und manche Männer
haben sogar aggressiv reagiert.
De nombreuses photos n'ont pu être réalisées qu'à
distance à l'aide d'un téléobjectif, car ces Nouba ont très
peu de l'appareil. Les femmes se sont parfois cachées
et quelques hommes se sont même montré agressifs.

236 Fetching water is especially wearying work for
the Nuba woman during the hot months. When the
village water-holes run dry, they have to fetch water
from far off in the mountains.
In den heißen Monaten ist das Wasserholen für die
Nuba-Frauen besonders anstrengend. Wenn die Was-
serstellen im Dorf versiegt sind, müssen sie das
Wasser von weither aus den Bergen holen.
Durant les mois chauds, aller puiser de l'eau est par-
ticulièrement pénible. Quand les points d'eau du vil-
lage sont taris, les femmes Nouba doivent aller la
chercher très loin dans les montagnes.

237 / 238 The young women possess a robust
pride, and take delight in their bodies. At times the
girls secretly meet their lovers in secluded caves
when they ought to be fetching water.
Die jungen Frauen sind stolz und sehr körperbetont.
Manchmal treffen sie sich heimlich mit ihren Liebha-
bern in Felshöhlen, wenn sie Wasser holen sollen.
Les jeunes femmes sont fières et très sensuelles.
Parfois les jeunes filles parties chercher de l'eau don-
nent en secret rendez-vous à leurs amants dans des
grottes cachées.

239 Love and sex are important to the Nuba of Kau.
As a result, large numbers of children are brought
into the world.
Liebe und Sexualität spielen bei den Nuba von Kau
eine große Rolle. Dementsprechend viele Kinder
werden geboren.
L'amour et la sexualité jouent un rôle important chez
les Nouba de Kau. Le nombre de leurs enfants est à
l'avenant.

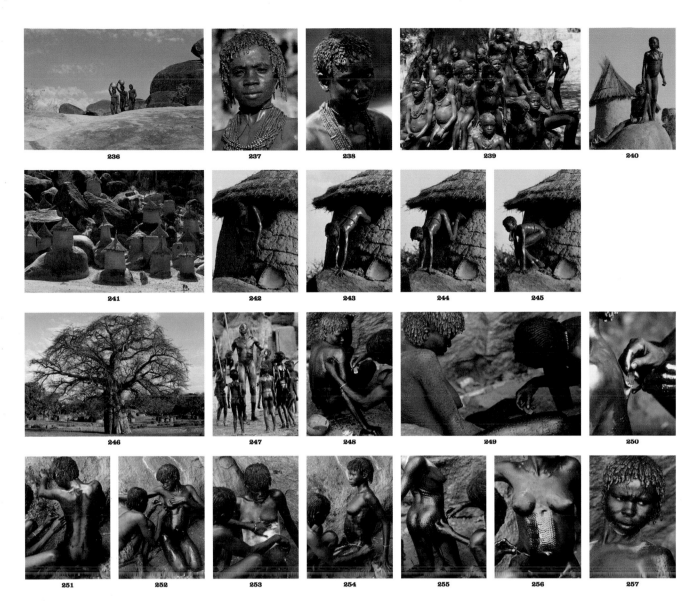

236

237

238

239

240

241

242

243

244

245

246

247

248

249

250

251

252

253

254

255

256

257

240 The girls' chief task is to look after their younger siblings. In the hot months they may also have to help fetch water.

Die Hauptaufgabe der Mädchen besteht darin, ihre jüngeren Geschwister zu betreuen. In den heißen Monaten müssen sie auch schon mal beim Wasserholen helfen.

La tâche principale des fillettes est de garder leurs frères et sœurs plus jeunes. Durant la saison chaude, elles doivent aussi aider à puiser de l'eau.

241 The village of Kau, some 200 kilometres east of the Mesakin Quissayr Nuba villages. Many of the mud huts are built on rocks, especially the small circular huts used to store the harvest. The rocks prevent the grain from being washed away when the flood waters come in the rainy season.

Ansicht des Dorfes Kau, das etwa 200 Kilometer östlich von den Dörfern der Masakin-Qisar liegt. Viele der Lehmhütten sind auf Felsen errichtet, insbesondere die kleinen Rundhütten, in denen die Ernte aufbewahrt wird. Die Felsen verhindern, dass die gewaltigen Wassermengen in der Regenzeit das Getreide wegspülen.

Le village de Kau, situé à environ 200 kilomètres à l'est des villages Masakin-Qisar. De nombreuses cases de terre sèche sont édifiées sur les rochers, particulièrement les petites huttes cylindriques qui abritent la récolte. Ainsi, les céréales ne peuvent être emportées par les torrents d'eau quand arrive la saison des pluies.

242 / 243 / 244 / 245 The circular huts are accessible only by a tiny opening high up. As well as being used for the storage of grain, they are where the young girls keep their make-up materials.

Die Rundhütten sind nur durch eine hoch gelegene, kleine Öffnung zugänglich. Sie dienen neben der Lagerung von Getreide auch noch einem anderen Zweck: Die jungen Mädchen bewahren hier ihre Schminkutensilien auf.

Seule une petite ouverture en hauteur permet d'entrer dans les cases. Celles-ci n'abritent pas seulement les réserves de céréales; en effet, c'est ici que les jeunes filles gardent leurs ustensiles de maquillage.

246 The South East Nuba, too, are a people who live by agriculture. Their fields are quite far from the villages. They grow sorghum, and also cotton, sesame and ground-nuts.

Auch die Südost-Nuba sind ein Agrarvolk, deren Felder ziemlich weit von den Dörfern entfernt liegen. Sie bauen Dura an, pflanzen aber darüber hinaus auch Baumwolle, Sesam und Erdnüsse.

Les Nouba du Sud-Est sont aussi des agriculteurs. Les champs, où ils cultivent de la durra mais aussi du coton, du sésame et des arachides, sont assez éloignés des villages.

247 The children are tightly knit into the tribal community and are familiarised with the combat and dance rituals from an early age.

Die Kinder sind eng in die Stammesgemeinschaft eingebunden und werden schon früh mit den Kampf- und Tanzritualen vertraut gemacht.

Les enfants sont étroitement associés à la vie de la communauté et sont familiarisés de bonne heure avec les danses et les luttes rituelles.

248 A Nuba girl from Kau, aged about fifteen, is tattooed. The girls of the South East Nuba are tattooed on their bodies and faces. The Nuba men, on the other hand, have only decorative cicatrices on their faces.

Ein etwa fünfzehn Jahre altes Nuba-Mädchen aus Kau erhält Schmucknarben. Bei den Südost-Nuba bekommen die Mädchen Körper- und Gesichtsverzierungen. Die männlichen Nuba hingegen tragen diese nur im Gesicht.

Une fillette Nouba de Kau d'une quinzaine d'années aux mains de la praticienne. Chez les Nouba du Sud-Est, les fillettes arborent des scarifications sur le corps et le visage. Les hommes n'en portent que sur le visage.

249 Every girl has to undergo three tattooing rituals, the first at the age of about ten, the second when she has begun to menstruate, and the third and most painful about three years after the birth of her first child.

Jedes Mädchen muss drei Rituale über sich ergehen lassen, bei denen es Schmucknarben erhält. Das erste mit ungefähr zehn Jahren, das zweite nach der Geschlechtsreife und das dritte, das schmerzhafteste, ungefähr drei Jahre nach der Geburt ihres ersten Kindes.

Chaque fille doit subir trois fois les scarifications rituelles. La première lorsqu'elle a une dizaine d'années, après ses premières règles, et la troisième, la plus douloureuse, environ trois ans après la naissance de son premier enfant.

250 The tattooing operations are performed by extremely skilful women. The skin is oiled, lifted with a thorn, and then slit with a sharp flat-bladed knife.

Die Rituale werden von außerordentlich geschickten Frauen durchgeführt. Die eingeölte Haut wird mit einem Dorn hochgezogen und dann mit einem scharfen, flachen Messer eingeschnitten.

Les femmes travaillent avec une dextérité remarquable. Elles soulèvent la peau huilée à l'aide d'une épine et l'incisent avec une lame plate et acérée.

251 / 252 During this extremely painful procedure, the girl betrays no sign of pain, and instead gives her close attention to how the desired pattern is achieved.

Während dieser äußerst schmerzhaften Prozedur verzieht das Mädchen keine Miene, sondern beobachtet aufmerksam die präzise Ausführung der gewünschten Muster.

La fillette subit sans sourciller cette procédure terriblement douloureuse. Elle observe attentivement l'exécution précise des motifs souhaités.

253 The woman dusts the wounds, which have been continually re-oiled during her work, with sorghum flour to ease the pain and protect them from infection.

Die Frau bestäubt die Wunden, die sie während ihrer Arbeit immer wieder eingeölt hat, mit Duramehl. Das lindert den Schmerz und schützt außerdem vor Infektionen.

La femme saupoudre de la farine de durra sur les plaies qu'elle n'a pas cessé de graisser tout en travaillant. Cela calme la douleur et évite les infections.

254 Any blood that flows from the wounds is wiped away with a twig.

Das aus den Wunden strömende Blut wird mit einem Zweig abgewischt.

Le sang qui coule des plaies est ôté à l'aide d'une petite branche.

255 Young girls receive only a few cuts below the navel. Only in the last tattooing are the hips, legs and buttocks covered with incisions.

Junge Mädchen erhalten nur wenige Schnitte unterhalb des Nabels. Erst bei der letzten rituellen Verzierung ihres Körpers werden Hüften, Beine und Po komplett mit Schmucknarben bedeckt.

Les petites filles ne reçoivent que quelques incisions en dessous du nombril. Les hanches, les jambes et le postérieur ne seront recouverts de scarifications que lors de la dernière séance rituelle.

256 A broad vertical band stretches from the navel to below the breasts.

Vom Nabel bis unter die Brust zieht sich ein breiter Streifen mit vertikalen Linien.

Une large bande de stries verticales s'étend du nombril à la poitrine.

257 The facial cicatrices are not only intended to beautify. Above the eyes, they are meant to enhance the eyesight, while to the side of the forehead they are supposed to prevent headaches.

Die Schmucknarben im Gesicht dienen nicht nur der Schönheit. Wenn sie sich über den Augen befinden, sollen sie die Sehkraft erhöhen, seitlich an der Stirn sollen sie Kopfschmerzen vorbeugen.

Sur le visage, les scarifications ne sont pas seulement décoratives. Placées au-dessus des yeux elles sont censées améliorer l'acuité visuelle; sur les tempes elles doivent prévenir les maux de tête.

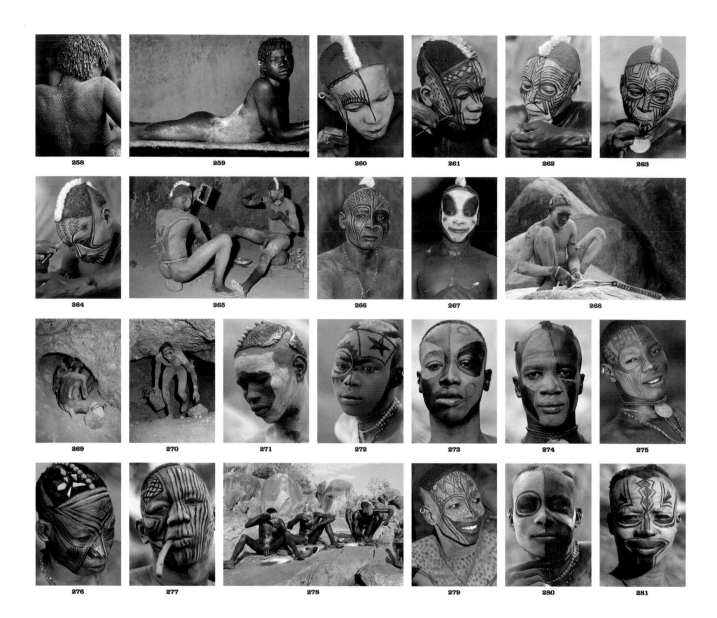

258 It takes about an hour to tattoo the front and back of the body.
Nach ungefähr einer Stunde Arbeit sind Vorder- und Rückseite des Körpers mit kleinen Narben über-säht.
Au bout d'une heure environ, la poitrine et le dos sont recouverts de scarifications.

259 The Nuba women are proud of their decorative scars. The flour dusted into the wounds has the additional effect of rendering the scars more three-dimensional. In this way they remain clearly discernible in old age.
Die Nuba-Frauen sind stolz auf ihre Schmucknarben. Das Mehl, welches direkt in die Wunde gestreut wird, lässt die Narben plastisch hervortreten. Auf diese Weise kann man sie auch im Alter noch gut erkennen.
Les femmes Nouba sont fières de leurs scarifications. La farine saupoudrée dans les plaies donne du relief aux cicatrices qui sont ainsi toujours reconnaissables, même chez les personnes âgées.

260 The art of face and body painting has been brought to a unique pitch of artistic perfection by the Nuba of Kau. When the photographer showed them her first picture volume, about the Mesakin Quissayr Nuba, numerous men painted in various ways allowed her to photograph them.
Die Kunst der Gesichts- und Körperbemalung erreicht bei den Nuba von Kau eine einmalige künstlerische Vollendung. Als ihnen die Fotografin ihren ersten Bildband über die Masakin-Qisar zeigt, lassen sich zahlreiche Männer mit unterschiedlicher Bemalung von ihr fotografieren.
L'art de la peinture corporelle atteint chez les Nouba de Kau une perfection unique en son genre. Après avoir vu le premier album de la photographe sur les Masakin-Qisar, de nombreux hommes aux masques très divers se sont laissé photographier par elle.

261 / 262 There are aspects of the classical and of the modern in the artistically painted patterns. The Nuba's sense of graphic form is extraordinary and no

one can quite account for the incredible talent they possess.
Die kunstvollen Muster enthalten sowohl klassische als auch moderne Elemente der Malerei. Das Gefühl der Nuba für graphische Gestaltung ist außergewöhnlich und niemand weiß, woher sie diese unglaubliche Begabung haben.
On retrouve des éléments picturaux classiques et modernes dans ces motifs sophistiqués. Les Nouba ont un sens inhabituel du dessin et nul ne sait d'où leur vient ce talent incroyable.

263 The lines and decorative motifs of a mask are never repeated. These powers of imagination seem inexhaustible.
Niemals werden die Linien und Ornamente einer Maske wiederholt. Die Fantasie scheint unerschöpflich.
Les lignes et les ornements du masque ne sont jamais répétés, l'inventivité semble inépuisable.

264 The "masks" possess aesthetic rather than ritual significance. The patterns accentuate their best facial and physical features. Apart from blue, which the Nuba obtain from Arab traders, they get all their pigments from natural sources.
Die Masken haben weniger kultische als ästhetische Bedeutung. Die Muster betonen die positiven Merkmale von Körper und Gesicht. Mit Ausnahme der blauen Farbe, die die Nuba im Tauschhandel von den Arabern erhalten, gewinnen sie alle Farben selbst aus der Natur.
La signification de la peinture corporelle est moins rituelle qu'esthétique. Les motifs soulignent les caractéristiques positives du corps et du visage. A l'exception du bleu, obtenu par échange des marchands arabes, toutes les couleurs utilisées sont naturelles.

265 The Nuba obtain mirrors from Arab traders. In earlier times they used to paint each other, as they still do when decorating their backs.
Spiegel bekommen die Nuba über arabische Händler. Früher haben sie sich immer gegenseitig bemalt, was sie auch heute noch tun, wenn sie ihre Rücken verschönern.

Grâce aux marchands arabes, les Nouba disposent de miroirs. Autrefois ils se peignaient mutuellement le corps, ce qu'ils font encore aujourd'hui quand ils se décorent le dos.

266 Some of the Nuba fashion stamps out of leather or wood and imprint their bodies with them.
Einige der Nuba haben aus Leder oder Holz Stempel angefertigt, um ihre Körper mit Farbe bedrucken zu können.
Certains Nouba se sont fabriqué des tampons de cuir ou de bois pour imprimer en outre de la couleur sur leur corps.

267 The daily toilette naturally includes the hair as well, which a friend will spend hours of patience on. Hairstyles are indicative of age group and social status.
Zu ihrem täglichen Make-up gehört natürlich auch die Frisur, die mit Hilfe eines Freundes in stunden-langer, geduldiger Arbeit geformt wird. Der Schnitt der Haare verweist auf das Alter und die soziale Stellung seines Trägers.
La coiffure fait évidemment partie des rites de beauté quotidiens. Elle est réalisée avec l'aide d'un ami pendant des heures de travail patient. La coupe de cheveux d'un homme indique son âge et son statut social.

268 Except during the months devoted to work in the fields, the Nuba oil, paint and adorn themselves daily from head to foot.
Mit Ausnahme der Monate, wo sie auf den Feldern arbeiten, ölen, bemalen und schmücken sich die Nuba täglich von Kopf bis Fuß.
A l'exception des mois où ils travaillent aux champs, les Nouba huilent, peignent et décorent leurs corps tous les jours de la tête aux pieds.

269 / 270 The main source of the yellow, ochre and red shades used by the Nuba is an underground cave of soft stone only a few miles from Kau.
In unterirdischen Höhlen, die nur wenige Kilometer von Kau entfernt liegen, finden die Nuba Gesteins-arten, die ihnen die Gelb-, Ocker- und Rottöne für ihre Farben liefern.

Dans des cavernes souterraines, à seulement quelques kilomètres de Kau, les Nouba trouvent des minéraux qui leur livrent les teintes jaunes, ocre et rouges dont ils ont besoin.

271 The hair is prepared with beeswax and then dusted with coloured powder. Only a *kadundor*, or knife-fighter, may shave off two wedge-shaped patches tapering from the temples to the back of the head.
Das Haar wird zunächst mit Bienenwachs präpariert, anschließend wird das farbige Pulver darüber verteilt. Eine Frisur mit zwei ausrasierten Keilen, die von den Schläfen zum Hinterkopf verlaufen, darf nur ein *kadundor*, ein Messerkämpfer, tragen.
Avant de saupoudrer les cheveux de poudre colorée, on les enduit de cire d'abeilles. Seul le *kadundor*, le lutteur au couteau, a le droit de se raser des bandes triangulaires partant des tempes et qui se rejoignent au sommet du crâne.

272 / 273 / 274 / 275 The Nuba wash themselves thoroughly before applying paint. The face and body are denuded of hair, to which pigments will not adhere, and then oiled because only oily skin enables them to stick.
Damit die Bemalung auf der Haut besser haftet, waschen sich die Nuba gründlich, bevor sie sich schminken, entfernen alle Haare von Gesicht und Körper und reiben sich mit Öl ein.
Afin que la couleur adhère bien à la peau, les Nouba se lavent avec soin avant de se maquiller, ils s'épilent le visage et le corps et s'enduisent d'huile.

276 / 277 They view their art only in relation to their bodies. The body is regarded by them as the consummation of Nuba art.
Sie sehen ihre Kunst nur in Verbindung mit ihren Körpern. Den Körper zur vollkommenen Schönheit zu führen, ist das höchste Ziel.
Pour eux, l'art n'est en relation qu'avec le corps, et leur objectif le plus haut est de rendre celui-ci parfaitement beau.

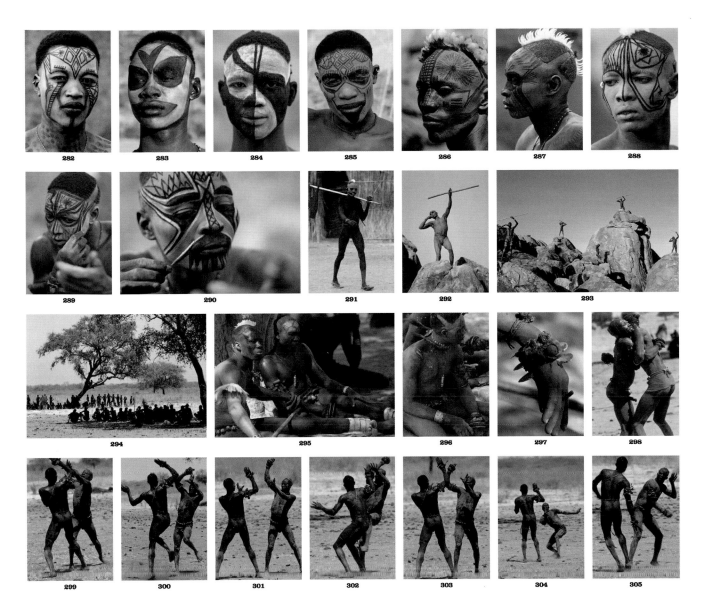

282 – 290

291

292 / 293

294

295

296

297

298

299 – 306

282 283 284 285 286 287 288

289 290 291 292 293

294 295 296 297 298

299 300 301 302 303 304 305

278 Face and body take roughly half an hour each to paint daily, but the men's hair styles can take twice as long. The head is adorned with feathers or ground-nuts.
Während die Gesichts- und Körperbemalung ungefähr eine halbe Stunde dauert, benötigen die Männer für ihre Frisuren manchmal doppelt so lange. Die Haare werden mit Federn oder Erdnüssen verziert.
Si peindre son visage et son corps ne dure qu'une demi-heure, se coiffer prend parfois le double de temps chez les hommes. Les cheveux sont ornés de plumes et de cacahuètes.

279 / 280 / 281 Young Nuba men are fearless and brave, but their vanity is every bit as great as their valour. With great skill and imagination they do anything they can to create an especially interesting mask.
Die jungen Nuba-Männer sind furchtlos und tapfer, doch ebenso groß wie ihr Mut ist ihre Eitelkeit. Mit Geschick und Fantasie setzen sie alles daran, eine besonders interessante Maske zu entwerfen.
Les jeunes Nouba sont intrépides et braves, mais leur courage n'a d'égal que leur vanité. Avec adresse et fantaisie, ils se surpassent pour dessiner un masque particulièrement intéressant.

282 – 290 The Nuba masks are rarely symmetrical, but the painting nonetheless achieves graphic harmony. Their sense of colour and appropriate lines and shapes draws astonished admiration even from Western artists.
Kaum eine Maske bei den Nuba ist symmetrisch, trotzdem wirken die Bemalungen graphisch ausgewogen. Wie sie die Farben aufeinander abstimmen, wie sie Ornamente, Linien und Figuren zu einer harmonischen Einheit zusammenfügen, versetzt auch westliche Künstler in Erstaunen und Bewunderung.
Bien que les motifs des masques Nouba soient rarement symétriques, leur dessin semble équilibré. Les artistes occidentaux sont remplis d'étonnement et d'admiration devant la manière dont ils accordent les couleurs, dont ils disposent les ornements, les lignes et les figures stylisées en un ensemble harmonieux.

291 Only champions are privileged to use jet-black pigment for their bodies. This puts fear into the adversary, but is also held to make the body invulnerable.
Nur die besten Kämpfer haben das Recht, ihren Körper tiefschwarz zu färben. So wollen sie einerseits dem Gegner Angst einjagen, andererseits glauben sie, dass diese Farbe sie unverletzbar macht.
Seuls les meilleurs lutteurs ont le droit de peindre leur corps en noir. D'un côté, ils veulent terrifier leur adversaire, d'un autre côté, ils croient que cette couleur les rend invulnérables.

292 / 293 When a bout of *zuar* is held—the traditional knife-fighting practised by the South East Nuba men aged between 18 and 30—look-outs posted on rocks herald with shrill screams the arrival of the fighters from the next village.
Findet ein *zuar* statt, der traditionelle Messerkampf, mit dem sich die Männer der Südost-Nuba im Alter zwischen 18 und 30 Jahren messen, so kündigen die schrillen Schreie der Beobachter auf den Felsen als Erste die Gruppen der Kämpfer des Nachbardorfes an.
Lorsqu'un *zuar* – la lutte traditionnelle au couteau où s'affrontent les hommes Nouba du Sud-Est âgés de 18 et 30 ans – a lieu, les cris perçants des guetteurs perchés sur les rochers annoncent les premiers l'arrivée des lutteurs du village voisin.

294 The scene of the battle is usually near the village. Fighters sit with their referees in the shade of large trees. The presence of women is forbidden at these ferocious knife fights.
Der Kampfplatz befindet sich meist in der Nähe des Dorfes. Im Schatten großer Bäume sitzen die Kämpfer mit ihren Schiedsrichtern. Frauen ist es nicht gestattet, bei diesen harten und brutalen Messerkämpfen zuzuschauen.
L'aire de combat est la plupart du temps située à proximité du village. Les lutteurs sont assis à l'ombre des grand arbres en compagnie de leurs arbitres. Il est interdit aux femmes d'assister à ces combats au couteau violents.

295 Fights are only held when the men are not working in the fields. Nobody can predict when or in which village a fight will be held. Rumours circulate for weeks beforehand, and the ritual excites tremendous interest.
Gekämpft wird nur, wenn keine Ernte eingebracht werden muss. Niemand weiß genau, wann und in welchem Dorf ein Kampf ausgetragen wird. Wochen vorher kursieren aber bereits Gerüchte. Wenn es schließlich soweit ist, blicken alle dem Ritual voller Erwartung entgegen.
Les combats n'ont lieu qu'en dehors de la saison des récoltes. Nul ne sait à quel moment et dans quel village un combat se déroule, mais des bruits circulent déjà des semaines auparavant. Quand le moment est venu, tous attendent le rituel avec impatience.

296 The many amulets worn on the upper arms and wrists reveal the influence of the priests, who decide the time and place of a *zuar*. The fighters have faith in the magical properties of the charms they wear.
Die zahlreichen Amulette an Oberarmen und Handgelenken zeugen vom Einfluss der Nuba-Priester, welche auch den Zeitpunkt des *zuar* bestimmen. Die Kämpfer glauben an die Zauberkraft dieser Glücksbringer.
Les nombreuses amulettes qui ornent les bras et les poignets témoignent de l'influence des prêtres Nouba qui décident aussi de la date du *zuar*. Les lutteurs croient à l'efficacité de ces talismans.

297 The heavy two-bladed knives used by the fighters in the *zuar* are secured to their wrists.
Am Handgelenk der Kämpfer sind die schweren Klingen der Doppelmesser befestigt, die sie im *zuar* einsetzen.
Les doubles lames massives sont fixées au poignet des combattants qui les utilisent durant le *zuar*.

298 The fighting is ferocious but fair. The fights are not merely a display of courage and skill but have a strong bearing on the fighters' love life. The better a fighter performs, the better his prospects with the opposite sex. Such is the prestige of a good fighter that any married woman may sleep with him.

Die Kämpfe sind hart, aber fair. Es geht nicht nur darum, Mut und Tapferkeit zu beweisen, sondern auch um die Liebe. Je besser ein Kämpfer ist, umso mehr Chancen hat er beim weiblichen Geschlecht. Das Ansehen eines guten Kämpfers ist so hoch, dass sogar verheiratete Frauen sich von ihm schwängern lassen können.
Les combats sont durs mais loyaux. Il ne s'agit pas seulement de prouver son courage et sa bravoure mais d'augmenter ses chances auprès des femmes. La renommée d'un champion est si grande qu'il peut même rendre enceintes des femmes mariées.

299 – 306 The fighters attempt to evade their opponent's knife attacks. Any kind of blow is permitted, and injuries are unavoidable.
Die Kämpfer versuchen den Angriffen mit den Messern auszuweichen. Jeder Schlag ist erlaubt, Verletzungen sind dabei nicht zu vermeiden.
Les lutteurs au couteau tentent d'éviter les attaques de l'adversaire. Tous les coups sont permis et les blessures sont inévitables.

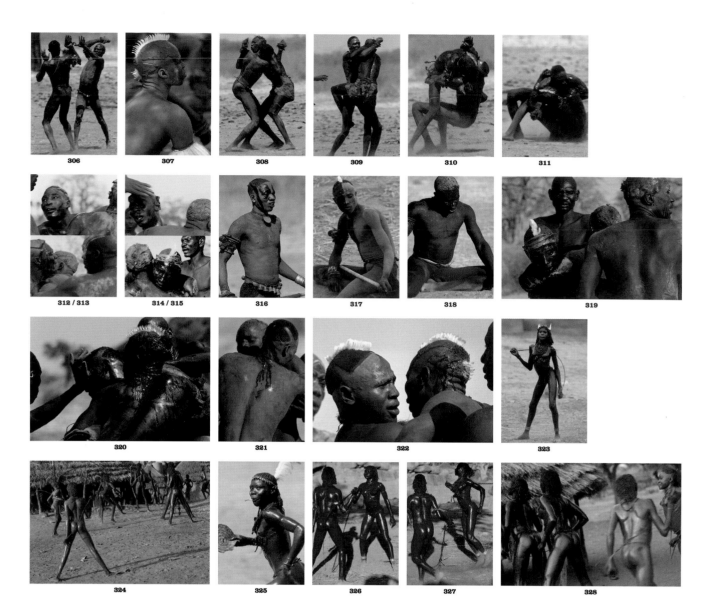

306 307 308 309 310 311

312 / 313 314 / 315 316 317 318 319

320 321 322 323

324 325 326 327 328

307 / 308 / 309 / 310 / 311 Referees observe closely and part the fighters before they inflict mortal injuries.
Schiedsrichter beobachten die Kämpfenden und trennen sie, bevor die Verletzungen tödlich werden.
Les arbitres veillent et séparent les adversaires avant qu'ils ne s'infligent des blessures mortelles.

312 / 313 / 314 / 315 The referees strive to part the two opponents, who are locked together and bleeding badly, but in vain. Neither will give up, although both have sustained several blows—they seem drunk with aggression.
Vergebens versuchen die Schiedsrichter, die ineinander verkeilten und stark blutenden Männer zu stoppen. Keiner will aufhören, obwohl beide schon viele Schläge einstecken mussten. Es ist, als ob die Kämpfer in einen Rausch geraten sind.
Les arbitres cherchent vainement à arrêter les adversaires qui s'étreignent en ruisselant de sang. Bien qu'ils aient déjà reçu de nombreux coups, ni l'un ni l'autre ne veut cesser de se battre. Ils sont comme grisés par la lutte.

316 / 317 The *kadundors* paint themselves less conspicuously before a fight, hoping to escape the envy of an opponent who may be roused to fury by an over-flamboyant design.
Die Körperbemalung der *kadundor* ist während der Kämpfe eher zurückhaltend. Sie wollen den Gegner nicht neidisch machen oder durch ein bestimmtes Muster reizen.
Durant les combats, les peintures corporelles des *kadundor* sont plutôt discrètes. Ils ne veulent pas éveiller l'envie de l'adversaire ou l'irriter à cause d'un motif déterminé.

318 A fighter who falls to the ground has not necessarily lost the bout. He can still win if he manages to regain his feet and fight on. The loser is the one who lacks the strength to continue.
Geht ein Kämpfer zu Boden, so ist er noch nicht besiegt. Gelingt es ihm aufzustehen und weiterzukämpfen, kann er den Kampf noch gewinnen. Verloren hat, wer keine Kraft zum Weiterkämpfen hat.
Le guerrier qui tombe n'est pas vaincu pour autant. S'il réussit à se relever et reprendre le combat, rien n'est perdu. Il n'est vraiment vaincu que s'il n'a plus la force de continuer.

319 / 320 / 321 The commonest target is the head. If a fighter bleeds too profusely, sand is sprinkled on his wounds or a palm-leaf bound round his gory head.
Die meisten Verletzungen entstehen am Kopf. Wenn ein Kämpfer zu stark blutet, wird ihm Sand in die Wunden gestreut oder sein blutender Kopf wird mit einem Palmenblatt verbunden.
La plupart des blessures sont à la tête. Quand un lutteur saigne en abondance, on saupoudre du sable sur ses plaies ou on panse sa tête avec une feuille de palmier.

322 Dire results are usually obviated by the referees' great skill and experience. Very few fighters ever succumb to their injuries. Wounds normally heal with extraordinary speed and most of the bloodstained heroes can be seen at the dance only a few hours later, freshly bathed, oiled, painted and adorned.
Durch die große Erfahrung und Geschicklichkeit der Schiedsrichter wird meist das Schlimmste verhindert. Nur sehr selten erliegt ein Kämpfer seinen Verletzungen. Normalerweise heilen die Wunden sehr schnell und man trifft die meisten Männer schon einige Stunden später frisch eingeölt und geschmückt auf dem Tanzfest wieder.
Le pire est évité la plupart du temps grâce à la grande expérience et l'habileté des arbitres. Il est très rare qu'un lutteur succombe à ses blessures. Normalement, celles-ci guérissent rapidement et quelques heures après on voit déjà la plupart des hommes en train de danser, huilés de frais et parés pour la fête.

323 Almost every major fight is followed, only a few hours later, by a dance the Nuba call *nyertun*. *Nyertun* is a ritual dance of love, in which virgin girls, with the approval of their parents, choose a partner.
Wenige Stunden nach Beendigung der Messerkämpfe findet fast immer ein Tanzfest statt, welches die Nuba *njertun* nennen. *Njertun* ist ein ritueller Liebestanz, an dem sich die jungfräulichen Mädchen mit Genehmigung ihrer Eltern einen Ehegatten auswählen.
Quelques heures après la fin des combats, se déroule presque toujours une fête dansée que les Nouba appellent *njertun*. Il s'agit d'un rituel amoureux au cours duquel les jeunes filles vierges choisissent un mari avec l'autorisation de leurs parents.

324 The start of a dance in the village of Nyaro. The first of the girls are here, holding supple twigs or long whips plaited from leather thongs, which age-old tradition declares an aid to the dance.
Der Beginn eines Tanzes im Dorf Nyaro. Die ersten Mädchen sind eingetroffen. In den Händen haben sie aus Lederriemen geflochtene Peitschen oder biegsame Zweige, mit denen sie nach uralter Tradition tanzen werden.

Le fête commence dans le village de Nyaro. Les premières jeunes filles sont arrivées. Elles tiennent des fouets faits de lanières de cuir tressées ou bien des rameaux flexibles avec lesquels elles vont danser comme le veut une tradition séculaire.

325 The girls' bodies, lavishly anointed with oil, shine as though coated with lacquer. They are adorned for the occasion with particular care. They wear ostrich plumes or gleaming brass clasps in their hair.
Die Mädchen haben sich eingeölt und glänzen, als wären sie mit Lack überzogen. Sie sind besonders hübsch geschmückt. In den Haaren tragen sie Straußenfedern oder auch goldschimmernde Messingspangen.
Elles sont très joliment parées. Leurs cheveux sont garnis de plumes d'autruche ou de barrettes de laiton qui jettent un éclat doré. Les jeunes filles ont huilé leur corps qui brille comme s'il était verni.

326 / 327 The girls' bodies gleam with the heavy application of oil in magical shades of red and black.
Fast verschwenderisch haben die Tanzenden ihre Körper mit Öl eingerieben. Diese glänzen magisch in Rot und Schwarz.
Les danseuses ont utilisé l'huile avec générosité. Leurs corps brillent magiquement en rouge et en noir.

328 The girls begin by dancing in groups of two or three, but the floor soon fills and comes alive with movement.
Während die Mädchen zu Beginn in Gruppen zu zweit oder dritt tanzen, füllt sich bald der Platz und es kommt Schwung in die Menge.
Alors qu'au départ, les fillettes dansaient à deux ou à trois, la place se remplit bientôt et la foule s'anime.

524

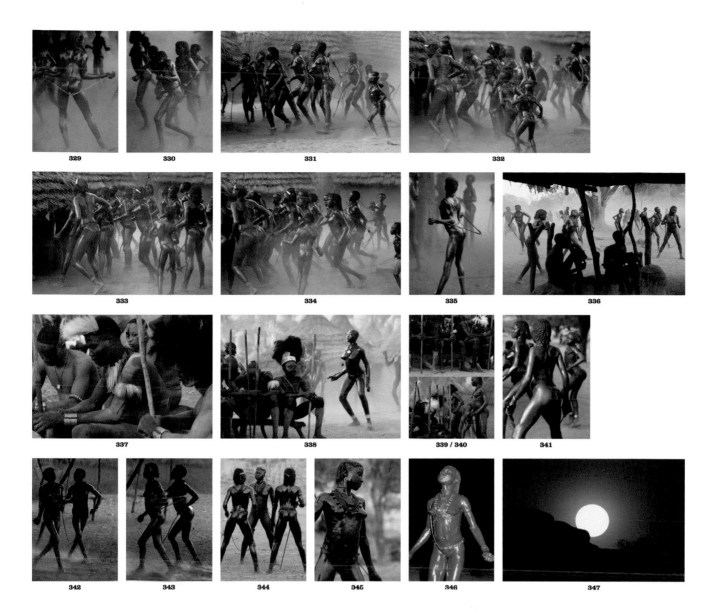

329 – 334 The drumming grows louder, the dancing wilder. The girls' bodies glint as if gilded among the swirling clouds of sunlit dust.
Das Trommeln wird stärker, das Tanzen wilder. In dem von der Sonne durchleuchteten, aufgewirbelten Staub wirken die glänzenden Körper fast surreal.
Le rythme des tam-tam s'accélère, les danseuses se déchaînent. Dans les tourbillons de poussière qu'éclaire le soleil, les corps brillants ont l'air quasi surréels.

335 The girls sway their hips in time to the drums.
Im Rhythmus der Trommeln wiegen die Mädchen ihre Hüften.
Les jeunes filles roulent des hanches au rythme du tam-tam.

336 The drummers and zuar fighters are gathered under the rakoba. This shady canopy is covered with sorghum stems and propped on slender tree trunks.
Die Trommler und zuar-Kämpfer halten sich unter der rakoba auf. Dieses Schatten spendende Dach ist mit Durastängeln abgedeckt und wird von kleinen Baumstämmen gestützt.
Les percussionnistes et les lutteurs zuar sont assis à l'ombre sous le rakoba. Son toit est recouvert de tiges de durra et repose sur de petits troncs.

337 The men have also painted and adorned themselves. While the girls are dancing, their place is on a low stone wall.
Die Männer haben sich ebenfalls bemalt und geschmückt. Während des Tanzes der Mädchen ist ihr Platz auf einer im Kreis angelegten, niedrigen Steinmauer.
Les hommes se sont aussi peint le corps et parés. Pendant que les jeunes filles dansent, ils sont assis sur un muret de pierre circulaire.

338 The first girls venture closer and closer to the men.
Nach und nach tanzen sich die Mädchen in die Nähe der Männer.
Petit à petit, les jeunes danseuses se rapprochent des hommes.

339 / 340 The men wait almost motionless for the girls' declaration of love, heads bowed. Their only movement is a continuous tremor in one leg, which has some small bells tied round the ankle. The tinkling sound is meant to be symbolic of their latent excitement. The girls wait till the drums beat a particular rhythm when they swing one leg over the shoulder of their chosen one.
Während die Männer fast bewegungslos auf die Liebeserklärung der Mädchen warten, halten sie ihre Köpfe gesenkt. Nur das Wippen eines ihrer Beine, an deren Fußgelenken kleine Glöckchen angebunden sind, soll ihre innere Erregung symbolisieren. Die Mädchen warten auf einen bestimmten Trommelwirbel, um ein Bein auf die Schulter ihres Auserwählten legen zu dürfen.
Les hommes attendent, tête baissée, que les filles leur déclarent leur amour. Ils sont presque immobiles, seul le mouvement d'une de leurs jambes, aux chevilles desquelles sont fixées des clochettes, est censé symboliser leur émoi. Les jeunes filles attendent un roulement particulier du tambour pour placer une jambe sur l'épaule de l'élu.

341 When the choice has been made, the dancing continues.
Auch nach der Wahl geht der Tanz weiter.
Les jeunes filles ont choisi, mais la danse continue.

342 / 343 / 344 / 345 The men leave the dancefloor before the dance is over. A man does not keep his tryst until nightfall, and then usually at the girl's parental home. Although unions of this kind can result in marriage, there is no compulsion.
Noch bevor das Tanzfest zu Ende geht, verlassen die Männer den Platz. Das Rendez-vous wird erst in der Nacht stattfinden, meist ist der Treffpunkt das Elternhaus des Mädchens. Aus dieser Zusammenkunft kann eine Ehe entstehen, es ist aber nicht zwingend.
Les hommes quittent la fête avant qu'elle ne s'achève. En effet, la rencontre avec la jeune fille n'aura lieu que pendant la nuit, la plupart du temps chez ses parents. Tout cela peut se terminer par un mariage, mais ce n'est pas obligatoire.

346 The festivities continue without the men, the dance continues ecstatically, till nightfall and beyond.
Das Fest geht ohne die Männer weiter, die bis zur Ekstase gesteigerten Tänze dauern oft bis zum Einbruch der Dunkelheit.
La fête se poursuit, entre femmes uniquement; les participants dansent jusqu'à tomber en extase, ne s'arrêtant souvent qu'après le coucher du soleil.

347 Full moon over the crags above Kau.
Vollmond über der Felswand von Kau.
Et seule la lune qui les observe au-dessus des rochers de Kau connaît la suite.

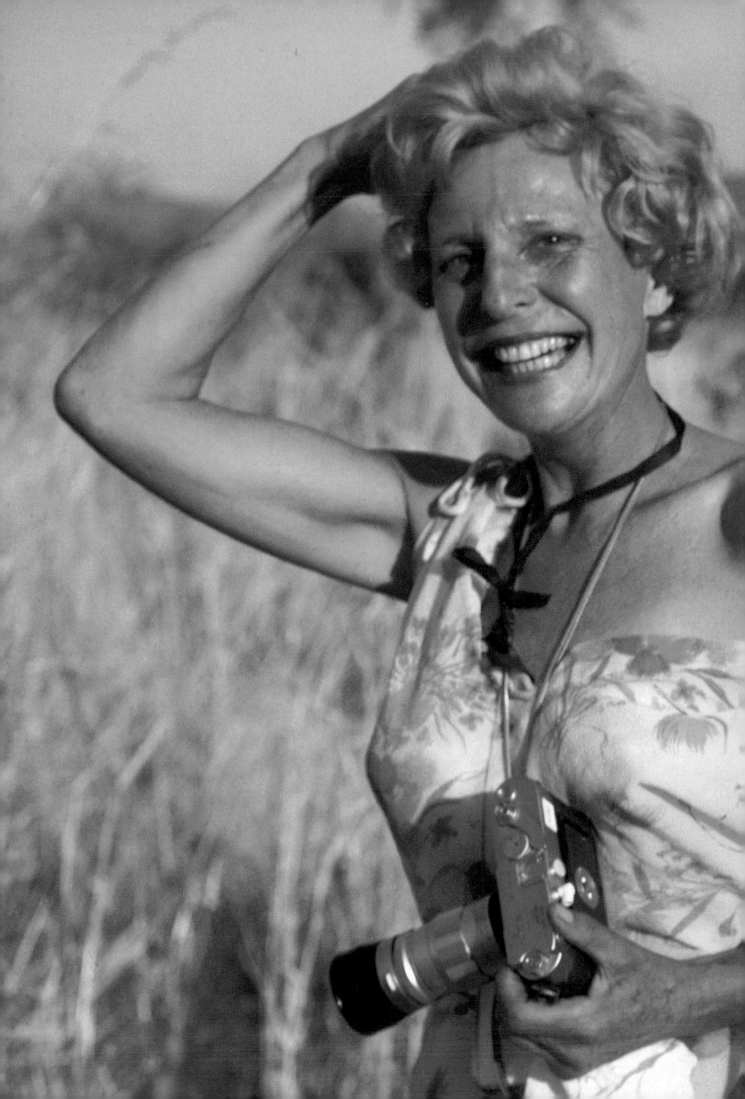

Biography Leni Riefenstahl

Biografie Leni Riefenstahl
Biographie Leni Riefenstahl

Leni as a two-year-old, circa 1904.
Leni als Zweijährige, um 1904.
Leni à l'âge de deux ans, vers 1904.

The family during a swimming excursion at Lake Zeuthen near Berlin, circa 1912.
Die Familie beim Badeausflug am Zeuthener See, um 1912.
Baignade en famille au lac de Zeuthen, près de Berlin, vers 1912.

Leni with her brother, Heinz, circa 1912. Photo: Atelier M. Appel
Leni mit ihrem Bruder Heinz, um 1912.
Leni avec son frère Heinz, vers 1912.

1902 Helene Amalia Bertha Riefenstahl is born on 22 August in the Wedding district of Berlin. Her father, Alfred Theodor Paul Riefenstahl (1878–1944), descended from a family of craftsmen in Brandenburg, establishes a successful firm that installs modern heating, ventilation and sanitary equipment in new buildings in Berlin. Her mother, Bertha Ida Riefenstahl, née Scherlach (1880–1965), was the 18th child of a master builder from West Prussia. Both parents love the theatre and attend performances frequently. When her husband goes hunting at weekends, Bertha Riefenstahl secretly attends balls or goes to the cinema with her daughter.

Helene Amalia Bertha Riefenstahl wird am 22. August in Berlin-Wedding geboren. Der Vater Alfred Theodor Paul Riefenstahl (1878–1944) entstammt einer Brandenburger Handwerkerfamilie und baut erfolgreich eine Firma auf, die in Berliner Neubauten moderne Heizungs-, Lüftungs- und Sanitäranlagen installiert. Ihre Mutter Bertha Ida Riefenstahl, geborene Scherlach (1880–1965), ist das 18. Kind eines Baumeisters aus Westpreußen. Die Eltern besuchen häufig Theateraufführungen. Wenn ihr Mann am Wochenende auf der Jagd ist, geht Bertha Riefenstahl mit der Tochter heimlich auf Bälle oder ins Kino.

Helene Amalia Bertha Riefenstahl naît le 22 août à Berlin-Wedding. Son père Alfred Theodor Paul Riefenstahl (1878–1944), issu d'une famille d'artisans du Brandebourg, monte avec succès une entreprise spécialisée dans l'installation d'équipements modernes (chauffage, sanitaires, aération) dans les nouveaux immeubles berlinois. Sa mère Bertha Ida Riefenstahl, née Scherlach (1880–1965), est le dix-huitième enfant d'un architecte de Prusse occidentale. Adeptes de théâtre, les parents de Leni se rendent souvent à des représentations. Le dimanche, quand son mari est à la chasse, Bertha Riefenstahl emmène sa fille en cachette au bal ou au cinéma.

1905 Her brother, Heinz, is born. The two siblings share a very close relationship.

Der Bruder Heinz wird geboren. Die beiden Geschwister haben ein sehr enges Verhältnis.

Naissance de son frère Heinz, auquel elle sera étroitement liée.

1914 – 1917 In 1914 she becomes a member of the "Nixe" swimming club and also joins a gymnastics club without her father's permission. She also likes to read fairy tales and to write short poems. Her father wants Heinz to follow him into the family business, while his daughter is to go to school in home economics. But the children have their own dreams: Heinz wants to be an architect and Leni an actress.

Sie wird 1914 Mitglied im Schwimmclub „Nixe" und tritt ohne Erlaubnis ihres Vaters auch einem Turnverein bei. Sie liest gerne Märchen und schreibt kurze Gedichte. Der Vater wünscht, dass Heinz seine Nachfolge im Familienbetrieb antritt, während die Tochter eine Haushaltsschule besuchen soll. Doch die Kinder haben ihre eigenen Träume: Heinz will Architekt und Leni Schauspielerin werden.

En 1914, elle devient membre du club de natation «Nixe» et adhère, sans la permission de son père, à une fédération de gymnastique. Elle aime lire des contes et écrire des poèmes. Le père souhaite que Heinz reprenne sa succession, tandis que Leni fréquenterait une école ménagère. Les enfants ont cependant leurs propres aspirations: Heinz veut être architecte et Leni actrice.

1918 She successfully completes her schooling at the Kollmorgen Lyceum in Berlin. In early summer she sees a newspaper advertisement seeking young actresses for the film *Opium* (1919); she attends the audition at the Helene Grimm-Reiter Dance School on Berlin's Kurfürstendamm. She is so taken by its atmosphere that, without her father's permission but with the support of her mother, she secretly attends courses in expressive dance and classical ballet. Her

first performance is a success, but now Alfred Riefenstahl learns of her dance lessons. He considers dance disreputable, and he forbids her to continue. In keeping with his wishes, in the autumn she attends the State School for Arts and Crafts for a semester to study painting.

Sie beendet erfolgreich ihre Schulausbildung am Kollmorgenschen Lyzeum in Berlin. Sie sieht im Frühsommer eine Zeitungsannonce, in der für den Film *Opium* (1919) junge Darstellerinnen gesucht werden, und geht zum Vorsprechen in die Helene-Grimm-Reiter-Schule für Tanz am Kurfürstendamm. Die Atmosphäre nimmt sie so sehr gefangen, dass sie ohne Erlaubnis ihres Vaters, aber mit Unterstützung der Mutter dort heimlich Stunden in Ausdruckstanz und klassischem Ballett nimmt. Ihr erster öffentlicher Auftritt ist ein Erfolg, aber nun erfährt Alfred Riefenstahl von den Tanzstunden der Tochter. In seinen Augen ist das Tanzen anrüchig, er verbietet es ihr. Auf seinen Wunsch hin belegt sie im Herbst an der Staatlichen Kunstgewerbeschule für ein halbes Jahr das Fach Malerei.

Elle achève sa scolarité avec succès au lycée Kollmorgen de Berlin. Au début de l'été, elle voit une petite annonce dans la presse qui recrute de jeunes actrices pour le film *Opium* (1919). Elle se rend à l'audition à l'école de danse Helene-Grimm-Reiter Schule, sur le Kurfürstendamm. Elle est tellement séduite par l'ambiance qu'elle s'inscrit à un cours de danse, sans l'autorisation paternelle. Grâce au soutien de sa mère, elle suit en cachette des leçons de danse de caractère et de danse classique. Sa première représentation connaît un vrai succès, mais Alfred Riefenstahl est désormais au courant des activités de sa fille. Considérant la danse comme mal famée, il lui interdit de continuer dans cette voie et la pousse à s'inscrire à l'École nationale des arts appliqués où, à partir de l'automne, elle étudie la peinture pendant six mois.

1920 Father and daughter reach a compromise: if Leni will work as a secretary in his business, her

father will permit her to take dance lessons at the Grimm-Reiter School and perform in public.

Vater und Tochter schließen einen Kompromiss: Leni wird Sekretärin in seinem Betrieb, dafür erlaubt ihr der Vater, Tanzstunden an der Grimm-Reiter-Schule zu nehmen und auch öffentlich aufzutreten.

Le père et la fille finissent par trouver un compromis: Leni sera secrétaire dans une entreprise, en échange de quoi son père lui permet de prendre des cours de danse à l'école Grimm-Reiter et de se produire en public.

1921 – 1922 Finally, Alfred Riefenstahl resigns himself to his daughter's dreams of the stage, and she begins training in classical ballet under Eugenie Eduardova, a former ballerina from St. Petersburg. In the afternoon she also takes lessons in expressive dance at the Jutta Klamt School. Her dance education lasts just two years in all, but she practices so intensively that she catches up with the other students who began at a younger age. During a vacation on the Baltic Sea she meets Harry (Henry) R. Sokal, a young businessman from Innsbruck.

Schließlich akzeptiert Alfred Riefenstahl die Bühnenträume seiner Tochter und sie beginnt eine klassische Ballettausbildung bei Eugenie Eduardowa, einer ehemaligen Ballerina aus St. Petersburg. Am Nachmittag lernt sie zusätzlich Ausdruckstanz an der Jutta-Klamt-Schule. Ihre Tanzausbildung dauert insgesamt nur zwei Jahre, aber sie übt so intensiv, dass sie bald den Vorsprung anderer Schülerinnen, die schon länger tanzen, aufholt. Bei einem Urlaub an der Ostsee lernt sie Harry (Henry) R. Sokal kennen, einen jungen Innsbrucker Kaufmann.

Alfred Riefenstahl finit par accepter les aspirations de sa fille, laquelle commence alors une formation de danse classique avec Eugénie Edouardova, ancienne ballerine de Saint-Pétersbourg. L'après-midi, elle suit également des cours de danse de caractère à l'école Jutta-Klamt. Sa formation ne dure en tout que deux

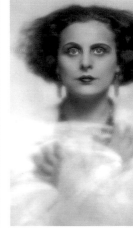

Leni as a dance student, 1918.
Leni als Tanzelevin, 1918.
Leni, élève de l'école de danse, 1918.

As a dancer at the Mary Wigman School in Dresden, 1923. / Als Tänzerin an der Mary-Wigman-Schule in Dresden, 1923. / Danseuse à l'école Mary-Wigman de Dresde, 1923.

Fiancé Otto Froitzheim.
Ihr Verlobter Otto Froitzheim.
Son fiancé Otto Froitzheim.

Photo: Binder

Publicity still, circa 1925.
Starfoto, um 1925.
Photo de star, vers 1925.

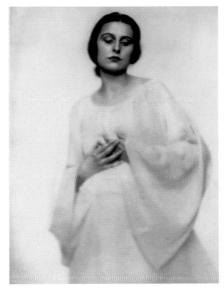

Publicity still for
The Holy Mountain (1926).
Starfoto für *Der heilige Berg* (1926).
Photo de star pour
La Montagne sacrée (1926).

With (from left to right) Arnold Fanck, the stunt pilot Ernst Udet,
and the producer Paul Kohner during the preparations for *SOS Iceberg*, 1932.
Mit Arnold Fanck, Ernst Udet und dem Produzenten Paul Kohner (von links nach rechts)
während der Vorbereitung der Dreharbeiten von *SOS Eisberg*, 1932.
Avec Arnold Fanck, le pilote Ernst Udet et le producteur Paul Kohner (de gauche à droite)

ans, mais elle s'entraîne avec une telle intensité qu'elle rattrape bientôt les élèves plus avancées. Lors de vacances sur la Baltique, elle fait la connaissance de Harry (Henry) R. Sokal, jeune négociant d'Innsbruck.

1923 For half a year she attends the Dresden dance school of the famous Mary Wigman. She choreographs on her own the cycle *The Three Dances of Eros*, to music by Tchaikovsky, Chopin and Grieg, which will later become part of her stage programme. On 23 October she has her first solo performance, with dances she has choreographed herself, at the Tonhalle in Munich. The evening is financed by Harry Sokal and is a great success—as is her solo recital several days later at the Blüthner Hall in Berlin. She is accoladed in Frankfurt, Leipzig, Düsseldorf, Cologne, Dresden, Kiel, Stettin, in the Schauspielhaus in Zurich and the Central Concert House in Prague. Bertha Riefenstahl always accompanies her daughter and sews the costumes Leni Riefenstahl designs herself.

Für ein halbes Jahr geht sie nach Dresden an die Tanzschule der berühmten Mary Wigman. Allein choreografiert sie den Zyklus *Die drei Tänze des Eros* zu Musik von Tschaikowsky, Chopin und Grieg, der später zu ihrem Bühnenprogramm gehören wird. Am 23. Oktober hat sie ihren ersten Soloauftritt mit eigenen Tanzchoreografien in der Tonhalle in München. Der Abend wird von Harry Sokal finanziert und ist ein großer Erfolg − ebenso der Soloauftritt einige Tage später im Blüthner-Saal in Berlin. Gefeiert wird sie unter anderem auch in Frankfurt, Leipzig, Düsseldorf, Köln, Dresden, Kiel, Stettin, im Züricher Schauspielhaus und dem Prager Konzertsaal Central. Bertha Riefenstahl näht die Kostüme nach den Entwürfen der Tochter und begleitet sie stets.

Elle passe un semestre à Dresde, à l'école de danse de la célèbre Mary Wigman. Elle chorégraphie toute seule le cycle *Les trois danses d'Éros* sur une musique de Tchaïkovski, Chopin et Grieg, qui fera ensuite partie de son programme de représentations. Le 23 octobre, elle se produit pour la première fois seule avec ses propres chorégraphies, à la Tonhalle de Munich. La soirée, financée par Harry Sokal, est une réussite, de même que la représentation en solo quelques jours plus tard à la Blüthner-Saal de Berlin. Elle est également très applaudie à Francfort, Leipzig, Düsseldorf, Cologne, Dresde, Kiel, Stettin, Zurich et Prague. Bertha Riefenstahl coud elle-même les costumes dessinés par sa fille et l'accompagne partout, où qu'elle aille.

1924 Injures her knee in a dance performance in Prague and is forced to stop dancing for a time. Becomes engaged to Otto Froitzheim, the internationally successful German tennis champion. A turning point in her life comes with *Mountain of Destiny* (1924), a mountain film set in the Dolomites by Arnold Fanck. On the way to a doctor's appointment, she happens to see the film poster and is so fascinated that she misses the appointment and instead sees the film over and over again. Some weeks later, in Berlin, Leni Riefenstahl meets Arnold Fanc. In contrast to other directors, Fanck, originally a documentary filmmaker, films on location in the Alps, not in the studio. He founds the so-called Freiburg School, a team of outstanding mountain climbers and skiers who serve as cameramen but also as actors, extras, and stuntmen. Leni Riefenstahl has to undergo an extensive operation on her injured knee. She spends three months in hospital, and during this time Arnold Fanck is writing the script for the film *The Holy Mountain*, in which she is to play the dancer Diotima. She takes the lead with an eye to continuing her dance career later. She breaks off her engagement to Otto Froitzheim following an argument.

Bei einem Tanzauftritt in Prag verletzt sie sich am Knie und muss eine Tanzpause einlegen. Sie verlobt sich mit Otto Froitzheim, dem international erfolgreichen Tennischampion. Einen Wendepunkt in ihrem Leben markiert der Film *Berg des Schicksals* (1924) von Arnold Fanck. Auf dem Weg zu einem Arzttermin sieht sie zufällig das Plakat zu dem Bergfilm und ist so begeistert, dass sie ihren Termin vergisst und sich stattdessen mehrere Male den Film ansieht. Einige Wochen später trifft sie in Berlin den Regisseur Arnold Fanck. Im Gegensatz zu anderen Regisseuren dreht Fanck, ein ehemaliger Dokumentarfilmer, an Originalschauplätzen in den Alpen und nicht im Studio. Er begründet die so genannte Freiburger Schule, ein Team hervorragender Bergsteiger und Skifahrer, die als Kameramänner, aber ebenfalls auch als Darsteller, Statisten und für Stunts eingesetzt werden. Leni Riefenstahl muss sich einer aufwändigen Operation an dem verletzten Knie unterziehen. Drei Monate liegt sie im Krankenhaus und in dieser Zeit schreibt Arnold Fanck für sie das Drehbuch zu dem Film *Der heilige Berg*, in dem sie die Tänzerin Diotima spielen soll. Sie übernimmt die Hauptrolle mit der Absicht, im Anschluss ihre Tanzkarriere fortzusetzen. Nach einem Zerwürfnis löst sie die Verlobung mit Otto Froitzheim.

Lors d'une représentation à Prague, elle se blesse au genou et doit observer un repos prolongé. Elle se fiance avec Otto Froitzheim, champion de tennis mondialement connu. Sa vie connaît un tournant avec *La Montagne du destin* (1924), un film de montagne d'Arnold Fanck. Alors qu'elle se rend chez le médecin, elle voit par hasard l'affiche du film dans le métro. Elle est tellement fascinée qu'elle en oublie le métro et son rendez-vous. Après avoir vu le film plusieurs fois, elle rencontre quelques semaines plus tard Arnold Fanck. Contrairement à d'autres cinéastes, Arnold Fanck, qui est documentariste à l'origine, tourne toujours en extérieur dans les Alpes, jamais en studio. Il fonde la fameuse «École de Fribourg», une équipe d'excellents alpinistes et skieurs engagés à la fois comme caméramans, acteurs, figurants et cascadeurs. Leni Riefenstahl doit subir une importante opération au genou et être hospitalisée pendant trois mois; Arnold Fanck écrit pour elle le scénario du film *La Montagne sacrée*, dans lequel elle doit jouer la danseuse Diotima. Elle accepte ce rôle avec l'intention de poursuivre ensuite sa carrière de danseuse. Cette même année, suite à une altercation,

Leni Riefenstahl rompt ses fiançailles avec Otto Froitzheim.

1925 In January filming for *The Holy Mountain* begins in the Grisons. Bad weather, storms, and injuries drag out the filming longer and longer, until finally a second winter has to be worked into the schedule. During the filming she becomes enthusiastic for the craft of filmmaking. She learns how to create lighting effects, is soon able to work with different lenses, discovers the importance of different colour filters and focal lengths, learns how film is developed and printed. For the first time she directs a few minor shots like the spring scene in the Bernese Oberland and later the torch-lit shots in St. Anton on the Arlberg. She is especially interested in editing as a creative process.

Im Januar beginnen die Filmarbeiten zu *Der heilige Berg* in Graubünden. Durch schlechtes Wetter, Stürme und Verletzungen ziehen sich die Dreharbeiten immer länger hin, bis ein zweiter Winter dafür eingeplant werden muss. Bei den Dreharbeiten begeistert sie sich für das Filmhandwerk. Sie lernt, wie Licht gesetzt wird, kann bald mit verschiedenen Optiken umgehen, erfährt die Bedeutung von Farbfiltern und verschiedenen Brennweiten, lernt, wie Filmmaterial entwickelt und kopiert wird. Sie führt erstmals Regie bei einigen Einstellungen wie den Frühlingsszenen im Berner Oberland und später bei den Fackelaufnahmen in St. Anton am Arlberg. Besonders der Filmschnitt als kreativer Vorgang interessiert sie.

En janvier commence le tournage de *La Montagne sacrée* dans les Grisons. Les intempéries et les blessures rallongent tellement le tournage qu'il faut prévoir de le reporter à l'hiver suivant. Leni Riefenstahl découvre avec passion les techniques de tournage: utilisation des éclairages, différents moyens optiques, fonctionnement des filtres colorés et des différentes focales, principes du développement et du tirage des copies. Pour la première fois, elle s'occupe de la réalisation de scènes annexes, celles tournées au printemps dans

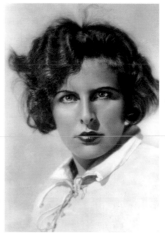

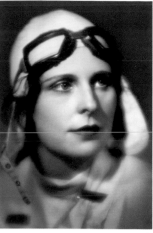

Publicity still for *The White Hell of Pitz Palu* (1929).
Starfoto für *Die weiße Hölle vom Piz Palü* (1929).
Photo de star pour *L'Enfer blanc du Piz Palü* (1929).

Publicity still for *SOS Iceberg*, 1932.
Starfoto für *SOS Eisberg*, 1932.
Photo de star pour *SOS Iceberg*, 1932.

With Marlene Dietrich and the Hollywood star Anna May Wong at a Berlin ball in 1928.
Mit Marlene Dietrich und Hollywoodstar Anna May Wong auf einem Berliner Ball, 1928.
Avec Marlene Dietrich et la star d'Hollywood Anna May Wong lors d'un bal à Berlin en 1928.

Photo: © Alfred Eisenstaedt Time Pix/Inter Topic

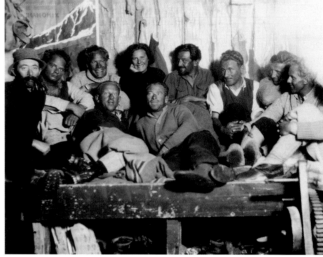

During the shooting of
Storm over Mont Blanc (1930).
Während der Dreharbeiten zu
Stürme über dem Montblanc (1930).
Lors du tournage de *Tempête sur
le Mont-Blanc* (1930).

le pays bernois ou celles aux flambeaux à Sankt-Anton dans l'Arlberg. Mais c'est le montage qui l'intéresse surtout, pour son aspect créateur.

1926 In January the filming for *The Holy Mountain* is continued on the Feldberg and the Arlberg. Even as the filming continues, Leni Riefenstahl resumes her dance training and reworks her choreography to use in the dance scenes of the film. She begins to accept dance performances again, appearing on stage in Düsseldorf, Frankfurt, Berlin, Dresde, Leipzig, Kassel, and Cologne. Her last official dance performance takes place on the stage of the cinema for the première of *The Holy Mountain* at the UFA-Palast am Zoo in Berlin.

Im Januar werden die Dreharbeiten für *Der heilige Berg* auf dem Feldberg und am Arlberg fortgesetzt. Noch während der Dreharbeiten nimmt sie das Tanztraining wieder auf und gestaltet für die Tanzszenen im Film ihre Choreografien neu. Sie nimmt wieder Tanzengagements an und tritt auf Bühnen in Düsseldorf, Frankfurt, Berlin, Dresden, Leipzig, Kassel und Köln auf. Ihren letzten öffentlichen Tanzauftritt hat sie auf der Bühne des Kinosaals bei der Premiere von *Der heilige Berg* im Berliner UFA-Palast am Zoo in Berlin.

En janvier, le tournage de *La Montagne sacrée* se poursuit sur le Feldberg et dans l'Arlberg. Pendant le tournage, Leni Riefenstahl reprend ses exercices de danse et remanie ses chorégraphies afin de les adapter au cinéma. Elle accepte de nouveau des engagements et se produit à Düsseldorf, Francfort, Berlin, Dresde, Leipzig, Kassel et Cologne. Sa dernière représentation publique a lieu sur la scène de la salle de cinéma, lors de la première de *La Montagne sacrée* au UFA-Palast am Zoo, à Berlin.

1927 She is offered and accepts the lead in Arnold Fanck's next film and thus decides once and for all to give up dancing in favour of an acting career. Her co-stars in the comedy *The Great Leap* are Hans Schnee-

berger, a brilliant ski racer and member of the Freiburg School, and Luis Trenker. The shooting takes place on the Arlberg and in the Dolomites under conditions that are physically demanding for the actors. For her second leading role, Leni Riefenstahl has to learn even barefoot rock climbing and to swim in Lake Carezza in water at 43°F. After the shooting, Leni Riefenstahl moves with Hans Schneeberger into a three-room apartment with a dance studio in the Wilmersdorf district of Berlin, where they live together for several years.

Als Arnold Fanck ihr die Hauptrolle in seinem nächsten Film anbietet, akzeptiert sie und entscheidet sich damit endgültig für das Fortsetzen ihrer Schauspielkarriere und gegen das Tanzen. Ihre Partner in der Komödie *Der große Sprung* sind Hans Schneeberger, ein brillanter Skirennfahrer und Mitglied der Freiburger Schule, sowie Luis Trenker. Die Dreharbeiten finden am Arlberg und in den Dolomiten statt und sind für die Schauspieler körperlich extrem anstrengend: Leni Riefenstahl muss in ihrer zweiten Hauptrolle barfuß klettern und bei 6° C durch den Karersee schwimmen. Nach den Dreharbeiten zieht Leni Riefenstahl mit Hans Schneeberger in eine Dreizimmerwohnung mit Tanzatelier in Berlin-Wilmersdorf, wo sie mehrere Jahre zusammenleben.

Elle accepte le rôle principal dans le prochain film d'Arnold Fanck et opte ainsi définitivement pour une carrière d'actrice. Ses partenaires dans la comédie *Le Grand Saut* sont Hans Schneeberger, excellent skieur de vitesse et membre de l'École de Fribourg, ainsi que Luis Trenker. Le tournage a lieu dans l'Arlberg et dans les Dolomites ; pour les acteurs, il est physiquement très éprouvant. Pour son deuxième grand rôle, Leni Riefenstahl doit escalader pieds nus et nager dans le lac de Kar dont l'eau n'est qu'à 6° C. Après le tournage, Leni Riefenstahl et Hans Schneeberger s'installent dans un trois-pièces avec atelier de danse à Berlin-Wilmersdorf, où ils vivent ensemble pendant quelques années.

1928 In February she travels to St. Moritz with Arnold Fanck and Hans Schneeberger, who film the Winter Olympic Games there. She describes her impressions in her first article, which is published in *Film-Kurier*. Since then she regularly publishes reports in various film journals about the filming of her works and she often writes her own publicity releases. In the film centre of Berlin she seeks out roles that will take her beyond the genre of the mountain film, because working as an actress under Fanck is unsatisfying from a dramatic standpoint. In the now-lost film *The Destiny of the Hapsburgs*, under the direction of Rolf Raffé she plays the Baroness Mary Vetsera, the lover of Rudolf, heir to the throne at the Vienna court. In Berlin she makes friends with the famous French film director Abel Gance and becomes acquainted with the director Walther Ruttmann, who garners attention for his experimental documentary *Berlin: Symphony of a Great City* (1927), and the famous director Georg Wilhelm Pabst.

Im Februar begleitet sie Arnold Fanck und Hans Schneeberger, als diese bei den Olympischen Winterspielen in St. Moritz filmen. Sie schildert ihre Eindrücke in einem ersten Artikel, der im *Film-Kurier* erscheint. Seitdem veröffentlicht sie regelmäßig Drehberichte zu ihren Filmarbeiten in verschiedenen Filmzeitschriften und verfasst häufig Pressetexte. In der Filmmetropole Berlin bemüht sie sich um Filmrollen außerhalb des Bergfilmgenres, denn die Arbeit als Schauspielerin unter Fanck ist in darstellerischer Hinsicht unbefriedigend. In dem heute verschollenen Film *Das Schicksal derer von Habsburg* spielt sie unter der Regie von Rolf Raffé die Baronesse Mary Vetsera, die Geliebte des Thronfolgers Rudolf am k. u. k.-Hof in Wien. In Berlin schließt sie Freundschaft mit dem französischen Filmregisseur Abel Gance und knüpft Bekanntschaft mit dem Regisseur Walther Ruttmann, der mit dem experimentellen Dokumentarfilm *Berlin, die Sinfonie der Großstadt* (1927) Aufsehen erregt, sowie mit dem bekannten Regisseur Georg Wilhelm Pabst.

En février, elle accompagne Arnold Fanck et Hans Schneeberger à Saint-Moritz où ils filment les Jeux

olympiques d'hiver. Elle retrace ses impressions dans un premier article qui paraît dans le *Film-Kurier*. Elle publiera ensuite régulièrement des récits de tournage dans différentes revues de cinéma et écrit également des textes pour la presse. À Berlin, capitale du cinéma, elle essaie de trouver des rôles qui changent du film de montagne. En effet, le travail avec Fanck n'est pas satisfaisant en ce qui concerne l'interprétation. Dans un film aujourd'hui disparu, *Le Destin des Habsbourg*, elle joue sous la direction de Rolf Raffé la baronne Mary Vetsera, amante du prince Rodolphe à la cour de Vienne. À Berlin, elle se lie d'amitié avec le réalisateur Abel Gance et fait connaissance avec le réalisateur Walther Ruttmann – rendu célèbre par le documentaire expérimental *Berlin – Symphonie d'une grande ville* (1927) – et avec le fameux cinéaste Georg Wilhelm Pabst.

1929 Her next engagement is the leading role in another mountain film by Arnold Fanck: *The White Hell of Pitz Palu*, which is filmed in the Engadine Valley on the Morteratsch Glacier and at Pitz Palu. Leni Riefenstahl's partners are Ernst Petersen and Gustav Diessl. Temperatures of minus 18°F create very difficult conditions for the actors and cameramen, but they nevertheless obtain fantastic images of the snow-covered mountains. In *The White Hell of Pitz Palu* Leni Riefenstahl gives her best acting performance under someone else's direction. At the end of the filming Hans Schneeberger breaks up with her. In Berlin she meets the Austrian-American director Josef von Sternberg, who is filming *The Blue Angel* (1929–1930) in Babelsberg with Marlene Dietrich, and Emil Jannings. She rejects Sternberg's offer to accompany him back to Hollywood.

Die Hauptrolle in einem weiteren Bergfilm von Arnold Fanck ist ihr nächstes Engagement. *Die weiße Hölle vom Piz Palü* wird im Engadin am Morteratsch-Gletscher und am Piz Palü gedreht. Die Partner von Leni Riefenstahl sind Ernst Petersen sowie Gustav Diessl. Bei Temperaturen von minus 28° C entstehen unter den härtesten Bedingungen für Schauspieler

530

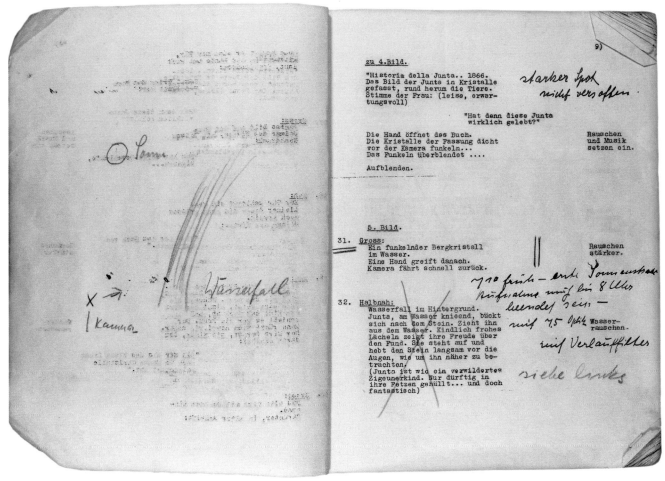

A page from the script of *The Blue Light*, 1931.
Eine Seite aus dem Drehbuch von *Das blaue Licht*, 1931.
Une page du scénario de *La Lumière bleue*, 1931.

und Kameramänner fantastische Bilder vom verschneiten Hochgebirge. Nach den Dreharbeiten trennt sich Hans Schneeberger von ihr. Zurück in Berlin lernt sie den österreichisch-amerikanischen Regisseur Josef von Sternberg kennen, der gerade in Babelsberg *Der blaue Engel* (1929–1930) mit Marlene Dietrich und Emil Jannings dreht. Das Angebot von Sternberg, ihn nach Hollywood zu begleiten, lehnt sie ab.

Elle accepte le rôle principal dans un nouveau film d'Arnold Fanck, *L'Enfer blanc du Piz Palu*, qui sera tourné dans l'Engadine, au glacier de Morteratsch et au Piz Palu. Les partenaires de Leni Riefenstahl sont Ernst Petersen et Gustav Diessl. C'est à des températures de moins 28° C, et dans des conditions effroyables pour les acteurs et les caméramans, que sont réalisées de fantastiques images de haute montagne sous la neige. Hans Schneeberger se sépare de Leni Riefenstahl à la fin du tournage. À Berlin, elle fait la connaissance du metteur en scène austro-américain Josef von Sternberg, qui tourne à Babelsberg *L'Ange bleu* (1929–1930) avec Marlene Dietrich et Emil Jannings. Elle refuse l'offre de Sternberg de la suivre à Hollywood.

1930 She accepts another leading role under Arnold Fanck's direction: *Storm over Mont Blanc* is the first sound film for both her and Fanck. During filming the entire crew spends several weeks at the Vallot shelter on Mont Blanc, and again storms, avalanches, and cracks in the glaciers are daily occurrences on the set. In one scene Leni Riefenstahl has to cross a rickety ladder over a 150-foot-deep crevasse in the Bosson Glacier, and later she is in the cockpit when Ernst Udet makes the first landing ever on a glacier, the Mont Blanc Glacier. Back in Berlin she trains her voice for sound films and takes speech lessons. She writes film treatments and the manuscript for what will become her own first film, *The Blue Light*. To raise start-up costs for the film, she sells personal possessions and earns money as the lead in Arnold Fanck's ski comedy *The White Flame*.

1931 For her own project *The Blue Light*, she gets Béla Balázs, the famous German-Hungarian film theorist and screenwriter, to collaborate on the script. She establishes her first film company, with herself as the sole owner: Leni Riefenstahl Studio-Film. After

Sie übernimmt eine weitere Hauptrolle unter der Regie von Arnold Fanck: *Stürme über dem Montblanc* ist Fancks und ihr erster Tonfilm. Während der Dreharbeiten wohnt das gesamte Team mehrere Wochen in der Vallot-Hütte am Montblanc und wieder gehören Stürme, Lawinen und aufbrechende Gletscherspalten zum Filmalltag. Für eine Szene muss Leni Riefenstahl einen 50 Meter tiefen Spalt des Bosson-Gletschers auf einer wackeligen Leiter überqueren und sie ist im Cockpit dabei, als Ernst Udet am Montblanc als erster Flieger überhaupt auf einem Gletscher landet. Zurück in Berlin lässt sie für die Tonaufnahmen ihre Stimme ausbilden und nimmt Sprechunterricht. Sie schreibt Filmexposés, darunter jenes für ihren ersten eigenen Film *Das blaue Licht*. Für die Vorfinanzierung ihres Films verkauft sie persönliche Wertgegenstände und übernimmt die Hauptrolle in der Skikomödie *Der weiße Rausch* von Arnold Fanck.

Elle travaille à nouveau avec Arnold Fanck, dans *Tempête sur le Mont-Blanc*, leur premier film parlant. Pendant les nombreuses semaines de tournage, toute l'équipe loge au refuge Vallot, sur le Mont-Blanc, et, de nouveau, tempêtes, avalanches et crevasses font partie du lot quotidien de l'équipe: sur le glacier des Bossons, Leni Riefenstahl doit, par exemple, traverser une anfractuosité de 50 mètres de profondeur en empruntant une passerelle branlante; ou encore, elle est dans le cockpit de l'avion lorsque Ernst Udet réalise une première: atterrir sur un glacier, celui du Mont-Blanc. De retour à Berlin, elle prend deux cours de diction pour les scènes parlantes. Elle écrit ses premiers scénarios, parmi lesquels celui de son premier film *La Lumière bleue*. Pour financer son film, elle vend une partie de ses biens et accepte le rôle principal dans *L'Ivresse blanche* d'Arnold Fanck.

the first test shots, the firm Henry R. Sokal-Produktion, which has already coproduced three of Arnold Fanck's mountain films, takes on coproduction. *The Blue Light* can be produced only because Leni Riefenstahl keeps the crew to a minimum. She directs and edits the film herself in addition to producing it and taking the lead. Most of the small crew either agree to defer their pay until the film is released or even work without pay altogether. She also films on location in the Alps, thereby avoiding expensive studio shots. She selects her crew from past films with Arnold Fanck: the cameraman Hans Schneeberger, the actors Beni Führer, Max Holzboer as well as the set builder Leopold Blonder. The village Foroglio, next to a waterfall in the Maggia Valley in Ticino and two hours by foot from the next village, suits her idea of the fictive Alpine village of Santa Maria. After a long search, she locates mountain villagers in the Sarn Valley near Bolzano. Although they live in complete isolation on their mountain farms, they agree to play the role of villagers once they have finished the harvest. Leni Riefenstahl edits the film herself, finding a rhythm of images that suits the fairytale theme. The music is composed by the director of UFA's music department, Giuseppe Becce.

Für die Mitarbeit an ihrem Filmprojekt *Das blaue Licht* gewinnt sie Béla Balázs, den bekannten deutsch-ungarischen Filmtheoretiker und Drehbuchautor. Sie gründet ihre erste eigene Filmgesellschaft mit ihr als alleiniger Gesellschafterin, die Leni Riefenstahl Studio-Film GmbH. Nach den ersten Probeaufnahmen gewinnt sie die Henry R. Sokal-Produktion, die bereits drei Bergfilme von Arnold Fanck mitproduziert hat, als Partnerfirma. Produziert werden kann *Das blaue Licht* nur, weil Leni Riefenstahl den Stab möglichst klein hält, neben Produktion und Hauptrolle auch Regie und Schnitt übernimmt und die wenigen engagierten Mitarbeiter größtenteils ihr Honorar bis zur Uraufführung zurückstellen oder auch auf die Gage verzichten. Zudem dreht sie vor Ort und verzichtet auf teure Atelieraufnahmen. Das Filmteam stammt aus dem Kreis um Arnold Fanck: Dazu gehören der Kameramann Hans Schneeberger, die

Schauspieler Beni Führer und Max Holzboer sowie der Filmarchitekt Leopold Blonder. Das Dorf Foroglio, an einem Wasserfall im Maggiatal im Tessin gelegen und zwei Stunden Fußweg vom nächsten Dorf entfernt, entspricht ihrer Vorstellung von dem fiktiven Alpendorf Santa Maria. Nach langem Suchen findet sie im Sarntal bei Bozen Bergbauern. Obwohl sie völlig zurückgezogen auf ihren Berghöfen leben, erklären sie sich bereit, nach der Ernte die Rolle der Dorfbewohner zu spielen. Die Regisseurin übernimmt selbst den Schnitt des Films, wobei sie einen dem märchenhaften Thema angemessenen Bildrhythmus findet. Die Musik komponiert der damalige Leiter der UFA-Musikabteilung, Giuseppe Becce.

Elle continue de préparer son propre projet *La Lumière bleue*. Béla Balázs, le célèbre critique et scénariste germano-hongrois, l'aide dans l'écriture du scénario. Elle fonde sa première société de production, la «Leni Riefenstahl Studio-Film GmbH», dont elle est la seule actionnaire. Après les premiers rushes, la coproduction est assurée par Henry R. Sokal, qui a déjà coproduit trois films de montagne d'Arnold Fanck. La production de *La Lumière bleue* n'est cependant possible que parce que Leni Riefenstahl engage une équipe très réduite, qu'elle joue elle-même le rôle principal, en plus d'assurer la réalisation et le montage, et que les rares collaborateurs engagés sont prêts soit à attendre la première pour être payés soit même parfois à renoncer à leurs gages. Le film est en partie celle qui travaillait aussi pour Arnold Fanck: le caméraman Hans Schneeberger, les acteurs Beni Führer, Max Holzboer et l'architecte de cinéma Leopold Blonder. C'est le village de Foroglio, au pied d'une cascade dans la vallée de la Maggia, dans le Tessin, situé à deux heures de marche du prochain lieu habité, qui correspond le mieux à l'idée qu'elle se fait d'un village fictif de Santa Maria. Après de longues recherches, elle trouve à Sarentino, près de Bolzano, des paysans. Bien qu'ils mènent une vie très reculée dans leurs fermes de montagne, ils acceptent de jouer, après la récolte toutefois, le rôle des villageois. Leni Riefenstahl se charge elle-même

Publicity still for *The Blue Light* (1932).
Starfoto für *Das blaue Licht* (1932).
Photo de star pour *La Lumière bleue* (1932).

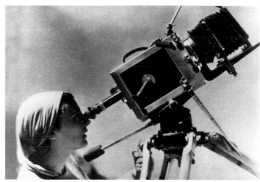

The director during the filming of *The Blue Light* in the Dolomites, 1931.
Die Regisseurin bei den Dreharbeiten zu *Das blaue Licht* in den Dolomiten, 1931.
La réalisatrice pendant le tournage de *La Lumière bleue* dans les Dolomites, 1931.

Enthusiastic spectators wait for the director at the premiere of *The Blue Light*, 1932.
Begeisterte Zuschauer warten bei der Premiere von *Das blaue Licht* auf die Regisseurin, 1932.
Des spectateurs enthousiastes attendent la réalisatrice lors de la première de *La Lumière bleue*, 1932.

du montage du film en trouvant un rythme adapté au caractère fabuleux du sujet. La musique est écrite par Giuseppe Becce, directeur du département musique à la UFA.

1932 The film *The Blue Light* has its premiere on 24 March 1932 in the UFA-Palast am Zoo in Berlin. It becomes a worldwide success and brings Leni Riefenstahl international fame as a producer, director, creator of images, and lead actress. At the Venice Film Biennale, which takes place for the first time, *The Blue Light* wins the silver medal. In February she hears a speech by Adolf Hitler in the Sports Palace in Berlin and is so impressed by his charisma that she writes him a letter in May, and he invites her to Horumersiel near Wilhelmshaven on the North Sea. Then she accepts her final starring role in a film by Arnold Fanck: in the German-American coproduction *SOS Iceberg*, which takes place in Greenland. In late May the whole crew—including two polar bears from Hamburg Zoo—travel to Greenland with a special permit from the Danish government. For five months the film crew lives in a tent camp near the Inuit village of Umanak, on the northwest coast. As the primary director, Arnold Fanck films a glacier that is breaking up and tries out scenes on icebergs and ice floes. For several scenes the actors have to swim in ice-cold water, and Sepp Rist develops a serious case of rheumatism. Leni Riefenstahl is forced to leave the set early, because her bladder colic becomes unbearable. In late September she is back in Berlin, where she meets with Adolf Hitler again. Her friend Manfred George—editor of the Berlin evening newspaper *Tempo* and from 1939 on publisher of *Aufbau*, a German-language Jewish newspaper published in New York—asks her to write a series of articles about her experiences in Greenland. These result in 1933 in the book *Kampf in Schnee und Eis* (literally: Struggle in Snow and Ice), which depicts the strenuous and dangerous work of shooting mountain films.

Der Film *Das blaue Licht* hat am 24. März 1932 im Berliner UFA-Palast am Zoo Premiere. Er wird ein Welterfolg und macht Leni Riefenstahl als weibliche Produzentin, Regisseurin, Bildgestalterin und Hauptdarstellerin international bekannt. Bei der Film-Biennale in Venedig, die erstmals stattfindet, wird *Das blaue Licht* mit der Silbermedaille ausgezeichnet. Im Februar hört sie eine Rede Adolf Hitlers im Sportpalast in Berlin und ist von seinem Charisma so beeindruckt, dass sie ihm im Mai einen Brief schreibt und von ihm nach Horumersiel bei Wilhelmshaven eingeladen wird. Im Anschluss übernimmt sie ihre letzte Hauptrolle in einem Film von Arnold Fanck: in der deutsch-amerikanischen Co-Produktion *SOS Eisberg*, die in Grönland spielt. Ende Mai reist das gesamte Filmteam – inklusive zweier Eisbären aus dem Hamburger Zoo – mit einer Sondergenehmigung der dänischen Regierung nach Grönland. Fünf Monate lebt das Filmteam in einem Zeltlager beim Eskimodorf Umanak an der Nordwestküste. Als erster Regisseur filmt Arnold Fanck einen auseinander brechenden Gletscher und probt Szenen auf Eisbergen und Eisschollen. Für einige Szenen müssen die Schauspieler im Eiswasser schwimmen, wobei Sepp Rist sich ein schweres Rheumaleiden zuzieht. Leni Riefenstahl muss den Set vorzeitig verlassen, weil ihre Blasenkoliken unerträglich werden. Ende September ist sie wieder in Berlin und trifft erneut Adolf Hitler. Ihr Freund Manfred George, der Redakteur der Berliner Abendzeitung *Tempo* und ab 1939 der Herausgeber der in New York erscheinenden jüdischen Zeitschrift *Aufbau*, bittet sie, eine Artikelserie über die Erlebnisse in Grönland zu schreiben. Daraus entsteht die Idee zu dem Buch *Kampf in Schnee und Eis* (1933), das anschaulich die strapaziösen und gefährlichen Dreharbeiten zu den Bergfilmen schildert.

La première de *La Lumière bleue* a lieu le 24 mars 1932 au UFA-Palast am Zoo, à Berlin. Le film sera un succès international et fera de Leni Riefenstahl une productrice, réalisatrice et actrice mondialement connue. Lors de la toute première Biennale de Venise, le film recevra la médaille d'argent. En février, elle entend un discours d'Adolf Hitler au Palais des Sports, à Berlin et, très impressionnée par son charisme, elle lui écrit une lettre en mai, suite à quoi il l'invite à venir à Horumersiel, près de Wilhelmshaven, au bord de la mer du Nord. Elle joue ensuite son dernier grand rôle dans un film d'Arnold Fanck, une coproduction germano-américaine, *SOS Iceberg*, qui se déroule au Groenland. Fin mai, toute l'équipe du film – y compris deux ours polaires du zoo de Hambourg – part pour le Groenland, avec une autorisation spéciale du gouvernement danois. Pendant cinq mois, l'équipe campe près du village esquimau d'Umanak, sur la côte nord-ouest. Arnold Fanck est le premier cinéaste à filmer des glaciers en train de «vêler». Sur des icebergs et des banquises, il tourne des scènes souvent très dangereuses pour l'équipe. Certaines scènes prévoient que les acteurs nagent dans les eaux glaciales: Sepp Rist est bientôt atteint de violents rhumatismes et Leni Riefenstahl doit quitter le tournage prématurément, tant ses coliques sont devenues insupportables. De retour à Berlin fin septembre, elle rencontre de nouveau Adolf Hitler. Son ami Manfred George, rédacteur au quotidien berlinois *Tempo* et, à partir de 1939, rédacteur en chef du journal juif *Aufbau*, paraissant à New York, lui propose d'écrire une série d'articles sur les expériences vécues au Groenland. De là naît l'idée du livre *Kampf in Schnee und Eis* (littéralement: Combat dans la neige et la glace, 1933), qui retrace les tournages périlleux et éprouvants des films de montagne.

1933 The final shooting for *SOS Iceberg* takes place over several months in the Bernina Pass. When she returns to Berlin in June, many of her Jewish acquaintances and friends have already emigrated: Manfred George, Max Reinhardt, UFA film producer Erich Pommer, stage star Elisabeth Bergner, and even Harry Sokal. Leni Riefenstahl is stunned and in despair. When, several days later, she receives an invitation from the Reich chancellery, she speaks to Hitler about the emigration of her friends. Leni Riefenstahl describes this speech in her memoirs (p. 137) as follows: "Hitler raised his hand as if to stem my flow of words. Rather angrily he said, 'Fräulein Riefenstahl, I know how you feel; you told me as much in Horumersiel. I respect you. But I would like to ask you not to talk to me about a topic that I find disagreeable. I have great esteem for you as an artist, you have a rare talent, and I do not wish to influence you. But I cannot discuss the Jewish problem with you.'" A few days before the National Socialist Party rally in Nuremberg, she is called to the Reich chancellery, where Hitler asks her how far her preparations for the Party rally film have progressed. Several months earlier, via his adjutant Wilhelm Brückner, he had told Joseph Goebbels and the Propaganda Ministry to give her this assignment; until this visit to Hitler, however, she had heard nothing about it. Leni Riefenstahl describes the conversation with Hitler at the Reich chancellery in her memoirs (p. 143): "'Why wasn't Fräulein Riefenstahl informed?' As he spoke he clenched his fists, glaring with anger. Before his terrified aide could reply, Hitler jeered, 'I can imagine how the gentlemen at the Propaganda Ministry must envy this gifted young artist. They can't stand the fact that such an honour has been awarded to a woman —and, indeed, an artist who isn't even a member of the Party.'" A heated discussion between Hitler and Goebbels follows, and this merely reinforces Goebbel's dislike of Leni Riefenstahl and is one of the causes behind the quarrels that the director will have with him and the Propaganda Ministry from then until the end of the war. Hitler insists that she travel to Nuremberg, despite the short notice and lack of preparation, in order to start filming. Without contract or funding, she travels to Nuremberg. Instead of receiving help from the Party, however, she and her camera crew are completely boycotted. They are not even given film stock, so that she cannot begin shooting. She wants to leave, but then the architect Albert Speer meets her, and it is thanks to his influence that she is at least able to film some of the events. When the Party rally ends, Hitler calls her back to the Reich chancellery to get a report on the filming. Leni Riefenstahl describes this encounter in her memoirs (p. 147): "Hitler's face turned crimson, while Goebbels became chalky white as the Führer leaped up and snapped: 'Doctor, you are responsible for this. It is not to happen again. The motion picture about the national Party rally [of 1934] is to be made by

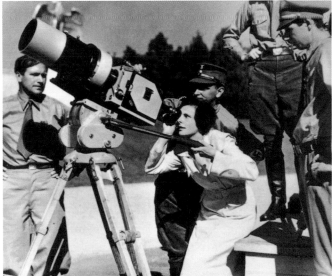

In the shooting of *Triumph of the Will*, the camera crew experimented with innovative techniques and angles.
Bei den Dreharbeiten zu *Triumph des Willens* experimentieren die Kameraleute mit innovativen
Aufnahmetechniken und Perspektiven. / Durant le tournage du *Triomphe de la volonté*, les cameramans
expérimentent des techniques de prises de vue et des perspectives innovantes.

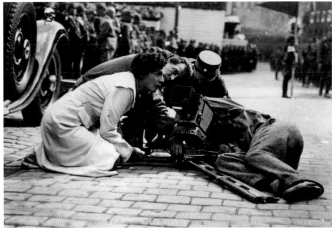

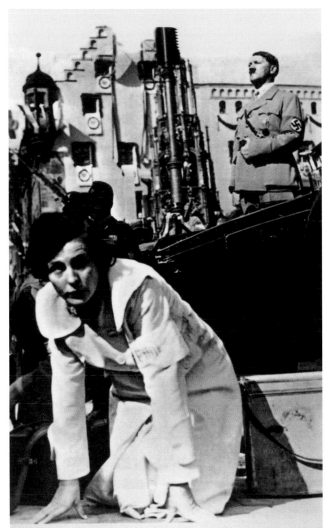

The director at work on *Triumph of the Will* (1935) in Nuremberg.
Bei den Regiearbeiten von *Triumph des Willens* (1935) in Nürnberg.
Mise en scène du *Triomphe de la volonté* (1935) à Nuremberg.

Fräulein Riefenstahl and not by the Party film people. Those are my orders!' Full of despair, I exclaimed: 'I can't, I absolutely can't!' Hitler's voice became icy. 'You can and you will. I apologize for what you have been through. It will not happen again." Although she does not like the film *Victory of Faith*, it is highly praised by the press and the party.

Die abschließenden Dreharbeiten für *SOS Eisberg* finden während mehrerer Monate auf dem Bernina-Pass statt. Als sie im Juni nach Berlin zurückkehrt, sind viele ihrer jüdischen Bekannten und Freunde bereits emigriert: Manfred George, Max Reinhardt, der UFA-Filmproduzent Erich Pommer, der Berliner Bühnenstar Elisabeth Bergner und auch Harry Sokal. Leni Riefenstahl ist fassungslos und verzweifelt. Als sie einige Tage danach eine Einladung von der Reichskanzlei bekommt, spricht sie Adolf Hitler auf die Emigration ihrer Freunde an. Dieses Gespräch beschreibt Leni Riefenstahl in ihren Memoiren (S. 197) wie folgt: „Hitler hob seine Hand, als wollte er meine Worte stoppen, und sagte dann etwas gereizt: ‚Fräulein Riefenstahl, ich kenne Ihre Einstellung, die Sie mir in Horumersiel mitteilten. Ich respektiere sie. Aber ich möchte Sie bitten, mit mir nicht über ein Thema zu sprechen, das mir unangenehm ist. Ich schätze Sie als Künstlerin hoch ein, Sie haben eine seltene Begabung, und ich möchte Sie auch nicht beeinflussen. Aber eine Diskussion über das jüdische Problem kann ich mit Ihnen nicht führen.'" Sie wird wenige Tage vor dem Reichsparteitag in Nürnberg erneut in die Reichskanzlei gerufen, wo sie von Hitler gefragt wird, wie weit sie mit ihren Vorbereitungsarbeiten für den Reichsparteitagsfilm sei, denn er hatte diesen Auftrag durch seinen Adjutanten Wilhelm Brückner an Joseph Goebbels und das Reichspropagandaministerium übergeben, doch sie weiß bis zu ihrem Besuch bei Hitler nichts davon. Das Gespräch mit Hitler in der Reichskanzlei beschreibt Leni Riefenstahl in ihren Memoiren (S. 204/205): „Warum wurde Fräulein Riefenstahl nicht informiert?' Dabei verkrampfte er seine Hände, er war rasend vor Zorn. So hatte ich Hitler noch nie erlebt. Ehe der erschrockene Brück-

ner antworten konnte, sagte er spöttisch: ‚Ich kann mir vorstellen, wie neidisch die Herren im Propagandaministerium auf diese junge, begabte Künstlerin sind. Sie können es nicht verkraften, daß eine so ehrenvolle Aufgabe einer Frau übertragen wird und noch dazu einer Künstlerin, die nicht einmal Parteimitglied ist.'" Die folgende Auseinandersetzung zwischen Hitler und Goebbels verstärkt dessen bereits vorhandene Abneigung gegen Leni Riefenstahl und ist eine der Ursachen für alle zukünftigen Behinderungen, die die Regisseurin bis Kriegsende von ihm und dem Reichspropagandaministerium bei ihren Filmarbeiten erfährt. Hitler besteht darauf, dass sie trotz der knappen Zeit und ohne Vorbereitung nach Nürnberg zu beginnen. Ohne Vertrag und ohne Geldmittel reist sie nach Nürnberg. Aber anstatt dort von der Partei Hilfe zu erhalten, werden sie und ihre Kameraleute komplett boykottiert. Sie bekommt nicht einmal Filmmaterial, so dass sie gar nicht mit den Filmaufnahmen beginnen kann. Sie will schon abreisen, da begegnet ihr der Architekt Albert Speer, dessen Einfluss es zu verdanken ist, dass sie einige der Veranstaltungen aufnehmen kann. Nach Beendigung des Reichsparteitags wird sie wieder von Hitler in die Reichskanzlei gerufen, um Bericht über die Dreharbeiten zu erstatten. Diese Begegnung beschreibt Leni Riefenstahl in ihren Memoiren (S. 208) wie folgt: „Hitler sprang auf und sagte zu Goebbels in scharfem Ton: ‚Doktor, Sie sind verantwortlich für das, was geschehen ist – es darf sich nie mehr wiederholen. Der Film über den Reichsparteitag [1934] wird von Fräulein Riefenstahl gemacht, und nicht von den Filmleuten der Partei – das ist mein Befehl.' Verzweifelt rief ich: ‚Das kann ich nicht, das kann ich nie!' Hitlers Gesicht wurde eisig: ‚Sie werden es können. Es tut mir leid, was Sie mitgemacht haben, und es wird nie wieder vorkommen.'" Obgleich ihr der Film *Sieg des Glaubens* überhaupt nicht gefällt, wird er von der Presse und der Partei gelobt.

La dernière phase du tournage de *SOS Iceberg* a lieu pendant plusieurs mois au col de la Bernina. Lorsqu'elle rentre à Berlin en juin, beaucoup de connaissances et

amis juifs ont déjà émigré: Manfred George, Max Reinhardt, le producteur de la UFA Erich Pommer, l'actrice berlinoise Elisabeth Bergner et Harry Sokal. Leni Riefenstahl est à la fois consternée et désespérée. Lorsqu'elle reçoit, quelques jours plus tard, une invitation à la Chancellerie du Reich, elle parle à Hitler de l'émigration de ses amis. Leni Riefenstahl retrace cet entretien dans ses mémoires (pp. 186–187): «Hitler leva la main dans un geste d'interruption: il ne voulait pas entendre parler de ce sujet. Puis il me dit, plutôt énervé: ‹Mademoiselle Riefenstahl, je connais votre position sur ces questions, et je la respecte. Vous m'en avez déjà parlé la première fois à Horumersiel. Mais je vous prie de ne pas aborder devant moi un thème qui m'est désagréable. Je vous place très haut en tant qu'artiste, vous possédez des dons tout à fait rares, et de ce point de vue je tiens à ne pas me laisser embarquer dans une discussion sur le problème juif.› Quelques jours avant le congrès du parti à Nuremberg, elle est convoquée à la Chancellerie, où Hitler lui demande où en sont les préparations pour le film sur le congrès en question; en effet, plusieurs mois auparavant, il avait chargé son adjudant Wilhelm Brückner de faire suivre sa demande de film à Joseph Goebbels et au ministère de la Propagande, mais jusqu'à sa visite chez Hitler, elle n'en sait absolument rien. Leni Riefenstahl évoque cet entretien dans ses mémoires (p. 194): «‹Comment se fait-il que l'information n'ait pas été transmise à Mlle Riefenstahl?› Il crispait ses mains, il levait le poing, c'était une vraie crise de rage et de fureur. Je ne l'avais encore jamais vu dans cet état. Avant que le pauvre Brückner, terrorisé, ait pu répondre, Hitler émit d'un ton moqueur son interprétation, qui disculpait son aide de camp: ‹Oh, je reconnais bien là la jalousie de ces messieurs du ministère de la Propagande, qui ne supportent pas que je favorise cette artiste plus jeune et plus douée qu'eux! Ils ne peuvent pas avaler qu'une commande aussi prestigieuse revienne à une femme! À une artiste! Et qui en plus n'est même pas membre du Parti!› L'altercation qui suit entre Hitler et Goebbels renforce l'hostilité de ce dernier envers Leni Riefenstahl et sera une raison pour laquelle, jusqu'à la fin de la

guerre, la cinéaste sera gênée dans son travail par lui-même et le ministère de la Propagande. Hitler insiste pour qu'elle aille à Nuremberg et qu'elle commence le tournage, en dépit du peu de temps imparti. Sans contrat et sans moyen financier, elle part pour Nuremberg. Mais au lieu d'obtenir de l'aide du parti, elle sera totalement boycottée. Ne recevant pas même le matériel nécessaire, elle ne peut pas commencer à tourner. Elle est sur le point de repartir lorsqu'elle rencontre l'architecte Albert Speer, grâce à l'influence duquel elle pourra filmer au moins quelques manifestations. Une fois le congrès terminé, Hitler la convoque de nouveau à la chancellerie pour avoir un rapport sur le tournage. La rencontre est décrite dans les mémoires (p. 198) de Leni Riefenstahl de la façon suivante: «Hitler sauta d'un bond de son fauteuil et s'avança sur Goebbels en lui lançant sur un ton tranchant: ‹Docteur, je vous tiens pour responsable de ce qui s'est passé là. Et cela ne doit jamais se reproduire. Je veux que le film sur le Congrès du Parti [de 1934] soit fait par Mlle Riefenstahl, et non pas par les cinéastes du Parti. C'est un ordre!› Je criai de désespoir: ‹Mais je ne peux pas! Je ne le pourrai jamais!› Les traits d'Hitler prirent une expression glaciale: ‹Vous le pourrez. Je suis désolé de ce que vous venez de subir, mais cela ne se reproduira plus jamais.» Bien que le film *Victoire de la foi* ne plaise pas du tout à la réalisatrice, il fut très acclamé par la presse et le parti.

1934 Despite Hitler's order for her to film the Party rally in 1934, Leni Riefenstahl still hopes to withdraw from the assignment. She asks her friend Walther Ruttmann, who was then the best documentary filmmaker, and whose film *Berlin: Symphony of a Great City* (1927) won prizes and has since become a classic, to direct the Party rally film. She accepts an offer from the Berlin production company Terra-Film to direct and star in the film *Tiefland*. She dives into her work in Spain, playing the role of the Gypsy dancer Martha, with such great fervour that she suffers a breakdown and spends two months in a hospital in Madrid. The work on *Tiefland* has to be

533

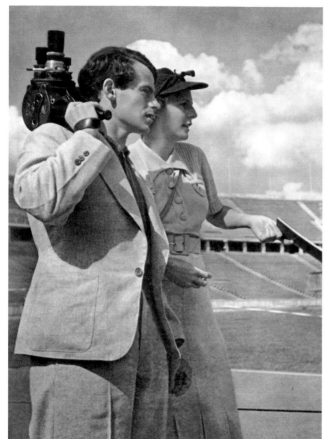

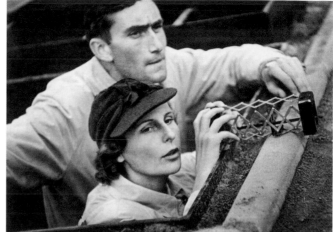

The directior with cameraman Walter Frentz in one of the six filming pits at the Berlin stadium, 1936.
Die Regisseurin mit Kameramann Walter Frentz in einer der sechs Filmgruben im Berliner Stadion, 1936.
La réalisatrice avec le cameraman Walter Frentz dans une des six tranchées creusées pour le tournage du film au stade de Berlin, 1936.

Leni Riefenstahl with the cameraman Guzzi Lantschner during the preparations for *Olympia* (1938).
Leni Riefenstahl mit Kameramann Guzzi Lantschner bei der Vorbereitung von *Olympia* (1938).
Leni Riefenstahl avec le cameraman Guzzi Lantschner pendant les préparations des *Dieux du stade* (1938).

With Lutz Long, silver medal winner in the long jump, she watches the Olympic champion Jesse Owens make his record jump, 1936.
Mit Lutz Long, Silbermedaillengewinner im Weitsprung, verfolgt sie den Weltrekordsprung von Olympiasieger Jesse Owens, 1936.
Avec Lutz Long, médaille d'argent au saut en longueur, elle suit le saut du champion olympique Jesse Owens, 1936.

called off. When she returns to Berlin after her recovery and sees Walther Ruttmann's edit, she is incredulous. Leni Riefenstahl realizes she cannot take responsibility for Ruttmann's film. Hitler would not accept it, and she will now have to make the film herself. Nevertheless, she makes one last attempt to discuss it with Hitler, and she travels to Nuremberg to meet him. The dramatic dialogue there is described in Leni Riefenstahl's memoirs (pp. 157–58) as follows: "After our exchange of greetings he [Hitler] said amiably, but earnestly: 'Party Member Heß has told me why you wish to speak to me. I can assure you that your worries are groundless. You will have no problem this time.' 'That is not all, my Führer. I am afraid I cannot make this film ... I am completely unfamiliar with all the subject matter. I can't even tell the SA from the SS.' 'That's an advantage. Then you'll see only the essentials. I don't want a boring Party rally film; I don't want newsreel shots. I want an artistic visual document. The Party people don't understand this. Your *Blue Light* proved that you can do it.' ... Then he said, smiling, but in a resolute tone, ' ... Don't worry, and don't force me to keep asking you. It's only six days you'll be giving me ... you have to have more self-confidence. You can and you will do this project.' It sounded almost like an order. I realized that I could not break Hitler's resolve." She films with a crew of 18 cameramen and their assistants, among them, once again, Sepp Allgeier, Franz Weihmayr, Walter Riml, and Walter Frentz. Some 400,000 feet of footage are produced in all, more than 100 hours. Leni Riefenstahl needs five months of intensive work to review the footage, edit it, and synchronize the music for *Triumph of the Will*. Not all of the events of the Party rally appear in the film; for example, the Congress of National Socialist Women and the army are not shown. The director is not concerned with the chronology and exact documentation of the event but rather with its atmosphere, mood, and inner rhythm. But even during the editing of *Triumph of the Will*, there are conflicts. Rainy weather results in footage of the army that Leni Riefenstahl considers far too bad to include in her film. General Walter von Reichenau is outraged that the army,

which has taken part in the Party rally for the first time, will not appear in the film at all and complains to Hitler. As a compromise she proposes making a short film of the army at the next Party rally. The result is the 28-minute film *Day of Freedom!—Our Armed Forces!* realized in Nuremberg in September 1935.

Trotz des Befehls von Hitler, den Reichsparteitag 1934 zu filmen, hofft Leni Riefenstahl immer noch, sich diesem Auftrag entziehen zu können. Sie bittet ihren Freund Walther Ruttmann, der damals der beste Dokumentarfilm-Regisseur ist und dessen Film *Berlin, die Sinfonie der Großstadt* (1927) Preise erhielt und ein Filmklassiker ist, den Reichsparteitagsfilm zu drehen. Sie akzeptiert das Angebot der Berliner Filmproduktionsfirma Terra-Film, Regie und Hauptrolle in dem Film *Tiefland* zu übernehmen. Sie stürzt sich mit so großem Engagement in ihre Arbeit in Spanien, in der sie die Rolle der Zigeunertänzerin Martha spielt, dass sie zusammenbricht und zwei Monate im Krankenhaus in Madrid liegt. Die Arbeiten an *Tiefland* müssen abgebrochen werden. Als sie nach ihrer Genesung Mitte August wieder in Berlin ist und den Filmschnitt von Walther Ruttmann sieht, kann sie es kaum fassen. Sie akzeptiert das Angebot der Berliner Filmproduktionsfirma Terra-Film, Regie und Hauptrolle in dem Film *Tiefland* zu übernehmen. Sie will für diese Arbeit nicht die Verantwortung übernehmen kann, Hitler dies nicht akzeptieren würde und sie den Film nun doch selbst machen müsste. Trotzdem unternimmt sie einen letzten Versuch, mit Hitler noch einmal darüber zu sprechen und reist ihm nach Nürnberg nach. Die dortige dramatische Unterredung ist in ihren Memoiren (S. 221–222) wie folgt beschrieben: „Nach der Begrüßung sagte er [Hitler] freundlich aber ernst: ‚Parteigenosse Heß weiß ich, warum Sie mich sprechen wollen. Ich kann Ihnen versichern, daß ihre Besorgnis unbegründet ist, Sie werden dieses Mal keine Schwierigkeiten haben.' ‚Das ist nicht alles, mein Führer. Ich fürchte, ich kann diesen Film nicht machen ... Die ganze Materie ist mir fremd, ich kann nicht einmal die SA von der SS unterscheiden.' ‚Das ist doch gut so, dann sehen Sie nur das Wesentliche. Ich wünsche keinen langweiligen Parteitagsfilm, keine Wochenschau-Aufnahmen,

sondern ein künstlerisches Bilddokument. Die dafür zuständigen Männer der Partei verstehen dies nicht. In Ihrem *Blauen Licht* haben Sie bewiesen, daß Sie es können.' ... dann sagte er lächelnd, aber mit Bestimmtheit: ‚... und lassen Sie sich doch nicht so bitten, es sind doch nur sechs Tage, die Sie mir schenken sollen. ... Sie müssen mehr Vertrauen zu sich haben. Sie können und Sie werden diese Arbeit schaffen.' Das klang fast wie ein Befehl. Ich sah ein, daß ich Hitlers Widerstand nicht brechen konnte." Sie filmt mit einem Team von 18 Kameramännern und deren Assistenten, zu denen wieder Sepp Allgeier, Franz Weihmayr, Walter Riml und Walter Frentz gehören. Ergebnis der Dreharbeiten sind ungefähr 130000 Meter Filmmaterial, was 100 Stunden Vorführzeit entspricht. Leni Riefenstahl benötigt fünf Monate intensiver Arbeit für das Sichten, Schneiden, Montieren und die musikalische Fertigstellung des Films *Triumph des Willens*. Nicht alle Veranstaltungen des Parteitags werden in den Film aufgenommen, so fehlen zum Beispiel die NS-Frauenschaft und die Reichswehr. Wichtig sind der Regisseurin nicht die Chronologie und genaue Dokumentation des Ablaufs, sondern die Atmosphäre, die Stimmung, der innere Rhythmus des Ereignisses. Doch schon während der Schnittarbeiten an *Triumph des Willens* gibt es heftige Diskussionen mit der Reichswehr. Wegen Regenwetter sind die Aufnahmen für Leni Riefenstahl qualitativ so schlecht, um sie in ihren Film einzuschneiden. General Walter von Reichenau ist verärgert, dass die Reichswehr, die 1934 das erste Mal an einem Reichsparteitag teilnehmen hat, nicht in dem Film erscheinen soll, und beschwert sich bei Hitler. Als Kompromiss schlägt sie vor, während des Parteitags im folgenden Jahr einen Kurzfilm über die Veranstaltungen der Wehrmacht herzustellen. So entsteht im September 1935 der 28-minütige Film *Tag der Freiheit! – Unsere Wehrmacht!*.

Bien que Hitler lui ait donné l'ordre de filmer le congrès du parti de 1934, Leni Riefenstahl espère toujours échapper à cette commande. Elle demande à son ami Walther Ruttmann, réalisateur primé du grand classique *Berlin – Symphonie d'une grande ville* (1927),

de tourner le film à sa place. Elle accepte l'offre de la société berlinoise Terra-Film de réaliser et interpréter le film *Tiefland*. Elle se donne pleinement à son travail en Espagne et se prépare au rôle de la gitane Martha avec tant de verve qu'elle devra passer deux mois à l'hôpital à Madrid. Le tournage de *Tiefland* doit être stoppé. Une fois guérie, il rentre à Berlin, à la mi-août, et visionne le montage de Walther Ruttmann: elle est atterrée par la médiocrité de ce qu'il a réalisé. Leni Riefenstahl comprend qu'elle ne pourra en prendre la responsabilité, que Hitler ne l'acceptera pas et qu'elle devrait faire le film elle-même. Dans une dernière tentative d'aborder la question avec Hitler, elle le suit à Nuremberg, où elle aura un entretien important, cité dans ses mémoires (pp. 211–212): «Après les salutations, il [Hitler] me dit sur un ton amical mais sérieux: ‹J'ai su par le camarade du Parti Rudolf Heß pourquoi vous vouliez me parler. Je peux vous assurer que vos inquiétudes ne sont pas fondées: vous n'aurez pas de difficultés cette fois-ci.› ‹Ce n'est pas tout, mon Führer. Je crains de ne pas être en mesure de faire ce film ... Le contenu m'en est totalement étranger. Je ne sais même pas distinguer les SA des SS.› ‹Mais c'est très bien, justement! Comme cela, vous ne verrez que l'essentiel. Je souhaite que nous n'ayons pas l'ennui des films de congrès habituels, je ne veux pas un style de bandes d'actualités de la semaine, mais bien une œuvre d'art en images qui soit en même temps un documentaire. Les hommes en place dans le Parti chargés du cinéma et de la propagande ne comprennent pas ce que j'entends par là. Mais vous, avec votre *Lumière bleue*, vous avez prouvé que vous en êtes capable.› Puis il me dit avec un sourire, mais sur un ton très ferme: ‹Cessez de vous faire prier à ce point. Je ne vous demande que de m'offrir six jours de votre temps. Il faut que vous ayez plus confiance en vous. Vous êtes capable de réaliser ce travail, et vous le réaliserez.› Le ton était devenu celui d'un commandement. Je me rendais compte que je ne parviendrais pas à briser la résistance d'Hitler.» Elle travaille avec une équipe de 18 caméramans et leurs assistants, parmi lesquels de nouveau Sepp Allgeier, Franz Weihmayr, Walter Riml et Walter Frentz. Ce sont ainsi 130000 mètres de pellicule qui

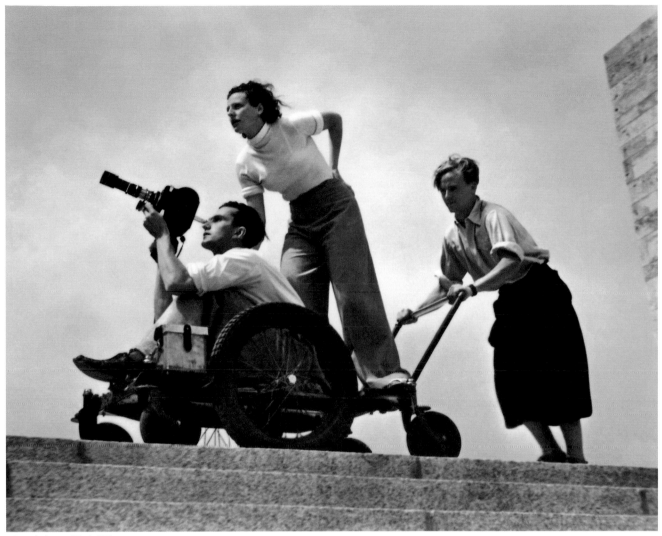

During the shooting of *Olympia*, 1936.
Bei den Dreharbeiten zu *Olympia*, 1936.
Lors du tournage des *Dieux du stade*, 1936.

ont été tournés, ce qui équivaut à 100 heures de projection. Il faudra cinq mois pleins à Leni Riefenstahl pour visionner, monter et mettre en musique *Le Triomphe de la volonté*. Les manifestations du congrès ne figurent pas toutes dans le film; il manque la «NS-Frauenschaft» et la «Reichswehr». La réalisatrice cherche moins à rendre la chronologie exacte de l'événement que l'ambiance, le rythme inhérent à ce rassemblement. Mais pendant le montage du *Triomphe de la volonté*, il y a déjà d'importants conflits. En raison de la pluie et du mauvais temps, les prises de vues de la Reichswehr sont de trop mauvaise qualité au goût de Leni Riefenstahl pour être intégrées aux autres séquences. Or le général Walter von Reichenau est outré que la Reichswehr, qui participait en 1934 pour la première fois à un congrès du parti, ne figure pas dans le film et s'en plaint auprès de Hitler. La cinéaste propose en guise de compromis de tourner l'année suivante un court métrage sur la Reichswehr. C'est ainsi que verra le jour en septembre 1935 le film de 28 minutes *Jour de liberté! – Notre Wehrmacht!*

1935 Professor Carl Diem, the secretary general of the organization committee for the Olympics and the International Olympic Committee offer her a chance to make a documentary on the Eleventh Olympic Games, which will take place in Germany for the first time in 1936. At first she hesitates, because she does not really want to make any more documentary films, but in the end she accepts because she is attracted to the idea of shaping the various contests into a film that is convincing both from the point of view of art and that of sports. Leni Riefenstahl signs a contract with the Tobis film company, which offers an enormous guarantee of 1.5 million reichsmarks. For the production of the film she establishes Olympia-Film—with herself and her brother, Heinz, as the partners—with financial support from the propaganda ministry of the Reich through the Film Credit Bank. For tax reasons, her firm functions in trust for the Reich.

1936 In preparation for the *Olympia* film, she visits the Winter Olympic Games in Garmisch-Partenkirchen and hires 42 cameramen, including Walter Frentz, Guzzi Lantschner, Hans Ertl, and Willy Zielke, who directed the experimental film *Das Stahltier* (The

Prof. Dr. Carl Diem, Generalsekretär des Organisationskomitees für die Olympiade, und das IOC bieten ihr die Produktion eines Dokumentarfilms über die XI. Olympischen Spiele an, die 1936 zum ersten Mal in Deutschland stattfinden werden. Zunächst zögert sie, weil sie eigentlich keine Dokumentarfilme mehr drehen möchte, doch schließlich nimmt sie an, weil es sie reizt, die verschiedenen Wettbewerbe zu einem künstlerisch und sportlich überzeugenden Film zu gestalten. Leni Riefenstahl schließt einen Verleihvertrag mit der Filmgesellschaft Tobis, die den enormen Garantiebetrag von 1,5 Millionen Reichsmark anbietet. Sie gründet für die Produktion des Films die Olympia-Film GmbH, deren Gesellschafter sie und ihr Bruder Heinz sind und die vom Reichspropagandaministerium über die Film-Kreditbank unterstützt wird. Aus steuerlichen Gründen arbeitet ihre Firma als Treuhänderin für das Reich.

Carl Diem, le secrétaire général du comité organisateur des Jeux olympiques et le Comité International Olympique lui demandent de réaliser un documentaire sur les XIe Jeux olympiques qui se tiendront pour la première fois en Allemagne en 1936. Après une phase d'hésitation – en fait, elle ne veut plus tourner de film documentaire –, elle finit par accepter car l'idée de filmer les différentes disciplines sportives sous un angle artistique l'intéresse. Leni Riefenstahl signe un contrat de distribution avec la société Tobis, qui propose un fixe faramineux de 1,5 million de reichsmarks. Pour produire le film, elle fonde la «Olympia-Film GmbH», dont elle est actionnaire avec son frère Heinz, et qui est subventionnée par la «Film-Kreditbank» du ministère de la Propagande du Reich. Pour des raisons fiscales, sa société travaille à titre fiduciaire pour le Reich.

1936 In preparation for the *Olympia* film, she visits the Winter Olympic Games in Garmisch-Partenkirchen and hires 42 cameramen, including Walter Frentz, Guzzi Lantschner, Hans Ertl, and Willy Zielke, who directed the experimental film *Das Stahltier* (The

Steel Animal, 1934–1935). In the months before the Games begin the camera crew is given a special training session, in which they practice capturing on film the rapid movements of the contests and the athletes in training, experiment with various camera positions, and test film stocks. On 1 August the Olympic Games open in Berlin. Using a model of the stadium, the director establishes the various camera positions and the cameramen specialize in particular disciplines. Despite violent resistance from the stadium officials, the director manages to get six pits dug from which the athletes in the sprinting and jumping contests can be filmed at unusual angles, for example framed against the sky. The cameramen develop soundproof housings to reduce the noise from the cameras as well as tracks for moving shots, for example, around the wire cage of the hammer throwers. Certain especially difficult shots, like the final race of the swimmers, are made during the training races and later dubbed with the sound from the actual contest.

Sie besucht zur Vorbereitung der *Olympia*-Filme die Olympischen Winterspiele in Garmisch-Partenkirchen und engagiert 42 Kameramänner, darunter Walter Frentz, Guzzi Lantschner, Hans Ertl und Willy Zielke, der den experimentellen Film *Das Stahltier* (1934/1935) gedreht hatte. In den Monaten vor Beginn der Spiele erhalten die Kameraleute eine Sonderausbildung, üben bei Sportfesten und beim Training der Sportler das Einfangen schneller Bewegungen, experimentieren mit verschiedenen Aufnahmestandorten und testen Filmmaterial. Am 1. August werden die Olympischen Spiele eröffnet. An einem Modell des Reichssportfeldes legt die Regisseurin die verschiedenen Kamerastandpunkte fest und die Kameramänner spezialisieren sich auf bestimmte Disziplinen. Gegen den heftigen Widerstand der Stadionfunktionäre setzt die Regisseurin sechs Filmgruben durch, aus denen besondere Aufnahmen, auch solche gegen den Himmel, gefilmt werden können. Die Kameramänner entwickeln Lärmschutzhauben, die das Surren der Kameralaufwerke dämpfen, sowie Fahrbahnen und Gleitschienen

für bewegte Aufnahmen, zum Beispiel um das Drahtgitter der Hammerwerfer herum. Besonders schwierige Szenen, wie der Endkampf der Schwimmer, werden im Training aufgenommen und später mit dem Originalton des Wettkampfes unterlegt.

Pour la préparation des deux volets des *Dieux du stade*, elle se rend aux Jeux d'hiver de Garmisch-Partenkirchen. Elle engage 42 caméramans, parmi lesquels de nouveau Walter Frentz, Guzzi Lantschner, Hans Ertl et Willy Zielke, qui a fait le film expérimental *Das Stahltier* (L'animal d'acier, 1934–1935). Dans les mois précédant les Jeux, les caméramans suivent une formation spéciale et s'exercent à filmer des manifestations sportives ou des séances d'entraînement. Ils expérimentent des perspectives et des pellicules nouvelles. Les Jeux olympiques sont inaugurés à Berlin le 1er août. À partir d'une maquette du terrain sportif, la cinéaste définit les différents points où seront placées les caméras et les caméramans sont spécialisés dans une discipline particulière. Malgré la résistance violente des responsables du stade, la cinéaste réussit à imposer six fosses à partir desquelles les sportifs sont filmés à contre-ciel. Les caméramans développent des casques anti-bruits qui atténuent le bruit des caméras, ainsi que des rails et des circuits pour les prises animées, par exemple autour du grillage des lanceurs de marteau. Des vues particulièrement difficiles, comme la course finale en natation, sont prises pendant l'entraînement et montées ensuite avec le son original de la compétition.

1937 For two years she reviews, archives and edits the film at the Geyer print lab in the Neukölln district of Berlin. Her goal is to create a film that is artistically satisfying but also interesting to non-athletes and viewers from all nations. She divides the material into two parts and uses the dramatic means of a feature film. The use of the camera varies between a straightforward documentary style and a more subjective one, while impressions and close-ups of the public create a mood of authenticity. For the soundtrack Leni Riefenstahl combines the film

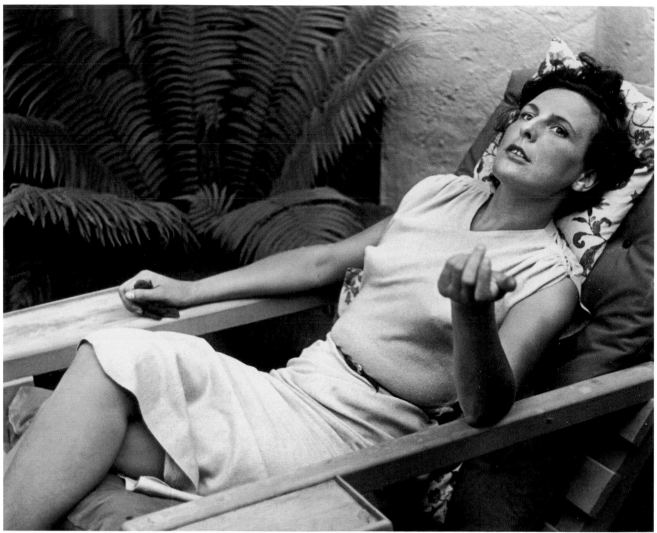

During a press interview in Helsinki, 1938.
Während eines Presseinterviews in Helsinki, 1938.
Lors d'une interview pour la presse à Helsinki, 1938.

music by Herbert Windt and Walter Gronostay, the live sound from the competitions and spoken commentary. During the editing process she receives a visit from Goebbels, who advises her to cut the shots of the black athlete and repeated medal winner Jesse Owens. She refuses, just as later she will refuse when the French distributor proposes removing the shots of Hitler, because she rejects any intrusions into her artistic concept. *Schönheit im olympischen Kampf* (literally: Beauty in the Olympic Competition, published in 1994 in English as Olympia), a book of photographs in five languages, with numerous photographs of the Olympic Games and a foreword by Leni Riefenstahl, is published by the Deutscher Verlag in Berlin.

Zwei Jahre sichtet, archiviert, montiert und schneidet sie das Filmmaterial in der Kopieranstalt Geyer in Berlin-Neukölln. Ihr Ziel ist es, einen künstlerisch befriedigenden Film zu machen, der auch Nicht-Sportler mitreißt und Zuschauer aller Nationen bewegt. Sie gestaltet das umfangreiche Material in zwei Filmteilen und arbeitet mit den dramaturgischen Mitteln des Spielfilms. Die Kameraführung wechselt zwischen reportagehaftem Abfilmen und subjektiver Kameraführung, während Impressionen und Nahaufnahmen aus dem Publikum eine authentische Stimmung schaffen. Bei der Tonbearbeitung verbindet Leni Riefenstahl die Filmmusik von Herbert Windt und Walter Gronostay, den Originalton der Wettkämpfe und gesprochenen Kommentar. Während der Schneidearbeiten erhält sie Besuch von Goebbels, der sie anweist, die Aufnahmen von dem schwarzen Sportler und mehrfachen Medaillengewinner Jesse Owens herauszuschneiden. Sie weigert sich, genau so wie sie sich später gegenüber dem französischen Verleih weigert, Aufnahmen von Hitler aus dem Film zu entfernen, da sie Eingriffe in ihr künstlerisches Konzept ablehnt. Der fünfsprachige Bildband *Schönheit im olympischen Kampf*, der mit zahlreichen Aufnahmen die Olympiade dokumentiert und ein Vorwort von Leni Riefenstahl enthält, erscheint im Deutschen Verlag in Berlin.

Leni Riefenstahl passe deux ans à visionner, archiver et monter le matériau du film dans l'atelier Geyer à Berlin-Neukölln. La cinéaste aspire à réaliser un film répondant à des critères artistiques, mais également passionnant pour les non-sportifs et les spectateurs de tous pays. Le matériau est traité en deux parties; là aussi, elle recourt aux procédés dramaturgiques du film de fiction. Le style de la caméra alterne entre celui du reportage et de la «caméra subjective»; des impressions et des détails saisis parmi le public assurent toute son authenticité à l'ambiance. Pour la bande sonore, Leni Riefenstahl associe la musique de film de Herbert Windt et Walter Gronostay, le son original des compétitions et un commentaire parlé. Au cours du travail de montage, elle reçoit la visite de Goebbels, qui lui demande de couper les passages avec Jesse Owens, sportif noir plusieurs fois médaillé. Elle refuse, tout comme elle refusera par la suite, pour des raisons artistiques, d'éliminer les passages avec Hitler pour le distributeur français. Un volume en cinq langues, *Schönheit im olympischen Kampf* (littéralement: La Beauté dans le combat olympique), qui retrace les Jeux olympiques avec de nombreuses photos et une préface de Leni Riefenstahl, paraît au Deutscher Verlag à Berlin.

1938 The premiere of both *Olympia* films—*Festival of the People* and *Festival of Beauty*—takes place on 20 April, Hitler's 49th birthday, at the UFA-Palast am Zoo in Berlin. Leni Riefenstahl travels throughout Europe with the *Olympia* films and in November she travels to America to find a distributor there. On her arrival in New York she learns of the *Reichskristallnacht* ("Crystal Night"), the night between 9 and 10 November when many Jewish synagogues and other places of worship, graveyards, homes, and businesses are destroyed and more than 30,000 people are arrested. She refuses to believe the news and travels to New York, Chicago, Detroit, Los Angeles, Hollywood, Palm Springs, and San Francisco. But the Anti-Nazi League and many German émigrés, including Fritz Lang, turn against performances of the *Olympia* films in America. She meets the producer Walt Disney, the

automobile manufacturer Henry Ford, and the director King Vidor, and, despite the protest, she manages to conclude a distribution agreement with the firm British Gaumont before returning home.

Die Premiere der beiden *Olympia*-Filme *Fest der Völker* und *Fest der Schönheit* findet am 20. April, dem 49. Geburtstag Hitlers, im Berliner UFA-Palast am Zoo statt. Danach reist Leni Riefenstahl mit den *Olympia*-Filmen durch Europa. Im November fährt sie nach Amerika, um Verleiher zu suchen. Bei der Ankunft in New York erfährt sie von Journalisten von der „Reichskristallnacht", bei der in Deutschland in der Nacht vom 9. zum 10. November zahlreiche Synagogen, jüdische Gebetshäuser, Friedhöfe, Wohn- und Geschäftshäuser zerstört und mehr als 30000 Personen verhaftet wurden. Doch sie schenkt der Nachricht keinen Glauben und reist nach New York, Chicago, Detroit, Los Angeles, Hollywood, Palm Springs und San Francisco. Die Anti-Nazi-Liga und zahlreiche deutsche Emigranten, unter anderem Fritz Lang, wenden sich gegen die Aufführungen der *Olympia*-Filme in Amerika. Sie lernt den Produzenten Walt Disney, den Regisseur King Vidor und Henry Ford kennen. Und trotz des Protests gelingt es ihr, einen Verleihvertrag mit der englischen Firma British Gaumont abzuschließen.

La première des deux volets des *Dieux du stade*, *Fête des peuples* et *Fête de la beauté*, a lieu le 20 avril, le jour des 49 ans d'Hitler, au UFA-Palast am Zoo, à Berlin. Ce film amène Leni Riefenstahl à voyager en Europe. En novembre, elle se rend avec son film en Amérique pour y chercher un distributeur. À son arrivée à New York, des journalistes lui annoncent la «Nuit de cristal»: dans la nuit du 9 au 10 novembre, en Allemagne, plusieurs synagogues, lieux de prières juifs, cimetières, lieux d'habitation et magasins ont été détruits; plus de 30000 personnes ont été arrêtées. Elle ne croit pas que la nouvelle soit vraie et se rend à New York, Chicago, Detroit, Los Angeles, Hollywood, Palm Springs et San Francisco. Mais la ligue antinazie et de nombreux émigrants allemands, notamment Fritz Lang, s'insurgent contre la présenta-

tion des *Dieux du stade* en Amérique. Elle fait cependant la connaissance du producteur Walt Disney, du fabricant automobile Henry Ford et du réalisateur King Vidor. Et malgré les protestations, elle réussit à passer un contrat, peu avant son retour, avec la société anglaise British Gaumont.

1939 Back in Europe, she gives a lecture in Paris in February on the topic "Is Film Art?" in which she advances the view that image and motion are the main criteria of the artistic film. She concentrates on her film project *Penthesilea* and in the spring she establishes the firm Leni Riefenstahl-Film for its production. She writes the screenplay for *Penthesilea*, based on Heinrich von Kleist's tragedy, and hires both the crew and actors. Leni Riefenstahl, too, prepares for the leading role, taking speech lessons and learning to ride bareback. To direct the scenes in which she is acting she chooses Jürgen Fehling, who is working at the Prussian State Theater on the Gendarmenmarkt in Berlin under Gustaf Gründgens. With the outbreak of the war, work on the costly project is halted. Just a few days after the start of the war on 1 September, Leni Riefenstahl and many of her colleagues from her production company offer their services to the army to produce war reportage. They travel to Końskie in Poland in order to produce weekly newsreels from General von Reichenau's section of the front. One day after her arrival, at a funeral for German soldiers killed the day before by Polish partisans, she witnesses German soldiers massacring Polish civilians and in disgust she immediately ceases her activity as a war correspondent. The Tobis production company picks up the *Tiefland* project again, which had been called off by Terra in 1934.

Zurück in Europa hält sie im Februar in Paris einen Vortrag zum Thema „Ist Film Kunst?" und vertritt dabei die Meinung, dass Bild und Bewegung Hauptkriterien des künstlerischen Films sind. Sie konzentriert sich auf ihr Filmprojekt *Penthesilea* und gründet im Frühjahr für die Produktion des Films die Leni Riefenstahl-Film GmbH. Nach der Vorlage von Heinrich

Leni Riefenstahl taking a photograph at the filming of *Tiefland* (Lowlands), circa 1940.
Arbeitsfoto bei den Dreharbeiten zu *Tiefland*, um 1940.
Photo réalisée lors du tournage de *Tiefland*, vers 1940.

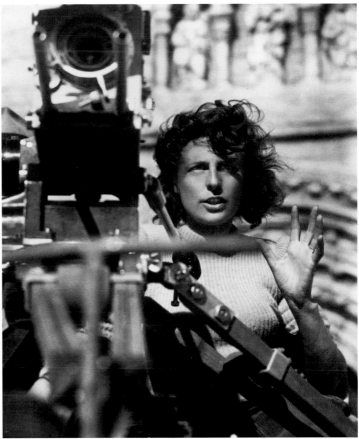

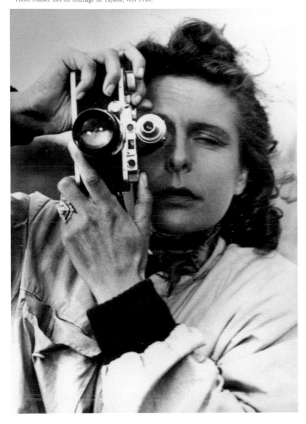

During the shooting of *Tiefland* (Lowlands), circa 1940.
Bei den Dreharbeiten zu *Tiefland*, um 1940.
Lors du tournage de *Tiefland*, vers 1940.

von Kleist schreibt sie das Drehbuch für *Penthesilea*, engagiert den Stab und die Schauspieler. Auch bereitet sich Leni Riefenstahl auf die Hauptrolle vor, nimmt Sprechunterricht und lernt Reiten ohne Sattel. Als Regisseur für die Szenen, in denen sie selbst spielt, wählt sie Jürgen Fehling, der am Preußischen Staatstheater am Gendarmenmarkt unter Gustaf Gründgens arbeitet. Mit Kriegsausbruch werden die Arbeiten an dem kostspieligen Projekt abgebrochen. Wenige Tage nach Kriegsausbruch am 1. September 1939 bieten sich Leni Riefenstahl und zahlreiche Mitarbeiter ihrer Firma der Wehrmacht als Kriegsberichterstatter an und fahren nach Końskie in Polen, um am Frontabschnitt von Generaloberst von Reichenau Wochenschauaufnahmen herzustellen. Einen Tag nach ihrer Ankunft erlebt sie, wie es bei der Beerdigung von deutschen Soldaten, die einen Tag zuvor von polnischen Partisanen getötet worden sind, zu einem Massaker deutscher Soldaten an polnischen Zivilisten kommt. Entsetzt legt sie sofort ihre Tätigkeit als Kriegsberichterstatterin nieder. Die Filmproduktionsgesellschaft Tobis greift das Projekt *Tiefland* wieder auf, das 1934 eingestellt wurde.

De retour en Europe, elle tient en février une conférence à Paris sur le thème «Un film est-il une œuvre art?» et défend l'idée que l'image et le mouvement sont les principaux critères du film d'art. Elle se concentre sur son projet de film *Penthésilée* et fonde au printemps, pour la production du film, la «Leni Riefenstahl-Film GmbH». Elle écrit le scénario de *Penthésilée* en adaptant la tragédie de Heinrich von Kleist, engage l'équipe et les acteurs. Leni Riefenstahl se prépare elle aussi à son rôle principal; elle prend des cours de diction, apprend à monter à cru. Pour la réalisation des scènes dans lesquelles elle joue elle-même, elle choisit Jürgen Fehling, lequel travaille au Preussisches Staatstheater am Gendarmenmarkt, à Berlin, sous la direction de Gustaf Gründgens. Mais la guerre vient interrompre ce projet d'envergure. Quelques jours après le début de la guerre, le 1er septembre, Leni Riefenstahl et plusieurs collaborateurs de sa société se proposent à la Wehrmacht comme correspondants de guerre; ils se rendent alors

à Końskie, en Pologne, et réalisent des documentations pour la Wochenschau sur le front du général Von Reichenau. Le lendemain de son arrivée, elle assiste au massacre par des soldats allemands de civils polonais lors de l'enterrement de soldats allemands tués la veille par des partisans polonais. Outrée, elle arrête aussitôt ses activités de correspondante de guerre. La maison de production Tobis reprend le projet *Tiefland* qui avait été interrompu en 1934.

1940 The beginning of the war on the western front means that *Tiefland* cannot be filmed, as originally planned, in the Pyrenees; consequently, she has the village, the castle, and the mill for the film built in Krün near Mittenwald, in the Karwendel Mountains. During the filming she meets Peter Jacob, first lieutenant in the mountain troops, whom she will later marry.

Durch den Kriegsbeginn im Westen kann *Tiefland* nicht – wie eigentlich geplant – in den Pyrenäen gedreht werden, weshalb sie das Filmdorf, das Kastell und die Mühle in Krün bei Mittenwald im Karwendelgebirge errichten lässt. Bei den Dreharbeiten lernt sie in Mittenwald ihren späteren Mann Peter Jacob kennen, Oberleutnant bei den Gebirgsjägern.

Après le début de la guerre à l'Ouest, *Tiefland* ne peut être tourné, comme prévu, dans les Pyrénées. À Krün, près de Mittenwald, dans le massif du Karwendel, le village du film, la forteresse et le moulin sont donc reconstitués. Lors du tournage elle fait la connaissance de son futur mari Peter Jacob, lieutenant-chef chez les chasseurs alpins.

1941 – 1944 The filming of *Tiefland* is supposed to continue in January 1941 in the Babelsberg studios, where the film architects Erich Grave and Isabella Ploberger have recreated the interior of the castle. On orders from the Ministry of Propaganda, however, the studios have to be vacated to begin shooting films important to the war effort. In Berlin she ex-

periences her first air raid. She rehearses her dance scenes with Harald Kreutzberg. Despite her illness, filming begins in the studio at first under the direction of G. W. Pabst and is then later continued by Arthur Maria Rabenalt. In the summer of 1942 filming continues in the Dolomites. On her 40th birthday she becomes engaged to Peter Jacob. In the spring of 1943 she finally receives the currency for the filming in Spain. After the shooting has been completed, she returns to Berlin, which is now subjected to constant air raids. She marries Peter Jacob on 21 March 1944 in Kitzbühel in a war wedding. On 30 March 1944 she meets Hitler at the Berghof for the last time, when he invites her and her husband Major Jacob. In July her father, Alfred Riefenstahl, dies in Berlin at the age of 65, and on 20 July her brother, Heinz, dies in a punishment battalion on the Russian front. In the autumn the final studio shots for *Tiefland* are completed in a studio in Prague. Filming has taken more than four years. In November 1944 Leni Riefenstahl evacuates together with her crew to Seebichl House near Kitzbühel, where she has her own editing, mixing and projection rooms built in order to complete work on the film *Tiefland*. Some of the copies, films and takes are stored in two bunkers in the Johannisthal district of Berlin.

Die Dreharbeiten für *Tiefland* sollen im Januar 1941 in den Ateliers von Babelsberg fortgesetzt werden, wo die Filmarchitekten Erich Grave und Isabella Ploberger den Innenhof des Kastells nachgebildet haben. Doch auf Befehl des Propagandaministeriums müssen die Studios noch vor Drehbeginn für kriegswichtige Filme geräumt werden. In Berlin erlebt sie ihren ersten Luftangriff. Sie studiert ihre Tanzszenen mit Harald Kreutzberg ein. Trotz ihrer Krankheit werden die Dreharbeiten im Studio zunächst unter der Regie von G. W. Pabst, dann von Arthur Maria Rabenalt weitergeführt. Im Sommer 1942 setzt sie die Filmarbeiten in den Dolomiten fort. An ihrem 40. Geburtstag verlobt sich die Regisseurin mit Peter Jacob. Im Frühjahr 1943 erhält sie endlich die Devisen für die Dreharbeiten in Spanien. Im Anschluss an die Dreharbeiten kehrt sie nach

Berlin zurück, das ständigen Luftangriffen ausgesetzt ist. Sie heiratet in einer Kriegstrauung Peter Jacob am 21. März 1944 in Kitzbühel. Am 30. März 1944 trifft sie Hitler, der sie und ihren Mann Major Jacob einlädt, zum letzten Mal auf dem Berghof. Im Juli stirbt der Vater Alfred Riefenstahl in Berlin im Alter von 65 Jahren und am 20. Juli fällt ihr Bruder Heinz in einem Strafbataillon an der russischen Front. Die letzten Atelieraufnahmen für *Tiefland* werden im Herbst in einem Prager Studio abgeschlossen. Damit haben sich die Dreharbeiten über vier Jahre erstreckt. Im November 1944 evakuiert sie ihren Mitarbeiterstab in das Haus Seebichl bei Kitzbühel, wo sie eigens Schneide-, Tonmisch- und Vorführräume einrichten lässt, um den Film *Tiefland* fertig zu stellen. Ein weiterer Teil der Kopien, Filme und Filmfassungen lagert in zwei Bunkern in Berlin-Johannisthal.

Le tournage de *Tiefland* se poursuit en janvier 1941 dans les studios de Babelsberg, où les architectes Erich Grave et Isabella Ploberger reconstituent la cour intérieure de la forteresse. Mais sur l'ordre du ministère de la Propagande, les studios doivent être libérés avant même le début du tournage pour des films importants pour la guerre. À Berlin, elle assiste à une première attaque aérienne. Elle répète les scènes de danse avec Harald Kreutzberg. Bien qu'elle soit malade, le tournage se poursuit en studio, d'abord sous la direction de G. W. Pabst, puis sous celle d'Arthur Maria Rabenalt. À l'été 1942, le tournage continue dans les Dolomites. Le jour de ses 40 ans, Leni Riefenstahl se fiance avec Peter Jacob. Au printemps 1943, elle reçoit enfin les devises pour tourner en Espagne. Après le tournage, Leni Riefenstahl retourne à Berlin, où les attaques aériennes se multiplient. Le 21 mars 1944, elle épouse Peter Jacob à Kitzbühel à l'âge de 65 ans; le 20 juillet, son frère Heinz tombe dans un bataillon disciplinaire sur le front russe. À l'automne, les dernières prises de vue pour *Tiefland* sont achevées dans un studio de Prague. Le tournage aura duré plus de quatre ans. En

For her role in *Penthesilea*
she learns to ride, 1939.
Für ihre Hauptrolle in *Penthesilea*
lernt sie reiten, 1939.
Elle apprend l'équitation pour
son rôle dans *Penthésilée*, 1939.

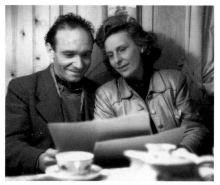

The director and her husband Peter Jacob
in the Seebichl House near Kitzbühel, 1945.
Die Regisseurin und ihr Mann Peter Jacob
im Haus Seebichl bei Kitzbühel, 1945.
La cinéaste et son mari Peter Jacob dans
leur chalet Seebichl près de Kitzbühel, 1945.

Her brother, Heinz, 1942.
Bruder Heinz, 1942.
Son frère Heinz en 1942.
Photo: Rolf Lantin

Her mother, Bertha Riefenstahl, at the age of 84.
Ihre Mutter Bertha Riefenstahl im Alter von 84 Jahren.
Sa mère Bertha Riefenstahl à l'âge de 84 ans.

novembre 1944, elle évacue son équipe de collaborateurs à la maison Seebichl à Kitzbühel, où elle fait spécialement installer, pour achever *Tiefland*, des pièces de montage, de mixage et de projection. Elle entrepose une autre partie des copies, films et pellicules dans deux bunkers de Berlin-Johannisthal.

1945 Her mother, Bertha, leaves Berlin in February and arrives at Seebichl House. When the Americans occupy the Tyrol in spring, Leni Riefenstahl is arrested and brought to the Dachau prisoner-of-war camp of the U.S. Seventh Army. The former concentration camp now holds leading National Socialists, including Hermann Göring. During the hearings she is confronted with photographs from concentration camps for the first time and is deeply affected. On 3 June the U.S. Army grants her permission to return to Kitzbühel. In the summer the French take over the occupation of the northern Tyrol and Vorarlberg. Owing to power struggles between the nationalistically inclined military government and the Communist Sûreté—the police for public security—Leni Riefenstahl is taken into custody several times, released again, and then finally placed under arrest. Her bank account is frozen, her house is seized and all her property, including her archive of film and photography, is taken to Paris.

Ihre Mutter Bertha verlässt im Februar Berlin und trifft in Haus Seebichl ein. Als die Amerikaner im Frühjahr Tirol besetzen, wird Leni Riefenstahl verhaftet und in das Gefangenenlager der VII. Amerikanischen Armee nach Dachau gebracht. In dem ehemaligen Konzentrationslager sitzen führende Nationalsozialisten ein, unter anderem Hermann Göring. Bei Verhören wird sie erstmals mit Fotos aus den Konzentrationslagern konfrontiert, die sie tief treffen. Am 3. Juni kehrt sie mit einer Entlastungsbescheinigung der amerikanischen Armee nach Kitzbühel zurück. Im Sommer übernehmen die Franzosen die Besatzung von Nord-Tirol und Vorarlberg. Aufgrund von Machtkämpfen zwischen der nationalistisch eingestellten französischen Militärre-

gierung und der kommunistisch orientierten Sûreté, der Polizei für öffentliche Sicherheit, wird sie mehrmals verhaftet, wieder freigelassen und schließlich unter Arrest gestellt. Das Bankkonto wird gesperrt, das Haus beschlagnahmt und ihr ganzer Besitz, das Film- und Fotoarchiv werden nach Paris gebracht.

Sa mère Bertha quitte Berlin en février et arrive à la maison Seebichl. Lorsque les Américains occupent le Tyrol au printemps, Leni Riefenstahl est arrêtée et amenée au camp de prisonniers de la VIIe Armée américaine à Dachau. Ce sont maintenant des dirigeants nazis, Hermann Göring entre autres, qui sont prisonniers dans l'ancien camp de concentration. Lors de l'interrogatoire, elle voit, très touchée, des photos qui lui dévoilent pour la première fois la réalité des camps. Le 3 juin, elle retourne à Kitzbühel avec une décharge de l'armée américaine. En été, les Français occupent le Tyrol du Nord et le Vorarlberg. En raison des conflits entre le gouvernement militaire français plutôt nationaliste et la police communiste pour la Sécurité publique, Leni Riefenstahl est arrêtée et libérée à plusieurs reprises, puis finalement emprisonnée. Son compte en banque, sa maison, sa fortune personnelle sont mis sous séquestre et le stock de films est emporté à Paris.

1946 – 1947 In early April 1946 she is sent to the French-controlled zone in Germany. With her mother, her husband and several colleagues, she is brought first, as a prisoner under police guard, to Breisach near Freiburg in the Black Forest. In August they are quartered in Königsfeld in the Black Forest. She is prohibited from leaving the area. Peter Jacob works as a wine salesman to earn the family income. In the spring of 1947 she divorces her husband after he is unfaithful to her. Leni Riefenstahl's situation is difficult: she suffers from depression. Against her will, she is placed by the French military government in the secured section of the Freiburg psychiatric clinic from May to August 1947 and treated with electroshock therapy.

Anfang April 1946 wird sie in die französische Zone nach Deutschland ausgewiesen. Mit ihrer Mutter, ihrem Mann und mehreren Mitarbeitern wird sie zunächst unter polizeilicher Bewachung als Gefangene nach Breisach bei Freiburg gebracht; im August werden sie in Königsfeld im Schwarzwald einquartiert und sie darf den Ort nicht verlassen. Peter Jacob arbeitet für den Unterhalt der Familie als Weinverkäufer. Im Frühjahr 1947 trennt sie sich von ihrem Mann, weil er sie betrügt. Ihre persönliche Situation ist schwierig: Sie leidet unter Depressionen. Gegen ihren Willen wird sie von Mai bis August 1947 von der französischen Militärregierung in die geschlossene Abteilung der Psychiatrischen Klinik Freiburg eingewiesen und mit Elektroschocks behandelt.

Début avril 1946, elle est expulsée vers l'Allemagne, dans la zone française. En compagnie de sa mère, de son mari et de plusieurs collaborateurs, elle est d'abord emmenée comme prisonnière à Breisach, près de Fribourg en Forêt Noire. En août, ils sont installés à Königsfeld, en Forêt Noire. Elle n'a pas le droit de quitter les lieux. Peter Jacob vend du vin pour subvenir aux besoins de la famille. Au printemps 1947, elle se sépare de son mari car il la trompe. La situation de Leni Riefenstahl est difficile: elle souffre de dépression. Contre sa volonté, elle est internée de mai à août 1947 par le gouvernement militaire français à la clinique psychiatrique de Fribourg, où elle subit des électrochocs.

1948 In early February, at the instigation of her lawyer in Paris, the French military government of the state of Baden overturns the arrest. The release of her confiscated property is, however, delayed when the alleged diary of Eva Braun, Hitler's lover, is published in the French newspaper *France Soir* and later in the German newspaper *Wochenende*. Luis Trenker vouches for the accuracy of the diary, which depicts pornographic scenes between Leni Riefenstahl and Hitler. Eva Braun's eldest sister sues the German publisher Olympia-Verlag; Leni Riefenstahl takes part as a joint plaintiff. The court judges that the diary was

forged—this is the first of more than 50 court cases that Leni Riefenstahl will be involved in, under right to legal aid, over the coming years. She continues the struggle for the release of the footage confiscated from her, which she will not regain until 1953. The Olympic Committee sends her Olympic Diploma for the *Olympia* films by mail, because she is not granted a travel visa for the award ceremony in Lausanne. United Artists shows the *Olympia* films in the United States for the first time.

Auf Betreiben ihres Pariser Anwalts hebt die französische Militärregierung des Landes Baden Anfang Februar den Arrest auf. Die Freigabe ihres beschlagnahmten Besitzes wird jedoch aufgeschoben, als das angebliche Tagebuch von Eva Braun, der Geliebten Hitlers, in der französischen Zeitung *France Soir* und später in der deutschen Zeitschrift *Wochenende* erscheint. Luis Trenker bürgt für das Tagebuch, das pornografische Szenen zwischen Leni Riefenstahl und Hitler schildert. Die älteste Schwester von Eva Braun verklagt den deutschen Olympiaverlag; Leni Riefenstahl beteiligt sich als Nebenklägerin. Das Gericht kommt zu dem Urteil, dass das Tagebuch gefälscht wurde – dies ist der erste Prozess im Armenrecht von mehr als 50 Prozessen, die Leni Riefenstahl in den kommenden Jahren führen wird. Sie setzt den Kampf um die Freigabe des beschlagnahmten Filmmaterials fort, das sie erst 1953 zurückhalten wird. Das Olympische Komitee schickt ihr mit der Post das Olympische Diplom für die *Olympia*-Filme, weil sie für die Verleihung in Lausanne keine Reiseerlaubnis erhält. United Artists zeigt zum ersten Mal die *Olympia*-Filme in den Vereinigten Staaten.

Sur l'intercession de son avocat parisien, le gouvernement militaire français du Land de Bade suspend son arrestation début février. Mais la saisie de sa fortune ne peut être levée, car le prétendu journal d'Eva Braun, l'amante de Hitler, vient de paraître dans *France Soir* (il sera publié plus tard par la revue allemande *Wochenende*). Luis Trenker se porte garant de l'authenticité des scènes pornographiques entre Leni Riefenstahl et Hitler. La sœur aînée d'Eva Braun porte

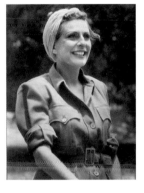

In April 1956 she travels to
Africa for the first time.
Im April 1956 reist sie das erste
Mal nach Afrika.
En avril 1956, elle se rend pour
la première fois en Afrique.

With warriors of the Jalau tribe in
Kisumu on Lake Victoria, 1956.
Mit Kriegern vom Stamm der Jalau
in Kisumu am Victoriasee, 1956.
Avec des guerriers de la tribu des
Jalou à Kisumu sur le lac Victoria,
1956.

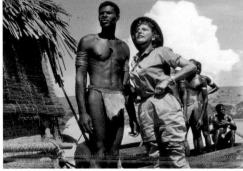

plainte contre les éditions allemandes Olympia-Verlag, Leni Riefenstahl s'associe à cette plainte: selon le verdict du tribunal, le journal a été falsifié – c'est le premier des quelque 50 procès que Leni Riefenstahl mènera dans les années suivantes en faisant jouer la dispense de frais. Elle continue à se battre pour libérer le stock de films saisi, mais ne le récupérera qu'en 1953. Le Comité olympique lui envoie le Diplôme olympique pour *Les Dieux du stade* par la poste, parce qu'elle n'obtient pas l'autorisation de sortie pour la remise du prix à Lausanne. United Artists montre pour la première fois le film aux États-Unis.

1949 In May an article appears in the Munich-based magazine *Revue*, in which she is accused of having forced Gypsies from a concentration camp to work as extras in the film *Tiefland*. She sues editor Helmut Kindler for defamation of character. The court comes to the conclusion that the Maxglan Camp was not a concentration camp but a reception camp for Gypsies and that Leni Riefenstahl was never at the camp. The Gypsies were selected there by Harald Reinl. Thus she wins the suit, but it is taken up again in 1982. On 16 December she is judged a "fellow traveller" in her third hearing in the denazification process (the French military government challenged two previous judgments that placed her in the classification "law not applicable"—i. e., innocent). This judgment is upheld by the ruling court in Berlin in April 1952, so that she once again has control over her private property in Berlin, though her house in Dahlem had been completely rebuilt in the meantime without her permission.

Im Mai erscheint in der Münchner Zeitschrift *Revue* ein Artikel, in dem ihr vorgeworfen wird, Zigeuner aus einem Konzentrationslager als Statisten für den Film *Tiefland* zwangsverpflichtet zu haben. Sie verklagt den Herausgeber Helmut Kindler wegen „übler Nachrede". Das Gericht kommt damals zu dem Ergebnis, dass das Lager Maxglan kein Konzentrationslager, sondern ein Auffanglager für Zigeuner war

und Leni Riefenstahl nie in dem Lager gewesen ist. Die Zigeuner wurden dort von Harald Reinl ausgewählt. Damit gewinnt sie den Prozess, der aber 1982 erneut aufgegriffen wird. Am 16. Dezember wird sie im Entnazifizierungsverfahren in einer dritten Verhandlung als „Mitläuferin" eingestuft. Die französische Militärregierung hatte Einspruch gegen die beiden vorhergehenden Urteile erhoben, die sie als „vom Gesetz nicht betroffen", das heißt als unschuldig, eingestuft hatten. Diese Einstufung wird aber von der Berliner Spruchkammer im April 1952 bestätigt, so dass sie nun wieder über ihr privates Eigentum in Berlin verfügen kann; ihr Haus in Dahlem wurde aber in der Zwischenzeit völlig verbaut.

En mai, le magazine munichois *Revue* publie un article reprochant à Leni Riefenstahl d'avoir obligé les Tsiganes d'un camp de concentration à être figurants dans le film *Tiefland*. Elle accuse l'éditeur Helmut Kindler de «diffamation». Le tribunal décide que le camp de Maxglan n'était pas un camp de concentration, mais un camp d'accueil pour Tsiganes et que Leni Riefenstahl n'a jamais pénétré dans l'intérieur du camp. Les Tsiganes ont été choisis par Harald Reinl. Elle gagne ainsi le procès, qui sera cependant repris en 1982. Le 16 décembre, une troisième instance de la procédure de dénazification la classe parmi les «compagnons de route». Le gouvernement français avait fait appel contre les deux jugements précédents qui l'avaient déclarée «non concernée par la loi», autrement dit innocente. Cette classification est confirmée en avril 1952 par la chambre berlinoise de dénazification, de telle sorte qu'elle peut désormais disposer de sa fortune personnelle à Berlin, mais entre-temps, sa maison de Dahlem a été complètement transformée.

1950 – 1952 With her mother she moves into Tengstrasse in the Schwabing district of Munich in 1950, where she begins film work again. In Fregene, near Rome, she writes for the Italian film company Capital Pictures a treatment for the ski film *The Red Devils*, which is a variation on the Penthesilea theme

and is planned as a colour film. Financial difficulties cause the company to pull out of the project in 1951. This puts a stop to it for the moment, but the director continues, despite interruptions, to work on the project until 1954. She meets film directors Vittorio De Sica and Roberto Rossellini in Rome. As representatives of neorealism, they have high regard for her film work because she has been among the first to shoot on location. Together with the Austrian general consul in Rome, she founds Iris-Film, in order to produce a remake of *The Blue Light*, as the original negative had been sold by Harry Sokal in America, without her permission. She edits a new version from the unused footage that has survived.

Mit ihrer Mutter zieht sie 1950 nach München-Schwabing in die Tengstraße und beginnt erneut mit Filmarbeiten. Im Auftrag der italienischen Filmgesellschaft Capital Pictures schreibt sie in Fregene bei Rom das Exposé zu dem Skifilm *Die roten Teufel*, der das Penthesilea-Thema variiert und als Farbfilm geplant ist. Finanzielle Probleme führen 1951 zum Rückzug der Firma. Damit ist dieses Projekt vorerst gescheitert, doch die Regisseurin setzt die Arbeit daran mit Unterbrechungen bis 1954 fort. In Rom trifft sie die Regisseure Vittorio De Sica und Roberto Rossellini, Vertreter des Neorealismus, die ihre Filmarbeiten schätzen, weil sie zu den ersten gehörte, die an Originalschauplätzen drehte. Gemeinsam mit dem österreichischen Generalkonsul in Rom gründet sie die Iris-Film, um ein Remake von *Das blaue Licht* zu produzieren, dessen Originalnegativ ihr damaliger Partner Harry Sokal ohne ihr Einverständnis vor Kriegsausbruch nach Amerika verkauft hat. Aus dem noch vorhandenen, nicht verwendeten Filmmaterial schneidet sie eine neue Fassung.

En 1950, elle s'installe avec sa mère à Munich, dans le quartier de Schwabing, Tengstrasse, et recommence à filmer. À la demande de la société cinématographique italienne Capital Pictures, elle rédige à Fregene, près de Rome, le synopsis du film de ski *Les Diables rouges*, une variation sur le thème de Penthésilée, qui doit être tourné en couleurs. Or, des problèmes fi-

nanciers font que la société se retire du projet en 1951. Malgré ce premier échec, la cinéaste poursuit le travail, avec des interruptions, jusqu'en 1954. À Rome, elle rencontre les réalisateurs Vittorio De Sica et Roberto Rossellini, deux représentants du néoréalisme qui apprécient son travail dans la mesure où elle est l'une des premières à avoir tourné en décors naturels. Avec le consul général d'Autriche à Rome, elle fonde Iris-Film, pour produire un remake de *La Lumière bleue*, car la pellicule originale avait été vendue par son ancien partenaire Harry Sokal aux États-Unis sans la permission de la cinéaste. Elle monte une nouvelle version à partir des prises de vue restantes.

1954 Following the premiere of *Tiefland* on 11 February at the EM-Theater in Stuttgart, she travels through Austria and presents the film. Once again, she concentrates on her work on the film project *The Red Devils*, which is planned to be filmed primarily in the Austrian Alps. She negotiates a co-production with the Austrian government and the Austrian Credit Bank, who expect the film to promote tourism. When the Vienna newspaper *Der Abend* accuses the government of financing a German film with Austrian tax money, the film project comes to a definitive end.

Nach der Premiere von *Tiefland* am 11. Februar im EM-Theater in Stuttgart reist sie durch Österreich und führt den Film vor. Sie konzentriert sich wieder auf die Arbeit an dem Filmprojekt *Die roten Teufel*, das größtenteils in den österreichischen Alpen gedreht werden soll. Für eine Co-Produktion verhandelt sie mit der österreichischen Regierung und der Österreichischen Kreditanstalt, die sich von dem Film einen Werbeeffekt für die Tourismusbranche versprechen. Als die Wiener Zeitung *Der Abend* der Regierung vorwirft, mit österreichischen Steuergeldern einen deutschen Film zu finanzieren, scheitert das Filmprojekt endgültig.

Après la première de *Tiefland* en février au EM-Theater à Stuttgart, elle parcourt l'Autriche pour

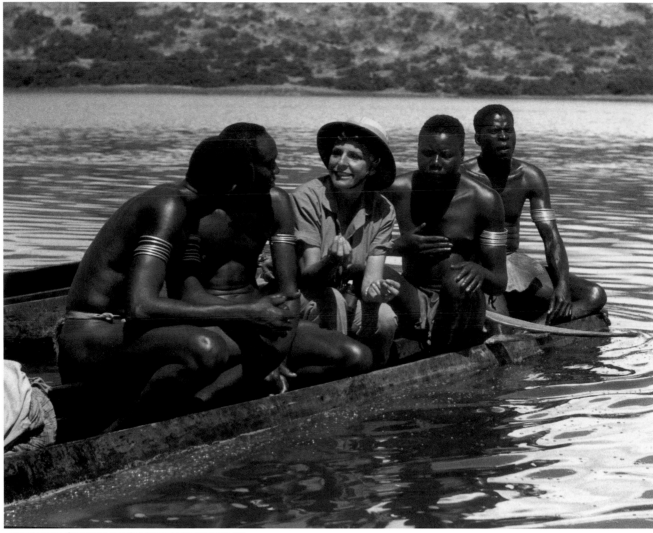

During the shooting of *Black Freight* in Queen Elizabeth National Park in West Uganda, 1956.
Bei den Dreharbeiten zu *Die schwarze Fracht* im Queen Elizabeth National Park in West-Uganda, 1956.
Lors du tournage de *La Cargaison nègre* au Queen Elizabeth National Park à l'ouest de l'Ouganda, 1956.

présenter le film. Elle se remet au projet des *Diables rouges*, qui doit être tourné en grande partie dans les Alpes autrichiennes. Elle essaie d'engager dans une coproduction le gouvernement autrichien et la banque nationale autrichienne, qui espèrent que le film favorisera le tourisme. Mais le journal viennois *Der Abend* reproche au gouvernement de financer un film allemand avec l'argent des contribuables autrichiens; le projet est définitivement stoppé.

1955 She works on several scripts, none of which can be made, however. With great enthusiasm she reads in a single night Hemingway's autobiographical travel journal *Green Hills of Africa*. She is fascinated with Africa for a time, and when she happens to come across an article in the *Süddeutsche Zeitung* on modern slavery in Africa, it reinforces her idea of making a film in Africa. Together with Helge Pawlinin, a director at the Munich Kammerspiele, she writes a treatment for *Black Freight*, a film on the modern slave trade. She plans to take the leading role herself. Gloria Film Distribution briefly shows an interest in *Black Freight*. The company insists that all the roles—even the Arab slave dealers and the slaves—must be played by German actors. The director adamantly refuses. In the end, they agree on the stars—O. E. Hasse and Winnie Markus or Ruth Leuwerik. However, one of the directors of the distribution company vetoes the project.

Sie arbeitet an mehreren Drehbüchern, von denen aber keines realisiert werden kann. Mit großer Begeisterung liest sie in einer einzigen Nacht Ernest Hemingways autobiografische Erzählung *Die grünen Hügel Afrikas*. Sie ist augenblicklich fasziniert, und als sie zufällig in der *Süddeutschen Zeitung* auf einen Artikel über moderne Sklaverei in Afrika stößt, verfestigt sich ihre Idee, in Afrika einen Film zu drehen. Mit Helge Pawlinin, der an den Münchner Kammerspielen inszeniert, schreibt sie das Treatment für *Die schwarze Fracht* über den modernen Sklavenhandel. Sie plant, die Hauptrolle selbst zu übernehmen. Kurzfristig zeigt sich der Gloria-Filmverleih inte-

ressiert, fordert allerdings, dass alle Rollen – auch die der arabischen Sklavenhändler und der Sklaven – mit deutschen Schauspielern besetzt werden. Das lehnt die Regisseurin strikt ab. Schließlich einigen sie sich auf die Stars O. E. Hasse und Winnie Markus oder Ruth Leuwerik. Doch einer der Direktoren des Verleihs legt sein Veto ein, das Filmprojekt wird abgesagt.

Elle rédige plusieurs scénarios, dont aucun cependant ne sera réalisé. Avec enthousiasme elle lit, en une seule nuit, le conte autobiographique *Les vertes collines d'Afrique* d'Ernest Hemingway. Aussitôt fascinée par l'Afrique, elle découvre en outre dans le journal munichois *Süddeutsche Zeitung* un article sur l'esclavage moderne en Afrique. Dès lors, elle a l'idée ferme de réaliser un film sur l'Afrique. Avec Helge Pawlinin, metteur en scène aux Kammerspiele de Munich, elle écrit le script pour *La Cargaison nègre* sur la traite moderne des esclaves. Elle envisage de jouer elle-même le rôle principal. Dans un premier temps, la «Gloria-Filmverleih» se montre intéressée par le film, mais elle exige que tous les rôles – y compris ceux des esclaves et des marchands arabes – soient interprétés par des acteurs allemands, ce que la cinéaste refuse catégoriquement. Ils finissent par se mettre d'accord sur les vedettes O. E. Hasse et Winnie Markus ou Ruth Leuwerik. Mais un des directeurs de la distribution met son veto – le projet est refusé.

1956 – 1957 Nevertheless, she decides to travel to Africa on her own—at the age of 54. In Kenya she makes contact with Lawrence-Brown Safaris. During an exploratory trip she is involved in a serious car accident, which she barely survives, and spends six weeks in a hospital in Nairobi. Lawrence-Brown Safaris becomes interested in the film project and offers to collaborate and provide equipment at its own expense. Together with her former colleague Walter Traut she founds Stern-Film. In August 1956 she begins the search in Kenya for locations and extras. The shooting is delayed; she flies to Munich to show the test shots to possible partners. But no contract results.

Die erste Retrospektive ihrer Filme findet auf der Biennale in Venedig statt; allerdings verlangt die Festspielleitung die ungekürzte Fassung der *Olympia*-Filme. Die englische Adventure Film Ltd. von Philip

Trotzdem beschließt sie – inzwischen 54 Jahre alt – alleine nach Afrika zu reisen. Sie nimmt Kontakt zur Lawrence-Brown-Safari in Kenia auf. Bei einer Erkundungsfahrt überlebt sie knapp einen schweren Autounfall und liegt sechs Wochen im Krankenhaus von Nairobi. Die Lawrence-Brown-Safari begeistert sich für das Filmprojekt und bietet ihre Mitarbeit und Ausrüstung zum Selbstkostenpreis an. Mit ihrem ehemaligen Mitarbeiter Walter Traut gründet sie die Stern-Film GmbH. Im August 1956 beginnt sie in Kenia mit der Suche nach Drehorten und Statisten. Die Dreharbeiten verzögern sich; sie fliegt nach München, um das Probematerial interessierten Partnern zu zeigen. Doch es kommt nicht zum Vertragsabschluss.

À l'âge de 54 ans, elle décide de se rendre seule en Afrique et rentre en contact avec les Safaris Lawrence-Brown, au Kenya. Lors d'un circuit de repérage, elle survit de justesse à un grave accident automobile et doit passer six semaines dans un hôpital de Nairobi. Les Safaris Lawrence-Brown sont emballés par le projet et lui proposent leur collaboration et l'équipement à leurs frais. Avec son ancien collaborateur Walter Traut, elle fonde la «Stern-Film GmbH». En août 1956, elle commence à chercher des lieux de tournage et des figurants au Kenya. Le tournage est reporté; elle s'envole de Munich pour y montrer des rushes à des partenaires potentiels. Mais aucun contrat n'est signé.

1959 The first retrospective of her films takes place at the Venice Biennale. The board of the festival demands the unabridged version of the *Olympia* films. The English company Adventure Film, led by Philip Hudsmith, offers to remake *The Blue Light*. Her partners withdraw, however, when journalists protest against the director at a press conference in London in January 1960.

Hudsmith bietet ihr das Remake von *Das blaue Licht* an. Ihre Partner ziehen sich zurück, als Journalisten auf einer Pressekonferenz in London im Januar 1960 gegen die Regisseurin protestieren.

La première rétrospective de ses films a lieu à la Biennale de Venise. La direction du festival exige toutefois que *Les Dieux du stade* soient montrés dans leur version non tronquée. La société anglaise Adventure Film Ltd. de Philip Hudsmith lui propose un re-make de *La Lumière bleue*. Mais les partenaires de Leni Riefenstahl se retirent du projet, suite à des protestations émises par des journalistes, lors d'une conférence de presse à Londres, en janvier 1960.

1960 – 1961 In 1960 she files suit for copyright infringement against the Swedish company Minerva Film which produced Erwin Leiser's film *Mein Kampf*. In Paris she successfully sues Plon, the publisher of the book *Six Million Dead*, about Adolf Eichmann's crimes against European Jews. Its author, Victor Alexandrov, falsely claims in one chapter that Leni Riefenstahl made several films in concentration camps for Eichmann.

Sie führt 1960 einen Urheberrechtsprozess gegen die schwedische Minerva-Film, die den Film *Mein Kampf* von Erwin Leiser produziert hat. In Paris prozessiert sie erfolgreich gegen den Verlag Plon, der das Buch *Sechs Millionen Tote* über die Verbrechen von Adolf Eichmann an den europäischen Juden herausbringt. In einem Kapitel behauptet der Autor Victor Alexandrov fälschlicherweise, sie habe für Adolf Eichmann Filme in Konzentrationslagern gedreht.

En 1960, elle engage un procès, pour violation de droit d'auteur, contre la société suédoise Minerva-Film qui a produit le film *Mein Kampf* d'Erwin Leiser. À Paris, elle remporte un procès contre l'éditeur Plon qui publie le livre *Six millions de morts* sur les crimes d'Adolf Eichmann perpétrés contre les Juifs d'Europe. Dans un chapitre, l'auteur Victor Alexandrov affirme à tort que Leni Riefenstahl a tourné, à la demande

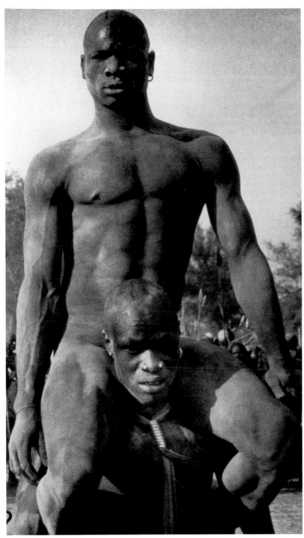

George Rodger (1908–1993): The victor of a wrestling match is carried shoulder high. Kordofan 1949.
George Rodger (1908–1995): Der Sieger eines Ringkampfes wird auf den Schultern getragen, Kordofan 1949.
George Rodger (1908–1995): Le vainqueur d'un concours de lutte est porté en triomphe, Kordofan 1949.

Photo: © George Rodger/Magnum/Agentur Focus

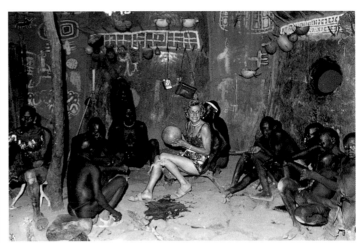

Leni's first visit to a Nuba house, in Tadoro, 1962.
Ihr erster Besuch in einem Nuba-Haus in Tadoro, 1962.
Sa première visite dans une case Nouba à Tadoro, 1962.

d'Adolf Eichmann, plusieurs films dans des camps de concentration.

1962 When Leni Riefenstahl learns that the Nansen Society, a German scientific organization, wants to make a documentary film in the Southern Sudan, she asks to be included and promises in return to make a film about the Nansen Society project. She takes part in the expedition. During her hospital stay in Nairobi in 1956 she had seen, in a back issue of *stern*, a photograph by George Rodger that showed two athletic Nuba wrestlers from the southern Sudan. Ever since, the image has not left her. In the southern Sudan, however, there are constant battles between Muslims and Christians, Arabs and black Africans, so that travel to the so-called closed districts requires a special permit. In October the members of the Nansen expedition fly to Khartoum. Because bad weather prevents the group from taking the direct route to the Nuer tribe, Leni Riefenstahl is able to persuade them to take the route over the Nuba Mountains in the region of Kordofan. After crossing arduous sand dunes, the expedition reaches the isolated Nuba village of Tadoro in mid-December and sets up camp there for seven weeks. In Tadoro she quickly makes friends with the initially shy villagers, learns their language, lives with them, and photographs them. In Tadoro she sees a wrestling contest that carries ritual significance for the Mesakin Quissayr Nuba, and she is taken to the *seribe*, a herd camp, where only Nuba men are allowed to stay.

Als Leni Riefenstahl erfährt, dass die wissenschaftliche Deutsche Nansen-Gesellschaft einen Dokumentarfilm im Südsudan drehen will, bittet sie darum, mitgenommen zu werden, und verspricht als Gegenleistung, einen Werkfilm über die Arbeit der Nansen-Gesellschaft zu drehen. Leni Riefenstahl nimmt daraufhin an der Expedition teil. Bei ihrem Krankenhausaufenthalt in Nairobi 1956 hat sie in einer alten Ausgabe des *stern* ein Foto von George Rodger gesehen, das zwei athletische Nuba-Ringkämpfer aus dem Südsudan zeigt. Seitdem hat dieses Bild sie nicht mehr losgelassen.

Doch im Südsudan kommt es immer wieder zu Auseinandersetzungen zwischen Moslems und Christen, Arabern und Schwarzafrikanern, weshalb für die Einreise in die so genannten „closed districts" eine spezielle Genehmigung benötigt wird. Im Oktober fliegt die Nansen-Expedition nach Khartum. Da die Gruppe wegen des schlechten Wetters nicht auf direktem Weg zu den Nuer-Stämmen fahren kann, überzeugt Leni Riefenstahl sie davon, die Route über die Nuba-Berge in der Region Kordofan zu nehmen. Über beschwerliche Sandpisten gelangt die Expedition Mitte Dezember in das entlegene Nuba-Dorf Tadoro und schlägt für sieben Wochen ihr Lager dort auf. Schnell schließt Leni Riefenstahl Freundschaft mit den zunächst scheuen Dorfbewohnern, lernt ihre Sprache und fotografiert sie. In Tadoro erlebt sie ein Ringkampffest, das bei den Masakin-Qisar-Nuba kultische Bedeutung hat, und wird in das Hirtenlager *seribe* geführt, in dem sich nur Männer aufhalten dürfen

Lorsque Leni Riefenstahl apprend que la société scientifique allemande Nansen veut tourner un documentaire au Sud-Soudan, elle demande à l'accompagner et propose en échange de tourner un film sur cette société scientifique. Leni Riefenstahl participe à l'expédition. Lors de son séjour à l'hôpital de Nairobi en 1956, elle avait vu dans un ancien numéro du *stern* une photo de lutteurs nouba prise par George Rodger dans le Sud-Soudan – cette photo ne l'avait plus quittée depuis. Or, ces régions étant constamment la proie de conflits entre musulmans et chrétiens, entre populations noires et arabes, une autorisation spéciale est nécessaire pour pénétrer dans les fameux «closed districts». En octobre, les membres de l'expédition Nansen prennent l'avion pour Khartoum. En raison du mauvais temps, le groupe ne peut prendre le chemin le plus direct menant aux tribus Nouer. Leni Riefenstahl parvient à convaincre les membres de l'expédition de passer par les monts Nouba, dans la région de Kordofan. Mi-décembre, après un trajet difficile sur des pistes de sable, l'expédition installe son campement pour sept semaines dans le village nouba de Tadoro. Leni Riefenstahl se

lie rapidement d'amitié avec les habitants d'abord réservés, apprend la langue des Nouba de Masakin-Qisar, vit avec eux et les photographie. À Tadoro, elle assiste à une lutte rituelle qui a valeur de culte chez les Nouba, et elle est conduite dans le camp de bergers de la *séribé*, auquel seuls les hommes ont accès.

1963 The Nansen Society leaves her, and she travels on alone. In April she accompanies the governor of the Upper Nile Province on a 14-day inspection trip and photographs the Anuak, Murle, Nuer, and Dinka tribes. In late May she undertakes a photo safari to the Masai in Laitokitok on Kilimanjaro, where she witnesses initiation rites. On her ten-month journey, travelling alone and without a tent, she shoots 210 rolls of film, but back in Germany she discovers that most of the film has deteriorated.

Die Nansen-Gesellschaft trennt sich von ihr und sie reist alleine weiter. Im April begleitet sie den Gouverneur der Upper Nile Province bei einer 14-tägigen Inspektionsreise und fotografiert die Stämme der Anuak, Murle, Nuer und Dinka. Ende Mai unternimmt sie eine Fotosafari zu den Masai in Laitokitok am Kilimandscharo, wo sie eine Initiationsfeier erlebt. Auf ihrer zehnmonatigen Reise, die sie allein und ohne Wagen und Zelt macht, belichtet sie insgesamt 210 Filme, stellt jedoch in Deutschland fest, dass die Mehrzahl der Filme verdorben ist.

La société Nansen se sépare d'elle et elle poursuit seule son voyage. En avril, elle accompagne le gouverneur de la province du Haut-Nil dans un circuit d'inspection de quinze jours et photographie les tribus des Anouak, Mourlé, Nouer et Dinka. Fin mai, elle entreprend un safari photo chez les Massaï, à Laitokitok, près du Kilimandjaro, où elle assiste à une cérémonie initiatique. Pendant son voyage de dix mois, qu'elle effectue seule, sans voiture ni tente, elle réalise 210 pellicules; or, une fois en Allemagne, elle constate que la plupart sont en mauvais état.

1964 A retrospective of her work has successful runs in Bremen. During the Winter Olympics in Innsbruck she takes photographs for the Olympia-Verlag. She gives slide lectures at Harvard University, at Kodak's George Eastman House in Rochester, and at *National Geographic Magazine* and the National Geographic Society in Washington, D.C. The American film company Odyssey Productions offers money for a film about the Nuba. Shortly before her departure in early November, she hears on the radio that a civil war has broken out in the Sudan. She decides to continue the expedition anyway and sets off with two drivers. In Khartoum the street fighting is intensifying, but she receives permission to visit the southern Sudan and film there. She spends Christmas back in Tadoro with the Nuba.

Eine Retrospektive ihres Werks läuft mit positiver Resonanz in Bremen. Bei der Winter-Olympiade in Innsbruck fotografiert sie im Auftrag des Olympia-verlags. Sie hält an der Harvard University, im George Eastman House von Kodak in Rochester, beim *National Geographic Magazine* und im National Geographic Society in Washington Dia-Vorträge über die Nuba. Die amerikanische Filmgesellschaft Odyssey Productions stellt Geld für einen Film über die Nuba zur Verfügung. Kurz vor der Abreise Anfang November hört sie im Radio, dass im Sudan ein Bürgerkrieg ausgebrochen ist. Trotzdem entscheidet sie sich für die Expedition und bricht mit zwei Fahrern auf. In Khartum finden immer noch Straßenkämpfe statt, doch sie erhält die Dreh- und Einreisegenehmigung für den Südsudan und verbringt Weihnachten wieder in Tadoro bei den Nuba.

Une rétrospective de son œuvre est proposée à Brême, où elle a à chaque fois le même succès. Lors des Jeux olympiques d'hiver à Innsbruck, elle est chargée par les éditions «Olympia-Verlag» de prendre des photos. À la Harvard University, à la George Eastman House de Kodak à Rochester, au *National Geographic Magazine* et à la National Geographic Society à Washington, elle donne des conférences et présente ses diapositives sur les Nouba. La société

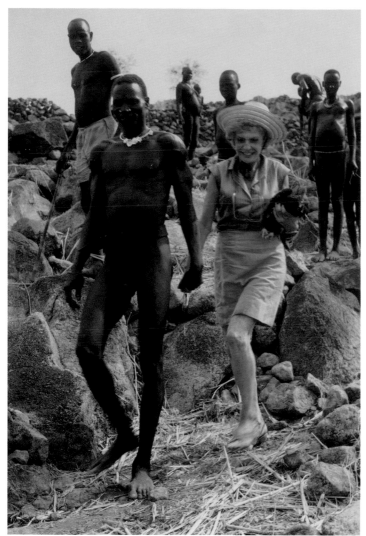

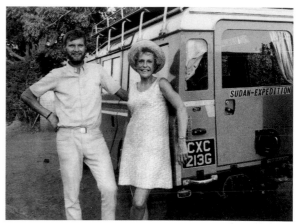

With her life partner, Horst Kettner, she returns to her Nuba friends in Tadoro in 1968.
Mit ihrem Lebensgefährten Horst Kettner fährt sie 1968 wieder zu ihren Nuba-Freunden in Tadoro.
Avec son compagnon Horst Kettner, elle retourne pendant l'hiver 1968 chez ses amis Nouba de Tadoro.

The heavy rains had made the road almost impossible to negotiate, Malakal 1963.
Durch den starken Regen war die Straße kaum passierbar, Malakal 1963.
Les fortes pluies ont rendu la route impraticable, Malakal 1963.

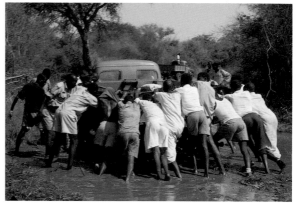

In the Korongo mountains, 1969.
In den Korongo-Bergen, 1969.
Dans les monts Korongo, 1969.

cinématographique américaine Odyssey Productions lui propose de financer un film sur les Nouba. Peu avant le départ prévu début novembre, elle apprend par la radio qu'une guerre civile a éclaté au Soudan. Elle décide quand même de partir, accompagnée de deux chauffeurs. À Khartoum, malgré les incessants combats de rue, elle obtient l'autorisation de circuler et de filmer dans le Sud-Soudan. De nouveau, elle passe Noël à Tadoro, en compagnie des Nouba.

1965 On 14 January her mother Bertha Riefenstahl, with whom she has been living since 1945 and whom she loves deeply, dies. She immediately halts the expedition and flies to Munich for the funeral. Afterwards she hires the young cameraman Gerhard Fromm. Back in Tadoro, she films Nuba wrestling matches, ritual acts, dances, and everyday life. While filming she gets too close to the wrestlers, and they fall on her in the struggle, breaking two of her ribs. Back in Munich she turns in the film stock—the new, especially light-sensitive ER Stock—for development, but it is returned in an unusable state with a green cast. This puts an end to her Nuba film for the time being.

Am 14. Januar stirbt ihre Mutter, Bertha Riefenstahl, mit der sie seit 1945 zusammengelebt hat und die sie über alles liebt. Sie unterbricht sofort die Expedition und fliegt für die Beerdigung nach München. Danach engagiert sie den jungen Kameramann Gerhard Fromm und filmt zurück im Sudan die Ringkämpfe der Nuba, die kultischen Handlungen, die Tänze und das Alltagsleben. Als sie beim Filmen zu nah an die Ringkämpfer herangeht und diese im Kampf auf sie fallen, bricht sie sich zwei Rippen. Zurück in München gibt sie das Filmmaterial – darunter das neue, besonders lichtempfindliche ER-Material – in die Entwicklung, erhält die Aufnahmen jedoch grünstichig und unbrauchbar zurück. Damit ist ihr Nuba-Film vorerst gescheitert.

Bertha Riefenstahl, sa mère, qu'elle aime par-dessus tout, meurt le 14 janvier. La mère et la fille vivaient

ensemble depuis 1945. Elle interrompt aussitôt son expédition et rentre à Munich pour les obsèques. Elle engage ensuite le jeune caméraman Gerhard Fromm et filme les luttes des Nouba, les rites, les danses et la vie quotidienne. Un jour, en filmant, Leni Riefenstahl s'approche trop près de lutteurs qui, par inadvertance, la font trébucher: elle se casse deux côtes. De retour à Munich, elle donne le film à développer, la nouvelle pellicule ER particulièrement sensible à la lumière. Mais les épreuves qu'on lui retourne ont toutes un défaut de couleur et sont de ce fait totalement inutilisables. Le projet sur les Nouba connaît un premier échec.

1966 The Nuba photographs appear for the first time in *African Kingdom*, a book of photographs published by Time Life Books. The Museum of Modern Art, New York, and the George Eastman House, Rochester, present retrospectives of the films by and with Leni Riefenstahl. In December she travels to the Sudan for 28 days and celebrates Christmas with her friends in Tadoro for the third time. She considers living with them permanently.

In *African Kingdom*, einem Bildband der amerikanischen Time & Life Books, werden erstmals ihre Nuba-Fotos veröffentlicht. Im Museum of Modern Art, New York, und im George Eastman House, Rochester, finden Retrospektiven der Filme mit und von Leni Riefenstahl statt. Im Dezember reist sie 28 Tage in den Sudan und feiert Weihnachten zum dritten Mal mit ihren Freunden in Tadoro. Sie trägt sich mit der Idee, für immer bei ihnen zu leben.

Des photos des Nouba sont publiées pour la première fois par l'éditeur américain «Time & Life Books» dans l'album *An African Kingdom*. Au Museum of Modern Art de New York, ainsi qu'à la George Eastman House, Rochester, se tiennent des rétrospectives des films de et avec Leni Riefenstahl. En décembre, elle part quatre semaines au Soudan et, pour la troisième fois, passe Noël avec ses amis à Tadoro. Elle envisage un temps d'y rester pour toujours.

1967 – 1968 The Austrian Film Museum in Vienna presents a Leni Riefenstahl Film Week in 1967, showing five of her films. She prepares a new expedition to the Sudan, and in order to raise money she gives slide lectures and interviews, for the Italian broadcasting company RAI and the BBC, among others. During preparations for the trip she meets Horst Kettner. He accompanies her as a camera assistant on all her trips from now on and becomes her life partner. They spend Christmas 1968 with the Mesakin Quissayr Nuba and show them 8-mm films of Charlie Chaplin, Harold Lloyd and Buster Keaton.

Das Österreichische Filmmuseum in Wien veranstaltet 1967 eine Leni-Riefenstahl-Filmwoche und zeigt fünf ihrer Filme. Sie bereitet eine neue Sudan-Expedition vor, hält zur Finanzierung der Reise Dia-Vorträge und gibt Interviews, unter anderem für den italienischen Fernsehsender RAI und die englische BBC. Bei den Reisevorbereitungen lernt Leni Riefenstahl Horst Kettner kennen. Er begleitet sie seitdem auf allen ihren Reisen als Kamera-Assistent und wird ihr Lebenspartner. Weihnachten 1968 verbringen sie bei den Masakin-Qisar-Nuba, denen sie 8-Millimeter-Filme von Charlie Chaplin, Harold Lloyd und Buster Keaton zeigen.

Le Musée autrichien du film à Vienne organise en 1967 une semaine «Leni Riefenstahl» et montre cinq de ses films. Elle prépare une nouvelle expédition au Soudan, qu'elle finance en donnant des conférences-diaporamas et des interviews, entre autres pour les télévisions italienne RAI et anglaise BBC. Lors des préparatifs de voyage, elle fait la connaissance de Horst Kettner qui l'accompagnera dès lors comme assistant caméraman dans tous ses voyages et qui deviendra son compagnon. Ils passent Noël 1968 chez les Nouba de Masakin-Qisar, auxquels ils montrent des films 8 mm de Charlie Chaplin, Harold Lloyd et Buster Keaton.

1969 The ruined photographs of 1965 are to be reshot. But civil war, the dress code forbidding

nakedness (imposed by the Muslim government) and tourism have affected the traditions and living conditions of the Nuba, and it is difficult to find the shots she hoped for. Back in Germany Leni Riefenstahl and the art director Rolf Gillhausen choose photographs for a 15-page series of images in *stern* magazine.

Die verdorbenen Aufnahmen von 1965 sollen nun wiederholt werden. Aber der Bürgerkrieg, die Kleidergesetze der moslemischen Regierung, die Nacktheit nicht duldet, und der Tourismus wirken sich bereits auf die Traditionen und Lebensbedingungen der Nuba aus, und es ist schwierig, die erhofften Motive zu finden. Zurück in Deutschland wählt sie gemeinsam mit dem Art Director Rolf Gillhausen Fotografien für eine 15-seitige Bildstrecke im *stern* aus.

Les précédentes prises de vue détériorées vont désormais être refaites. Mais la guerre civile, le gouvernement musulman, qui a émis une loi interdisant la nudité, et le tourisme ont déjà modifié les traditions et les conditions de vie des Nouba; il est donc difficile de retrouver les anciens motifs. De retour en Allemagne, elle sélectionne avec le directeur artistique Rolf Gillhausen des photos pour un reportage de 15 pages dans *stern*.

1970–1972 Leni Riefenstahl travels repeatedly with Horst Kettner to East Africa. In 1971 in Malindi on the Indian Ocean she hears of snorkeling for the first time and joins a group of divers.

Leni Riefenstahl reist wiederholt gemeinsam mit Horst Kettner nach Ostafrika. Im Jahr 1971 hört sie in Malindi am Indischen Ozean das erste Mal vom Schnorcheln an und schließt sich einer Gruppe von Tauchern an.

Leni Riefenstahl se rend de nouveau avec Horst Kettner en Afrique orientale. En 1971, à Malindi, dans l'océan Indien, elle entend parler pour la première fois de plongée sous-marine et s'associe à un groupe de plongeurs.

Shooting a portrait photograph of Mick and Bianca Jagger for the *Sunday Times Magazine*, London, 1974.
Bei der Porträtaufnahme von Mick und Bianca Jagger für das Londoner *Sunday Times Magazine*, 1974.
Faisant le portrait de Mick et Bianca Jagger pour le *Sunday Times Magazine* de Londres, 1974.

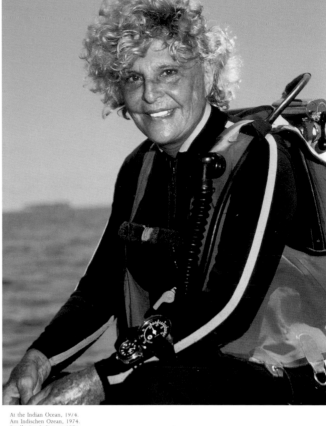

At the Indian Ocean, 1974.
Am Indischen Ozean, 1974.
Sur l'océan Indien en 1974.

With Andy Warhol in New York, 1974.
Mit Andy Warhol in New York, 1974.
Avec Andy Warhol à New York, 1974.

1973 Her first collection of photographs of the Nuba is published by Paul List Verlag in Munich, with a title that translates as *The Nuba: Like People from Another Star* (published in 1974 in English as *The Last of the Nuba*). Leni Riefenstahl did the layout and wrote the texts. The publishers Tom Stacey, Harper & Row, and Denoël withdraw on short notice from the planned international co-publication; Paul List Verlag takes the risk of publishing it alone. The book is a great success and appears—as do almost all of the following books of photographs—later in America, Great Britain, France, Italy, and Japan. She travels with Horst Kettner to Mombasa and Malindi and passes a diving test. To register for the diving course, she has to give the year of her birth as 1922 instead of 1902. When she announces that secret at the celebration for passing the test, she is much admired. She is fascinated with the world under water, the feeling of weightlessness, the beauty of the color and forms. The president of the Sudan, Gaafar Muhammad al-Nimeiry, grants her Sudanese citizenship in recognition of her services to the Sudan, she is the first female foreigner to be granted this honour. She asks him to ban harpooning in the Red Sea. On the return trip she dives in the Red Sea and photographs underwater for the first time.

Ihr erster Bildband über die Nuba erscheint im Münchner Paul List Verlag unter dem Titel *Die Nuba – Menschen wie von einem anderen Stern*. Leni Riefenstahl machte auch das Layout und schrieb die Texte. Die Verlage Tom Stacey, Harper & Row und Denoël sind kurzfristig von der geplanten internationalen Co-Produktion zurückgetreten; der Paul List Verlag wagt die Publikation allein. Der Bildband ist ein großer Erfolg und wird – wie fast alle folgenden Bildbände – später auch in Amerika, Großbritannien, Frankreich, Italien und Japan erscheinen. Sie reist mit Horst Kettner nach Mombasa und Malindi und legt dort die Tauchprüfung ab. Um sich in den Tauchkurs einschreiben zu können, gibt sie als ihr Geburtsjahr 1922 statt 1902 an. Als sie bei der Feier zur bestandenen Tauchprüfung ihr Geheimnis lüftet, wird sie gefeiert. Sie ist fasziniert von der Unterwasserwelt,

dem Gefühl der Schwerelosigkeit, der Schönheit der Farben und Formen. Der Präsident des Sudan, Jaafar Mohammed an-Numeiri, verleiht ihr die sudanesische Staatsangehörigkeit in Anerkennung ihrer Verdienste um den Sudan. Sie ist die erste Ausländerin, der diese Ehre zuteil wird. Sie bittet ihn, im Roten Meer das Harpunieren zu verbieten. Auf der Rückreise taucht sie im Roten Meer und fotografiert erstmals die Unterwasserwelt.

Son premier album sur les Nouba paraît à Munich aux éditions Paul List: *Les Nouba: des hommes d'une autre planète* (publié en France en 1976). Leni Riefenstahl a réalisé la maquette et rédigé les textes. Les éditeurs Tom Stacey, Harper & Row et Denoël s'étaient retirés à brève échéance d'une coproduction internationale prévue – seul le Paul List Verlag a osé la publication. L'album connaît un grand succès et paraîtra – comme presque tous les recueils suivants – en Amérique, en Grande-Bretagne, en France, en Italie et au Japon. Elle part avec Horst Kettner pour Mombasa et Malindi et y passe son examen de plongée. Pour pouvoir s'inscrire, elle change son année de naissance de 1902 en 1922, et ne dévoilera son secret que lors de la fête marquant sa réussite. Elle est fascinée par le monde sous-marin, la sensation d'apesanteur, la beauté des couleurs et des formes. Le président du Soudan Gaafar Mohamed Nimairi lui accorde la nationalité soudanaise en reconnaissance de ses mérites pour le pays: elle est la première étrangère à bénéficier de cet honneur. Leni Riefenstahl prie le président soudanais d'interdire la chasse au harpon en mer Rouge. Sur le voyage du retour, elle passe par la mer Rouge et photographie pour la première fois l'univers sous-marin.

1974 Leni Riefenstahl and Horst Kettner spend several weeks with the Mesakin Quissayr Nuba and show them the first Nuba book. Learning of the southeast Nuba and their traditional knife duels, they set out—with a limited supply of gasoline and without an accurate map—to find them. They manage to find the villages of Kau, Fungor, and Nyaro, where

they can stay for just three days. They photograph the dances of the young girls, the knife duels and body paintings of the young men. Afterwards they travel to the Gulf of Honduras where they go diving off the island of Roatan and barely survive hurricane Fifi, in which eight to ten thousand people die. She is the guest of honour at the first Telluride Film Festival in Colorado. The festival opens with the film *The Blue Light* and presents all of the artist's other films as well. Together with the actress Gloria Swanson and the director Francis Ford Coppola she is honoured with a silver medal for her artistic achievements.

Leni Riefenstahl und Horst Kettner verbringen mehrere Wochen bei den Masakin-Qisar-Nuba und zeigen ihnen das erste Nuba-Buch. Sie hören von den Südost-Nuba und ihren traditionellen Messerkämpfen und machen sich auf die Suche nach ihnen, mit knapp bemessenem Benzinvorrat und ohne genaue Landkarte. Tatsächlich finden sie die Dörfer Kau, Fungor und Nyaro, wo sie nur drei Tage bleiben können. Sie fotografieren die Tänze der Mädchen, die Schlagringkämpfe und die Körperbemalungen der jungen Männer. Im Anschluss unternehmen sie eine Tauchreise auf die Insel Roatan im Golf von Honduras und überleben dort knapp den Hurrikan „Fifi", bei dem 8000 bis 10000 Menschen umkommen. Sie ist Ehrengast auf dem ersten Filmfestival von Telluride, Colorado. Das Festival wird mit dem Film *Das blaue Licht* eröffnet und zeigt alle anderen Filme der Künstlerin. Gemeinsam mit Gloria Swanson und Francis Ford Coppola wird sie für ihre künstlerischen Leistungen mit einer Silbermedaille geehrt.

Leni Riefenstahl et Horst Kettner passent plusieurs semaines chez les Nouba de Masakin-Qisar auxquels ils montrent le premier volume sur les Nouba. Curieux de découvrir les Nouba du Sud-Est et leurs luttes traditionnelles, ils se mettent en route, avec très peu d'essence et sans carte précise du pays. Ils traversent les villages de Kau, Fungor et Nyaro, où ils ne peuvent rester que trois jours, et photographient les danses des jeunes filles, les luttes et les tatouages

des hommes. Ils achèvent leur périple par un séjour de plongée sur l'île Roatan, dans le golfe de Honduras, et réchappent de justesse au cyclone «Fifi» qui tue entre 8000 à 10000 personnes. Leni Riefenstahl est invitée d'honneur au premier festival de film de Telluride, Colorado. Le Festival ouvre avec le film *La Lumière bleue* et montre également tous les autres films de la cinéaste. Avec la vedette Gloria Swanson et le réalisateur Francis Ford Coppola, elle reçoit une médaille d'argent pour ses performances artistiques.

1975 Together with Horst Kettner she spends five months with the southeast Nuba. She takes more than two thousand photographs of women being tattooed, men being painted, the knife duels of the young warriors and the *nyertun* dance festival. From October on the photographs begin to appear in magazines in Europe, America, Japan, Australia and Africa. The Art Director's Club in Germany awards her a gold medal for photography; the 20-page spread in *stern*, designed by Rolf Gillhausen, wins a prize for the best layout. Leni Riefenstahl travels to the Caribbean, including the Cayman and Virgin Islands, for diving. She photographs while diving during the day and at night and films underwater for the first time.

Gemeinsam mit Horst Kettner lebt sie fünf Monate bei den Südost-Nuba. Mehr als 2000 Aufnahmen macht sie von den Tätowierungen der Frauen, den Bemalungen der Männer, den Messerkämpfen der jungen Krieger und dem Tanzfest *njertun*. Die Fotos erscheinen ab Oktober in Zeitschriften in Europa, Amerika, Japan, Australien und in Afrika. Vom Art Directors Club Deutschland wird die Fotografin mit einer Goldmedaille ausgezeichnet; die 20-seitige Bildstrecke im *stern*, die von Rolf Gillhausen gestaltet wurde, erhält einen Preis für das beste Layout. Eine Tauchreise führt sie in die Karibik, unter anderem auf die Cayman- und Jungfern-Inseln. Sie fotografiert bei Tag- und Nachttauchgängen und filmt zum ersten Mal die Unterwasserwelt.

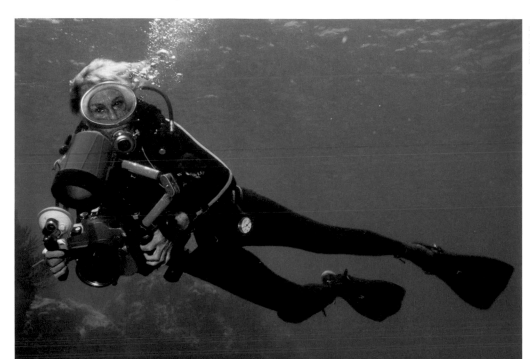

Diving to photograph the
underwater world, circa 1973.
Als Taucherin fotografiert sie die
Unterwasserwelt, um 1973.
Elle plonge et photographie
le monde sous-marin, vers 1973.

With Helmut Newton in Havana, 1987.
Mit Helmut Newton in Havanna, 1987.
Avec Helmut Newton à La Havane, 1987.

Dr. Albrecht Knaus congratulates
her on her 95th birthday, 1997.
Dr. Albrecht Knaus gratuliert ihr
zum 95. Geburtstag, 1997.
Albrecht Knaus lui présente tous ses
vœux à l'occasion de ses 95 ans, 1997.

Avec Horst Kettner, elle vit cinq mois chez les Nouba du Sud-Est et réalise plus de 2 000 photos des tatouages des femmes, de peintures des hommes, de luttes de jeunes guerriers et de la fête dansée de *nyertoun*. Les photos paraissent à partir d'octobre dans diverses revues en Europe, en Amérique, au Japon, en Australie et en Afrique. Elle reçoit la médaille d'or du «Art Directors Club Deutschland» et le reportage de 20 pages dans *stern*, conçu par Rolf Gillhausen, est recompensé du prix de la meilleure maquette. Elle part plonger dans la mer des Caraïbes, à la Grande Caïman et aux îles Vierges. Elle photographie de jour et de nuit, et filme pour la première fois le monde sous-marin.

1976 – 1977 In 1976 the BBC broadcasts for the first time excerpts of the film she took of the Nuba of Kau. Her second book of photographs is presented at the Frankfurt Book Fair of 1976 and published that same year under the English title *The People of Kau*; the photographer was responsible for the text and layout as well. Under contract from the magazine *GEO*, she travels again to the southeast Nuba in 1977. In the Sudan President Gaafar Muhammad al-Nimeiry decorates her in recognition of two books of Nuba photographs. In a television studio in Japan in 1977 she meets all of the Japanese athletes who participated in the 1936 Olympics, including the marathon winner Kitei Son. She and Horst Kettner take many diving trips to the Caribbean, the Indian Ocean and the Red Sea, where she films with a 16-mm camera for the first time.

Die BBC zeigt erstmals Ausschnitte aus dem gefilmten Material zu den Nuba von Kau. Auf der Frankfurter Buchmesse 1976 wird ihr zweiter Bildband *Die Nuba von Kau* präsentiert, dessen Text und Layout von der Fotografin stammen und der im selben Jahr ebenfalls in London, New York und Paris veröffentlicht wird. Im Auftrag der Zeitschrift *GEO* reist sie 1977 erneut zu den Südost-Nuba. Präsident Jaafar Mohammed an-Numeiri verleiht ihr in Anerkennung der beiden Nuba-Bildbände einen Orden. Mehrere Tauchreisen

führen sie und Horst Kettner in die Karibik, zum Indischen Ozean und zum Roten Meer, wo sie erstmals mit einer 16-Millimeter-Kamera filmt.

Cette même année, la BBC montre pour la première fois des extraits des films sur les Nouba de Kau. Son deuxième album sur les Nouba dont la maquette et le texte sont également de la photographe, est présenté en 1976 à la Foire du livre de Francfort et publié la même année en France sous le titre *Les Nouba de Kau*. Pour le magazine *GEO*, elle se rend de nouveau chez les Nouba du Sud-Est en 1977. Au Soudan, le président Gaafar Mohamed Nimaïri lui décerne une décoration pour ses albums sur les Nouba. Dans les studios de la télévision japonaise, elle retrouve en 1977 des sportifs qu'elle avait connus à Berlin en 1936, parmi lesquels le vainqueur du marathon Kitei Son. En copagnie de Horst Kettner, elle part plonger aux Caraïbes, dans l'océan Indien et dans la mer Rouge, où elle filme pour la première fois avec une caméra 16 mm.

1978 – 1981 Her first book of photographs of the undersea world is published in 1978 by Paul List Verlag and released in the same year under the English title *Coral Gardens*. She buys property in Pöcking, near Munich, where she has a prefabricated house set up. There she lives together with Horst Kettner. She fractures her femur in a ski accident at St. Moritz and is bedridden for a long time. Despite several operations, she suffers repeatedly from pain that only goes away when swimming or diving. In the following decades, Leni Riefenstahl and Horst Kettner make several diving trips to the Bahamas, the Caribbean, the Maldive Islands, Indonesia, Micronesia and Papua New Guinea. In 1980 Eiko Ishioka, an artist, internationally active art director and Oscar winner, organizes the exhibition *Nuba by Leni Riefenstahl* at the Seibu Museum of Art in Tokyo with 120 Nuba photographs, some of which are enlarged to sizes up to ten square yards.

Unter dem Titel *Korallengärten* erscheint 1978 im Paul

List Verlag ihr erster Bildband über die Unterwasserwelt. Sie kauft ein Grundstück in Pöcking in der Nähe von München und lässt dort ein Fertighaus erstellen. Seitdem lebt sie dort gemeinsam mit Horst Kettner. Bei einem Skiunfall in St. Moritz erleidet sie einen Oberschenkelhalsbruch und ist lange Zeit ans Bett gefesselt. Trotz mehrerer Operationen wird sie immer wieder von Schmerzen gequält und ist nur beim Schwimmen und Tauchen schmerzfrei. Tauchreisen führen sie in den folgenden Jahrzehnten wiederholt auf die Bahamas, auf die Malediven und in die Karibik, nach Indonesien, Mikronesien und Papua-Neuguinea. 1980 organisiert die Künstlerin, Art Directorin und Oscar-Preisträgerin Eiko Ishioka im Seibu Museum of Art in Tokio die Ausstellung *Nuba by Leni Riefenstahl* mit ungefähr 120 Nuba-Fotos, von denen einige bis auf zehn Quadratmeter vergrößert werden.

Chez Paul List Verlag paraît en 1978 son premier album sur le monde sous-marin; il est publié la même année en France sous le titre *Jardins de corail*. Elle achète un terrain à Pöcking, près de Munich, et y fait construire une maison où elle vit depuis avec Horst Kettner. Lors d'un accident de ski á Saint-Moritz, elle se casse le col du fémur et doit rester alitée très longtemps. Malgré plusieurs opérations, elle souffre de fortes douleurs que seules la natation et la plongée parviennent à apaiser. Dans les décennies suivantes, à plusieurs reprises, elle part plonger aux Bahamas, dans la mer des Caraïbes aux Maldives ainsi qu'en Indonésie, en Micronésie et en Papouasie-Nouvelle Guinée. En 1980, Eiko Ishioka, artiste et directrice artistique de rang international récompensée par un Oscar, organise au Musée Seibu de Tokyo l'exposition *Nuba by Leni Riefenstahl*, pour laquelle certaines des 120 photos de Nouba sont agrandies jusqu'à dix m².

1982 – 1989 The International Olympic Committee awards her a gold cup in 1982 in recognition of her *Olympia* films. Her book *Beauty in the Olympic Competition* (1937) is reprinted and also released in 1994 in London and New York under the title *Olympia*. On her 80th birthday she presents her fourth book of

photographs, released in the same year under the English title *Leni Riefenstahl's Africa*, for which once again she wrote the text and did the layout. The book documents her many trips in East Africa and shows photographs of various tribes, including the Nuba, the Shilluk, the Masai, and others. After many unsuccessful attempts with ghost writers, she decides to write her memoirs herself.

Vom Internationalen Olympischen Komitee erhält sie 1982 in Anerkennung ihrer *Olympia*-Filme einen Goldpokal. Das Buch *Schönheit im Olympischen Kampf* erscheint 1988 in einer Neuausgabe in München sowie 1994 auch in London und New York. An ihrem 80. Geburtstag stellt sie ihren vierten Bildband *Mein Afrika* vor, für den sie den Text geschrieben und das Layout gestaltet hat. Der Band dokumentiert ihre zahlreichen Reisen in Ostafrika und zeigt Aufnahmen verschiedener Stämme, unter anderem der Nuba, Schilluk und Masai. Nach verschiedenen erfolglosen Versuchen mit Ghostwritern entscheidet sie sich, ihre Memoiren selbst zu schreiben.

Du Comité International Olympique, elle reçoit en 1982 une coupe d'or pour *Les Dieux du stade*. Le livre *La Beauté dans le combat olympique* est réédité en Allemagne et publié en 1994 à Londres et à New York. Le jour de ses 80 ans, elle présente son quatrième album *Mon Afrique* pour lequel elle a de nouveau conçu la maquette et écrit le texte. L'ouvrage retrace ses nombreux voyages en Afrique orientale et montre des photos de différentes tribus, Nouba, Shillouk et Massaï. Elle confie la rédaction de ses mémoires à des nègres – en vain; elle décide alors de les écrire elle-même.

1990 – 1992 In 1990 her second book of photographs is published by Herbig Verlag, and is also published one year later in England under the title *Wonders under Water*. At the Bunkamura Cultural Center in Tokyo in the winter of 1991–1992, Eiko Ishioka organizes the exhibition *Leni Riefenstahl: Life*, which presents the artist's complete oeuvre for the first time;

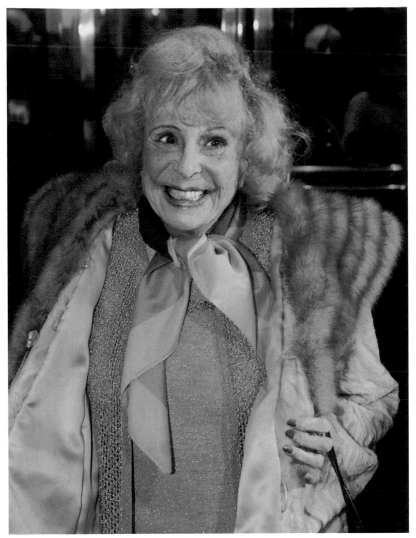

At the Munich Film Ball, 2000.
Beim Münchner Filmball, 2000.
Lors du bal du cinéma à Munich, 2000.

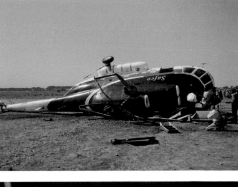

Photo: Bogdan Kramliczek

The helicopter crashes, during shooting of a documentary film about
Leni Riefenstahl's visit to the Nuba, February 2000.
Absturz des Hubschraubers bei den Dreharbeiten zu einem Dokumentarfilm
über Leni Riefenstahls Besuch bei den Nuba, Februar 2000.
Accident d'hélicoptère pendant le tournage d'un documentaire retraçant
la visite de Leni Riefenstahl chez les Nouba, février 2000.

In the hospital of El-Obeid in Sudan, 2000.
Im Krankenhaus von El-Obeid im Sudan, 2000.
A l'hôpital d'El-Obeid au Soudan, 2000.

it is enthusiastically received. Parts of the exhibition are shown in Kuopio, Finland, and Milan in 1996 and in Rome 1997.

Der Herbig Verlag veröffentlicht 1990 den Bildband *Wunder unter Wasser*, der später auch in Großbritannien publiziert wird. Im Bunkamura-Kulturzentrum in Tokio organisiert und gestaltet Eiko Ishioka im Winter 1991/1992 die Ausstellung *Leni Riefenstahl – Life*, die erstmals das Gesamtwerk der Künstlerin vorstellt. Teile der Ausstellung werden 1996 auch in Kuopio in Finnland und in Mailand sowie 1997 in Rom gezeigt.

L'éditeur Herbig publie en 1990 le volume *Wunder unter Wasser* (littéralement: Merveilles sous l'eau), qui paraîtra en 1991 en Grande-Bretagne. Au Centre culturel Bunkamura de Tokyo, Eiko Ishioka organise pendant l'hiver 1991–1992 l'exposition *Leni Riefenstahl – Life* qui présente pour la première fois l'œuvre complète de l'artiste. En 1996, l'exposition sera montrée partiellement à Kuopio, en Finlande, et à Milan et en 1997 à Rome.

1993 The three-hour documentary *The Wonderful, Horrible Life of Leni Riefenstahl* by Ray Müller, a German-English-Belgian co-production, receives international awards, including an Emmy Award and the Japanese Special Prize of Film Critics.

Der dreistündige Dokumentarfilm *Die Macht der Bilder – Leni Riefenstahl* von Ray Müller, eine deutsch-englisch-belgische Co-Produktion, erhält internationale Auszeichnungen, unter anderem den Emmy Award und den japanischen Spezialpreis der Filmkritiker.

Le documentaire de trois heures *Le Pouvoir des images – Leni Riefenstahl* de Ray Müller, une coproduction anglaise, allemande et belge, est récompensé au niveau international par le Emmy Award et le prix spécial du film de la critique japonaise, entre autres distinctions.

1997 In Leipzig, a complete retrospective of her films is shown, for the first time in Germany. Leni Riefenstahl is the guest of honour at the Cinecon film festival in Los Angeles and receives the honorary prize of the festival.

In Leipzig läuft zum ersten Mal in Deutschland eine vollständige Retrospektive ihrer Filme. Leni Riefenstahl erhält den Ehrenpreis beim Filmfest von Cinecon in Los Angeles.

À Leipzig se tient la première rétrospective complète de ses films en Allemagne. Leni Riefenstahl est invitée d'honneur de «Cinecon» à Los Angeles et reçoit le prix d'honneur du festival

1998 *Time Magazine* celebrates its 75th birthday at Radio City Music Hall in New York. The guests of honour include all the people still living who had ever appeared on the cover of the magazine. The only two German guests of honour are Leni Riefenstahl and Claudia Schiffer. The Film Museum in Potsdam shows *Leni Riefenstahl*, the artist's first solo show in Germany. The opening speech is given by her friend Kevin Brownlow, the British film journalist and director.

Das *Time Magazine* feiert seinen 75. Geburtstag in der Radio City Music Hall in New York. Als Ehrengast geladen sind alle lebenden Personen, die auf einem Titelfoto der Zeitschrift abgebildet waren. Die beiden einzigen deutschen Ehrengäste sind Leni Riefenstahl und Claudia Schiffer. Das Filmmuseum Potsdam zeigt mit *Leni Riefenstahl* die erste Einzelausstellung der Künstlerin in Deutschland. Die Eröffnungsrede hält ihr Freund, der englische Filmpublizist und Regisseur Kevin Brownlow.

Le *Time Magazine* fête ses 75 ans dans la Radio City Music Hall de New York et invite pour l'occasion toutes les personnalités encore vivantes ayant figuré en page de couverture. Les deux seules invitées allemandes sont Leni Riefenstahl et Claudia Schiffer. Au

Filmmuseum de Potsdam a lieu la première exposition personnelle *Leni Riefenstahl* en Allemagne, en association avec une rétrospective de ses films. L'allocution d'ouverture est prononcée par son ami, le journaliste de cinéma et réalisateur anglais Kevin Brownlow.

1999 The pain from a slipped disc from which Leni Riefenstahl has long suffered becomes so unbearable that she must undergo a very risky operation in May. A hospital stay of eight weeks follows, during which she is treated with strong painkillers. Nevertheless, she soon takes up her work again. In December press agencies report that the American actress, producer, and director Jodie Foster is working on a film on the life of Leni Riefenstahl. Since 1987 several Hollywood stars, including Madonna, have been interested in the film rights. Odeon-Film in Munich is also interested in filming her life story. The plan is for a European coproduction together with Thomas Schühly, a former assistant of Rainer Werner Fassbinder; Schühly became known internationally for *The Deathmaker* (1995) and *The Name of the Rose* (1986).

Die Bandscheibenschmerzen, unter denen Leni Riefenstahl leidet, werden für sie so unerträglich, dass sie sich im Mai einer sehr riskanten Operation unterzieht. Es folgt ein Krankenhausaufenthalt von acht Wochen, bei dem sie mit starken Betäubungsmitteln behandelt wird. Trotzdem nimmt sie ihre Arbeit bald wieder auf. Im Dezember melden Presseagenturen, dass sich die amerikanische Schauspielerin Jodie Foster um die Verfilmung der Lebensgeschichte von Leni Riefenstahl bemüht. Seit 1987 haben sich einige Hollywoodstars für die Filmrechte interessiert, unter anderem Madonna. Die Odeon Film AG aus München interessiert sich auch für die Verfilmung. Geplant ist eine europäische Co-Produktion in Zusammenarbeit mit Thomas Schühly, einem ehemaligen Mitarbeiter von Rainer Werner Fassbinder, der bekannt geworden ist mit *Der Name der Rose* (1986) und *Der Totmacher* (1995).

Les douleurs vertébrales, dont Leni Riefenstahl souffre depuis longtemps, sont désormais tellement insupportables qu'elle doit subir en mai une opération très risquée. Elle est ensuite hospitalisée huit semaines, au cours desquelles on lui administre des calmants à fortes doses. Elle reprend néanmoins très vite son travail. En décembre, des agences de presse annoncent que l'actrice américaine Jodie Foster, également productrice et réalisatrice, envisage de filmer la vie de Leni Riefenstahl. Depuis 1987, plusieurs stars d'Hollywood, Madonna entre autres, cherchent à en obtenir les droits. La maison de production munichoise «Odeon Film AG» envisage elle aussi de réaliser un film sur la vie de Leni Riefenstahl, en coproduction avec Thomas Schühly, ancien collaborateur de Rainer Werner Fassbinder et metteur en scène mondialement connu depuis *Le Nom de la rose* (1986) et *Totmacher* (1995).

2000 The play *Marleni: Preussische Diven blond wie Stahl* (literally: Marleni: Prussian Divas Blond as Steel) by Thea Dorn is performed at the Hamburg Theater. Under Jasper Brandis's direction the story tells of an imaginary meeting between Marlene Dietrich (Ilse Ritter) and Leni Riefenstahl (Marlen Diekhoff). In February the artist returns to the Nuba after 23 years to see whether her friends are still alive and to help them. She is accompanied by Ray Müller, who is making a second documentary film about her. During the filming the helicopter crashes from a height of 50 feet, and Leni Riefenstahl is taken to a Munich hospital, where she spends several weeks recovering from broken ribs and lung injuries. In May Leni Riefenstahl attends the opening at Camera Work gallery in Berlin for an exhibition of photographs that she took at the Olympic Games in 1936. The first exhibition of the artist's work in her native city attracts much attention. The exhibition is subsequently seen in other cities worldwide, among them Los Angeles, New York, London and Amsterdam.

Im Hamburger Schauspielhaus wird das Stück *Marleni. Preussische Diven blond wie Stahl* von Thea Dorn aufge-

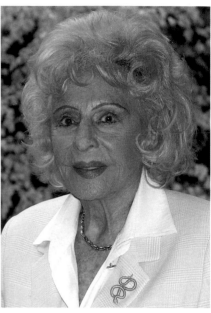

Leni Riefenstahl signing the book *Leni Riefenstahl – Five Lives*, 2001.
Leni Riefenstahl signiert den Band *Leni Riefenstahl – Fünf Leben*, 2001.
Leni Riefenstahl signe le livre *Leni Riefenstahl – Cinq vies*, 2001.

With Juan Antonio Samaranch
in Lausanne, 2001.
Mit Juan Antonio Samaranch
in Lausanne, 2001.
Avec Juan Antonio Samaranch
à Lausanne, 2001.

führt, das die Geschichte eines fiktiven Treffens zwischen Marlene Dietrich (Ilse Ritter) und Leni Riefenstahl (Marlen Diekhoff) erzählt. Im Februar fährt die Künstlerin nach 23 Jahren wieder zu den Nuba, denn sie will endlich erfahren, ob ihre Freunde noch leben und will ihnen helfen. Es begleitet sie Ray Müller, der einen weiteren Dokumentarfilm über sie dreht. Bei den Dreharbeiten stürzt der Hubschrauber aus 15 Metern Höhe ab, sie wird mit Rippenbrüchen und Verletzungen der Lunge für mehrere Wochen in ein Münchner Krankenhaus eingeliefert. Im Mai eröffnet in der Berliner Galerie Camera Work in Anwesenheit von Leni Riefenstahl eine Ausstellung mit Fotos, die sie während der Olympischen Spiele 1936 aufgenommen hat. Die erste Ausstellung der Künstlerin in ihrer Geburtsstadt erregt großes Aufsehen. Im Anschluss wird die Ausstellung in weiteren Städten gezeigt, unter anderem in Los Angeles, New York, London und Amsterdam.

La pièce *Marleni. Preussische Diven blond wie Stahl* (littéralement: Marleni. Divas prussiennes blondes comme l'acier) est présentée au Schauspielhaus de Hambourg. L'auteur en est Thea Dorn, connue jusque-là pour ses romans policiers. La mise en scène est de Jasper Brandis et raconte l'histoire d'une rencontre fictive entre Marlene Dietrich (Ilse Ritter) et Leni Riefenstahl (Marlen Diekhoff). En février, au bout de 23 ans, elle retourne chez les Nuba, pour voir s'ils vivent encore et si elle peux les aider. Ray Müller l'accompagne pour tourner un deuxième film documentaire sur elle. Lors du tournage, l'hélicoptère fait une chute de 15 mètres: Leni Riefenstahl subit d'importantes fractures des côtes et des blessures au poumon et doit être hospitalisée plusieurs semaines à Munich. En mai, dans la galerie berlinoise Camera Work se déroule une exposition des photos réalisées par Leni Riefenstahl lors des Jeux olympiques de Berlin en 1936. L'artiste est présente au vernissage. La première exposition de l'artiste dans sa ville natale rencontre beaucoup d'intérêt. Ensuite l'exposition est présentée dans d'autres villes, entre autres à Los Angeles, New York, Londres et Amsterdam.

2002 Several substantial interviews are published in the press. In March she again goes diving in the Maldives; her new underwater film is scheduled for completion by August. Oscar-winning Giorgio

2001 In March, Ladomir Publishing House in Moscow acquires the rights to publish her memoirs in Russian. At the St. Petersburg Film Festival in June, Leni Riefenstahl is awarded the "Centaur" in honour of her important contribution to the development of film. Shortly afterwards in Lausanne, IOC President Juan Antonio Samaranch confers on her a gold medal for her 1936 Olympics films. In July she goes diving in the Maldive Islands. In September a Russian film crew visits Leni Riefenstahl's home to shoot footage for a TV documentary about her life.

Das Ladomir Publishing House Moskau erwirbt im März die Rechte zur Veröffentlichung ihrer Memoiren in russischer Sprache. Anlässlich des St. Petersburger Filmfestivals im Juni erhält Leni Riefenstahl den „Centaurus" als Ehrenpreis für ihren wichtigen Beitrag zur Entwicklung des Films. Kurz darauf überreicht ihr der Präsident des IOC Juan Antonio Samaranch in Lausanne nachträglich die Goldmedaille für ihre Olympiafilme von 1936. Im Juli unternimmt sie eine Tauchreise auf die Malediven und im September macht ein russisches Filmteam im Haus von Leni Riefenstahl Aufnahmen für einen Fernsehfilm über ihr Leben.

La maison d'édition Ladomir de Moscou acquiert en mars les droits sur ses mémoires qui seront publiés en langue russe. En juin, à l'occasion du festival cinématographique de Saint-Pétersbourg, le «Centaure» d'honneur est remis à Leni Riefenstahl pour le rôle majeur qu'elle a joué dans le développement du film. Peu de temps après à Lausanne, le président de l'IOC, Juan Antonio Samaranch lui décerne la médaille d'or pour ses films olympiques de 1936. En juillet, elle entreprend un voyage de plongée aux Maldives et en septembre, une équipe de cinéma russe qui tourne un film sur sa vie, fait des prises de vues dans sa maison.

Moroder is under contract to compose the film music. In June, film shooting in the Dolomites takes Leni Riefenstahl and Reinhold Messner back to places that have had meaning for them in the past. On 22 August, Leni Riefenstahl celebrates her 100th birthday.

Es erscheinen mehrere große Interviews in Zeitungen. Im März folgt eine weitere Tauchreise auf die Malediven, ihr neuer Unterwasserfilm soll zum August fertig gestellt werden. Als Komponisten konnte sie Oscar-Preisträger Giorgio Moroder gewinnen. Im Juni entstehen mit Leni Riefenstahl und Reinhold Messner Filmaufnahmen in den Dolomiten, bei denen sie an Orte vergangener Tage zurückkehrt. Am 22. August feiert Leni Riefenstahl ihren 100. Geburtstag.

Plusieurs grandes interviews paraissent dans les journaux. En mars, elle retourne faire de la plongée aux Maldives – son nouveau film sur les fonds sous-marins doit être prêt en août. Elle a pu gagner à son projet le compositeur Giorgio Moroder, titulaire d'un Oscar. En juin, un film avec Leni Riefenstahl et Reinhold Messner est tourné dans les Dolomites et la montre retournant à des endroits qu'elle a connus autrefois. Le 22 août, Leni Riefenstahl fête son centième anniversaire.

2003 Leni Riefenstahl dies on 8 September at the age of 101, in Pöcking on Lake Starnberg.

Leni Riefenstahl stirbt am 8. September im Alter von 101 Jahren in Pöcking am Starnberger See.

Leni Riefenstahl s'est éteinte le 8 septembre dans sa maison de Pöcking sur le lac de Starnberg. Elle était âgée de 101 ans.

Facing page: In front of her portrait painted in 1924 by Eugen Spiro, 2000.
Rechte Seite: Vor ihrem 1924 entstandenen Porträt von Eugen Spiro, 2000.
Page de droite: Devant son portrait signé Eugen Spiro (1924), 2000.

Photo: © Daniel Mayer, Sunday Telegraph Magazine, London

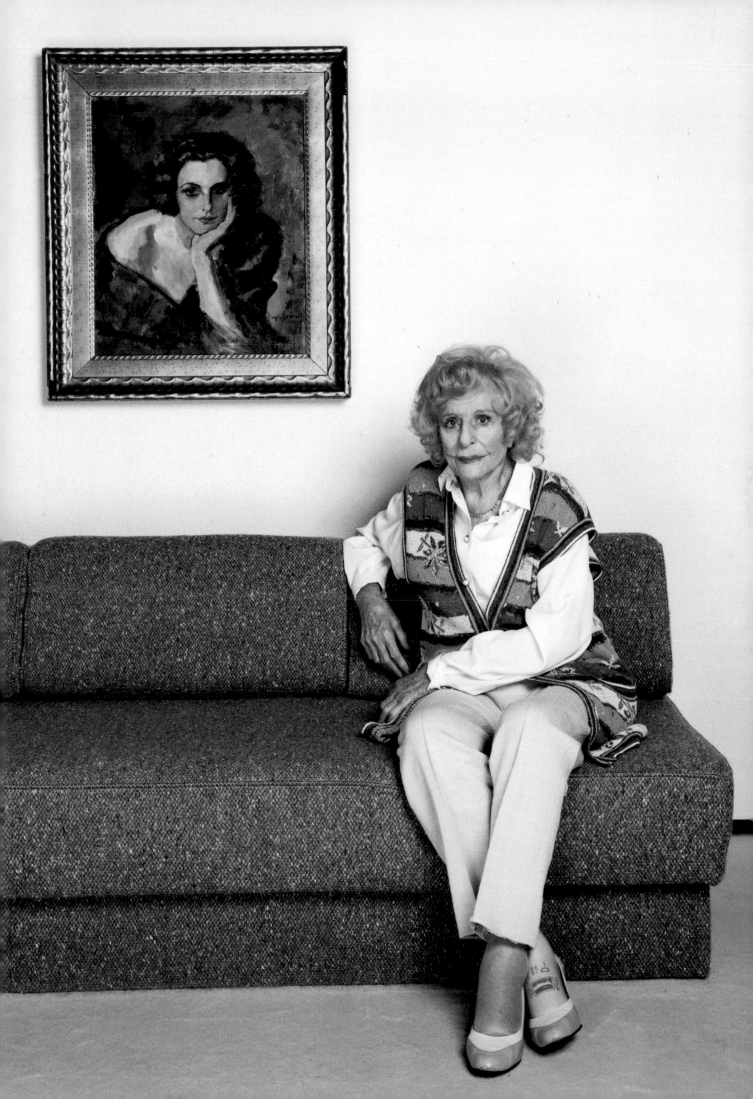

Filmography and Biblfography

Filmografie und Bibliografie
Filmographie et bibliographie

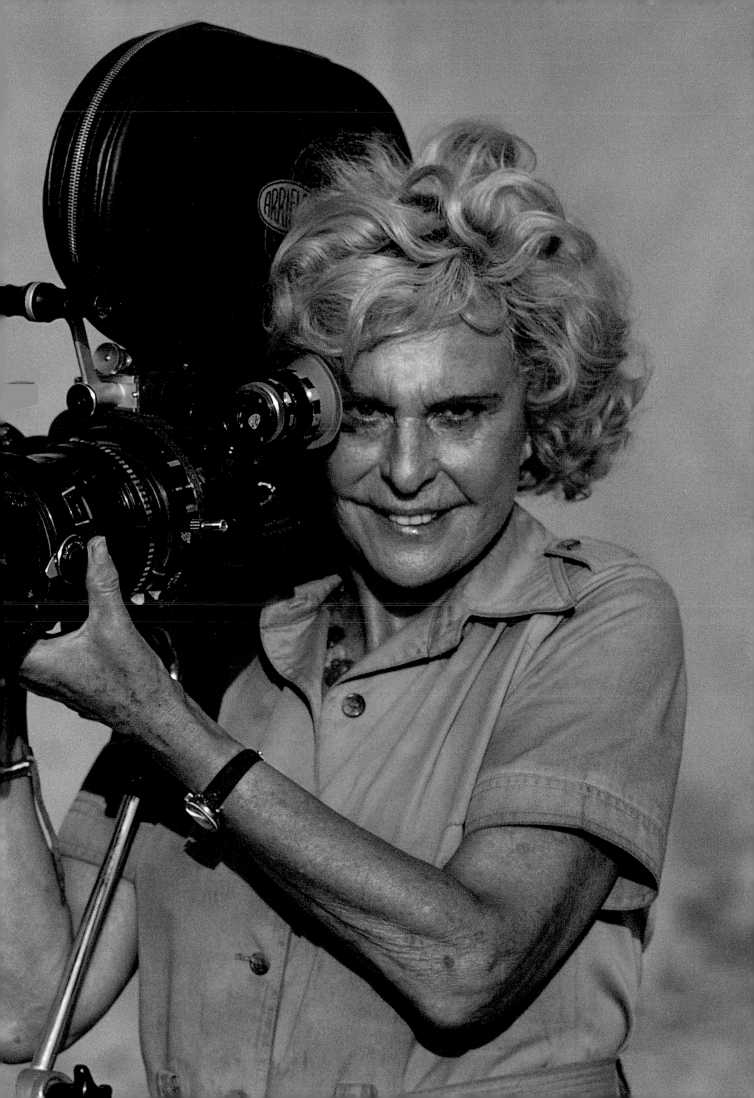

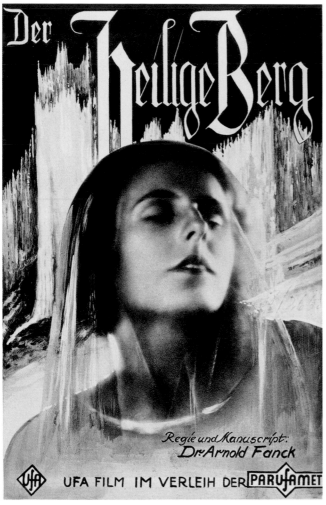

The Great Leap
Der große Sprung
Le Grand Saut
1927

The Destiny of the Hapsburgs
Das Schicksal derer von Habsburg
Le Destin des Habsbourg
1928

The Holy Mountain
Der heilige Berg
La Montagne sacrée
1926

The White Hell of Pitz Palü
Die weiße Hölle vom Piz Palü
L'Enfer blanc du Piz Palu
1929

1926

**The Holy Mountain—A Heroic Song
from a Towering World of Heights**
Der heilige Berg –
Ein Heldenlied aus ragender Höhenwelt
**La Montagne sacrée –
Hymne aux sommets alpins**

SILENT FILM, B/W, 118 MINUTES

DIRECTOR Arnold Fanck PRODUCTION COMPANY
Universum-Film AG (UFA), Cultural Division, Berlin
CAMERA Sepp Allgeier, Helmar Lerski, Hans Schnee-
berger; on location: Arnold Fanck and the Freiburg
School SCREENPLAY Arnold Fanck, Hans Schneeberger
SETS Leopold Blonder CAST Leni Riefenstahl, Luis
Trenker, Ernst Petersen, Hannes Schneider, Friedrich
Schneider, Frida Richard, Edmund Meisel

SUBJECT The plot of the film is a dramatic triangle
involving a dancer, Diotima, and two Alpine mountain
climbers. Both men want her, and her decision is for
the elder of the two. Jealousy sparks discord between
the men, and in the course of a dangerous climb they
fall. The movie, which was a great hit, is especially im-
pressive for its unusual shots of landscape and clouds.

SUJET Der Film erzählt eine dramatische Dreiecks-
geschichte zwischen der Tänzerin Diotima und zwei
Alpinisten. Beide Männer begehren sie, aber sie ent-
scheidet sich für den Älteren. Durch Eifersucht kommt
es zum Zerwürfnis zwischen den beiden Freunden, die
schließlich bei einer gefährlichen Klettertour abstürzen.
Der erfolgreiche Film beeindruckt die Zuschauer be-
sonders durch die ungewöhnlichen Landschafts- und
Wolkenaufnahmen.

SUJET Deux alpinistes sont amoureux de la danseuse
Diotima. Elle choisira le plus âgé et la jalousie séparera
les deux amis qui finiront par tomber dans un précipice
lors d'une ascension dangereuse. Le film dramatique
a connu un grand succès et les scènes inhabituelles de
paysages et de nuages sont particulièrement impres-
sionnantes.

1927

**The Great Leap—
An improbable but happy story**
Der große Sprung –
Eine unwahrscheinliche, aber
lustige Geschichte
**Le Grand Saut – Une histoire
invraisemblable et amusante**

SILENT FILM, B/W, 112 MINUTES

DIRECTOR Arnold Fanck PRODUCTION COMPANY
Universum-Film AG (UFA), Berlin CAMERA Sepp
Allgeier, Hans Schneeberger, Albert Benitz, Richard
Angst, Kurt Neubert, Charles Métain SCREENPLAY
Arnold Fanck CAST Leni Riefenstahl, Luis Trenker,
Hans Schneeberger, Paul Graetz

SUBJECT Goatherd Gita, who lives in a small village
in the Alps, is doted on by the rather gawky Toni.
Herself an excellent climber, one day she saves the
life of Michael Treuherz, an heir to millions. The vis-
itor from Berlin now learns to ski, under Gita's and
Toni's instruction. When a skiing competition is
held, Gita offers herself as the prize. The race ends
in victory for Treuherz.

SUJET Die Ziegenhirtin Gita, die in einem kleinen
Dorf in den Alpen lebt, wird von dem etwas linkischen
Toni verehrt. Als hervorragende Bergsteigerin rettet
sie eines Tages dem Berliner Millionenerben Michael
Treuherz das Leben, der nun unter ihrer und Tonis
Leitung das Skifahren erlernt. Bei einem Skiwettren-
nen setzt Gita sich selbst als Preis aus. Das Rennen
endet mit dem Sieg von Treuherz.

SUJET La gardienne de chèvres Gita vit dans un petit
village des Alpes et Toni, un jeune homme un peu
maladroit, est amoureux d'elle. Alpiniste remarquable,
Gita sauve la vie de l'héritier berlinois Michael Treu-
herz qui prend dès lors les leçons de ski auprès
d'elle et de Toni. Lors d'une compétition de ski, Gita
déclare qu'elle sera le prix du vainqueur. C'est Treu-
herz qui gagne la course.

1928

**The Destiny of the Hapsburgs—
The Tragedy of an Empire**
Das Schicksal derer von Habsburg –
Die Tragödie eines Kaiserreiches
**Le Destin des Habsbourg –
Tragédie d'un Empire**

SILENT FILM, B/W

DIRECTOR Rolf Raffé PRODUCTION COMPANY
Essem-Film Produktion, Berlin CAMERA Marius
Holdt SCREENPLAY Max Ferner CAST Fritz Spira,
Erna Morena, Maly Delschaft, Leni Riefenstahl,
Alfons Fryland, Franz Kammauf, Willi Hubert, Ernst
Recniczek, Albert Kersten, Paul Askonas, Ferry Lukacs,
Irene Kraus, Carmen Cartellieri, Alice Roberte, Minje
van Gooten NOTES The film is lost; the plot has been
taken from a surviving programme book.

SUBJECT The plot is about love tangles at the Austrian
imperial court around 1900, and the decline of the
Hapsburg dynasty. The protagonists are the heirs of
Empress Elisabeth and Emperor Franz Joseph I: the
story follows an amour between Crown Prince Rudolf
and Baroness Mary Vetsera (Leni Riefenstahl), and
an affair between his cousin Franz Ferdinand and
Countess Chotek, a liaison that conflicts with ideas
of rank and station.

SUJET Der Film handelt von den Liebeswirren am öster-
reichischen Kaiserhof um 1900 und vom Niedergang
der Familie von Habsburg. Im Mittelpunkt stehen die
Erben von Kaiserin Sisi und Kaiser Franz Joseph I.:
Zum einen geht es um die Affäre zwischen Kronprinz
Rudolf und Baronesse Mary Vetsera (Leni Riefenstahl),
zum anderen um seinen Cousin Franz Ferdinand und
dessen nicht standesgemäße Geliebte, Gräfin Chotek.

SUJET La cour autrichienne et ses péripéties amou-
reuses vers 1900, le déclin des Habsbourg. Les héri-
tiers de l'impératrice Sissi et de l'empereur François-
Joseph Ier sont les héros du film. Le prince héritier
Rodolphe a une affaire avec la baronne Mary Vetsera

(Leni Riefenstahl), et son cousin François-Ferdinand
a une épouse morganatique, la comtesse Chotek.

1929

The White Hell of Pitz Palu
Die weiße Hölle vom Piz Palü
L'Enfer blanc du Piz Palu

SILENT FILM, B/W, 127 MINUTES
SOUND VERSION, 1935, B/W, 92 MINUTES

DIRECTOR Arnold Fanck, Georg Wilhelm Pabst
PRODUCTION COMPANY Henry R. Sokal-Film
GmbH, Berlin PRODUCER Henry Richard Sokal
CAMERA Sepp Allgeier, Richard Angst, Hans Schnee-
berger SCREENPLAY Arnold Fanck, Ladislaus Vajda;
based on an idea by Arnold Fanck EXTERIOR
LOCATIONS Morteratsch Glacier, Piz Palu CAST Leni
Riefenstahl, Gustav Diessl, Ernst Petersen, Ernst Udet,
Mizzi Götzel, Christian Klucker

SUBJECT Mountain climber Johannes Krafft and a
couple, Maria Majoni and Hans Brandt, are climbing
the north face of Pitz Palü when Hans breaks a leg
and the three have to wait on an outcrop for help.
Three days go by, the mountain rescue services still
haven't located them, and Krafft attempts the descent
alone, unsecured, and freezes to death. Maria and
Hans are rescued.

SUJET Bergsteiger Johannes Krafft und das Paar Maria
Majoni und Hans Brandt besteigen die Nordwand
des Piz Palü, als Hans sich das Bein bricht und die
drei auf einem Felsvorsprung auf Hilfe warten müs-
sen. Als die Bergwacht sie nach drei Tagen noch nicht
gefunden hat, versucht Krafft ungesichert den Abstieg
und erfriert. Maria und Hans werden gerettet.

SUJET L'alpiniste Johannes Krafft et le couple Maria
Majoni et Hans Brandt sont en train d'escalader le
flanc nord du Piz Palu, quand Hans se casse la jambe.
Les trois jeunes gens doivent attendre l'arrivée des
sauveteurs sur un rebord rocheux. Au bout de trois

Storm over Mont Blanc　　　　　　1930
Stürme über dem Montblanc
Tempête sur le Mont-Blanc

The White Flame　　　　　　1931
Der weiße Rausch
L'Ivresse blanche

The Blue Light　　　　　　1932
Das blaue Licht
La Lumière bleue

The Blue Light　　　　　　　　　　1932
Das blaue Licht
La Lumière bleue

jours, ne voyant toujours rien venir, Krafft tente de descendre sans cordée et meurt de froid. Maria et Hans seront sauvés de justesse.

1930
Storm over Mont Blanc
Stürme über dem Montblanc
Tempête sur le Mont-Blanc

SOUND FILM, B/W, 110 MINUTES

DIRECTOR Arnold Fanck PRODUCTION COMPANY AAFA-Film (Tobis) CAMERA Hans Schneeberger, Richard Angst, Sepp Allgeier; pilot of the camera plane: Claus von Suchotzky SCREENPLAY Arnold Fanck, Carl Mayer EXTERIOR LOCATIONS Arosa, Mont Blanc, Vallot Observatory, Bernina Pass, Babelsberg Observatory CAST Leni Riefenstahl, Sepp Rist, Ernst Udet, Mathias Wieman, Friedrich Kayssler, Alfred Beierle, Ernst Petersen

SUBJECT The meteorological observer Hannes, who lives on Mont Blanc, and Hella Armstrong, who runs the observatory with her father in the valley, fall in love. While Hannes is getting ready to be relieved at the weather station, Hella spends the time tending to his sick friend Walter. Through a misunderstanding, Hannes thinks that the two are having an affair, so he spends another year on Mont Blanc. A storm sets in. Hannes risks the descent but is forced to turn back. His only hope of rescue is an SOS message on his radio transmitter, which Hella picks up at the observatory.

SUJET Der auf dem Montblanc lebende Wetterwart Hannes und Hella Armstrong, die mit ihrem Vater im Tal die Sternwarte leitet, verlieben sich. Während Hannes die Ablösung auf der Wetterwarte vorbereitet, soll sich Hella um seinen kranken Freund Walter kümmern. Durch ein Missverständnis glaubt er, dass die beiden ein Verhältnis haben und verbringt ein weiteres Jahr auf dem Montblanc. Als ein Sturm aufzieht, wagt Hannes den Abstieg, muss aber um-

kehren und wird nur durch einen Hilferuf über Funk, den Hella in der Sternwarte auffängt, gerettet.

SUJET Le météorologue Hannes vit seul sur le Mont-Blanc et Hella Armstrong dirige avec son père un observatoire dans la vallée. Les jeunes gens tombent amoureux l'un de l'autre. Pendant que Hannes attend son remplaçant, Hella doit s'occuper de son ami malade Walter. Hannes se méprend sur leurs relations et reste une année de plus sur le Mont-Blanc. Et puis une tempête se lève; Hannes tente la descente mais doit rebrousser chemin. Il ne sera sauvé que parce qu'il a envoyé un appel radio reçu par Hella à l'observatoire.

1931
The White Flame—
New Miracles of the Snowshoe
Der weiße Rausch –
Neue Wunder des Schneeschuhs
L'Ivresse blanche – Les joies du ski

SOUND FILM, B/W, 94 MINUTES

DIRECTOR Arnold Fanck PRODUCTION COMPANY Henry R. Sokal-Film, Berlin (AAFA-Film, Berlin) PRODUCER Henry Richard Sokal CAMERA Richard Angst, Kurt Neubert (on location), Hans Karl Gottschalk (in the studio); according to Fanck's programme text, Benno Leubner as well SCREENPLAY Arnold Fanck CAST Leni Riefenstahl, Hannes Schneider, Guzzi Lantschner, Walter Riml, Rudi Matt, Lothar Ebersberg, Luggi Föger, Josef Gumboldt, Hans Kogler, Benno Leubner, Otto Leubner, Harald Reinl

SUBJECT This slapstick comedy set in the Austrian Alps is about Leni, a young woman from Berlin spending a solo winter vacation at St. Anton in Arlberg. Skiing instructor Hannes teaches her to ski-jump, and the following year they are the "fox" couple in a light-hearted "fox hunt" on skis. This was the first talkie about Alpine skiing and remains cult viewing among devotees of winter sports.

SUJET Diese slapstickhafte Komödie spielt in den österreichischen Alpen und handelt von der jungen Berlinerin Leni, die allein Urlaub in St. Anton am Arlberg macht. Skilehrer Hannes bringt ihr das Skispringen bei und im nächsten Jahr bildet sie mit ihm das „Fuchspaar" bei einer lustigen „Fuchsjagd" auf Skiern. Der erste Tonfilm über den alpinen Skilauf gilt als einer der Kultfilme des weißen Sports.

SUJET Une comédie burlesque ayant pour cadre les Alpes autrichiennes. Leni, une jeune Berlinoise, passe seule des vacances d'hiver à St. Anton dans l'Arlberg et le moniteur de ski Hannes lui apprend à sauter. L'année suivante, elle est sa partenaire dans une joyeuse «chasse au renard» à ski. Ce premier film parlant sur le ski de fond alpin est considéré comme l'un des premiers films cultes sur ce sport.

1932
The Blue Light—
A Mountain Legend from the Dolomites
Das blaue Licht –
Eine Berglegende aus den Dolomiten
La Lumière bleue –
Légende alpestre dans les Dolomites

SOUND FILM, B/W, 86 MINUTES

DIRECTOR Leni Riefenstahl PRODUCTION COMPANY Leni Riefenstahl Studio-Film (H. R. Sokal-Film, Berlin) PRODUCERS Leni Riefenstahl, Henry Richard Sokal (uncredited) CAMERA Hans Schneeberger EDIT Leni Riefenstahl SCREENPLAY Leni Riefenstahl, Béla Balázs, Hans Schneeberger CAST Leni Riefenstahl, Mathias Wieman, Beni Führer, Max Holzboer, Franz Maldacea, Martha Mair, farmers from the Sarn Valley AWARDS silver medal of the International Film Exhibition 1932 in Venice (Biennale) NOTES In the first film she produces herself, Leni Riefenstahl becomes internationally famous as a woman producer, director, inventor of images, and leading actress. The original negative is lost during the war; as a result she cuts a new version in 1951 from the unused footage.

SUBJECT The film is set in the Alpine village of Santa Maria, where some of the young village men, drawn by a blue light seen on Monte Cristallo on full moon nights, fall on a night climb. A girl named Junta, who lives alone in the mountains, is blamed. Her secret turns out to be a cave full of rock crystal, which gives off the blue light, and villagers break off chunks and sell it. In despair, Junta hurls herself into the abyss.

SUJET Der Film spielt im Alpendorf Santa Maria, wo einige junge Männer des Dorfes, angelockt von einem blauen Licht, das in Vollmondnächten am Monte Cristallo schimmert, beim nächtlichen Aufstieg abstürzen. Schuld daran soll das Mädchen Junta sein, das allein in den Bergen lebt. Als ihr Geheimnis, eine Grotte voller Bergkristalle, die das blaue Licht verursachen, entdeckt wird, schlagen die Dorfbewohner die Kristalle ab und verkaufen sie. Junta stürzt sich daraufhin verzweifelt in den Abgrund.

SUJET À Santa Maria, un village des Dolomites, des jeunes gens partis à la recherche des lueurs scintillantes visibles sur le mont Cristallo les nuits de pleine lune, ne sont jamais revenus. Les gens du village accusent Junta qui vit seule dans les montagnes de leur avoir jeté un sort. Les villageois découvrent son secret – une grotte remplie de cristaux qui génèrent la lumière bleue – et les arrachent pour la vendre. Désespérée, elle se jette dans un précipice.

1933
Victory of Faith—The Film
of the National Socialist Party Rally
Sieg des Glaubens – Der Film
vom Reichsparteitag der NSDAP
Victoire de la foi –
Le congrès du parti national-socialiste

SOUND FILM, B/W, 64 MINUTES

DIRECTOR Leni Riefenstahl PRODUCTION COMPANY Propaganda Department of the National Socialist Party,

Victory of Faith
Sieg des Glaubens
Victoire de la foi
1933

SOS Iceberg
SOS Eisberg
SOS Iceberg
1933

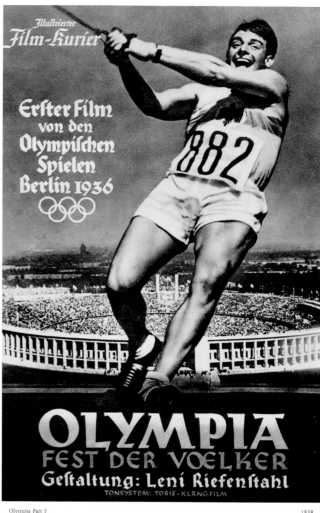

Olympia Part I
Olympia Teil 1
Les Dieux du stade 1ère partie
1938

Triumph of the Will
Triumph des Willens
Le Triomphe de la volonté
1935

Division IV (Film), Berlin CAMERA Sepp Allgeier, Franz Weihmayr, Walter Frentz, Richard Quaas, Paul Tesch EDIT Leni Riefenstahl, Waldemar Gaede SOUND Siegfried Schulze Distribution UFA, State Film Authorities of the National Socialists NOTES *Victory of Faith* is shot with very little preparation time and is the director's first documentary film. The film department of the National Socialist propaganda ministry, to which Leni Riefenstahl is officially subordinate, hampers the director during the filming, because Hitler chose her even though she is a woman and not a party member. Although the film, made under difficult circumstances, does not please her at all, it is highly praised by the party and the press.

SUBJECT Documentary film about the Fifth Party Rally of the National Socialists (Nazi Party), which takes place from 30 August to 3 September 1933 in Nuremberg and represents the first party rally following the Nazi seizure of power in January 1933. The film contains no voice-over or insert titles; rather, the film sequences combine the original sound—marching music, speeches, songs of the National Socialists—with music composed especially for the production.

SUJET Dokumentarfilm über den 5. Reichsparteitag der NSDAP, der vom 30. August bis 3. September 1933 in Nürnberg stattfindet und der erste Parteitag nach der „Machtergreifung" vom Januar 1933 ist. Der Film enthält weder Kommentar noch Zwischentitel, vielmehr sind die einzelnen Sequenzen durch Originalton – Marschmusik, Reden, Lieder der NSDAP – und eigens komponierte Filmmusik verbunden.

SUJET Documentaire sur le Ve congrès du parti NSDAP qui se tient du 30 août au 3 septembre 1933 à Nuremberg; c'est aussi le premier congrès du parti après la prise de pouvoir en janvier 1933. Le film ne comprend ni commentaire ni intertitres; les différentes séquences sont rattachées les unes aux autres par le biais du son original – musique de marche, discours, chants du NSDAP – et une musique spécialement composée.

1933
SOS Iceberg
SOS Eisberg
SOS Iceberg

SOUND FILM, B/W
103 MINUTES

DIRECTOR Arnold Fanck PRODUCTION COMPANY Deutsche Universal-Film AG Berlin CAMERA Richard Angst, Hans Schneeberger SPECIAL CAMERA/SPECIAL EFFECTS Aerial photographs: Hans Schneeberger; photographs from the plane: Ernst Udet, Franz Schrieck SCREENPLAY Arnold Fanck, Fritz Löwe (uncredited); Ernst Sorge (uncredited), Hans Hinrich EXTERIOR LOCATIONS Greenland, Bernina Pass, Berlin CAST Leni Riefenstahl, Gustav Diessl, Ernst Udet, Gibson Gowland, Sepp Rist, Max Holzboer, Walter Riml, Arthur Grosse, Tommy Thomas; mountain guides: David Zogg, Fritz Steuri, Hans Ertl

SUBJECT The film recounts the dramatic attempts to rescue missing members of an expedition to Greenland. Polar scientists Dr. Carl Lawrence, together with his aviator wife Ellen, are rescued at the last minute from an ice floe, in the most extreme conditions.

SUJET Der Film zeigt die dramatischen Versuche, die Teilnehmer einer Grönland-Expedition, die verschollen sind, zu retten. Zusammen mit seiner Frau Ellen, einer Fliegerin, wird der Polarforscher Dr. Carl Lawrence von den übrigen Expeditionsteilnehmern unter extremsten Bedingungen und in allerletzter Minute auf einem schwimmenden Eisberg geborgen.

SUJET Les membres d'une expédition scientifique au Groenland qui se sont réfugiés sur un iceberg. Le chercheur polaire Dr Carl Lawrence et sa femme Ellen, une pilote dont l'avion s'est écrasé alors qu'elle cherchait à lui venir en aide, sont sauvés in extremis par les autres membres de l'expédition dans des conditions dramatiques.

1935
Triumph of the Will
Triumph des Willens
Le Triomphe de la volonté

SOUND FILM, B/W, 114 MINUTES

DIRECTOR Leni Riefenstahl ASSISTANT DIRECTORS Erna Peters, Guzzi Lantschner, Otto Lantschner, Walter Prager PRODUCTION COMPANIES Reichsparteitag-Film (Leni Riefenstahl Studio-Film, Berlin); NSDAP, Commerce Authority of Party Rally Film EXECUTIVE PRODUCER Leni Riefenstahl CAMERA Sepp Allgeier, Karl Attenberger, Werner Bohne, Walter Frentz, Hans Gottschalk, Werner Hundhausen, Herbert Kebelmann, Albert Kling, Franz Koch, Herbert Kutschbach, Paul Lieberenz, Richard Nickel, Walter Riml, Arthur von Schwertführer, Karl Vaß, Franz Weihmayr, Siegfried Weinmann, Karl Wellert EDIT Leni Riefenstahl SCREENPLAY Leni Riefenstahl RATING politically and artistically significant, didactic AWARD National Film Prize 1934–1935; International Film Festival Venice 1935: Coppa dell'Istituto Nazionale LUCE (best foreign documentary film); Medaille d'or and Grand Prix of France 1937 NOTES After World War II *Triumph of the Will* is rated a "restricted film" and may thus only be shown together with an introduction in film clubs or for scholarly purposes. The director is accused of having significantly increased, by means of this film, the emotional bond of the Germans to Hitler and the National Socialists. *Triumph of the Will* is one of the most-discussed German films of all time. Its montage of images creates an intensity that was unsurpassed in documentary films of the time. Filmmakers have repeatedly borrowed the camera positions that epitomize *Triumph of the Will*, including such Hollywood directors as Paul Verhoeven in *Starship Troopers* (1997) and George Lucas in *Star Wars: Episode I* (1999).

SUBJECT Documentary film on the Sixth National Socialist Party Rally in Nuremberg held from 4 to 10 September 1934, under the slogan "Party Rally of

Unity". Again, the film has no voice-over and the soundtrack consists of the sound from the events combined with original film music.

SUJET Dokumentarfilm über den 6. Reichsparteitag der NSDAP in Nürnberg vom 4. bis 10. September 1934, unter dem Motto „Parteitag der Einheit". Der Film hat keinen Kommentar und besteht aus Originalton und eigens komponierter Filmmusik.

SUJET Film documentaire sur le VIe congrès du parti NSDAP qui se tient du 4 au 10 septembre 1934, à Nuremberg, sous la devise «Congrès de l'Unité». Le film est réalisé sans commentaire, il est constitué sur le plan sonore de sons originaux et d'une musique spécialement écrite pour le film.

1935
Day of Freedom!—Our Armed forces!
Tag der Freiheit! – Unsere Wehrmacht!
Jour de liberté! – Notre Wehrmacht!

SOUND FILM, B/W, 28 MINUTES

DIRECTOR Leni Riefenstahl PRODUCTION COMPANY Reichsparteitag-Film (Leni Riefenstahl Studio-Film, Berlin) EXECUTIVE PRODUCER Leni Riefenstahl CAMERA Willy Zielke, Guzzi Lantschner, Walter Frentz, Hans Ertl, Kurt Neubert, Albert Kling EDIT Leni Riefenstahl RATING artistically and politically significant NOTES The film comes about because the director did not want to include the army drills from the previous year in *Triumph of the Will* since they were filmed during poor weather. But General Walter von Reichenau insisted strongly on the shots because 1934 was the first year in which the army participated in the Party Rally. As a compromise, she proposed that a separate film about the army be shot the following year. The film is distributed as a short "army didactic film".

SUBJECT Documentary film on the army's drills during the Seventh National Socialist Party Rally

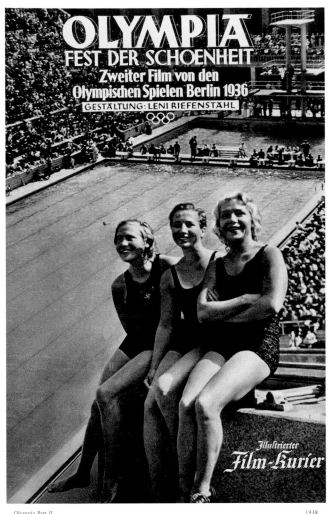

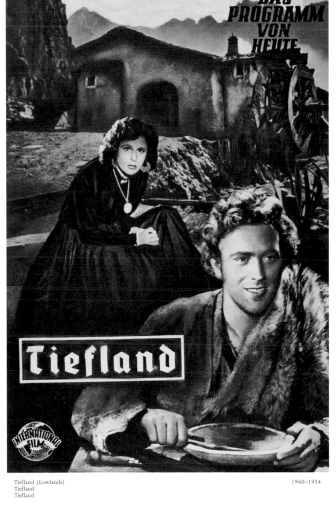

Olympia Part II
Olympia Teil 2
Les Dieux du stade 2ᵉ partie

1938

Tiefland (Lowlands)
Tiefland
Tiefland

1940–1954

that takes place from 10 to 16 September 1935 in Nuremberg. The film contains no commentary but consists of original sound and film music composed especially for it.

SUJET Dokumentarfilm über das Manöver der Wehrmacht während des 7. Reichsparteitags der NSDAP vom 10. bis 16. September 1935 in Nürnberg. Der Film enthält keinen Kommentar und besteht aus Originalton und eigens komponierter Filmmusik.

SUJET Film documentaire sur les manœuvres de la Wehrmacht au VIIᵉ congrès du parti NSDAP qui eut lieu du 10 au 16 septembre 1935 à Nuremberg. Le film est dépourvu de tout commentaire; le montage sonore est réalisé à partir de sons originaux et d'une musique spécialement composée à cet effet.

1938
Olympia Part I—
Festival of the People
Olympia Teil 1 –
Fest der Völker
Les Dieux du stade 1ère partie –
Fête des peuples

SOUND FILM, B/W, 126 MINUTES (version approved by the Voluntary Self-Supervision Board of the German Film Industry: 117 minutes)

Olympia Part II—
Festival of Beauty
Olympia Teil 2 –
Fest der Schönheit
Les Dieux du stade 2ᵉ partie –
Fête de la beauté

SOUND FILM, B/W, 100 MINUTES (version approved by the Voluntary Self-Supervision Board of the German Film Industry: 99 minutes)

DIRECTOR Leni Riefenstahl PRODUCTION COMPANY Olympia-Film GmbH, Berlin PRODUCER Leni

Riefenstahl CAMERA Hans Ertl, Walter Frentz, Guzzi Lantschner, Kurt Neubert, Hans Scheib, Willy Zielke, Leo de Laforgue, among many other cameramen EDIT Leni Riefenstahl, Max Michel, Johannes Lüdke, Arnfried Heyne, Guzzi Lantschner NARRATORS Paul Laven, Rolf Wernicke, Henri Nannen, Johannes Pagels RATING artistically and politically significant, culturally significant, for popular education, didactic film AWARDS National Film Prize 1937–38, International Film Festival Venice 1938: Coppa Mussolini (Best Film), Polar Prize Sweden 1938, Greek Sports Prize 1938; Olympic Gold Medal of the Comité International Olympique 1939; International Film Festival Lausanne 1948: Olympic Diploma NOTES The *Olympia* films are considered unsurpassed in pictorial aesthetic, and even today are counted among the greatest documentary films on sports. In 1956 American directors include the *Olympia* films among the ten best films of all times. Other critics, including Susan Sontag, have found a fascist aesthetic in the films and emphasize that at the time of their production, they helped to convey the image of a peace-loving nation to the outside world.

SUBJECT Documentary film on the 11th Olympic Games, which took place from 1 to 16 August 1936 in Berlin. Leni Riefenstahl had so much visual material that she made the film in two parts, *Festival of the People* (Part I) and *Festival of Beauty* (Part II).

SUJET Dokumentarfilm über die XI. Olympischen Spiele, die vom 1. bis 16. August 1936 in Berlin stattfinden. Auf Grund der Fülle an belichtetem Material gestaltet Leni Riefenstahl zwei Filmteile mit den Titeln: *Fest der Völker* (Teil 1) und *Fest der Schönheit* (Teil 2).

SUJET Il s'agit d'un documentaire sur les XIᵉʳ Jeux olympiques qui se déroulèrent à Berlin du 1ᵉʳ au 16 août 1936. Il y eut une telle quantité de pellicule impressionnée que Leni Riefenstahl divisa le film en deux parties, *Fête des peuples* (1ère partie) et *Fête de la beauté* (2ᵉ partie).

1940 – 1954
Tiefland (Lowlands)
Tiefland
Tiefland

SOUND FILM, B/W, 99 MINUTES

DIRECTOR Leni Riefenstahl PRODUCTION COMPANIES Riefenstahl-Film, Berlin (Tobis Filmkunst, Berlin) (until 1945), Plesner Film PRODUCERS Leni Riefenstahl, Josef Plesner CAMERA Albert Benitz EDIT Leni Riefenstahl SCREENPLAY Leni Riefenstahl, Harald Reinl LITERARY MODEL The play *Terra baixa* (1896) by Eugen d'Albert CAST Leni Riefenstahl, Franz Eichberger, Bernhard Minetti, Aribert Wäscher, Maria Koppenhöfer (Speaker: Til Klockow), Luis Rainer, Frida Richard, Karl Skraup, Max Holzboer, Bekuch Hamid, Charlotte Komp, Hans Lackner

SUBJECT Pedro, a simple shepherd, and his despotic master, Marques Sebastian Roccabruna, both fall in love with a gypsy woman, Martha. Don Sebastian takes Martha as his lover, but when he marries the wealthy Doña Amelia for her money he loses Martha to Pedro, who marries her. But Roccabruna means to keep Martha as a mistress. The resulting duel fought between the two men ends fatally for the Marques.

SUJET Der Schäfer Pedro und sein despotischer Herr Marques Sebastian Roccabruna verlieben sich beide in die Zigeunerin Martha. Don Sebastian macht Martha zu seiner Geliebten, verliert sie aber durch eine Geldheirat mit der reichen Doña Amelia an Pedro, der gleichzeitig Martha heiratet. Weil Roccabruna Martha als Geliebte behalten will, kommt es zum Zweikampf zwischen den beiden Männern, der für den Marques tödlich endet.

SUJET Pedro, un berger naïf, et son seigneur, le despotique marquis Sebastian Roccabruna, sont amoureux de Martha, la bohémienne. Celle-ci devient la maîtresse de Don Sebastian, mais quand il fait un mariage

d'argent avec Doña Amelia, elle épouse Pedro. Roccabruna ne voulant pas renoncer à Martha, les deux hommes se battent en duel et le marquis y perdra la vie.

1992 – 2002
Impressions under Water
Impressionen unter Wasser
Impressions sous-marines

SOUND FILM, 45 MINUTES

DIRECTOR Leni Riefenstahl PRODUCTION COMPANY Leni Riefenstahl-Produktion PRODUCER Leni Riefenstahl CAMERA Horst Kettner EDIT Leni Riefenstahl MUSIC Giorgio Moroder, Daniel Walker

SUBJECT A film about the underwater world in tropical seas. The footage was shot in a variety of diving regions around the world.

SUJET Film über die Unterwasserwelt der tropischen Meere. Die Aufnahmen sind in den verschiedenen Tauchgebieten der Welt entstanden.

SUJET Les fonds sous-marins tropicaux. Le film a été tourné dans les diverses régions de plongée du monde entier.

The script of *The Red Devils*.
Das Script zu *Die roten Teufel*.
Le scénario des *Diables rouges*. 1950–1954

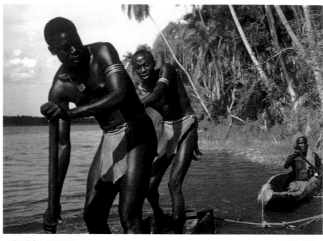

Filmstill from *Black Freight*.
Filmstill *Die schwarze Fracht*.
Photogramme de *La Cargaison nègre*. 1955–1956

Registering the title for the film *Penthesilea* at the Reich film board. 1939
Eintragung des Titels von *Penthesilea* bei der Reichsfilmkammer.
Enregistrement du titre *Penthésilée* à la Chambre cinématographique du Reich.

Unrealized film projects
Nicht realisierte Filmprojekte
Les projets non aboutis

1933
Planned Title:
Mademoiselle Docteur

IDEA Arnold Fanck, Leni Riefenstahl DIRECTOR G. W. Pabst or Frank Wysbar PRODUCTION COMPANY UFA, Karl Ritter's production group SCRIPT Gerhard Menzel CAMERA Hans Schneeberger ACTOR Leni Riefenstahl

SUBJECT The script tells the true story of a spy who works for German defense forces during World War I. The UFA initially accepts the film project but later turns it down because of the spy theme, following a request from the Ministry of Defense. In 1936 Georg Wilhelm Pabst directs *Mademoiselle Docteur* in France with Dita Parlo, using a different script.

SUJET Es handelt sich um die authentische Geschichte einer Spionin, die während der Zeit des Ersten Weltkriegs für die deutsche Abwehr arbeitet. Die UFA nimmt das Projekt zunächst an, doch das Reichswehrministerium verbietet die Herstellung von Spionagefilmen. 1936 verfilmt Pabst *Mademoiselle Docteur* in Frankreich nach einem anderen Drehbuch mit Dita Parlo.

SUJET L'histoire véridique d'une espionne travaillant pour le contre-espionnage allemand pendant la Première Guerre mondiale.
D'abord la UFA accepte le projet, mais le ministère de la Reichswehr interdit les films d'espionnage. En 1936, G. W. Pabst réalise *Mademoiselle Docteur* en France, d'après un autre scénario, avec Dita Parlo dans le rôle principal.

1939
Planned Title:
Penthesilea
Penthesilea
Penthésilée

IDEA/SCRIPT Leni Riefenstahl, based on a play by Heinrich von Kleist DIRECTOR Leni Riefenstahl, Jürgen Fehling PRODUCTION COMPANY Leni Riefenstahl-Film CAMERA Hans Schneeberger, Albert Benitz SETS Robert Herlth, Walter Röhrig MUSIC Herbert Windt CAST Leni Riefenstahl, Maria Koppenhöfer, Elisabeth Flickenschildt, extras for the Amazons SCHEDULED FILMING Fall 1939 EXTERIOR LOCATIONS Libyan desert and either the island of Sylt or the Kurisch Spit

SUBJECT The dialogue would use Kleist's verse. The battle of the sexes is not planned as filmed theater; the lyrical language of Kleist and the stylized images are meant to form a unity.
The director prepares the filming, hires the actors and crew, finds mastiffs and Lipizzan horses for the film, and learns to ride bareback. With the outbreak of the war on 1 September 1939, however, filming is called off and for reasons of cost never resumed.

SUJET Der Film soll in den Versen von Kleist gesprochen werden. Der Kampf der Geschlechter ist nicht als verfilmtes Theater geplant, vielmehr soll die Verssprache von Kleist mit stilisierten Bildvisionen eine Einheit bilden.
Die Regisseurin bereitet die Dreharbeiten vor, engagiert die Schauspieler und den Stab, sucht Lipizzaner und Doggen für den Film und lernt das Reiten ohne Sattel. Doch nach Kriegsausbruch am 1. September 1939 werden die Dreharbeiten abgesagt und aus Kostengründen nicht wieder aufgenommen.

SUJET Le film doit reprendre les vers de Kleist dans le texte. S'il ne s'agit pas de présenter la guerre des sexes sous forme de théâtre filmé, la langue de Kleist et la stylisation des images doivent cependant former une unité.

La réalisatrice prépare le tournage, engage les interprètes et l'équipe technique, sélectionne des chevaux et des dogues et apprend à monter à cru. Mais avec le début de la guerre, le 1ᵉ septembre 1939, le tournage est annulé et, pour des raisons financières, ne sera pas repris.

1943
Planned Title:
Van Gogh

IDEA Leni Riefenstahl

SUBJECT A film about the artist's passion, his genius, and madness. Filming is to be primarily in black-and-white; only the scenes that depict the painting process are to be shot in color. The project is not pursued.

SUJET Ein Film über die Leidenschaft des Künstlers, über Genie und Wahnsinn. Gedreht werden soll vorwiegend in Schwarzweiß, in Farbe allein jene Szenen, in denen die Gemälde entstehen. Das Projekt wird nicht weitergeführt.

SUJET Passion artistique trouvant son expression dans le génie et la folie. Le film doit être tourné essentiellement en noir et blanc; seules seraient en couleurs les scènes dans lesquelles on voit l'artiste en train de peindre. Aucune suite n'est donnée au projet.

1950
Planned Title:
The Dancer of Florence
Der Tänzer von Florenz
Le Danseur de Florence

IDEA Leni Riefenstahl

SUBJECT A homage to the dancer Harald Kreutzberg. No producer can be found for the idea.

SUJET Eine Hommage an den Tänzer Harald Kreutzberg. Für die Idee kann jedoch kein Produzent gefunden werden.

SUJET Hommage au danseur Harald Kreutzberg. Le projet échoue faute de producteur.

1950
Planned Title:
Eternal Peaks
Ewige Gipfel
Cimes éternelles

IDEA Leni Riefenstahl

SUBJECT A documentary film about four historical first climbs of famous mountains throughout the world: Mont Blanc, the north face of the Drei Zinnen, the Eiger, and Mount Everest. No producer can be found for the idea.

SUJET Ein dokumentarischer Film über vier historische Erstbesteigungen von berühmten Berggipfeln der Welt: Montblanc, Nordwand der Drei Zinnen, Eigerwand und Mount Everest. Für die Idee kann kein Produzent gefunden werden.

SUJET Film documentaire sur les quatre premières ascensions historiques de sommets célèbres: le Mont-Blanc, la face nord des Trois Pitons, le mur de l'Eiger et le Mont Everest. Le projet échoue faute de producteur.

1950 – 1954
Planned Title:
The Red Devils
Die roten Teufel
Les Diables rouges

IDEA Leni Riefenstahl SCRIPT Leni Riefenstahl, Harald Reinl, Joachim Bartsch PRODUCTION COMPANIES Capital Pictures (Italy); after Capital's withdrawal in

1952, Minerva Film (Italy) and Herzog-Film (Germany) coproduced with Iris-Film; from 1953 on, Junta-Film CAMERA Bruno Mondi, Walter Frentz, Guzzi Lantschner, Otto Lantschner CAST Vittorio De Sica, Brigitte Bardot, Jean Marais, male and female skiers

SUBJECT The skiing film "The Red Devils" is a variation on the Penthesilea theme and is planned as a color film. The climax of the film is to be a "fox hunt" with skiers in red and blue outfits, making a sharp color contrast with the snow-covered slopes and mountains. The film falls through for lack of financing.

SUJET Der Skifilm „Die roten Teufel" variiert das Penthesilea-Thema und ist als Farbfilm geplant. Höhepunkt des Films soll eine Verfolgungsjagd mit Skiläufern in roten und blauen Anzügen werden, die einen starken Farbkontrast zu den verschneiten Hängen und Bergen bilden. Schließlich scheitert „Die roten Teufel" an der Finanzierung.

SUJET Ce film de ski, variation sur le thème de Penthésilée, doit être tourné en couleur. L'action doit culminer dans une course effrénée à laquelle participent des skieurs vêtus de combinaisons rouges ou bleues, qui contrastent fortement avec les montagnes et les pentes enneigées. Le projet échoue pour des raisons financières.

1955
Planned Title:
Cobalt 60
Kobalt 60

IDEA Leni Riefenstahl

SUBJECT A documentary and feature film on the destructive potential of nuclear power. No producer can be found for the idea.

SUJET Ein Dokumentar- und Spielfilm über die zerstörerische Macht der Atomkraft. Für die Idee kann kein Produzent gefunden werden.

SUJET Docudrame sur le pouvoir destructeur de l'énergie atomique. Le projet échoue faute de producteur.

1955
Planned Title:
Frederick the Great and Voltaire
Friedrich der Große und Voltaire
Frédéric II et Voltaire

IDEA Jean Cocteau SCRIPT Leni Riefenstahl, Herrmann Mostar CAST Jean Cocteau

SUBJECT A black-and-white film intended to dramatize the relationship of the king and the philosopher—and the love-hate relationship of the Germans and French. Jean Cocteau plans to play both roles. No producer can be found for the idea.

SUJET Der Schwarzweißfilm soll die Beziehung zwischen dem König und dem Philosophen – und damit das schwierige deutsch-französische Verhältnis – thematisieren. Jean Cocteau plant, beide Hauptrollen zu übernehmen; als sie ihn in seinem Haus in Cap Ferrat an der Côte d'Azur besucht, spielt er ihr die Rollen vor. Für die Idee kann kein Produzent gefunden werden.

SUJET Ce film en noir en blanc doit dépeindre les rapports entre le monarque et le philosophe et ainsi les liens mitigés entre la France et l'Allemagne. Jean Cocteau envisage de jouer les deux rôles principaux; lorsque Leni Riefenstahl lui rend visite dans sa maison de Cap Ferrat, sur la Côte d'Azur, il lui donne un aperçu de son interprétation. Le projet échoue faute de producteur.

1955
Planned Title:
Three Stars on the Cloak of the Madonna
Drei Sterne am Mantel der Madonna
Trois étoiles sur le manteau de la Vierge

IDEA Leni Riefenstahl SCRIPT Leni Riefenstahl, Margarete E. Hohoff ACTOR Anna Magnani

SUBJECT A woman loses her husband and her three sons. She endures her fate thanks to the strength of her faith. No producer can be found for the idea.

SUJET Eine Frau verliert ihren Mann und ihre drei Söhne. Sie erträgt ihr Schicksal durch die Kraft ihres Glaubens. Für die Idee kann kein Produzent gefunden werden.

SUJET Une femme perd son mari et ses trois fils. Seule la foi lui permet de supporter le poids du destin. Le projet échoue faute de producteur.

1955
Planned Title:
The Bull Fight of Monsieur Chatalon / Dance with Death
Der Stierkampf des Monsieur Chatalon / Tanz mit dem Tod
La corrida de Monsieur Chatalon / Danse avec la mort

IDEA/SCRIPT Leni Riefenstahl, Herrmann Mostar PRODUCTION COMPANY Cea (Spain)

SUBJECT Stories concerning bullfighting in Spain. No producer can be found for the idea.

SUJET Geschichten über und um den spanischen Stierkampf. Für die Idee kann kein Produzent gefunden werden.

SUJET Histoires de corridas en Espagne. Le projet échoue faute de producteur.

1955
Planned Title:
Sol y Sombra (Sun and Shadow)
Sol y Sombra (Sonne und Schatten)
Sol y Sombra (ombre et soleil)

IDEA/SCRIPT Leni Riefenstahl PRODUCTION COMPANY Cea (Spain)

SUBJECT Documentary film on the religious, geographic and architectural variety of Spain. Cea withdraws from the project.

SUJET Dokumentarfilm über die religiöse, geografische und architektonische Vielfalt Spaniens. Die Produktionsfirma zieht sich aus dem Projekt zurück.

SUJET Film documentaire sur les contradictions religieuses, géographiques et architecturales en Espagne. La société de production espagnole se retire du projet.

1955 – 1956
Planned Title:
Black Freight
Die schwarze Fracht
La Cargaison nègre

IDEA Leni Riefenstahl, based on a work by Hans Otto Meissner SCRIPT Leni Riefenstahl, Helge Pawlinin, Kurt Heuser DIRECTOR Leni Riefenstahl PRODUCTION COMPANY Stern-Film with Lawrence-Brown Safaris, Nairobi CAMERA Heinz Hölschner, R. von Theumer CAST Leni Riefenstahl, extras from the Jalau tribe, Arab extras SCHEDULED FILMING Early September to late November 1956 EXTERIOR LOCATIONS Kenya, Queen Elizabeth National Park in Uganda

SUBJECT A scientist is searching for her lost husband in Africa and becomes caught up in the modern slave trade.
The Suez crisis delays the shooting because the ship carrying the equipment has to round the cape, resulting in several weeks' delay. For financial reasons the project is halted and cannot be continued as no backers can be found.

SUJET Eine Wissenschaftlerin sucht ihren in Afrika verschollenen Mann und wird in den modernen Sklavenhandel verwickelt.
Durch die Suezkrise verschiebt sich der Drehbeginn, da das Schiff, mit dem die Filmausrüstung transportiert wird, den Umweg über Südafrika nehmen muss und mit mehreren Wochen Verspätung eintrifft. Aus finanziellen Gründen wird das Projekt zunächst abgebrochen und wird später mangels Partner nicht fortgesetzt.

SUJET Une scientifique recherche son mari disparu en Afrique et se retrouve mêlée à la traite moderne des esclaves.
En raison de la crise de Suez, le début du tournage est reporté, car le bateau qui achemine tout l'équipement technique doit faire un détour par l'Afrique du Sud et n'arrive à bon port qu'avec plusieurs semaines de retard. Pour des raisons financières, le projet «La Cargaison nègre» est annulé et ne pourra être poursuivi, faute de partenaires.

1957
Planned Title:
African Symphony
Afrikanische Symphonie
Symphonie africaine

IDEA Leni Riefenstahl SCRIPT Leni Riefenstahl, Helge Pawlinin

SUBJECT A look at Africa from four different perspectives: from the realistic perspective of a reporter, the surrealistic-romantic view of an artist, the adventurous tale of a hunter and the ethnological enquiry of the scientist. No producer can be found for the idea.

SUJET Afrika wird aus vier verschiedenen Blickwinkeln gesehen: aus dem realistischen des Reporters, dem surrealistisch-romantischen des Künstlers, dem abenteuerlichen des Jägers und dem ethnologischen des Wissenschaftlers. Für die Idee kann kein Produzent gefunden werden.

SUJET L'Afrique vue sous quatre angles différents: le réalisme du reporter, le romantisme de l'artiste, la soif d'aventure du chasseur et le point de vue ethnologique du scientifique. Le projet échoue faute de producteur.

1959 – 1960
Planned Title:
The Blue Light
Das blaue Licht
La Lumière bleue

SCRIPT initially W. Somerset Maugham; from 1960 on L. Ron Hubbard, Philip Hudsmith based on the original script by Leni Riefenstahl and Béla Balázs DIRECTOR Leni Riefenstahl PRODUCTION COMPANY Adventure Film Ltd., London

SUBJECT The remake of *The Blue Light* is planned as a dance film in color, in the style of *The Red Shoes* (1948). The new 70-mm wide-screen technique is to be used in this film. Adventure Film withdraws from the project.

SUJET Das Remake von *Das blaue Licht* ist als Tanzfilm in Farbe und im Stil von *Die roten Schuhe* (1948) von Michael Powell und Emeric Pressburger geplant. Das neue aufwändige Super-Technirama-70-Verfahren soll zum Einsatz kommen. Die Produktionsfirma zieht sich aus dem Projekt zurück.

SUJET Le remake de *La Lumière bleue* se conçoit comme un film de danse en couleur, dans le style des *Souliers rouges* (1948). Il est prévu de recourir au nouveau procédé du Technirama en 70 mm. La société de production se retire du projet.

1961
Planned Title:
The Nile
Der Nil
Le Nil

DIRECTOR Leni Riefenstahl PRODUCTION COMPANY Kondo-Film

SUBJECT Together with her partners in the Kondo-Film company—the Berlin-based Japanese film enthusiasts Michi, Yoshi, and Yasu Kondo—she plans a documentary that will depict the life and customs of the various native peoples on the banks of the Nile.
With the building of the Berlin Wall on 13 August 1961, the Kondo brothers return to Tokyo, Kondo-Film is dissolved, and the film project falls through.

SUJET Gemeinsam mit den Mitinhabern ihrer Kondo-Film GmbH, den in Berlin lebenden japanischen Filmenthusiasten Michi, Joshi und Yasu Kondo, plant sie einen Dokumentarfilm, der das Leben und die Sitten der verschiedenen Naturvölker sowie die historisch bedeutenden Ereignisse an den Ufern des Nils schildert.
Nach dem Mauerbau am 13. August 1961 kehren die Brüder Kondo nach Tokio zurück, die Kondo-Film GmbH wird aufgelöst und das Projekt scheitert.

SUJET Un film documentaire sur la vie et les coutumes des différentes populations vivant sur les bords du Nil et les événements historiques qui s'y sont produits. Elle projette le film en commun avec les actionnaires de sa société Kondo-Film GmbH, Michi, Joshi et Yasu Kondo, trois Japonais passionnés de cinéma et vivant à Berlin.
Après la construction du Mur de Berlin le 13 août 1961, les frères Kondo décident de retourner à Tokyo; la société Kondo-Film doit être dissoute et le projet échoue.

1962 – 1963
Planned Title:
African Diary
Afrikanisches Tagebuch
Journal africain

DIRECTOR Leni Riefenstahl

SUBJECT She plans a small documentary film, to be made during a scientific expedition led by the German Nansen Society to the Nuer tribe in the southern Sudan. She takes part in the expedition to the Nuba village of Tadoro, but later the Nansen Society leaves her, and she travels on alone.

SUJET Während der wissenschaftlichen Expedition der Deutschen Nansen-Gesellschaft zum Stamm der Nuer im Südsudan soll ein kleiner Dokumentarfilm entstehen. Die Expedition reist zunächst zu den Nuba nach Tadoro, doch im Anschluss trennt sich die Gruppe von Leni Riefenstahl.

SUJET Un petit film documentaire doit être réalisé au cours de l'expédition scientifique de la société allemande Nansen chez les Nouer du Sud-Soudan. Elle participe à l'expédition, mais après un séjour au [...] Nouba de Tadoro, la [...] l'abandonne et elle continue seule.

1964 – 1975
Planned Title:
Alone among the Nuba
Allein unter den Nuba
Seule parmi les Nouba

IDEA Leni Riefenstahl PRODUCTION COMPANY Odyssey Productions (USA) and Leni Riefenstahl-Film CAMERA Gerhard Fromm; from 1968 on Horst Kettner and Leni Riefenstahl

SUBJECT Documentary film on the life of the Nuba. During the winter of 1964–1965 in Tadoro, Leni Riefenstahl films the wrestling matches, ritual acts, dances, and daily life of the Nuba.
The new, highly light-sensitive ER film is destroyed in processing. Odyssey Productions then withdraws from the project, which is put off for the time being. During later expeditions in 1968–1969, 1974, and 1975, she films again in the Nuba villages of Tadoro and Kau but never completes the final edit.

SUJET Dokumentarfilm über das Leben der Nuba. Im Winter 1964–1965 werden in Tadoro die Ringkämpfe der Nuba, die kultischen Handlungen, die Tänze und das Alltagsleben gefilmt.
Das neue, besonders lichtempfindliche ER-Material verdirbt bei der Entwicklung. Die Odyssey Productions zieht sich daraufhin aus dem Projekt zurück, das zunächst eingestellt wird. Bei ihren späteren Expeditionen 1968–1969, 1974 und 1975 filmt sie wieder in den Nuba-Dörfern Tadoro und Kau, doch sie schneidet den Film nie fertig.

SUJET Film documentaire sur la vie des Nouba. Leni Riefenstahl filme pendant l'hiver 1964–1965, à Tadoro, les luttes des Nouba, les danses et la vie quotidienne.
Le nouveau matériau ER est endommagé lors du développement. La société Odyssey Productions se retire du projet qui est d'abord annulé. Lors d'expéditions ultérieures en 1968–1969, en 1974 et en 1975, elle filme à nouveau les villages nouba de Tadoro et Kau, mais ne montera jamais le film jusqu'au bout.

Kampf in Schnee und Eis 1933

Olympia
Schönheit im olympischen Kampf 1937

The Last of the Nuba 1973
Die Nuba – Menschen wie von einem anderen Stern
Les Nouba – des hommes d'une autre planète

Coral Gardens 1978
Korallengärten
Jardins de corail

Leni Riefenstahl's Africa 1982
Mein Afrika
L'Afrique de Leni Riefenstahl

The Sieve of Time: 1987
the Memoirs of Leni Riefenstahl
Memoiren
Mémoires

Wonders Under Water 1990
Wunder unter Wasser

Books by Leni Riefenstahl
Bücher von Leni Riefenstahl
Livres de Leni Riefenstahl

Riefenstahl, Leni:
KAMPF IN SCHNEE UND EIS,
Hesse & Becker, Leipzig 1933.

Riefenstahl, Leni:
HINTER DEN KULISSEN DES REICHSPARTEITAGS-
FILMS
Franz Eher Nachfolge Verlag, München 1935.

Riefenstahl, Leni:
SCHÖNHEIT IM OLYMPISCHEN KAMPF
Mit einem Vorwort von Leni Riefenstahl, Dokumen-
tation zum Olympia-Film mit zahlreichen Aufnahmen
von den Olympischen Spielen 1936, Textunter-
schriften in Deutsch, Französisch, Englisch, Spanisch
und Italienisch, Originalausgabe im Deutschen Verlag
(Ullstein-Verlag), Berlin 1937. Neuausgabe mit
einem Geleitwort von Monique Berlioux, Direktor
des Internationalen Olympischen Komitees, und
einer Einführung von Kevin Brownlow, Film-
historiker und Filmemacher, Mahnert-Lueg Verlag,
München 1988.
English edition:
OLYMPIA
Documentation for the Olympia film with numerous
photographs of the Olympic Games 1936, foreword
by Monique Berlioux; introduction by Kevin Brown-
low, Quartet Books, London 1994.
OLYMPIA
Documentation for the Olympia film with numerous
photographs of the Olympic Games 1936, foreword
by Monique Berlioux; introduction by Kevin Brown-
low, St. Martin's Press, New York 1994.

Riefenstahl, Leni:
DIE NUBA – MENSCHEN WIE VON EINEM
ANDEREN STERN
Paul List Verlag, München 1973, [2]1977. Ungekürzte Neuausgabe als Taschenbuch im Deutschen
Taschen Verlag, München 1982; ungekürzte Neu-

ausgabe als Taschenbuch beim Ullstein Verlag,
Frankfurt/Main, Berlin, Wien 1990.
English edition:
THE LAST OF THE NUBA
Harper & Row, New York 1974. New edition
by St. Martin's Press, New York 1995.
THE LAST OF THE NUBA
Collins, London 1976, [2]1986.
Édition française:
LES NOUBA – DES HOMMES D'UNE AUTRE
PLANÈTE
Traduit par Laurent Dispot, Chêne, Paris 1976.
Edición española:
LOS NUBA – HOMBRES COMO DE OTRO MUNDO
Lumen, Barcelona 1978.
Edició catalana:
ELS NUBA – HOMES D'UN ALTRE MÓN
Lumen, Barcelona 1978.
Edizione italiana:
I NUBA
Traduzione di Lia Volpatti, A. Mondadori,
Milano 1978.
Japanese edition:
NUBA
Parco View Series, Parco Publishing Press, Tokyo
1980 & 1981. Paperback edition: Shincho-sha Press,
Tokyo 1986.

Riefenstahl, Leni:
DIE NUBA VON KAU
Fotos, Text und Layout von Leni Riefenstahl, Paul
List Verlag, München 1976. Ungekürzte Neuaus-
gabe als Taschenbuch im Deutschen Taschen Verlag,
München 1982; ungekürzte Neuausgabe als Taschen-
buch beim Ullstein Verlag, Frankfurt/Main, Berlin,
Wien 1991.
English edition:
THE PEOPLE OF KAU
Photographs, text and layout by Leni Riefenstahl,
translated from the German by J. Maxwell Brown-
john, Collins, London 1976.
THE PEOPLE OF KAU
Photographs, text and layout by Leni Riefenstahl,
translated from the German by J. Maxwell Brown-

john, Harper & Row, New York 1976. New edition
by St. Martin's Press, New York 1997.
Édition française:
LES NOUBA DE KAU
Texte et photographies de Leni Riefenstahl, traduit
par Laurent Dispot, Chêne, Paris 1976, [2]1997.
Edizione italiana:
GENTE DI KAU
Fotografie, layout e testo di Leni Riefenstahl, tradu-
zione di Lia Volpatti, A. Mondadori, Milano 1977.
Edición española:
LOS NUBA DE KAU
Fotografías, texto y maquetas de Leni Riefenstahl,
Lumen, Barcelona 1978.
Edició catalana:
ELS NUBA DE KAU
Fotografies, text i maquetes de Leni Riefenstahl,
Lumen, Barcelona 1978.

Riefenstahl, Leni:
DIE NUBA
Gemeinschaftsausgabe von „Die Nuba – Menschen
wie von einem anderen Stern" und „Die Nuba von
Kau", Komet, Frechen 2000.

Riefenstahl, Leni:
KORALLENGÄRTEN
Fotos, Text und Layout von Leni Riefenstahl, Paul
List Verlag, München 1978. Ungekürzte Neuausgabe
als Taschenbuch im Deutschen Taschen Verlag, Mün-
chen 1982. Ungekürzte Neuausgabe als Taschenbuch
beim Ullstein Verlag, Frankfurt/Main, Berlin 1991.
English edition:
CORAL GARDENS
Photos, text and layout by Leni Riefenstahl, translated
by Elizabeth Walter, Collins, London 1978.
CORAL GARDENS
Photos, text and layout by Leni Riefenstahl, trans-
lated by Elizabeth Walter, Harper & Row, New
York 1978.
Édition française:
JARDINS DE CORAIL
Texte et photographies de Leni Riefenstahl, traduit
par Geneviève Dispout, Chêne, Paris 1978.

Edizione italiana:
GIARDINI DI CORALLO
Traduzione di Francesco Maria Bernardi, A. Monda-
dori, Milano 1979.

Riefenstahl, Leni:
MEIN AFRIKA
Fotos, Text und Layout von Leni Riefenstahl, Paul
List Verlag, München 1982.
English edition:
LENI RIEFENSTAHL'S AFRICA
Photographs, text and layout by Leni Riefenstahl,
translated by Kathrine Talbot, Collins, London 1982.
VANISHING AFRICA
Photographs, text and layout by Leni Riefenstahl,
translated by Kathrine Talbot, Harmony Books,
New York 1982.
Édition française:
L'AFRIQUE DE LENI RIEFENSTAHL
Texte et photographies de Leni Riefenstahl, traduit
par Louise Dupont, Herscher, Paris 1982.
Edizione italiana:
LA MIA AFRICA
Foto, testo e layout di Leni Riefenstahl, traduzione
di Fernando Solina, Mondadori, Milano 1983.

Riefenstahl, Leni:
MEMOIREN
Albert Knaus Verlag, München, Hamburg 1987.
Neuauflage in 2 Bänden, Herbig, München 1997;
für das Taschenbuch neu eingerichtete Ausgabe beim
Ullstein Verlag, Bd. I (1902–1945) Frankfurt/Main,
Berlin 1990, [2]1994, [3]1996 und Bd. II (1945–1987),
Frankfurt/Main, Berlin 1992, [2]1995. Neuausgabe
in einem Band bei TASCHEN, Köln 2000.
Edición española:
MEMORIAS
Prólogo de Román Gubern, traducción de Juan
Godó Costa, Lumen, Barcelona 1991. Nueva edición:
TASCHEN, Colonia 2000.
Japanese edition:
MEMOIREN – THE GREATEST MEMOIR IN THE
20TH CENTURY
Bungei Shunju Press, Tokyo 1991, [2]1995.

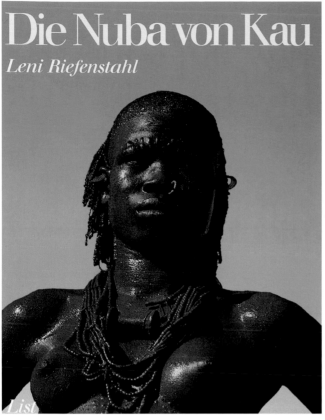

The People of Kau 1976
Die Nuba von Kau
Les Nouba de Kau

Leni Riefenstahl. Five Lives 2000
Leni Riefenstahl. Fünf Leben
Leni Riefenstahl. Cinq Vies

English edition:
THE SIEVE OF TIME: THE MEMOIRS OF LENI
RIEFENSTAHL. Quartet Books, London 1992.
LENI RIEFENSTAHL. A MEMOIR
St. Martin's Press, New York 1993. Paperback
edition: Picador, New York 1995.
Edizione italiana:
STRETTA NEL TEMPO: STORIA DELLA MIA VITA
Altri Autori: Valtolina, Amelia, Bompiani, Milano
1995.
Finnish edition:
LENI RIEFENSTAHL
Editor Ritta Raatikainen, Viktor Barsokevitsch-senra,
Kuopio 1996.
Édition française:
MÉMOIRES
Traduction de l'allemand et postface par Laurent
Dispot, Grasset, Paris 1997.
Greek edition:
MEMOIRS
Terzo Books, Athens 1997.

Riefenstahl, Leni:
WUNDER UNTER WASSER
Herbig Verlag, München 1990.
English edition:
WONDERS UNDER WATER
Quartet Books, London 1991.

**Selected articles, scripts, and inter-
views by and with Leni Riefenstahl**
Ausgewählte Artikel, Drehberichte und
Interviews mit und von Leni Riefenstahl
Sélection d'articles, de rapports de
tournage et d'interviews avec et de
Leni Riefenstahl

Riefenstahl, Leni:
DIE WEISSE ARENA, Filmkurier, 17. Februar 1928.

Riefenstahl, Leni:
MAN FRIERT SICH DURCH, Die Filmwoche,
Nr. 44, 30. Oktober 1929.

Riefenstahl, Leni:
DREHBERICHT VOM FILM „DIE WEISSE HÖLLE
VOM PIZ PALÜ", Die Filmwoche, Nr. 44,
30. Oktober 1929.

Riefenstahl, Leni:
5 MONATE IN DER „HÖLLE", Mein Film,
Nr. 207, Wien 1929.

Ohne Autor:
FILMARBEIT WIE NOCH NIE –
EIN GESPRÄCH MIT LENI RIEFENSTAHL
(über „Sieg des Glaubens"), Mein Film,
Nr. 238, Wien 1932.

Riefenstahl, Leni:
WIE ICH SEPP RIST ENTDECKTE, 8 Uhr Blatt
Nürnberg, 16. Juni 1933.

Alice:
JUNG SEIN UND SCHÖN BLEIBEN. Plaudereien
mit Filmkünstlern: Leni Riefenstahl, Filmwelt,
Nr. 35, 27. August 1933.

Ohne Autor:
FILMKAMERAS AUF DEM REICHSPARTEITAG.
Eine Unterredung mit Leni Riefenstahl, Völkischer
Beobachter, Sondernummer 1934, 6. September
1934.

Riefenstahl, Leni:
„TRIUMPH DES WILLENS". Wie wir den Reichs-
parteitag drehten, Die Woche, 13. Oktober 1934.

Ohne Autor:
WIE DER REICHSPARTEITAGSFILM ENTSTEHT.
„Noch nie in der Welt hat sich ein Staat derart für
einen Film eingesetzt", Magdeburger Tageszeitung,
13. Januar 1935.

von Wehenalp:
LENI RIEFENSTAHL ÜBER DEN
REICHSPARTEITAGSFILM, Der Angriff,
26. März 1935.

Riefenstahl, Leni:
WIE DER NEUE WEHRMACHTSFILM ENTSTAND,
Filmwoche, Nr. 52, 29. Dezember 1935.

Ohne Autor:
LENI RIEFENSTAHL ÜBER IHREN FILM („Triumph
des Willens"), Film Journal, 14/1935.

Riefenstahl, Leni:
KRAFT UND SCHÖNHEIT DER JUGEND MÖGEN
FILMISCHE FORM GEFUNDEN HABEN, Filmkurier,
31. Dezember 1937.

Riefenstahl, Leni:
SCHÖNHEIT UND KAMPF IN HERRLICHSTER
HARMONIE, Licht-Bild-Bühne, 13. April 1938.

Riefenstahl, Leni:
DER OLYMPIA-FILM, Filmwoche, Nr. 16, 15. April
1938.

Ohne Autor:
GESPRÄCH MIT LENI RIEFENSTAHL. So entstand
„Das Blaue Licht", Filmkurier, 24. September
1938.

Riefenstahl, Leni:
NOTIZEN ZU PENTHESILEA (1939), Filmkritik XVI,
1. August 1972, S. 416–425.

Riefenstahl, Leni:
ÜBER WESEN UND GESTALTUNG DES DOKU-
MENTARISCHEN FILMS, Der deutsche Film,
Zeitschrift für Filmkunst und Filmwissenschaft,
Berlin, Sonderausgabe, 1940/1941.

Ohne Autor:
„TIEFLAND" – ENDLICH AM START. Ein Interview
mit Leni Riefenstahl, Aktuelle Film-Nachrichten,
5. Jg., Nr. 2, 20. Januar 1954.

Delahaye, Michel:
LENI ET LE LOUP, Cahiers du Cinéma, n° 170,
Septembre 1965, pp. 42–63.

English edition:
INTERVIEW WITH LENI RIEFENSTAHL,
Sarris, Andrew: Interview with Film Directors,
Avon, New York 1967, pp. 386–402.

Riefenstahl, Leni:
ZÄRTLICH SIND DIE SCHWARZEN RIESEN,
stern 51/1969, S. 84–98.

Flot, Y.:
BRÈVE RENCONTRE AVEC LENI RIEFENSTAHL
(Interview), Écran (Fr), 9 Novembre 1972,
pp. 28–30.

Riefenstahl, Leni:
THE GAMES THAT SURVIVED,
Sunday Times Magazine,
1 October 1972.

Weigel, Herman:
INTERVIEW MIT LENI RIEFENSTAHL,
Filmkritik 8/1972.

Hitchen, Gordon:
LENI RIEFENSTAHL INTERVIEWED OCTOBER
11TH, 1971, Film Culture (US), 56–57,
Spring 1973, pp. 94–121.

Riefenstahl, Leni:
SO STILL WAR WEIHNACHTEN NOCH NIE,
Bunte 1/1975, S. 64–69.

Riefenstahl, Leni:
„NIE ANTISEMITIN GEWESEN", Der Spiegel
11/1976.

Riefenstahl, Leni:
BERICHT ÜBER DAS „ABENTEUER KAU",
Foto Magazin 08/1976.

Riefenstahl, Leni:
LA VIE SECRÈTE DES NOUBA,
Photo n° 110, Novembre 1976,
pp. 48–69.

Riefenstahl, Leni:
DIE NUBA VON KAU. Bildbericht über den zweiten
Aufenthalt der Fotografin im Sudan. Europäische
Bildungsgemeinschaft, Stuttgart 1976.

Riefenstahl, Leni:
MEIN PARADIES AFRIKA. In: Grzimek, B./Messner
R./Riefenstahl, L./Tichy. H.: Paradiese, Saphir,
München 1978.
English edition:
MY PARADISE, AFRICA. In: Grzimek, B./Messner
R./Riefenstahl, L./Tichy. H.: Visions of Paradise,
Hodder & Stoughton, London 1981.

Schreiber, Hermann:
IM GESPRÄCH MIT LENI RIEFENSTAHL. In: Schrei-
ber, Hermann: Lebensläufe. Hermann Schreiber im
Gespräch mit Joseph Beuys, Julius Hackethal, Ernst
Herhaus, Manfred Krug, Hans Küng, Loriot, John
Neumeier, Leni Riefenstahl, Ullstein Verlag, Frank-
furt am Main, Berlin, Wien 1980.

Riefenstahl, Leni:
BERICHT ÜBER DAS SCHAFFEN LENI RIEFENSTAHLS
IN AFRIKA, Westermanns Monatshefte, Oktober 1982.

Riefenstahl, Leni:
AFTER A HALF-CENTURY, Leni Riefenstahl
confronts the US army report that exonerated
her of War Crimes, Film Culture (US), 79,
Winter 1996, pp. 27–34.

Riefenstahl, Leni:
„MIR KAM NICHTS OBSKUR VOR", Die Woche,
22. August 1997, S. 38.

Riefenstahl, Leni:
„REALITÄT HAT MICH NIE INTERESSIERT". Über
ihre Filme, ihr Schönheitsideal, ihre NS Verstri-
ckungen und Hitlers Wirkung auf die Menschen,
Der Spiegel, Jg. 51, Heft 34/1997, S. 202–205.

Riefenstahl, Leni:
MEINE NUBA, „Mein Photo des Jahrhunderts":
Leni Riefenstahl über den Stamm im Sudan, der
ihr Leben veränderte, Zeitmagazin, 23. April
1998.

Millot, Lorraine:
CROIX GOMMÉE. Leni Riefenstahl, 97 ans, cinéaste
allemande, Libération, 5 janvier 2000.

Tremper, Celia und Groenewoud, André:
MIT 99 IST NOCH LANGE NICHT SCHLUSS, Bunte,
Nr. 35, 2001.

Hoffmann, Hilmar:
„ZUM 100. MEIN NEUER FILM" (I), „ICH WÄRE
EINE GUTE SOZIALDEMOKRATIN GEWORDEN" –
„DAS MÜSSEN SIE ERKLÄREN" (II und III), Die
Welt, 7. Januar 2002.

Fritz, Herbert und Linnartz, Mareen:
„ICH BIN SEHR MÜDE". Leni Riefenstahl über
ein Leben im Schatten Hitlers, ihren ersten Film
seit 60 Jahren und die Sehnsucht nach dem Tod,
Magazin der Frankfurter Rundschau, Nr. 17,
27. April 2002, S. 4–5.

Selected books on Leni Riefenstahl
Ausgewählte Bücher über Leni
Riefenstahl
Sélection de livres sur Leni Riefenstahl

Kreimeier, Klaus:
FANCK – TRENKER – RIEFENSTAHL: DER
DEUTSCHE BERGFILM UND SEINE FOLGEN
Stiftung Deutsche Kinemathek, Berlin 1972.

Barsam, Richard M.:
FILM GUIDE TO TRIUMPH OF THE WILL
Series: Indiana University Press Film Guide Series,
Indiana University Press, Bloomington 1975.

Wallace, Peggy Ann:
A HISTORICAL STUDY OF THE CAREER OF LENI
RIEFENSTAHL FROM 1923 TO 1933
Berkeley 1975.

Infield, Glenn B.:
LENI RIEFENSTAHL. THE FALLEN FILM GODDESS
Thomas Y. Crowell, New York 1976.
Édition française:
LENI RIEFENSTAHL ET LE TROISIÈME REICH
Traduit de l'americain par Véronique Chauveau,
Seuil, Paris 1978.
Japanese edition:
BETWEEN THE ART AND THE POLITICS
Libro Port Press, Tokyo 1981.

Ford, Charles:
LENI RIEFENSTAHL
Series: Filmmaker no. 29, La Table Ronde, Paris
1978.
Deutsche Ausgabe:
LENI RIEFENSTAHL – SCHAUSPIELERIN,
REGISSEURIN UND FOTOGRAFIN
Übersetzt von Antoinette Gittinger, Heyne,
München 1982.

Hinton, David B.:
THE FILMS OF LENI RIEFENSTAHL
The Scarecrow Press, Metuchen (NJ), London
1978, [2]1991, [3]2000.

Berg-Pan, Renata:
LENI RIEFENSTAHL
Twayne, Boston 1980.

Loiperdinger, Martin:
„TRIUMPH DES WILLENS" – EINSTELLUNGS-
PROTOKOLL DES FILMS VON LENI RIEFENSTAHL
Filmland-Presse, München 1980.

Graham, Cooper C.:
A HISTORICAL AND AESTHETIC ANALYSIS OF
LENI RIEFENSTAHL'S „OLYMPIA"
Ann Arbor University Microfilms International,
Michigan 1984.

Quaresima, Leonardo:
LENI RIEFENSTAHL
La Nuova Italia, Firenze 1984.

Culbert, David:
LENI RIEFENSTAHL'S TRIUMPH OF THE WILL
Series: Research collections in the social history
of communications, University Publications of
America, Frederick, MD 1986.

Graham, Cooper C.:
LENI RIEFENSTAHL AND OLYMPIA
Based in part on the author's thesis. New York
University, Series: Filmmakers no. 13, The Scare-
crow Press, Metuchen (NJ.), London 1986.

Loiperdinger, Martin:
RITUALE DER MOBILMACHUNG – DER PARTEI-
TAGSFILM „TRIUMPH DES WILLENS" VON LENI
RIEFENSTAHL
Leske und Budrich, Opladen 1987.

Smith, David Calvert:
TRIUMPH OF THE WILL: A FILM BY LENI
RIEFENSTAHL
Original shooting script never before released, as
written by Leni Riefenstahl herself, scene by scene
shot list (366 scenes), selected still picture repro-
ductions of unpublished scenes from the film
(80 pictures), translated from the original shooting
script in German, Series: Chronicle film script
series, Celluloid Chronicles Press, Richardson,
Texas 1990.

Yamazaki, Yoko:
WOMEN WHO BECAME "THE LEGEND"
Kodan-sha press, Tokyo 1990 & 1994.

Aas, Nils Klevjer:
FASCISMENS FASCINASJON – ET DIDAKTISK
DILEMMA: LENI RIEFENSTAHLS „VILJENS TRIUMF"
SOM KILDEMATERIALE OG PÅVIRKNINGSKILDE
Statens filmsentral, Oslo 1991.

Ishioka, Eiko:
LENI RIEFENSTAHL – LIFE
Photographer Leni Riefenstahl, producer and art
director Eiko Ishioka, text in Japanese, Kyuryudo
Art Pub. Co., Tokyo 1991.

Hoffmann, Hilmar:
MYTHOS OLYMPIA.
Autonomie und Unterwerfung von Sport und
Kultur: Hitlers Olympiade, olympische Kultur
und Riefenstahls Olympia-Film, Aufbau Verlag,
Berlin 1993.

Vernet, Sandrine/Gerke, Klaus:
LENI RIEFENSTAHL. LE POUVOIR DES IMAGES
Dossier réuni par Sandrine Vernet & Klaus Gerke,
Forme écrite d'une discussion avec Hilmar Hoff-
mann, Erwin Leiser, Bernhard Eisenschitz, Hans-
Peter Kochenrath, Frieda Grafe, Francis Courtade
sous la direction de Frédéric Mitterrand, ZDF/Arte
de 1993, K. films éd, Paris 1995.

Bignardi, Irene/Borghese,
Alessandra/Falzone Del Barbarò:
LENI RIEFENSTAHL. IL RITMO DI UNO SGUARDO,
(Milano, Palazzo della Ragione; 10 luglio – 6 otto-
bre 1996), Leonardo Arte Milano, Milano 1996.
English version:
LENI RIEFENSTAHL
Art Books International 1997.

Defeni, Sonie:
„DAS BLAUE LICHT"
La leggenda della regista Leni Riefenstahl, tese di
laurea in lingue e letterature straniere, Istituto
Universitario di Lingue Moderne, Facoltà di
Lingue e Letterature Straniere, Feltre 1996.

Salkeld, Audrey:
A PORTRAIT OF LENI RIEFENSTAHL
Originally published: Jonathan Cape, London 1996.
New edition: Pimlico, London 1997.

Phillips, Peggy:
TWO WOMEN UNDER WATER: A CONFESSION
Fithian Press, Santa Barbara 1998.

Filmmuseum Potsdam (Hg.):
LENI RIEFENSTAHL
Mit Beiträgen von Oksana Bulgakowa, Bärbel Dali-
chow, Claudia Lenssen, Felix Moeller, Georg Seeß-
len, Ines Walk, Henschel Verlag, Berlin 1999.

Camera Work (Hg.):
LENI RIEFENSTAHL
Katalog zur Ausstellung ihrer Olympia-Fotos vom
6. Mai bis 24. Juni 2000 in der Galerie Camera
Work in Berlin, mit einem Text von Michael
Krüger, Berlin 2000.

Rother, Rainer:
LENI RIEFENSTAHL. DIE VERFÜHRUNG DES
TALENTS
Henschel Verlag, Berlin 2000.

Taschen, Angelika (Hg.)
LENI RIEFENSTAHL. FIVE LIVES
TASCHEN, Cologne 2000.
Deutsche Ausgabe:
LENI RIEFENSTAHL. FÜNF LEBEN
TASCHEN, Köln 2000.
Édition française:
LENI RIEFENSTAHL. CINQ VIES
TASCHEN, Cologne 2000.
Edición española:
LENI RIEFENSTAHL. CINCO VIDAS
TASCHEN, Colonia 2001.
Edizione italiana:
LENI RIEFENSTAHL. CINQUE VITE
TASCHEN, Colonia 2001.
Edição português:
LENI RIEFENSTAHL. CINCO VIDAS
TASCHEN, Colónia 2001.

Kinkel, Lutz:
DIE SCHEINWERFERIN. LENI RIEFENSTAHL
UND DAS „DRITTE REICH"
Europa Verlag, München 2002.

Degen, Angelika:
LENI RIEFENSTAHL
Eine Zwiesprache mit ihren Memoiren gehalten von
Angelika Degen, Verlag Bärbel Müller, Großpösna
2002.

Trimborn, Jürgen:
RIEFENSTAHL. EINE DEUTSCHE KARRIERE
Aufbau Verlag, Berlin 2002.

**Selected articles and essays
on Leni Riefenstahl**
Ausgewählte Artikel und Aufsätze
zu Leni Riefenstahl
**Sélection d'articles et d'essais
à propos de Leni Riefenstahl**

Allgeier, Sepp: DIE JAGD NACH DEM BILD.
18 Jahre als Kameramann in Arktis und Hochgebirge.
Stuttgart: Engelhorn 1931.

Weiss, Trude: THE BLUE LIGHT, Close Up,
9 February 1932.

Ohne Autor: BAHNBRECHENDER ERFOLG IN
DEN VEREINIGTEN STAATEN. Amerikanische
Pressestimmen über „Das Blaue Licht", Film-Kurier,
6. November 1934.

Ohne Autor: BOTSCHAFTERIN DES DEUTSCHEN
FILMS. Bericht über Leni Riefenstahls Vorträge in
England, Film-Kurier, 2. März 1943.

Kracauer, Siegfried: FROM CALIGARI TO HITLER.
A PSYCHOLOGICAL HISTORY OF GERMAN FILM,
Princeton University Press, Princeton 1947, [2]1966;
Dobson, London 1974.
Edizione italiana:
CINEMA TEDESCO: DAL «GABINETTO DEL DOTT.
CALIGARI» A HITLER (1918–1933), traduzione
di Giuliana Baracco e Carlo D'Oglio, A. Mondadori,
Milano 1954.
Deutsche Ausgabe:
VON CALIGARI ZU HITLER. EINE PSYCHOLO-
GISCHE GESCHICHTE DES DEUTSCHEN FILMS,
übersetzt von Ruth Baumgarten und Karsten Witte,
deutsche Erstausgabe Rowohlt, Hamburg 1958.
Neuausgabe: Suhrkamp Verlag, Frankfurt am Main
1979, [2]1984, [3]1993.
Edition française:
DE CALIGARI À HITLER: UNE HISTOIRE
PSYCHOLOGIQUE DU CINÉMA ALLEMAND,
traduit de l'anglais par Claude B. Lebenson, L'Âge
d'homme, Lausanne 1973. Reprint: Flammarion,
Paris 1987.
Edición española:
DE CALIGARI A HITLER: UNA HISTÓRIA PSICO-
LÓGICA DEL CINE ALEMÁN,
traducción de Héctor Grossi, Paidós Ibérica, Barce-
lona 1985, [2]1995.
Finnish edition:
CALIGARISTA HITLERIIN: SAKSALAISEN ELOKUVAN
PSYKOLOGINEN HISTORIA, Valtion painatuskeskus,
Helsinki 1987.

Gunston, David: LENI RIEFENSTAHL, Film Quarterly,
14 January 1960.

Ohne Autor: LENI RIEFENSTAHLS FALSCHE
TRÄNEN. Die Urheberrechte der Parteitagsfilme –
Streit um Leisers „Mein Kampf", Kölner Rundschau,
14. Januar 1961.

Kuhlbrodt, Dietrich: LENI RIEFENSTAHL
WIEDER OFFIZIELL –
Auf der Berlinale begrüßt, Die Zeit, 24. Juli 1964.

Gardner, Robert: CAN THE WILL TRIUMPH?,
Film Comment, vol. 3, no. 1, Winter 1965.

Brownlow, Kevin: LENI RIEFENSTAHL,
Film (London), 47, Winter 1966–67.

Richards, Jeffrey: LENI RIEFENSTAHL:
STYLE AND STRUCTURE, Silent Picture 8,
Autumn 1970, pp. 17–19.

Alpert, Hollis: THE LIVELY GHOST OF LENI,
Saturday Review, 25 March 1972.

Kreimeier, Klaus: ZUM RIEFENSTAHL-HEFT
DER „FILMKRITIK", epd Kirche und Film,
25. September 1972.

Linder, Herbert (Redaktion): LENI RIEFENSTAHL.
In: Filmkritik XVI, 01. August 1972. Darin
enthalten: Weigel, Herman: INTERVIEW MIT LENI
RIEFENSTAHL, S. 395–410 und *Randbemerkungen
zum Thema*, S. 426–433

Cocteau, Jean: FOUR LETTERS BY JEAN COCTEAU
TO LENI RIEFENSTAHL, Film Culture (US), 56–57,
Spring 1973, pp. 90–93. Dossier Filmography,
Film Culture (US), no. 56–57, Spring 1973,
p. 94–226.

Fanck, Arnold: ER FÜHRTE REGIE MIT
GLETSCHERN, STÜRMEN UND LAWINEN.
Ein Filmpionier erzählt. Nymphenburger Verlags-
Handlung, München 1973, S. 151–310.

HENRY JAWORSKY INTERVIEWED BY GORDON
HITCHENS, KIRK BOND, AND JOHN HANHARDT,
Film Culture (US), 56, Spring 1973.

Vogel, Amos: CAN WE NOW FORGET THE EVIL
THAT SHE DID?, New York Times, 13 May 1973.

Barkhausen, Hans: FOOTNOTE TO THE HISTORY
OF RIEFENSTAHL'S OLYMPIA, Film Quarterly,
21 January 1974, pp. 8–12.

Vogel, Amos: FILM AS SUBVERSIVE ART, George
Weidenfeld and Nicolson Ltd, London 1974, [2]1997.
Nederlandse uitgave:
DE FILM ALS TABOE-BREKER,
Übersetzer: A. Haakman, Gaade, Den Haag 1974.
Édition française:
LE CINÉMA: ART SUBVERSIF, traduit de l'américain
par Claude Frégnac, Éditions Buchet/Chastel, Paris
1977.
Deutsche Ausgabe:
FILM ALS SUBVERSIVE KUNST. KINO WIDER
DEN TABUS – VON EISENSTEIN BIS KUBRICK,
aus dem Englischen übersetzt von Felix Bucher,
Monika Curths, Alexander Horwarth, Pierre Lachat
und Gertrud Strub, Robert Azderball, Hannibal
Verlag, St. Andrä-Wördern 1997, S. 173–180.

Sontag, Susan: FASCINATING FASCISM, New York
Review of Books, 2 February 1975; reprint in:
Sontag, Susan: Under the Sign of Saturn, originally
published: Farrar, Straus & Giroux, New York
1980. Reprint: Anchor Books, New York 1991;
Writers and readers, London 1980, [2]1983;
Deutsche Ausgabe:
FASZINIERENDER FASCHISMUS,
Die Zeit, 02./09.03.1975; Der Artikel erschien
auch in: Frauen und Film, Heft 14, Rotbuch
Verlag, Berlin 1977, S. 6–18 und in Sontag, Susan:
Im Zeichen des Saturn. Essays, Carl Hanser Verlag,
München 1981. Weitere Ausgabe im Fischer
Taschenbuch Verlag, Frankfurt/Main [2]1990,
S. 96–125.
Svensk upplagan:
I SATURNUS TECKEN, Översättning: Eva Liljegren,
Bromberg, Stockholm, Uppsala 1981.
Edizione italiana:
SOTTO IL SEGNO DI SATURNO, traduzione di
Stefania Bertola, Einaudi, Torino 1982.
Nederlandse uitgave:
IN HET TEKEN VAN SATURNUS, Villa, Weesp 1984.
Édition française:
SOUS LE SIGNE DE SATURNE, traduit par Phillippe
Blanchard [et al.], Seuil, Paris 1985.
Edición española:
BAJO EL SIGNO DE SATURNO, traducción de Juan
Utrilla Trejo, Edhasa, Barcelona 1987.
Ukrainian edition:
MAGIČESKIJ FAŠIZM, Iskusstvo Kino (UR), 6 June
1991, pp. 50–57.

Holthausen, Hans Egon: LENI RIEFENSTAHL
IN AMERIKA. Zum Problem einer faschistischen
Ästhetik, Merkur 29 (1975), S. 569–578.

Jagger, Bianca: LENI'S BACK AND BIANCA'S GOT
HER, Andy Warhol's Interview no. 5, January 1975.

Steinert, Jörg: DAS FEST DER MESSER UND
DER LIEBE, stern Nr. 41, 2. Oktober 1975,
S. 34–58.

Bittorf, Wilhelm: BLUT UND HODEN,
Der Spiegel, Nr. 44/1976.

Sokal, Harry: ÜBER NACHT ANTISEMITIN
GEWORDEN?, Der Spiegel, Nr. 46/1976.

Ohne Autor: LENI RIEFENSTAHL UNTER DEN
NUBA, Bunte 37/1976, S. 44–53.

Hansen, Sven: VON NÜRNBERG ZU DEN NUBA,
Die Welt, Ausgabe B, 20. August 1977.

Schille, Peter: LENIS BLÜHENDE TRÄUME,
stern, Nr. 35, 18. August 1977.

Schille, Peter: ABSCHIED VON DEN NUBA,
Geo 9/1977, S. 6–32.

Ohne Autor: MEIN WILDES LEBEN,
Quick 35/1977, S. 41–52.

Harmssen, Henning: DER FALL LENI
RIEFENSTAHL, Neue Züricher Zeitung,
12. Januar 1978.

Rich, B. Ruby: LENI RIEFENSTAHL: THE
DECEPTIVE MYTH. In: Erens, Patricia (Ed.),
Sexual Stratagems: The World of Women in Film,
Horizon, New York 1979, pp. 202–209.

von Wysocki, Gisela: DIE BERGE UND DIE
PATRIACHEN. LENI RIEFENSTAHL. In: von
Wysocki, Gisela: Die Fröste der Freiheit. Aufbruchs-
phanatasien, Syndikat, Frankfurt/Main 1980.

Bergmann, Lutz: DIE LENI MIT DER LEICA,
Bunte 34/1982, S. 20–21.

Grafe, Frieda: RIEFENSTAHL. In: Grafe, Frieda:
Beschriebener Film. 1974–1985. Murnau,
Lubitsch, Renoir, Rietenstahl, Ophuels, Mizoguchi,
Verlag Die Republik, Salzhusen Luhmuehlen 1985.

Leiser, Erwin: VOM KONZENTRATIONSLAGER
ZUM FILM – UND ZURÜCK. Leni Riefenstahl
wehrt sich gegen den Vorwurf, KZ-Gefangene
als Statisten zwangsverpflichtet zu haben,
Die Weltwoche, Nr. 10, 7. März 1985.

Augstein, Rudolf: LENI, DIE „FÜHRERBRAUT",
Der Spiegel, 33/1987, S. 75.

Doane, Mary Ann: THE MOVING IMAGE: PHOTOS
AND THE MATERNAL. In: Doane, Mary Ann: The
Desire to Desire. The Woman's Film of the 1940s,
Bloomington & Indianapolis 1987, pp. 70–97.

Drews, Jürgen: LENI RIEFENSTAHL.
MIT 85 ENTDECKT SIE DIE SCHÖNHEIT DER
TIEFE, Bunte 48/1987, S. 88–102.

Mitscherlich, Maragarete: TRIUMPH DER
VERDRÄNGUNG. Über die Filmregisseurin Leni
Riefenstahl und die Memoiren der glühenden
Hitler-Verehrerin, stern 49/1987.

Spiess-Hohnholz, M.: VERLORENER KAMPF UM
DIE ERINNERUNG, Der Spiegel, Nr. 33/1987.

Loiperdinger, Martin/Culbert, David:
LENI RIEFENSTAHL, THE SA, AND THE NAZI
PARTY RALLY FILMS, NURENBERG 1933–34:
SIEG DES GLAUBENS UND TRIUMPH DES
ILLENS, Historical Journal of Film, Radio and
Television (UK), VIII/1, 1988, pp. 3–38.

Loiperdinger, Martin: HALB DOKUMENT, HALB
FÄLSCHUNG. Zur Inszenierung der Eröffnungs-
feier in Leni Riefenstahls Olympia-Film „Fest der
Völker", Medium, 1988, 18. Jahrgang., Heft 3,
S. 42–62.

Rentschler, Eric: FATAL ATTRACTIONS:
LENI RIEFENSTAHL'S „THE BLUE LIGHT",
October no. 48, Spring 1989, pp. 46–68.

Rentschler, Eric: MOUNTAINS AND MODERNITY:
RELOCATING THE BERGFILM, New German
Critique 51 (1990), pp. 137–161.

Sander-Brahms, Helma: TIEFLAND: TYRANNEN-
MORD, In: Prinzler, Hans Helmut (Hg.): Das Jahr
1945: Filme aus 15 Ländern, ein Katalog zur
Retrospektive der 40. Internationalen Filmfestspiele
Berlin 1990, Stiftung Deutsche Kinemathek, Berlin
1990, S. 173–176.

Reichelt, Peter: „VOLKSGEMEINSCHAFT"
UND FÜHRERKULT / „FEST DER SCHÖNHEIT"
UND SPIELE DER GEWALT: OLYMPIA 1936.
In: Reichelt, Peter: Der schöne Schein des Dritten
Reiches – Faszination und Gewalt des Faschismus,
München 1991, S. 114–138, S. 162–172.

Vetten, Detlef: SCHÖNE WELT AM RIFF,
stern 19/1991, S. 62–74.

Culbert, David/Loiperdinger, Martin: LENI
RIEFENSTAHL'S TAG DER FREIHEIT: THE NAZI
PARTY RALLY FILM, Historical Journal of Film,
Radio and Television, 1992, vol. 12, no. 1,
pp. 3–40.

Elsaesser, Thomas: LENI RIEFENSTAHL:
THE BODY BEAUTIFUL, ART CINEMA AND
FASCIST AESTHETICS. In: Cook, Pam/Dodd,
Phillip (Ed.), Women in Film: A Sight and Sound
Reader, Temple UP, Philadelphia 1992,
pp. 186–197.

Knef, Hildegard: NICHTS ALS NEUGIER,
Interviews zu Fragen der Parapsychologie
mit Gabriele Hoffmann, Kardinal König,
Professor Pritz, Bruno Kreisky, Niki Lauda,
Reinhold Messner, Henry Miller, Lilli Palmer,
Leni Riefenstahl, Carrol Righter, Françoise Sagan,
Gütersloh, o. J.

Kreimeier, Klaus: DIE UFA-STORY. Geschichte
eines Filmkonzerns, Carl Hanser Verlag, München,
Wien 1992, S. 271–273, 296–299.
English edition:
THE UFA-STORY: A history of Germany's greatest
film company, 1918–1945, translated by Robert
and Rita Kimber, Hill & Wang, New York 1996.
Édition française:
UNE HISTORE DU CINÉMA ALLEMAND, LA UFA,
traduit par l'allemand par Olivier Mannoni,
Flammarion, Paris 1994.

Quaresima, Leonardo: ARNOLD FANCK –
AVANTGARDIST: „DER HEILIGE BERG"/
KINEMATOGRAPHIE ALS RITUELLE ERFAHRUNG.
In: Bock, Hans Michael / Töteberg, Michael in
Zusammenarbeit mit Cine-Graph – Hamburgisches
Zentrum für Filmforschung e.V. (Hg.):
Das Ufa-Buch: die internationale Geschichte von
Deutschlands größtem Film-Konzern; Kunst und
Krisen, Stars und Regisseure, Wirtschaft und
Politik, Verlag Zweitausendeins, Frankfurt/
Main, S. 250–252, S. 372–374.

Schiff, Stephan: LENI'S OLYMPIA, Why did Leni
Riefenstahl, publishing her memoirs this month
in the U.K., choose to become the documentarian
of the Third Reich?, Vanity Fair, 1 September 1992,
vol. 55, no. 9, pp. 251–296.

Seeßlen, Georg: DAS MÄDCHEN, DAS KRIEGER
SEIN WOLLTE. Zu Leni Riefenstahls Filmen und
Bildern, aus Anlaß des 90. Geburtstages,
Der Tagesspiegel, 22. August 1992.

Cauby, Vincent: LENI RIEFENSTAHL IN A LONG
CLOSE-UP, New York Times, 14 October 1993.

Corliss, Richard: RIEFENSTAHL'S LAST TRIUMPH,
Time, 18 October 1993, pp. 91–94.

Culbert, David: LENI RIEFENSTAHL AND THE
DIARIES OF JOSEPH GOEBBELS, Historical Journal
of Film, Radio and Television (UK), 13,
1 March 1993, pp. 85–93.

Faris, J. C.: LENI RIEFENSTAHL AND THE NUBA
PEOPLE OF KORDOFAN PROVINCE, Historical
Journal of Film, Radio and Television (UK), 13,
1 March 1993, pp. 95–97.

Foss, Kim: DET TREDJE RIGES FALDUE ENGEL,
Kosmorama (Denmark), XXXIX/203, Spring 1993,
pp. 40–44.

Hoffmann, Hilmar: EINFÜHRUNG ZU OLYMPIA,
MENETEKEL DER VERGANGENHEIT ODER
ZUKUNFT – NACHBETRACHTUNGEN ZU LENI
RIEFENSTAHLS OLYMPIAFILM/SPORT UND RASSE.
In: Cine Marketing GmbH (Hg.): Sport und Film:
bewegte Körper – bewegte Bilder, Internationale
Sportfilmtage Berlin 1993, Redaktion: Anette C.
Eckert, Thomas Til Redevagen, Aufbau Verlag,
Berlin 1993, S. 98–101, S. 108–113.

Niroumand, Miriam: BILDER AN DIE MACHT,
tageszeitung, 30.12.1993.

Panitz, Hans Jürgen: FANCK, TRENKER,
RIEFENSTAHL. In: Berg '93 (Alpenvereinsjahrbuch),
München – Innsbruck – Bozen 1993.

Schlüpmann, Heide: TRUGBILDER WEIBLICHER
AUTONOMIE IM NATIONALSOZIALISTISCHEN
FILM. LENI RIEFENSTAHLS OLYMPIA: TRIUMPH
DES WEIBLICHEN WILLENS? In: Cine Marketing
GmbH (Hg.): Sport und Film: bewegte Körper –
bewegte Bilder, Internationale Sportfilmtage
Berlin 1993, Redaktion: Anette C. Eckert, Thomas
Til Redevagen, Aufbau Verlag, Berlin 1993,
S. 102–107.

Simon, John: THE FÜHRER'S MOVIE MAKER,
New York Times Book Review, 26 September
1993, pp. 1, 26–29.

Witte, Karsten: FILM IM NATIONALSOZIALISMUS.
In: Jacobsen, Kaes, Prinzler (Hg.): Geschichte des
deutschen Films, Stuttgart 1993, S. 124–133.

Compare, Manohla Dargis: QUEEN OF DENIAL:
THE LIFE AND LIES OF LENI RIEFENSTAHL, Voice
Literary Supplement 123, March 1994.

Elsaesser, Thomas: PORTRAIT OF THE ARTIST
AS A YOUNG WOMAN, Sight and Sound
(London), 1994, vol. 3, no. 2, pp. 15–18.

Hausschild, Joachim/Sibylle Bergmann:
EINE FRAU MIT VERGANGENHEIT, stern TV,
März 1994, S. 4–9.

Holthof, Marc: DE WITTE EXTASE: OVER
BERLUSCONI BERGFILMS EN DE GEEST VAN
MÜNCHEN, Andere Sinema (Belgium), no. 121,
May–June 1994, p. 17–21.

Mitscherlich, Margarete: EINE DEUTSCHE FRAU
– LENI RIEFENSTAHL. In: Mitscherlich, Margarete:
Über die Mühsal der Emanzipation, Frankfurt/
Main 1994.

Mulder, Arjen: DEN KONNTE ICH NICHT
OPTISCH ZEIGEN, Andere Sinema (Belgium),
no. 121, May–June 1994, pp. 13–16.

Schlapper, Martin: EIN MONUMENT DER
EINSICHTSLOSIGKEIT, „Die Macht der Bilder –
Leni Riefenstahl", Neue Züricher Zeitung,
26. November 1994.

Seeßlen, Georg: DIE MACHT DER BILDER,
epd Film, 1/1994.

Sklar, Robert: THE DEVIL'S DIRECTOR.
HER TALENT WAS HER TRAGEDY, Cineaste (US),
XX/3, 1994, pp. 18–23.

Sudendorf, Werner: NICHT ZUR
VERÖFFENTLICHUNG. Zur Biografie des
Filmjournalisten Ernst (Ejott) Jäger. In: Filmexil
(Stiftung Deutsche Kinemathek Berlin), Heft 5
Dezember 1994, S. 61–66.

Weidinger, Brigitte: DIE MACHT DER BILDER.
Wie die ARD auf Ray Müllers Film reagierte,
Süddeutsche Zeitung, 9./10. April 1994.

Ohne Autor: KEINE HOMMAGE AN LENI
RIEFENSTAHL. Interview mit Regisseur Ray
Müller, Frankfurter Allgemeine Zeitung,
26. März 1994.

Duerr, Hans Peter: DAS BEISPIEL DER ALTEN
GRIECHEN UND DER NUBA. In: Duerr, Hans
Peter: Frühstück im Grünen. Essays and Interviews,
Suhrkamp Verlag, Frankfurt am Main 1995,
S. 52–77.

Neubauer, Ruodlieb: 92 JAHRE – UND KEINE
SCHEU VOR NEUER TECHNIK. LENI RIEFENSTAHL
ZU IHREM NEUEN FILM, Professional Production,
Nr. 90, Juli/August 1995, S. 12–14.

Veld, Renee in't: RIEFENSTAHL. In: Veld, Renée
in't: Uit liefde voor de Fuehrer vrouwen van het
Derde Rijk: Eva Braun, Magda Goebbels, Leni
Riefenstahl, Florrie Rost van Tonningen, Winifred
Wagner, Walburg Pers, Zutphen 1995.

von Dassanowsky, Robert: "WHEREVER YOU
MAY RUN, YOU CANNOT ESCAPE HIM": Leni
Riefenstahl's self-reflection and romantic tran-
scendence of Nazism in Tiefland, Camera Obscura
(US), no. 35, May 1995, pp. 106–129.

Lenssen, Claudia: DIE FÜNF KARRIEREN
DER LENI RIEFENSTAHL, epd-film, 1/1996.

Manzoli, G.: LA BELLA MALEDETTA,
Cineforum, XXXVI/358, October 1996, p. 38–45.

Müller, Almut/Pottmeier, Gregor:
FASCHISMUS UND AVANTGARDE, Leni Riefen-
stahls „Triumph des Willens". In: Müller, Almut/
Pottmeier, Gregor: Das kalte Bild – Neue Studien
zum NS-Propagandafilm, Augen-Blick, Marburger
Hefte zur Medienwissenschaft, Nr. 22,
Januar 1996, S. 39–58.

Rentschler, Eric: A LEGEND FOR MODERN TIME:
THE BLUE LIGHT. In: Rentschler, Eric: Ministry of
Illusion. Nazi Cinema and its Afterlife, Harvard
University Press, Cambridge, London 1996,
pp. 27–37.

Soussloff, Catherine/Nichols, Bill:
LENI RIEFENSTAHL: THE POWER OF THE
IMAGE, Discource, Spring 1996, vol. 18, no. 3,
p. 20.

Nowinska, Ewa: LENI RIEFENSTAHL:
DIE REGISSEURIN VON MACHT UND
SCHÖNHEIT. In: Olivier, Antje/ Braun, Sevgi:
Anpassung oder Verbot: Künstlerinnen und die
30er Jahre – Vicki Baum, Eta Harich-Schneider,
Clara Haskil, Hannah Höch, Else Lasker-Schüler,
Lotte Lenya, Erika Mann, Leni Riefenstahl,
Charlotte Salomon, Mary Wigman/ Gret Palucca,
Droste Verlag, Düsseldorf 1997, pp. 263–294.

Rapp, Christian: HÖHENRAUSCH: DER DEUTSCHE
BERGFILM, Sonderzahl Verlagsgesellschaft m.b.H.,
Wien 1997, S. 105–156.

Yoshida, Kazuhiko: MEDIA AND FASCISM (1).
An Inquiry about Leni Riefenstahl, Hosei Riron,
1 November 1997, vol. 30, no. 2, p. 202,
text in Japanese.

Sigmund, Anna Maria: LENI RIEFENSTAHL:
DIE AMAZONENKÖNIGIN. In: Sigmund, Anna:
Die Frauen der Nazis, Wien 1998, S. 99–117.

Hake, Sabine: OF SEEING AND OTHERNESS:
LENI RIEFENSTAHL'S AFRICAN PHOTOGRAPHS.
In: Friedrichmeyer, Sara/Kennox, Sara/Zantop,
Susanne: The imperialist imagination, Series: Social
history, popular culture, and politics in Germany,
Ann Arbor: University of Michigan Press 1999.

Schühly, Thomas: LENI RIEFENSTAHL – DIE
MACHT DER BILDER, Welt am Sonntag, Nr. 21,
23. Mai 1999, S. 44.

Schwarzer, Alice: LENI RIEFENSTAHL.
PROPAGANDISTIN ODER KÜNSTLERIN, Emma,
Januar/Februar 1999.

Werneburg, Brigitte: RIEFENSTAHL'S RETURN,
Art of America, October 1999.

Müller, Ray: DER BESUCH DER ALTEN DAME,
stern 14/2000, S. 63–70.

Koetzle, Hans-Michael und Moser, Horst:
LENI RIEFENSTAHL. BIS ZUR BESESSENHEIT,
Leica World, 2/2000, S. 25–33.

Lindemann, Thomas: VON LENI LERNEN?,
Die Woche 44/00, 27. Oktober 2000.

Schwarzer, Alice: 100 PROZENT MANN, 100
PROZENT FRAU, Profil 46, 13. November 2000.

Jenkins, David: DID SHE SELL HER SOUL?,
Chicago Sunday Times, December 3, 2000.

Rodek, Hanns-Georg: DIE FILMSENSATION DES
JAHRES, Die Welt, 7. Januar 2002; UNSERE LENI,
Die Welt, 7. Januar 2002.

Herles, Wolfgang: OFFENE BLENDE. NAZISMUS
ALS NARZISMUS: LUTZ KINKEL ZERLEGT DIE
LEGENDEN UM LENI RIEFENSTAHL, Die Welt,
27. April 2002.

Horst, Ernst: ZÄHER ALS DIE ZÄHESTEN. Der
Berg ruft, und Leni Riefenstahl kam noch einmal
dorthin zurück, wo sie Klettertagebuch geführt
hat, Frankfurter Allgemeine Zeitung, 2. Juli 2002.

Internet Addresses and Links
Internet-Adressen und Links
Liens et adresses Internet

The Perpetual Dancer. Celebrating the Art of Leni
Riefenstahl: http://www.leniriefenstahl.co.uk/

Internet Resources on Leni Riefenstahl:
http://www.webster.edu/~barrettb/riefenstahl2.htm

Flippo, Hyde: Leni Riefenstahl. Links, films and
books: http://www.german-way.com/cinema/rief2.html

von Dassanowsky, Robert: "Wherever you may
run, you cannot escape him". Leni Riefenstahl's
self-reflection and romantic transcendence of
Nazism in Tiefland (originally published in Camera
Obscura no. 35, May 1995):
www.powernet.net/~hflippo/cinema/tiefland.html

Excerpts from Leni Riefenstahl's films can
be seen in Ray Müller's three-hour documentary
THE WONDERFUL, HORRIBLE LIFE OF LENI
RIEFENSTAHL (1993), an English-German-Belgian
coproduction, which has received various inter-
national awards.

Ausschnitte aus den Filmen von Leni Riefenstahl
sind in dem preisgekrönten dreistündigen Dokumen-
tarfilm LENI RIEFENSTAHL – DIE MACHT DER
BILDER (1993) von Ray Müller zu sehen, einer
englisch-deutsch-belgischen Co-Produktion.

Des extraits de films de Leni Riefenstahl figurent
dans le documentaire de trois heures LE POUVOIR
DES IMAGES – LENI RIEFENSTAHL (1993) de
Ray Müller – une coproduction anglaise, allemande
et belge, récompensée au niveau international.

Front cover: Portrait of Jamila, a Nuba woman, 1998 (see p. 234)
Back cover: The *Nyertun* dance of the Nuba (see p. 338)

To stay informed about upcoming TASCHEN titles, please
request our magazin at www.taschen.com or write to
TASCHEN, Hohenzollernring 53, D-50672 Cologne, Germany,
Fax: +49-221-254919. We will be happy to send you a free copy
of our magazin which is filled with information about all of our books.

© 2005 TASCHEN GmbH
Hohenzollernring 53, D-50672 Köln
www.taschen.com

Original edition: © 2002 TASCHEN GmbH
© 2005 for the photography: Leni Riefenstahl
All Photographs: Leni Riefenstahl Archiv

© 2002 for the photograph by Alfred Eisenstaedt:
Alfred Eisenstaedt Time Pix/Inter Topic
© 2002 for the photograph by Daniel Mayer:
Daniel Mayer, Sunday Telegraph Magazine, London
© 2002 for the photograph by George Rodger:
Magnum/Agentur Focus
© 2005 for the work by Eugen Spiro:
VG Bild-Kunst, Bonn

Every attempt has been made to obtain copyright clearance
on all images contained herein; any copyright holder omitted,
please contact TASCHEN GmbH
so that the situation may be rectified.

Edited by Angelika Taschen, Cologne
Design by Sense/Net, Andy Disl and Birgit Reber, Cologne
Lithography management by Thomas Grell, Cologne
Lithography by NovaConcept, Berlin

Preface text by Kevin Brownlow, London
French translation of the text by Kevin Brownlow
by Michèle Schreyer, Cologne
Japanese translation of the text by Kevin Brownlow
by Mari Kiyomiya, Chiba-ken

Appendix text by Ines Walk, Berlin
English translation of the appendix text
by Steven Lindberg, Pasadena; Michael Hulse, Golbach
French translation of the appendix text by Martine Passelaigue, Munich;
Michèle Schreyer, Cologne

Printed in China
ISBN 3-8228-4791-7